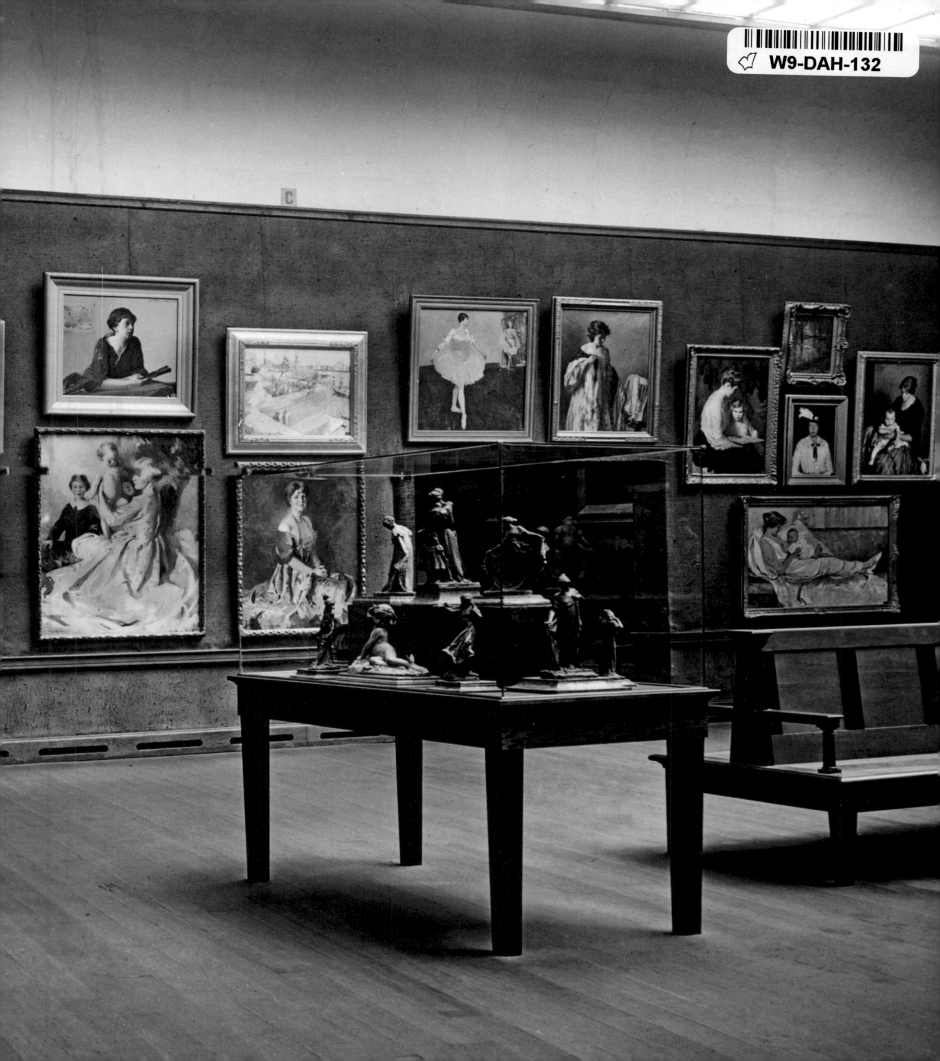

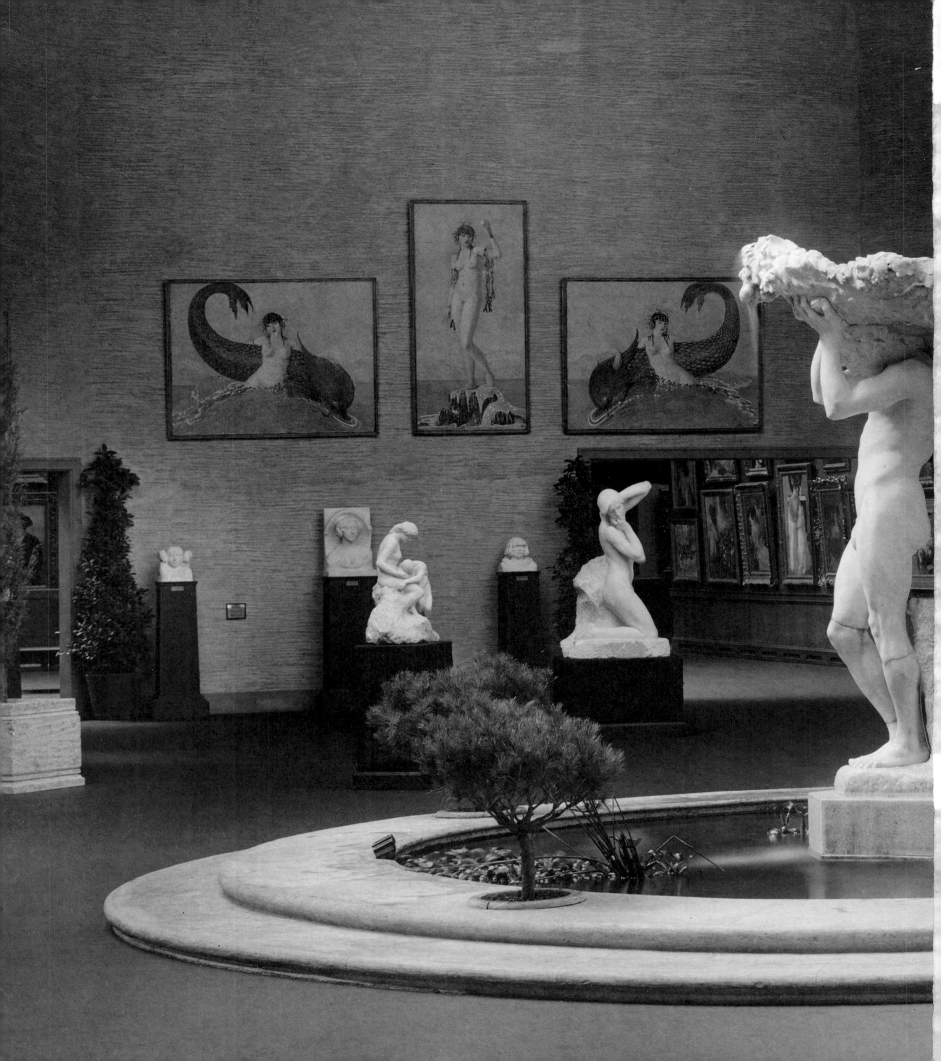

JEWEL CITY

JEWEL CITY

Art from San Francisco's Panama-Pacific International Exposition

❈

Edited by James A. Ganz

with

Emma Acker, Laura A. Ackley, Heidi Applegate, Gergely Barki, Karin Breuer,

Melissa E. Buron, Martin Chapman, Renée Dreyfus, Victoria Kastner,

Anthony W. Lee, Scott A. Shields, and Colleen Terry

❈

Fine Arts Museums of San Francisco

University of California Press

CONTENTS

FOREWORD7
Richard Benefield

LENDERS TO THE EXHIBITION8

ACKNOWLEDGMENTS9

INTRODUCTION11
"A Beautiful Jewel Set in the Turquoise of the Sea,"
James A. Ganz

THE SPIRIT OF THE EXPOSITION

Gem of the Golden Age of World's Fairs, *Laura A. Ackley*43

The Power of Beauty: Bernard Maybeck's Palace of Fine Arts, *Victoria Kastner*51

The Classical Ideal in the New Athens, *Renée Dreyfus*61

Harmony and Discord in the Murals, *Anthony W. Lee*71

AMERICAN ART

"A Pageant of American Art": Constructing Nation and Empire at the Fair, *Emma Acker*111

Jewels of Light and Color: American Painting in the Palace of Fine Arts, *Scott A. Shields*125

"Progressing Along Normal, Wholesome Lines": Modern American Painting, *Heidi Applegate*139

PRINTMAKING AND PHOTOGRAPHY

Prints at the Exposition, *Colleen Terry*215

Gallery 34: Contemporary Color Prints, *Karin Breuer*227

Exposing Photography at the Fair, *James A. Ganz*237

THE FRENCH PAVILION AND THE ANNEX

The French Pavilion, *Martin Chapman*303

French Paintings at the Exposition: A Triumph of Diplomacy, *Melissa E. Buron*311

A Debut of Hungarian Art in America, *Gergely Barki*325

GROUND PLAN AND FLOOR PLANS376

CHRONOLOGY380

CATALOGUE OF THE EXHIBITION384

SELECTED BIBLIOGRAPHY392

INDEX394

FOREWORD

It has been nearly thirty years since the Fine Arts Museums of San Francisco organized *The New Painting, Impressionism: 1874–1886* (National Gallery of Art, Washington, DC, and de Young, San Francisco, 1986), which reassembled 160 works from the eight original Impressionist exhibitions. *The New Painting* made a profound contribution to the scholarship of nineteenth-century French art, and, although it was not the first curatorial venture to do so, it set a precedent for restaging historic exhibitions, now a regular practice in the museum world. In such recent examples as *1912: Mission Moderne* (Wallraf-Richartz-Museum, Cologne, 2012), *The Armory Show at 100: Modernism and Revolution* (New-York Historical Society, 2013), and *Degenerate Art: The Attack on Modern Art in Nazi Germany, 1937* (Neue Galerie, New York, 2014), institutions have taken on the challenges of reconstructing and reconsidering important exhibitions of the past to show the impact they had on the public at the time as well as how they have influenced the course of art history.

In this centennial year of the Panama-Pacific International Exposition (PPIE), it is especially appropriate for the Fine Arts Museums of San Francisco to revisit the artistic component of a world's fair that played a pivotal role in shaping the modern cultural history of San Francisco. Occupying 635 acres in the Marina district, the fair attracted nearly nineteen million visitors during its run from February 20 to December 4, 1915. It was a triumph for the city that had suffered such a terrible blow in the earthquake and fire of 1906. The founding of the California Palace of the Legion of Honor; the significant expansion of the Memorial Museum (now the de Young); and the establishment of a third art museum in the city under the auspices of the San Francisco Art Association, which laid the groundwork for the San Francisco Museum of Modern Art, all were legacies of the PPIE.

This exhibition has been an in-depth undertaking by our institution, and I want to thank our dedicated curatorial team of Emma Acker, Karin Breuer, Melissa E. Buron, Martin Chapman, Renée Dreyfus, and Colleen Terry, who, under the leadership of James A. Ganz, have brought into focus several key aspects of the multifaceted art exhibition of 1915. We are delighted to share what our curators have discovered about the art of the PPIE, alongside significant contributions from outside scholars Laura A. Ackley, Heidi Applegate, Gergely Barki, Victoria Kastner, Anthony W. Lee, and Scott A. Shields.

Without the generosity of the many private collectors and institutions that own the works of art shown in the PPIE, as noted on the following page, it would have been impossible for us to stage this exhibition. I would like to give special recognition to Elizabeth Murray, managing director of the San Francisco War Memorial and Performing Arts Center, who has made available to us two of the original murals commissioned for the Exposition. The presentation of these works, as well as a number of objects in the Museums' collections that have not been on view for many years, has been facilitated by our team of talented conservators, including Victoria Binder, Lesley Bone, Heather Brown, Catherine Coueignoux, Debra Evans, Sarah Gates, Anne Getts, Geneva Griswold, Sarah Kleiner, Laura Kolkena, Yadin Larochette, Natasa Morovic, Patricia O'Regan, and Lisa Sardegna. I especially am proud of our paintings conservators' outstanding work on restoring *The Victory of Culture over Force (Victorious Spirit)* (1914, San Francisco War Memorial), the mural by Arthur Frank Mathews that graces the cover of this book.

All of our presentations are made possible through the generous support of our donors. We are grateful to the National Endowment for the Arts and the Lisa and Douglas Goldman Fund for their sponsorship of this exhibition, and to the Andrew W. Mellon Foundation Endowment for Publications for its support of this catalogue. The Achenbach Graphic Arts Council generously provided funding for Kirk Nickel, a research fellow dedicated to this project.

Richard Benefield
DEPUTY DIRECTOR OF MUSEUMS AND CHIEF OPERATING OFFICER
FINE ARTS MUSEUMS OF SAN FRANCISCO

Lenders to the Exhibition

Albright-Knox Art Gallery, Buffalo, New York

American Academy of Arts and Letters, New York

David H. Arrington Collection

Art Institute of Chicago

Avery Architectural & Fine Arts Library, Columbia University, New York

Melza and Ted Barr, Houston

Berkeley Art Museum, California

Cantor Arts Center, Stanford University, California

Carnegie Museum of Art, Pittsburgh

Cincinnati Art Museum

Massimo and Sonia Cirulli Archive, New York

Cleveland Museum of Art

Crocker Art Museum, Sacramento

Dayton Art Institute, Ohio

The Delman Collection, San Francisco

Epstein Family Collection

Exploratorium, San Francisco

Florence Griswold Museum, Old Lyme, Connecticut

John and Berthe Ford, Baltimore

Frye Art Museum, Seattle

Galleria d'arte moderna di Palazzo Pitti, Florence

Gari Melchers Home and Studio, University of Mary Washington, Fredericksburg, Virginia

George Eastman House, Rochester, New York

Jacque Giuffre and Bill Kreysler

Margaret E. Haas

Laura and Byrne Harper

Herbert F. Johnson Museum of Art, Cornell University, Ithaca, New York

High Museum, Atlanta

Hirshhorn Museum and Sculpture Garden, Smithsonian Institution, Washington, DC

Donna Ewald Huggins

Hyde Collection Art Museum, Glens Falls, New York

Irvine Museum, California

J. Paul Getty Museum, Los Angeles

Kieselbach Collection, Budapest

Greg Latremoille

Library of Congress, Washington, DC

Magyar Nemzeti Galéria, Budapest

John J. Medveckis

Memorial Art Gallery, University of Rochester, New York

Metropolitan Museum of Art, New York

Mills College Art Museum, Oakland

Musée de Grenoble, France

Musée d'Orsay, Paris

Museum of Fine Arts, Boston

Museum of Fine Arts, Houston

Museum of Modern Art, New York

Muskegon Museum of Art, Muskegon, Michigan

National Gallery of Art, Washington, DC

National Gallery of Canada, Ottawa

Oakland Museum of California

Peggy Guggenheim Collection, Venice

Pennsylvania Academy of the Fine Arts, Philadelphia

Philadelphia Museum of Art

Portland Art Museum, Portland, Oregon

Rockwell Museum, Corning, New York

Ruth Chandler Williamson Gallery, Scripps College, Claremont, California

San Francisco Museum of Modern Art

San Francisco War Memorial

M. Christine Schwartz Collection, Chicago

Smithsonian American Art Museum, Washington, DC

Drs. Thomas Sos and Shelley Wertheim, and Lidia Szajko and Nanci Clarence

Sterling and Francine Clark Art Institute, Williamstown, Massachusetts

Ulrich Museum of Art, Wichita State University, Kansas

Collection Siegfried Unterberger

Elisabetta Vedres

Virginia Museum of Fine Arts, Richmond

Walters Art Museum, Baltimore

Ambassador and Mrs. Ronald Weiser

Whitney Museum of American Art, New York

William Benton Museum of Art, University of Connecticut, Storrs

Wilson Centre for Photography, London

Jill A. Wiltse and H. Kirk Brown III, Denver

Private collections

Acknowledgments

On behalf of the Fine Arts Museums of San Francisco, I wish to thank Diane B. Wilsey, president of our Board of Trustees, for her support of this project, as well as Richard Benefield, deputy director of Museums and chief operating officer; Michele Gutierrez-Canepa, chief financial officer and foundation fiscal officer; Julian Cox, founding curator of photography and chief administrative curator; and Colin B. Bailey, former director of Museums.

This volume could not have come to fruition without the dedicated efforts of this volume's authors. Within the Fine Arts Museums, these collaborators were Emma Acker, assistant curator of American art; Karin Breuer, curator in charge of the Achenbach Foundation for Graphic Arts (AFGA); Melissa E. Buron, associate curator of European paintings; Martin Chapman, curator in charge of European decorative arts and sculpture; Renée Dreyfus, curator in charge of ancient art and interpretation; and Colleen Terry, assistant curator of the AFGA. Outside the Museums, significant contributions were made by Laura A. Ackley, Heidi Applegate, Gergely Barki, Victoria Kastner, Anthony W. Lee, and Scott A. Shields. Research assistance was provided by Kirk Nickel and made possible through the gracious support of the Achenbach Graphic Arts Council.

Leslie Dutcher, director of publications, and Danica Michels Hodge, editor and project manager, expertly guided the publication to completion, with support from Jane Hyun, editor, and Diana K. Murphy, editorial assistant. Additional thanks are due to Sue Grinols, director of photo services, and Randy Dodson, photographer, for providing many of the beautiful photographs in this catalogue. Bob Aufuldish, of Aufuldish & Warinner, created the magnificent design and typesetting. I thank Kathryn Shedrick for her copyediting expertise, Susan Richmond for her proofreading assistance, and Jane Friedman for her indexing. I am grateful to Amanda Freymann, partner of Glue + Paper Workshop, as well as Pat Goley, Jane Messenger, and the staff of ProGraphics for their management of the color separations, printing, and binding of this volume; and Karen A. Levine and all of our collaborators at UC Press for their esteemed publishing partnership. This catalogue was graciously funded by the Andrew W. Mellon Foundation Endowment for Publications.

For the organization and installation of the exhibition, I extend my appreciation to Krista Brugnara, director of exhibitions; Sarah Hammond, senior exhibitions coordinator; the entire exhibition preparation staff, including Robert Haycock and Don Larsen; and Therese Chen, director of collections management, along with Steven Correll, collections manager, and the Museums' registration staff, Douglas DeFors, Julian Drake, and Kimberley Montgomery.

I am especially grateful to the conservation teams led by Patricia O'Regan, conservator of paintings; Debra Evans, head conservator of works on paper; Lesley Bone, head objects conservator; and Sarah Gates, head textiles conservator, for their successful efforts in assessing and restoring many of the works of art in this exhibition.

For institutional support of the exhibition, I thank Lisa Podos, director of strategic projects; Suzy Varadi, Laura Florio, and the staff of the Development department; the marketing and communications team; librarians Abigail Dansiger, Jane Glover, and Richard Sutherland; Stuart Hata, director of retail operations, and Tim Niedert, book and media manager for the Museum Stores; and the Education department for their excellent and ongoing support. Thanks also are given to Brian Marston, controller, and Daiquiri Weed, principal accounts clerk.

Of course, the exhibition would not have been possible without the extreme generosity of our many lenders, both public and private, who have agreed to share their prized artworks with wider audiences, and who are recognized on the opposite page. I am particularly grateful to many individuals who provided critical assistance by sharing information and directing me to a wealth of resources. They include Laura A. Ackley, Scott Allan, Heidi Applegate, Gergely Barki, Melza and Ted Barr, Aaron Bastian, Bonnie Bell, Olivier Bertrand, Cheri Bianchini, Jonathan Bober, Kathleen Burnside, Kayla Carlsen, Mary Weaver Chapin, Erin Coe, Renato Consolini, James Delman, Kirk Delman, Marie and Murray Demo, Peter Fairbanks, Starr Figura, Alfred Harrison, Anthea M. Hartig, Eleanor Harvey, Erica Hirshler, Lisa Hodermarsky, Libby Horner, Donna Ewald Huggins, Drew Johnson, Gary Kurutz, Richard Levin, Nancy Mowll Mathews, Suzanne McCullagh, Jean Moulin, Laura Nagle, Mary Ellen Oldenburg, Barbro Osher, Helen Papoulias, Brian H. Peterson, Charles S. Pyle, Christopher Riopelle, Jason Schoen, David Silcox, Janne Sirén, Jonathan Stuhlman, Alexandra Suda, Robert Tat, Martha Tedeschi, and Donald Whitton.

Finally, we would like to acknowledge the generosity of those whose financial support has made this presentation possible, including the Lisa and Douglas Goldman Fund and the National Endowment for the Arts.

James A. Ganz
CURATOR, ACHENBACH FOUNDATION FOR GRAPHIC ARTS
FINE ARTS MUSEUMS OF SAN FRANCISCO

JAMES A. GANZ

INTRODUCTION:
"A BEAUTIFUL JEWEL SET IN THE TURQUOISE OF THE SEA"

San Francisco's Panama-Pacific International Exposition (PPIE) of 1915 presented one of the largest art exhibitions ever shown within the context of a world's fair. Although the organizers were significantly challenged by the outbreak of the First World War during its planning, the Exposition introduced a number of European movements to American audiences, including Italian Futurism, Austrian Expressionism, and Hungarian modernism. Portions of the main exhibition space in the Palace of Fine Arts were devoted to a historical survey of American art and its European roots, including retrospective galleries of prominent American painters, with an emphasis on Impressionism. When it was all over, more than half of the roughly nineteen million fairgoers had visited the Palace and its Annex.[1] By popular demand, Bernard Maybeck's iconic Palace of Fine Arts was preserved as a museum, while the French Pavilion inspired Alma de Bretteville Spreckels's creation of the California Palace of the Legion of Honor. Even institutions not directly involved in the Exposition, such as the Memorial Museum in Golden Gate Park and the Oakland Public Museum, benefited from the legacy of the art exhibition, which helped erase memories of the 1906 earthquake and establish San Francisco as the epicenter of culture on the West Coast.

John E. D. Trask, the Exposition's chief of fine arts, recorded 11,403 works of art in the Palace of Fine Arts and its neighboring Annex, a figure more or less consistent with the *Official Catalogue of the Department of Fine Arts*, but the art component of the PPIE was actually much larger.[2] Thousands of works classified outside his department were installed inside the Palace of Education

and Social Economy, the Palace of Liberal Arts, and the foreign and state pavilions, not to mention the public murals (see Lee, this volume) and sculptures scattered throughout the grounds. The grand total was probably closer to 20,000, a number more than double that of the Saint Louis Louisiana Purchase Exposition of 1904, the Paris Exposition Universelle of 1900, or the Chicago World's Columbian Exposition of 1893. Indeed, the word "overwhelming" may be the only adjective that accurately describes both the art experience offered fairgoers in 1915 and the challenges faced by scholars examining the fair's artistic significance a century later.

A fundamental stumbling block in evaluating the art of the PPIE is the difficulty in identifying a critical mass of the works shown in 1915 and afterward dispersed. The contemporary catalogues and guidebooks provide valuable insights, but the relative paucity of illustrations and the rudimentary checklists, which omit dates, dimensions, and often lenders of individual works, complicate efforts to pinpoint submissions even by some of the most prominent exhibitors. For instance, none of the twenty-eight works by the California-based Scottish-American landscapist William Keith have been identified, eleven of which were listed simply as *Landscape*.[3] The situation is even more acute for the preponderance of entries by lesser-known figures whose artistic productions and reputations have faded into obscurity.

Another significant hindrance to scholarship is the disappearance of the records of the fair's Department of Fine Arts. After the Panama-Pacific International Exposition Company, the private corporation organized in March 1910 to organize

the fair, was finally dissolved in 1920, it gave its archive of official records to the newly founded San Francisco War Memorial, which in 1938 and 1939 transferred the files to the Bancroft Library at the University of California, Berkeley.[4] This collection has been made accessible to scholars by the compilation of a detailed finding aid in 2005 and 2006.[5] During the cataloguing of the archive, it was noticed that the Fine Arts files had gone missing, although some of that department's interoffice correspondence was preserved by other divisions, as were records relating to the fair's murals and public sculptures as well as the photographs exhibited under the direction of the Departments of Liberal Arts, Education, and Social Economy (see "Exposing Photography at the Fair," this volume).

Trask's final *Report of the Department of Fine Arts*, a copy of which is in the San Francisco History Center, is a key source of information and an unexpected page-turner. Dated September 16, 1916, and addressed to Charles C. Moore, president of the Exposition Company, the report is not simply a dry recitation of facts and figures, but a personal account of the trials, tribulations, and pet peeves of the chief of fine arts. While this typescript was clearly not meant for immediate public consumption—a published edition half its length omits the contentious passages—it seems to have been composed by Trask with an eye toward setting the record straight for posterity, if only to help future fair organizers avoid the pitfalls he experienced.[6]

Finally, the archive of the San Francisco Art Association (SFAA) held by the San Francisco Art Institute is the main repository of documents relating to the post-Exposition period. After the fair, the Palace of Fine Arts remained open for several months under the auspices of the Exposition Company, after which the SFAA took it over to operate as an art museum until 1924. The mostly uncatalogued files of the museum's director J. Nilsen Laurvik, who was also a prime mover in the PPIE's Fine Arts Department, illuminate the art that remained after the fair, including the tortuous story of the foreign works that became stranded in San Francisco during the war.[7]

PICTURING THE FAIR

When the United States took over the construction of the Panama Canal from the French in 1904, and announced that it would be completed in a decade, a group of San Francisco's civic leaders and businessmen initiated plans to organize a world's fair celebrating this monumental accomplishment. Their planning was undeterred by the great earthquake and fire of 1906 which forced new and immediate priorities, including caring for the victims, sheltering the homeless, and rebuilding the infrastructure. But the city also had a serious public relations problem to overcome. The popularity of imagery of the ruined metropolis circulating in photographs (see fig. 1) as well as paintings (see fig. 2) was threatening to brand San Francisco as a disaster area and to cast a pall on efforts to revive its economy.

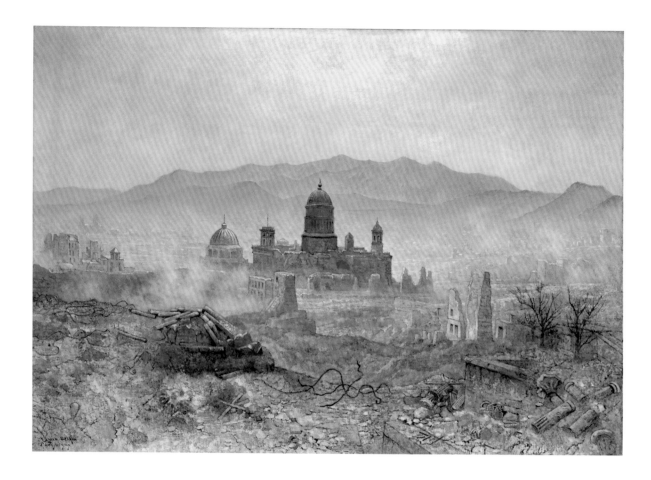

From the beginning, the organizers in San Francisco recognized the need for compelling marketing materials to win the right to host the exposition (see Ackley, this volume), attract exhibitors, and build excitement among potential fairgoers. Painter Jules Guérin, the PPIE's director of color and decoration, played a key role in the visualization process. A Saint Louis native who had studied in Paris, Guérin was a muralist, illustrator, and one of the best architectural draftsmen in the United States.[8] Working with such prominent city planners as McKim, Mead and White; Daniel Burnham; and Edward H. Bennett, he had previously produced conceptual illustrations for a number of major projects, including the McMillan Plan for Washington, DC (1902), and the Burnham Plan of Chicago (1909). His presentation watercolors and paintings generally evoked the feeling of a place more effectively than the cold technical drawings of engineers and architects.

Guérin also mastered the art of painting pictures with words for the purposes of marketing. "Imagine a gigantic Persian rug of soft, melting tones, with brilliant splashes here and there, spread down for a mile or more, and you may get some idea of what the Panama-Exposition will look like if viewed from a distance," he told the press in 1913,[9] elsewhere characterizing the fair as "a beautiful jewel set in the turquoise of the sea."[10] Although his main responsibilities were overseeing the color scheme and mural program, he proposed soon after his appointment in August 1912 to create a series of colored renderings of the fairgrounds that could be used for promotion. "Four papers in New York have interviewed me," Guérin wrote to chief architect George Kelham in September, "and they were begging for material. From an advertising standpoint, this work would pay for itself in a short time."[11] Subsequent correspondence records the long-distance collaboration between the New York–based Guérin and the San Francisco architects that yielded a group of elevations in dramatic single-point perspective (see fig. 49), as well as a panoramic view from Presidio Heights, located to the southwest (see pl. 6).[12] These illustrations debuted in articles on the fair's color scheme in the *New York Times* and *Scribner's Magazine* in June and July of 1913, and continued to appear in official publications, brochures, and postcards through the run of the Exposition.[13]

Guérin also played a role in selecting Perham Nahl's *The Thirteenth Labor of Hercules* (pl. 1) as the Exposition's official poster, a powerful design in which the muscular colossus pries open the Panama Canal's Culebra Cut to reveal the "Jewel City," as the fair was known, twinkling in the distance. The Committee on Exploitation and Publicity put out a call for poster designs in 1913 and, from forty entries by eighteen artists, selected twelve for review by a blind jury consisting of Guérin, Kelham, Trask, director of exploitation George Perry, and William B. Faville, one of the official architects.[14] Although Nahl's winning design was widely praised when announced in February 1914, the competition was not without controversy. A writer for the *Oakland Tribune* claiming to have

inside information complained that the judges prohibited the Berkeley artist from signing his poster because they feared charges of favoritism might be made back East, concluding "a Californian . . . given for once an 'even break' with the rest of the world, won first honors hands down and was promptly robbed of the dearest perquisite of his success!"[15]

The fair's construction was thoroughly documented by the Company's photographers as well as by artists and other visitors to the grounds, which were open during the pre-Exposition period until January 10, 1915.[16] But to protect the commercial interests of the official concessioners, strict rules were imposed on amateur photographers, who had to purchase a daily twenty-five-cent license to enter with a camera. Tripods and cameras using negatives larger than four by five inches were banned. Sigismund Blumann, a local photographer who was initially critical of this policy, finally admitted in the *Photographic Journal of America* that the fee was nominal "and it is worth many times that to get a half dozen of the beauties perpetuated on film or plate. The perspectives are awe-inspiring and the coloring of delicacy that defies description."[17]

Although color photography was still in its infancy, the novel process of autochrome attracted artists and amateurs even while it remained impractical for commercial publishing. Glass autochrome plates were prepared by spreading a photographic emulsion over a microscopic matrix of potato starch grains dyed in red, green, and blue that worked as chromatic filters upon exposure. While most color views of the fair were produced by traditional hand tinting of black-and-white prints, two little-known caches of autochromes record the true colors of the PPIE. Helen Messinger Murdoch, a Bostonian who belonged to London's Royal Photographic Society, created the first group on an around-the-world tour.[18] In her notes on the trip, she described sailing into the San Francisco Bay on September 28, 1914, "passing through the Golden Gate in the early morning and getting a glimpse of what looked like a fairy city."[19] During the following month, she created at least a dozen autochromes, including views of the Palace of Fine Arts (fig. 3) and the Arch of the Nations of the East under construction (fig. 4). Amateur photographer Murray Warner, a retired military engineer residing in San Francisco, produced an even larger number of autochromes during the pre-Exposition period (see figs. 5, 34, 55, and 72).[20]

While artists flocked to the fair with their sketch pads and painting materials, confusion reigned during the early months regarding a ban on sketching, which was reported by Michael Williams, a well-informed member of the local arts community, in *American Art News*.[21] In fact, sketching on the grounds was not entirely banned, for artists could obtain permits from chief of works Harris Connick, who finally sent an order to the commandant of the guards on March 29, the day that Williams submitted his story, withdrawing the unpopular policy.[22] One of the earliest requests on file is a handwritten note dated March 2, 1915, from E. (Euphemia) Charlton Fortune asking for permission to paint on the fairgrounds (see fig. 7 and pl. 13).[23] Like Fortune, fellow Bay Area painter Anne M. Bremer was particularly inspired by the dazzling, color-coordinated gardens (see pl. 14). Maybeck's elegiac Palace of Fine Arts (see Kastner, this volume) inspired countless artists, among them Edwin Deakin, an English-born

FIG. 3
Palace of Fine Arts, under construction, 1914.
Autochrome by Helen Messinger Murdoch.
Science and Society Picture Library, London

FIG. 4
Arch of the Nations of the East, under construction, 1914. Autochrome by Helen Messinger
Murdoch. Science and Society Picture Library,
London

member of the Bohemian Club, a private San Francisco organization of artists, writers, and musicians, many of whom contributed their talents to the PPIE. Less than a decade after he had memorialized the smoldering skyline of San Francisco from the top of Nob Hill (see fig. 2), the Palace appealed to Deakin's insatiable appetite for picturesque ruins (see pl. 10).

SCULPTURE, INSIDE AND OUT

The PPIE's ambitious public sculpture program was entrusted to Karl Bitter, whose rapid rise to the top of his profession after emigrating from Austria in 1899 led to appointments as director of sculpture for both the Pan-American Exposition in Buffalo (1901) and the Saint Louis world's fair, and the presidency of the National Sculpture Society. In fact, Bitter was in so much demand that he predicated his acceptance of the San Francisco post in 1912 on the joint appointment of Alexander Stirling Calder, a former pupil of Thomas Eakins in Philadelphia and Alexandre Falguière in Paris. As acting chief, Calder took on the department's day-to-day work in San Francisco, while Bitter remotely supervised from New York.[24] Together, the two men outlined the master plan, hired sculptors, and critiqued their designs, which would be manufactured by ninety artisans working in San Francisco. It was a tall order, encompassing ornamentation of the buildings and courts, as well as the design and fabrication of numerous fountains and freestanding monuments. And there was more to the sculpture program than mere decoration. Like the muralists, the sculptors were charged with articulating the fair's overarching themes of peace, progress,

and prosperity, without neglecting the subtexts of Manifest Destiny, cultural imperialism, and racial superiority that from today's vantage point reflect the dark undercurrents of the fair's iconography (see Acker, this volume).[25] Bitter's sudden death in April 1915 in New York City (he was hit by a car while jaywalking across Broadway after attending a performance at the old Metropolitan Opera House) left Calder as the department's spokesman, and he rose to the occasion. "It is the sculpture that interprets the meaning of the exposition," he boasted, "that symbolizes the spirit of conquest and of adventure, and lends imagery to all the elements that have resulted in the union of the Eastern and Western seas. Divest the exposition of its sculpture and you would have no visible symbols to characterize or interpret its purpose and its accomplishment."[26] Calder conceived one of the Exposition's most popular sculptural monuments, the Column of Progress, which stood on the north end of the fairgrounds near the yacht harbor. Designed by William Symmes Richardson of McKim, Mead and White, the 185-foot-tall column was topped by a sculpture group by Hermon Atkins MacNeil including *The Adventurous Bowman* (see fig. 71), an allegory of progress posed in the instant after shooting his arrow skyward.

Like the fair's buildings, its sculpture was not made to last, but was executed in impermanent staff, a cheap type of plaster mixed with burlap fibers that could be painted to resemble bronze or otherwise harmonize with the architecture. Calder himself would design several major sculptural elements, including the iconic *Star Maiden* (pl. 15), for which model and actress Audrey Munson posed (see fig. 8). Dozens of identical Star Maidens stood at regular intervals above the colonnades

of the Court of the Universe, representing an array of stars in the sky (see fig. 9). Designed to sparkle in the glow of spotlights, their headdresses bore the same cut-glass multicolored "Novagem" crystals that appeared on the Tower of Jewels and that gave the Exposition its nickname, the Jewel City. Munson herself became famous as the "Panama-Pacific Girl" for her well-publicized ubiquity in the public art.[27] Hers was "a face ten million people are expected to admire at the Panama-Pacific Exposition," according to one headline, but it was her lithe physique that aroused even more attention.[28] Munson was in great demand as a nude model, and posed for Adolph Alexander Weinman's *Descending Night*, which stood opposite his *Rising Day (Rising Sun)* atop tall columns surrounded by fountains in the Court of the Universe.[29]

Sculptures like Calder's *Star Maiden*, Weinman's *Descending Night*, and James Earle Fraser's equestrian monument *The End of the Trail* (see pls. 21–22 and fig. 69) were among the PPIE's most popular artistic productions and earned the official concessioners handsome profits from sales of postcards and reproductions. The artists, having signed away their copyrights, were prohibited by the terms of their contracts from exhibiting or selling casts for a year after the fair's close. "I have been told that more than $250,000 worth of prints and photographs were sold of [*The End of the Trail*]," Fraser grumbled in his memoirs, adding "Who got the money, I don't know. I do know I didn't get any of it. As a matter of fact, everyone knew of the statue, but no one seemed to know its sculptor. I'm afraid I was too busy to take advantage of how much it was liked."[30]

That the rules could be bent was demonstrated in October 1914, when Weinman obtained permission from Bitter to cast a bronze reduction of *Descending Night* for display in the Palace of Fine Arts (he would later cast reductions of

Rising Day) (pls. 17–18).[31] According to interdepartmental correspondence, the same privilege was granted to other sculptors.[32] Like Weinman, Fraser would eventually commission bronze reductions of his PPIE sculpture from New York's Roman Bronze Works, the premier foundry of the day (see pl. 22). Although Calder seems not to have sold casts of his *Star Maiden*, a small number of bronze reductions were produced posthumously from an original terra-cotta maquette in the collection of the Oakland Museum of California (see pl. 15).[33]

Not all of the monumental sculpture fell under the control of Bitter and Calder. Most notably, the Department of Fine Arts assumed responsibility for Auguste Rodin's *The Thinker*, which stood before the French Pavilion (see Chapman, this volume), and Charles Grafly's *Pioneer Mother Monument*, which was placed near the main entrance to the Palace of Fine Arts (see fig. 10). Representing a colonial-era woman and her two children, *Pioneer Mother* was one of the fair's most troubled commissions.[34] The idea for a monument on this theme was conceived by local writer Ella Sterling Mighels, and the project was taken over by the Pioneer Mother Monument Association, a group drawn mainly from the Woman's Board of the PPIE, which raised funds and selected Philadelphian Grafly after he was strongly promoted by Trask.[35] The stakes were especially high because this heroic memorial to California's motherhood would be cast in bronze to become a permanent monument in San Francisco.[36] Controversy arose from the sculptor's original plans to clothe the mother in a Native American buckskin dress and moccasins and leave the children naked (see pls. 19–20), representing his own conception of the "wild West" that ran afoul of the Association's more conservative members, including Phoebe Apperson Hearst. Although Grafly adjusted the mother's attire to remove any doubts about her Caucasian race,

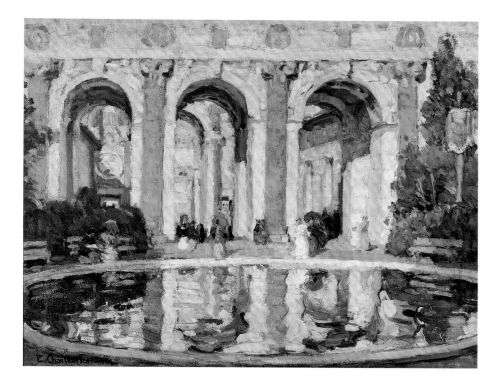

he insisted on the children's nudity. The sculpture was unveiled on June 30 to mostly negative reviews, and Grafly ultimately had to accept a reduced fee when fund-raising efforts were aborted.

"The installation of sculpture is the only part of the installation in the United States Section of which the Department is really proud," wrote Trask in his final report. "Small sculpture was shown throughout the building [the Palace of Fine Arts] in connection with the pictures, in cases especially designed and built for the purpose . . . and the large sculpture was shown out-of-doors in and about the colonnade."[37] Proper garden statuary like Clement Barnhorn's *Boy Pan with Frog* (pl. 49) particularly benefited from the plein-air installation, as did Edward Berge's mournful marble of the *Muse Finding the Head of Orpheus* (pl. 48), which was placed beneath an acacia tree along the south peristyle. It was a particularly photogenic installation (see fig. 44), appearing as the frontispiece to Maybeck's book *Palace of Fine Arts and Lagoon* opposite several lines of poetry by Trask.[38]

Inside the Palace, the eclectic sculptural offerings reflected a range of historical styles and movements, from the smooth neoclassicism of the nineteenth-century master Hiram Powers (see pl. 27) to the rustic realism of Frederic Remington (see pl. 28), who had died in 1909.[39] Bessie Potter Vonnoh won a silver medal for her feminine figurines in Gallery 65 (see pl. 46), which was devoted to women artists. Local animalier Arthur Putnam, whose mermaids (see pl. 16) graced a pair of fountains in the South Gardens, was awarded a gold medal for his small sculptures of tigers, pumas, and snakes in combat (see pl. 50), some of which he had previously exhibited in New York's Armory Show in 1913. Another gold medalist was Paul Manship (see pl. 51), a former student of Grafly whose

elegant bronzes offered a foretaste of Art Deco style. And the internationally fashionable sculptor Prince Paolo Troubetzkoy exhibited his lively bronzes of Gilded Age celebrities, including the dancers Mademoiselle Svirsky and Lady Constance Richardson (pls. 147–148). Fairgoers looking for avant-garde sculpture—if only for a laugh—would have to seek out Umberto Boccioni's *Muscles in Movement* (1913, destroyed) on display in the Fine Arts Annex (see fig. 18).

THE DEPARTMENT OF FINE ARTS

In contrast to the immensity of the exhibition, the curatorial infrastructure supporting the PPIE's Department of Fine Arts was remarkably thin. What visitors to the Palace of Fine Arts and its Annex experienced was initiated by three key officials working intensively behind the scenes, and not always in harmony. Above and beyond the official advisory committees and juries, it was the trio of administrator John E. D. Trask, artist Robert B. Harshe, and critic J. Nilsen Laurvik whose activities most strongly influenced the organization, presentation, and dispersal of the fair's massive art exhibition.

The first in place was Harshe, an assistant professor of graphic art at Stanford University who arrived in California after more than a decade of study, at the University of Missouri, where he graduated with a bachelor of laws degree in 1899, and also at multiple centers for artistic training: Columbia University's Teachers College, the Art Institute of Chicago, the Art Students League in New York, the Académie Colarossi in Paris, and the Central School of Arts and Crafts in London.[40] For this ambitious artist, the opportunity to contribute to the planning of the Exposition proved irresistible, prompting him to take a leave of absence from his comfortable teaching position at the end of the spring

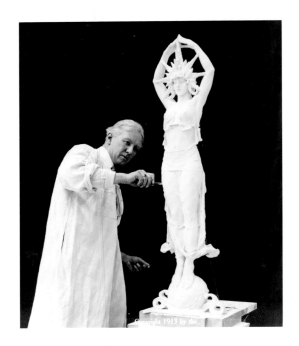

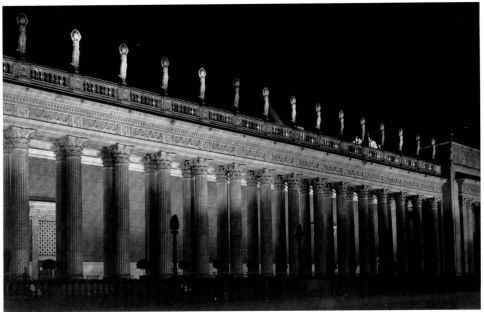

semester in 1911.[41] "The writer has just been appointed Special Fine and Applied Arts Commissioner to the Panama-Pacific International Exposition," Harshe wrote to introduce himself to Detroit collector Charles Lang Freer in May 1911, going on to articulate his new responsibilities: "Pending the appointment of a Chief of the Department of Fine Arts I will visit the various museums and private galleries in the United States and Canada collecting data along the following lines: Retrospective group of American Art to 1904. . . . A list of the most important American pictures, sculpture and handicraft produced since 1904. . . . Works of art by foreign artists owned by Americans, available for exhibition purposes."[42] Harshe also provided insight into the early conceptualization of the art section, which was expected to include one-man galleries of James McNeill Whistler, Augustus Saint-Gaudens, Winslow Homer, John Henry Twachtman, George Inness, William Keith, and John Singer Sargent, and a separate building for Asian art. Besides Freer's own holdings, Harshe set his sights on the upper echelon of American industrialist-connoisseurs as sources of loans: "Among the many from whose collections I hope to obtain select examples are Mr. [J. Pierpont] Morgan, Mr[s]. [Louisine] Havemeyer, Mr. [Henry Clay] Frick, Mr. [Joseph] Widener, Mrs. [Arabella] Huntington, Sir Wm. Van Horne and Mr. [Richard] Canfield."[43]

Harshe hit the ground running. Within two months of this correspondence, he had succeeded in soliciting hundreds of works for the Exposition. Newspaper articles heralded his success and promoted the vital role of art in the fair, even while the site of its primary venue was still uncertain. "The present plans for the art exhibition provide for the housing of the main exhibit in the permanent, fireproof gallery that will be built in Golden Gate park," reported the *San Francisco Call* at the end of July, quoting Harshe's prediction that "the San Francisco exposition will be the grandest art display ever held in the United States. We will have a representative collection of modern and old masters. Every nation and every school will be represented in painting and in sculpture."[44] Remarkably, the coverage of Harshe's accomplishments in the summer of 1911 included an extensive preliminary checklist of paintings from the Carnegie Institute, Corcoran Gallery, Detroit Museum of Art, Saint Louis Art Museum, Art Institute of Chicago, Cincinnati Art Museum, Buffalo Fine Arts Academy, and Pennsylvania Academy of the Fine Arts. All of these institutions would eventually participate, but few of the specific works would materialize in 1915, with the notable exception of Edwin Austin Abbey's *The Penance of Eleanor, Duchess of Gloucester* (pl. 32), which was already committed by the Carnegie Institute. Other than Freer, there were still few "big names" among the announced private lenders at this early date.

While Harshe continued to lay the curatorial groundwork, Moore and the Exposition's director-in-chief, Frederick Skiff, turned their attention to hiring a chief of fine arts. Their first choice was Francis D. Millet, a painter from Boston who had served with Skiff in the administration of a number of recent world's fairs. He seemed a perfect fit, as a high-ranking and well-connected figure in the art world, a trustee of the Metropolitan Museum of Art, and the newly appointed chief administrator of the American Academy in Rome, but his untimely death aboard the *Titanic* in April 1912 left the field wide open.[45] Moore and Skiff eventually focused on Trask (see fig. 11), who, in addition to managing the Pennsylvania Academy of the Fine Arts (which held a major annual exhibition program), had been the US commissioner-general to the Exposición Internacional del Centenario of 1910, an exposition in Buenos Aires marking the centenary of Chile's independence from Spain. The Brooklyn native got strong recommendations from Freer,[46] Philadelphia lawyer and collector John G. Johnson, and printmaker Joseph Pennell, but was blackballed by J. Pierpont

Morgan on the advice of unnamed artists.[47] Not wanting to alienate the New York millionaire whom they were trying desperately to engage as a sponsor, but feeling their backs against the wall as winter approached, they devised a carefully worded telegram: "The time has now come when we must have someone and even if Mr. Trask is not all that is to be desired the question confronts us 'Is he the best that can be obtained and obtained promptly?,'" Moore wrote to Morgan.[48] Obviously annoyed that his advice had been ignored, Morgan retreated, while Trask aced his interviews with Skiff in Chicago and Moore in San Francisco, and was appointed chief of fine arts on November 9, 1912.[49]

One of Trask's first deeds was to recommend Harshe's promotion to assistant chief of fine arts, an appointment that would take effect upon his resignation from Stanford at the end of the spring 1913 semester (see fig. 12).[50] While Harshe would continue to play a key role in the organization of the art exhibition—Michael Williams revealed in *American Art News* the "open secret that much of the most solid and fundamental work of the fine arts department has been handled by him [Harshe]"—he was also responsible for a large display of fine and applied arts from academic institutions at the Palace of Education that would compete for his attention.[51] He did find time to write *A Reader's Guide to Modern Art*, a bibliographic handbook on contemporary artists at the fair, and to contribute to the deluxe edition of the Fine Arts Department's official catalogue.[52] He also served as the secretary to the International Jury of Awards.

Trask's other significant hire was Chicagoan Charles Francis Browne as superintendent of the American section of the Fine Arts Department, effective March 1, 1914. A respected artist and critic, Browne had worked closely with Trask on the Exposición Internacional del Centenario. For the PPIE, he first served as a special representative, traveling to help raise awareness of the Exposition among American artists working abroad. He was later based in the

Aeolian Building in New York, which served as the PPIE's eastern headquarters starting in October 1914, and still toured widely to make speeches and help arrange institutional loans and meetings of the selection juries.[53]

There were few substantial roles for women in the department. Harriet Pullman Carolan, daughter of the inventor of the Pullman railway sleeping car, was an honorary assistant, though between serving on the Woman's Board and monitoring the construction of her Hillsborough dream home "Carolands" in the vain hope that it would be ready to host PPIE visitors, she would have had little time to support the department beyond lending Sargent's *The Sketchers* (pl. 40).[54] The most demonstrable contributions made by women were in the realm of education. Specifically, three female docents lectured in the community and guided visitors through the galleries for a small fee, the returns from which were used to pay their salaries.[55] Among them was the only bona fide art historian attached to the Palace of Fine Arts: Elizabeth Denio, a University of Rochester art history professor who had earned her doctorate in Germany and previously served as a guide at the Saint Louis Exposition.[56] Senior docent Ella Johnston was a teacher from Indiana who spearheaded a movement to establish art programs in public schools, and served as chairman of fine arts for the General Federation of Women's Clubs. Her successor in that post and fellow educator in the Palace, Berkeley resident Rose V. S. Berry, wrote *The Dream City: Its Art in Story and Symbolism*, a guidebook to the public murals, sculptures, and art galleries of the Exposition in the populist voice of a well-meaning and well-informed docent.[57]

ASSEMBLING THE ART

It was not until the summer of 1914 that Trask publicized his master plan for the art exhibition. "Apropos of the very interesting agitation of the Jury versus

'invitation' exhibition questions," an anonymous writer asked in *American Art News* in May 1914, "would it not be well to turn the 'bright light' of inquiry on the system of selection for the coming San Francisco Exposition beforehand, instead of afterward?"[58] In Trask's lengthy response, he predicted that four to five hundred contemporary paintings would be secured by invitation, while a similar number of historical and foreign works would be solicited from American institutions and individuals for the "loan collection," and another eight hundred to a thousand paintings would be admitted through jury selection. "The jury-system for making up an art exhibition without invitations for certain important works is a perfectly lovely system," he wrote, "but, like the famous plan for making hens lay twins, it will not work."[59] Later, in his 1916 retrospective report, he outlined his major challenges in attracting lenders and exhibitors: "The principal difficulties which were early found to confront the Department arose from the distance of the Exposition site from the principal centers of production of painting and sculpture, the feeling on the part of artists generally that sales in the West would be of no great volume, the unusual duration of the Exposition and a very considerable prejudice in the minds of collectors arising from the earthquake and fire of 1906."[60]

A large roster of art world figures serving on the various advisory panels and juries played critical roles in assembling the art. At the top, a largely nominal national advisory committee, drawn from wealthy industrialist-collectors, included Freer, Frick, Widener, Archer Huntington, John Frederick Lewis, Howard Mansfield, Martin Ryerson, and Henry Walters. Serving in a more hands-on capacity were the seven regional advisory committees representing New England (chaired by Edmund Charles Tarbell), New York (John White Alexander), Pennsylvania and the South Atlantic States (Edward Willis Redfield), the Midwest (Frank Duveneck), the West (Eugen Neuhaus), Great Britain (John Singer Sargent), and Europe (Walter MacEwen, vice-president of the Society of American Painters in Paris).[61] Composed mainly of artists, these groups functioned as the extended eyes and ears of the department within their jurisdictions, and included the art directors of three recent world's fairs: William A. Coffin (Buffalo, 1901), Frank Vincent DuMond (Portland, 1905), and George L. Berg (Seattle, 1909). "The work of these Committees was not only the giving to the Department of abstract advice," Trask explained, "but embraced especially . . . the visiting of artists all over the country and a report as to the individual activity of these artists and the availability of the most important of their work, together with the gathering of information regarding works which might be borrowed and many of which were included in the loan collection."[62] A number of the advisory committee members were themselves lenders, such as C. E. S. Wood of Portland, whose loans included Gustave Courbet's *The Violoncellist* (pl. 137) (an amateur painter, Wood exhibited his own work in the Oregon State Building).[63] From members of the national advisory committee, the most notable loans were received from Frick (Pascal Adolphe Jean Dagnan-Bouveret's *Consolatrix Afflictorum*, lent anonymously [see Buron, fig. 142]), Lewis (historical American paintings), and Ryerson (paintings

by Sir Joshua Reynolds, Camille Pissarro, and Alfred Sisley, among others).

The advisory committees also helped decide which American artists would be given their own galleries, and, in fact, four of the chairmen were so honored (Duveneck, Redfield, Sargent, and Tarbell) (see Shields, this volume). Documents scattered in various archives shed light on how the chosen artists participated in the process. For instance, although New York chairman John White Alexander did not ultimately follow through with a solo gallery, Trask wrote him in August 1913 to formally offer a space of twenty-two by thirty feet and indicated that a blueprint would be forthcoming.[64] Pledging his department's resources to arrange the loans of paintings no longer in Alexander's possession, the chief assured him that shipping and insurance would be covered by the Exposition. In the case of Gari Melchers, correspondence between the artist, Trask, Freer, and the Pennsylvania Academy record Melchers's efforts to assemble a representative group of his paintings.[65] Installation planning is referenced in a letter from Trask to Melchers from May 1915, after the artist had left San Francisco for Europe. "I want to tell you that your 'Blacksmith' picture has safely arrived on the 'Jason' as shipped by Pennell from London and is now hung, which greatly improves the looks of the gallery. It is hung on a diagonal as you wished and the other changes were made exactly in accordance with the little plan you left."[66]

For deceased artists Twachtman and Whistler, the Fine Arts Department assumed the full curatorial burden of organizing their mini retrospectives. In the latter case, the primary lender would be the Smithsonian Institution with the blessing of Freer, who had donated his collection there in 1906. Trask also sought the advice of the artist's executor, Rosalind Birnie Philip, in London, and was able to borrow *Arrangement in Black, No. 2: Portrait of Mrs. Louis Huth* (1872–1873, private collection) from the English sitter.[67] Additional pictures were solicited from the recently opened Hackley Gallery of Fine Arts in Muskegon, Michigan (*Study in Rose and Brown* [pl. 31], a work that had previously appeared in the New York Armory Show of 1913), from Samuel Untermyer (*Nocturne in Black and Gold: The Falling Rocket* [see fig. 81]), and from the estate of Walter Sickert's wife (*Green and Violet: Portrait of Mrs. Walter Sickert*, 1885–1886, Fogg Art Museum). Trask's attempt to borrow *Arrangement in Grey and Black No. 1 (Portrait of the Artist's Mother)* (1871, Musée d'Orsay) from the Musée du Luxembourg, mentioned in an October 1913 letter to Freer, was unsuccessful, though the Luxembourg would ultimately become the primary lender to the French Pavilion (see Buron and Chapman, this volume).[68]

Many American museums sent art to San Francisco. Trask leaned heavily on his former institution the Pennsylvania Academy of the Fine Arts for a substantial number of works, including William Merritt Chase's *Portrait of Mrs. C. (Lady with a White Shawl)* (pl. 35), which the artist requested for his one-man gallery, and Cecilia Beaux's *New England Woman* (pl. 43), which she specified should be exhibited under the title *Study in Whites*.[69] Other major institutional lenders were the Cincinnati Art Museum, which sent much of Duveneck's retrospective, including his iconic *Whistling Boy* (pl. 33); the Carnegie Institute in Pittsburgh, which lent the late Edwin Austin Abbey's

monumental *The Penance of Eleanor, Duchess of Gloucester* and Pierre Puvis de Chavannes's *A Vision of Antiquity—Symbol of Form* (pl. 142); the Buffalo Fine Arts Academy, which sent James Tissot's *L'ambiteuse* (*The Political Woman*) (pl. 138) and several American works; the Brooklyn Museum,[70] which sent paintings by Homer, Chase, and Twachtman, among others; and the National Academy of Design, which lent nineteenth-century American paintings. Of the private organizations that participated, one of the most generous was the Lotos Club, a literary society in New York that counted painter Julian Alden Weir among its members and denuded its walls of four paintings, including Homer's *Saco Bay* (pl. 30).

Other important sources of art were recent juried exhibitions held in other venues. For instance, a large number of canvases were shipped to San Francisco directly from the *Fifth Exhibition of Oil Paintings by Contemporary American Artists* that closed at the Corcoran Gallery of Art in Washington, DC, on January 24, 1915, including Mary Cassatt's *On a Balcony* (1878–1879, Art Institute of Chicago) and *Woman with a Fan* (ca. 1878–1879, National Gallery of Art), Eakins's *The Concert Singer* (pl. 36) and *Portrait of Henry O. Tanner* (pl. 34), Harry Leslie Hoffman's *A Mood of Spring* (pl. 63), Frederick Carl Frieseke's *The Garden Chair* (pl. 54), Daniel Garber's *Quarry, Evening* (pl. 66), Robert Spencer's *Courtyard at Dusk* (pl. 67), and John Sloan's *Renganeschi's Saturday Night* (pl. 69). From the American fine arts section of London's *Anglo-American Exhibition* of 1914 came Chase's *Just Onions* (1912, Los Angeles County Museum of Art), Edward Francis Rook's *Laurel* (pl. 62), Robert Henri's *Lady in Black Velvet (Portrait of Eulabee Dix Becker)* (pl. 38), Childe Hassam's *The South Ledges, Appledore* (1913, Smithsonian American Art Museum), and Weir's *The Plaza: Nocturne* (pl. 71), among others. When the PPIE's Chicago jury met at the Art Institute, it perused the museum's *27th Annual Exhibition of American Paintings*, selecting sixty-nine paintings and nine sculptures that had been submitted for review, and proactively invited another thirteen paintings and three sculptures out of the show.[71] For the international section (discussed below), thirty-nine German paintings came from the annual *International Exhibition* of the Carnegie Institute, and a collection of Norwegian, Hungarian, and Finnish works from the Venice Biennale.

THE JURIES

In September 1914 the Fine Arts Department issued a *Circular of Information* that spelled out the procedures for submitting to the local juries of selection, which were drawn primarily from the regional advisory committees and met in Boston, New York, Philadelphia, Chicago, Cincinnati, Saint Louis, San Francisco, London, and Paris later that fall. The general classifications of fine arts were arranged and described as follows:

Group 1. Paintings and Drawings
Class 1. Paintings on canvas, wood or metal, by all direct methods in oil, wax, tempera or other media; enamels; paintings on porcelain, faience and on various preparations, of purely pictorial intent; mural paintings in any media.

Class 2. Paintings and drawings in water color, pastel, chalk, charcoal, pencil and other media, on any material. Miniatures on ivory or ivory substitutes.
Group 2. Prints
Class 3. Etchings, engravings and block prints in one or more colors. Auto-lithographs with pencil, crayon or brush.
Group 3. Sculpture
Class 4. Works in the round, high and low relief; busts, single figures and groups in marble, bronze or other metal; in terra cotta, plaster, wood, ivory, or other materials.
Class 5. Medals in plaster and terra cotta.
Class 6. Medals, plaques, engravings on gems, cameos and intaglios.
Class 7. Carvings in stone, wood, ivory or other materials.[72]

The greatest controversies surrounding the selection juries were centered in San Francisco. A writer in the *Oakland Tribune* complained that many prominent local artists were conspicuous by the absence of their works in the Palace of Fine Arts, including such figures as Charles Rollo Peters, Will Sparks, Grace Hudson, Theodore Wores, and Bruce Porter.[73] Some were rejected, while others refused to submit their work in the first place. *American Art News* blamed the artists' discontent on the entirely local composition of the jury, which was caused by the failure of all three Eastern jurors to appear (Alexander was seriously ill, and Redfield and Tarbell were too busy).[74] Without objective outsiders on the jury, the boycotting artists feared that the judging would be contaminated by homegrown biases and cliques. Thus, the artworks from California were reviewed by three San Franciscans—Neuhaus, Arthur Frank Mathews, and Francis McComas—along with landscape painters William Wendt of Los Angeles and Paul Gustin of Seattle. Trask participated as well and noted, "The criticism of the jury in San Francisco, if it can be summed up in a single sentence, was that it was too severe upon the artists who entered their works. This criticism is answered, I believe, by the fact that the percentage of works accepted from those submitted to the Jury was higher in San Francisco than at any other point in the United States."[75] Of the 830 works they reviewed, about 130 were accepted, and an unknown number were admitted by invitation.[76]

The malcontents came together to organize an alternate exhibition of California art at the Memorial Museum. The jury and hanging committee for this exhibition of some 250 works consisted of Bay Area artists Peters, Sparks, M. Earl Cummings, Frank van Sloun, and Charles Dickman.[77] Taking up four large galleries normally devoted to mineral collections, the exhibition opened on April 17, 1915, and continued through the closing of the PPIE. Like the Palace of Fine Arts, it reopened with a refreshed selection in the new year.

When the International Jury of Awards met in May 1915 (see fig. 168), the Palace of Fine Arts was still only partially installed, and the Annex was not yet under construction, though apparently the foreign works were made available for review. By virtue of his presidency of the National Academy of Design, Julian Alden Weir was named chairman of the jury for oil paintings, whose membership

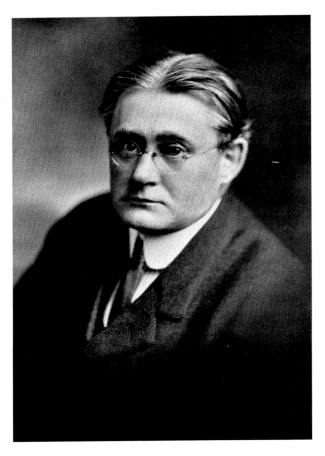

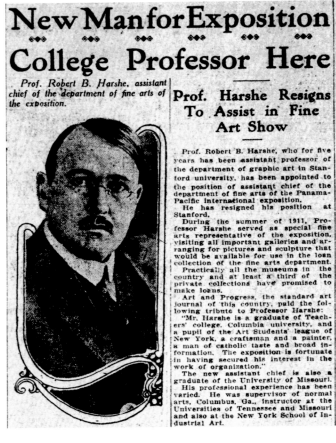

numbered thirty-six men, including Chase, Duveneck, Mathews, Redfield, Tarbell, and Laurvik. Ineligible were works created before the previous world's fair of 1904 and submissions by members of the jury, artists given individual galleries, and "certain eminent artists who had received the highest honors at previous International Expositions, thus making it possible to adequately honor an entirely new group of brilliant young artists."[78] Medals were not awarded to individual objects, but to artists based on the totality of their submissions. The highest award in painting, the grand prize, went to Frieseke, whose works appeared in Gallery 117 (see fig. 78), while Duveneck received a special honorary medal despite being technically ineligible for award consideration.

Fallout from the announcement of the awards was swift and vicious. There were the usual complaints of the juries' blindness and flawed procedures, including claims that one unnamed prizewinner was recognized only because she was the widow of an important artist.[79] Among the most vocal and articulate critics was Pennell, himself a member of the juries of selection in Europe and chairman of the jury of awards in San Francisco for etchings and engravings, who believed that too many works of art had been admitted to the Palace in the first place. His informed comments give insights into the reasons for the overcrowded galleries. "Mr. Trask was naturally much worried after the war's outbreak through fear that he would not receive . . . enough works to fill the galleries," Pennell explained. "I know, at any rate, that he asked the European committees to send more works, and I believe he also wrote to the same effect to the various American committees on the art display."[80] But many of the European countries came through in the end, while a great deal of American works "came in response to later invitations—in fact during the time the International Jury was sitting" (George Bellows's works, for example, were received after the jury began its sessions). According to Pennell, Trask's biggest failure was not instituting a "Jury of Revision" in San Francisco to fine-tune the final selection. Had such a step been taken, he concluded, "the finest display of American art ever held would have resulted, for there is a large amount of good things in the exhibition. As everyone familiar with the arrangement of art exhibitions knows, the best display can be ruined by overcrowding and this was and is the defect with the art display in the Exposition Fine Arts Galleries."

FOREIGN ART

Twelve nations besides the United States officially participated in the fine arts branch of the PPIE and were allocated gallery space in the Palace of Fine Arts and the Annex: Japan (Palace Galleries 1–10), France (11–18), Uruguay (19), Cuba (20), Italy (21–25), China (94–97),[81] the Philippines (98), Sweden (99–107),[82] Portugal (109–111), Argentina (112), the Netherlands (113–116), and Norway (Annex galleries 144–150).[83] Within their assigned footprints, the foreign commissioners had full autonomy in their installations, from the selection of

FIG. II
John E. D. Trask. Photograph by Fred Hartsook.
From *California's Magazine, Edition de Luxe*, vol. 1
(San Francisco: California's Magazine Company,
1916). San Francisco History Center, San
Francisco Public Library

FIG. 12
Article in *San Francisco Call* (May 28, 1913)
announcing the appointment of Robert B. Harshe
as assistant chief of the Department of Fine Arts
of the PPIE

FIG. 13
Alfred Stieglitz (American, 1864–1946),
J. Nilsen Laurvik, probably 1911. Platinum print,
9⅜ × 7⅛ in. (23.8 × 18.1 cm). National Gallery
of Art, Washington, DC, Alfred Stieglitz
Collection, 1949.3.417

works to the interior wall configurations and treatments and gallery furniture.[84] Artists from nonparticipating countries were relegated to the international section, which was ultimately the responsibility of Trask and his department.

In the years leading up to the Exposition, growing instability abroad had jeopardized its international scope. Trask spent much of his first half year on a European campaign to recruit foreign governments, with two of the biggest holdouts being England and Germany. The chief of fine arts reported that "every effort was made to influence public opinion in favor of British participation in the Exposition and, especially British participation in the Department of Fine Arts. That this effort was a failure was due to influences entirely beyond the power of the Exposition or of the United States to overcome."[85] As opposed to the overtly antagonistic attitude of the British government, which was motivated at the time by unhappiness over the Panama Canal Tolls Act of 1912, the Germans seemed merely apathetic to the prospect of the fair.[86] In the absence of government support, Trask secured a pledge from the Gesellschaft für deutsche Kunst im Ausland to send about four hundred modern paintings to San Francisco, but with the outbreak of the war even this unofficial display would fall through.[87]

Continued anxiety over commitments from foreign art centers led to the appointment of Laurvik (see fig. 13) as a special representative of the Department of Fine Arts in the spring of 1914. Norwegian by birth, Laurvik moved to the United States in 1892 and a decade later became a citizen. He resided in New Jersey with his mother and sister, and worked primarily as a journalist and art critic for the *New York Evening Post*, *New York Times*, and *Boston Transcript* while organizing exhibitions for the National Arts Club. A well-connected member of the East Coast art world, he joined the circle of Alfred Stieglitz and showed his own autochromes at the 291 Gallery in 1909.[88] He also became a good friend of Trask, who described him as such in a letter to Freer in October 1913.[89] Recommending Laurvik for the open directorship of the Detroit Museum, Trask considered him as "a man of high character and broad culture, and great common sense," who having just returned from an extended period of travel and study abroad was particularly up-to-date on the European art scene. Although he was passed over for the Detroit position, when Trask needed a special agent to help with his growing European predicament some six months later, Laurvik seemed tailor-made for the job. With credentials from the Exposition Company as well as the State Department,[90] he spent much of the summer of 1914 testing the waters for foreign participation in Christiania (now Oslo), Berlin, Vienna, and Budapest, where he coincidentally married his Hungarian fiancée, Elma Pálos, in September. The following month Laurvik was back in the United States to report on his progress, which seemed promising enough to arrange a second trip. After a mere four weeks, he returned to Europe on an Italian steamer to complete negotiations with foreign artists and cultural organizations under the darkening clouds of war.

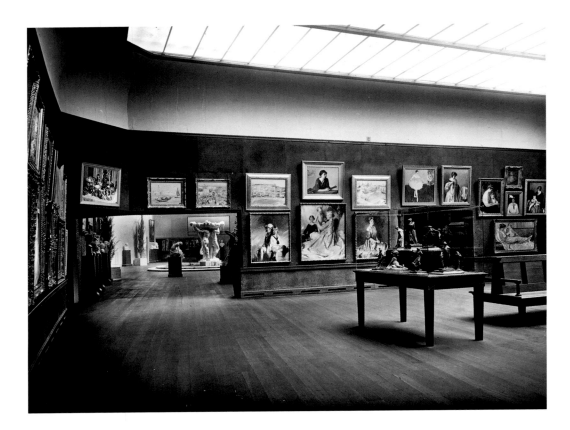

FIG. 14
Gallery 65 in the Palace of Fine Arts, 1915.
Lantern slide by Gabriel Moulin

FIG. 15
Gallery 68 in the Palace of Fine Arts, 1915.
Lantern slide by Gabriel Moulin

Laurvik's mission was a stunning success. With the assistance of his wife, Elma, who spoke four languages and had experience as a translator, he was able to organize a significant, if eclectic, array of contemporary European paintings, sculptures, and prints. The haul would include approximately three hundred works from Norway selected by a committee chaired by the director of the National Gallery in Christiania; a group of Norwegian, Hungarian, and Finnish works from the Venice Biennale that had become stranded in Italy because of the war, including a retrospective of paintings by the internationally renowned Finnish artist Akseli Gallen-Kallela; an exhibition of Italian Futurism from the Doré Gallery in London promised by the movement's founder, the poet and theorist Filippo Tommaso Marinetti, in Milan; fifteen portraits from the Expressionist painter Oskar Kokoschka and his patrons in Vienna, along with a survey collection of Austrian printmaking arranged by dealer Hugo Heller; and nearly five hundred works from Hungary, including a large graphic section from Budapest's Szépművészeti Múzeum (see Barki, this volume).

Although Laurvik was not able to broker any deals in Germany, the PPIE organizers took advantage of the situation when a shipment of thirty-nine German paintings from the Carnegie Institute's Annual Exhibition (held April 30 through June 30, 1914) became spoils of war. The paintings, including works by Leo Putz (pl. 150) and Franz von Stuck (pl. 151), left Philadelphia on July 25 aboard the SS *Kronprinzessin Cecilie* bound for Germany, but war broke out while they were in transit and the ship was captured. In March 1915 a British prize court finally condemned its cargo as enemy property, returning the art to Pittsburgh.[91] The Carnegie Institute, already a major lender to the Exposition, agreed to send the paintings on to San Francisco, where they were shown and won prizes without the artists' knowledge.

During the six months leading up to Opening Day, when only a small number of galleries in the Palace would be open to visitors, uncertainty over the outcome of Laurvik's negotiations—combined with construction delays and ongoing miscommunications between the Department of Fine Arts and the Division of Works concerning the usable square footage of the Palace of Fine Arts—complicated Trask's planning for the installation.[92] Like the other major pavilions, the Palace proper was a cavernous shell of a building, but with two characteristics that set it apart. The first was its curved footprint, designed to wrap around the detached rotunda and colonnade. The second concerned the treatment of the interior, which, instead of being left as a vast open space, was subdivided into modestly scaled, fully enclosed rooms. The galleries were topped with frosted glass ceilings to let in diffused light from skylights in the roof; incandescent lamps installed in the rafters would illuminate the galleries at night. Trask claimed that he was initially told in May 1913 that there would be 140,000 square feet of space for the art, and that subsequently the number was cut to 127,000 (August 1913) and finally 110,000 (December 1913).[93] According to the Division of Works, the final figures were 126,208 gross square feet, with 113,610 of net square footage (presumably usable floor space), and 142,000 square feet of picture-hanging space.[94]

It was not going to be enough room, and compounding Trask's difficulties

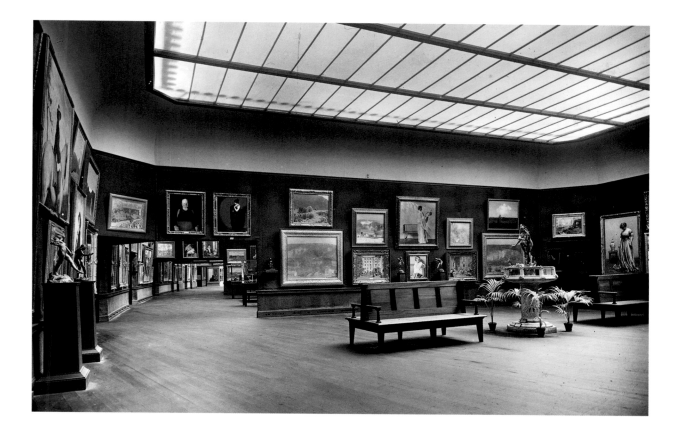

were slowdowns in the work on the building that seemed to intensify as the deadline approached. His complaints to Asher C. Baker, the director of exhibits, regarding the Division of Works reached epic heights of exasperation in the month before Opening Day. "The situation in the Fine Arts Building today," he wrote on January 15,

> is, that the plans . . . are being carried out in a garbled form and, even so, are being carried out so slowly that it is impossible for me to foresee a possibility of opening the building on February 20th. There is not one single gallery in the whole extent of the Building which is either completed or so near completion that even a tentative arrangement of exhibits in it may be made. There is not one single gallery in which the walls, the covers or the skylights are completed and, in the last week there has been so little advance made that if future progress is at the same rate it will not be possible to have the gallery walls lined by February 20th.[95]

He complained that the rapidly accumulating crates containing works of art could not be unpacked, that the offices of his department were uninhabitable, and that the bathrooms were nonfunctional. Of the latter inconvenience, he was able to keep his sense of humor, writing, "I am reluctantly reaching the conclusion that it may be the intention of the Division of Works that certain of these appurtenances should be used by the Department simply as objects of virtu, in which connection I may say, parenthetically, that undecorated ceramics, under the Exposition's classification, do not belong in the Department of Fine

Arts."[96] Ten days later, Trask doubtless was not laughing when he reported that "there has been no portion of the Palace of Fine Arts which resembles a Palace as much as it resembles a carpenter shop or smithy."[97]

Faced with a growing number of crates that would be arriving from Europe, in addition to the thousands of American works coming from all forty-eight states as well as from abroad, Trask finally recognized the gravity of his space problem. Even by filling the walls chockablock with frames closely abutting each other "salon style" (see figs. 14–15), it became clear that the Palace of Fine Arts could not hold all of the committed artwork, and so creative juxtapositions, such as the appearance of Russian painter Nikolay Fechin's *Lady in Pink (Portrait of Natalia Podbelskaya)* (pl. 149) in a gallery primarily dedicated to French art, would sometimes be necessary. Assigned to the international section, Fechin was one of only three Russian artists to exhibit in the PPIE.[98] His painterly canvas, a portrait of young art student Natalia Podbelskaya, had earned Fechin some celebrity in the Carnegie Institute's Annual Exhibition of 1913, and was purchased by Pittsburgh collector William S. Stimmel, who lent it to the Exposition. With a rawness of technique that rivaled the spontaneous brushwork of the Impressionists, the vibrant canvas hung comfortably in Gallery 61 among the loan collection of nineteenth-century French paintings.

THE ANNEX

To address the late windfall of art from Europe, a plan was hatched at the eleventh hour to erect an additional gallery to the west of the Palace of Fine

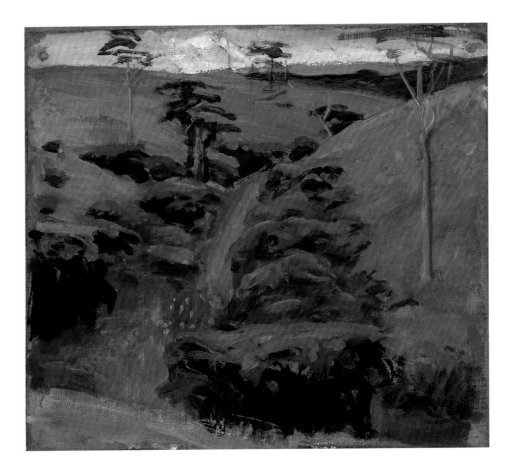

FIG. 16
Akseli Gallen-Kallela (Finnish, 1865–1931), *The Little Valley*, 1910. Oil on canvas, 12 ½ × 13 ¼ in. (31.8 × 33.7 cm). Private collection

Arts to house the Norwegian section and the majority of the international section. Unlike its architecturally distinguished neighbor, the Fine Arts Annex was designed without frills by general contractor David Elms Graham, who signed his contract on June 2, 1915, and was given just thirty days to complete the job.[99] Built at a modest cost of $13,000, the 22,350-square-foot structure contained thirty windowless galleries on two floors, with a total hanging space of 27,200 square feet.

Inside this boxlike structure, which was apparently too drab to inspire anyone with a camera to photograph its exterior, was an unlikely melting pot of modernism, with works of art from warring nations hanging in adjacent galleries without a hint of geopolitical discord. Strolling over from the Palace of Fine Arts, visitors to the Annex were in for a jolt. Compared with the relative conservatism of the offerings next door, the Annex contained an eyeful of challenging contemporary art that was unfamiliar to most Americans. Among the highlights were nine paintings and fifty-seven prints by Norwegian Edvard Munch (see pls. 159–161), and eight Symbolist landscape paintings by his countryman Harald Oskar Sohlberg, including his *Winter Night in the Mountains* and its companion *Fisherman's Cottage* (pl. 162), lent from the collection of Byron Smith of Chicago at the artist's request.[100] A large retrospective gallery of canvases by Gallen-Kallela included his mystical *Mäntykoski Waterfall* (*Mäntykoski*) (pl. 163), in which five gold threads are mysteriously superimposed over its surface, evoking the strings

of a musical instrument. Gallen-Kallela made his personal presence explicit in several canvases, including his early work *Symposion (The Problem)* (*Symposion [Probleema]*) (pl. 164) in which he appears at left peering anxiously at a winged creature mostly hidden from view. During a more recent painting excursion in British Equatorial Africa (see fig. 16), he portrayed himself as a hunter (see pls. 165–166). Among the handful of English exhibitors was Laura Knight, whose *Self-Portrait* (fig. 17), which raised eyebrows in England for showing a female artist painting a nude model, found acceptance in the Annex and won a gold medal.[101]

The gallery of Italian Futurism (Gallery 141) on the second floor, which was independent from the official Italian section in the Palace of Fine Arts, presented the only art at the PPIE that rivaled the Armory Show in aggressive modernism (fig. 18). The most radical paintings in the Palace of Fine Arts—arguably the contributions of William Zorach (see pl. 85), Arthur Beecher Carles (see pl. 84), or members of the Ashcan School (see pls. 38, 69, 74)—were tame in comparison to the outlandishness of Futurism (see Applegate, this volume). The appearance of this body of work in San Francisco represented a real curatorial coup, an accomplishment Laurvik eagerly revealed to *American Art News*:

New Yorkers will be interested to hear that I was able to persuade [Filippo Tommaso Marinetti], the prophet and leader of the Italian "futurists," to go back on this threat of never permitting the Italian "futurist" work to come

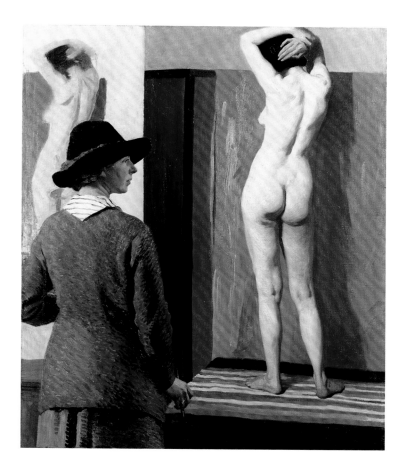

FIG. 17
Laura Knight (English, 1877–1970), *Self-Portrait*,
1913. Oil on canvas, 60 × 50 in. (152.4 × 127 cm).
National Portrait Gallery, London, NPG 4839

to this country, because of what he considered the discourtesy shown him by the managers of the so-called Armory exhibition. [Marinetti] claims that the pictures advertised at that show as "futurist" were nothing of the sort, and he declared then that America would be cut out of the future of "futurism." But he has relented, and a curious and exceptionally puzzling group of sure-enough Italian "futurists" will be shown here.[102]

The term "Futurism" had arrived in America several years before actual Futurist works landed in California, and was used derisively as a catchall "-ism" standing for any type of avant-garde contemporary art, an umbrella phrase covering everything from Cubism to Dada.[103] Marinetti recognized the opportunity to exhibit at the PPIE as a chance not only to set the record straight, but to do so on a world stage.

The resulting gallery was in every way a tour de force, offering fifty major works of the previous three years that effectively encapsulated the provocative movement. The group that Laurvik called "curious and exceptionally puzzling" included such seminal canvases as Umberto Boccioni's *Matter* (*Materia*) (pl. 167), a fragmented representation of the artist's mother that demonstrated the "simultaneousness of states of mind" that Marinetti claimed as "the intoxicating aim of our art" in an essay published in the PPIE's *Catalogue de Luxe*.[104] Marinetti's text offers a hypothetical example of Futurist painting that could elucidate Boccioni's complex composition:

In painting a person on a balcony, seen from inside the room, we do not limit the scene to what the square frame of the window renders visible; but we try to render the sum total of visual sensations which the person on the balcony has experienced: the sun-bathed throng in the street, the double row of houses which stretch to right and left, the beflowered balconies, etc. This implies simultaneousness of the ambient, and, therefore, the dislocation and dismemberment of objects, the scattering and fusion of details, freed from accepted logic, and independent from one another.[105]

In Boccioni's *Dynamism of a Soccer Player* (pl. 168) and *Dynamism of a Cyclist* (*Dinamismo di un ciclista*) (pl. 169), Luigi Russolo's *Plastic Synthesis of a Woman's Movements* (*Synthèse plastique des mouvements d'une femme*) (pl. 172), and Giacomo Balla's *Disintegration × Speed, Dynamic Dispersions of an Automobile* (*Disgregazione × velocità, penetrazioni dinamiche d'automobile*) (pl. 170), the artists applied these principles to subjects literally in motion, seeking visual equivalents of speed and energy. Several of Gino Severini's canvases, including *Spherical Expansion of Light, Centripetal* (pl. 171), crossed over into a fully dematerialized frontier in which vividly colored abstract shapes are meant to evoke heat, sound, and motion.

The gallery itself reportedly was packed with curiosity seekers, eager to poke fun at what they did not understand. It was a type of art that was lampooned even on the walls of the Palace of Fine Arts, where *San Francisco Chronicle* art

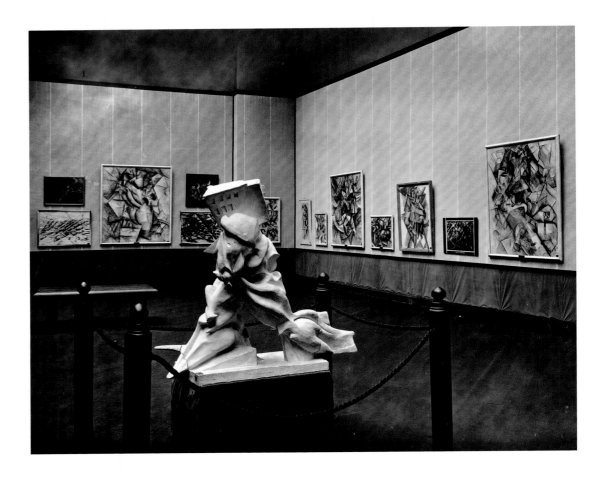

critic Ben Macomber called out Albert Guillaume's *The Pitch* (*Le boniment*) (see fig. 19) in the French Section as "a rich burlesque of Futurist art,"[106] but it seems that the Annex presentation did not go entirely over the heads of the locals. A close reading of Macomber's own analysis of the Futurist gallery finds a mixture of cheap shots and surprisingly insightful observations. The writer understood, "These are the two elements of Futurist art—action and time. These are what he tried to represent," and he encouraged visitors to study Boccioni's plaster *Muscles in Movement*:

> It will be easy to see here that the sculptor has tried to represent the muscular action of a man running. He has made the piece not the fixing of an instant of the man's action, but has carried that action through a certain length of time. Try to look at it as you would look at the several pictures that go to make up a movie film. If the sculptor has succeeded, you should see the man running.[107]

At the same time, Macomber admitted, "I confirm that I am unable to see a picture [i.e., a work of art] in a Futurist canvas," adding, "I wouldn't have one in my house. But I am willing to let others have their own opinion, and, having some glimmering of what the Futurist is trying to do, and of the real effect he has had upon the world, I respect him if I don't care for his work."[108]

An extraordinary record of one prominent local artist's response to Futurism

is found in a letter composed by Gottardo Piazzoni shortly after the closing of the Exposition, addressed to Balla, whom he had met and befriended some years earlier.[109] Although the tranquility of Piazzoni's Tonalist style as exemplified by his *Lux Aeterna* (pl. 79) could not have been further from the raucousness of Futurism, he respected the movement's bold originality. "I meant to write earlier but waited because I wanted to see, study, absorb your Futurist works of art before writing my impressions," he explained:

> After visiting several times and studying the manifesto and the writings on Futurism, I want to warmly congratulate you but hardly know how to describe my impressions. I greatly admire the courage of this brave group and I see clearly that this revolutionary movement could not have happened except in a place like Italy where the spirit of the Renaissance obstinately persists.[110]

Futurism, he concluded, was that country's best hope, and while he found the gallery to be spacious, properly lit, and well installed, he mused that it could have been more effectively situated:

> How much more meaningful and advantageous for you Futurists if you had been displayed in the Palace of [Varied] Industr[ies]. One sees, instead, innumerable marbles with their beautiful and cloyingly sweet smiles that were copied and recopied ad infinitum—these types of marble statues that

Italy "strews" without shame around the world. Hurrah for the Futurists and encouragement for their cause that shall not be in vain.[111]

The Futurist gallery was reinstalled in the Palace of Fine Arts early in 1916 and remained on view until May of that year, when Marinetti requested that the works be returned to Europe.[112]

AFTER THE EXPOSITION

San Francisco art historian Nancy Boas has offered a thorough view of the Exposition's influence on local artists, but the PPIE's art exhibition also had undeniably profound and lasting effects on local cultural institutions long after the fair closed on December 4, 1915.[113] The Crocker-Langley San Francisco directory of that year listed only one major museum within the city limits, the Memorial Museum in Golden Gate Park (see fig. 20), a remnant of the California Midwinter International Exposition of 1894 (the State operated a small mining museum in the Ferry Building, and the California Academy of Sciences was still under construction). The Memorial Museum was an omnivorous all-purpose institution with eclectic holdings ranging from California historical artifacts to natural history specimens, "Indian curios," totem poles, Oriental rugs, laces, armor, netsuke, colonial period rooms, maps, coins, and a smattering of artworks. Its founder and largest donor, *San Francisco Chronicle*

publisher Michael H. de Young, maintained a special relationship with the museum and the park surrounding it. In the months following the close of the fair, the *Chronicle* ran a series of articles publicizing the museum's acquisitions deriving from the Exposition, mainly as gifts from de Young and several foreign commissions, including Chinese cloisonné, drawings, and scrolls; Japanese inlaid woods, costumed dolls, and seashells; and Italian and French sculptures.[114] A frequent refrain was that the Memorial Museum was running out of space and would soon need to be significantly expanded. The paper also published several self-serving editorials disparaging any plan to save the Palace of Fine Arts that did not involve moving it to Golden Gate Park, de Young's strong preference.[115] When that suggestion failed to gain traction, and he realized that the Palace would have its own life after the fair and potentially compete with his creation, he refocused his efforts on the Memorial Museum. On the occasion of its twenty-first anniversary, March 25, 1916, de Young announced an infusion of funding toward a major expansion that would ensure its status as San Francisco's preeminent municipal museum.[116]

Across the Bay, the Oakland Public Museum was in a similarly woolly state at the time of the fair, encompassing natural history, ethnology, and colonial and Pacific Coast history. After the fair, Harshe, the Fine Arts Department's assistant chief, became its new director. Predicting "that the San Francisco Bay region will in a few years become one of the art centers of America," Harshe promptly

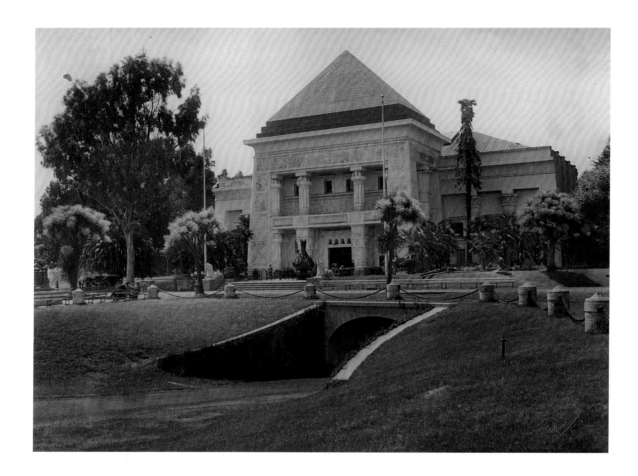

expanded the Oakland Museum's mission to include art.[117] On February 1, 1916, he opened the museum's art galleries in the new Municipal Auditorium building on Lake Merritt, planning a series of monthly shows of work by individual California artists. The Oakland Museum was also the recipient of many odds and ends from the Exposition. "Just at present," Harshe reported, "the museum is suffering from an embarrassment of riches. Foreign and state commissioners and the National Government itself have been so generous that we have thousands of dollars' worth of exhibits and exhibit cases and no adequate space in which to display them."[118] Out from under the shadow of Trask, Harshe saw his museum career take off. From Oakland he moved on to the Carnegie Institute and ultimately the directorship of the Art Institute of Chicago, where he served as one of that museum's most influential leaders of the twentieth century.

The San Francisco Art Association (SFAA), having become invigorated by absorbing the San Francisco Society of Artists and the Sketch Club, set its sights on preserving the Palace of Fine Arts. By the summer of 1915, a groundswell had arisen to save Maybeck's masterpiece, which was slated for demolition along with the rest of the fairgrounds. Conserving the building was not an entirely new idea, as there had been talk during the earliest planning of the PPIE of creating an art pavilion that could afterward serve as a museum for the city of San Francisco, as had happened most recently in Saint Louis.[119]

But the stark realities of the building's enormous scale, temporary construction materials, and difficult site, which was partially on both federal and private lands in a relatively undeveloped location, introduced considerable obstacles. Such diverse civic leaders as Hearst, Spreckels, and de Young came together on this issue before the fair closed, and October 16 was designated as "Fine Arts Preservation Day," with a percentage of gate receipts going into a fund to save the Palace.[120] Within the Exposition Company, a Committee on the Preservation of Such Part of the Exposition as May Seem Desirable and Practicable got to work in August, after which an Exposition Preservation League of prominent San Franciscans was formed to raise money and advocate for saving certain features of the PPIE, including the Palace of Fine Arts, the California Building, and the Column of Progress.[121]

In November the PPIE's executive committee asked Trask to outline the necessary steps to reopen the Palace for several months in 1916 while the Preservation League continued to seek permanent funding. The chief of fine arts had little enthusiasm for the concept, as he was all too familiar with the building's challenges, but he replied with a proposal and rough budget.[122] When the board informed Trask that his plan had been approved,[123] he was quick to respond, for the record, that the initiative was not his own, stating, "Had I consulted my personal wishes and desires, I would not have suggested the undertaking of an extremely arduous and nerve-racking task which must be

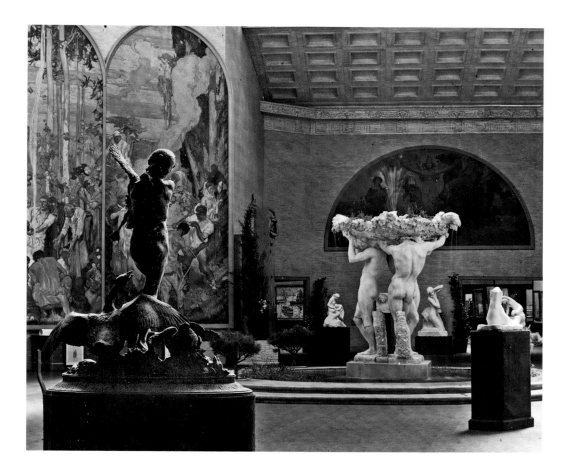

FIG. 20
Willard E. Worden (American, 1868–1946), *The Memorial Museum, Golden Gate Park*, ca. 1910s. Sepia-toned gelatin silver print, 10 ½ × 13 ½ in. (26.7 × 34.3 cm). Collection of the Oakland Museum of California, gift of Robert Shimshak, A82.107.35

FIG. 21
Murals by Frank Brangwyn and Arthur Frank Mathews (pl. 23) installed in the Palace of Fine Arts in the post-Exposition period, ca. 1916. Lantern slide by Gabriel Moulin

performed under a strain which, after the Exposition period I would personally be very loath to undergo did I not feel that the continuance of an exhibition in the Fine Arts Palace until May 1st will be of great benefit to the City of San Francisco."[124] His immediate task was to determine which works of art could remain on view, and plan a dramatic reinstallation of the galleries. Many objects had been sold, while others were previously committed to exhibitions elsewhere, including whole sections (such as the French and Belgian displays) that were packaged into traveling shows of Exposition art. Trask spent December on a cross-country trip with Francis McComas to negotiate extensions from key lenders and secure additional loans to fill in the many gaps.

The post-Exposition exhibition ran from January 1 to May 1, 1916. Some of the Annex art was reinstalled in the Palace, as were eleven of the murals, including Mathews's *The Victory of Culture over Force (Victorious Spirit)* (pl. 23) and Frank Brangwyn's eight murals from the Court of the Ages (see fig. 21) and the collection of casts of ancient sculpture from the Greek Pavilion that would later be donated to the Memorial Museum (see Dreyfus, this volume).[125] Secured by Trask and McComas from private collectors, dealers, and the artists themselves, many new works arrived by progressive artists who were previously unrepresented, including Arthur B. Davies, Max Weber, Francis Picabia, Pablo Picasso, and Henri Matisse. Meanwhile, the SFAA edged forward with its plan to take over the building. Passing over Trask, the board appointed Laurvik to

direct both the Association and the Palace of Fine Arts in April 1916.[126] "The news . . . comes as a surprise to the American art world," reported *American Art News*, "as it was generally understood that Mr. Trask himself was virtually slated for the position."[127] The writer lodged a surprising objection based on the fact that Laurvik, although an American citizen, was born on foreign soil. In a subsequent letter to the editor, New York artist Charles Vezin took the xenophobic argument a step further. "Mr. Laurvik is not only an alien but a sponsor for alienist art," Vezin ranted. "Unless he has completely changed his point of view . . . his appointment would be nothing short of a calamity. If Matisse were appointed director of the Metropolitan Museum of Art it would mean to New York what the appointment of Mr. Laurvik would mean to San Francisco."[128]

With Trask still on the Exposition payroll, this arrangement would prove to be awkward, leading to the precipitous deterioration of the former colleagues' relationship as they worked essentially at cross-purposes: Laurvik trying to keep as much of the PPIE art on the premises as possible, and Trask attempting to close the books on the fair and return works to their original lenders or new owners. During the late spring of 1916, the galleries were handed off one by one from the outgoing chief of fine arts to the incoming director of the Palace of Fine Arts.

The emptying of the galleries is reflected in the sales figures of art from the fair, which totaled $267,970.95 for 1,569 objects, including 1,083 American and

FIG. 22
Caricature of J. Nilsen Laurvik by Otto D. Ronchi, in the *San Francisco Bulletin*, April 12, 1919

FIG. 23
"Marina Graveyard," after the Exposition, ca. 1916. San Francisco History Center, San Francisco Public Library

486 foreign works, with many staying in California: "The permanent placing of 963 works of art in the State of California is, I believe, fraught with great possibilities for future cultural advances," Trask observed in his 1916 report, but apparently few of the collectors were from San Francisco.[129] J. B. Levinson, then a vice president of the Fireman's Fund insurance company, bought a painting by Redfield, as did perhaps Marian Huntington, a daughter of railroad magnate Henry E. Huntington, who donated a Redfield that had been in the PPIE to the Legion of Honor in 1928 (pl. 65).[130] Thanks to the detailed records that survive for the French section, it is known that French paintings were purchased by prominent Californians James Leary Flood, Sigmund Stern, E. J. Heller, William Henry Crocker, and Abraham Kingsley Macomber; buyers of French decorative arts included Mrs. Hearst, Mrs. A. C. Balch of Los Angeles, Mrs. Herbert Fleishhacker of San Francisco, Edward Brandenstein of San Francisco, and Trask, who bought a Lalique cachet poisson (crystal letter seal in the form of a fish).[131]

Some of the PPIE's art found its way into local institutions.[132] With $10,000 left to the city by former resident Alice Warren Skae specifically earmarked for the purchase of art, the Memorial Museum in April 1916 acquired a significant group of California paintings, watercolors, and prints that had been shown at the fair and the alternative exhibition staged in Golden Gate Park, including Joseph M. Raphael's *Spring Winds* (pl. 57), Francis McComas's *Navajo Gateway,*

Arizona (pl. 77), Clark Hobart's *The Blue Bay: Monterey* (pl. 80), and E. Charlton Fortune's *Summer* (pl. 82) (the latter two are visible on either end of the far wall in the installation photograph of Gallery 117; see fig. 78).[133] The Skae Fund Legacy bequest, the first of its kind in San Francisco, gave de Young the opportunity to sing the praises of the Memorial Museum. "In point of situation and in possibilities of expansion," he editorialized in the *San Francisco Chronicle*, "the Memorial Museum has all the advantages of the Metropolitan in Central Park and, like that institution, is destined to receive bequests from the Altmans, Hiltons and Wolfes of the future."[134] In speaking of the permanence of gifts made to the city-owned Memorial Museum, he took an indirect jab at the privately operated Palace of Fine Arts: "The trouble with private corporations and private organizations is that they do not, and cannot, live for ever. They disintegrate, they have their schisms, and disputes, sometimes they amalgamate and take in other institutions, and one never knows how long they will endure, or when they will go out of existence."[135] Meanwhile, for its new museum in the Palace of Fine Arts, which was temporarily filled with leftovers from the fair, the SFAA received two PPIE paintings, one each by Carles (pl. 84) and Hugh Henry Breckenridge (*The White Vase*; see fig. 92) as gifts from Mrs. E. H. (Mary Williamson Averell) Harriman,[136] and Childe Hassam's *Yachts, Gloucester Harbor* (1899, location unknown) from the San Francisco Society of Artists, who raised funds toward its purchase.[137]

In the immediate wake of the fair, the SFAA had made an unsuccessful play for Alma de Bretteville Spreckels's collection of Rodin bronzes that had been shown in the French Pavilion, hoping that she would donate them to the Palace of Fine Arts. Writing to her in February 1916, president of the SFAA John I. Walter referenced "a great variance of opinion as to the suitability of the Fine Arts Palace," pointing out that "the chief opposition [comes] from those who favor the Park and its museum," a thinly veiled reference to de Young, whose legendary feud with the Spreckels family dated back to 1884 when Alma's husband shot the newspaper publisher for defaming him in the *Chronicle*.[138] He added, "I rather believe that the proponents of the Park Museum have entertained a mistaken idea that we intend to deduct from the value and efficiency of that institution. As we propose absolutely to confine our galleries to the Fine Arts, such an idea is erroneous." Alma Spreckels agreed to exhibit her Rodin and Putnam bronzes in the Palace, and would maintain close ties to the SFAA and Laurvik in the coming years.

One of the most tangled loose ends from the Exposition was the considerable quantity of foreign art that could not be returned immediately to Europe, a problem that would continue to preoccupy Laurvik long after Trask had retired to the East Coast. In particular, the works from Germany, Austria, Hungary, and Finland became stranded in the United States as enemy property. While the German paintings went back to Pittsburgh immediately after the fair, where they would become the Carnegie Institute's responsibility for the duration of the war, the works by Kokoschka, Gallen-Kallela, and the Hungarians would remain temporarily exiled in San Francisco and on view in the Palace of Fine Arts until 1923.

The saga of Gallen-Kallela's protracted efforts to retrieve his seventy works is recorded in the Palace of Fine Arts director's files. Procured from the Venice Biennale in 1914, the collection occupied its own gallery in the Annex, and afterward was displayed in the Palace with the artist's consent. Although Finland was not directly involved in the war, its declaration of independence from Russia and treaty signed with Germany in 1917 were enough to cause the US government to sequester the Gallen-Kallela collection as enemy property in January 1919, along with the Austrian and Hungarian exhibits. Subsequently, the artist's futile attempts to reclaim his work were thwarted by quibbling between the SFAA and the Exposition Company over shipping costs, a matter that embroiled the State Department because of the US ambassador to Rome's involvement in the original negotiation. There were additional complications pertaining to missing funds from the sale of some of Gallen-Kallela's paintings, including two canvases representing his daughters that were family heirlooms and expressly not for sale. The Finnish Legation in Washington, DC, became involved in 1920 and was able to secure a promise of release from the US government, but the works remained stranded in San Francisco until the fall of 1923 amid finger-pointing

between the SFAA, the Exposition Company, and the government's Alien Property Custodian. It was Robert B. Harshe, then the director of the Art Institute of Chicago, who helped settle the matter by agreeing to organize an exhibition of Gallen-Kallela's work at his own institution in 1924 and assume the costs of shipping the artwork back to Finland.[139]

Notwithstanding the distraction of the stranded foreign art, Laurvik made an energetic attempt to operate the Palace as an art museum for the city of San Francisco. In recognition of its eclectic mission, he called the institution a Comparative Museum of Art, "wherein one may study the interrelation of all the arts, observing how the same principles of design and color operate in arts as diversely different as tapestries and engravings, rugs, porcelains, and Persian manuscripts."[140] In April 1920 it would be incorporated as the San Francisco Museum of Art with its own board of trustees. Laurvik won the support of critic Willard Huntington Wright (the brother of avant-garde painter Stanton Macdonald-Wright), who was effusive in his praise: "The official status of J. Nilsen Laurvik is that of Director of the Palace of Fine Arts at Exposition Park," he wrote in 1919, "but his unofficial status is of far greater importance. Laurvik is much more than a mere director of a museum. His tireless activities as San Francisco's aesthetic impresario have made him a sort of indirect arbiter of our cultural taste [see fig. 22]—and furthermore, he has appointed himself a committee of one to see to it that, so far as it is humanly possible, we are properly taken care of artistically."[141] But in time, Laurvik lost the support of the local art community, who found him aloof and more focused on Eastern and foreign artists, and unable to grow the institution's collection or attendance.[142]

Laurvik tried to convince his board to relocate the San Francisco Museum of Art to temporary quarters downtown before a permanent gallery could be established in the new War Memorial complex, but instead the decision was made to lock its doors on June 1, 1924, with no immediate plans to open a new facility.[143] Several months later, the board relieved Laurvik of his duties, asking him to tender his resignation by March 1, 1925.[144] It would be another decade before the San Francisco Museum of Art was finally reborn in the War Memorial under new leadership, a new board, and a new mission to focus on contemporary art. Eventually this institution would be transformed into the San Francisco Museum of Modern Art (SFMOMA).[145]

The decline of the San Francisco Museum of Art in the early 1920s coincided with the rise of a new institution, the California Palace of the Legion of Honor (see Chapman, this volume). In January 1920 the Board of Supervisors of the City and County of San Francisco passed a resolution formally thanking Mr. and Mrs. Spreckels for their offer to build a permanent Legion of Honor in San Francisco dedicated to the memory of California's war dead. A year prior to the Legion's opening, Alma Spreckels proposed a formal alliance with the Art Association that would have resulted in the Trustees of the San Francisco Museum of Art overseeing its operation, but the plan was rejected.[146] She also tried, unsuccessfully, to woo Laurvik to direct her institution.[147]

After the Palace's closure, the San Francisco Museum of Art temporarily shifted some of its collections and activities to the new Legion, which opened on November 11. The annual juried exhibitions of the SFAA were held at the Legion of Honor in 1925, 1930, 1931, and 1932.[148] The last of the art was finally removed from the Palace in July 1931, including Mathews's *Victorious Spirit* and paintings that had been in the PPIE by San Franciscan Henry Varnum Poor and Seattle artist Fokko Tadama (see pl. 75), all of which would be sent to the Legion.

The rest of the fair's public art was not dispersed as widely as the contents of the art pavilions. Having been executed on removable canvases, most of the murals were saved and turned over to the Trustees of the San Francisco War Memorial in the hope that they could be installed in other public buildings (Brangwyn's murals were eventually installed in the War Memorial's Herbst Theatre, which was completed in 1932, while the others were placed in storage). The monumental plaster sculptures posed a bigger problem. The Exposition Company had offered to give them away to American municipalities willing to cover the costs of removal and shipping, but there was little interest. For instance, the *San Francisco Chronicle* reported, "*The End of the Trail* alone was applied for more than 500 times. Upon further inquiry, though, the representatives of the cities, finding that the statuary was not permanent in character, cancelled their requests."[149] When fund-raising efforts by the California Club and the City Federation of Women's Clubs to cast Fraser's sculpture in bronze for installation at the end of the Lincoln Highway in Lincoln Park failed, the plaster was left to disintegrate in the so-called "Marina Graveyard" of homeless PPIE sculptures (see fig. 23) until it was adopted by a county park near Visalia, California, in 1919.[150]

Local journalists could not resist speculating on the eventual placement of Grafly's *Pioneer Mother Monument* almost immediately after its unveiling. "One of the figure pieces that is sure to create almost a riot when a permanent home for it is sought, is the mother's monument," editorialized the *Oakland Tribune* in August 1915, adding "the criticism of this is very unfavorable, and if an attempt is made to place it in the park, there will be a storm from the artists and beauty-lovers."[151] It remained in the colonnade of the Palace of Fine Arts until 1939, when it appeared again in the Golden Gate International Exposition on Treasure Island, but Golden Gate Park is where it finally landed, in 1940.

Donated to the city by Alma Spreckels, Rodin's *The Thinker* also spent several years in Golden Gate Park, where it was set down on a rustic pedestal of reddish rock (see fig. 171) in March 1916 (in 1924, it would be moved to the new Legion of Honor in Lincoln Park).[152] In 1920, local sculptor Haig Patigian cited its haphazard presentation, along with the unloved *Pioneer Mother Monument*, as evidence of San Francisco's need for a municipal art commission: "If we had an art commission," he suggested, "such barbarities as 'The Thinker,' sitting on the grass in the park as though he were looking for lost pennies, and the 'Pioneer Mother,' a figure of a female in the costume of an uncertain period, leading the Gold Dust twins to their bath, would not be tolerated."[153] One of

FIG. 24
Column of Progress in the Marina after the fair structures had been demolished, ca. 1920. San Francisco History Center, San Francisco Public Library

the last sculptural remnants of the fair to be left in situ, the Column of Progress (see fig. 24) stood in the Marina until the 1920s, when it finally succumbed to the elements, and ironically, to progress, as the Army declared it dangerously close to the airstrip at Crissy Field.[154]

Buried in the postscript to a letter from the Exposition Company's executive secretary Joseph Cumming to Frederick Skiff dated February 7, 1917, is a passage that captures the mixed emotions of the team that put the sparkle in San Francisco's Jewel City and then made it all go dark:

> I was out this morning to the Grounds to check up some of our property still in the Fine Arts Palace, and while of course the chief beauty of the place is gone, it did strike me that the Fine Arts Palace and the California Building, together with the Lagoon and the trees still make a very beautiful picture. As I was walking down to the Fine Arts Palace I looked across the waste of sands that marks the site and I thought of Aladdin's father-in-law, the Sultan, who used to look out of his window every day to see the beautiful Palace that Aladdin had erected, and I recalled his amazement and despair when he looked out of his window the morning after the wicked [magician] had seized the lamp and transported the Palace away. Without becoming pessimistic, I fell to thinking about it all and how ephemeral the whole thing had been and what it all meant, and the trials, and troubles and tribulations we all went through. It certainly made me melancholy, but I looked up and it struck me that everything that had been done was finely commemorated by the *Adventurous Bowman* who is still on his pedestal aiming at the sky."[155]

Achenbach Foundation Research Fellow Kirk Nickel made a significant contribution to the archival research carried out for this introductory essay. I also wish to acknowledge my colleagues at the Fine Arts Museums of San Francisco who provided valuable assistance: Emma Acker, Esther Bell, Victoria Binder, Karin Breuer, Heather Brown, Melissa E. Buron, Aliza Cohen, Abigail Dansiger, Douglas DeFours, Leslie Dutcher, Debra Evans, Jane Glover, Stuart Hata, Danica Michels Hodge, Diana K. Murphy, Maria Santangelo, and Colleen Terry. I am also grateful to my many colleagues around the Bay and around the world who helped in the preparation of this essay: Laura A. Ackley, Scott Allan, Heidi Applegate, Emanuel Berman, Tim Brown, Katharine Burnett, Tom Carey, Joanna Catron, Diane Dillon, Brent Glass, Susan Goldstein, Jeff Gunderson, Ann Harlow, Karen Holmes, Donna Ewald Huggins, Sherrill Ingalls, Mark Jacobs, Sarah Kennel, Leftwich Kimbrough, Valerie Krall, Julie Ludwig, Anna Lucas Mayer, Laure Meslay, Jean Moulin, Elizabeth Murray, Clinton Nagy, Monique Nonne, Shannon Perich, Pamela Roberts, Bart Ryckbosch, Kathryn Shedrick, Mark Simpson, Katie Steiner, Jodi Throckmorton, and Bob Workman.

1. "[T]he Exposition was visited by 18,876,438 visitors. No exact count throughout the Exposition period was kept of the visitors to the Palace of Fine Arts, but from test counts, from time to time, it is estimated that the exhibition in the Department of Fine Arts was seen by something over ten million visitors." *Panama-Pacific International Exposition, San Francisco 1915, Report of the Department of Fine Arts* (San Francisco: Panama-Pacific International Exposition, 1915) (hereafter cited as *Report of the Department of Fine Arts*, 1915), 8.

2. John E. D. Trask, "Report of the Department of Fine Arts" (unpublished typescript, September 16, 1916), 29, San Francisco History Center, San Francisco Public Library (hereafter cited as Trask, "Report").

3. *Official Catalogue of the Department of Fine Arts, Panama-Pacific International Exposition (With Awards)* (San Francisco: Wahlgreen, 1915), 152–153.

4. This move was proposed in 1938 by Herbert O. Brayer, who was at the time the holder of the Panama-Pacific International Exposition Memorial Fellowship in Pacific Coast History, a position sponsored by the San Francisco War Memorial trustees using funds donated by the former trustees of the PPIE.

5. Bancroft Library staff, "Finding Aid to the Panama Pacific International Exposition Records, 1893–1929, bulk 1911–1916," BANC MSS C-A 190, The Bancroft Library, University of California, Berkeley, http://pdf.oac.cdlib.org/pdf/berkeley/bancroft/mca190_cubanc.pdf.

6. *Report of the Department of Fine Arts*, 1915. See note 1 above.

7. A small selection of these records was microfilmed by the Archives of American Art in the early 1980s. See San Francisco Art Association and related organizational records, 1871–1978, (bulk 1871–1920), http://www.aaa.si.edu/collections/san-francisco-art-association-and-related-organizational-records-8413.

8. See Mark A. Hewitt, *Jules Guérin: Master Delineator*, exh. cat. (Houston: Rice University, 1983).

9. Jules Guérin, quoted in Hamilton Wright, "Creating an Exposition," *Overland Monthly* 61, no. 2 (February 1913): 177.

10. Jules Guérin, quoted in "Exposition Will Excel in Color," *San Francisco Chronicle*, August 17, 1912.

11. Jules Guérin to George Kelham, September 30, 1912, carton 62, folder 17, Panama Pacific International Exposition Records, BANC MSS C-A 190, The Bancroft Library, University of California, Berkeley (hereafter cited as PPIE Records).

12. Guérin interoffice communication, carton 62, folder 68, PPIE Records; and Guérin to Kelham, September 30, 1912, PPIE Records.

13. "First World's Fair to Have a Careful Color Scheme," *New York Times*, June 1, 1913; Elmer Grey, "The Panama-Pacific International Exposition of 1915," *Scribner's Magazine*, July 1913, 44–57.

14. "Announce 1915 Poster Awards," *San Francisco Chronicle*, February 21, 1914. In this article, George Kelham is misidentified as George Pelham, and William B. Faville as William B. Farrell.

15. "Unsigned Poster at the Exposition," *Oakland Tribune*, February 28, 1915.

16. Frank Morton Todd, *The Story of the Exposition: Being the Official History of the International Celebration Held at San Francisco in 1915 to Commemorate the Discovery of the Pacific Ocean and the Construction of the Panama Canal* (New York: G. P. Putnam's Sons, 1921), 2: 181.

17. Sigismund Blumann, "A Personal Correspondent at the Panama-Pacific International Exposition. II. Doing the Exposition with a Four-by-Five," *Photographic Journal of America* 52, no. 6 (June 1915): 292.

18. Pamela Glasson Roberts, "The Intrepid Helen Messinger Murdoch," *Magazine Antiques*, November/December 2010, 80, http://www.themagazineantiques.com/articles/the-intrepid-helen-messinger-murdoch.

19. Quotation from Murdoch's lecture notes provided to the author by Pamela Roberts, e-mail communication, August 19, 2014.

20. The Warners were notable collectors of Asian art who shared a passion for photography and lived for a period of time in Shanghai. They settled in San Francisco in 1909. See obituary of Murray Warner in *Mechanical Engineering* 43, no. 1 (January 1921): 9. On Gertrude Bass Warner, see David A. Robertson, ed., *Precious Cargo: The Legacy of Gertrude Bass Warner*, exh. cat. (Eugene: University of Oregon Museum of Art, 1997). On Warner's gift to the Smithsonian Institution, see *Report of Secretary of the Smithsonian Institution for the Year Ending June 30, 1922* (Washington, DC: Government Printing Office, 1922), 34.

21. Michael Williams, "Exp'n Art Not Yet Ready," *American Art News*, April 3, 1915, 1.

22. Harris Connick to the commandant of the guards, March 29, 1915, carton 61, folder 12 "Sketching permits, Division of Works," PPIE Records.

23. Handwritten request from E. Charlton Fortune, March 2, 1915, carton 61, folder 12 "Sketching permits, Division of Works," PPIE Records.

24. Ferdinand Schevill, *Karl Bitter: A Biography* (Chicago: University of Chicago Press, 1917), 56.

25. See Brian Edward Hack, "Spartan Desires: Eugenics and the Sculptural Program of the 1915 Panama-Pacific International Exposition," in *PART: Journal of the CUNY PhD Program in Art History* 6, 2000, http://part-archive.finitude.org/part6/articles/bhack.html. The murals program is covered further by Anthony W. Lee in this volume.

26. A. Stirling Calder, "Sculpture," *California's Magazine* 1 (July 1915): 322.

27. Munson's interview with journalist Norman Rose was published under the headline "How'd You Like to Talk with Nearly All the Statuary at the Panama-Pacific Expo?" in newspapers across the country in January 1915. See, for example, *Tacoma Times*, January 7, 1915.

28. *Fort Wayne Journal-Gazette*, February 7, 1915.

29. Munson's first-person account of posing for Weinman was included in a syndicated memoir published in 1921: "The Story of Audrey Munson—Intimate Secrets of Studio Life Revealed by the Most Perfect, Most Versatile, Most Famous of American Models, Whose Face and Figure Have Inspired Thousands of Modern Pieces of Sculpture and Painting," *Spokane Daily Chronicle*, January 14, 1921.

30. Fraser's unpublished memoirs of March 1953, quoted in Dean Krakel, *End of the Trail: The Odyssey of the Statue* (Norman: University of Oklahoma Press, 1973), 4–6.

31. Karl Bitter to A. A. Weinman, October 28, 1914 (copy is misdated 1915), carton 168, folder 9 "Contracts, Division of Works," PPIE Records.

32. "We have granted this privilege to other sculptors and I can see no reason why we should not grant Mr. Weiman's [sic] request. The custom has been to have the attorney draw up a supplementary contract which both the Exposition and Mr. Weiman will have to sign." Harris D. H. Connick to Frederick Skiff, undated memo from September 1915, carton 168, folder 9 "Contracts, Division of Works," PPIE Records.

33. An unknown number of posthumous bronzes were cast in the 1970s and 1980s under the authority of Calder's daughter, Margaret Calder Hayes.

34. See "All Honor to the Pioneer Mothers of California," *Overland Monthly* 64, no. 5 (November 1914): 438–441; Dorothy Grafly Drummond et al., *The Sculptor's Clay: Charles Grafly (1862–1929)*, exh. cat. (Wichita: Edwin A. Ulrich Museum of Art, 1996), 51–58, 72, 140–143; Brenda D. Frink, "San Francisco's Pioneer Mother Monument: Maternalism, Racial Order, and the Politics of Memorialization, 1907–1915," *American Quarterly* 64, no. 1 (March 2012): 85–113.

35. Several documents relating to the commission reside in the Pennsylvania Academy of the Fine Arts (PAFA) Archives. Trask sent a telegram to the Academy on August 5, 1913: "TO ASSIST IN SECURING IMPORTANT COMMISSION FOR GRAFLY MUST ASK YOU TO MAIL ME SPECIAL DELIVERY WEDNESDAY COMPLETE ASSORTMENT PHOTOGRAPHIC PRINTS HIS WORK AS IS POSSIBLE." In a subsequent letter dated August 11, 1913, to John Andrew Myers at the Academy, Trask thanks him for the photographs that were en route, stating "I sincerely trust that they will be here for a Committee meeting to be held late this afternoon. At a later time I will tell you all about the occasion for their use and what I am trying to do for Grafly." Panama-Pacific Exhibition file, John A. Myers papers, general correspondence, 1914/15, PAFA Archives.

36. See note "The Pioneer Mother," in "Art at Home and Abroad," *New York Times*, October 25, 1914.

37. Trask, "Report," 30.

38. Bernard R. Maybeck, *Palace of Fine Arts and Lagoon. Panama-Pacific International Exposition, 1915* (San Francisco: Paul Elder, 1915).

39. Powers's bust-length marble *California* would have been well known to San Franciscans: it was exhibited for many years in the art gallery incorporated into Woodward's Gardens, an amusement park in the Mission District. The sculpture was probably lent to the Exposition by Michael H. de Young, who donated the work to the Memorial Museum late the following year; when he acquired it is unknown. "Marble Treasure Presented to Museum in Park," *San Francisco Chronicle*, January 1, 1917.

40. "Robert B. Harshe," *Bulletin of the Art Institute of Chicago* 32, no. 4 (April–May 1938): 48–51. This number of the *Bulletin* is dedicated entirely to Harshe's life and achievements.

41. *Eighth Annual Report of the President of the University for the Year Ending July 31, 1911*, Leland Stanford Junior University Publications, Trustees' Series no. 20 (Stanford: Stanford University, 1911), 40.

42. Robert B. Harshe to Charles Lang Freer, May 19, 1911, Charles Lang Freer Papers, Freer Gallery of Art and Arthur M. Sackler Gallery Archives (hereafter cited as Freer Papers).

43. Ibid.

44. "Fine Paintings Will Hang in Art Building," *San Francisco Call*, July 30, 1911.

45. Charles C. Moore to J. Pierpont Morgan, telegram, September 25, 1912, "The plans for the artistic development of the Exhibit Division of this Exposition and in particular those of Fine Art Exhibits were so cruelly stopped by the lamentable death of Francis D. Millet, with whom I was in hopeful correspondence, that nothing has been done toward the selection of a Chief of the Department of Fine Art and we are at a loss to determine the appointment of a man who will be acceptable to the art world and capable of meeting the managerial and tactful requirements of this most important position." PPIE Records.

46. Charles Lang Freer to Charles C. Moore, August 26, 1912, Freer Papers.

47. The relevant communications are contained in carton 8, folder 12 "Executive Files," PPIE Records.

48. Charles C. Moore to J. Pierpont Morgan, telegram, October 28, 1912, carton 1, folder 19 "Executive Files, Skiff," PPIE Records.

49. Trask, "Report," 1. In the report, Trask indicates that he did not decide to vacate his position in Philadelphia until February 1913.

50. "In conformity with the recommendation made by Mr. Trask, Chief of the Department of Fine Arts, in his letter dated December 6th, 1912, and addressed to the Director of Exhibits; and with the understanding that Prof. Harshe has resigned from the Stanford University to give his entire time to the Art Department of the Exposition, I have the honor to recommend that Mr. Robert G. [sic] Harshe be appointed Assistant Chief of

the Department of Fine Arts at a salary of three thousand dollars per annum, such appointment to take effect June 1st of this year." Asher C. Baker, director of exhibits, to Frederick Skiff, director-in-chief, May 15, 1913, carton 1, folder 18 "Executive Files, Skiff," PPIE Records.

51. Michael Williams, "San Francisco," *American Art News*, May 15, 1915, 7. Harshe was given the title Superintendent of Fine, Applied, and Manual Art Education in March 1915. Executive Secretary to R. S. Durkee, Comptroller, March 9, 1915, carton 1, folder 18 "Executive Files, Skiff," PPIE Records. Harshe seems to have retained the title Assistant Chief in the Department of Fine Arts in addition to this new title.

52. Robert B. Harshe, *A Reader's Guide to Modern Art* (San Francisco: Wahlgreen, 1915).

53. Browne resigned in April 1915, and the reasons are unknown. Given his tough public stance against the modernist component of the Armory Show, and his stated opinion that the one-man gallery scheme was inappropriate within the context of a world's fair, perhaps he simply could not stomach the exhibition as it finally came together along with the preparations for an annex of European avant-garde art. See Melissa Wolfe and Joel Dryer, "Charles Francis Browne (1859–1920)," Illinois Historical Art Project, text and n119, http://www.illinoisart.org/#!charles-francis-browne/c140s. Browne's resignation is indicated on the title page of the *Official Catalogue of the Department of Fine Arts* under his name and title, where the date of his resignation is given as April 1, 1915. In Trask's "Report," his dates of employment are given as March 1, 1914, and April 22, 1915 (4).

54. "Prominent Women to Aid, P.P.I.E. Enlists Their Services," *San Francisco Call*, June 16, 1913; "Mrs. W. H. Crocker and Mrs. Francis Carolan Will Assist—Tennesseans to Meet," *San Francisco Chronicle*, June 16, 1913; Francis Carolan to Charles C. Moore, August 12, 1913, carton 47, folder 10 "Intercommunication, Fine Arts," PPIE Records; Mr. Cumming to Mr. Trask, interoffice memo, August 15, 1913, carton 47, folder 10 "Intercommunication, Fine Arts," PPIE Records; Charles C. Moore to Francis Carolan, August 21, 1913, carton 47, folder 10 "Intercommunication, Fine Arts," PPIE Records.

55. Trask, "Report," 32.

56. On Denio, see Sandra L. Singer, *Adventures Abroad: North American Women at German-Speaking Universities, 1868–1915*, Contributions in Women's Studies, no. 201 (Westport: Praeger, 2003), 163–165; Anja Werner, *The Transatlantic World of Higher Education: Americans at German Universities* (New York and Oxford: Berghahn, 2013), 92.

57. Rose V. S. Berry, *The Dream City: Its Art in Story and Symbolism* (San Francisco: Walter N. Brunt, 1915).

58. "Attention, Mr. Trask!," *American Art News*, May 9, 1914, 4. The letter is signed "A. Reader" and dated "New York, May 4, 1914."

59. "Mr. Trask's Letter," *American Art News*, July 18, 1914, 2. Trask was responding to Charles Vezin's letter, published in the June 12 issue, that posed questions similar to those of the anonymous letter writer. See note 128 below.

60. Trask, "Report," 2.

61. MacEwen's role was announced in *American Art News*, March 15, 1913, 3. Trask announced the appointments of Tarbell, Alexander, Redfield, and Duveneck in *American Art News*, March 29, 1913, 1. Sargent's appointment was made prior to Trask's. Writing to Charles C. Moore on July 6, 1912, Frederick Skiff reported that he had offered Sargent the chairmanship on March 1 when the two men met at a dinner in London; carton 1, folder 17 "Executive Files, Skiff," PPIE Records. The full American Advisory Committee for Great Britain was announced in *American Art News*, November 8, 1913, 1.

62. Trask, "Report," 6.

63. See Robert Lundberg, "The Art Room in the Oregon Building: Oregon Arts and Crafts in 1915," *Oregon Historical Quarterly* 101,

no. 2 (Summer 2000): 214–227. Wood was represented in the Art Room by a copy of his book *The Poet in the Desert* (1913), lent by Allen H. Eaton, and by eleven paintings.

64. John Trask to John White Alexander, August 23, 1913, John White Alexander Papers, carton 1, folder 56, Archives of American Art.

65. John Trask to John Andrew Meyers, secretary of PAFA, July 22, 1914, PAFA Archives: "I write to you now, however, with especial reference to the painting 'The Skaters' by Gari Melchers because I am in receipt of a letter from Mr. Melchers asking that I help him to secure from the Pennsylvania Academy the loan of this painting, that it may be included in the special gallery which is to be devoted to Mr. Melchers' work. No doubt you will hear direct from Mr. Melchers, but I would be obliged if you would make note of the fact that the Panama-Pacific International Exposition will be greatly obliged if you can accede to Mr. Melchers' wish that this painting shall be loaned to us." Charles Lang Freer to John Trask, December 14, 1914, Freer Papers: "I have recently received a letter from Mrs. Gari Melchers, who wrote me from Holland on behalf of her husband, who, as you doubtless know, is now in Germany, asking me to loan for your forthcoming exhibition the canvas by Melchers entitled 'The Sailor and his Sweetheart,' and this I am pleased to do."

66. John Trask to Gari Melchers, May 7, 1915, archives of the Gari Melchers Museum. The painting, *The Smithy* (ca. 1910, sold Christie's, New York, 4 December 2008, lot 142), was part of London's *Anglo-American Exhibition* of 1914 (no. 241).

67. The official catalogue credits Louis Huth as the lender of this painting, but he died in 1905 and the picture belonged to his widow, Helen Rose Huth, at the time of the Exposition.

68. "I have already started matters in train in an effort to borrow 'The Mother' from the Luxembourg." John Trask to Charles Lang Freer, October 16, 1913, 1, Freer Papers.

69. "The 'New England Woman' which Miss Beaux desires to be called 'Study in Whites' I have concluded will be sufficiently valued at four thousand dollars." John F. Lewis to Willcox, Peck, Brown and Crosby (insurance agents), January 16, 1915, PAFA Archives.

70. See "Notes," *Brooklyn Museum Quarterly* 2 (1915): 311.

71. "Panama-Pacific Exposition," *Bulletin of the Art Institute of Chicago* 9, no. 1 (January 1, 1915): 13. The Chicago jury consisted of Trask, William Paxton (Boston), Daniel Garber (Philadelphia), Frank Duveneck and L. H. Meakin (Cincinnati), Edmund H. Wuerpel (Saint Louis), and Lawton Parker and Frederic C. Bartlett (Chicago).

72. *Circular of Information, Panama-Pacific International Exposition, San Francisco, 1915, Department of Fine Arts* (San Francisco, 1914), 4.

73. "Conspicuous by Their Absence," *Oakland Tribune*, February 28, 1915. Grace Hudson, one of the artists mentioned in this article, wrote to a friend to complain about her rejection, placing the blame on the juror McComas, who reportedly denied seeing her work: "I am quite willing to believe that McComas was serious and truthful when he said he had not seen my pictures—that is exactly the idea—they were rejected without looking at." Hudson to Mabel Phelps, n.d. (but postmark is partially legible and reads either January 23 or 25, 1915), archives of the Grace Hudson Museum, Ukiah, California. She went on to claim that "[Giuseppe Leone] Cadenasso and some others whose work was rejected went to Trask—and pulled wires and their work was taken back."

74. "Local Art at Exposition," *American Art News*, March 27, 1915, 3.

75. Trask, "Report," 18.

76. "Local Art at Exposition," 3.

77. "Coast Artists to Exhibit in Park Museum," *San Francisco Chronicle*, April 12, 1915; "Art Exhibit Opens at Golden Gate Park," *San Francisco Chronicle*, April 16, 1915; Anna Cora Winchell, "Art and Artists," *San Francisco Chronicle*, April 18, 1915.

78. Jury report, quoted in Rose Berry, *Dream City*, 293.

79. "Side Light on Exposition Awards," anonymous letter of October 26, 1915, *American Art News*, October 30, 1915, 2.

80. Joseph Pennell, "Pennell on Exposition Art," *American Art News*, September 18, 1915, 4.

81. See Katharine P. Burnett, "Inventing a New 'Old Tradition': Chinese Painting at the Panama-Pacific International Exposition," in *Meishu shi yu guannian shi* (*History of Art and History of Ideas*) (Nanjing: Nanjing Normal University, 2010), 9: 17–57.

82. See Christian Brinton, "Scandinavian Art at the Panama-Pacific Exposition," *American-Scandinavian Review* 3, no. 6 (November–December 1915): 349–357.

83. Other than Uruguay, all of these nations had their own pavilions, though art was only a significant component of the French, Italian, and Chinese pavilions.

84. Trask, "Report," 29.

85. Ibid., 10–11.

86. "Panama-Pacific Exposition: Policy of Great Powers Toward Support—Progress of Great Work," *Chicago Commerce* 9, no. 14 (August 8, 1913): 10.

87. Trask's German Committee advised him on September 20, 1914, that there would be no German section. Trask, "Report," 12.

88. *Exhibition of Caricatures in Charcoal by Mr. Marius de Zayas and Autochromes by Mr. J. Nilsen Laurvik*, 291 Gallery, New York, January 4–16, 1909 (no catalogue). According to a review in the *New York Times*, Laurvik exhibited thirty autochromes; "Gallery Notes," January 13, 1909. Two of Laurvik's autochromes surfaced in a Swann Galleries auction in New York, April 22, 1994, lot 246A (*Group Portrait with George Seeley*) and lot 246B (*Portrait of a Woman*); their current whereabouts is unknown. Laurvik was a contributor to Stieglitz's *Camera Work* and published an article on Stieglitz in 1911: J. Nilsen Laurvik, "Alfred Stieglitz, Pictorial Photographer," *International Studio* 44 (August 1911): xxi–xxvii.

89. John Trask to Charles L. Freer, October 16, 1913, enclosing letter to be forwarded to the President of the Detroit Museum of Art, dated October 17, 1913. Freer acknowledged receipt on October 29, 1913. Freer Papers.

90. Asher C. Baker to Frederick Skiff, July 22, 1914; Skiff to Charles C. Moore, July 24, 1914; Moore to William J. Bryan, secretary of state, July 30, 1914, carton 1, folder 19 "Executive Files, Skiff," PPIE Records.

91. "Report of John W. Beatty, Director, Department of Fine Arts, Carnegie Institute, Pittsburgh, for the Year Ending March 31, 1915," *Carnegie Institute Annual Reports* (1915): 28–29.

92. A. H. Markwart, *Building an Exposition: Report of the Activities of the Division of Works of the Panama-Pacific International Exposition* (San Francisco: Panama-Pacific International Exposition, 1915), 74.

93. Trask, "Report," 20.

94. Markwart, *Building an Exposition*, 143.

95. John Trask to Asher C. Baker, January 15, 1915, quoted in Trask, "Report," 22.

96. Ibid., 23.

97. Ibid., 24.

98. The others were the painter Grigory Bobrovsky (no. 71, *Portrait of a Woman* [date and location unknown]) and Prince Paolo Troubetzkoy (nos. 1082–1104).

99. Markwart, *Building an Exposition*, 521. Graham also received contracts for building telephone pay stations in several locations (ibid., 560, 562). According to his obituary in the *San Mateo Times* (March 27, 1944), he was the architect of Santa Clara and Loyola Universities. Markwart may have been mistaken about the date Graham's contract was signed, as the *San Francisco Chronicle* reported the groundbreaking for the Annex on May 20, 1915.

100. Sohlberg wrote to Smith of the two paintings on January 27, 1915: "I believe they will go well together as regards colour, and

they will moreover deepen each other. Thus although these paintings offer the greatest contrast to each other, they are both a story of the Northern Night, one a summer night's dream, and the other a winter fairy story." Quoted in Roald Nasgaard, *The Mystic North: Symbolist Landscape Paintings in Northern Europe and North America, 1890–1940*, exh. cat. (Toronto: University of Toronto Press, 1984), 116. Sohlberg apparently was unaware that the Chicago banker had died on March 22, 1914, but Smith's heirs followed through with the loan of the painting.

101. See Pamela Gerrish Nunn, "Self-portrait by Laura Knight (1877–1970)," *British Art Journal* 8, no. 2 (2007): 53–57.

102. "Laurvik on Exposition Art," *American Art News* 13, no. 27 (April 10, 1915), 1. Marinetti's name is misspelled as "Martinetti" throughout the article.

103. See John Oliver Hand, "Futurism in America: 1909–14," *Art Journal* 41, no. 4 (Winter 1981): 337–342.

104. Filippo Tommaso Marinetti, "The Italian Painters and Sculptors: Initiators of Futurist Art," in *Catalogue de Luxe of the Department of Fine Arts, Panama-Pacific International Exposition*, eds. John E. D. Trask and J. Nilsen Laurvik (San Francisco: Paul Elder & Company, 1915), 1: 123–127. The essay had appeared previously in English as "The Exhibitors to the Public," signed by Umberto Boccioni, Carlo Carrà, Luigi Russolo, Giacomo Balla, and Gino Severini, in the exhibition catalogue *Exhibition of Works by the Italian Futurist Painters* (London: Sackville Gallery, 1912).

105. Ibid., 124–125.

106. Ben Macomber, *The Jewel City: Its Planning and Achievement; Its Architecture, Sculpture, Symbolism, and Music; Its Gardens, Palaces, and Exhibits* (San Francisco: John H. Williams, 1915), 124. The location of Guillaume's original painting is unknown; it is only known through a postcard reproduction.

107. Ben Macomber, "Weird Pictures at P.P.I.E. Art Gallery Reveal Artistic Brainstorms," *San Francisco Chronicle Sunday Magazine*, August 8, 1915.

108. Ibid.

109. Gottardo Piazzoni to Giacomo Balla, December 9, 1915, Robert Whyte papers, American Art Department, de Young. The text of the original draft of this letter survives in a typescript in the papers of Piazzoni scholar Robert A. Whyte transferred to the de Young in 2015. The typescript includes the original Italian and a translation by Whyte that has been slightly modified in the quotation used here. An excerpt from this letter also appears in Whyte's monograph *Gottardo Piazzoni: Painter of the California Landscape, 1872–1945* (privately published: ca. 2014): 85.

110. Piazzoni to Balla, December 9, 1915.

111. Ibid.

112. J. Nilsen Laurvik to John Trask, May 18, 1916, Archives of the San Francisco Art Association, San Francisco Art Institute (hereafter cited as SFAA Archives): "We have received a cable from Marinetti, the leader of the Futurist artists in Milan, stating that, owing to some unforeseen exigencies, the exhibit will have to be returned to them forthwith."

113. See Nancy Boas, "At the Fair," in *The Society of Six: California Colorists* (1988; repr., Berkeley: University of California Press, 1997), 53–71.

114. "Memorial Museum to Get Marvelous Cloisonnes / M. H. de Young Buys Imperial Treasures for City," *San Francisco Chronicle*, December 12, 1915; "Fine Pompeiian Bronzes Go to Memorial Museum / Antique Art Is Given to City by M. H. de Young," *San Francisco Chronicle*, December 19, 1915; "Memorial Museum to Have Art of Renaissance / M. H. de Young Gives Representative Collection," *San Francisco Chronicle*, December 26, 1915; "Italian Majolica Is Included in Gifts of M. H. de Young to Memorial Museum," *San Francisco Chronicle*, January 2, 1916; "Memorial Museum Is Given Exquisite French Sculpture by M. H. de Young," *San Francisco Chronicle*, January 9, 1916;

"Modern Italian Bronzes Given to Memorial Museum by M. H. de Young," *San Francisco Chronicle*, March 5, 1916; "Larger Museum Wanted as Result of Many Rich Gifts," *San Francisco Chronicle*, March 20, 1916.

115. "The Proper Place for a Museum / An Institution of That Sort Should Be Situated Where It Will Attract the Greatest Number of Visitors," *San Francisco Chronicle*, December 6, 1915; "Reconstruction of Fine Arts in Park Advocated," *San Francisco Chronicle*, December 30, 1915.

116. See "Proposed Addition to the Memorial Museum and a Glimpse of the Founder's Day Parade," *San Francisco Chronicle*, March 26, 1916; "M. H. de Young Explains Memorial Museum Plans," *San Francisco Chronicle*, September 24, 1916.

117. Robert B. Harshe, "The Oakland Public Museum," *California's Magazine* 2 (1916): 103–104.

118. Ibid.

119. "It has been decided that the Art Building shall be a permanent structure, to be used after the close of the Exposition as a Municipal Gallery for San Francisco." Robert Harshe report in *American Art Annual* 9 (1911): 261.

120. Todd, *Story of the Exposition*, 3: 149–150.

121. "Positive Step to Preserve P.P.I.E.," *San Francisco Chronicle*, November 10, 1915.

122. John Trask to R. B. Hale, vice president of the Exposition, November 16, 1915, carton 47, folder 11 "Intercommunication, Fine Arts," PPIE Records.

123. Joseph Cumming, executive secretary, to John Trask, November 25, 1915, carton 47, folder 11 "Intercommunication, Fine Arts," PPIE Records.

124. John Trask to Joseph Cumming, November 26, 1915, carton 47, folder 11 "Intercommunication, Fine Arts," PPIE Records.

125. In a letter from John Trask to J. Nilsen Laurvik, dated May 9, 1916 (SFAA Archives), reference is made to arranging the display of the murals by Brangwyn (eight total), Hassam, Mathews, and Holloway.

126. Laurvik was appointed executive director of the SFAA at the April 20, 1916, board meeting. Minutes of the Board of Directors' Meetings, San Francisco Art Association, SFAA Archives.

127. "A New Art Director," *American Art News*, May 13, 1916, 4.

128. Charles Vezin, letter to the editor, June 12, 1916, *American Art News*, June 17, 1916, 4.

129. Trask, "Report," 37.

130. Levinson's purchase was noted in a letter from sales manager John G. Dunlap to Frank Todd, October 30, 1915, carton 87, folder "Records, 1911–1929," PPIE Records. Dunlap describes Levinson as "one of the few San Franciscans to purchase anything from the show." It is not known whether Huntington bought her Redfield directly out of the fair or acquired it subsequently, but the work, *The Hills and River*, was listed among the canvases sold out of the PPIE. *Report of the Department of Fine Arts*, 1915, 22.

131. Dossier 1, oeuvres vendues, F/21/4074, Archives Nationales, Paris.

132. On December 20, 1915, the *San Francisco Chronicle* reported "Miss Edith Bull and Mrs. [Kathleen Bull] Pringle presented the [Memorial] Museum with a collection of forty-seven oil paintings, which were until recently on exhibition at the exposition," adding, "It is a complete and comprehensive group, embracing many fine portrait and landscape studies," but neglecting to provide the names of any of the artists. No such gifts have been found in the records of the Memorial Museum from 1915 or 1916. See "Rare Works of Art Donated to Golden Gate Park Museum," *San Francisco Chronicle*, December 20, 1915.

133. Alice Warren Skae died in 1903, leaving a complex trust for the benefit of her daughter, who shared her name. Her will included a provision for $10,000 to be donated to the art museum in San

Francisco for the purchase of paintings, a sum that was turned over to the city when her daughter died in 1915. The fund was formally accepted by the Board of Supervisors on December 20, 1915 (see *Journal of Proceedings, Board of Supervisors of the City and County of San Francisco* 10 [1915]: 1434), and the money was made available to spend on March 25, 1916 (see "Legacy of Mrs. Skae Will Found Exhibit of State's Artists," *San Francisco Chronicle*, March 26, 1916; Proceedings of the Park Commission, April 6, 1916, *San Francisco Municipal Record* 9 [1916]: 123).

134. "Gifts to the Museum. They Are Guarantees of Perpetual Remembrance and Public Gratitude," *San Francisco Chronicle*, April 10, 1916.

135. Ibid. Ironically, only a handful of the Skae Fund Legacy bequest pictures remain in the collection of the Fine Arts Museums of San Francisco, the majority having been deaccessioned over the years. Seven oil paintings, two watercolors, and seven prints remain in the collection from the original 1916 purchase.

136. In a letter to John I. Walter, president of the SFAA, dated July 27, 1916 (SFAA Archives), John Trask explained that Mrs. E. H. Harriman of Arden, New York, purchased the two paintings with the intention of donating them to a public arts institution in San Francisco as a way of encouraging interest in American painting in the local community. Trask was given discretion to place the objects, and chose the SFAA as the recipient. Mrs. Harriman also purchased Edward Redfield's *Overlooking the Valley* (1911) out of the PPIE and donated the work in 1916 to the Metropolitan Museum of Art, where it remains.

137. The SFAA Archives contain incomplete correspondence from Laurvik's office that records the convoluted details of the Hassam purchase, which dragged on until September 1916. When the Exposition closed, the San Francisco Society of Artists, chaired by Arthur Mathews, committed to buying the painting from the artist for $1,500 for presentation to the SFAA in commemoration of the amalgamation of the two groups. The payment was held up when Mathews disputed the legality of the merger and froze the Society's bank accounts. In the end, the former Society of Artists paid $800 with the balance assumed by the SFAA, the recipient of the gift. See letters from Laurvik to Hassam, June 5, 1916 (summarizing the situation); Hassam to Laurvik, July 2, 1916 (expressing gratitude for the explanation and suggesting that his "old friend and schoolmate in Paris, Arthur Mathews I am sure would do anything to straighten the matter out"); Trask to John I. Walter, July 7, 1916 (regarding partial payment to Hassam); Trask to Laurvik, August 25, 1916 ("Now that the Department of Fine Arts is closing up its affairs, it becomes necessary either to deliver the picture to the San Francisco Art Association or to return it to Mr. Hassam"); Laurvik to Trask, August 29, 1916 ("I believe it would be best [if] the painting in question were delivered to us pending the payment of the balance due on it"); Trask to Laurvik, August 30, 1916 (agreeing to release the painting pending indemnification of the Exposition); Laurvik to Trask, September 1, 1916 (asking for an indemnification form); Trask to Laurvik, September 5, 1916 (asserting that the SFAA will assume full responsibility of payment of balance to Hassam); Trask to Laurvik, September 6, 1916 ("I have turned over today to your representative the painting . . . belonging to Mr. Hassam, but contracted for [it] to be bought by the Society of Artists for the Art Association at $1500.00 of which amount $800.00 has been paid").

138. John I. Walter to Mrs. Alma de Bretteville Spreckels, February 18, 1916, SFAA Archives.

139. Robert Harshe first wrote to Laurvik of a possible Finnish traveling exhibition on June 4, 1921, when Harshe was associate director of the Art Institute of Chicago. In the letter he writes: "If I were you I would show every eagerness to help the Finnish brethren. Otherwise they may make quite a lot of trouble for you." As director of the Art Institute of Chicago, Harshe wrote

again to Laurvik on January 5, 1922 (SFAA Archives): "It seems to me that we ought to try to clean up this matter for the sake of the Exposition, for your sake, and because of the fact that it reflects discredit on America." Of Gallen-Kallela's paintings he added, "I will be very glad to arrange a series of exhibitions across the country, which would lay them down in New York ready for shipment abroad at no expense to the Exposition."

140. J. Nilsen Laurvik, preface to *Catalogue of Mrs. Phoebe A. Hearst Loan Collection*, exh. cat. (San Francisco: Palace of Fine Arts, 1917), iv. The institution is identified as the Comparative Museum of Art in *American Art Annual* 13 (1917): 433.

141. Willard Huntington Wright, "J. Nilsen Laurvik—A Man of Tireless Energy Who Has Achieved Great Work," *San Francisco Bulletin*, April 12, 1919.

142. The first evidence of the erosion of confidence in Laurvik appears in the Minutes of Regular Meeting of Board of Directors, SFAA, October 18, 1921 (SFAA Archives), where "On motion of Mr. [John] Walter, seconded by Mr. Piazzoni, the President was requested to appoint a committee of three (the President to be an ex-officio member) to look for a man to take the place of Mr. Laurvik as Director of the San Francisco Art Association." Piazzoni forced the issue in March 1922, when he threatened to resign from the board over the lack of resolution. The minutes of the May 16, 1922, meeting record: "On motion of Mr. [Willis] Polk, seconded by Mr. Piazzoni, a resolution was offered that the office of director of the Art Association now held by Mr. Laurvik be declared vacant."

143. See letter from the SFAA assistant secretary to Herbert Fleishhacker, November 14, 1923 (SFAA Archives), in which reference is made to "working out the plan for temporary housing of the collections of the San Francisco Museum of Art at the Spreckels Museum [i.e., the Legion of Honor]." In the same letter, the secretary states that "at the meeting held on Nov. 2, 1923, the Trustees of the S.F. Museum of Art appointed James D. Phelan and Walter S. Martin, a committee, with power to act on all questions relating to the installation and exhibition at the Spreckels Museum of the collections of the S.F. Museum of Art." Also see Minutes of the Meeting of the Trustees of the San Francisco Museum of Art, October 15, 1924, SFAA Archives: "Mr. Laurvik stated that he had talked with many supporters and was confident the Museum was in a better position now than ever before; that with announcement of downtown location in War Memorial he believed we could get all needed support; on the other hand if activities are completely discontinued he felt that only the Spreckels Museum would profit. He urged continuance of exhibitions and lectures."

144. At the November 7, 1924, meeting of the Trustees of the San Francisco Museum of Art, Laurvik was given a leave of absence until March 1, 1925, at one half of his salary. His resignation was accepted at the February 27, 1925, board meeting. The minutes of these meetings are in the SFAA Archives.

145. See Katherine Church Holland, introduction to *San Francisco Museum of Modern Art, The Painting and Sculpture Collection* (New York: Hudson Hills Press, 1985), 14–15; Sarah Roberts, "SFMOMA: A Chronology," in *75 Years of Looking Forward*, exh. cat. (San Francisco: San Francisco Museum of Modern Art, 2009), 392.

146. See Walter S. Martin to George A. Pope, president of the San Francisco Museum of Art, April 13, 1923, SFAA Archives.

147. See "Transfer of Art Treasures Urged," *San Francisco Journal and Daily Journal of Commerce*, March 7, 1923: "Mr. and Mrs. Spreckels have announced their invitation to Mr. Laurvik to become curator of the Legion of Honor Palace but the latter stated yesterday that pending official announcement of the removal proposal he did not care to make a statement."

148. Forty-Eighth Annual Exhibition of the San Francisco Art Association, California Palace of the Legion of Honor, April 23–

June 1, 1925; Fifty-Second Annual Exhibition of the San Francisco Art Association, California Palace of the Legion of Honor, May 3–June 1, 1930; Fifty-Third Annual Exhibition of the San Francisco Art Association, California Palace of the Legion of Honor, April 26–May 31, 1931; Fifty-Fourth Annual Exhibition of the San Francisco Art Association, California Palace of the Legion of Honor, April 24–May 29, 1932.

149. "Tulare will Get P.-P.I.E. Statue," *San Francisco Chronicle*, April 21, 1916.

150. "'The End of the Trail,' one of the most-discussed bits of statuary on the grounds of the Panama-Pacific Exposition, has been secured by the Forestry Commission for Mooney Grove, the big county playground near Visalia." Untitled item on page 5 of the *Van Nuys News*, September 26, 1919. Eventually it would find its permanent home in the National Cowboy and Western Heritage Museum in Oklahoma City.

151. "What Will Become of Statues," *Oakland Tribune*, August 15, 1915.

152. "Superintendent McLaren reported that the great statue 'The Thinker,' by Rodin, and presented to Golden Gate Park by Mr. and Mrs. A. B. Spreckels had been erected at Favorite Point on a pedestal of the red rock of the peninsula. The statue was unveiled by Master and Misses Spreckels on Tuesday, March 21st, 1916. The Secretary was instructed to send an engrossed copy of the Superintendent's report to the generous donors and thank them in the name of the people of San Francisco and the Board of Park Commissioners." *San Francisco Municipal Record* 9, no. 16 (April 20, 1916): 123.

153. Haig Patigian, quoted in "Plan to Extend Park Memorial Museum and to Foster Art in S.F. Is Told by M. H. de Young," *San Francisco Chronicle*, February 1, 1920.

154. Stephen A. Haller, *The Last Word in Airfields: A Special History Study of Crissy Field, Presidio of San Francisco, California* (San Francisco: National Park Service, 1994), 48.

155. Joseph Cumming to Frederick Skiff, February 7, 1917, carton 10, folder 31 "Executive Files, Cumming," PPIE Records. Cumming erroneously wrote "musician" instead of "magician" in referencing the tale of Aladdin, and called the sculpture *The Adventuresome Bowman*.

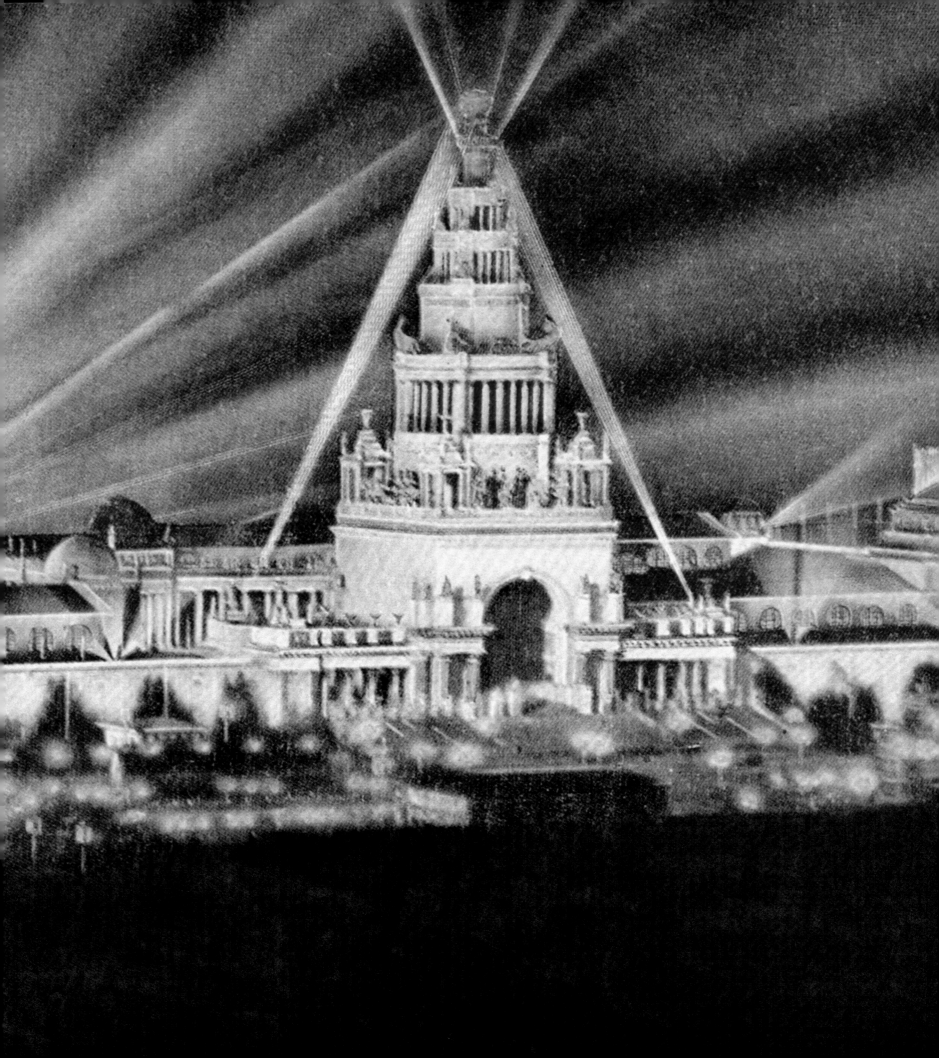

THE SPIRIT OF
THE EXPOSITION

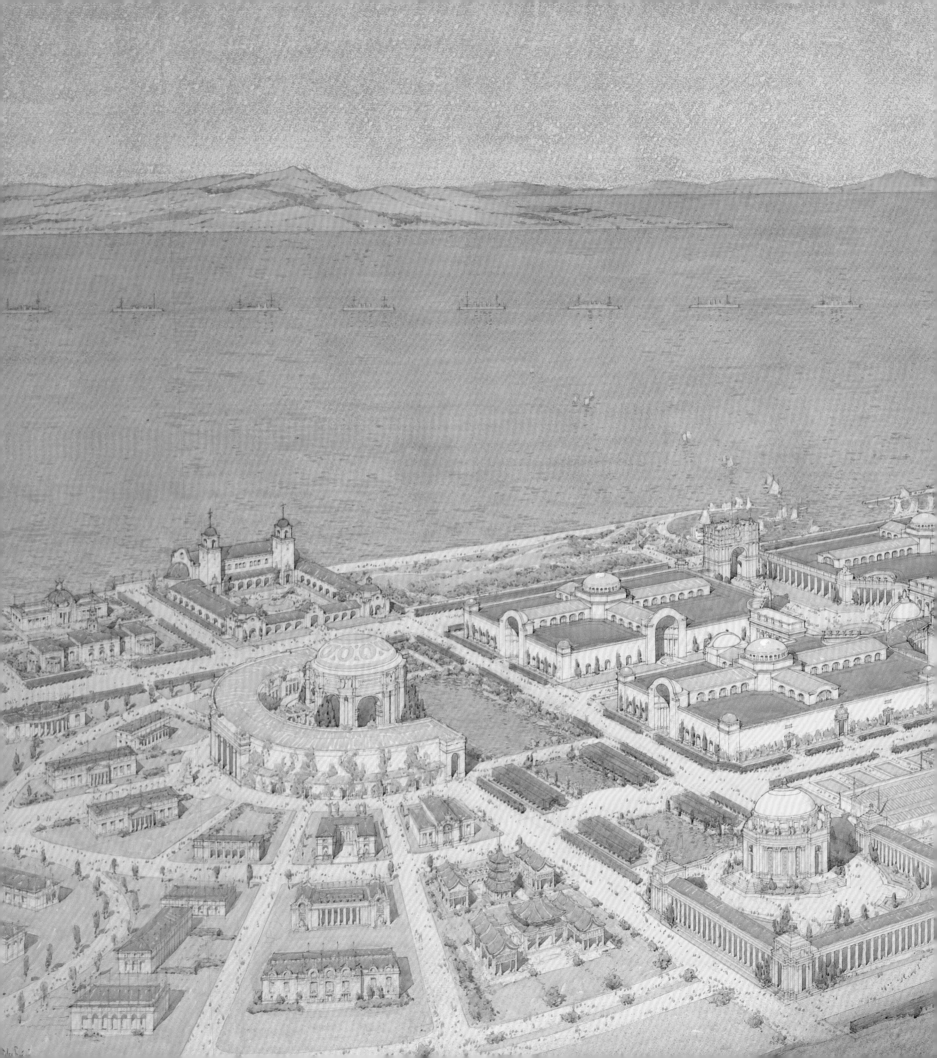

GEM OF THE GOLDEN AGE OF WORLD'S FAIRS

San Francisco is known worldwide as a beautiful, cosmopolitan city, but many—even some San Franciscans—have forgotten that shortly after the turn of the twentieth century, its image was that of a smoking ruin, a city destroyed by the great earthquake and fire of 1906. The Panama-Pacific International Exposition (PPIE) of 1915 proclaimed San Francisco's recovery from the catastrophe of less than a decade before, as well as trumpeted the United States's successful completion of the Panama Canal, from which the fair took its name. The Exposition was, perhaps, the most gorgeous world's fair ever conceived and executed, the pinnacle of the golden age of international expositions, which began in the mid-nineteenth century and ended, arguably, when the PPIE closed at the end of 1915.

That year, a palatial complex with patterned minarets, celadon domes, and golden statues rising above ivory-colored walls presided over the city's northern shore (see fig. 25). At the center of this miniature city, an ornate forty-three-story tower sparkled with more than one hundred thousand cut-glass jewels. To the west, a spray of festive international buildings terminated at a huge racetrack and stadium. On the eastern end an undulating thoroughfare lined with fantastic midway concessions extended from Fillmore Street all the way to Van Ness Avenue. The entire 635-acre ensemble presented a magnificent spectacle to the 18,876,438 visitors who eventually passed through its gates.

PROGRESS AND GLORY: PATH TO THE PPIE

The PPIE was a product of the classic era of world's fairs, which began in 1851 when Britain's Prince Consort Albert sponsored the Great Exhibition of the Works of Industry of All Nations—better known as the Crystal Palace Exhibition—in London's Hyde Park. The immense iron-and-glass conservatory of culture displayed more than fourteen thousand exhibits and touched off a craze for expositions throughout the second half of the nineteenth century and into the first decades of the twentieth.

Dozens of world's fairs were staged in the period following London's celebration. The most notable European fairs took place in Paris (1889 and 1900) and Brussels (1910). In the United States, Philadelphia's 1876 Centennial Exposition celebrated the nation's hundredth anniversary; Chicago's 1893 Columbian Exposition observed the four-hundredth anniversary of the arrival of Christopher Columbus in the New World; Buffalo's 1901 Pan-American Exposition promoted cultural and commercial unity in the Western Hemisphere; and Saint Louis's 1904 event, the last major American fair prior to the PPIE, commemorated the centennial of the Louisiana Purchase.

Each international exposition glorified its host country and city, and planners invariably attempted to surpass their predecessors in design and content. The world's fairs displayed the finest wares, introduced the latest products and industrial innovations, exposed visitors to "exotic" cultures, and tried to catalogue human progress. The fairgrounds, each designed to be temporary, also provided testing grounds for the latest technologies, especially in infrastructural advances.

Few world's fairs were profitable, but their host locales had additional, broader aims: to increase commerce, tourism, settlement, and investment, and to reinforce

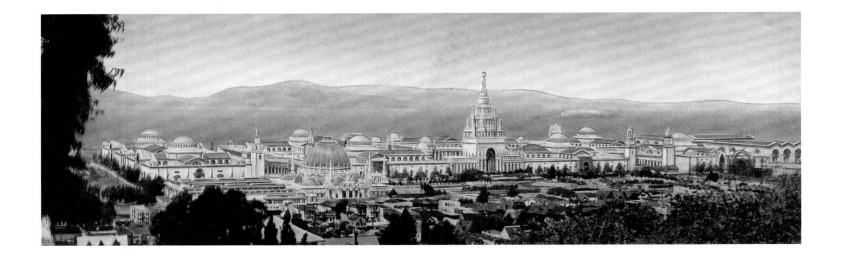

imperial aspirations (see Acker, this volume). The day before he was fatally shot at the 1901 Pan-American Exposition, President William McKinley said in an address at the fair, "Expositions are the timekeepers of progress. They record the world's advancement. They stimulate the energy, enterprise, and intellect of the people, and quicken human genius."[1]

In its earliest planning stages, the PPIE aspired to all of these objectives, but disaster triggered a more compelling goal. San Francisco's civic organizations and politicians had contemplated hosting a world's fair since at least 1891. Planning did not begin in earnest, however, until Reuben Brooks Hale, cofounder of Hale Brothers Department Stores, suggested in January 1904 that the city host an exposition to commemorate either the discovery of the Pacific Ocean by the Spaniard Vasco Núñez de Balboa in 1513, or, perhaps, the opening of the Panama Canal, which was planned for 1915 (though it would actually open ahead of schedule, in 1914).

The latter suggestion was particularly audacious, as the French endeavor to build the waterway had just ended in failure after twenty-three years of effort, and the United States had not yet assumed control of the canal's construction. Nevertheless, the idea stuck and the PPIE became the first international exposition to celebrate a contemporary rather than a historical event. The PPIE's assistant director of works, Arthur H. Markwart, explained, "One might say the exposition has been established at the western terminus of the Panama Canal, in order to announce its completion, and thus situated at California's front entrance, it will extend a hearty welcome to all visitors passing through the far-famed Golden Gate."[2]

On April 18, 1906, the mission of the proposed San Francisco fair took on a new, even more critical dimension when an earthquake struck and subsequent fires swept the city, leading to an estimated three thousand deaths, destroying almost four square miles of buildings, and causing approximately five hundred million dollars in damage (see fig. 26). With thousands of people remaining homeless, rubble still being cleared, and the daunting task of rebuilding just getting under way, city leaders recognized that a world's fair could restore San Francisco's international image as a renewed and vibrant center of commerce.

But San Francisco's hopes for holding the 1915 event were nearly quashed when several other cities, notably San Diego and New Orleans, also announced they wanted to host a world's fair that year. San Francisco boosters first had to convince the state of California that their city stood the best chance of winning a national bid for the 1915 exposition. In March 1910 the president of a Los Angeles bank suggested holding a convention of commercial organizations representing all cities in the state with populations greater than 3,000 persons to make that decision. Since California's population was then overwhelmingly concentrated in the northern part of the state, San Francisco won the vote handily.

Immediately following its victory over San Diego, the City by the Bay entered into a fierce competition against New Orleans for endorsement from the US government, which was required to hold an officially sanctioned "International Exposition." Though both cities plied senators and congressmen with local delicacies and libations (including California wines and New Orleans Sazeracs), two factors proved key to San Francisco's victory. First was the support of President William Howard Taft, who called San Francisco "The City That Knows How."[3] Second was the city's promise that it would not request or accept federal funding for its exposition, a pledge New Orleans refused to make. San Francisco emerged triumphant after the House of Representatives voted 259 to 43 in its favor on January 31, 1911. The Senate affirmed the House vote on February 11.

THE EXPOSITION TAKES SHAPE

As soon as the contest to host the celebration was settled, the question of where to locate the fair arose. The Exposition's board of directors, composed of prominent businessmen, joined with noted architects to consider as many as a dozen sites strewn across the entire Bay Area. They eventually chose a district then known as Harbor View, a marshy area of more than six hundred acres between the Presidio and Fort Mason on the northern shoreline of San Francisco.

Then planning shifted into high gear. The first order of business was filling in more than seventy-one acres of tidal lagoon that lay as much as twenty feet

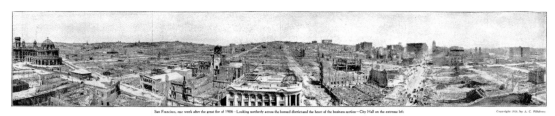

underwater at high tide (see fig. 27). A total of 1.4 million cubic yards of mud, sand, and silt were pumped from the floor of the bay into the site. Once the fill was complete, ground was broken on the first exhibit hall, the giant Palace of Machinery, on New Year's Day of 1913. This left only twenty-five months to construct all of the major buildings, the state and foreign pavilions, and the midway prior to the fair's planned opening day in February 1915.

A team of nationally renowned architects devised a novel plan in which a central, walled block of eight palaces enclosed five great open interior courtyards (see fig. 158). To these features they added colonnades and gardens adorned with reflecting pools, fountains, murals, and monumental sculptures. This "Block Plan" was a first in exposition design. In addition to its beauty, it provided shelter from wind and a compact footprint for fairgoers to navigate. The palace block was bracketed by the Palace of Fine Arts to the west, the Palace of Machinery to the east, and the Palace of Horticulture and Festival Hall set in the gardens south of the central palaces.

The facades of the entire ensemble were executed in the Beaux-Arts style, which emphasized symmetry and order, incorporated a variety of styles from neoclassical to Baroque, and featured lavish ornamentation (see fig. 29). The architectural embellishments were created from "faux travertine," a newly formulated mixture of gypsum, asbestos fiber, pigment, and other ingredients that combined to create a material that mimicked Roman limestone in appearance.

As Opening Day neared, the millions of board feet of lumber delivered to the Exposition docks resolved into immense, wood-framed buildings that were coated with the ivory-hued "travertine." Cornices, moldings, cartouches, and a myriad of other sculptural elements were applied, and then the details were painted with a palette of hues developed by director of color Jules Guérin. Inspired by the Mediterranean ambience of the site, Guérin selected exquisite tones reminiscent of Italy and Greece—including oxidized copper green, Pompeiian red, cerulean blue, and golden orange (see fig. 28). Lastly, immense murals, including some by world-renowned painters, were mounted within the courts (see Lee, this volume).

Meanwhile, special delegates of the Exposition traveled the globe soliciting exhibitors and international participants. Despite the outbreak of World War I in August 1914, treasures began to arrive, many brought by ships that had to dodge explosive marine mines that had been placed by both the Central and Allied combatants. Art objects, examples of mineral wealth, industrial products, handicrafts, and the latest technological achievements began to line the aisles of the capacious palaces. Finally, on February 20, 1915, more than a quarter of a million revelers pushed through the turnstiles to catch their first glimpse of the finished Exposition, officially nicknamed the "Jewel City."

A VERY FAIR YEAR

For the next 288 days, gaiety dominated San Francisco even as the war raged in Europe, hindering foreign attendance. Each day of the fair was dedicated as a "special day" honoring one or more individuals, groups of people, or locations; and featured parades, speeches, and concerts. These special festivities were supplemented by a panoply of holiday commemorations, agricultural competitions, athletics meets, and musical attractions.

The Music Department arranged a program of the finest bands and orchestras, including the final world's fair appearance of composer and conductor John Philip Sousa. On stage in the domed Festival Hall, the Boston Symphony Orchestra performed thirteen sold-out shows, renowned contralto Ernestine Schumann-Heink trilled, and dancer Loïe Fuller's troupe capered.

Celebrities who came to the Jewel City included Helen Keller, Maria Montessori, and Buffalo Bill Cody. Politicians came to orate; two of the most stirring speeches were by William Jennings Bryan, who touted pacifism, and Teddy Roosevelt, who espoused military preparedness. Famous industrialist-inventors Henry Ford and Thomas Edison visited the Exposition together. Ford had installed a working auto assembly plant in the Palace of Transportation, and it produced eighteen Model T cars each day. Movie stars, including Charlie Chaplin, Mabel Normand, and Roscoe "Fatty" Arbuckle, represented the nascent film industry.

Within the splendid facades of the palaces, the spaces were defined by industrial trusswork, which spanned stupendous exhibits of such luxurious goods as French tapestries, Indian rugs, model Chinese pagodas, Swiss wood carvings, and Italian marbles. However, only items that demonstrated advances of the preceding decade were eligible to vie for official medals of award. Two examples inside the palaces were the Telegraphone, a device that magnetically recorded audio onto a wire, and the Transcontinental Telephone Call Theater, in which audiences could listen to a phone call transmitted over the newly operational cross-country line (see fig. 30).

A cutting-edge scheme illuminated the Exposition. General Electric donated the latest equipment and sent the chief of its Illuminating Engineering Laboratory, Walter D'Arcy Ryan, to design an array of spectacular effects and "indirect lighting," which washed the surfaces of the buildings with soft, even light, setting a new standard for architectural illumination. He also adorned the Tower of Jewels with 102,000 colorful cut-glass "jewels," called Novagems, which swung and sparkled in the bay breezes. The Electric Kaleidoscope, inside the Palace of Horticulture, was a series of animated effects projected inside the building's glass dome. The Great Scintillator, mounted on a two-level pier in the bay near the Yacht Harbor, created an animated aurora of light over San Francisco Bay using a battery of forty-eight-inch spotlights operated by a company of US Marines (see fig. 31).

Aviation had not played a role at any world's fair prior to 1915, as the Wright brothers' landmark flight occurred just prior to the 1904 Saint Louis exposition. Flying was still perilous: local aviator Lincoln Beachey died just a few weeks into the PPIE season when the wings of his plane sheared off during an upside-down maneuver, sending him plunging into the bay. Nonetheless, stunt flying was seen as a prime attraction and flights soon resumed with other pilots assuming Beachey's mantle. Entrepreneurial brothers Allan and Malcolm Loughead sold ten-dollar rides in their hand-built seaplane. The profit they earned soaring above the Jewel City bankrolled their new company—the Lockheed Aircraft Manufacturing Company.

The Exposition's midway, nicknamed the "Joy Zone," was half a mile long and lined with whimsical facades resembling castles, ships, toy soldiers, ice cream cones, elephants, and giant ostriches (see fig. 32). In addition to enjoying animal shows, roller coasters, fortune-tellers, and a merry-go-round, fairgoers could enter one of several theaters offering "scenographs." These electromechanical spectacles told the tales of Robert Scott's fatal South Pole expedition, the 1913 Dayton Flood, the Civil War naval battle of the *Monitor* and *Merrimac*, and the creation of Earth as described in the book of Genesis. Zone customers could visit a replica of Yellowstone National Park, complete with a "Geyserland Spectatorium," within which spectators thrilled to the sight of colored lights playing across mimic geysers. In a concession operated by the Atchison, Topeka and Santa Fe Railway, passengers in a full-scale train observation car navigated a scale reproduction of the Grand Canyon, which simulated the mile-deep gorge using clever perspective paintings on canvas backdrops, three-dimensional sculpted stone formations, and

twenty-six freight-car loads of actual desert material. Most acclaimed was the model Panama Canal, in which riders encircled a five-acre topographic model of the waterway. As viewers listened to a description of the canal's workings, tiny ships made their way through the working locks of the model below (see fig. 65).

The Zone also was home to several attractions that featured degrading depictions of minorities (see Acker, this volume). Three concessions, African Dip (later called Soakum), Dixie Land, and Creole Belles, featured exaggerated, offensive caricatures of African Americans on their facades (see fig. 62). An attraction called Underground Chinatown portrayed San Francisco's Chinese community as rife with opium use and white slavery, causing an outcry among local Chinese Americans and Chinese nationals who had invested heavily in exhibits and a national pavilion at the PPIE. After these objections were raised, the attraction was briefly closed, and it reopened with Caucasian-appearing replacement mannequins. However, its insulting content was scarcely altered. The Zone also contained several "demonstration villages" of foreign cultures. Such villages had been staple attractions at world's fairs since the 1860s. While evidence indicates that by 1915 exposition audiences understood that such displays were not entirely authentic, these enclaves were still presented in a patronizing manner that exalted Western imperialism. Most were unprofitable, and three of them failed before the Jewel City closed.

While those overseeing the Joy Zone fought a continuous battle with certain concessionaires who promoted vice and salacious attractions, the PPIE faced additional challenges. Early bad weather limited attendance, and budget shortfalls resulted in "retrenchment" efforts, including painful staff reductions. The Great War not only curtailed foreign visitation but also caused the cancellation of several internationally themed events, including a naval pageant, a military tournament, and an around-the-world air race.

However, the global conflict resulted in one surprising upside for the fair—many of the warring nations sent priceless artworks to San Francisco to ensure their safety. As the *San Francisco Chronicle* reported, "Art treasures of the Old World that otherwise never would have been removed from their places in famous galleries have been shipped to San Francisco on the United States Government collier *Jason* as a measure of protection in the event that opposing armies should happen to lay waste other famous cities as the cities of Belgium have been wasted."[4]

A MULTIFACETED SUCCESS

The Panama-Pacific International Exposition was by any measure a great achievement. Where most American world's fairs lost money, the Jewel City was profitable. It earned enough to give the city the million-dollar Exposition Auditorium in the Civic Center, known today as the Bill Graham Civic Auditorium, which was originally built to house conferences associated with the fair. The PPIE also reimbursed its shareholders, many of whom then signed over their stock to purchase the Marina Green, which had been part of the fairgrounds, as public space for the city.

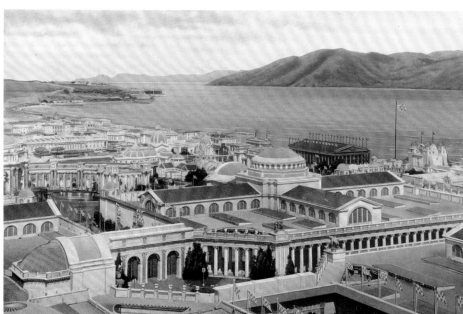

FIG. 27
The Harbor View site, with pre-existing lagoon, before 1912. Edward A. Rogers Panama Pacific International Exposition photograph collection, The Bancroft Library, University of California, Berkeley

FIG. 28
The lofty vantage from the forty-three-story Tower of Jewels reveals the fair's exhibition palaces, state and foreign pavilions, and the Golden Gate strait beyond. From *Natural Color Studies of the Exposition* (San Francisco: Robert A. Reid, 1915). Ackley Collection

FIG. 29
The opalescent glass dome crowning the Palace of Horticulture was captured during construction using an early color film process, 1914. Autochrome by Helen Messinger Murdoch. Science and Society Picture Library, London

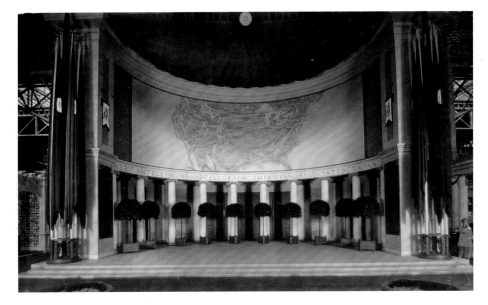

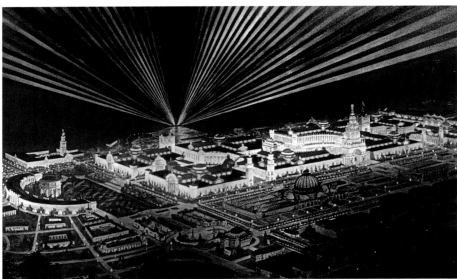

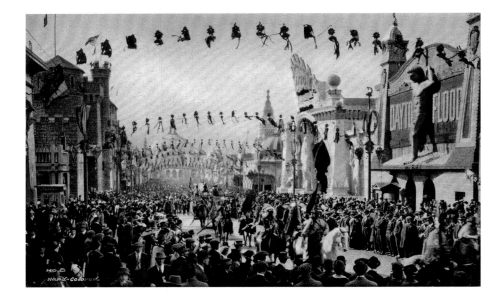

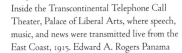

FIG. 30
Inside the Transcontinental Telephone Call Theater, Palace of Liberal Arts, where speech, music, and news were transmitted live from the East Coast, 1915. Edward A. Rogers Panama Pacific International Exposition photograph collection, The Bancroft Library, University of California, Berkeley

FIG. 31
This 1913 illustration anticipates how Walter D'Arcy Ryan's Great Scintillator would wash San Francisco's fog with rainbow-hued light. Lantern slide. Ackley Collection

FIG. 32
A parade wends its way between the whimsical facades of the Joy Zone, the PPIE's midway, 1915. Albertype postcard by Chas. Weidner. Ackley Collection

Agents for New Orleans had argued in 1910 that San Francisco was too far away from most of the US population to host a successful 1915 fair. In fact, the PPIE managed to draw nearly 19 million visitors, at the time second only to Chicago's Columbian Exposition and roughly equal to the Saint Louis fair—both of which were more accessible to most Americans.

The Panama-Pacific International Exposition marked the end of the grand era of world's fairs. Its promotional literature had touted the Jewel City as the embodiment of a grandiose American superiority. The "new world" was held to be immune to the mistakes of the old, with the current European war as an example of such mistakes. As plant scientist Luther Burbank wrote, "The Panama-Pacific International Exposition . . . is a living demonstration that the path of Peace brings life, strength, health, courage, valor, harmony, happiness and prosperity."[5] However, by the time of the next major world's fair, the 1933 Century of Progress Exposition in Chicago, the world was a very different place. The United States had fought in World War I and had lived through Prohibition and the onset of the Great Depression, events that shook the country's confident self-image. These nation-changing events diminished the concept of international expositions as physical manifestations of lofty ideals.

Technological advances also reduced the impact of world's fairs on American culture. By the 1930s, the nation's roads were highly developed, as was the automobile. Commercial air flight had become a reality. Beaux-Arts architecture had given way to the speed-influenced Streamline Moderne. The sweeping, curved halls of the Century of Progress buildings looked inward from mostly windowless facades. Communication was also radically different: by the time the 1933 Chicago fair commenced, film, telephony, and radio were well established, and commercial television was on the horizon. While world's fairs remained notable, they no longer served to the same extent their traditional role of bringing the world's progress to public attention. Additionally, increased specialization and expansion of industries prevented comprehensive displays, which would otherwise have become so vast that they could no longer be contained by limited physical areas. This resulted in the contemporary trade-show model for industrial exhibitions. Despite all of these factors working against international expositions, they still are held in modern times, typically every five years.[6]

The PPIE bridged the nineteenth and twentieth centuries. Its architecture was in many ways a legacy of the preceding era. Yet many of the innovative products and technologies displayed within its halls still benefit humanity one hundred years later. The fair also succeeded in rehabilitating San Francisco's world reputation after the 1906 calamity. As *Travel* magazine put it a century ago, "The world has never ceased to marvel at the enterprise of this city in attempting such a celebration so soon after the disaster which visited it. But visitors this year will have a twofold marvel in the splendid city itself, no less than in the stately exposition buildings nestling by the water front leading to the Golden Gate."[7]

1. William McKinley, quoted in "Reciprocity Is His Keynote," *Boston Herald*, September 6, 1901.

2. Arthur H. Markwart, "The Organization and Description of the Panama Pacific International Exposition," July 30, 1913, carton 16, folder 28, Panama-Pacific International Exposition Records, BANC MSS C-A 190, The Bancroft Library, University of California, Berkeley.

3. William Howard Taft, quoted in "Hotel Association Holds Its Fifth Annual Banquet," *San Francisco Chronicle*, March 24, 1912.

4. "Exhibits Are Epitome of World Progress," *San Francisco Chronicle*, February 21, 1915.

5. James A. Barr, *The Legacy of the Exposition: Interpretation of the Intellectual and Moral Heritage Left to Mankind by the World Celebration at San Francisco in 1915* (San Francisco: John H. Nash, 1916), 11.

6. According to Google, a common Internet query is "Why are there no more world's fairs?"

7. "The San Francisco Exposition," *Travel*, February 1915, 40.

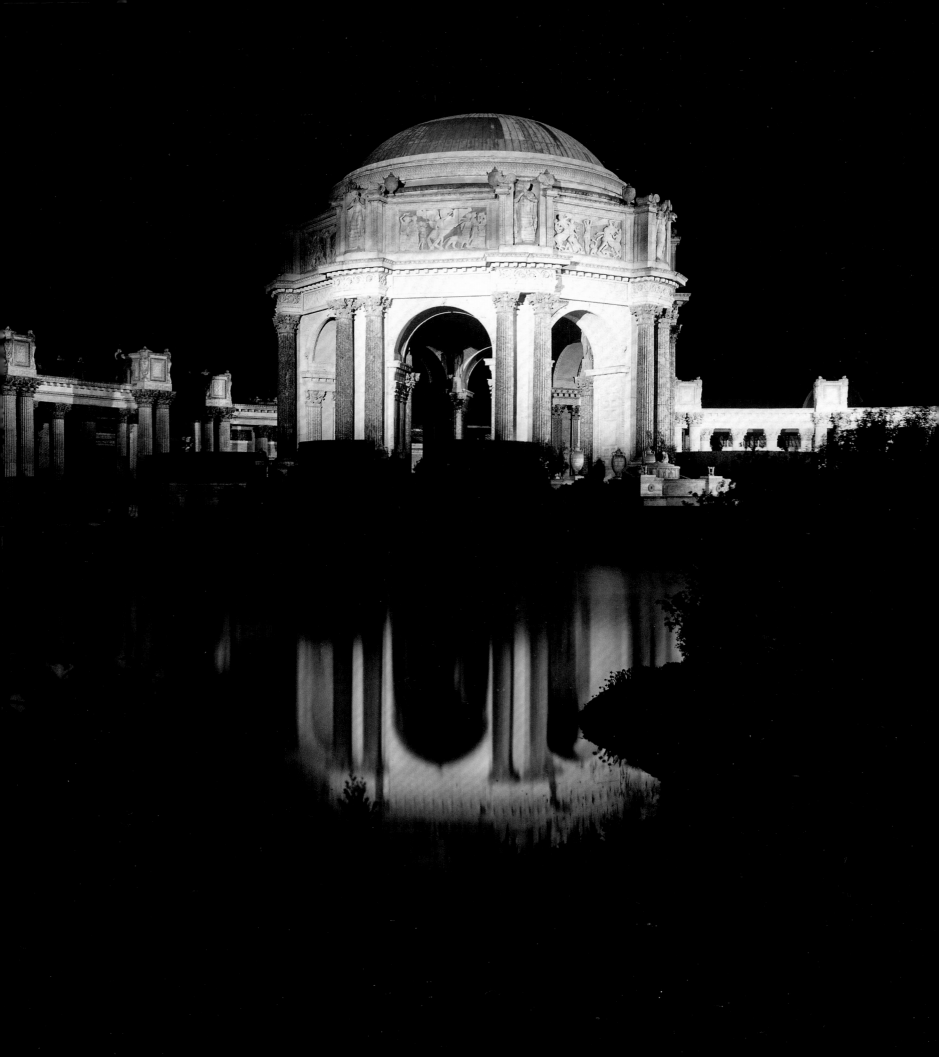

Victoria Kastner

The Power of Beauty: Bernard Maybeck's Palace of Fine Arts

With characteristic modesty, Bernard Maybeck once remarked to a longtime employee: "I'm not an architect. I'm just an artist who paints pictures in stone and concrete."[1] This description is especially relevant to his majestic Palace of Fine Arts at the Panama-Pacific International Exposition (PPIE): in certain lighting and from certain vantages, the building's wistful grandeur evokes a painting.[2] Its romantic and melancholy beauty captured the imagination of San Franciscans, who fought to preserve it when the rest of the fair's buildings were largely demolished in 1916. Originally constructed from temporary materials, the Palace of Fine Arts was permanently reconstructed in concrete in 1967 and extensively restored in 2009. Its improbable survival has transformed it into San Francisco's equivalent of the Eiffel Tower in Paris: both were created for world's fairs, and never intended as permanent structures, yet both endured, becoming revered symbols of the spirit of their respective cities.[3]

The singular reference to a "Palace of Fine Arts" is somewhat misleading, as the Palace is not one building but rather encompasses several architectural elements. Its massive octagonal rotunda, colored burnt orange and red, is 162 feet tall (see fig. 33). Flanking it are two immense detached peristyles, or colonnades, creating a total span of 1,100 feet. This impressive sight appears not once but twice; it is also reflected within a large lagoon that fronts it. Along the colonnade above each set of four Corinthian columns, four carved figures of toga-clad women turn their backs to the viewer and rest their arms atop deep boxes, into which they gaze. This vast elegiac ensemble, originally colored in alternating shades

of ocher and turquoise green, shields the facade of an enormous crescent-shaped building beyond (see fig. 34). This enclosed structure is the actual Palace of Fine Arts that housed the PPIE's main art exhibition; now shorn of its classical decoration—which included sculptured niches, Roman urns, and Corinthian columns identical to those on the peristyles, topped with enigmatic maidens peering into boxes—it lacks the dramatic impact it possessed in 1915. The 950-foot-long windowless edifice is a skylit hall spanning five acres, originally divided into 120 separate galleries showcasing paintings and sculptures. These objects represented the collective wonders of the world's culture, and Maybeck's Fine Arts Palace was regarded as the crowning beauty of the world's fair. It remains the most dreamlike creation conceived by the legendary architect who was once described as "filled with the yeast of dreams."[4]

Bernard Maybeck (see fig. 163) was born in 1862 in New York City's Greenwich Village, the son of Elizabeth Kern and Bernhardt Maybeck, a furniture maker who emigrated from Germany in 1848. Elizabeth died in 1865 when young Ben (as he was then known) was three years old. She wanted her son to be an artist, and both father and son dedicated themselves to fulfilling her wish. Ben was particularly close to his maternal grandfather, who taught him French and discussed German politics and metaphysics with him. The young Maybeck also admired the writings of the transcendentalists, particularly Emerson and his gospel of self-reliance. Even in his youth, Maybeck was an innovator, inventing a patented reversible seat for Pullman train cars when he was only nineteen.[5] He apprenticed briefly at his father's firm, but his tendency to alter the Pottier

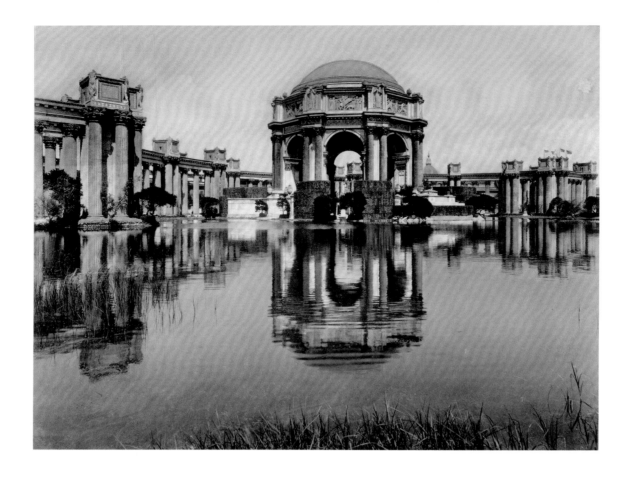

& Stymus furniture designs displeased the foreman, and his father sent him to Paris to study furniture design with Pottier's brother Christian.[6] The workshop happened to be across the street from the École des Beaux-Arts, the finest school of art and architecture in the Western world. When he saw an elegantly dressed and top-hatted young man (American architect Thomas Hastings) emerge from its gates, and later learned that he was an architecture student, Maybeck decided that he also wanted to become an architect. His early training as a craftsman remained a lifelong influence. Architectural historian Esther McCoy wrote: "Maybeck practiced architecture as if it were a craft, constantly revising—in order to bring closer together the possibility and the actuality. This accounts to a large degree for his successes in blending unrelated styles."[7]

Maybeck studied at the École from 1882 to 1886, an era when its traditional classical curriculum expanded to include gothic forms and an emphasis on construction techniques. Students were first tasked with passing the school's challenging admission exams; then they joined an atelier (architect's studio) where they prepared assignments for the juried competitions that determined their scholastic advancement. Studying at the atelier of Louis-Jules André, Maybeck learned the primary significance of the architectural plan. Every aspect of a building derived from its plan, which must be reflected externally as well as internally. He also learned that the ability to draw was an architect's most essential skill and that every design must possess *caractère*. That is, the architect must convey a building's essential nature—both its form and its function—through the skillful employment of design elements.[8] Maybeck's distinctive chalk drawings—on kraft paper that grew more smudged, rubbed, and redrawn as his designs developed—are one legacy of his training at the École.[9] Another was his discovery that architecture could create emotional resonance. Maybeck often walked through the medieval church Saint-Germain-des-Prés in a shortcut to his Paris lodgings. One day he heard its choir singing and was dumbstruck. For the first time, he perceived the building's sacred beauty, an epiphany he never forgot.

When Maybeck left the École, he worked at his friend Thomas Hastings's New York City firm Carrère and Hastings on designs for the ornate Ponce de Léon Hotel in Saint Augustine, Florida.[10] In 1889 he moved to Kansas City, Missouri, to start his own firm, a plan soon derailed by the worsening economy. While there, he met Annie White through her brother Mark, who later became Maybeck's engineer and business partner. Ben married Annie in October 1890, and they moved to San Francisco. While living in a cottage in the Oakland hills, the couple met Reverend Joseph Worcester, a Swedenborgian minister and amateur architect. Worcester's Church of the New Jerusalem in San Francisco (today the Swedenborgian Church of San Francisco), on which Maybeck worked with painter William Keith, artist Bruce Porter, and architect A. C. Schweinfurth, is now regarded as the earliest expression of California's Arts and Crafts movement.[11]

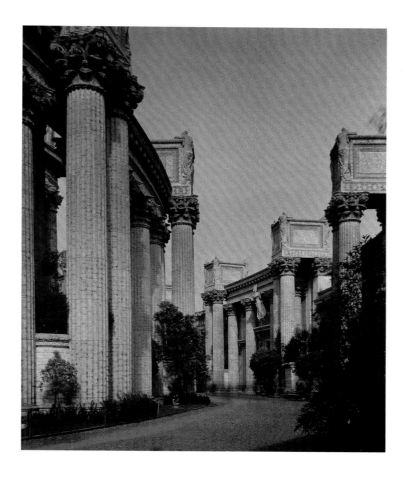

Maybeck also introduced the woodsy architectural style that would later become associated with Berkeley and that is known today as the First Bay Tradition. Its origins date to 1891, when the architect met naturalist Charles Keeler on the ferry from Berkeley to San Francisco. They soon became close friends, and in 1895 Maybeck designed Keeler's simple open-timbered home in the Berkeley hills. It was his first residential commission. Keeler recalled: "My attention had been attracted by a man of unusual appearance. . . . He was of a solid build with a round face and a chin more or less covered with whiskers. . . . Instead of a vest he wore a sash, and his suit seemed homespun of a dark brown color. . . . He was so simple, so vital, so fundamental in his thinking and feeling that he exercised a profound influence . . . on all who came in contact with him. His style was so novel and his personality so naive that some of his townspeople made fun of what they considered his eccentricities. They were but evidencing their own lack of artistic appreciation."[12]

In 1894 Maybeck began teaching applied geometry classes at Berkeley's then-small public university, the University of California. He soon initiated Saturday drawing sessions in his own home, forming an atelier that included Julia Morgan and Arthur Brown Jr. among its members. The following year, when philanthropist Phoebe Apperson Hearst wanted to construct a campus building for mining instruction to honor her recently deceased husband, George Hearst, Maybeck (the only architect on the faculty) was hastily summoned to produce the design. He did much more, convincing Mrs. Hearst to underwrite a worldwide competition to redesign Berkeley's entire campus.[13] As her representatives, the Maybecks traveled throughout Europe promoting the competition. (Maybeck also took advantage of the welcome opportunity to view many buildings and further expand his architectural knowledge.)

Several significant commissions followed their return to the Bay Area. In 1899, Mrs. Hearst hired Maybeck to design Hearst Hall, her temporary residence near the University of California campus. He created an enormous and startlingly original structure composed of a series of laminated wooden arches, allowing it to be easily disassembled a few years later when the building was moved onto campus. In 1901, she engaged him to design Wyntoon, her seven-story Bavarian-style castle built beside a rushing river near Mount Shasta (see fig. 35 for a later design). A few years later, Maybeck designed the large Tudor-style Leon L. Roos house in San Francisco's Presidio Heights, where he made effective use of the hillside's steep slope, and also designed much of the furniture that filled its elegant public rooms. In 1910, he produced his greatest architectural triumph, Berkeley's First Church of Christ, Scientist. Using simple materials—cast concrete, wooden trusses, and factory windows—he created an eclectic building of astonishing splendor. Esther McCoy wrote of his wide-ranging style: "Maybeck moved with confidence from Renaissance plan to flamboyant Gothic tracery, from Romanesque columns to Japanese timber

THE POWER OF BEAUTY

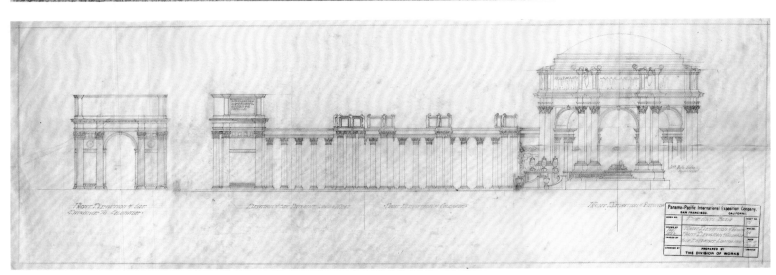

work, to Byzantine decoration. No one has ever carried the burden of the past more weightlessly."[14]

In spite of these distinguished buildings, few of his architectural colleagues took Maybeck seriously. His handmade clothes, otherworldly demeanor, and disregard for profits (he often was reluctant to bill his clients, and Annie therefore managed the office accounts) prompted many to refer to Maybeck as a "freak." He was heedless of such slights. His daughter-in-law, Jacomena Maybeck, recalled him once telling a student, "Never consider yourself snubbed."[15] When work was scarce in 1911, Maybeck took a lower position as a draftsman in his friend Willis Polk's architectural office. He also entered juried competitions, including the international contest to design the civic buildings of Canberra, which was declared Australia's new capital city in 1911. Though he did not win that lucrative commission, his entry revealed his architectural philosophy, much of which soon became evident in his design for the Palace of Fine Arts.

To augment the Canberra drawings in his submission, Maybeck included an essay stating his views on civic architecture: "Natural drains and water courses . . . should be retained . . . to make lakes or supply constant fountains, waterfalls, and pools for public pleasure, often planted with deep-growing trees to hold unstable soil. . . . New trees should be planted right through the old forest, clearing only enough to make the new growth thrive. The sharp contrast of the fresh young trees . . . and the rugged grey of the rough and old, has the charm of some music—you endure in delicious agony an hour of musical discord and all at once a sweet melody gives relief." Civic buildings should be magisterial: "Whatever the interior may be, the outside of the building intended to be seen from afar should be of heroic proportions. . . . It should have for a facade one single motive from the ground to the roof, not be cut up into basement, mezzanine, body, cornice, and attic." Time itself was a design element, conferring its own important benefits: "In the modern wholesale way we have of doing things we feel impatient to see things finished right away. . . . This is not necessary or wise. . . . The effort should be not to look nice and new and shiny, but to keep from looking so. . . . Where once we put a statue, where some ornament is needed, put a box with trees and bushes. Only one law is absolute: ten times what seems enough is too little."[16]

Maybeck wrote this essay immediately before he designed the Palace of Fine Arts, a commission with unusual origins. In 1912 he was passed over during the selection of architects appointed to the fair's advisory commission.[17] Many local practitioners—including some of his former students—were chosen. His daughter-in-law, Jacomena, recalled Annie's outrage: "Annie, his little fighting tiger, went after a job for him. She was a great letter writer. After many letters Maybeck was hired to coordinate work in the Zone."[18] The Joy Zone, the fair's midway for boisterous public attractions, was sited on the eastern boundary to prevent more high-minded fairgoers from being disturbed by its noisy participants.

As head of the fair's architectural committee, Willis Polk was assigned the Palace of Fine Arts, perhaps the fair's most important project. Its location, however, was unpromising: a water-filled bog at the western edge of the fairground's middle portion. Preoccupied with his many organizational responsibilities, Polk suggested that his office employees stage their own design competition for the building. Maybeck was familiar with the site, having spent considerable time at the fairgrounds laying out the Zone. Instead of regarding the bog as a disadvantage, he characteristically viewed it as an asset. Maybeck often advised his students, "If you strike a difficulty, don't shy away from it. Maybe it's an opportunity in disguise, and you can make a feature of it."[19]

A few days later, Maybeck pinned a large charcoal drawing onto Polk's office wall: the bog had become a lagoon in which a vast domed rotunda was reflected. Flanking it were cypress trees—symbols of mourning—and a long, curving colonnade that skirted the water's edge.[20] Traversing the lagoon and colonnade provided an interval for contemplation before the observer left the clamor of the fairgrounds to enter the hushed beauty of the galleries. Maybeck's design electrified Polk's office staff. In fact, virtually all of the fair's officials responded to his ideas with extraordinary enthusiasm. Polk—who had a widespread reputation for being temperamental—on this occasion graciously stepped aside and gave Maybeck the commission.[21]

The Palace of Fine Arts was the last major structure built for the fair. At a cost of $631,929—roughly equivalent to fifteen million dollars today—it was also one of the most expensive. It was not a lucrative job for Maybeck, however, since throughout the project he earned only draftsman's wages from Polk's office.[22] In 1912, mule teams dredged the bog, deepening it into a lagoon. Construction began on June 10, 1913. As were most buildings at the fair, the rotunda and colonnade were framed in wood and covered with staff, a mixture of burlap and pulverized and tinted plaster that was cast in large molds. When dry, it resembled carved travertine.[23] Since the gallery housed irreplaceable art, it was constructed of concrete instead of staff (see fig. 36), and framed with sturdy three-hinge metal arches instead of wooden beams. William G. Merchant, a young architect in Maybeck's office, designed many of the ensemble's decorative elements, including its Corinthian capitals and stone urns. Bruno F. Zinn created the dome's entablature panels, whose processional scenes of Apollo and Pegasus celebrated the primacy of art. Sculptor Ulric Ellerhusen produced the statues of women peering into boxes, high atop the rectangular groups of columns that punctuate the colonnade. Originally the boxes were to be filled with living, trailing vines, but this idea was abandoned as too impractical and expensive. Determining the composition's meaning became a subject of great public speculation. Maybeck never commented on these maidens' symbolism, but the notion quickly took hold that they were weeping into their boxes because of the beauty of art.[24]

Maybeck's highest priority was to integrate the architecture with the surrounding landscape. In the fairgrounds' general plan, he regarded the Palace of Fine Arts as the "top" element, facing the distant Palace of Machinery as the "bottom" element. He sited his rotunda on the fairgrounds' central axis, banking the soil and elevating it by a few feet to improve the dome's reflection. He reduced the traditional classical proportions of his Corinthian columns to create more

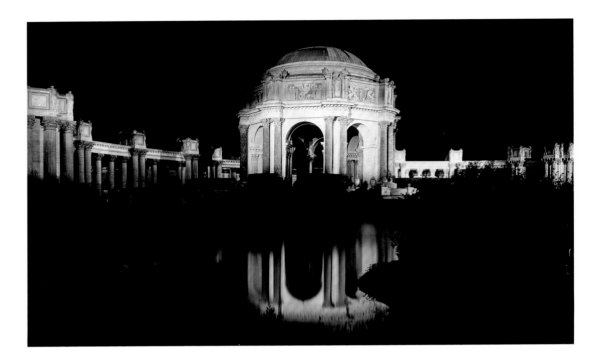

architectural intensity (see fig. 37), and manipulated the spatial relationships between the rotunda and colonnades to provide dramatic vistas that altered each time the viewer moved.[25] He wrote, "On the whole the lagoon is the crux of the whole composition," and he successfully prevented a bridge from being built across it when the fair's administrators requested one.[26] Maybeck worked closely with his friend John McLaren, chief of landscaping for the fair, to plant as many trees as possible. (They actually diverted a large number of trees intended for other areas—including young cypresses and willows—an action discovered only after they had planted them securely in place.) McLaren developed the ingenious method of growing ice plant on netting, then turning it vertically to create walls of continuous vines. These trellises visually anchored the rotunda to the site and evoked a centuries-old Mediterranean ruin.[27] Fairgoers returned often to the lagoon to track the changes of light on the soft turquoise-green and ocher colors of the columns. The Palace was most spectacular at night, however, when hidden floodlights illuminated the dome and colonnade with breathtaking effect (see fig. 38).[28]

The popularity of the Fine Arts Palace, described by fair historian Frank Morton Todd as "A cloister enclosing nothing, a colonnade without a roof, [and] stairs that ended nowhere,"[29] prompted Maybeck to explain his views.[30] In a lecture given to San Francisco's Commonwealth Club, the architect identified the Palace of Fine Arts's general theme as "sadness modified by the feeling that beauty has a soothing influence," and asserted that an art gallery can be a "sad and serious matter," but beauty can also temper sadness.[31]

This romantic viewpoint often diverged from the teachings of the École des Beaux-Arts, which focused on the functional aspects of design and ornament rather than its emotional context. On several occasions Maybeck mentioned various sources of inspiration for his design. When listed together, they present a bafflingly wide range of subjects, but he saw no incongruity in this; his unifying principle was simply beauty. Maybeck's inspirations included Roman ruins; the fountains at Versailles; Giovanni Battista Piranesi's eighteenth-century engravings of decaying classical buildings; Gottfried Semper's once-controversial nineteenth-century theory that ancient Greek architecture was decorated with color; Jean-Léon Gérôme's 1876 painting *Chariot Race* (see fig. 73), which depicts a tumultuous Roman chariot race rounding the corner of a vast and crowded stadium; Arnold Böcklin's paintings of the Island of the Dead (see fig. 39), in all of which a small boat—carrying an oarsman, a standing shrouded figure, and a coffin—approaches a tomb-lined rocky island overgrown with cypress trees; Hector d'Espouy's 1905 drawing of the entablature from the ancient Roman Temple of the Sun; Edward Berge's *Muse Finding the Head of Orpheus* (pl. 48), a marble sculpture that depicted a sorrowful muse mourning Orpheus's destruction at the hands of the maenads, and which was displayed beneath the peristyle of the Palace of Fine Arts during the Exposition; the architecture of ancient Greece (in which domes were never employed); and Michelangelo's dome for Saint Peter's Basilica in Rome.[32]

Critic Allan Temko knew Maybeck personally; in a conversation between the two men that took place in the 1950s, the architect explained the difference he perceived between borrowing the outward forms of past architecture versus borrowing its inward emotions: "So far as the Palace of Fine Arts was concerned, it was 'all right to copy Michelangelo'—he [Maybeck] really didn't, of course—'as long as you copy him from here.' And he pointed to his heart. 'But beware of those who copy him only from here'—and he pointed to his head."[33] Critic Paul Goldberger justified Maybeck's eclecticism by identifying

him among a "select group of architects throughout history who . . . pushed and pulled traditional languages in ways in which others could not imagine, and in so doing made poetry."[34]

Even while the fair was still under way, the Fine Arts Palace's immediate popularity led to widespread demand for its long-term preservation. The public petitioned the PPIE's board of directors to keep the Palace of Fine Arts open for six months after the official closing date to allow further fund-raising toward making it a permanent structure.[35] Phoebe Apperson Hearst headed these early efforts. In 1917 she prolonged the building's relevance by lending tapestries, armor, paintings, and metalwork from her collection, in quantities sufficient to compose the bulk of a gallery exhibition that was mounted there and attended by more than 200,000 people.[36] Soon after that installation closed, however, the gallery building was relegated to various mundane purposes: it housed indoor tennis courts, served as a garage for the city, and even became a warehouse for newly printed telephone books.

Over time the Palace began to decay. It faced near-certain destruction several times over the past century and has endured only through the determined efforts of generations of San Franciscans. In 1930, $500,000 was raised from the public to replace its original wood footings. In 1959, philanthropist Walter S. Johnson made the first of many large donations to fund its reconstruction in concrete, an effort assisted by countless other contributors and California assemblyman Caspar Weinberger, who secured a $2 million matching grant for the project. Architect Hans G. Gerson used Maybeck's drawings to duplicate the plan, and William G. Merchant returned to oversee the project. The rotunda was rebuilt in 1967, and the colonnades were completed in the 1970s.[37] By the late 1990s, however, another massive restoration was necessary, due in part to damage

caused by the 1989 Loma Prieta earthquake. This time the landscape and lighting features were also upgraded; this $21 million effort was completed in 2009. Though Maybeck once remarked that redwood trees should be planted and allowed to overtake the Palace's lonely ruins, on several other occasions he expressed his hope that the Palace would be preserved and restored.[38]

Though his professional practice slowed in the 1940s, Maybeck never stopped designing. "Never put your pencil down," he said.[39] The American Institute of Architects belatedly acknowledged his contributions to the field by giving him a gold medal—their highest honor—in 1951. Maybeck sent his son, Wallen, to New York to accept the award, since at eighty-nine he was too frail to travel. Annie died in 1956, and Ben died the following year, at age ninety-six. Their daughter-in-law, Jacomena, recalled his final years: "He came to all the parties and was the center of the stage. He told all the ladies they were beautiful and would be more so as they grew older."[40] The same can be said for his buildings, which time has finally softened, giving them the patina of age he so admired. Maybeck once declared, "Give me four sticks of wood and I can express emotion,"[41] a claim he masterfully proved with his incomparable Palace of Fine Arts.

1. Suzanne Riess, ed., *Julia Morgan, Her Office and a House*, vol. 2 of *The Julia Morgan Architectural History Project,* Regional Oral History Office, The Bancroft Library, University of California, Berkeley (Berkeley: Bancroft Library, 1976), 81. Edward Hussey recalled Maybeck's remark. He worked in Maybeck's office for eight years and even lived with his family for a time.

2. Newcomers to San Francisco often confuse the Palace of Fine Arts with the California Palace of the Legion of Honor. The latter art museum is a war memorial based on the French Pavilion at the 1915 fair. See Chapman, this volume, for a discussion of the French Pavilion's influence on Alma de Bretteville Spreckels and the Legion of Honor.

3. Gustave Eiffel's tower was constructed as the gateway to the 1889 Exposition Universelle and was slated to be demolished after twenty years. Unlike the Palace of Fine Arts, it was unpopular at first, but acclaimed after completion. Today's Palace of Fine Arts looks very different from the original (beyond the obvious residences, Golden Gate Bridge views, and parkway that characterize its modern setting). Its color scheme no longer includes the turquoise-green that was originally used on the dome and on alternating groups of columns. Robert Reid's eight paintings on the interior coffers of the rotunda are now absent. The gallery building (whose ornamentation matched the peristyle's) has never been restored. Sculptures have also been removed, most noticeably Paul Wayland Bartlett's equestrian statue of Lafayette, erected in support of France—the only statue in the rotunda—and Ralph Stackpole's kneeling Venus, a lone spotlit figure originally framed by the rotunda's wall-like hedges, and shown worshipping at the *Shrine of Inspiration*.

4. Jacomena Maybeck, *The Family View* (Berkeley: Berkeley Architectural Heritage Association, 1980), 8. The author, who was Maybeck's daughter-in-law and knew him for nearly eighty years, provides the most insightful portrait. Artist and critic Eugen Neuhaus wrote, "One has the feeling that this great temple is a realized dream; that it was imagined irrespective of time, cost, or demand." Eugen Neuhaus, *The Art of the Exposition* (San Francisco: Paul Elder, 1915), 81.

5. Kenneth H. Cardwell, *Bernard Maybeck: Artisan, Architect, Artist* (Los Angeles: Hennessey and Ingalls, 1996), 27. Cardwell knew Maybeck for seventeen years, and his volume provides an excellent source for biographical details. In addition to the patented Pullman seat, Maybeck also invented a ladies' fan, patented in 1890; a series of perforations in its paddle shape ensured air was propelled from only one side, increasing its force.

6. Sally Woodbridge, *Bernard Maybeck: Visionary Architect* (New York: Abbeville, 1992), 16. Bernhardt Maybeck was the foreman of carving at Pottier & Stymus, a company specializing in elaborately carved furniture.

7. Esther McCoy, *Five California Architects* (Los Angeles: Hennessey and Ingalls, 1960), 18. McCoy knew Maybeck in his final years.

8. Jeffrey T. Tilman, *Arthur Brown Jr.: Progressive Classicist* (New York: Norton, 2006), 20–25. Founded by Cardinal Mazarin in 1648, the École became the preeminent training ground for American architects from the 1880s to 1910. Richard Morris Hunt, its first American student, enrolled in 1846.

9. Several examples of these drawings survive in the Environmental Design Archives at the University of California, Berkeley (hereafter cited as Environmental Design Archives).

10. Maybeck's degree of involvement in the Ponce de Léon Hotel isn't fully known, but it appears he was largely responsible for its carefully conceived plan and its exuberantly romantic decoration.

11. Founded in the nineteenth century, the Swedenborgian Church is a Christian sect based on the biblical teachings of Swedish philosopher and scientist Emanuel Swedenborg.

12. Charles Keeler, "Friends Bearing Torches" (unpublished manuscript, [ca. 1934]), Keeler Papers, The Bancroft Library, University of California, Berkeley.

13. Frederick Law Olmsted Sr. laid out the Berkeley campus master plan in 1865. In 1899 it consisted of a handful of buildings on a sloping hillside intersected by Strawberry Creek. Phoebe Hearst became its greatest benefactor and the first woman to serve on its board of regents.

14. McCoy, *Five California Architects*, 24. McCoy's 1960 essay on Maybeck was among the first publications to treat him as a significant figure.

15. Jacomena Maybeck, *Family View*, 4; Cardwell, *Bernard Maybeck: Artisan, Architect, Artist,* 150. Many descriptions emphasize Maybeck's serenity and lack of vanity. Nevertheless, he was a determined and decisive personality, especially on a construction site.

16. Maybeck's 1911 unpublished essay accompanying his Canberra competition drawings is housed at the Environmental Design Archives. Maybeck also entered the competition for San Francisco's new city hall in 1911. He did not win, but his students Arthur Brown Jr. and John Bakewell did.

17. Woodbridge, *Bernard Maybeck: Visionary Architect,* 101; Cardwell, *Bernard Maybeck: Artisan, Architect, Artist,* 30. Maybeck worked briefly for A. Page Brown in San Francisco when he contributed to the design for the California building for the 1893 World's Columbian Exposition in Chicago. He also collaborated with J. B. Matthieson on another design entry for the California building, which featured abundant Mission influence. These past experiences make his exclusion from the commission even more striking.

18. Jacomena Maybeck, *Family View,* 16.

19. Maybeck, quoted in Suzanne Riess, ed., *The Work of Steilberg and Morgan,* vol. 1 of *The Julia Morgan Architectural History Project,* Regional Oral History Office, The Bancroft Library, University of California, Berkeley (Berkeley: Bancroft Library, 1976), 56–57.

20. In the ancient world, cypresses were associated with mourning. Their boughs were fashioned into funerary wreaths, their fragrant wood was burned to fumigate cremations, and their sap was thought to represent tears.

21. There are several versions of this story, some including a competition and some not. In every version, the reaction to Maybeck's design was awestruck wonder. In his volume *Palace of Fine Arts and Lagoon. Panama-Pacific International Exposition, 1915* (San Francisco: Paul Elder, 1915), Maybeck credits John E. D. Trask, the director of the fair's Department of Fine Arts, with generating the concept of a transitional experience between the fairgrounds and the galleries.

22. McCoy, *Five California Architects,* 38. Maybeck was paid only his draftsman's wages on an hourly basis. He recalled, "I didn't get rich on that job."

23. Artist Paul E. Denivelle developed the fair's building material. Author Juliet James described it as "a plastic travertine, composed of gypsum from Nevada combined with hemp fiber and a coloring pigment, which has been applied to all of the Exposition buildings . . . and the architectural statues." Juliet James, *Palaces and Courts of the Exposition* (San Francisco: California Book Company, 1915), 9–10.

24. John D. Barry, *The City of Domes: A Walk with an Architect About the Courts and Palaces of the Panama-Pacific International Exposition with a Discussion of Its Architecture, Its Sculpture, Its Mural Decorations, Its Coloring, and Its Lighting. Preceded by a History of Its Growth* (San Francisco: John J. Newbegin, 1915), 63; Woodbridge, *Bernard Maybeck: Visionary Architect,* 109; Frank Morton Todd, *The Story of the Exposition: Being the Official History of the International Celebration Held at San Francisco in 1915 to Commemorate the Discovery of the Pacific Ocean and the Construction of the Panama Canal* (New York: G. P. Putnam's Sons), 3:23. Barry criticized the public's need to assign meaning to the women in boxes, attributing it to "the literary habit of the day, the result of universal reading."

25. According to the classical orders, a column's height is determined by a ratio formula based on multiplying the diameter of its lower shaft, typically by a factor of ten or eleven. Maybeck compressed his composition by reducing the height of his columns to a measurement equaling eight diameter-widths.

26. Bernard Maybeck, "Building Specifications for the Palace of Fine Arts" (unpublished manuscript, 1913), Environmental Design Archives. Architectural historian Gray Brechin discussed Maybeck's plans to build a "Peace Palace" south of the Palace of Fine Arts. It was eliminated as too costly, but his early drawings show the two buildings linked by walkways spanning the lagoon. Maybeck later expressed his relief that these walkways had been eliminated, as they would have detracted from the effect. Gray Brechin, "Sailing to Byzantium: The Architecture of the Fair," in *The Anthropology of World's Fairs: San Francisco's Panama-Pacific International Exposition of 1915,* ed. Burton Benedict (Berkeley: Lowie Museum of Anthropology, 1983), 105–107.

27. Dianne Harris, *Maybeck's Landscapes: Drawing to Nature* (San Francisco: William Stout, 2004), 125; Maybeck, "Building Specifications for the Palace," Environmental Design Archives. Maybeck wrote: "Usually in good planning, when the plan of the walls on the building are blacked in on good paper the picture thus made is agreeable to the eye. . . . To get this result in the Fine Arts plan, the shrubs were used to fill the vacancies that usually are filled out with walls."

28. Ben Macomber, *The Jewel City: Its Planning and Achievement; Its Architecture, Sculpture, Symbolism, and Music; Its Gardens, Palaces, and Exhibits* (San Francisco: John H. Williams, 1915), 25; Bernard Maybeck, "Building Specifications for the House of Hoo Hoo" (unpublished manuscript, 1913), Environmental Design Archives. In addition to designing the fair's livestock building, Maybeck also created an entirely different landscape feature, the fair's amusing House of Hoo Hoo, headquarters for the lumberman's association. Located behind the Palace of Horticulture, it was described by Macomber as "a sylvan idyll, telling of lofty trees, cool shades, and secret bowers of fern and vine and wild flower, in the moist and tangled redwood forests." This witty parody of the Palace of Fine Arts's peristyle consisted of a colonnade of artificial redwood tree trunks, each sixteen feet in diameter. It even featured open boxes for vegetation in its upper colonnades. In his specifications for the House of Hoo Hoo, Maybeck wrote, "All exterior surfaces to be covered with redwood bark, with redwood shingles on the roof and flower boxes."

29. Todd, *Story of the Exposition,* 2:316–317.

30. The text of Maybeck's speech was published in a small book that begins with an excerpt from Edgar Allan Poe's "To Helen," extolling Helen of Troy: "On desperate seas long wont to roam / Thy hyacinth hair, thy classic face, / Thy naiad air have brought me home / To the glory that was Greece / And the grandeur that was Rome."

31. While Maybeck's essay for the Canberra competition is well organized and incisive, his volume on the Palace of Fine Arts is not. One has the impression that his off-the-cuff remarks to the Commonwealth Club have been enshrined as his definitive explanation for the Palace of Fine Arts.

32. For a lengthy critical analysis of the antecedents of the Palace of Fine Arts, see William H. Jordy, *Progressive and Academic Ideals at the Turn of the Century,* vol. 4 of *American Buildings and Their Architects* (New York: Oxford University Press, 1972), 275–300.

33. Allan Temko, quoted in Jacomena Maybeck, *Family View,* vii.

34. Paul Goldberger, quoted in Robert H. Craig, *Bernard Maybeck at Principia College: The Art and Craft of Building* (Salt Lake City: Gibbs Smith, 2004), 8.

35. Todd, *Story of the Exposition,* 3:149. The Exposition Preservation League was organized midway through the fair.

36. J. Nilsen Laurvik, ed., *Catalogue Mrs. Phoebe A. Hearst Loan Collection* (San Francisco: San Francisco Art Association, 1917).

37. Brechin, "Sailing to Byzantium," 107–110; Ruth Newhall, *San Francisco's Enchanted Palace* (Berkeley: Howell-North Books, 1967). From the close of the fair, the difficulty has been finding an effective use for the massive gallery. The Exploratorium occupied it from 1969 to 2013; since its move, the building's only tenant is the Palace of Fine Arts Theatre.

38. Newhall, *San Francisco's Enchanted Palace,* 75. The author quotes Maybeck: "I think the main building should be torn down and redwoods planted around—completely around—the rotunda. . . . As they grow, the columns would slowly crumble at the same speed. Then I would like to design an altar, with the figure of a maiden praying, to install in the grove of redwoods. . . . I should like my palace to die behind those great trees of its own accord, and become its own cemetery." However, Maybeck also wrote in a letter: "If I were to suggest, I would say to let the building alone, and if it wears well, do those things necessary to preserve it longer. . . . If a man were hired to watch the building, putting a patch over the leaks in roofs, painting the foundations at the water surface, filling in the pockets behind the ornaments, cutting holes to go down into the columns to let the air in and keeping busy in a conscientious way all the year around at the cost of five or six dollars per day, the building would last many years." Bernard Maybeck to R. Tobin, May 16, 1916, Environmental Design Archives.

39. Jacomena Maybeck, *Family View,* 28. Among Maybeck's later buildings showing the influence of the Palace of Fine Arts are his 1926 Packard showroom in San Francisco and 1928 Packard showroom in Oakland, as well as the unbuilt 1929 Phoebe Apperson Hearst Memorial on the University of California's Berkeley campus. In 1947, Maybeck reiterated his philosophy: "How important spirit is in architecture. . . . That is the essence of architecture, gentlemen, spirit." Frederick D. Nichols, "A Visit with Bernard Maybeck," *Journal of the Society of Architectural Historians* 11 (October 1952): 31.

40. Jacomena Maybeck, *Family View,* 38. She wrote, "His quality increased as his body faded—not just a spiritual quality, rather a quality of the spirit."

41. Edward Hussey, quoted in Riess, *Julia Morgan, Her Office and a House,* 83.

THE CLASSICAL IDEAL IN THE NEW ATHENS

Your country deserves great credit, as well as the thanks of the world, for having corrected a fault of nature, in its construction of the Panama Canal.[1]

These were the words of Eleutherios Venizelos, prime minister of Greece, replying to an invitation for his country to participate in the Panama-Pacific International Exposition (PPIE), the 1915 world's fair in San Francisco that commemorated the opening of the canal. Given his support for the PPIE and Greece's ultimate decision to sponsor a pavilion, it was appropriate that Perham Wilhelm Nahl's lithograph *The Thirteenth Labor of Hercules* (pl. 1) was the official image of the fair, appearing on posters, postcards, and a variety of other ephemera. The image, which was chosen by a jury of Exposition organizers from among forty entries competing for the honor, depicts the Greek hero prying apart Culebra Cut, one of the most challenging aspects of the Panama Canal's construction, in a symbolic allusion to the triumph of man over nature. The selection of this image and its ubiquity at the PPIE suggest the influence of classical art and architecture in the United States at the time. In the years leading up to the Exposition, the country was in the midst of a nationalistic movement known as the American Renaissance (ca. 1876–1917), a period marked by the identification of many artists, architects, scholars, collectors, politicians, and city planners with the European Renaissance, especially its manifestation in Italy (1420–1580), and its debt to the aesthetics and noble ideals of ancient Greece and Rome.[2] In this spirit, leading citizens of San Francisco considered the city to be the new Athens,[3] and, building on the

art of the past, proudly proclaimed this legacy through the prominent display of classical elements in the fairgrounds.[4]

THE MOTHER OF CIVILIZATION

Greece was one of the last nations to agree to send a pavilion to the Exposition. The country had just emerged from the Balkan Wars (1912–1913) and was in political turmoil over its role in World War I. Venizelos and his followers sided with the Allies, which brought them in direct conflict with the king, who favored Germany and the Central Powers and wanted Greece to remain neutral. The pavilion that was offered to Greece originally had been planned to house a collection of objects arriving from Germany, but the outbreak of hostilities in Europe forced Germany to withdraw from the fair and abandon the building. The unfinished structure was sold to Greece and was completed by the PPIE's Division of Works with an architectural design more suited to its new occupants.[5]

Located just inside the Presidio entrance to the fairgrounds, the Greek Pavilion (see fig. 40) was a large neoclassical building with a broad, three-tiered staircase leading to a portico with Doric columns and a pediment reminiscent of an ancient Greek temple. As the official guide to the Exposition described it, "The structure is typical, architecturally, of the country it represents, and is well set off with terraced gardens. The main feature of the interior of the building is the sculpture gallery, occupying most of the main floor space, where is to be seen a magnificent showing of ancient and modern Greek works of art."[6] As

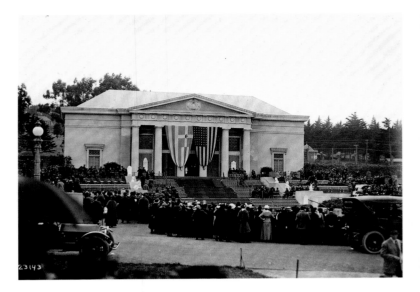

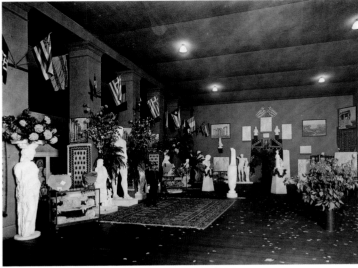

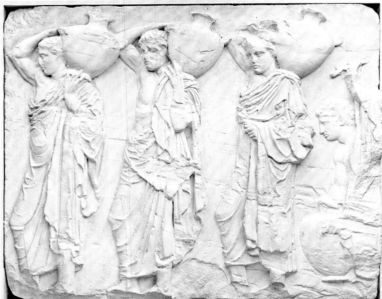

FIG. 40
Dedication of the Greek Pavilion, 1915. San Francisco History Center, San Francisco Public Library

FIG. 41
Interior of the Greek Pavilion, 1915. San Francisco History Center, San Francisco Public Library

FIG. 42
Cast of a scene from the north frieze of the Parthenon, the Acropolis, Athens: four youths carrying water pitchers, followed by a piper, before 1915. Plaster, 40 ⅛ × 48 ¼ × 5 in. (101.9 × 122.5 × 12.7 cm). Fine Arts Museums of San Francisco, gift of the Greek Government, PPIE, 44925

FIG. 43
Cast of a scene from the north frieze of the Parthenon, the Acropolis, Athens: procession of three horses and riders followed by a boy adjusting the belt on the last horseman's tunic, before 1915. Plaster, 40 × 64 × 5 in. (101.6 × 162.5 × 12.7 cm). Fine Arts Museums of San Francisco, gift of the Greek Government, PPIE, 44921

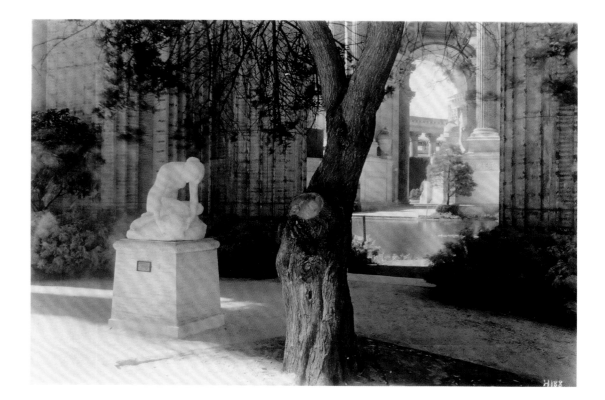

FIG. 44
Edward Berge's *Muse Finding the Head of Orpheus* (pl. 48) in front of the Palace of Fine Arts. Photograph by Gabriel Moulin. Views of the Panama Pacific International Exposition, vol. 2, The Bancroft Library, University of California, Berkeley

it had at Chicago's 1893 World's Columbian Exposition and San Francisco's 1894 California Midwinter International Exposition, the Greek government sent reproductions of classical statues cast after ancient sculptures to the PPIE. This large number of plaster casts represented Greece's cultural heritage as "The Mother of Civilization."[7]

The guidebook to the Greek Pavilion includes a complete catalogue of the casts exhibited, under the heading "Casts of Ancient Greek statues, exhibited by the Greek Committee and offered by the Greek government to the City and County of San Francisco as a friendly gift of Greece, a message from the Old World to the New."[8] The catalogue states that only the "finest specimens" were chosen from the holdings of the National Museum, and a few works were selected from other Greek museums as well.[9] The casts were taken from famous works dating from the thirteenth century BC, during the Mycenaean Age, to the Roman conquest in 146 BC and produced "in a special laboratory belonging to the National Museum at Athens, which alone has the right to make and sell them."[10] These reproductions were installed in chronological order to illustrate the development and beauty of Greek art (see fig. 41). The earliest work reproduced for the installation was the Lion Gate from Mycenae, which was so large it had to be placed outside the building. It was followed by copies of Archaic sculptures, representing Greece's first foray into monumental marble statues, dating to the seventh and sixth centuries BC. The display included replicas of Praxiteles's Hermes with the infant Dionysos from fourth-century Olympia (which was featured on the cover of the catalogue) and of Hellenistic works from the third to first centuries BC, ending with casts of Roman portraits from the first century AD. The most comprehensive section dated to the Golden Age of Athens in the fifth century BC, exemplified by the sculptor Phidias, whose work was represented both by casts of the sculptures from the Parthenon in Athens (figs. 42–43)[11] and by small copies of the sculptor's colossal statue of Athena that once stood in the Parthenon.[12]

The exhibition of plaster casts was not new to the PPIE or even to world's fairs. The practice has a long history dating back to antiquity, when plaster casts were used not only for the dissemination of three-dimensional forms but also as objects worthy of display in their own right. In fact, had it not been for these reproductions of ancient Greek works by the Romans, there would have been no far-reaching spread of Greek art throughout the Roman world.[13] During the nineteenth century, the British Museum played a similarly significant role in the propagation of Greek art after acquiring an important collection of original sculptures and architectural elements from the Parthenon.[14] As interest in that collection grew, the museum began to produce casts of the works commercially and disperse them to museums worldwide, where they were displayed alongside original Greek sculptures in bronze and marble. By the second half of the nineteenth century, the demand for reproductions of ancient art eventually became so great that institutions such as the Metropolitan Museum of Art in New York sent crews of cast-makers to Europe to bring back replicas of the most celebrated pieces. The museum looked upon these likenesses as representations of world-renowned works of art: "objects of the highest beauty and of inestimable value toward the foundation of sound taste in Art."[15]

For most Americans, for whom travel to see the great treasures of antiquity

was expensive and difficult (and during wartime impossible), plaster casts were their only contact with ancient art and architecture. These highly valued copies served to educate the public and to feed its fascination with ancient Greece and Rome. They also became a cornerstone of the curriculum in schools teaching art, architecture, and the history of art. Students had the opportunity to study and draw from replicas of original monuments, perpetuating the classical tradition and assuring its influence. Copying from white plaster casts did much to shape the modern idea of classical art, in particular the all-white sculptural and architectural styles that were hallmarks of neoclassicism. Pure white forms continued to define classical art even after scholars recognized that ancient artists often painted sculpture and architecture in vivid colors. For this reason, such classically inspired statues as Edward Berge's *Muse Finding the Head of Orpheus* (pl. 48) and others placed throughout the PPIE were created of stark white marble (see fig. 44).

Cast reproductions also were displayed in the Italian Pavilion, where magnificent copies of bronzes and other replicas of antiquities that had been excavated at Pompeii and Herculaneum were on view. These works were installed in one room of the central building of the Pavilion, which featured a classic Roman facade, where they constituted "a Pompeian museum, with bronze tripods, candlesticks, marble busts and marble basins, dancing fauns and Bacchantes."[16] The bronze castings were made by J. Chiurazzi & Sons of Naples, a firm that at this time held the exclusive license issued by the Italian government to make bronze reproductions of objects from these sites. They created faithful copies of the originals that attracted the attention of Michael H. de Young, the driving

force behind the Memorial Museum in Golden Gate Park (founded after the successful 1894 Midwinter Exposition and named in memory of it; later the M. H. de Young Memorial Museum). At the close of the PPIE he bought a group of these reproductions, which had been popular during the Exposition. The pieces were added to other replicas from Pompeii that he had previously purchased in Naples for display in his museum. One remnant of the exquisite collection of casts in the Italian Pavilion, *Resting Hermes* from the Villa of the Papyri in Herculaneum (see fig. 45), was purchased by the University Club after the fair. It now sits outside the club's building on California Street in San Francisco, where it remains a monument to the splendor of the classical sculpture on view at the PPIE.

Actual antiquities also found their way to the Exposition. The Italian government allocated a special area in its pavilion to the collection of Ercole Canessa, the most famous art and antiquities dealer of his time, who sent, in addition to European masterworks, a selection from his vast collection of Greek, Roman, and Etruscan antiquities. One of Canessa's finest Roman works in this display, dating to the second century AD, was the *Three Graces*, a masterpiece of classical art now in the collection of the Metropolitan Museum of Art, New York. Canessa also sent a dazzling collection of unique objects that came primarily from the Maikop Treasure, artifacts found among burial mounds of wealthy Scythians that had been discovered in Southern Russia and the northwestern Caucasus in the northern Black Sea region,[17] marking the first time that such gold, silver, and bronze decorations, horse trappings, weapons, and other objects in the Scythian animal style were shown in the United States (see fig. 46).[18]

FIG. 45
Fonderia Chiurazzi (Italian, est. 1870), late 19th–early 20th century replica of *Resting Hermes* found in Herculaneum (Roman, 1st century AD, National Archaeological Museum, Naples). University Club, San Francisco

FIG. 46
Plaque, Scythian, 5th century BC. Gold, height 1 ⅛ in. (3 cm). University of Pennsylvania Museum of Archaeology and Anthropology, Philadelphia, Museum Purchase, subscription of William Hinckle Smith, 30-33-1.1

FIG. 47
San Francisco City Hall, Polk Street elevation. History of the City Hall and Civic Center by T. B. McGinnis Collection, 1912–1918, The Bancroft Library, University of California, Berkeley

FIG. 48
Artist's rendering of the Oregon State Building on a postcard, 1914. University of Oregon Libraries, Eugene

FIG. 49
Jules Guérin (American, 1866–1946), *Arch of the Rising Sun from the Court of the Universe*, 1913. Watercolor, 40 × 38 in. (101.6 × 96.5 cm). San Francisco History Center, San Francisco Public Library

THE AMERICAN RENAISSANCE: THE NEW ATHENS AND THE WHITE CITY

Outside the international pavilions, throughout the architecture of the fair, classicism prevailed, signaling one of the tenets of the American Renaissance, that the United States was the heir to the great civilizations of the past. This illusion of antiquity was not intended to create the impression of an actual classical city; rather, by incorporating other influences, the corps of architects of the PPIE created a spirit of romanticism that Gray Brechin referred to as "uniquely Californian . . . and . . . the cumulative product of the court scheme, illumination, color and—most of all—material."[19] This unique, eclectic style combined Greek, Roman, and Italian Renaissance architectural details of the Beaux-Arts style (named after the academic, neoclassical architecture promoted by the École des Beaux-Arts in Paris) with Spanish and Moorish features.

As the American Renaissance swept the country, architecture influenced by classical precedents was widespread, with an emphasis on order, symmetry, and proportion. Greek columns outside a bank or federal building represented stateliness and respectability and suggested security, impenetrability, and permanence. Even before plans for the fair began, San Francisco was under the sway of the American Renaissance with its City Beautiful movement. Reflecting an image of the city as the new Athens, a 1902 plan included the proposal to erect a replica of the Parthenon on the summit of Telegraph Hill: "The city

itself is full of bold hills rising steeply from the deep water. The air is keen and dry and bright, like the air of Greece, and the waters not less blue. Perhaps it is the air and light recalling the cities of the Mediterranean, that makes one involuntarily look up to the tops of these hills for the feudal castle, or the ruins of the Acropolis which must crown them."[20] By 1912, during the planning for the PPIE, the organizers hoped that the Greek residents of the United States would contribute to this project to beautify Telegraph Hill. Although the replica of the Parthenon was not built in the new Athens, such monumental neoclassical buildings as Arthur Brown Jr.'s City Hall (see fig. 47), completed in 1915, expressed San Francisco's aspirations to evoke the ancient city.

In the years following the 1906 earthquake, San Francisco's city fathers were seeking ways to inspire civic pride and make their home a leading American metropolis. Willis Polk, a local architect who oversaw the architectural committee for the Exposition, sought further connections with the Golden Age of Athens. In 1909 he declared the following to an appreciative audience at a meeting of the Merchants' Association:

In the days of Pericles, when Athens was at the zenith of her commercial prosperity and had just commenced to feel the rivalry and competition of Syracuse, Pericles cast about for some method by which Athens could retain her commercial supremacy. Finally, merely as a matter of statesmanship,

they decided to make Athens beautiful; not for any inherent love of beauty itself, but purely and simply as a business proposition. . . . If Pericles as a matter of statesmanship did what he did for Athens, don't you think it is up to San Francisco to develop a little statesmanship?[21]

The Columbian Exposition in Chicago, nicknamed the "White City" for its chalky white buildings, was the first world's fair to reflect this lofty image of American culture and to promote an interest in classical architectural forms. The architects of the White City employed both the Classical Revival style, featuring massive columns capped with Corinthian, Doric, or Ionic capitals and topped by a pediment, and the Beaux-Arts style, which also makes use of classical forms but is more elaborate, incorporating opulent decorative details often derived from Rococo and Renaissance motifs. After the Chicago fair, the Classical Revival architectural style was commonly seen in American architecture: it is unmistakably present in the Greek templelike forms that often were used for government buildings, courthouses, banks, churches, schools, mansions patterned after Renaissance palazzi, and exposition structures. Inspired by the White City, the world's fairs that followed, including the PPIE, continued to unify their design schemes with classical architecture.

Beaux-Arts architecture also became widespread after the Columbian Exposition. One of the most hauntingly romantic structures in the PPIE was the Palace of Fine Arts, designed by Bernard Maybeck, who had studied at the École des Beaux-Arts. Sited at the edge of a lagoon, this extraordinary building featured two detached colonnades leading to the central domed rotunda (see Kastner, this volume). Using elements from the Greek and Roman architectural vocabularies[22] but not following customary forms or adhering to classical orders at all, Maybeck created a fantasy that was hailed as the most original design of the Exposition. According to fair historian Frank Morton Todd, "it represented the beauty and grandeur of the past. A cloister enclosing nothing, a colonnade without a roof, stairs that ended nowhere, a fane [temple] with a lonely votary kneeling at a dying flame, fluted shafts that rose, half hid in vines, from the lush growth of an old swamp."[23] The building and its overgrown garden were meant to represent a decaying Roman ruin and, in Maybeck's own words, gave a sense of "sadness modified by the feeling that beauty has a soothing influence."[24] Like no other building at the fair, it answered the American Renaissance's call for a uniquely American art using architectural forms derived from antiquity in a new and fanciful way.

The Greek and Italian Pavilions and the Palace of Fine Arts were not the only buildings that exemplified the influence of classical architecture at the fair. The Oregon State Building, for example, referenced the classical form as a model of one of the world's most recognizable ancient structures, the Parthenon, wrought in wood instead of marble (see fig. 48). Detractors described it as being constructed of "dark and crude logs," but the building was a conscious effort to advertise that Oregon held one-quarter of all the timber in the United States.[25] The Palace of Machinery, the largest wood and steel building in the world at the time, was styled after the Roman Baths of Caracalla, and the Column of Progress (see fig. 70) was inspired by Trajan's Column, also in Rome. These, like most of the temporary structures at the Exposition, were built of wood and covered in a specially blended, ivory-hued plaster that incorporated gypsum and hemp. This material's unique tone, which differed from the stark white of previous fairs, was created by Jules Guérin, who oversaw the fair's color scheme. He intended it to create a sense of antiquity by mimicking the travertine marble used in ancient Rome. The architecture firm McKim, Mead and White also expressed its debt to classical forms at the PPIE, employing triumphal arches

and curved colonnades reminiscent of Saint Peter's Basilica at the Vatican in the Arch of the Rising Sun in the Court of the Universe (see fig. 49).

THE PLASTER CASTS AFTER THE EXPOSITION

When the PPIE closed in December 1915, the Greek government formally gave the casts from the Greek Pavilion to the city of San Francisco, a fitting gift for the new Athens. Cleanthe Vassardakis, commissioner-general of the fair's Greek Commission, officially presented the casts on King Constantine Day, December 2, 1915.[26] It originally was intended that the celebration of the gift would be held in honor of Venizelos, who helped bring about Greece's participation in the PPIE, but his political fortunes had diminished, so the king was honored instead. During the presentation, Vassardakis announced the group of men who would receive and care for the statues, which included such prominent citizens as San Francisco's mayor, James Rolph Jr., Michael H. de Young, and Bernard Maybeck.[27]

Now property of the city, the casts remained in the Palace of Fine Arts, which, by popular demand, continued to display art from the PPIE after the fair's closure. At the post-Exposition exhibition, which ran from January 1 until May 1, 1916, the casts were given pride of place in four rooms that surrounded the central court. This placement revealed the fundamental contribution of classical Greek sculpture, with its symmetry, balance of proportion and line, and idealization of beauty, to the evolution of Western civilization. The extraordinary interest of visitors in this installation suggests that Greek art remained a source of inspiration to the city as it had been to the organizers of the fair.[28]

Deciding on a permanent home for the casts after the post-Exposition exhibition was not without complications. When it closed, the casts continued to be on display at the Palace of Fine Arts, which was operated by the San Francisco Art Association (SFAA, now the San Francisco Art Institute) under the direction of J. Nilsen Laurvik, director of the SFAA and the Palace of Fine Arts, and John I. Walter, president of the SFAA and the California School of Fine Arts (see Introduction, this volume). Letters retained in the archives of the SFAA dating from February 1917 to November 1918 reveal a struggle over where in the city the casts would be installed. Laurvik and Walter were joined by the executive committee of the Women's Auxiliary of the Palace of Fine Arts and the Federated Women's Clubs of San Francisco (representing fifty organizations) in wanting the casts to stay in the Palace, "where the San Francisco Art Association has provided a very efficient docent service in the interest of making these casts of the greatest educational value possible."[29] Walter wrote a compelling plea to the Board of Park Commissioners on February 16, 1917: "Because of the splendid use to which we are putting this collection and the advantages we are offering to the public by means of them, I sincerely hope that the Honorable Board of Park Commissioners will see fit to permit them to remain in the Palace of Fine Arts indefinitely under the condition that we will of course, surrender them whenever the City shall make such a demand, this condition being accepted by me on behalf of the San Francisco Art Association."[30]

In a reply from the president of the Park Commission written that very day, Walter was informed that it was the judgment of the park commissioners that the casts should eventually be installed in the Memorial Museum in Golden Gate Park, but that they would continue to reside at the Palace of Fine Arts, where "they will receive all possible care and will contribute their share toward the development of the artistic sense in the community which is the recipient of the gift."[31] But a letter concerning the fate of the casts, dated October 26, 1918, from Laurvik to Charles Penez, curator of the Memorial Museum, makes clear that the collection would not be delivered to the museum until a "formal demand in writing upon them for this collection is supplied."[32] The formal request came just days later, on October 29, 1918, when an official document was sent to Bernard Maybeck, then president of the SFAA, stating: "By order of the Board of Park Commissioners you will kindly deliver the Greek casts now in your possession to Mr. Chas. E. Penez, Curator of the Park Museum. The Park Commissioners have decided that these works of art properly belong in the new Memorial Museum."[33]

Once the issue of where the casts would be kept was settled, they joined those previously given to the city by Greece after the California Midwinter Fair, supplemented by other works of classical art given to the Memorial Museum in the intervening years, to form the core of its collection of Greek and Roman sculpture. The collection was exhibited in the museum's newly installed Statuary Hall, which became a popular destination for visitors after the building reopened in late December 1918 after an epidemic of influenza had forced it to close its doors temporarily (see fig. 50).[34]

By the mid-twentieth century, the once-popular casts were beginning to be looked upon at most American museums as inferior substitutes for original works and were removed from view. Ironically, many of these casts still retained details that over the years became lost on the original sculptures due to vandalism, environmental damage, and other causes. Once the de Young Museum was able to purchase original classical works of art, the replicas were dispersed to universities and schools throughout California. Although several of these reproductions have disappeared, an important group from the PPIE—including casts taken from the Parthenon frieze and several well-known freestanding Greek statues, such as Praxiteles's sculpture of Hermes—has been preserved. These works of art were transferred to the Department of Classics at the University of California, Berkeley, where they joined a cast collection given to the school in the early twentieth century by the philanthropist Phoebe Apperson Hearst. There, the combined collection has been conserved, cleaned, and installed in Dwinelle Hall, the building that houses the Classics Department. In that space, which is dedicated to the study of ancient Greece and Rome, the works function, as they did in the PPIE's Greek Pavilion—as representatives from a civilization that is worthy of being emulated.

The author would like to thank James A. Ganz and Louise Chu, whose conversations with her have enhanced this essay greatly.

1. Eleutherios Venizelos, quoted in Frank Morton Todd, *The Story of the Exposition: Being the Official History of the International Celebration Held at San Francisco in 1915 to Commemorate the Discovery of the Pacific Ocean and the Construction of the Panama Canal* (New York: G. P. Putnam's Sons, 1921), 3:245.

2. For an in-depth study of the American Renaissance, see Richard Guy Wilson, *The American Renaissance: 1876–1917*, exh. cat. (New York: Brooklyn Museum, 1979).

3. One of the first city officials to connect San Francisco with Athens was mayor James Phelan (1897–1902). Phelan's vision for the city compared the future San Francisco with Athens after Pericles's beautification. Phelan claimed to "render the citizens cheerful, content, yielding, self-sacrificing, capable of enthusiasm," according to Robert W. Cherny in "City Commercial, City Beautiful, City Practical: The San Francisco Visions of William C. Ralston, James D. Phelan, and Michael M. O'Shaughnessy," *California History* 73, no. 4 (Winter 1994/1995): 304.

4. B. J. S. Cahill, a contemporary cartographer and architect, made the point that inspiration from the classical world was required as a major element of the PPIE: "Much more than in Europe, already stocked and overflowing with classic masterpieces, do we here, on the edge of the white man's world, need to see realized and visualized some of the spirit of the masterpieces of old. It's a long, long way to the Acropolis, and what we need here is something of the godlike simplicity of the Athens of Pericles before our eyes, and something of the monumental and massive dignity of Imperial Rome." In "The Panama-Pacific Exposition from an Architect's Viewpoint," *Architect and Engineer of California*, 39, no. 2 (December 1914): 58.

5. Todd, *Story of the Exposition*, 3:246.

6. *Official Guide of the Panama-Pacific International Exposition 1915* (San Francisco: Wahlgreen, 1915), 84.

7. This is the title of Todd's chapter on the Greek Pavilion in *Story of the Exposition*. It was based on the toast made by Charles C. Moore, president of the Exposition, during the dedication of the Greek Pavilion: "To Civilization and to its Mother." Todd, 3:207.

8. *Casts of Ancient Greek Statues, exhibited by the Greek Committee and offered by the Greek Government to the City and County of San Francisco* (Athens: Printing Office "Hestia," [1915?]).

9. Ibid., 3.

10. Ibid., 5.

11. With the inclusion of the casts of sculpture from the Parthenon and its narrative frieze, which had been described as representing the great Panathenaic Festival in honor of the goddess Athena, it was fitting that Loïe Fuller's troupe performed a classically inspired dance interpretation of the festival at the Pavilion's opening-day celebration. For a delightful description of this unique performance, which ended with an "orgiastic rout," see Todd, *Story of the Exposition*, 3: 88–89.

12. Todd, *Story of the Exposition*, 3: 245.

13. Rune Frederiksen, "Plaster Casts in Antiquity," in *Plaster Casts: Making, Collecting, and Displaying from Classical Antiquity to the Present*, ed. Rune Frederiksen and Eckart Marchand (Berlin and New York: Walter de Gruyter, 2010), 25–26.

14. Thomas Bruce, Seventh Lord Elgin, the British ambassador to the Ottoman Empire, received official permission to remove original sculptures from the Parthenon and sent crates of them to England, where they were sold to the British Museum in 1816. Before Lord Elgin, in the 1780s, the French vice-consul and antiquarian Louis-François-Sébastien Fauvel commissioned casts to be made of the Parthenon's sculpture. He was assisting the French ambassador to the Ottoman Empire, the Comte de Choiseul-Gouffier, who also sought sculptures from the Parthenon, but the Turkish authorities refused to let them remove any of the originals.

15. See Elizabeth J. Milleker, "A Brief History of the Cast Collection," The Institute of Classical Architecture and Art, accessed November 24, 2014, http://www.plastercastcollection.org/en/database.php?d=lire&id=172; and *Historic Plaster Casts from the Metropolitan Museum of Art, New York* (New York: Sotheby's, 2006).

16. For further details, see "Fine Pompeiian Bronzes Go to Memorial Museum. Antique Art Is Given to City by M. H. de Young," *San Francisco Chronicle*, December 19, 1915; and Todd, *Story of the Exposition*, 3:265–266.

17. Todd, *Story of the Exposition*, 3:267–268. For more on the Maikop Treasure, see Aleksandr Leskov, "The Maikop Treasure," *Silk Road* 2, no. 2 (December 2004): 3–11; and Leskov, *The Maikop Treasure* (Philadelphia: University of Pennsylvania Museum of Archaeology and Anthropology, 2008).

18. See A. Colosanti, *Catalogue Canessa's Collection, Panama-Pacific International Exposition, 1915* (San Francisco: Canessa Printing, 1915).

19. Gray Brechin, "Sailing to Byzantium: The Architecture of the Fair," in *The Anthropology of World's Fairs: San Francisco's Panama Pacific International Exposition of 1915*, ed. Burton Benedict (Berkeley: Lowie Museum of Anthropology, 1983), 101.

20. "The Improvement of Telegraph Hill," *Merchants' Association Review* (May 1902): 1. The Parthenon project was discussed at great length by the city government as well as in newspapers and magazines, including *Merchants' Association Review* (May 1902), *San Francisco Municipal Reports* (1903), *Municipal Journal and Engineer* (March 7, 1906), *San Francisco Call* (June 5, 1912), and *California Outlook* (June 13, 1912).

21. *Merchants' Association Review* (June 1909) and quoted in Mansel G. Blackford, *The Lost Dream: Businessmen and City Planning on the Pacific Coast, 1890–1920* (Columbus: Ohio State University Press, 1993), 53.

22. Bernard Maybeck describes how the elevation of the Palace of Fine Arts "was designed to harmonize with a cornice belonging to a Temple of the Sun" in Rome, as illustrated by Hector d'Espouy in his reconstruction (see Hector d'Espouy and Georges Daumet, *Fragments d'architecture antique d'après les relevés & restaurations des anciens pensionnaires de l'Académie de France à Rome*, 2 vols. (Paris: C. Schmid, [189-]–1905). Maybeck chose this architectural feature "because, it is the one cornice that had the simplicity of the Greeks. . . . Because this man's work [the ancient architect] is the keynote to the whole composition, the general feeling of the Fine Arts Palace is Greek." Bernard Maybeck, "Architecture of the Palace of Fine Arts at the Panama-Pacific International Exposition," in Bruce Porter et al., *Art in California: A Survey of American Art with Special Reference to Californian Painting, Sculpture, and Architecture, Past and Present, Particularly as Those Arts Were Represented at the Panama-Pacific International Exposition* (San Francisco: R. L. Bernier, 1916), 162.

23. Todd, *Story of the Exposition*, 2:316–317.

24. Bernard R. Maybeck, *Palace of Fine Arts and Lagoon: Panama-Pacific International Exposition, 1915* (San Francisco: Paul Elder, 1915), 9.

25. C. E. S. Woods, "The Sunset Country 'at Home' in San Francisco: Photographs of Western Pavilions at the Panama-Pacific Exposition," *Sunset* 35, no. 1 (July 1915): 917. The forty-eight pillars, each five feet in diameter by forty feet high, were contributed by various logging companies of Oregon.

26. At the ceremony marking this gift to the city of San Francisco, Vassardakis said: "The King's gift comes . . . in recognition of the kinship in feeling between San Francisco and the Athens of the Golden Age. In no other city of the United States is the love of city, and pride in its beauty, so strong as in San Francisco. You have never grown away from the spirit of the Argonauts." Todd, *Story of the Exposition*, 3:247.

27. Ibid.

28. A letter from the director of the Palace of Fine Arts includes a resolution by the Women's Auxiliary of the Palace of Fine Arts requesting that the casts be allowed to remain in that building or its successor and mentions that in the "past eight months these casts have been beautifully and adequately installed, and have been viewed by over 100,000 people." J. Nilsen Laurvik to Judge Mathew Sullivan, February 9, 1917, Archives of the San Francisco Art Association, San Francisco Institute of Art (hereafter cited as SFAA Archives).

29. Resolution of the Women's Auxiliary of the Palace of Fine Arts endorsed at their executive meeting of February 9, 1917, SFAA Archives.

30. John I. Walter to the Honorable Board of Park Commissioners, c/o Judge Curtis H. Lindley, Chairman, February 16, 1917, SFAA Archives.

31. Curtis H. Lindley to John I. Walter, February 16, 1917, SFAA Archives.

32. J. Nilsen Laurvik to Charles Penez, Esq., curator, Golden Gate Park Museum [Memorial Museum], October 26, 1918, SFAA Archives.

33. Office of the Park Commissioners to Mr. B. R. Maybeck, October 29, 1918, SFAA Archives.

34. "Statuary Hall, with its spacious extent of 140 by 48 feet, is filled with marbles and bronzes that, with very few exceptions, are of high artistic value. A gallery is devoted to plaster reproductions of the work of ancient Greek sculptors, and in several of the art galleries are found excellent bronzes, classic reproductions and modern conceptions." "Statuary Hall," in *The M. H. de Young Memorial Museum: Golden Gate Park: San Francisco, California* (San Francisco: Park Commission, 1921), 74.

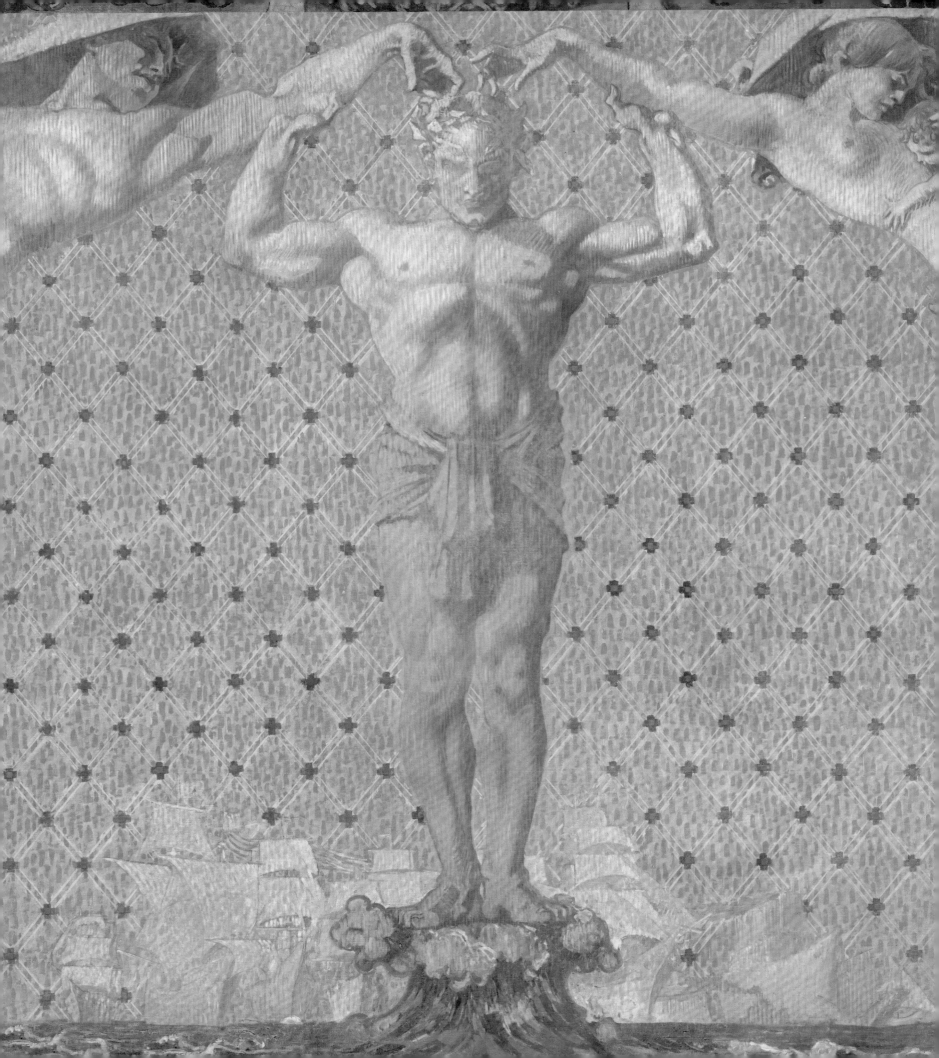

ANTHONY W. LEE

HARMONY AND DISCORD IN THE MURALS

Unlike every previous world's fair, where the major wall paintings had been displayed indoors, the Panama-Pacific International Exposition (PPIE) could boast that, because of San Francisco's mild climate, its murals were proudly hung outdoors. To a visitor of the fair, the paintings must have seemed stunningly everywhere—inside the great arches, along the friezes of the big towers, adorning courtyards, over doorways, between pillars, at eye level, under domes, overhead—and came in every form—gargantuan panels, smaller lunettes, even a triptych. Indeed, it was hard to take a step anywhere on the vast grounds without spotting one.

The extraordinary visibility of the murals was one of the PPIE's signature features and invited scrutiny, in the form of written criticisms, rarely seen in coverage of fairs. They appeared in many kinds of publications, including art magazines, daily newspapers, gossipy handbooks, art histories, and of course the countless souvenir booklets produced for tourists. But no matter their format, the writings tended to arrive at one of two conclusions. Take, as an example of the first, the criticisms of Ben Macomber, a journalist who turned his wanderings of the vast grounds into a running column for the *San Francisco Chronicle*. To his eye, although the murals were ubiquitous and had much attention lavished on them, they were happily part of the overall scenery and blended in quite well with the architecture, the sculpture, even the imported flowers. "The color scheme covers everything," he observed, "from the domes of the buildings to the sand in the driveways and the uniforms of the Exposition guards. The walls, the flags and pennants that wave over the buildings, the

shields and other emblems of heraldry . . . [t]he flowers of the garden conform to it, the statuary is tinted in accordance with it, and even the painters whose mural pictures adorn the courts and arches [are] obliged to [it]."[1] The murals certainly beckoned attention, he understood, but the quality of that attention was best measured by how well the paintings *belonged* to their surrounds. "All other Expositions have been almost colorless," he told his readers. At the PPIE, everything gave instead an "infinite delicacy" and "the absolute rightness of shade and tint."[2] The result was a prismatic unity, a "Jewel City," as he and others called the whole spectacle.

Take, as an example of the second, the assessments of Arthur Frank Mathews, whose *The Victory of Culture over Force (Victorious Spirit)* (pl. 23) was one of the murals that appeared on the fairgrounds. Mathews was a local artist, a longtime teacher, and at one time the director of San Francisco's only major art school, the California School of Design (now the San Francisco Art Institute). He was alternately revered as one of the few muralists in the city worth his salt and dismissed as a fusty traditionalist whose opinions on painting (and most everything else) bordered on the cranky. He, too, set down his wanderings in print, publishing his observations in his own magazine, *Philopolis*, a monthly high-end chapbook intended for the city's artistically minded. He closely studied the paintings of other muralists and, although aware of their ambitions, was mostly dismayed. In pointed counter to observations like Macomber's, he warned that "[t]o leave any one for a moment under the false impression that the Mural Paintings are free exhibits and show the American painters in full strength, is

to gag the better understanding while giving the weaker unlimited license of public expression. In other words, the impatient are warned that the American painters are shown in 'Mural Decorations' in 'Our Exposition' in antagonistic association—in bad frames and against troubled backgrounds."[3]

An etching by Cadwallader Washburn (fig. 51) could not have warmed Mathews's heart. In it, we see the Arch of the Setting Sun, an important portal on the west end of the PPIE's central Court of the Universe. Washburn was careful to register the big arch and the sweeping arcades off to either side, a prized sculpture called *Descending Night* by Adolph Alexander Weinman (pl. 18) sitting atop a tall column off to the left, a figure group called the *Nations of the West* at the top of the arch, and even brief notations of relief sculptures on a frieze and a silhouette of another figure group out front—but there is not the slightest hint of a mural. Or consider a photograph of the same portal that Macomber included with his essays (fig. 52). In the picture, the mural by Frank DuMond finally appears—it can be spotted on the inner wall of the arch, along with statuary in front and pretty flowers just below—but the overall effect is much the same as that proposed by the etching. Although everywhere on the fairgrounds, the murals did not always stand on their own as forceful statements. Where Macomber celebrated the fit, Mathews felt the gag.

Worse, the fair's color scheme not only stifled expression but gave a mere patina of harmony when, in fact, just beneath the surface lay opposition, even

hostility. Indeed, "while 'Our Exposition' on first sight gives the impression of oneness," Mathews complained, "on close inspection [the] color . . . fall[s] apart. The [murals and buildings] are not really amalgamated, do not quite express a single purpose, and the technical execution of parts are virtually in opposition, or tamely inadequate."[4]

Why did it matter that the PPIE's murals either smoothly blended with or were choked by their surroundings? When the writers spoke of harmony and discord in the paintings, were they actually trying to point to larger concerns? Indeed, as this essay will suggest, rather than evidence of an old truism about the habits of viewers at world's fairs, in which distracted visitors (like Macomber) were interested mostly in the general effect while self-absorbed painters (like the finicky Mathews) were more anxious about the importance of their own work, the two points of view stood for something particular in 1915 San Francisco, about civic responsibility and the role of art in a public setting.

THE "EASTERN MEN"

Jules Guérin, the man in charge of the Exposition's color scheme and a muralist and painter in his own right, took up his position in the summer of 1912.[5] Within months, he had outlined a general program for wall paintings and identified seven artists to paint approximately thirty official murals.[6] The murals were "official" in the sense that they were to adorn the major arches, buildings, and

courtyards, distinct from paintings that might hang in the national pavilions or the kitschy arena of the Joy Zone. (Guérin preferred not to think of that place—it was all coloristic anarchy there.) The murals would be painted on monumental canvases, as was the practice at world's fairs, and attached to the walls; at the fair's conclusion, they could be removed, rehung, stored, or destroyed. The number of painters would eventually expand to nine, and the murals to thirty-five, but in the earliest stages of planning, Guérin preferred to rely on painters he knew from his student days in Paris or those he had befriended in and around his New York studio. Today, they are hardly household names, though in their own time they had more considered reputations. In addition to the more recognized William de Leftwich Dodge, Frank Vincent DuMond, and Childe Hassam, they included Milton Bancroft, Charles Holloway (see fig. 53), Robert Reid, and Edward Simmons. Many knew each other—the personal relationships stood well in the eyes of the chief of color, who already was plotting a coherent program—and had worked or exhibited in such previous fairs as the 1893 World's Columbian Exposition in Chicago or, more recently, the 1905 Lewis and Clark Centennial Exposition in Portland, Oregon.

The telling features of this initial group are that they had experience with the administrative demands of fairs (DuMond had been chief of the Fine Arts Department at Portland) and, perhaps crucially for our purposes, that hardly any of them—with the exception of Simmons, who for a brief time had been a drama critic at the *Chronicle*—had ever set foot in San Francisco. They were "eastern men": "That [Guérin's] choice fell largely on eastern men," the Berkeley painter and critic Eugen Neuhaus observed, "was only too natural."[7] It was his polite way to say that Guérin knew little of the local art scene and what scant things he had seen from its painters did not impress him.

The painters were an extraordinarily conservative bunch in their artistic approaches. At an exposition that would boast the latest developments in industrial technology—where an automobile factory was replicated and a

Ford Model T built and distributed in the Palace of Transportation at a rate of eighteen a day; where electric dishwashers, curling irons, vacuum cleaners, toasters, coffee percolators, and electric clothes irons were introduced at the Palace of Manufactures; where motion pictures and Kodak color photographs appeared at the Palace of Liberal Arts; and where an eighty-horsepower rotary engine airplane did loop-the-loops overhead every night—Guérin chose painters whose artistic styles harked back to the previous century.[8] The men were trained in the grand manner of the École des Beaux-Arts in Paris, either in the studios of such longtime classicists as Jean-Léon Gérôme or at the Académie Julian, where expatriate Americans found a secondhand version of the same tradition. Such an aesthetic commitment was evidence of a familiar dialectic at world's fairs, of a futuristic fantasy world clothed in Old World garb. While the Exposition's organizers certainly understood that an American "industrial" culture was flying headlong into modernity, they preferred to preserve "fine" culture's link to an ennobled past.

The word most often used to describe the painters was "academicians." To Guérin and the Exposition's most supportive enthusiasts, it had a noteworthy air, but to others there was something musty about it. Dodge, who received the choice commission to paint murals for the enormous Tower of Jewels, got the most spleen. He clung to an outmoded art, his harshest critics said, because it claimed to represent "eternal verities." "What is so perfectly delightful about eternal verities," one wrote, "is the fact that without knowing what they are they [the painters] impress us all as if we did. Everybody takes it for granted that everybody else knows the exact difference between an eternal verity and a fugitive dogma." Such assumptions ran the risk of leaving everyone at the fairgrounds befuddled. Indeed, "[t]he business of [academicians] is to preserve in sweet syrup eternal verities that remain eternally undefined."[9]

Strong words these were—and the sting was probably felt—but they deterred neither the painters nor the chief of color. Guérin's efforts to dictate

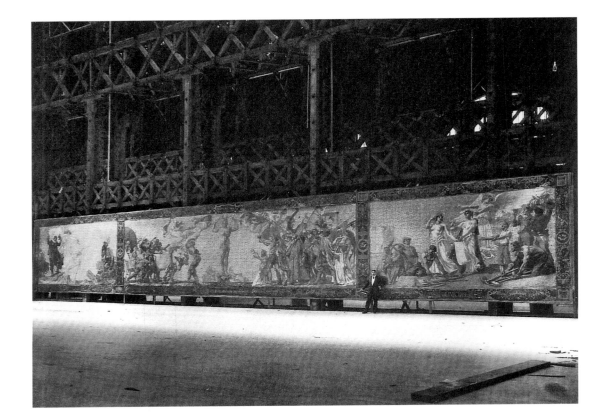

FIG. 54
William de Leftwich Dodge in front of his
murals *Discovery*, *Atlantic and Pacific* (pl. 26), and
The Purchase in the Palace of Machinery before
installation on the fairgrounds, 1914. Photo by
Gabriel Moulin

the look and consistency of the murals soon took on an obsessive quality. In the spring and summer of 1913, he gathered the painters in New York and outlined his expectations.[10] The choice of the paintings' subjects was left to them (provided the scenes had "meaning and life," so a chronicler tells us), and, at any rate, the chief of color had to approve all sketches before they could proceed, and he could fix their scale to his liking.[11] More importantly, the painters needed to adhere to the Jewel City color scheme. "Nothing has been left to chance or to the individual taste of those in charge of the decoration," an observer reported.[12] "There will be no garishness, no startling combinations," another declared.[13] But such a charge was maddening because the scheme was not, initially, very clear, at least to the painters. There were originally three colors, they thought, an oriental blue, an orange, and a dull terra-cotta red.[14] That soon expanded to five and became more nuanced: bronze, cerulean blue, burnt orange, Pompeiian red, and gold.[15] But even these more precise hues could be fudged. Could the "gold" be metallic and wheat, as Robert Reid offered in his painting?[16] Maybe there were "five or six colors," the fair's official historian explained when he saw the variety on the walls, though he couldn't quite tell.[17] Instead of five or six, Macomber thought he spotted nine or ten, including some he couldn't quite place as to their specific hue: "pinkish-red-gold," he tried to name one, "wall-red," "yellow-golden-orange," and about four shades of green and perhaps another two or three of blue.[18] The demand that the colors be controlled strictly alongside the wholly ambiguous list of approved tints and hues caused no end of anxiety among the painters, a charge that "presented

difficult problems."[19] At one point, Guérin, who thought he had been explicit enough, must have thrown up his hands at all the many liberties the painters were proposing. He finally declared that the painters could begin their works in their studios but needed to finish the canvases in San Francisco under his watchful eye. He even arranged for the cavernous Palace of Machinery to serve as a temporary workshop.

To discover how all of this played out in any individual painting, take an example by Dodge. On the face of things, Dodge was precisely the kind of painter Guérin wanted. Born in Virginia but raised mostly in Paris, Dodge embodied the link between an American identity and an Old World culture. He entered Gérôme's studio in 1881 and, by all accounts, was a prize pupil, learning his teacher's craft and extending the Beaux-Arts tradition into the late nineteenth century.[20] It was an affiliation Dodge never left behind, even late in life calling Gérôme "my master."[21] When he debuted at the Salon in 1886, Dodge took first prize for a large history painting, *The Death of Minnehaha* (1885, American Museum of Western Art, The Anschutz Collection), which featured a subject drawn from Longfellow's poetry; the propitious mixture of American and French influences seemed well on its way to fruition. The effects of contemporary art—in the same year, Le Douanier Rousseau exhibited his *Carnival Evening* (1886, Philadelphia Museum of Art) at the same Salon, and Georges Seurat's controversial *La Grande Jatte* (1884–1886, Art Institute of Chicago) appeared at the eighth and final Impressionist exhibition—were nowhere evident in Dodge's work.

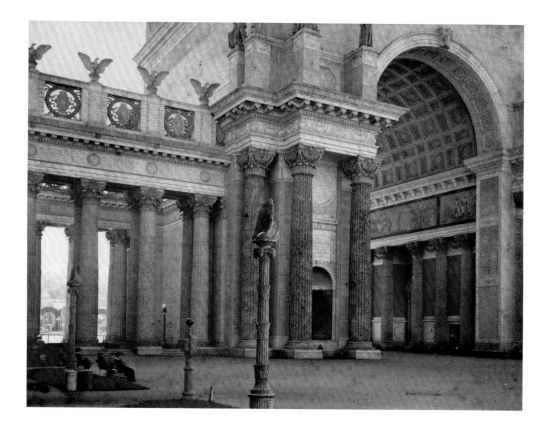

FIG. 55
William de Leftwich Dodge's mural *Atlantic and Pacific* (pl. 26) in situ at the Exposition, 1915. Autochrome by Murray Warner. Photographic History Collection, Archives Center, National Museum of American History, Smithsonian Institution, Washington, DC

Dodge returned to the United States in 1889, settled in New York, and almost immediately transformed himself into a muralist. His first major commission was for Richard Morris Hunt's Administration Building at the 1893 Chicago fair, a plum job for an aspiring painter. A large work for a pavilion at the Library of Congress followed in 1895. The two paintings secured his reputation, and he hardly was without a large-scale wall project afterward. For nearly three decades he was one of the few professional painters in the country whose work and income derived mostly from murals.[22] He developed a recognizable mural style, which he proudly called "decorative." "[S]omebody said, the other day, that I was essentially a decorator," he explained to a journalist. "This remark was meant to be rather uncomplimentary, but I don't feel the sting of it at all I hope my work is decorative."[23]

The "decorative" was easy to see. In Dodge's *Atlantic and Pacific* (pl. 26) for the PPIE, the central panel of a large triptych about the meeting of cultures east and west of the Panama Canal, we observe a lateral spread of figures on either side of a heroic male, the allegorical form of Labor. The gestures across the painting rhyme—arms and legs bend in tune, the masses of forms are balanced left and right, the symmetry is strong. All of that evenness is further condensed in the figure of Labor, whose body is matched left and right, whose arms are raised in perfect unison, whose legs are like foundation blocks—a stable figure at the center of a stable composition. The "decorative," that is to say, did not produce an off-kilter or eccentric structure; the aggregate was balanced so as to fit within the symmetry and geometry of the building on which the painting would be

hung. It had to be "architectural" in its awareness of forms. Combine that with the shallow stage on which the figures seem to walk and the two-dimensional diamond pattern in the background (a critic called it a "diaper" pattern), and the result is an overall flatness, like a wall itself.[24] We can see the results in an autochrome of Dodge's painting in place (fig. 55). The lead figures on the right and left line up with the tall columns; the flat blue of the painting's background matches the flat red of the walls below; and the three panels of the triptych are framed by borders, like decorative molding. The painting contributes to, rather than upsets or offsets, the building's measured structure. "I should say that it was to place colors and patterns in such a way as to make them charming and interesting to the eyes," Dodge told a journalist who asked him how he had developed the murals, "without in any way making the spectator doubt that it is a wall that he is looking at."[25] Why such respect for the wall? "Wall painting is representation, it is true, of things in life but the representation is purely decorative and not an effort to give an illusion of reality," he explained.[26] Unlike easel paintings, that is, murals owed their existence to buildings, and that recognition structured the work itself. That was the muralist's special problem, and his special obligation.

Guérin wrote Dodge repeatedly during the year of sketching and mock-ups, always dropping reminders about the color scheme. "Don't let the matter of samples of color escape your mind . . . and send a sample to my house," he implored Dodge in the summer of 1913, when the painter already had massed all the forms into place. "Please write to me, telling me you have executed this,"

Guérin begged, to no avail.[27] When the painter showed up at the Palace of Machinery in January 1914 to paint the final touches (see fig. 54), the "decorative" elements of rhythmic patterning and composition and an overall effect of flatness already were in place.[28] But the color still needed adjustment in order to match the buildings, the gardenias and lilies in the gardens, the guard's khaki jackets, and the other murals; so Dodge applied some finishing brushwork to the surface. These last, individual strokes of color were large, long, and discrete, and they swam across the surface like a school of fish migrating to warmer waters. They seemed like mere applications—they were an extra action over an already coherent painting. And for some observers, they read too much like additions for a single purpose, in this case, to harmonize with their surrounds, when the paintings themselves had another surface consistency born in the studio.

Of course, all of this attention to color and decoration says nothing about the subject matter, which also betrayed something of the eastern men's dilemma. That few of them ever had set foot in San Francisco left them to imagine, at a remove, subject matters suitable for a local audience. They resorted to generalities and Beaux-Arts allegories, paying little attention to San Francisco's peculiar history and much more to the developments concerning the Panama Canal. Dodge populated his *Atlantic and Pacific* with stock characters drawn from folktales, popular histories, and costume dramas, including Orientalist figures taken from his studies with Gérôme. For example, the cultures of the Atlantic are represented by an ox-drawn prairie schooner and a farmer and

his family, and those of the Pacific by Aztecs, Asians (of what countries or ethnicities no one seemed to know), and more—mothers and children, robed figures, and others in antique-looking boxers. At the center, the heroic figure of Labor probably was modeled on the bodybuilder Charles Atlas, though some accounts suggest it was the strongman Eugene Sandow.[29] Whichever the case, he was an "ideal" man. The problem was that hardly anyone at the PPIE could decipher who was who, and which figure stood for what meaning. "One figure, with covered face, flees from the appeal of the siren," Macomber explained to his readers, as he looked at another of Dodge's panels, "but whom he represents, or why he flees, I cannot tell."[30] *Atlantic and Pacific*'s farmer, his family, and their ox-drawn schooner were thought to be crossing the American plains, though maybe it was the Isthmus of Panama, as some guidebooks said.[31] Perhaps he wasn't even a farmer, another suggested; he could be a miner, an engineer, or possibly a prospector.[32] And the Aztec, maybe he was another kind of noble savage. Those figures off to the right, too, could be gainsaid; maybe the allegorical figures weren't standing for the cultures of the Pacific at all but, in fact, for those cultures that stood to gain by the opening of the canal. In these roles, were they Californians, even San Franciscans? Doubtless, the panel seemed to contain subjects related to the history of California, an architect wrote, but he couldn't say exactly where or how.[33] And Labor could be Neptune, controlling the waters of the canal. Or was the figure of the bodybuilder some other ideal, doing some other task? "[He] might be many other things," an exasperated critic wrote. "People look up there and wonder what those figures are doing."[34] The

allegories—the "eternal verities," some laughed—were enough to baffle some fairgoers and leave others cold.

THE EMIGRANTS

Unlike Dodge, Frank Vincent DuMond primarily was an easel painter and book illustrator; he occasionally took on mural commissions when he needed money, to avoid "the least worries of poverty," he explained.[35] (He also needed hard cash to invest in New York real estate.[36] Indeed, by 1906 he amassed enough to buy property for a communal studio in downtown Manhattan and a grand house on the Connecticut coast.) DuMond had trained in Paris at the Académie Julian in the late 1880s and by the mid-1890s had developed a style of landscape painting indebted to the work of the Barbizons and the Impressionists. Upon his return to the United States, he advertised himself as a flexible painter, at once able to draw ads for Pears soap or illustrations for Mark Twain's fiction, but it was eventually to small canvases that he devoted most of his energy.[37] By the time Guérin contacted him, DuMond had transformed himself into a teacher of drawing and painting, spending his time during most of the year at the Art Students League of New York and the summers at an art colony in Old Lyme, Connecticut. It was within those contexts that he began to formulate a color palette system, known later by him and his students as "the prismatic palette," which organized hues into gradations of lighter and darker shades by steps and half-steps, the better to approximate the subtle and shifting light on a landscape.[38] In the right hands, the system led to a simple and yet extraordinarily refined handling of a scene, whereby soft touches and dabs of color could capture dappled or fleeting light and a busy system of brushwork allowed for painterly flourishes. The work was exquisite, masterly, full of understated decisions, and completely inappropriate for large-scale wall painting.

DuMond compensated in nearly the other extreme. Whereas his small canvases are full of bravura brushwork, marked by subtle shifts of shade and tint, his wall paintings are flat planes, broad masses, and expanses of unmodulated color; and whereas the landscapes attend to the complicated action of light on various surfaces, the scenes he created for the PPIE have no discernible light source whatsoever. In his hands, wall painting partly took shape, we might say, contrary to routine. Something of the struggle of working against his usual habits can be seen in his two PPIE panels (pls. 24–25), in the comic repetition of square jaws, boxy chins, and aquiline profiles, in the forward, chest-jutting, back-arching lean of the main male figures, or in the humorous, upturned noses that punctuate the parade of men and women, as if they were all sniffing some sweet scent in the air. He had latched onto a few figure types and stuck with them as a way to handle such a large composition. In fact, they came to dominate the composition.

Perhaps DuMond sensed, too, that his murals needed more historical specificity than what some of his colleagues were proposing with their vague allegories. He researched aspects of western history that could be said to belong to Northern California. In the second of the two panels, *Arrival in the West*, he claimed to include the profiles of the San Francisco writer Bret Harte, the painter

FIG. 59
Arthur Frank Mathews (American, 1860–1945), *Untitled (Mural)*, ca. 1911. Oil on canvas with frame, 49 × 80 in. (124.5 × 203.2 cm). Collection of the Oakland Museum of California, gift of Concours d'Antiques, the Art Guild, A72.8.1

William Keith, the Spanish explorer Juan Bautista de Anza, the Franciscan friar Junipero Serra, the minister Thomas Starr King, and others.[39] They are led by the Spirit of Enlightenment. At least that was what he hoped fairgoers would accept. The profiles hardly matched what most of the subjects actually looked like, including those whose faces were known by surviving portraits; and sometimes the Spirit of Enlightenment was just as easily interpreted as the Spirit of Adventure.[40] No matter, the men represented the arts, religions, and cultures brought to San Francisco—civilization into the wilderness—and they marched toward an ensemble of characters at the far right: a miner; a fruit picker; the California grizzly; a grand, seated, newly christened allegorical figure called Califia; and more, all waiting to receive the procession of historical and cultural figures and bestow their bounties upon them. The mural suggests that the conquerors of the West are due the wealth that they find, and that such a historical development was interpreted by men like DuMond as "progress." Nowadays we would call such a scheme Social Darwinism.[41] Some contemporaries of the fair saw much the same thing in the "progressive" views put forth by the mural. "[T]hey are not orthodox ideas, not conventional parlor ideas," the PPIE's official historian remarked at the time, "but rough, brutal, Darwinian, evolutionary ones."[42]

As if to make such a tale vivid and personal, the companion panel, called *Departure from the East*, is structured around emigrants leaving their New England homes to go west. That the site was New England—indeed, Old Lyme, where he owned a home—DuMond made clear. The building off to the right was a "Meeting House," he told an interviewer who had misidentified the building, "not a Church, understand—but a Meeting House," just like the one down the road from his house.[43] The church with the spire was modeled on the town's

First Congregational Church, a favorite subject matter for the art colony. The team of oxen was a theme borrowed from the colony's animal painters. Even the emigrants were modeled on his wife, Helen, and their children (see figs. 56–58). Helen appeared again and again in the mural, as the emigrant mother, as the trumpeting guide in the *Departure* panel, and as the Spirit of Enlightenment in the *Arrival* panel. Of course, she was a convenient model in the studio, but her continual reappearance also had to do with the autobiographical nature of the westward march, for the mural is a fantasy of what it would be like for DuMond's own family to leave the comforts of their Connecticut village and head west. They would follow in the footsteps of Bret Harte, William Keith, and all the others—and they, too, would bring a new kind of civilizing force.

In early 1914 DuMond, like the others, rolled up his mostly finished panels and shipped them to San Francisco—in fact, by way of the Panama Canal, which to him was an impetus for such a painting in the first place.[44]

A WESTERN MAN

Given Dodge's and DuMond's efforts, Mathews's misgivings about the PPIE's mural program may now make more sense. On closer inspection of murals like Dodge's, the colors fell apart, we will remember Mathews complaining, and the execution of the component parts, for example the final application of brushstrokes that swam like fish upstream, was in "opposition" to the structure underneath. But it was more than simply the awkward attempts to rhyme the murals with their surrounds that irked him. It was the arrogance of it all: the preponderance of eastern men who knew nothing of the city and its arts; the chauvinistic images of civilization being brought to the Pacific; the overbearing color scheme and the image of consensus it suggested; and most especially the

manic control from above, a top-down management that, to Mathews, was connected with unsavory local politics.

Unlike the other muralists, Mathews was raised in San Francisco. He, too, trained at the Académie Julian in Paris (he attended at roughly the same time as DuMond, though there is no evidence that the two ever met then). He returned to San Francisco in 1889 and became the lead painter at the California School of Design and then the Mark Hopkins Institute of Art.[45] By the turn of the century, he had had a hand in teaching a slew of notable artists in the Bay Area. Mathews lived through San Francisco's 1906 earthquake and fire and the contentious, decade-long efforts to rebuild the city. The decisions surrounding the rebuilding—the countless missteps, in his mind—gave him no end of subjects about which to complain, and he regularly turned to the pages of *Philopolis* to vent his anger. He detested the helter-skelter, predatory, developer-driven programs that took shape, and he especially detested the City Hall officials who facilitated them. "Imagine our condition," he told his readers, "if San Francisco, instead of having an openly dishonest and incomparably incompetent 'civic government,' had possessed [another] that goes by the surname of Old Honesty."[46] The city might look different, he wrote. There might be parks and libraries, open squares for public assembly, generous schools, a decent sewage system, well-lit streets, maybe even a well-appointed art museum.[47] Instead, "the city of San Francisco has no government," he fumed. "Government is an anachronism today both in deed and word. . . . We only have self-willed and unskillful servants, men who know little or nothing of street repairing, railroading, surveying, building, policing or education. We are ministered to by a horde of amateurs in all manners of business except good business."[48] It hardly needs saying that Mathews had as many detractors as supporters; and when the time came to choose prominent locals to have a hand in the PPIE, he ran up against those who had been pricked by his pen.

Mathews initially viewed the Exposition enthusiastically. For him and many others, it might be a miniature of what they wished San Francisco could still become, a city full of bright, walkable streets and a generous system of public spaces—a hilly Paris or Mediterranean town on the Bay.[49] He went about preparing to contribute, somehow getting himself on the International Jury of Awards, designing the Exposition's official gold seal (although it is unclear whether it ever was used), and grabbing half of a gallery in the Palace of Fine Arts to show sixteen canvases.[50] But it was a mural that he wanted most. For Mathews, wall painting represented a public good and, moreover, required a generous civic-mindedness of its maker that he thought few in the city's officialdom possessed. It needed to speak intelligently about important matters, not rehearse myopic or empty celebrations or, worse, pander to authority, and its language needed care and thoughtfulness, lest it be vain or airy. Mathews's paintings in the Palace of Fine Arts were slapdash in comparison, he knew. "An easel painting may be fumbled through to completion," he told his readers, "[but] not so with the mural painting. The end of the latter must be seen and clearly understood in the beginning."[51] Murals had large public obligations.

Mathews thought he was right for the job. He had painted about a dozen murals in the years between the earthquake and the initial stages of the PPIE, and he was planning a dozen more. While Guérin was being considered as the chief of color, Mathews put together a sketch for a mural he had been commissioned to paint in San Francisco (*Vision of Saint Francis*, 1911, Crocker Art Museum), providing a sample of what an exposition mural from him would look like (fig. 59). A train of migrants in the background heads west. They are accompanied by Greek muses in the foreground, a medieval knight on horseback, and a Native American at far left—a dose of the allegorical and the historical that also was present in such murals as DuMond's. Aside from the greater sensitivity to the local terrain—California oaks and poppies and a suggestion of the San Francisco Bay—the initial ideas were not so different from some of those that would eventually be painted by the eastern men. It is not clear whether Guérin saw the sketch; what is clear is that when he gave Mathews a mural contract, it was for the smallest and least desirable location of the many that were available.[52] He was to paint a single lunette over the poorly lit entrance to the Court of Palms—a place nobody else would want, as it simply was too dark. The choice must have grated on Mathews to no end: while the other muralists happily accepted their commissions, he dragged on accepting his.[53] And when the other muralists gathered at the Palace of Machinery to administer their final brushwork, he refused to join, "for the concert method did not appeal to him," an early observer explained delicately.[54] Guérin was less delicate: he wanted Mathews fired and another painter hired to replace him.[55]

The mural *Victorious Spirit* is a distant cry from the early sketch. It is not that Mathews departed entirely from the Beaux-Arts–derived language of the other muralists, but there are important differences between his mural and the rest. In the matter of decoration, for example, he paid little heed to the "wall" that others like Dodge and DuMond wanted to respect. He encouraged his viewers to peer into the distance, to the temples, blue bay, and parklike setting that are integral to the scene. The rearing horse, whose large hindquarters are thrust into the field of vision and whose silhouetted head falls behind the central figure's arm, fell along a raking axis and further emphasized that the scene worked into depth and not merely across the surface. In the matter of color, he dashed the palette with purples and bright oranges and trespassed over the boundaries of the chief of color's scheme. And in subject matter, he encouraged his viewers to make fine distinctions about how allegories could have local meanings. The number of figures in the final mural was far fewer than in the sketch (for that matter, than in nearly every other mural at the fair), the migrant trains so familiar everywhere else were now missing, and the suggestion of a westward movement was completely gone. Instead, the scene is situated in place—the San Francisco Bay behind and a gigantic California oak spilling off to the side. It is as if the mural insists on place itself and not on the fantasy of migration or adventure (or colonial possession and bounties) that the Panama Canal seemed to elicit from others. And what of the figures? The guidebooks explained their meanings: that the young boy to the left (Youth)

is being shepherded by a trio of elders, alternately recognized as "mother love" or Religion (left); Philosophy, Education, or Astronomy (center); and History or the Arts (right).[56] Whatever their precise symbolic meanings, the figures are the elements of learning, at least they seemed to be in Mathews's eyes, and they are a contrast to the rearing horse and rider to the right, standing for Materialism and "brute force."[57]

Such details were everywhere consonant with Mathews's pleas to San Franciscans. "There is no doubt in my mind that the modern ideal, is the betterment of the city in its public aspect," he wrote, "and that this ideal is not to be expressed by grandiose public office buildings, but by better streets, better parks, more open spaces, more presentable and generous schools and libraries, and a larger share than the people now possess in the enjoyment of those attributes of the so-called civilized life."[58] The goal for such a life superseded the celebratory claims of the PPIE or the naked commercial ambitions of its organizers. There was still a chance to make good on the promises of a renewed life on the other side of the disastrous earthquake and fire, he believed. The other murals, so accepting of myths of progress and evolution, simply acquiesced to a ruling ideology that took no stock of the needs of the city's people.

If private interests were being expressed as a public good, as Mathews grew to believe was happening at the PPIE, what purpose could murals play other than ratifying contrivances hatched from above, or becoming the harmonious image of managed consent? In that guise, wall paintings were not "free exhibits," we will remember him fuming, but merely ritualistic witnesses to the demands of officialdom. "And there you have it—the hysteria of public business—its fits and starts—the petty quarrels over details of no consequence, the passion for vast schemes, and the neglect of the duty at the door," he told his readers.[59] What irresponsibility, he thought, what a gag. He thought public paintings should do better.[60]

1. Ben Macomber, *The Jewel City: Its Planning and Achievement; Its Architecture, Sculpture, Symbolism, and Music; Its Gardens, Palaces, and Exhibits* (San Francisco: John H. Williams, 1915), 36–39. Macomber's *Chronicle* columns were compiled into this guidebook.

2. Ibid.

3. Arthur Mathews, "The Panama-Pacific International Exposition as a Work of Art," *Philopolis*, June 25, 1915, 162.

4. Arthur Mathews, "The Panama-Pacific International Exposition as a Work of Art, continued," *Philopolis*, July 25, 1915, 177.

5. Guérin was known by many names: "master colorist," "chief of color decoration," "Director of Color," and eventually, in the official histories, simply "Chief of Color." On "master colorist," see Macomber, *Jewel City*, 36; on "chief of color decoration," see Sheldon Cheney, *An Art-Lover's Guide to the Exposition: Explanations of the Architecture, Sculpture, and Mural Paintings, with a Guide for Study in the Art Gallery* (Berkeley: At the Sign of the Berkeley Oak, 1915), 11; on "Director of Color," see "Coloring of the Panama-Pacific International Exposition," *Fine Arts Journal* 30, no. 2 (February 1914): n.p.; on "Chief of Color," see Frank Morton Todd, *The Story of the Exposition: Being the Official History of the International Celebration Held at San Francisco in 1915 to Commemorate the Discovery of the Pacific Ocean and the Construction of the Panama Canal* (New York: G. P. Putnam's Sons, 1921), 1:347. According to his correspondence with PPIE officials at the time his contract was signed, Guérin's official title was "Director of Color and Decoration."

6. The number of murals at the earliest stages of planning varies, though the lowest number seems to have been thirty. See "Palace of Fine Arts Houses Treasures of Many Lands," *San Francisco Bulletin*, [1913?], William de Leftwich Dodge scrapbook, Archives of American Art. On the timing of the invitations, Guérin had already contacted the painters by January 1913. See Guérin, letter to Dodge, January 23, 1913, Archives of American Art, in which he congratulates both Dodge and himself for having secured the commission.

7. Eugen Neuhaus, "Sculpture and Mural Decoration," *Art and Progress*, August 1915, 371.

8. There is sometimes a discrepancy in the number of Model Ts produced daily. The figure of eighteen per day derives from Terry Smith, *Making the Modern: Industry, Art, and Design in America* (Chicago: University of Chicago Press, 1993), 137. On the domestic advancements, see French Strother, *The Panama-Pacific International Exposition: Where the Twentieth Century Has Paused to Take Stock of Itself and to Record Mankind's Progress in the Past Ten Years* (New York, Doubleday, 1915), 359, San Francisco Public Library. On the photographs (they were autochromes), see *Catalogue of the Kodak Pictorial Exhibit, Liberal Arts Building, Panama-Pacific International Exposition* (Rochester: Eastman Kodak, 1915). On the airplane, see Frank Marrero, *Lincoln Beachey: The Man Who Owned the Sky* (San Francisco: Scottwall, 1997); and Todd, *Story of the Exhibition*, 3:43. For a general discussion of the PPIE's technological exhibits, see Astrid Böger, *Envisioning the Nation: The Early American World's Fairs and the Formation of Culture* (Frankfurt: Campus Verlag, 2010), 243–256.

9. Forbes Watson, "Just a Few Eternal Verities," unidentified clipping [*New York Evening Post*?], William de Leftwich Dodge scrapbook, Archives of American Art.

10. The meetings took place on April 4 and July 12 at Guérin's atelier. Bancroft, Dodge, DuMond, Hassam, Holloway, Reid, and Simmons attended the first meeting; the same men minus Hassam attended the second. Minutes of the Panama-Pacific International Exposition, carton 62, folder 19, Panama-Pacific International Exposition Records, BANC MSS C-A 190, The Bancroft Library, University of California, Berkeley (hereafter cited as PPIE Records).

11. John D. Barry, *The City of Domes: A Walk with an Architect about the Courts and Palaces of the Panama-Pacific International Exposition with a Discussion of Its Architecture, Its Sculpture, Its Mural Decorations, Its Coloring, and Its Lighting, Preceded by a History of Its Growth* (San Francisco: John J. Newbegin, 1915), 18.

12. "Coloring of the Panama-Pacific International Exposition," n.p.

13. "Color Decoration: The Panama Exposition," *Art and Progress*, February 1914, 148.

14. "Coloring of the Panama-Pacific International Exposition," n.p.

15. "Color Decoration," 148.

16. Neuhaus, "Sculpture and Mural Decoration," 371.

17. Todd, *Story of the Exposition*, 1:350.

18. Macomber, *Jewel City*, 40–41.

19. Barry, *City of Domes*, 18.

20. The best account of Dodge's early training is the unabashedly celebratory Sara Dodge Kimbrough, *Drawn from Life: The Story of Four American Artists Whose Friendship and Work Began in Paris during the 1880s* (Jackson, MS: University of Mississippi Press, 1976).

21. Frederick Platt, "A Brief Autobiography of William de Leftwich Dodge," *American Art Journal* 14, no. 2 (Spring 1982): 63.

22. The income could be considerable. Dodge was paid $20,000 for the PPIE murals. See Harris D. H. Connick, January 28, 1913, carton 168, folder 3 "Approval of Contracts, Department of Works," PPIE Records.

23. J. Herbert Welch, "A Painter of Promise and Achievement," *Truth*, March 1901, n.p.

24. Cheney, *Art-Lover's Guide*, 52.

25. William de Leftwich Dodge, quoted in "Painting Flat: How Outdoor Coloring Is Coaxed Into Mural Decorations," unidentified clipping [*Kansas City Star?*], William de Leftwich Dodge scrapbook, Archives of American Art.

26. Ibid.

27. Jules Guérin, letter to William de Leftwich Dodge, July 30, 1913, William de Leftwich Dodge Papers, Archives of American Art.

28. It's difficult to know the state of the paintings when they arrived in San Francisco. Todd claims the murals were as much as three-quarters done (*Story of the Exposition*, 1:350). Kimbrough claims that Dodge's paintings were nearly complete and implies that the muralists swapped color samples in San Francisco for the finishing touches (*Drawn from Life*, 105–106).

29. Kimbrough, *Drawn from Life*, 105.

30. Macomber, *Jewel City*, 46.

31. *Official Guide of the Panama-Pacific International Exposition 1915* (San Francisco: Wahlgreen, 1915), 33.

32. Katherine Delmar Burke, *Storied Walls of the Exposition* (San Francisco, 1915), 66.

33. As recorded in Barry, *City of Domes*, 42 and 109.

34. Barry, *City of Domes*, 49. He is referring to Edward Simmons's murals just beyond the Tower of Jewels.

35. Frank DuMond, letter to his parents, [1907?], Archives of American Art.

36. Jeffrey W. Andersen, *The Harmony of Nature: The Art and Life of Frank Vincent DuMond, 1865–1951* (Old Lyme, CT: Florence Griswold Museum, 1990), 15.

37. On the soap ads, see Frank Vincent DuMond scrapbook, N70-76, Archives of American Art. On his illustrations for Twain, see Mark Twain, *Personal Recollections of Joan of Arc by the Sieur Louis de Conte* (New York: Harper and Brothers, 1896).

38. On DuMond's teachings, see Frank Vincent DuMond, "The Lyme Summer School and Its Theory of Art," *Lamp*, August 1903, 7–18; and Herbert E. Adams, "The Teachings of Frank Vincent DuMond: Penetrating Light," *American Artist*, March 1974, esp. 37–45 and 65. On the prismatic palette, see Leslie Watkins, "Art: The Prismatic Palette," *Art Times* (May/June 2012): 5.

39. On the identifications of the men, see Macomber, *Jewel City*, 56.

40. On "Enlightenment" versus "Adventure," compare Cheney, *Art-Lover's Guide*, 33, and Macomber, *Jewel City*, 56.

41. On the Social Darwinist aspects of the Exposition, see Burton Benedict, *The Anthropology of World's Fairs: San Francisco's Panama Pacific International Exposition of 1915* (Berkeley: Lowie Museum of Anthropology, 1983), esp. 49–52. See also Sarah J. Moore, *Empire on Display: San Francisco's Panama-Pacific International Exposition of 1915* (Norman: University of Oklahoma Press, 2013); Michael Leja, "Progress and Evolution at the U.S. World's Fairs, 1893–1915," *Nineteenth-Century Art Worldwide* 2, no. 2 (2003): esp. 91; and Alexander Missal, *Seaway to the Future: American Social Visions and the Construction of the Panama Canal* (Madison: University of Wisconsin Press, 2008), esp. 178–182. See also Emma Acker's essay in this volume.

42. Todd, *Story of the Exposition*, 2:330.

43. Frank DuMond, quoted in Rachel Gersterhaber, "The Early Works of Frank Vincent DuMond, 1865–1971" (honor's thesis, Yale University, 1987), 52.

44. Barbara Rizza Mellin, "Universal Truths and the Laws of Nature: The Life, Art, and Teaching of Frank Vincent DuMond" (master's thesis, Harvard University, 1994), 161.

45. On Mathews's early career, see Harvey L. Jones, *The Art of Arthur and Lucia Mathews* (San Francisco: Pomegranate, 2006), 21–55. See also Harvey L. Jones, *Mathews: Masterpieces of the California Decorative Style* (Layton, UT: Gibbs M. Smith in association with the Oakland Museum, 1985).

46. Arthur Mathews, "Babelonian Towers," *Philopolis*, October 25, 1907, 14.

47. Arthur Mathews, "Art and Business," *Philopolis*, February 25, 1908, 112.

48. Arthur Mathews, "Art and Business," *Philopolis*, November 25, 1907, 49.

49. The attitude was common. See Kevin Starr, *Americans and the California Dream, 1850–1915* (New York: Oxford University Press, 1973), 288–306; and Gray Brechin, "Sailing to Byzantium: The Architecture of the Fair," in Benedict, *Anthropology of World's Fairs*, 94–113.

50. See John E. D. Trask and J. Nilsen Laurvik, eds., *Catalogue de Luxe of the Department of Fine Arts, Panama-Pacific International Exposition* (San Francisco: Paul Elder, 1915), 1:220.

51. Arthur Mathews, "Mural Painting, or Painting as a Fine Art," *Philopolis*, December 25, 1907, 58.

52. Guérin's disregard of Mathews spilled over to the publicity; the painter was frequently omitted in puff pieces about the murals. See "Palace of Fine Arts Houses Treasures of Many Lands." As late as 1915, as the fair was preparing to open, Mathews is still occasionally omitted from the roster. See "Paintings Adorn Outer Walls for First Time," *Associated Sunday Magazine*, January 1915, n.p.

53. Mathews was offered a contract on January 18, 1913. See Contract #64, carton 168, folder 6 "Department of Works," PPIE Records. All of the other muralists except Frank Brangwyn (he was offered a commission much later) had accepted by February 27. Mathews appears to have accepted his in early March. See Harris D. H. Connick, March 10, 1913, carton 168, folder 3 "Approval of Contracts, Department of Works," PPIE Records.

54. Todd, *Story of the Exposition*, 1:351.

55. F. S. Brittain, letter to C. C. Moore, March 31, 1914, carton 168, folder 6 "Department of Works," PPIE Records.

56. For Religion, Philosophy, Education, and the Arts, see Cheney, *Art-Lover's Guide*, 45. For "mother love," Astronomy, and History, see Jones, *Art of Arthur and Lucia Mathews*, 91.

57. For Materialism, see Barry, *City of Domes*, 125; for "brute force," see Macomber, *Jewel City*, 82.

58. Mathews, "Art and Business," *Philopolis*, February 25, 1908, 112.

59. Arthur Mathews, "Art and Business," *Philopolis*, August 25, 1908, 257.

60. On the relationship between private interests and the public sphere, see Jürgen Habermas, *The Structural Transformation of the Public Sphere: An Inquiry into a Category of Bourgeois Society*, trans. Thomas Burger (Cambridge: MIT Press, 1991). On the "public" aspect of the murals, see Anthony W. Lee, *Painting on the Left: Diego Rivera, Radical Politics, and San Francisco's Public Murals* (Berkeley: University of California Press, 1998), esp. 1–24.

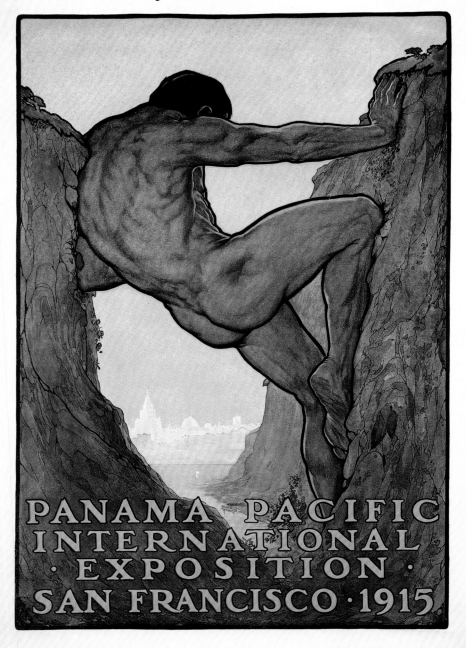

1 Perham Wilhelm Nahl (American, 1869–1935)
 The Thirteenth Labor of Hercules: Official Poster for the Panama-Pacific
 International Exposition, 1913–1914
 Color offset lithograph poster
 Sheet: 22 × 14 in. (55.9 × 35.6 cm)
 Collection of Donna Ewald Huggins

2 Alson Skinner Clark (American, 1876–1949)
In the Lock, Miraflores, 1913
Oil on canvas
38 ½ × 51 ¼ in. (97.9 × 127.6 cm)
Private collection
Palace of Fine Arts, Gallery 73, wall A, no. 3534

3 Alson Skinner Clark (American, 1876–1949)
Panama Canal, the Gaillard Cut, 1913
Oil on canvas
21 × 22 ½ in. (53.3 × 57.2 cm)
The Delman Collection, San Francisco

4 Cadwallader Washburn (American, 1866–1965)
 Exposition Palace Interior, from the portfolio
 Building of the Panama-Pacific International Exposition, ca. 1914
 Lithograph
 14 ½ × 10 ⅛ in. (36.8 × 25.7 cm)
 Fine Arts Museums of San Francisco, Achenbach Foundation for Graphic Arts, 1963.30.26362
 Palace of Fine Arts, print cabinets, no. 7364(?) as *The Half Dome*

5 Cadwallader Washburn (American, 1866–1965)
 Liberal Arts Building—The Entrance, from the portfolio
 Building of the Panama-Pacific International Exposition, ca. 1914
 Lithograph
 15 ¼ × 11 ¾ in. (38.6 × 29.7 cm)
 Fine Arts Museums of San Francisco, Achenbach Foundation for Graphic Arts, 1963.30.26372
 Palace of Fine Arts, print cabinets, no. 7322

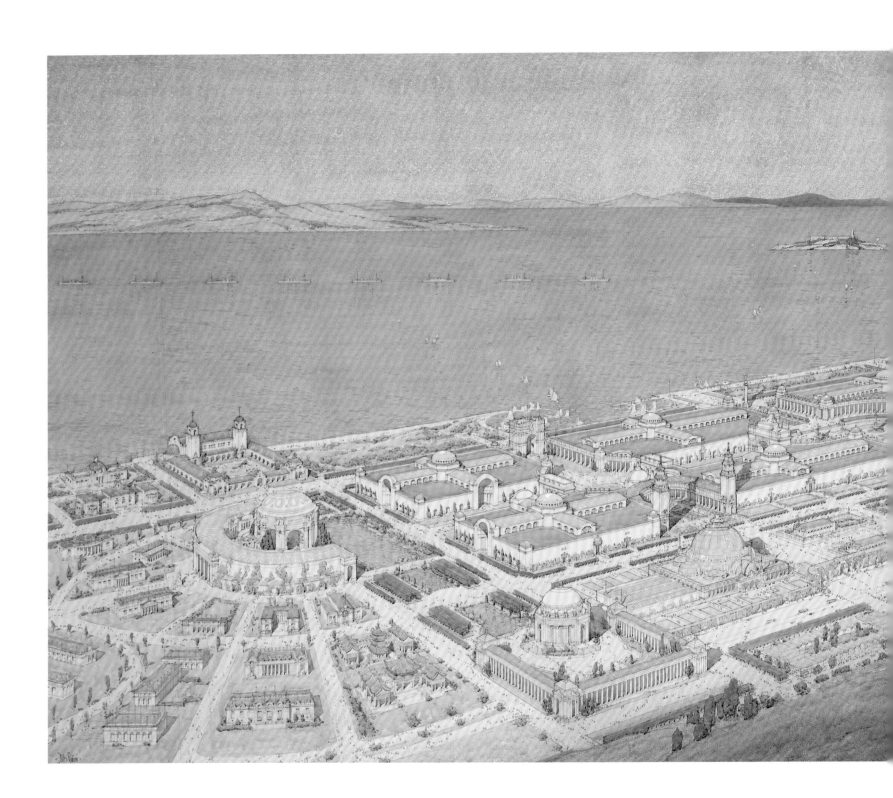

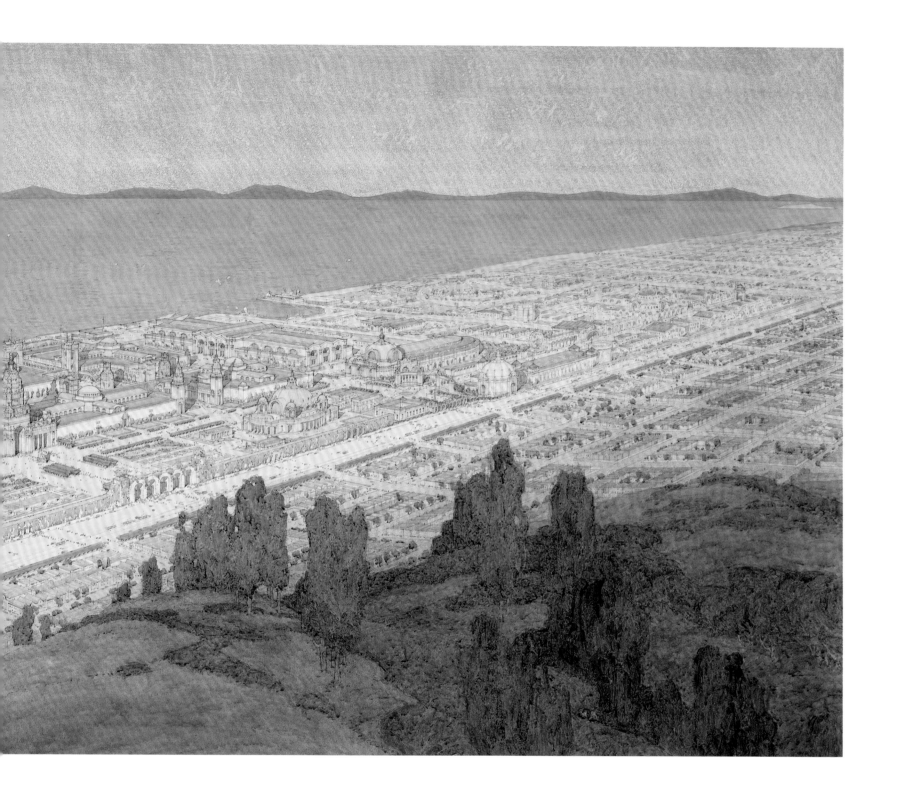

6 Jules Guérin (American, 1866–1946)
Panoramic View of the Panama-Pacific International Exposition, 1913
Watercolor and opaque watercolor over graphite on paper
49 × 97 in. (124.5 × 246.4 cm)
Collection of the Exploratorium, San Francisco

7 *Panoramic View of the Panama-Pacific International Exposition—*
San Francisco, California, 1915, 1915
Published by Pacific Novelty Company
Color letterpress halftone
5½ × 26¼ in. (14 × 66.8 cm)
Fine Arts Museums of San Francisco,
gift of Barbara Jungi in memory of Elsie F. Miller, 1990.1.8

8 *Night Illumination—Panama-Pacific International Exposition—*
San Francisco, California, 1915, 1915
Published by Pacific Novelty Company
Color letterpress halftone
5½ × 26¼ in. (14 × 66.8 cm)
Fine Arts Museums of San Francisco,
gift of Barbara Jungi in memory of Elsie F. Miller, 1990.1.9

9 *Panorama of the Panama-Pacific International Exposition*, 1915
Published by Cardinell-Vincent Company
Gelatin silver print with applied color
7⅛ × 41¾ in. (18 × 106 cm)
Fine Arts Museums of San Francisco,
Achenbach Foundation for Graphic Arts, 1963.30.38418

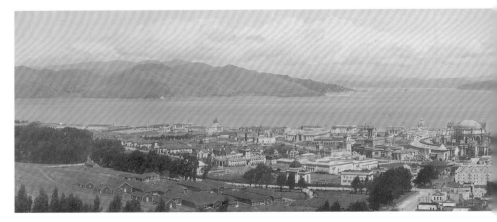

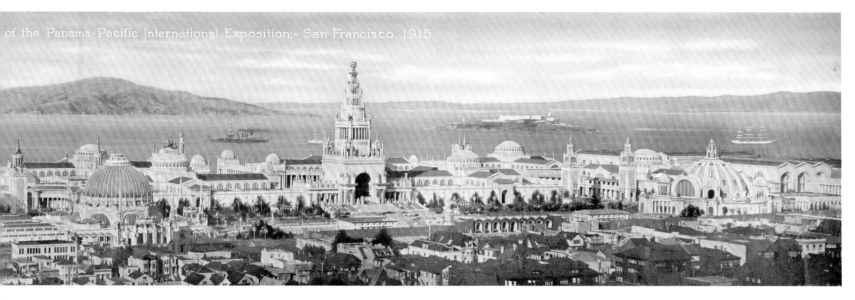
of the Panama-Pacific International Exposition:- San Francisco, 1915.

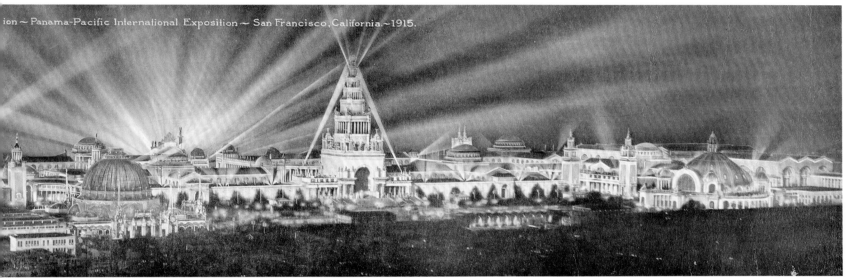
ion ~ Panama-Pacific International Exposition ~ San Francisco, California. ~ 1915.

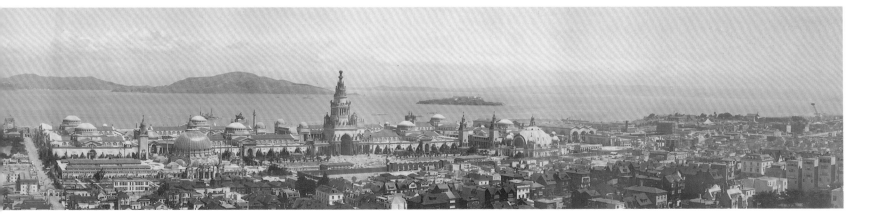

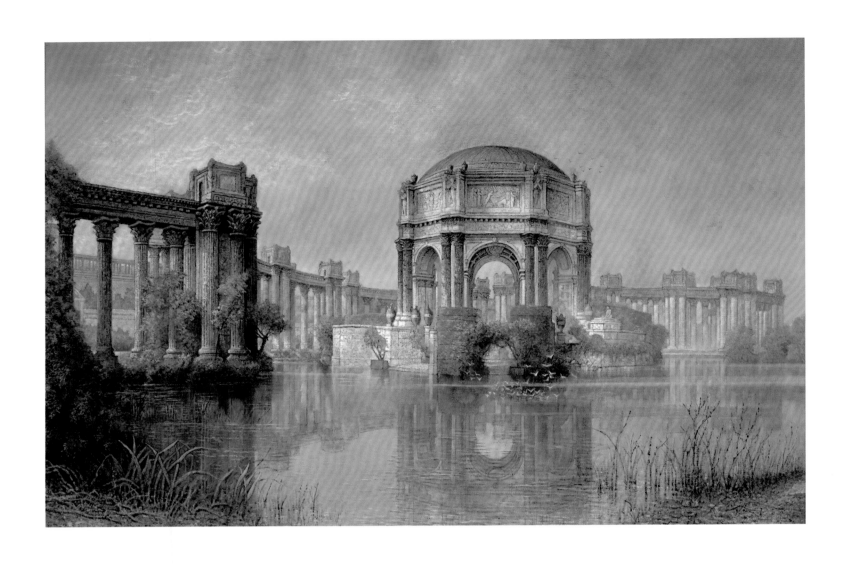

10 Edwin Deakin (American, b. England, 1838–1923)
Palace of Fine Arts and the Lagoon, ca. 1915
Oil on canvas
32 ⅜ × 48 ⅜ in. (82.1 × 122.8 cm)
Crocker Art Museum, Sacramento, long-term loan from the California Department of Finance,
conserved with funds provided by Gerald D. Gordon, LOAN.2006.Deakin

11 **Benjamin Chambers Brown** (American, 1865–1942)
Art Palace, Reflections (Panama-Pacific International Exposition), ca. 1915
Soft-ground etching in color
6 7/8 × 4 7/8 in. (17.5 × 12.8 cm)
Fine Arts Museums of San Francisco, California State Library long loan, A028550

12 **Benjamin Chambers Brown** (American, 1865–1942)
Art Palace, S.F. Moonlight (Panama-Pacific International Exposition), ca. 1915
Soft-ground etching in color
6 7/8 × 4 3/4 in. (17.5 × 12.2 cm)
Fine Arts Museums of San Francisco, California State Library long loan, A028551

13 E. Charlton Fortune (American, 1885–1969)
Court of Flowers, 1915
Oil on canvas
12 × 16 in. (30.5 × 40.6 cm)
Collection of Melza and Ted Barr, Houston

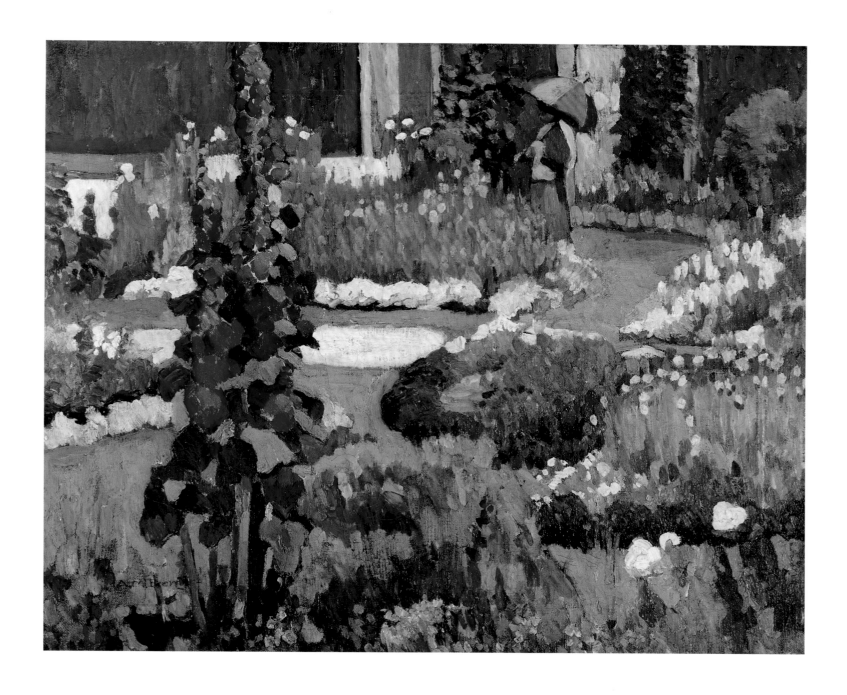

14 Anne M. Bremer (American, 1872–1923)
An Old-Fashioned Garden, 1915
Oil on canvas
19 ½ × 23 in. (49.5 × 58.4 cm)
Mills College Art Museum, Oakland, gift from the Albert M. Bender Estate

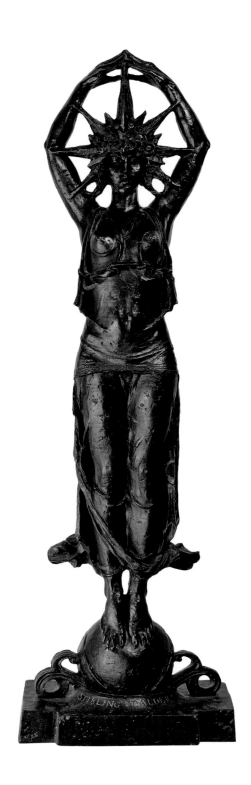

15 Alexander Stirling Calder (American, 1870–1945)
Star Maiden, 1914 (cast 1985)
Bronze
51 × 15 × 9¼ in. (129.5 × 38.3 × 23.5 cm)
Collection of Jacque Giuffre and Bill Kreysler

16 Arthur Putnam (American, 1873–1930)
The Mermaid, 1909
Bronze
32 × 13½ × 26¾ in. (81.3 × 34.3 × 67.9 cm)
Fine Arts Museums of San Francisco, gift of Alma de Bretteville Spreckels, 1924.181.1

17 Adolph Alexander Weinman (American, b. Germany, 1870–1952)
Rising Day (Rising Sun), ca. 1914, cast later
Bronze
56 × 54 × 19 in. (142.2 × 137.2 × 48.3 cm)
Museum of Fine Arts, Houston, 26.2

18 Adolph Alexander Weinman (American, b. Germany, 1870–1952)
Descending Night, ca. 1914, cast later
Bronze
54 × 54 × 19 in. (137.2 × 137.2 × 48.3 cm)
Museum of Fine Arts, Houston, 26.3
Palace of Fine Arts, Gallery 63, no. 2930

19 Charles Grafly (American, 1862–1929)
Sketch for Pioneer Mother Monument, 1913–1914
Bronze
15 × 8 ½ × 4 in. (38.1 × 21.6 × 10.2 cm)
Ulrich Museum of Art, Wichita State University, Kansas, gift of Mr. Charles H. Drummond, 1982.27.47

20 Charles Grafly (American, 1862–1929)
Sketch for *Pioneer Mother Monument*, 1913–1914
Plaster
Figures without base: 21 × 6 ½ × 4 ½ in. (53.3 × 16.5 × 11.5 cm)
Ulrich Museum of Art, Wichita State University, Kansas, gift of Dorothy Grafly Drummond and
Charles H. Drummond, 71.16.123 (base) and 71.16.11 (figures)

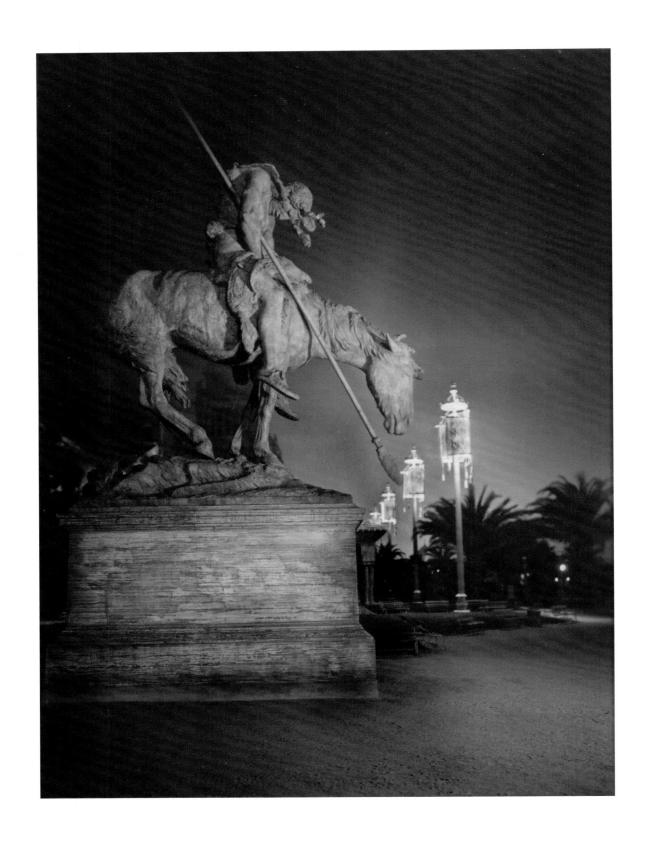

21　Willard E. Worden (American, 1868–1946)
The End of the Trail, 1915
Sepia-toned gelatin silver print
9 ⅜ × 7 ¼ in. (24.5 × 18.5 cm)
Jerry Bianchini Collection

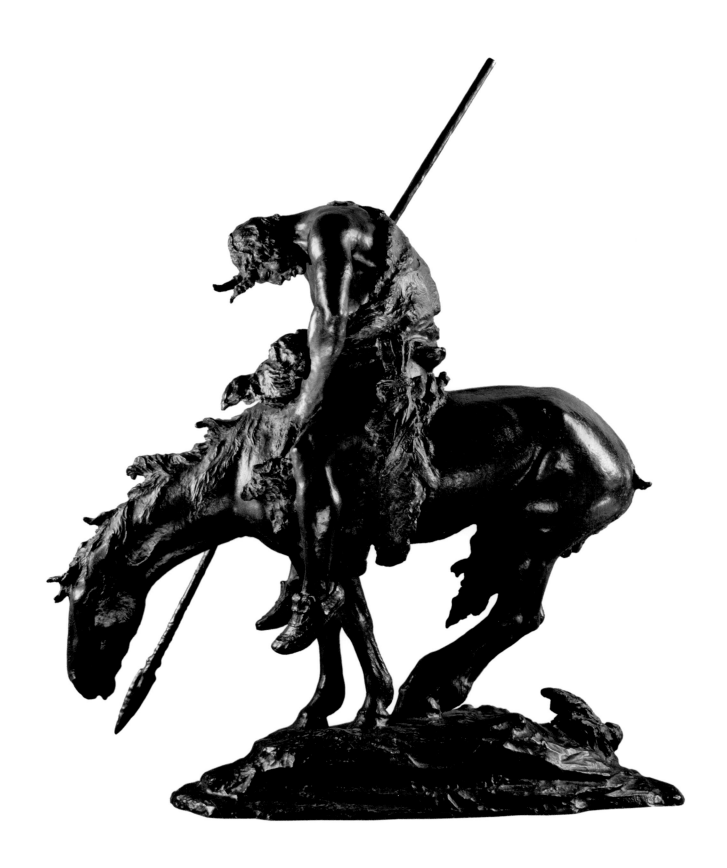

22 James Earle Fraser (American, 1876–1953)
The End of the Trail, modeled ca. 1894, cast ca. 1925
Bronze
44 ½ × 34 × 11 in. (113 × 86.4 × 27.9 cm)
The Rockwell Museum, Corning, New York, 78.88

23 Arthur Frank Mathews (American, 1860–1945)
The Victory of Culture over Force (Victorious Spirit), 1914
Oil on canvas
119 × 238 in. (302.3 × 604.5 cm)
San Francisco War Memorial

24 Frank Vincent DuMond (American, 1865–1951)
Study for *The Westward March of Civilization: Departure from the East*, 1913
Oil on canvas, squared in pencil
32 × 100 in. (81.3 × 254 cm)
Florence Griswold Museum, Old Lyme, Connecticut, gift of Harold and Barbara Goodwin, 1984.21.5

25 Frank Vincent DuMond (American, 1865–1951)
Study for *The Westward March of Civilization: Arrival in the West*, 1913
Oil on canvas, squared in pencil
32 × 100 in. (81.3 × 254 cm)
Florence Griswold Museum, Old Lyme, Connecticut, gift of Harold and Barbara Goodwin, 1984.21.6

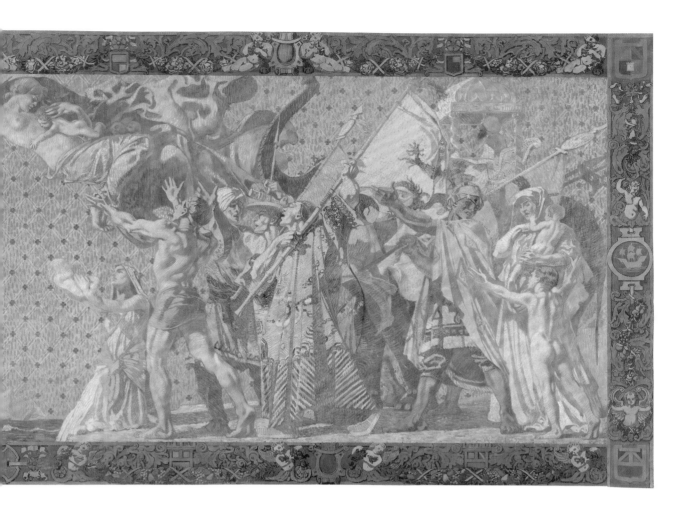

26 William de Leftwich Dodge (American, 1867–1935)
Atlantic and Pacific, 1914
Oil on canvas
Without ornamental borders: 146 × 559 ½ in. (370.8 × 1421.1 cm)
San Francisco War Memorial

Francis McComas 1914

AMERICAN ART

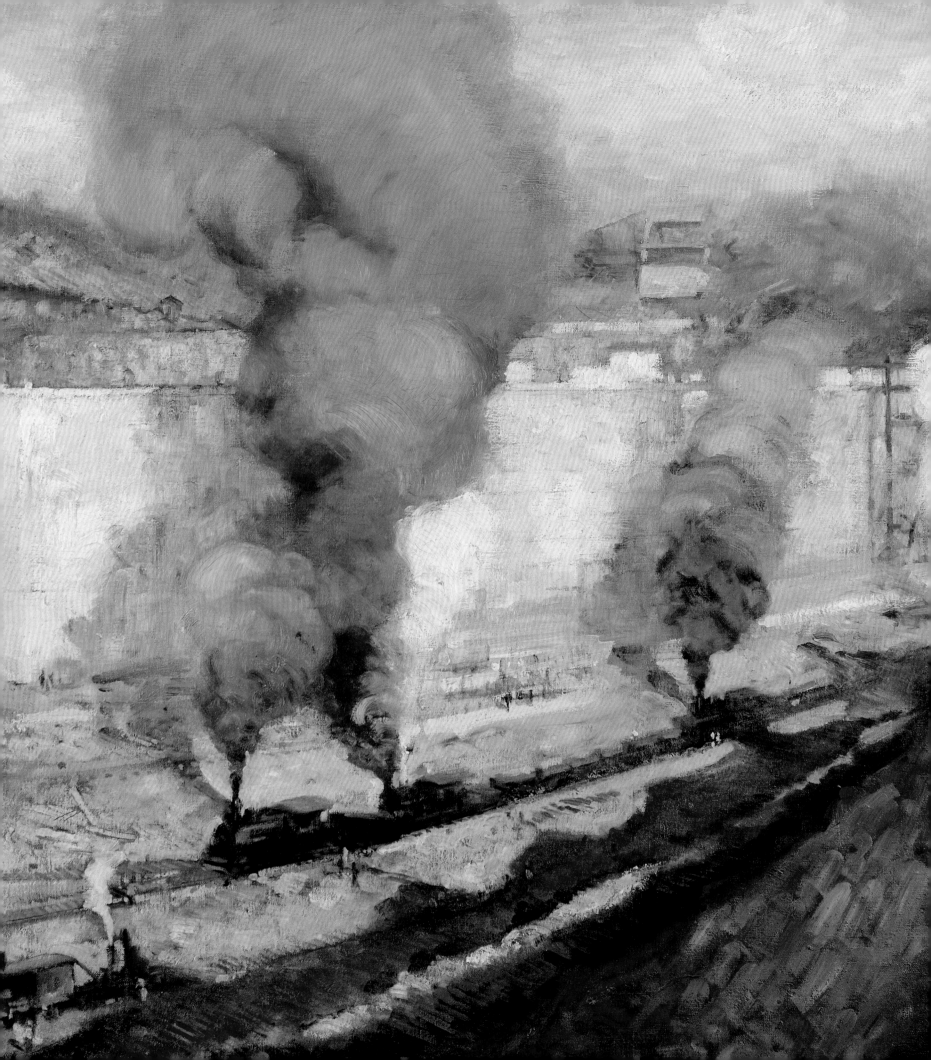

"A PAGEANT OF AMERICAN ART": CONSTRUCTING NATION AND EMPIRE AT THE FAIR

The Panama-Pacific International Exposition (PPIE) of 1915, like the major world's fairs that preceded it, celebrated and commemorated a momentous occasion, the 1914 opening of the Panama Canal and its significance for the American West and the trade expansion of the United States. The Exposition occurred at a unique and important juncture in American history; as art historian Sarah J. Moore explains, the fair was "temporally situated between the Spanish-American War (and consequent [American] establishment of a Pacific empire) and World War I, where the United States takes on a defining role in European world affairs. . . [and] provided evidence—visual, spatial, ideological—of the efficacy and efficiency of America's transgressions on national borders."[1]

The core messages of the Exposition—emphasizing the meeting of East and West, with San Francisco as a gateway, and America's newfound status as a technologically superior world power, extending its frontier across the Pacific Ocean—centered, as at earlier world's fairs, around assumptions about the perceived superiority of Anglo-Saxon culture and justifications for its dominion over other races and nations. As we will see, such attitudes were expressed subtly through the PPIE's architecture and landscaping and more overtly in its public art, as well as in many of the concessions housed in its amusement section known as the "Joy Zone." And, although its contents were not necessarily tied to these themes, the display at the Palace of Fine Arts—in terms of its conception, organization, layout, marketing, and critical reception—further reinforced the nationalist and imperialist thrusts of the Exposition by highlighting the American art on view as proof of the cultural apotheosis of the United States over Europe, and as a symbol of and justification for the forward march of its empire.[2]

Built along San Francisco's northern bay front (in what is now the Marina district), the 635 acres of the Exposition fairgrounds ran east to west from Van Ness Avenue to Presidio Street, and south to north from Chestnut Street to the bay. On once marshy land that had just four years earlier been deemed an eyesore rose the "City of Domes," as it was widely known, a majestic suite of courts and palaces carved of "staff" (plaster) designed to look like travertine (see fig. 7). The eleven thematic exhibit palaces of the Exposition were grouped in the center of the grounds, flanked on one side by the Joy Zone, and on the other by foreign and state pavilions, with additional grounds for livestock, military, and athletic displays.[3]

The major influence on the fair's architecture was the Beaux-Arts style of the 1893 World's Columbian Exhibition in Chicago, which was rearticulated in Daniel Burnham's 1905 City Beautiful plan for San Francisco.[4] Though Burnham's plan was never realized, the Exposition was a similar, miniature version of it, which captured its spirit while tempering its classical and historicizing influences with regional ones better suited to the climate, topography, and culture of the Bay Area. The incorporation of indigenous, "hillside" building traditions; architectural references to the Asian and Spanish heritage of Northern California; and the creation of a "Walled City" of interconnected outdoor courtyards were all unique features of the PPIE.

A primary goal of the architects responsible for the design of the fair was

FIG. 60
Exhibit of the Race Betterment Foundation. From
*Official proceedings of the second national conference on
race betterment: August 4, 5, 6, 7 and 8, 1915* (Battle
Creek, MI: Race Betterment Foundation, 1915).
Willard Library, Battle Creek, Michigan

the successful integration of art and nature.[5] John McLaren, chief of landscape gardening, planted a verdant landscape of trees, shrubs, and flowers, including a twenty-foot-high living wall of flowering Mesembryanthemum (ice plant) at the entrance to the Exposition. Chief of color Jules Guérin coordinated the entire fair using hues inspired by the Northern California landscape.[6] Guérin's vibrant color scheme and McLaren's lush plantings reinforced a sense of California as a New World Garden of Eden, and emphasized its resemblance, in both climate and topography, to the Mediterranean—a region similarly associated with natural abundance.

The design and decor of the Exposition courts visually reinforced Anglocentric narratives such as the superiority of Western culture and America's Manifest Destiny to tame and conquer the wilderness—invoked through imagery illustrating civilization's progress from east to west, as well as the triumph of mankind over nature.[7] As Moore argues, the orientation of the courts from the east to the west symbolized the westward march of empire.[8] Furthermore, the California Building dominated the state pavilions in both its size and its location at the head of the Avenue of States—marking the ascendance of the West as a center of US power and the achievement of the Manifest Destiny ideal. Meanwhile, buildings representing America's territories and colonies were given a lesser placement, and contained displays that presented these sites as the beneficiaries of American paternalism.[9] The Palace of Fine Arts, situated at the westernmost edge of the fairgrounds, was geographically opposed to the Palace of Machinery; together, they represented the technological and cultural prowess of an ideal, "civilized" society, the epitome of human progress to date.[10] Finally, the location of the fairgrounds along the San Francisco Bay underscored the theme of maritime expansionism manifested in the Panama Canal and celebrated at the Exposition, which was articulated forcefully by the first president of the Panama-Pacific International Exposition Company, Homer S. King: "Not merely to claim the honor of connecting the two oceans did the United States undertake the greatest

engineering achievement man ever attempted. It is to dominate the politics and commerce of the Pacific that our country is cleaving two continents."[11]

The vast and encyclopedic range of displays in the many pavilions at the PPIE was meant to impress the viewer with the recent industrial, technological, and cultural achievements in America at both state and national levels—instilling a sense of civic pride in the public that, as historian Robert Rydell argues, ultimately served the interests of the ruling elite. Rydell posits that the men who financed and directed the PPIE—who were at the highest echelons of wealth and power in California—sought to "preserve the people's faith in the idea of progress—with all its interlaced connotations of technological advance, material growth, racism, and imperialism—and to reshape the faith with particular reference to the challenges posed by domestic and international turmoil."[12] According to Rydell, the "community of shared experience" provided to visitors at world's fairs helped smooth over the social upheavals engendered by industrialization, particularly the labor unrest and class conflict that had erupted in America with the Great Railroad Strike of 1877 and persisted for decades to come.[13] One of the ways in which the elite organizers of the fair could mollify the (white) working poor and divert them from questioning existing power relations was to foster the sense that Anglo-Americans from across the socioeconomic spectra stood in solidarity. This strategy depended upon demonizing a racial "other" against which whites of all classes could unite; as Rydell explains, "nationalism and racism became crucial parts of the legitimizing ideology offered to a nation torn by class conflict."[14] He argues that the pervasive stereotyping and even caricaturing of nonwhite cultures at the PPIE, along with the persistent glorification of Western culture, resulted in the construction of "elaborate racial fantasies about California's history."[15]

One of the most overt manifestations of the racist and xenophobic attitudes and agendas undergirding the PPIE was the highly visible presence of the eugenics movement at the fair. Based on his reading of Charles Darwin, Sir

FIG. 61
Joy Zone entrance with cigar shop, 1915. Hand-colored photograph by Branson DeCou. Branson DeCou Archive, University of California, Santa Cruz, Special Collections

FIG. 62
African Dip in the Joy Zone, 1915. San Francisco History Center, San Francisco Public Library

FIG. 63
Samoan dance display in the Joy Zone, 1915. San Francisco History Center, San Francisco Public Library

FIG. 64
Postcard of Pueblo Village in the Joy Zone. Published by Cardinell-Vincent Co., San Francisco, 1915

Francis Galton developed the concept of eugenics in 1883, and it grew into a widespread social philosophy focused on the improvement of the human race through selective breeding and sterilization, and immigration restriction.[16] Described as "the science of improving the human stock," eugenics was promoted by boosters who argued that policies such as enforcing same-race marriages would yield more desirable genetic traits and improve the overall health of the population.[17] The eugenics movement became a hallmark of the Progressive Era in the United States and grew in force as labor strikes, urban poverty, and increased immigration from non-English-speaking countries in the first decades of the twentieth century caused concern among middle- and upper-class white Americans.[18] By appealing to "nativist" desires to preserve a "superior" Anglo-American stock, eugenicists built upon widespread public fears that the country would soon be "overtaken" by immigrants.[19]

At the time of the fair, California was at the forefront of the eugenics movement.[20] The PPIE was the first fair to host a wide array of eugenics-related displays, conferences, and lectures; according to the historian Alexandra Stern, "the nucleus of California's eugenics movement converged at the PPIE."[21] During the Second National Conference on Race Betterment, hosted for one week in August 1915 at the PPIE, leading eugenicists—such as cereal magnate and founder of the Race Betterment Foundation, Dr. John Harvey Kellogg—expounded upon the proper methods for achieving racial purity, including the establishment of a eugenic registry.

At one of the most popular booths at the fair, in the Palace of Education, the Race Betterment Foundation displayed charts that warned against "mixed-race breeding" (see fig. 60) and provided printed notices that explained its goals: "To present the evidence of race deterioration, to show the possibility of race improvement. . . . The Race Betterment movement aims to create a new and superior race through euthenics, or personal and public hygiene, and eugenics, or race hygiene."[22] The organizers of the PPIE clearly approved of these aims, and wrote to the organizers of the Race Betterment Foundation, "You represent the very spirit, the very ideal of this great Exposition that we have created here."[23] The "science" of "race betterment" promoted through eugenics at the fair was in keeping with the overarching emphases at the PPIE on mankind's ability to control, tame, and shape nature using technology and science.

These themes were echoed in the Joy Zone, a sixty-five-acre amusement section located on the eastern edge of the main fairgrounds (see fig. 61). Constructed at a cost of more than ten million dollars, the Zone boasted booths lined up longer than half a mile, entertainment venues, pavilions, theaters, and rides, and was a decidedly raucous counterpoint to the "high culture" embodied at the Palace of Fine Arts. Photographer Ansel Adams evoked the tawdriness of this section of the fair, writing, "In addition to the usual neck-breaking rides, tumblers, twisters, and tunnels of love, there were the seamy traps of girlie shows, curio shops, and freak displays. If the front of these establishments were bad, the backs were worse—plywood, tar paper, trash, as well as drunks and assorted strange fragments of humanity."[24]

The attractions along the Zone were among the most profitable and popular at the Exposition, and they reflected—and fueled—fairgoers' unfiltered anxieties and prejudices related to race and class, tensions that ran rampant in California at the time. In these gaudy, burlesque areas, the basest and ugliest representations of and assumptions about nonwhite cultures and women were on display.[25] Although the fair organizers did not play an active role in shaping the flagrantly racist and sexist displays along the Zone—the content was left to the concessionaires—their presence at the Exposition was certainly not accidental. According to the *Panama-Pacific International Exposition Booklet no. 1*, "Rigid selection has governed the granting of all the concessions. Every one accepted has satisfied a high standard of propriety, good taste and educational value, as well as effective funmaking and entertainment."[26] Rydell asserts that fair organizers, in their tacit approval of the Zone's operations, consciously deployed "low culture" to construct a racialized negative analogue to the idealized representations of Western civilization found throughout the fair, thus justifying an imperialist worldview.[27]

Among the most offensive concessions along the Zone were a ball-playing game called the African Dip (later named Soakum), which was housed within a gargantuan sculpted caricature of a pierced African (see fig. 62); Somali Land, whose entertainers, in the guise of village "savages," were deemed by visitors and fair organizers "too tame" and were deported by US immigration officials midway through the Exposition;[28] the Samoan Village, which the *San Francisco Examiner* promised would "amuse . . . with the primitive ways of its semi-naked citizens" (see fig. 63);[29] the Pueblo Village (the headquarters of the Daughters of the Revolution at the fair), for which the Santa Fe railroad brought twenty Zuni and Hopi families from their reservations to live on the roof of a miniature Grand Canyon and to make and sell "traditional" handicrafts (see fig. 64); and Underground Chinatown (later renamed Underground Slumming).

The controversies associated with the final example point to some of the complexities and contradictions inherent in an exposition that ostensibly celebrated the strengthening of ties between the United States and Asia, but in reality perpetuated a myriad of stereotypes and fears about Asian culture and, particularly, about Japanese and Chinese Americans living on the West Coast. Operated by the theater executive Sid Grauman, the Underground Chinatown concession was located in the "Chinese Village" of the Zone. Whereas the "living villages" exhibits such as Somali Land attempted to re-create "primitive" life abroad, Underground Chinatown caricatured Chinese-American culture in the United States. Exploiting popular associations of San Francisco's Chinatown with sex, drugs, and violence, the exhibition titillated viewers with "shrieking hatchet men (tong assassins), bleary-eyed addicts, bookmakers with sing-song voices, and, most popular of all, prostitutes 'imported' from China who called to visitors from behind prison bars."[30] After members of the local Chinese-American business community and the Chinese consul raised objections to the exhibit, the fair directors temporarily closed the concession, yet reopened it soon thereafter as Underground Slumming.[31] The revised attraction did not use live actors

FIG. 65
Model of Panama Canal in the Joy Zone, 1915.
Charles C. Moore albums of Panama Pacific
International Exposition views, vol. 3. The
Bancroft Library, University of California,
Berkeley

as had the original, but implied the same racist and xenophobic assumptions about Chinese-American culture.

The presence of a concession at the fair presenting such a degrading view of Asian culture might seem surprising, given that the Exposition putatively celebrated ties between the East and the West, and that China's participation in the Exposition was of crucial importance to the fair organizers.[32] Yet such stereotyped caricatures reflected the same pervasive anti-Asian sentiment and political rhetoric manifested in local and national policies such as the Chinese Exclusion Act (1882), the Open Door policy (1899), and the California Alien Land Law (1913).[33] Furthermore, the concession was tremendously lucrative, and any political capital it may have compromised was overlooked in favor of the bottom line. The negative portrayals of Asians perpetuated by the Underground Chinatown concession were mirrored in a less blatantly offensive manner in the monumental murals and statuary groups found in the official sections of the fair that were planned by the PPIE organizers. Underground Chinatown served to reinforce these stereotypes under the guise of entertainment, rather than edification.[34]

Perhaps the most overtly didactic concession along the Zone was the Miniature Canal, which featured an elaborate model of the celebrated subject of the Exposition, set within an oval amphitheater 1,440 feet in length (see fig. 65). Traveling in trams on moving walkways, spectators were able to peer down at the sprawling replica and marvel at this triumph of engineering, which represented America's imperial might and ability to civilize and control nature—a marked contrast to the "wild," "savage," and "primitive" displays of nonwhite culture at the surrounding concessions. These themes were echoed in the gargantuan replicas along the Zone of tourist sites such as Yellowstone Park and the Grand Canyon, which symbolized America's dominion over both the landscapes and indigenous inhabitants of the American West.

The grand, serene Palace of Fine Arts, situated at the western terminus of the main axis of the fair, flanking nine of the main exhibit palaces, was both the geographic and conceptual antipode to the boisterous Zone (see Kastner, this volume). Comprising a semicircular colonnaded exhibition building fronted by a rotunda and lagoon, the Palace of Fine Arts was conceived as a temple of high culture and as a peaceful respite from and alternative to the crowds and commotion of the fairgrounds. Bernard Maybeck, the building's architect, recalled, "When the Division of Fine Arts [director-in-chief John E. D. Trask] explained what he felt was necessary for a Fine Arts Palace, he said that he did not want the visitors to come directly from a noisy boulevard into collections of pictures, but on the contrary he wanted everybody to pass through a gradual transition from the exciting influences of the Fair to the quiet serenity of the galleries."[35]

Like the selection of the works on view inside the building, Maybeck's design for the Palace of Fine Arts emphasized the importance of Europe as the progenitor of American culture, and incorporated Greco-Roman and Italian Renaissance architectural influences—such as the thirty Corinthian columns that framed an open walkway. The magnificent domed rotunda at the center of Maybeck's architectural ensemble was conceived as a temple of the arts, complete with an altar—Ralph Stackpole's *Shrine of the Inspiration*—and various other sculptural and mural decorations that reinforced the concept of art and beauty as moral, spiritual, and civilizing forces. Also influenced by German Romanticism and the "vanished grandeur" of Giovanni Battista Piranesi's architectural engravings, Maybeck strove to convey a sense of mystery and melancholy; he wished to evoke the "sad, minor note" of "an old Roman ruin . . . partly covered with bushes and trees."[36] Ulric Ellerhusen's "weeping women"—larger-than-life female figures who lean, their backs to the viewer, against sarcophagus-like boxes atop the corners of the colonnade—heightened this sense of pathos.

FIG. 66
Richard Caton Woodville (American, 1825–1855),
War News from Mexico, 1848. Oil on canvas, 27 × 25
in. (68.6 × 63.5 cm). Crystal Bridges Museum of
American Art, Bentonville, Arkansas

FIG. 67
Thomas Hovenden (American, 1840–1895),
Breaking Home Ties, 1890. Oil on canvas,
52 ⅛ × 72 ¼ in. (132.4 × 183.5 cm). Philadelphia
Museum of Art, gift of Ellen Harrison
McMichael in memory of C. Emory McMichael,
1942, 1942-60-1

McLaren further enhanced the somber, reflective mood by populating the massive lagoon surrounding the Palace with papyrus plants and Japanese water lilies; incorporating a subdued palette and plants associated with melancholy, such as yews, cypresses, and weeping willows; and trailing myrtle and pillar roses up the columns to suggest the passage and destruction of time.

The lagoon, upon which Maybeck based his entire scheme, was intended as a meditative space where visitors could slow down and mentally prepare for the emotional experience of viewing art. After absorbing its beauty, fairgoers approached the Palace of Fine Arts via the 1,100-foot-long peristyle walk, which followed the western curve of the lagoon. According to Maybeck, his aim in designing the ensemble was to "convey the same impression to the heart and mind [of the viewer] as those impressions made by the works of art inside . . . [in order that] the mind of the visitor to the gallery is prepared as he enters for what he is to see."[37]

The exhibition that confronted viewers upon entering the main fine arts building was staggering in scope and scale. The estimated ten million visitors to the PPIE's fine arts display at the Palace of Fine Arts and adjacent Annex building met with 150 galleries containing more than eleven thousand paintings, sculptures, and works on paper by artists from the United States, Europe, Asia, and South America.[38] Trask solicited loans of works from public and private collections across the country and abroad to support the presentation of a cohesive and compelling display focused primarily on the development of the fine arts in the United States, but contextualized within a much larger,

multinational history of art. In keeping with the didactic thrusts of late nineteenth- and early twentieth-century museums, one of Trask's primary goals was to uplift viewers and improve their sense of culture, and he felt that together, the historical, contemporary, and global components of the exhibition would present an authoritative narrative of the history of Western art that would be both informative and ennobling for the public.[39]

The American section was by far the largest and most prominent of the thirteen national groupings (see fig. 159).[40] Displays from foreign nations were spread over fifty-four galleries, with no single nation allotted more than ten, while the United States grouping alone consisted of sixty-one galleries. Here, ranged roughly chronologically, were sculptures, paintings, and works on paper (as well as models, medals, plaques, and carvings) by American artists from the colonial period to the first decade of the twentieth century and by foreign artists who were thought to have influenced the development of American painting. In addition, one-man exhibition rooms displayed examples by nineteenth- and early twentieth-century American artists deemed particularly accomplished and noteworthy, and several contemporary galleries displayed pieces made after 1904. In all, there were more than 7,500 objects in the American section (including several sculptures placed on the grounds surrounding the exhibition palace)—well over half the total number of works exhibited (see Applegate and Shields, this volume).

Although it was staged nearly two years after the landmark New York Armory Show and was almost ten times as large, the Palace of Fine Arts

exhibition presented a far more conservative display, dominated by Impressionist and academic styles.[41] Trask's emphasis on constructing a retrospective view of American art and his desire to focus on contemporary works that were clearly the direct heirs of European Impressionism was in keeping with traditions established at previous world's fairs in the United States, in which organizers wished to demonstrate that America's competency in the arena of art was equal to that of Europe.[42]

By interspersing foreign with American works in the historical loan section, Trask sought to illuminate the origins of and influences on painting in the United States.[43] The starting point for this sequence was Gallery 91, which contained works by old masters from various European traditions described as "typical examples of certain factors of prime importance connected with the beginning of American art."[44] The adjacent Gallery 63 presented examples of British portraiture by artists such as Thomas Gainsborough, Sir Joshua Reynolds, George Romney, and Sir Henry Raeburn, which provided "a profitable acquaintance with the formative influences of our native painting. . . . It was the great Englishmen . . . whom we meet here who immediately inspired our first American artists—[John Singleton] Copley, [Gilbert] Stuart, [Benjamin] West, [Thomas] Sully and the others."[45] The adjoining Gallery 60 featured pieces by these Americans, with a particular focus on Copley and West, along with such pupils of West as Matthew Pratt, Charles Willson Peale, Gilbert Stuart, and John Trumbull.[46] This emphasis on the European influence on American art continued throughout the remaining historical loan galleries of the American section.

A spirit of ardent nationalism suffused much of the American art displayed in the historical loan section and many of the sculptures located outside the Palace of Fine Arts. Monumental statues placed near the entrance to the fine arts building celebrated heroic figures in US history: Paul Bartlett's *Lafayette* (1908–1915), Karl Bitter's *Thomas Jefferson*, Augustus Saint-Gaudens's *Seated Lincoln* (1897–1906), and Daniel Chester French's *Lincoln* (1911–1915).[47] Such history paintings as Emanuel Gottlieb Leutze's *Columbus Discovering America* (date and current location unknown) and genre paintings such as Thomas Hovenden's *Breaking Home Ties* (fig. 67), Eastman Johnson's *The Wounded Drummer Boy* (1871, Union League Club, New York), and Richard Caton Woodville's *War News from Mexico* (fig. 66) illustrated typically patriotic and sometimes sentimental scenes from American life. Landscape painting, particularly that of the Hudson River School, was well represented, with works such as Frederic Edwin Church's *Niagara* (fig. 76) praised as an example of the "national spirit in art."[48]

Ultimately, Trask's efforts to contextualize art in the United States within a larger narrative of European cultural development were nationalist in aim, as he viewed American artists as the inheritors of the torch of Western civilization, stating that "nowhere in the world today are professional painters and sculptors doing as vital work as they are in our own land."[49] Trask considered the galleries of "contemporary" American art as the "climax of the whole exhibition," where the superior cultural accomplishments of the United States would be truly manifest.[50] The artists shown in this section were chosen according to a dual method of both direct invitation and juried submissions, a controversial system

that tended to overlook younger, emerging artists in favor of those associated with established art schools, galleries, museums, and collectors.[51]

In general, the selection of works in the exhibition primarily expressed the taste of East Coast art communities, with limited input from West Coast–based jurors (with the exceptions of Eugen Neuhaus, Arthur Frank Mathews, Francis McComas, William Wendt, and Paul Gustin).[52] California artists were nonetheless well represented at the Palace of Fine Arts, with more than four hundred objects by eighty-eight painters, nine sculptors, and eighteen printmakers.[53] The absence of a separate regional gallery dedicated to California art appeared to some as a rejection of local artists by the fair organizers; the tensions culminated in an alternative exhibition held at the Memorial Museum in Golden Gate Park (now the de Young) titled the first "Annual Exhibition of Painting and Sculpture by California Artists." A few local artists, such as Charles Rollo Peters, refused to participate in the Palace of Fine Arts exhibition, and showed work only at the Memorial Museum.[54]

Many living artists exhibited at the Palace of Fine Arts competed for awards within what came to be known as the Skiff System, named for Dr. Frederick Skiff, director in chief of the PPIE, who created a broad network of exhibits at the fair.[55] The American Impressionist painter Frederick Carl Frieseke won the grand prize. Among his entries was *Summer* (fig. 77). The painting, which depicts a nude woman reclining on a riverbank, bathed in dappled sunlight, shows the marked influence of both the French Impressionist Pierre-Auguste Renoir and the Post-Impressionist Pierre Bonnard. The critic Christian Brinton noted the rather superficial, albeit aesthetically pleasing, qualities of Frieseke's work, writing, "By no means profound, or divulging any disquieting depth of feeling, his canvases are nevertheless captivating in their sheer, bright-toned beauty."[56] That Frieseke was accorded the highest honor reflected the jury's relatively conservative preference for American Impressionism, the predominant style exhibited at the Palace of Fine Arts, which, in 1915, was a far cry from the aesthetic vanguard that had greeted the American public at the 1913 Armory Show.

Another gauge of the taste of fair organizers could be found in the single-artist galleries, which strategically flanked both the main entrance to the Palace and the historical loan section, emphasizing their importance to the exhibition as a whole. These galleries featured works by select American artists deemed masters of their genres, most of whom were already established and mature in their styles, which tended toward academic realism, Impressionism, or an art-for-art's-sake aesthetic. James McNeill Whistler was heavily represented, with two galleries comprising a total of sixty-three paintings and prints, as was Frank Duveneck, with forty-four works. Four of the remaining artists given one-man galleries were members of the American Impressionist group known as "The Ten" (Childe Hassam, William Merritt Chase, Edmund Charles Tarbell, and John Henry Twachtman); the American Impressionist Edward Willis Redfield also a had one-man gallery. Out of the sixteen galleries devoted to individual artists, two were given to California-based artists William Keith and, sharing a room, Arthur Frank Mathews and Francis McComas.[57]

In contemporary critical accounts of and guidebooks to the galleries of the Palace of Fine Arts, American artists were often discussed in terms of the foreign schools or influences with which their works were associated, but with an emphasis on their originality and ultimate independence from these traditions. While works by French Barbizon and Impressionist painters were displayed to illuminate the influence of European painting on the development of Tonalist and Impressionist styles in the United States, commentators again took pains to emphasize that the American artists associated with these styles were not derivative. George Inness, for example, was described as no "mere imitator . . . [but a] pathfinder whose originality and fiery zeal for nature blazed a new trail that has led to the notable expansion of American landscape painting."[58] In the official *Catalogue de Luxe of the Department of Fine Arts*, J. Nilsen Laurvik wrote, "It is . . . not at all surprising to find that the genius of American art achieves its most characteristic and truly national expression in landscape painting. While acknowledging its indebtedness to foreign models, in this as well as in all other branches of artistic endeavor, it cannot be denied that here America is in a fair way of winning artistic independence, and to-day its landscape painters need to defer to no one."[59] These sentiments are echoed in another profusely patriotic contemporary text, Michael Williams's aptly titled "A Pageant of American Art," in which he asserted that, "although American art is necessarily synthetic it has begun to master the synthesis; it has begun to play with the results of its lessons and influences from abroad; it has begun to create vigorously and boldly instead of imitating dully and dutifully."[60] Williams added that the one-man galleries most dramatically illustrated the notion "that true Americanism in art is the emergence of unique individualities from a soil of sympathetic influences and ideas."[61]

Fascinatingly, the language used by critics such as Laurvik and Williams to describe the American works on view at the Palace of Fine Arts reflects the imperialist and nationalist rhetoric invoked in the general Exposition literature to glorify the United States and its Manifest Destiny to dominate the world stage. Laurvik described the artists of the Hudson River School as "pioneers in the best sense of the word. Like [Davy] Crockett and Daniel Boone, they opened up new vistas in the impenetrable jungle of American aesthetics."[62] Laurvik went on to praise the "individuality" and "robust, masculine vigor" in the work of Redfield; the "independent gait" of John Singer Sargent; the "true American audacity" of Whistler's art; and the "virile and homely Americanism" of the sculpture of John Quincy Adams Ward.[63] Similarly, Williams extolled the "pioneer message" of Theodore Robinson; the "varied and virile work" of the American Impressionists; and the "virile Americanism" of the Ashcan School artists Robert Henri and George Bellows, of which he wrote, "I affirm this quality. I dare to assert that it is the most American thing that has happened in art on this western continent. It closes the epoch of our dependence upon the elder world; it throws open the gates of the future, which is in the keeping of America. And those gates are golden."[64]

Unsurprisingly, critics also directed such boosterism toward the arts of

California. In "The Pageant of California Art," Williams wrote, "If it be true, and surely all these emphatic prophecies uttered by so many world-travelers, students, critics, and artists can not be wrong, that California is the Greece of the Western world, or its Italy, then it is of primary importance that its people, aroused as they are today to the public value of art, must understand that they have something to foster, guide, and direct with generous wisdom, for the sake of the rest of the nation."[65] Similarly invoking comparisons of the Golden State to the cultural centers of classical antiquity, architect Willis Polk wrote, "California is supremely endowed by nature for the development of art in all its phases. Here are the Rome and Athens of the new world."[66] Trask joined in this chorus, stating that he believed "the next great forward movement in the Fine Arts will center about the Golden Gate."[67] Such posturing echoed the general characterization at the PPIE of California—and specifically, San Francisco—as a "new frontier" poised to lead the future progress of the nation.

The imperialist and nationalist overtones at the Exposition were most manifest in the displays of large-scale public art. The murals and sculptures placed throughout the grounds abounded with allegorical imagery celebrating Western civilization's triumphant conquest of nature and nonwhite cultures. Director of sculpture Alexander Stirling Calder made these associations plain when he wrote, "Vitality and exuberance, guided by a distinct sense of order, are the dominant notes of the Arts of the Exposition, and pre-eminently of the sculpture. It proclaims in no uncertain voice that all is right with this Western world."[68] As Trask had done with the American works on view at the Palace of Fine Arts, Calder sought to situate the sculpture displayed throughout the fairgrounds within a larger history of Western art and culture. Disregarding California's Spanish Colonial, Mexican, and Asian roots and cultural influences,

he described "the many sources of inspiration of the Exposition sculptures" as "all European, as is, indeed, the source of our racial origins."[69]

The pairing of two prominent statues—Solon Hannibal Borglum's *The American Pioneer* (see fig. 68) and James Earle Fraser's *The End of the Trail* (see pls. 21–22 and fig. 69)[70]—reflected most overtly the fair's widespread glorification of the white conquest of native Californians. *The American Pioneer*, situated at the entrance to the Court of Flowers, portrayed a frontiersman astride a magnificently decorated prancing horse. A contemporary wrote of the sculpture, "The American Pioneer appears before us, reminding us that to him should be given the glory for the great achievements that have been made on the American Continent. He it was who blazed the trail that others might follow. He endured the hardships, carved the way across the continent, and made it possible for us of today to advance thru his lead. All hail to the white-headed, noble old pioneer who, with gun and axe, pushed his way thru the wilderness; whose gaze was always upward and onward, and whose courage was unfaltering!"[71]

In contrast to this celebratory symbol of America's Manifest Destiny, *The End of the Trail*—given pride of place at the center of the Exposition, in front of the Tower of Jewels in the Court of Palms, and directly opposite *The American Pioneer*—depicted a Native American man, slumped forward on his exhausted horse as though in defeat, his spear pointed downward toward the earth. Underscoring the symbolism of the work's title, the horse seems to have reached an impasse, and peers down over what appears to be the edge of a cliff. Among the most popular sculptures at the fair, *The End of the Trail* won the Exposition's gold medal for its medium, and the work was reproduced on the cover of numerous guides during the Exposition's closing ceremonies, bearing the word "Farewell." The sculpture and its reception by critics and the

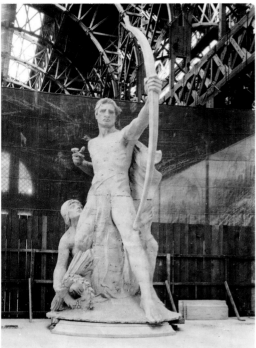

public served to reify the Exposition's central theme of Western supremacy and conquest. According to Fraser, he "sought to express the utter despair of this conquered people, a weaker race . . . steadily pushed to the wall by a stronger one."[72] Contemporary critics, who similarly described the sculpture in terms that fixed Native Americans as a "vanishing race," actively encouraged viewers to study and interpret the work in connection with *The American Pioneer*.[73]

The oppositions this pairing established—between nature and culture, wilderness and civilization, conquered and conqueror—were echoed in public works of art throughout the fair, such as the monumental sculptural groupings *Nations of the East* and *Nations of the West* by Calder, Leo Lentelli, and Frederick George Richard Roth, which symbolized the meeting of East and West brought about by the Panama Canal, and suggested the inevitable triumph of Western civilization. The groups contrasted figures meant to represent Asian, Middle Eastern, and African civilizations—many of whom were depicted as servile, and who were described by fair chronicler Frank Morton Todd as being consigned to an "endless, fateful march"—with the confident, robust figures used to symbolize the West, whom Todd characterized as "hopeful, buoyant, and progressive" and expressive of "the thrusting heave of western ambition and progress."[74] These works also reinforced the narratives of Social Darwinism and Anglocentric evolutionary progress promoted by eugenics boosters and reflected in the racialized displays along the Zone.[75]

Such historic "conquests" as the settling of the American frontier served as the precedents and models for the kinds of imperialist expansions—most notably, the construction of the Panama Canal—that were promoted visually and rhetorically at the fair. Among the most prominent of the monuments

celebrating America's rising stature as an imperial power, newly expanding its reach across the Pacific Ocean, was the Column of Progress, topped by Hermon Atkins MacNeil's *The Adventurous Bowman* (figs. 70–71). In the sculpture, an allegorical figure of a male nude, described by a contemporary as a man of "splendid daring, of consummate achievement . . . [who] has striven and has reached the top," gazes to the West, where he has shot an arrow and with "confident eye . . . looks to see it hit the mark." A female nude at his side prepares to hand him a laurel wreath to signify his incipient victory.[76] The positioning of the sculpture near the entrance to the harbor underscored the theme of maritime expansionism celebrated at the fair, and drew viewers' attention to the myriad displays of military might staged there throughout the run of the Exposition.[77]

The preponderance of fountains throughout the fairgrounds further underscored these aquatic associations with empire. Topped by a male nude known variously as Energy, the Lord of the Isthmian Way, and the Victor of the Canal—whose extended arms symbolized the parting of lands needed to join the waters of the Atlantic and the Pacific—Calder's *Fountain of Energy* (see fig. 72) was hailed as "a joyous triumph celebrating the completion of the Panama Canal,"[78] which embodied "the qualities of force and dominance that had ripped a way across the continental divide for the commerce of the world."[79]

Many of the murals commissioned for the Exposition reiterated the themes of Western superiority and imperial expansionism, most notably William de Leftwich Dodge's two massive triptychs presenting allegories of the construction of the canal, which decorated the walls of the arcade through which visitors could pass through the Tower of Jewels to the Court of the Universe. The 2015 de Young exhibition *Jewel City: Art from San Francisco's Panama-Pacific International*

Exposition features one of these, *Atlantic and Pacific* (pl. 26), the central painting of the triptych that adorned the west wall of the Tower Gate.[80] In the mural a central male form personifying the canal stands between two figural groupings. To his left, and associated with the Atlantic, is a group of hardy pioneers and laborers, pulled forward by an oxcart—symbols, as elsewhere at the fair, of the West—who are described as "discoverers and adventurers."[81] To his right is the group that represents the Pacific, with figures garbed in costumes traditionally associated with the East, and described disparagingly as "types of tribes who followed the discoverer"—suggesting their secondary and subservient role to the Western explorers.[82]

Collectively, Dodge's murals were said to "give one a feeling of the spiritual and racial significance of the Panama Canal," and were credited with interpreting the "history, spirit, and achievement of the Panama Canal and its lasting signif-icance as a bond through which the Orient, rich in its splendors and seemingly entrenched in its traditions of thousands of years, meets the West, adventurous, pushing forward, and ready to exchange its arts and achievements for those of the mystic East."[83] This characterization of Eastern culture as "entrenched" and mired in the past, ripe for domination by the forward-looking West, was the pervasive and lasting message imparted by the Exposition, communicated forcefully through the large-scale murals and statuary at the fair.

The Panama-Pacific International Exposition is certainly not unique within the long tradition of American world's fairs in its celebration of a significant event of national import; promotion of the host city and nation through displays of the fine arts and the latest mechanical and industrial inventions; and use of monumental and historicizing architecture and public art to affirm national ambitions. Yet its focus on a contemporaneous event with such global implica-tions was anomalous at the time. The "meeting of East and West" engendered by the opening of the Panama Canal became a central focus in the rhetoric and marketing of the fair, and hopes ran high that the Exposition would promote peace and harmony among nations—a goal that took on greater urgency and significance after the outbreak of the First World War. As the director of domestic exploitation (the publicity department of the fair) wrote to Michigan governor Woodbridge Ferris on January 15, 1913, "The Exposition will mark the beginning of a closer fellowship and a better understanding with all Nations and all peoples and, what is equally desirable, the east will come to know the truth about the west and the west will exchange realities for fiction concerning the east. A representation of all states will surely lead to the elimination of old prejudices based on misinformation and be the beginning of a new and better understanding among (them)."[84]

Despite such lofty aspirations for the PPIE to serve as a unifier of nations and cultures, in reality the Exposition perpetuated many of the nativist, xenophobic, and provincial attitudes that were then pervasive in California—and across the country—rather than truly acknowledging and celebrating the multicultural heritage of the Bay Area, and fostering peace with and understanding of Eastern nations and cultures. While base attitudes about race and culture were crudely flaunted at lowbrow areas such as the Zone, the architectural ensembles and displays of fine art at the fair—both large-scale outdoor commissions, and the presentation of American art at the Palace of Fine Arts—converged to construct "an enduring vision of empire," in which the cultural achievements of the nation were paraded to promote and justify America's preeminence on the world stage.[85]

1. Sarah J. Moore, "Manliness and the New American Empire at the 1915 Panama-Pacific Exposition," in *Gendering the Fair: Histories of Women and Gender at World's Fairs*, eds. T. J. Boisseau and Abigail M. Markwyn (Urbana: University of Illinois Press, 2010), 76.

2. This kind of ideological drumbeating is certainly not unique to the PPIE; it is characteristic of world's fairs, which served to glorify the achievements of the respective host cities and nations. See Robert Rydell, *All the World's a Fair: Visions of Empire at American International Expositions, 1876–1916* (Chicago: University of Chicago Press, 1984).

3. The eleven thematic palaces of the PPIE were: the Palace of Fine Arts, Palace of Agriculture, Palace of Transportation, Palace of Mines and Metallurgy, Palace of Machinery, Palace of Varied Industries, Palace of Manufactures, Palace of Liberal Arts, Palace of Education and Social Economy, Palace of Horticulture, and the Palace of Food Products.

4. In 1904 progressive city leaders commissioned Burnham, the architect and director of the Columbian Exposition, to design a plan for San Francisco. Burnham envisioned a "hilly Paris by the Golden Gate," inspired by Georges Eugène Haussmann's Paris and Pierre L'Enfant's Washington, DC. Burnham's plan had not yet been implemented when the earthquake of 1906 struck, causing a massive fire that devastated much of the city. Following the disaster, the city decided to rebuild quickly on old property lines rather than follow Burnham's costly and labor-intensive plan.

5. George Kelham, chief architect of the Exposition, explained, "If we have succeeded in combining art and nature so that each seems a part of the other, in bringing the wonderful Bay of San Francisco into our picture, in making our great group of buildings nestle into their surroundings both in form and color, then the real meaning of what we have tried for is made clear." George Kelham, "Will the Panama-Pacific International Exposition Be an Architectural Influence?" *Pacific Coast Architect* (May 9, 1915): 59.

6. Guérin coordinated the color of all the design elements at the fair in shades of terra-cotta, ivory, cerulean blue, gold, green, and rose. The extensive use of color at the PPIE was in stark contrast to previous world's fairs, notably the Chicago world's fair, which was dubbed "The White City" for its monochrome faux-marble exteriors.

7. The central and largest of the principal courts, the Court of the Universe, depicted scenes illustrating civilization's progress from east to west; the Court of the Four Seasons incorporated symbolism representing the conquest of nature by mankind; and the Court of Abundance (Court of Ages) featured the Tower of Ages, with imagery tracing the evolutionary progress of mankind. See Sarah J. Moore, *Empire on Display* (Norman: University of Oklahoma Press, 2013), 115.

8. Moore, *Empire on Display*, 108.

9. The Philippines Educational Exhibit contained displays illustrating "what had been going on to elevate life in the islands since the United States took control." Frank Morton Todd, *The Story of the Exposition: Being the Official History of the International Celebration Held at San Francisco in 1915 to Commemorate the Discovery of the Pacific Ocean and the Construction of the Panama Canal* (New York: G. P. Putnam's Sons, 1921), 4:49.

10. The Palace of Machinery, which was modeled after the Roman baths of Caracalla and contained more than two thousand displays, was the site of the first indoor flight, by aviator Lincoln Beachey.

11. Homer S. King, "California's Exposition Ambitions," *Sunset*, December 1910, 623.

12. Rydell, *All the World's a Fair*, 219.

13. Ibid., 3.

14. Ibid., 236.

15. Ibid., 209. Exposition publicity downplayed California's indigenous, Spanish, and Mexican heritages in an attempt to make the state seem more Anglicized and thus appeal to white tourists and potential settlers.

16. Espoused most notoriously by the Nazis later in the century, eugenics was one aspect of a broader argument for Social Darwinism, whose proponents sought to apply Darwin's biological theory of "survival of the fittest" (a term coined by British biologist and philosopher Herbert Spencer) to politics, economics, and social development.

17. Czech anthropologist Aleš Hrdlička, from an address read in 1915 at the meeting of the American Association for the Advancement of Science, "Eugenics and Its Natural Limitations in Man," *Science*, n.s., 42 (October 15, 1915): 546.

18. In 1914, a few months before the fair opened, a record-high 1,218,480 immigrants entered the United States.

19. Grassroots campaigns such as the "better babies" contests held at county fairs throughout the country in the first decades of the twentieth century reflected this national obsession with racial purity.

20. In 1850 California enacted one of the earliest antimiscegenation laws in the nation. Furthermore, in 1909 it was the third state in the country to pass a sterilization law. By 1921 California was responsible for eighty percent of all sterilizations nationwide.

21. Alexandra Stern, *Eugenic Nation: Faults and Frontiers of Better Breeding in Modern America* (Berkeley: University of California Press, 2005), 55.

22. Race Betterment Table, "The Race Betterment Movement Aims," *Official Proceedings*, 147; quoted in Todd, *Story of the Exposition*, 4:39.

23. Cited in Wendy Kline, *Building a Better Race: Gender, Sexuality, and Eugenics from the Turn of the Century to the Baby Boom* (Berkeley: University of California Press, 2001), 141.

24. Ansel Adams, with Mary Street Alinder, *Ansel Adams: An Autobiography* (Boston: Little, Brown, 1985), 18.

25. A ninety-foot-tall wooden caricature of a suffragist beating a drum and waving a flag stood at the entrance to Toyland Grown Up. Due to concerns that the name "Panama Pankaline Imogene Equalrights" would offend women, fair directors dubbed her Little Eva. One of the most popular (and scandalous) attractions along the Zone was Stella, a massive lifelike painting of a seminude woman lit in such as way as to appear to be breathing. Further titillation was available to male spectators from the numerous scantily clad female workers at the concessions along the Zone, who played a central role in conveying a romanticized and sexualized image of an exotic "other."

26. *Panama-Pacific International Exposition Booklet no. 1*, 2nd ed. (1915), archives of the California Society of Pioneers.

27. Rydell, *All the World's a Fair*, 236.

28. Todd, *Story of the Exposition*, 2:375.

29. "A City of Lovely Light," *San Francisco Examiner*, January 21, 1915, supplement.

30. Anthony W. Lee, *Picturing Chinatown: Art and Orientalism in San Francisco* (Berkeley: University of California Press, 2001), 171.

31. The revised name referred to the popular pastime among whites of visiting Chinatown in search of salacious and illicit amusement.

32. Rydell explains the complexities of China's involvement in the fair, "The nationalist revolution of 1911 and the subsequent creation of the Republic of China created a willingness of the Chinese to woo American capital; little surprise that the Chinese government, even in the face of California's anti-alien legislation, decided to participate in the Exposition." Rydell, *All the World's a Fair*, 228–229.

33. Cognizant of its potential to deter China and Japan from participating in the Exposition, fair organizers made a plea to the state legislature to wait until the fair had ended to pass the Alien Land Law, but despite their efforts the law passed in 1913 and remained in place until it was declared unconstitutional in 1952.

34. Interestingly, despite these negative depictions of Asian culture along the Zone, the PPIE was the first international world's fair at which China created its own exhibition halls and gallery. China also hosted exhibits in the Exposition's fine arts section.

35. Bernard R. Maybeck, *Palace of Fine Arts and Lagoon. Panama-Pacific International Exposition 1915* (San Francisco: Paul Elder, 1915), 3–4.

36. Ibid., 10.

37. Ibid., 12. Contemporary accounts described the Palace of Fine Arts in terms that emphasized its spiritual and poetic nature; one reviewer characterized it as "an island set amid a shimmering sea of colour, a haven where the spirit sought graceful repose." Christian Brinton, *Impressions of the Art at the Panama-Pacific Exposition* (San Francisco: Panama-Pacific International Exposition, 1915), 87.

38. I was greatly aided in my research for this section by Nancy M. Servis, "The Palace of Fine Arts Exhibition at San Francisco's 1915 Panama-Pacific International Exposition" (master's thesis, Hunter College of the City University of New York, 1991).

39. The educational efforts of the organizers were numerous: various written guides were disseminated, docents led visitors through the galleries, and artists and historians gave lectures.

40. Art was also displayed outside the Palace of Fine Arts, in pavilions belonging to states and foreign countries. An annex behind the main complex of the Palace of Fine Arts housed works by artists from countries excluded from official participation in the Palace of Fine Arts exhibition, often due to complications with the war. Known for its "esthetic rebellion," the international section of the Annex presented some of the most avant-garde works at the fair. In particular, the second-floor installation of Italian Futurism presented a dramatic counterpoint to the post-Victorian Beaux-Arts aesthetic celebrated at the fair. See James A. Ganz, Introduction, this volume.

41. There were some exceptions to the conservative styles that dominated the art program at the Palace of Fine Arts; see essays by Heidi Applegate and Scott A. Shields in this volume. The *International Exhibition of Modern Art* in New York in 1913, known as the Armory Show, was the first large-scale exhibition of modern art in the United States, and introduced the American public to European modernists such as Marcel Duchamp, Wassily Kandinsky, Henri Matisse, and Pablo Picasso; to movements such as Impressionism, Fauvism, Cubism, Orphism, Synchromism, Symbolism, and Expressionism; and to work by American modernists. Although some artists were included in both the Armory Show and the PPIE, the overlap totaled no more than thirty works.

42. The fine arts traditionally played a critical role at world's fairs, beginning in this country with the 1876 Philadelphia Centennial Exposition, which was the first American fair to formally present the visual arts to the public. Trask situated the PPIE within a long line of world's fairs: "Let it be hoped that, as the Centennial Exposition in Philadelphia awakened the aesthetic sense in the East, as the Chicago Exposition of 1893 revived the artistic life in the Middle West, that the San Francisco Exposition of 1915 prove to be the real starting point of a growth of the love of beauty in the West, where every element of beauty now exists, needing only the fusing influence of man's endeavor to make it man's servant for better and higher things in social life." John E. D. Trask, "The Department of Fine Arts at the Panama-Pacific International Exposition," in Bruce Porter et al., *Art in California: A Survey of American Art with Special Reference to Californian Painting, Sculpture, and Architecture, Past and Present, Particularly as Those Arts Were Represented at the Panama-Pacific International Exposition.* (San Francisco: R. L. Bernier, 1916), 87–88.

43. Trask wrote, "In the loan collection, in order that the popular error of supposing that the American artist of today is without ancestry of tradition may be refuted, there will be a chronological historical showing of American painting and sculpture conveying the period from Colonial and Revolutionary times down to the years just preceding our own . . . there will be shown also a collection of foreign works (not contemporaneous) arranged by schools, which will, as fully as the Department's powers permit, make clear what their influence has been on the Fine Arts in America, and at the same time, serve as a sort of index to the vast wealth of our public and private art collections." *Circular of Information, Panama-Pacific International Exposition, San Francisco, 1915, Department of Fine Arts* (San Francisco, 1914).

44. Michael Williams, *A Brief Guide to the Department of Fine Arts: Panama-Pacific International Exposition, San Francisco, California, 1915* (San Francisco: Wahlgreen, 1915), 10.

45. Ibid., 11.

46. Many of these artists studied in England, where they absorbed the Grand Manner portrait tradition and brought it back to the United States, depicting American Federalists rather than aristocratic British subjects.

47. These sculptures were produced in multiple editions, making them difficult to trace in current collections.

48. Williams, *Brief Guide*, 23.

49. John E. D. Trask, "The Influence of World's Fairs on the Development of Art," *Art and Progress*, February 1915, 116.

50. "Mr. Trask's Letter," *American Art News*, July 18, 1914, 2.

51. Most American artists in the exhibition had to submit work to a jury for selection; however, some who were considered outstanding were exempt from the jury process and were invited to show work. Objections to this seemingly dual approach were expressed in the contemporary press. Trask and Charles Vezin, president of New York's Salmagundi Art Club, exchanged heated letters on the topic that were published in *American Art News* in the summer of 1914. See note 50 above.

52. For a complete list of jury members, see John E. D. Trask and J. Nilsen Laurvik, eds., *Catalogue de Luxe of the Department of Fine Arts, Panama-Pacific International Exposition* (San Francisco: Paul Elder, 1915), 1:137.

53. Among the California artists who received awards were: H. J. Breuer (gold); Carl Oscar Borg, E. Charlton Fortune, Armin Hansen, Clark Hobart, Henry V. Poor, and Mary C. Richardson (silver); Anne M. Bremer, Maynard Dixon, Perham Nahl, and Gertrude Partington (bronze); and Pedro J. de Lemos and Xavier Martinez (honorable mention).

54. According to a contemporary account, "There has been, of course, a great deal of smoldering discontent among local and coast artists generally because of what many of them assert is the unjust and summary treatment accorded them by the Exposition. This discontent has been fanned from the smoldering condition to one of active revolt culminating in an exhibition by the artists whose works were rejected at the Exposition, and by others who refuse to send their works at all." *American Art News*, May 15, 1915, 7.

55. The International Jury of Awards granted the awards in six levels: grand prize; medal of honor; gold, silver, and bronze medals; and honorable mention. Out of 820 total awards, 386 went to American artists, followed by 101 for Japan and 37 for China. In the US section, the highest honors went to Frieseke and Duveneck; nine other American artists received standard medals of honor in painting: John White Alexander, Cecilia Beaux, Emil Carlsen, Walter Griffin, Willard Metcalf, Richard E. Miller, Violet Oakley, Lawton Parker, and W. Elmer Schofield. The three sculptors who received highest honors were Herbert Adams, Karl Bitter, and Daniel Chester French.

56. Christian Brinton, *Impressions of the Art*, 97.

57. John Singer Sargent, Gari Melchers, Howard Pyle, John McClure Hamilton, and Joseph Pennell also received one-man galleries. Many of these artists were given separate essays written by J. Nilsen Laurvik in the fair's *Catalogue de Luxe*. Other American artists deemed seminal but not awarded a "one-man gallery"—including Edwin Austin Abbey, John La Farge, Theodore Robinson, and Winslow Homer—were given full-wall displays. Against Skiff's recommendation, Trask also included a special gallery with the work of women artists. See Applegate, this volume.

58. Williams, *Brief Guide*, 25.

59. J. Nilsen Laurvik, "Edward W. Redfield," in *Catalogue de Luxe*, ed. Trask and Laurvik, 1:36.

60. Michael Williams, "A Pageant of American Art," *Art and Progress*, August 1915, 338. In the essay, Williams writes that the Palace of Fine Arts exhibition brought "America face to face with the pageant of its art; showing the people the place of art in their national forces; vividly recalling the past, emphasizing the ideas and tendencies of the present, and throwing open the vistas and gateways of the future." (340).

61. Ibid., 344. Similarly, Laurvik used the term "assimilative" to describe the work of John Singer Sargent, John Henry Twachtman, and William Merritt Chase, but emphasized these artists' independence from and transcendence of foreign influences. *Catalogue de Luxe*, ed. Trask and Laurvik, 1:13.

62. *Catalogue de Luxe*, ed. Trask and Laurvik, 1:13.

63. Ibid., 38, 41, 48, 54.

64. Williams, "A Pageant of American Art," 331–333, 347. Nancy Boas notes that Bellows, one of the most popular American artists at the time, was represented by only four works at the PPIE to minimize any "rawness" that might have offended conservative viewers. Nancy Boas, *The Society of Six California Artists* (Berkeley: University of California Press, 1997), 67.

65. Michael Williams, "The Pageant of California Art," in Porter et al., *Art in California*, 52.

66. Willis Polk, "A Brilliant Future for American Art," in Porter et al., *Art in California*, 77.

67. John E. D. Trask, "The Department of Fine Arts," 82. Trask's comments about the arts in California were not always glowing; in another instance he wrote that the California presentation showed that artists in the state were "lacking in their own innovations in art not having derived their inspiration from their native landscape" (88).

68. Alexander Stirling Calder, quoted in Stella G. S. Perry, *The Sculpture and Mural Decorations of the Exposition* (San Francisco: Paul Elder, 1915), 6.

69. Ibid., 5.

70. *The American Pioneer* is no longer extant. The National Cowboy and Western Heritage Museum in Oklahoma City owns the 1915 plaster version of *The End of the Trail* exhibited at the PPIE; reproductions of the sculpture exist in various collections.

71. Juliet James, *Sculpture of the Exposition Palace and Courts* (San Francisco: H. S. Crocker, 1915), 30.

72. James Earl Fraser, quoted in Dean Krakel, *End of the Trail: Odyssey of a Statue* (Norman: University of Oklahoma Press, 1973), 3.

73. See Elizabeth Gordon, *What We Saw at Madame World's Fair* (San Francisco: Samuel Levinson, 1915), 44; and Eugen Neuhaus, *The Art of the Exposition: Personal Impressions of the Architecture, Sculpture, Mural Decorations, Color Scheme and Other Aesthetic Aspects of the Panama-Pacific International Exposition* (San Francisco: Paul Elder, 1915), 32.

74. Todd, *Story of the Exposition*, 2:302.

75. For a discussion of *Nations of the West* and American eugenics, see Elisabeth Nicole Arruda, "The Mother of Tomorrow: American Eugenics and the Panama-Pacific International Exposition, 1915" (master's thesis, San Francisco State University, 2004).

76. James, *Sculpture of the Exposition*, 56.

77. These included mock ship battles, yacht racing, and exhibitions by submarines and hydroplanes. See Moore, *Empire on Display*, 113.

78. *Official Guide of the Panama-Pacific International Exposition 1915* (San Francisco: Wahlgreen, 1915), 21.

79. Todd, *The Story of the Exposition*, 2:310. For a discussion of the gendered symbolism of such artworks, see Moore, *Empire on Display*, 107–108.

80. The facing triptych, installed on the east wall, presented *The Gateway of All Nations* and pictured the colossal locks of the canal opening, flanked by *Labor Crowned* and *Achievement*.

81. Jessie Niles Burness, *Sculpture and Mural Paintings in the Beautiful Courts, Colonnades, and Avenues of the Panama-Pacific International Exposition at San Francisco 1915* (San Francisco: Robert A. Reid, 1915), n.p.

82. Ibid.

83. Hamilton Wright, "Mural Decorations at the Panama-Pacific International Exposition," in Porter et al., *Art in California*, 132.

84. Director of domestic exploitation George Hough Perry, Panama-Pacific International Exposition, to Governor Woodbridge Ferris, January 15, 1913. San Francisco History Center, San Francisco Public Library.

85. Rydell, *All the World's a Fair*, 237.

JEWELS OF LIGHT AND COLOR:
AMERICAN PAINTING IN THE
PALACE OF FINE ARTS

When visitors arrived at the gates of San Francisco's Panama-Pacific International Exposition (PPIE) in 1915, they immediately knew that they were in for something different. This was no Great White City, as the 1893 Chicago World's Columbian Exposition had been. This exposition, the grandest to date in the American West, was filled with the light and colors of California. The main entrance at the foot of Scott Street boasted a living wall of vivid, flowering ice plant, suggesting the oasis of colors waiting inside, and through the gates the spectacular Tower of Jewels beckoned (see pls. 7–8). Ornamented with more than 100,000 colorful glass Novagems—faceted, mirror-backed jewels that oscillated and sparkled in the sun—the building cast a flickering radiance that was "dazzling and joyous."[1] At night, the 435-foot-tall tower continued to scintillate, illuminated by twenty colored searchlights. Under its great arch, enormous murals by New York artist William de Leftwich Dodge conveyed the impetus and theme of the fair, which officially celebrated the completion of the Panama Canal. The Exposition also repositioned San Francisco as an economic and cultural leader following the earthquake and fire of 1906.

Artist Jules Guérin developed the Exposition's boldly exotic color scheme, composing it in complementary arrangements of copper green and Pompeian red, and sky blue and poppy orange. Guérin, the first official director of color and decoration for an international exposition, conceived his plan as a contrast to the aesthetic program that other fairs, most notably Chicago, had pursued. The hues were meant to reflect the surrounding landscape. "I saw the vibrant tints of the native wild flowers, the soft browns of the surrounding hills, the

gold of the orangeries, the blue of the sea," he explained, "and I determined that, just as a musician builds his symphony around a motif or chord, so must I strike a chord of color and build my symphony on this."[2]

Guérin also kept color in mind in his choice of building materials.[3] Most official buildings, not meant to be permanent, were convincingly clad in simulated travertine, which was warm in tone and included "accidental effects" of weather and age. Faux-marble accents contributed deeper colors. "Glaring white, with its many ugly and distracting reflected lights," was consciously absent, a decision especially pleasing to artists.[4] Abundant and carefully calculated plantings brought additional seasonal color and softness to the program, with John McLaren, Golden Gate Park's landscape architect, designing the grounds and determining the selection and placement of trees, shrubs, and flowers. Throughout, architects, sculptors, gardeners, painters, and artisans worked in a unified spirit of "disciplined subordination," each contributing to an overarching plan that was inspiring in effect.[5] Though a few critics objected to the artificial colors of the architecture, the vast majority praised the Exposition as the most beautiful to date, in large part due to its abundant hues. Author Mary Austin described it as a richly patterned splendor "of poppies, of lupines, of amber wheat, of rosy orchard, and of jade-tinted lakes . . . as bright as an Indian blanket."[6]

Many artists depicted views of the fair's beautiful grounds (see fig. 7 and pls. 6–14), and they were charmed particularly by Bernard Maybeck's dreamily evocative Palace of Fine Arts, which featured inside an international array of paintings, sculpture, and graphics, in some cases by these same artists.[7] Resembling an

overgrown "Roman ruin," Maybeck's building appropriately found its inspiration in painting, specifically Jean-Léon Gérôme's *Chariot Race* (fig. 73) and, to a lesser degree, one of Arnold Böcklin's paintings of the Island of the Dead (see fig. 39).[8] By day, the building's pale-green peristyle, ocher columns, red gallery wall, and orange rotunda contributed to the fair's palette. At night, the rich blue of evening and the golden, artificially lit colonnade evoked the magical art of Maxfield Parrish, which artist Colin Campbell Cooper exploited in paintings of the building (see fig. 74).

The combination of classicizing architecture and a progressive approach to illumination and color was not unlike the paintings displayed within, many of which were traditional in their iconography but colorful, light filled, and painterly in treatment. The same was true of the murals by New York Impressionist Robert Reid that ornamented the interior of the Palace's rotunda (see fig. 75). Four irregularly shaped panels featured the ideals, inspirations, and origins of art (both in Europe and Asia),[9] and another four presented the Golden State's namesake color through four California golds (metal, wheat, citrus, and poppies). Dynamic and vivid, though not universally acclaimed, the murals nevertheless hinted at the dizzying chromatic abundance that visitors could expect to see inside.[10]

The Palace itself housed 120 galleries, and an accompanying annex held another 30. In the main building, sixty-one of the galleries featured art that was American in origin. The rest, with the exception of six administrative spaces, were devoted to the art of other countries. For the most part, the European galleries displayed nineteenth- and early twentieth-century works, which included a cross section of important artistic trends, though predominantly in well-established styles. Fewer than fifty paintings by French Impressionists were shown, and most of these were housed in Gallery 61. A wall of seven canvases by Claude Monet and four paintings by Pierre-Auguste Renoir offered examples of quintessential Impressionism, whereas Camille Pissarro's three contributions and one of Alfred Sisley's three pieces leaned more toward Pointillism.[11] Other artists, mostly Frenchmen, shared the space, including Pierre Puvis de Chavannes, whose *A Vision of Antiquity—Symbol of Form* was a crowd favorite (pl. 142).

Though the art in this and most of the other galleries of the Exposition was pleasing and palatable to the general public, there were some pieces for which the uninitiated visitor was "cruelly unprepared."[12] Pointillist paintings, works by the Nabis, portraits by Oskar Kokoschka, and fifty-seven prints by Edvard Munch mystified many, but nothing primed the masses for the gallery of Italian Futurists. While most visitors held unfavorable opinions of the Futurists' radical approach, an occasional voice emerged in their favor. "They have truly given the visitor something to look at, something to think of, something to puzzle over," wrote reviewer and docent Rose V. S. Berry. "It is good they are here, the public would have missed this ultra-modern experience altogether but for this."[13]

However, it was the American artists who truly dominated the Exposition, and their galleries seemed "businesslike and very democratic" compared to

FIG. 73
Jean-Léon Gérôme (French, 1824–1904), *Chariot Race*, 1876. Oil on cradled panel, 34 × 61 ⅜ in. (86.3 × 156 cm). Art Institute of Chicago, George F. Harding Collection, 1983.380

FIG. 74
Colin Campbell Cooper (American, 1856–1937), *Palace of Fine Arts, San Francisco*, 1916. Oil on canvas, 40 ⅜ × 50 ⅜ in. (102.7 cm × 128.1 cm). Crocker Art Museum, Sacramento, gift of Helene Seeley in memory of Mr. and Mrs. C. C. Cooper, conserved with funds provided by Gerald D. Gordon and Louise and Victor Graf, 1940.24

FIG. 75
Interior of the rotunda, Palace of Fine Arts, showing murals by Robert Reid, ca. 1915. Photograph by Gabriel Moulin. San Francisco History Center, San Francisco Public Library

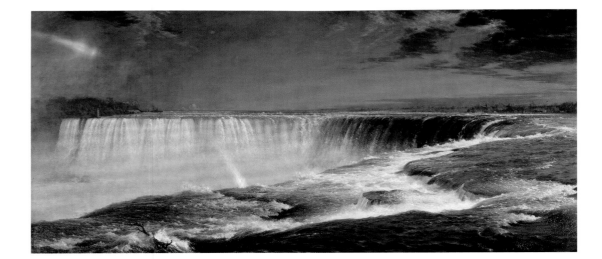

FIG. 76
Frederic Edwin Church (American, 1826–1900),
Niagara, 1857. Oil on canvas, 40 × 90 ½ in.
(106.5 × 229.9 cm). National Gallery of Art,
Washington, DC, Corcoran Collection (Museum
Purchase, Gallery Fund), 2014.79.10

those of foreign nations, "without all the frills and fancies."[14] American artists included those who were historical, those who were established, and those who were emerging, and their approaches ran the gamut from static portraiture by colonial limners to gritty, painterly productions by artists of the Ashcan School. There were landscapes by Hudson River School painters; genre and academic scenes of American life and mythology; productions of the Düsseldorf, Munich, and Barbizon schools; European scenes painted abroad by expatriates (see pl. 60); and imposing depictions of the American West rendered both by artists who lived there and those, such as Arthur Wesley Dow, who only visited (see pl. 76). There were also portraits of famous and not-so-famous men, and numerous depictions of women. The latter included not only portraits, but also idealized images of mothers with children, nudes, allegorical depictions, and, most often, fashionably dressed "adornments" that idled within domestic interiors and landscapes. Sculpture occupied the interiors of most of the rooms, and there were galleries dedicated to prints, but crafts and decorative arts (with the exception of a small display of Louis Comfort Tiffany's metalwork in Gallery 71) occupied other buildings. The same was true for other nations' galleries, except for those of China and Japan, where decorative arts were held in equal esteem and thus on par with other genres.

In a spirit of "synthetic Americanism," artworks representing the East, the West, and places in between were hung side by side.[15] Gallery 47 included Southwestern subjects by Ernest Leonard Blumenschein and Eanger Irving Couse, Impressionist New York street scenes by Colin Campbell Cooper, and Post-Impressionist Belgian landscapes by the Californian-turned-expatriate Joseph M. Raphael (see pl. 57) who, like these other artists, exhibited pieces in more than one room. Many works in Gallery 64 were older, and these subjects were equally diverse. The Corcoran Gallery of Art lent Frederic Edwin Church's *Niagara*, his one painting in the Exposition (fig. 76), and Thomas Eakins exhibited six works, including *The Crucifixion*, *Portrait of Henry O. Tanner* (pl. 34), and *The Concert Singer* (pl. 36). These subjects shared space with and

provided contrast to Frederic Remington's Western paintings and sculptures, including *The Bronco Buster* (pl. 28). Similar juxtapositions appeared throughout. "The greatness of the San Francisco show is simply that it does show, more comprehensively and adequately than ever before, the whole of American art," wrote reviewer Michael Williams, "vividly recalling the past, emphasizing the ideas and tendencies of the present, and throwing open the vistas and gateways of the future."[16]

Though most galleries included work by an array of artists, many featured multiple pieces by a single practitioner. A wall of Winslow Homer paintings could be found in Gallery 54, including *The Artist's Studio in an Afternoon Fog* (pl. 29), lent by Maine architect John Calvin Stevens. Tonalist and Impressionist landscapes by Dwight William Tryon and Julian Alden Weir dominated Gallery 49 (see pls. 70–71). Gallery 57 memorialized three artists: the historicizing painter Edwin Austin Abbey, who was represented by twenty-two works (see pl. 32); the cosmopolitan John La Farge, who had five; and Theodore Robinson, whose "pioneer message of light and direct impressionism" was expressed by nine (see pl. 52).[17] Alson Skinner Clark took over much of Gallery 73 with his Panama Canal scenes (see pls. 2–3), which were perfectly in keeping with the impetus of the fair, but the gallery also included paintings by other progressive colorists such as brothers Reynolds and Gifford Beal (see pl. 68), Ernest Lawson of The Eight, and a promising young California woman, E. Charlton Fortune.

Women were, in fact, represented in most of the group galleries, but they also occupied a dedicated space of their own. Many of the women who exhibited there were Impressionists, such as Mary Cassatt, who displayed three paintings (see pl. 44), and Cecilia Beaux, who showed seven (see pls. 42–43) and garnered a medal of honor. Multiple works by New York's Ellen Emmet Rand and California's Mary Curtis Richardson, who respectively won a gold and a silver medal, commanded even greater attention. The especially popular *In the Studio* (pl. 45) by Rand depicted a little girl and her black cat; Richardson's image of a recumbent young mother and baby (fig. 88) appeared on an Exposition postcard.

Like these paintings, the majority of the American submissions were produced in the recent past, though these were generally more conservative stylistically than European works from the same era. Only a few progressed much beyond Impressionism, prompting Arthur Mathews, then San Francisco's leading painter, to admit that the "American is conservative in art . . . [and] does not take the new things until Europe or someone else has tried them out." [18] In Gallery 40, however, graphic watercolors by the American-trained Canadian David Brown Milne (see pls. 72–73) stood out in their silhouetted acknowledgment of the French Nabis, just as in Gallery 51 "sensational experiments" by Ashcan School artists Robert Henri (see pl. 38), John Sloan (see pl. 69), and William James Glackens (see pl. 74) shocked in their subject matter and paint handling. [19] In Gallery 120, equally bold canvases by George Bellows hung alongside progressive, sometimes controversial works by Guy Pène du Bois, Rockwell Kent, George Luks, Alfred Henry Maurer, Anne M. Bremer (see pl. 83), and others. Such modern contributions as paintings by the Futurists added "paprika and 'pep'" to the show, "stirring up interest, stirring up discussion, stirring up the opposition of academicism—and stirring up rows!" [20]

Most of the American paintings at the Exposition were Impressionist in style, reflecting the aesthetic's dominance nationwide. Practiced by artists working in the major urban art centers of New York, Boston, Philadelphia, and San Francisco, Impressionism also appeared in varying forms in the production of smaller art colonies, including those in Old Lyme, Connecticut (Harry Leslie Hoffman and Edward Francis Rook, see pls. 62–63); New Hope, Pennsylvania (Daniel Garber, see pl. 66); Brown County, Indiana; Taos, New Mexico; and the Monterey Peninsula in California (Bruce Nelson, see pl. 81). Indicated not only by the overall number of Impressionist works shown, the primacy of Impressionism was further reinforced by the fact that the majority of artists accorded their own galleries practiced variants of the style (at least at some point in their career), and that Impressionist paintings garnered a disproportionate share of the prizes. Most gold, silver, and bronze medals were given to Impressionist productions, and the top awards in oil painting—the medals of honor—were claimed by Beaux, John White Alexander, Emil Carlsen, Walter Griffin, Willard LeRoy Metcalf, Richard E. Miller, Violet Oakley, Lawton Silas Parker (see pl. 55), and W. Elmer Schofield, most of whom worked in the style.

In painting, Frederick Carl Frieseke was the overall grand-prize winner from the United States and a leading Impressionist, representative of the new "Paris group" that included medal-of-honor winners Griffin, Miller, and Parker, as well as Max Bohm and Henry Ossawa Tanner, who both won gold. Frieseke earned the top prize for his group of eight paintings, which Exposition chronicler Eugen Neuhaus, chairman of the advisory committee for the West and a member of the International Jury of Awards, described as "jewels of light and color" that expressed the "best tendency" of the day (see figs. 77 and 95 and pl. 54). [21] Reviewer Michael Williams also lauded Frieseke's Impressionism, but suggested it was not so much of the present day but "the last word in the style that was modern before the Modernists came along." [22] Other American Impressionists shared Frieseke's gallery (see fig. 78), including Theodore Earl Butler and Louis Ritman, the latter winning a silver medal, as well as the Californians Clark Hobart (see pl. 80), Nelson, and Fortune (see pl. 82), who each took home silver. [23]

But many of the artists shown were not allowed to compete for prizes, having been declared *hors concours* because they were jurors, because they had received the highest honors at previous international expositions, or because they were among the dozen-plus artists already honored with their own galleries. Frank Duveneck was both a member of the International Jury of Awards and given his own room, making him ineligible for competition, though he was awarded a special grand prize, the highest art honor the Exposition could bestow. The award was for Duveneck's accomplishments as a practicing artist and as a teacher with broad influence. His gallery included forty-four works, mostly paintings, along with thirteen etchings and a plaster cast of the memorial he made for his wife, Elizabeth Boott Duveneck, which attracted attention as the only memorial of its kind in the galleries. [24] The Cincinnati Art Museum generously lent the sculpture and most of Duveneck's paintings. Other crowd favorites included the artist's *Whistling Boy* (pl. 33), *Woman with Forget-Me-Nots* (ca. 1876, Cincinnati Art Museum), and *The Turkish Page* (fig. 79). Most of the paintings were from the 1870s and dark in tone, exemplifying the Munich school where Duveneck had trained and taught. Like several other artists who contributed to the overall design of their solo galleries, Duveneck had a hand in fashioning the decor of his space, selecting a gray-green color for the carpet, wall coverings, and seat cushions that reinforced his somber palette. Though by the time of the Exposition Duveneck's tenebrous, German style of painting had become decidedly old-fashioned— "superseded in the affection of Americans by French methods"—his works were nevertheless extolled for their bold brushwork and "juiciness" of pigment. [25]

The fair organizers' plan to include solo galleries like Duveneck's was met with favor by critics, who appreciated the cohesiveness that such displays offered, even though most artists, including Duveneck, did share their gallery's floor space with the work of one or more sculptors. Other American painters accorded their "own" rooms included William Merritt Chase, Childe Hassam, William Keith, Gari Melchers, Edward Willis Redfield, John Singer Sargent, Edmund Charles Tarbell, John Henry Twachtman, James McNeill Whistler, and, jointly, Arthur Frank Mathews and Francis McComas. In addition to these painting galleries, Howard Pyle's illustrations occupied their own room; John McLure Hamilton's drawings shared space with cast medals and plaques; and Joseph Pennell (see pl. 96) and Whistler (see pls. 86–89) each had a gallery of prints. Michael Williams appreciated the underlying message of "true Americanism" that could be found in these featured-artist galleries and in the emergence of "unique individualities from a soil of synthetic influences and ideas." "The poetics of Twachtman should not make one dim-eyed to the realities of Redfield," he wrote, "nor the physiological-psychology of Sargent stun us to the psychic enchantments of Whistler. In the house of art are many mansions, in each of which reigns a different mood." [26]

None of the innovators given their own gallery was more significant or

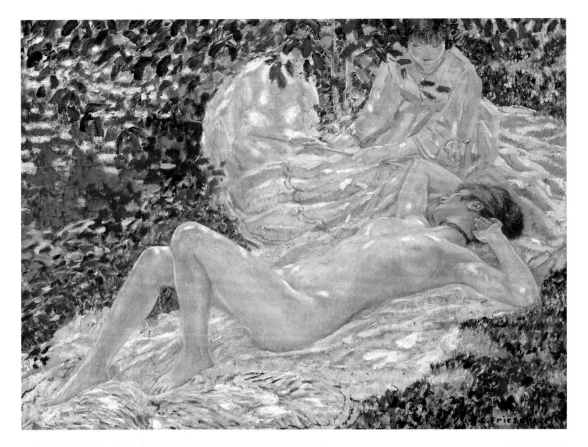

FIG. 77
Frederick Carl Frieseke (American, 1874–1939), *Summer*, 1914. Oil on canvas, 45¼ × 57¾ in. (114.8 × 146.7 cm). The Metropolitan Museum of Art, New York, George A. Hearn Fund, 1966, 66.171

FIG. 78
Gallery 117 in the Palace of Fine Arts, 1915. Paintings exhibited in this room included works by Frederick Carl Frieseke (fig. 77, pl. 54), Clark Hobart (pl. 80), and E. Charlton Fortune (pl. 82), among others. Photograph by Gabriel Moulin. San Francisco History Center, San Francisco Public Library

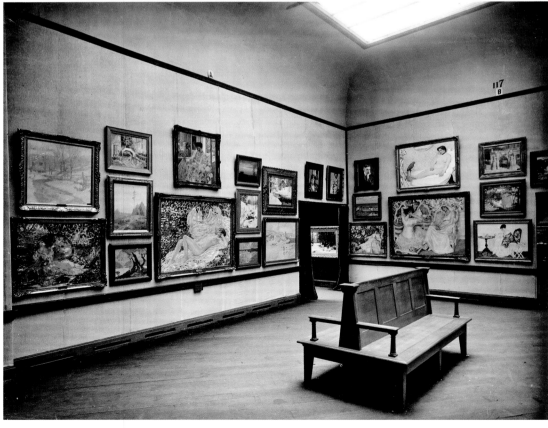

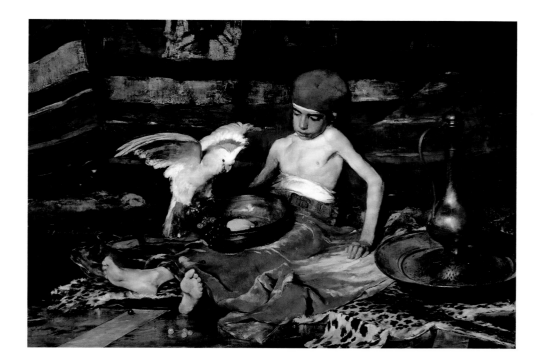

FIG. 79
Frank Duveneck (American, 1848–1919),
The Turkish Page, 1876. Oil on canvas, 42 × 58 ¼ in.
(106.7 × 148 cm). Pennsylvania Academy of
the Fine Arts, Philadelphia, Joseph E. Temple
Fund, 1894.1

influential than Whistler, whose paintings and prints helped set the stage for much of the American art that would follow. Fair organizers honored the artist, who died in 1903, with two adjacent spaces, one devoted to prints and the other dedicated primarily to paintings, making his painting gallery physically removed from the other one-artist displays in that medium. With a nod to Whistlerian aestheticism, designers draped his painting gallery in white so as not to detract from the artist's subtle color harmonies. Portraits, landscapes, and depictions of unnamed sitters and nudes represented the artist's range, with the majority of the twenty-five works coming as loans from the Freer Collection of the Smithsonian Institution. Many paintings and watercolors were evocatively titled by color, denoting their status as works of art rather than as transcriptions of the natural world or of particular persons, including *Symphony in Blue and Pink*, *Variations in Blue and Green*, and *Symphony in White and Red* (all ca. 1868, Freer Gallery of Art, Washington, DC). Especially lovely in the "fragrant looseness of their spacing" and in their "neutralized colour," emphasized here and there by stronger notes of vermilion and other hues, these figural compositions wedded classical and Japanese elements.[27]

But it was Whistler's notorious *Nocturne in Black and Gold: The Falling Rocket* (fig. 81) that garnered the most attention, with critics and erudite visitors alike recounting John Ruskin's libelous accusation that Whistler, just by making this work, had flung a pot of paint in the public's face. An almost complete abstraction of fireworks falling over Cremorne Gardens, London, the painting was still shocking in its modernity but now also served as a source of inspiration to other artists. California painter Will Sparks, for instance, immediately followed Whistler's example and painted new views of fireworks over the Exposition's buildings (see fig. 80).

Twachtman's gallery was the most similar to Whistler's, as Twachtman also favored subtle color tonalities, though in a higher key.[28] Half of his paintings were snow scenes so bright as to almost glare in his sunny, skylit room. Cheesecloth on the walls softened this effect, allowing visitors such as artist Clara MacChesney a chance to "linger long and dream" among his lyrical creations, though most average fairgoers still failed to understand his progressive, painterly technique.[29] Half of Twachtman's twenty-six submissions were borrowed from public and private collections; the rest came from the artist. Only one was a figurative subject—a mother in black holding a baby (see pl. 59); the remaining works were florals and landscapes that, while wide ranging, consistently evoked the spirit of the land rather than its outward appearance.

Snowy winter scenes also dominated Redfield's solo gallery, which was painted white, the chief color present in many of the canvases. The paintings were not as introspective as Twachtman's, though, like his productions, they were loosely painted—and with a fully loaded brush. The directness of Redfield's *alla prima* style of working wet on wet was rich, but also candid and convincing in capturing patches of melting snow in the sunlight, trees silhouetted against pale skies, and houses lining a frozen riverbank, such as in his *The Hills and River* (pl. 65). Two New York City scenes, one of the Brooklyn Bridge and the other of skyscrapers, became elegiac through a deeper palette evoking early evening.

Snow and ice were perfect subjects for light-filled Impressionist paintings, and many artists of the era—both American and European—painted them. Eugen Neuhaus called these domestic landscape painters "the backbone of our American outdoor artists." "All of them," he wrote, "with the exception of Gardner Symons, can be found in the exhibition. To this group, beside Redfield and Schofield . . . belong Charles Morris Young, John F. Carlson, Charles

FIG. 80
Will Sparks (American, 1862–1937), *Owl's Roost*,
1916. Oil on board, 15 ½ × 20 ½ in. (39.4 × 52 cm).
Private collection

FIG. 81
James McNeill Whistler (American, 1834–1903),
Nocturne in Black and Gold: The Falling Rocket,
1875. Oil on panel, 23 ¾ × 18 ⅜ in. (60.2 × 46.7 cm).
Detroit Institute of Arts, gift of Dexter M.
Ferry, Jr., 46.309

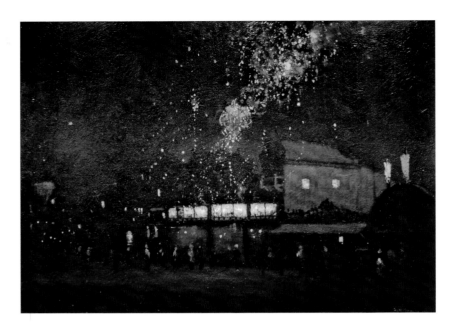

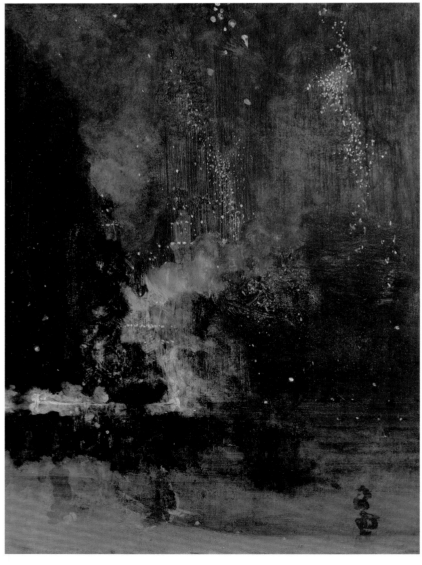

FIG. 82
Childe Hassam (American, 1859–1935), *California Hills in Spring*, 1914. Oil on canvas, 30 × 32 in. (76.2 × 81.3 cm). American Academy of Arts and Letters, New York

Rosen, and others."[30] Willard LeRoy Metcalf also showed a white-on-white snow scene with lavender shadows, one of seven landscapes that he contributed to the Exposition (see pl. 64). These shared space with other landscapes and numerous figurative paintings, including notable submissions by William McGregor Paxton, Philip Leslie Hale, and Lilian Westcott Hale, all of whom specialized in elegant depictions of women in indoor and outdoor settings.[31]

Childe Hassam painted women in similarly genteel environments, and his gallery included depictions of idle ladies in interior settings: in a hammock on the porch, serving peaches under a sunlit arbor, posing nude as a goddess in the American landscape (see pl. 61), and enjoying Gloucester harbor views and breezes. Still lifes and pure landscapes also counted among his thirty-eight oils, watercolors, and pastels, and these, like his figurative works, vibrated with broken brushwork, divided color, and a pervasive sense of light. Perhaps in an effort to please the local audience, Hassam also contributed his recent *California Hills in Spring* (fig. 82), the perceived success of which perhaps depended on the viewer's familiarity with the state's vibrant green hills after a rain. Jessie Maude Wybro of California's *Overland Monthly* described the painting as "typical" of the state's "wonderful living green," but MacChesney, by contrast, called the "exaggerated green" a "libel."[32] Hassam painted the canvas while preparing his mural *Fruit and Flowers* (1914) for the Court of Palms. Shown in proximity to Arthur Frank Mathews's richly tonal mural *The Victory of Culture over Force* (*Victorious Spirit*) (pl. 23), Hassam's effort literally paled by comparison, and some, including

Neuhaus, felt the artist's technique and color were unsuited to mural work. "Nobody ever suspected Childe Hassam of being a decorator," Neuhaus chided, "no matter how admittedly important a place he holds in the field of easel painting."[33] Hassam's light and airy gallery was adjacent to that of William Merritt Chase, whose space displayed a preponderance of dark portraits and still-life paintings. Neuhaus, nearly "overcome" by this juxtaposition, wrote, "The contrast of the classic academic atmosphere of Chase's room shows Hassam pronouncedly as the most radical impressionist we have."[34] Most of the paintings Chase exhibited exemplified traditions in Munich, where he had studied, as opposed to the brighter, Impressionist-inspired views for which he had since become known. Additionally, the gallery's decor reinforced the darkness of the paintings. Whereas Hassam kept his gallery white, Chase chose a richer color scheme, painting the walls a deep blue, adding blue drapes to the doorways, blue cushions to the seats, and a blue canopy to soften the light. He even brought in a blue carpet, which he found added the benefit of muffling the "terrible noise of tramping feet."[35]

Of Chase's thirty-two paintings, the majority were portraits (see pl. 35), including ones of himself, his wife, photographer Edward Steichen, artist Joseph Frank Currier, and Whistler. There were also five still lifes of humble subjects and half a dozen sunnier examples of his outdoor work in Italy. To Chase, subject matter was less important than execution, and it was his consistently bravura paint handling that truly brought unity to the display.

While reviewers typically described both Edmund Charles Tarbell and Gari

FIG. 83
Gari Melchers (American, 1860–1932),
A Sailor and His Sweetheart, 1899. Oil on canvas,
50 × 57⅞ in. (127 × 147 cm). Freer Gallery of Art,
Smithsonian Institution, Washington, DC, gift
of Charles Lang Freer, F1913.10a–b

Melchers as realists due to the relative evenness of their paint handling and their adherence to subject, their work certainly also incorporated Impressionist light and color. Tarbell displayed twenty canvases in his gallery, all but three from museums, clubs, and private collectors. These works included several life-sized portraits and scenes of well-dressed ladies lounging, performing domestic activities indoors, and, occasionally, pursuing outdoor pleasures (see pl. 60). Melchers also painted women in sunny interiors (see pl. 58) and as modern Madonnas with children. Though large and stylistically modern in their direct approach, his paintings presented subjects in a manner nevertheless "wholesome and sane." [36] Melchers traveled from Weimar to hang a number of his submissions, twenty-one in all, some of which were borrowed from public collections to enrich the display. The Detroit Museum of Art lent *The Fencing Master* (ca. 1900), the Pennsylvania Academy of the Fine Arts contributed *Skaters* (ca. 1892), and the Smithsonian Institution sent *A Sailor and His Sweetheart* (fig. 83) from Charles Lang Freer's collection, which pleased crowds because it convincingly told a story in a traditional way, admirably fulfilling expectations of what art should be.

John Singer Sargent's gallery adjoined Melchers's, though his thirteen works were "buried in a small, dark, arsenic-green room." [37] To mitigate this effect as much as possible in Sargent's absence, several of the artist's friends "redecorated" it, tacking up white cheesecloth to cover the walls as they thought he might have done and adding a white canopy overhead. *The Sketchers* (pl. 40) was the most recent and most Impressionist painting of the group in its handling, color, and subject matter—artists working *en plein air*. *Reconnoitering (Portrait of Ambrogio Raffaele)* (pl. 39) also featured an artist, here preparing a sketch on a stool with the snow-covered mountains of Tyrol in the distance. [38] Three Venetian and Spanish subjects—a courtyard, a stable (see pl. 41), and a gypsy—exemplified Sargent's loose, painterly handling and penchant for using bold dabs of color to animate more neutral hues.

The portraiture, for which Sargent was best known, tended toward the traditional, except for one painting, *Madame X (Madame Pierre Gautreau)* (fig. 87). [39] Unlike at the 1884 Paris Salon, where the painting created a scandal, the now-recognized masterpiece occasioned relatively little comment in San Francisco. Clara MacChesney acknowledged the painting, but not positively. "Sargent was not as impressed by her [Virginie Amélie Avegno Gautreau] as was Gustave Courtois, whose painting of her is far superior," she wrote. "I heard one lady say of it: 'I always turn my back on that every time I come in this room; I dislike it so much.'" [40] Sargent himself disagreed. Within months of the July 1915 death of the portrait's sitter, and shortly after the Exposition's close, Sargent sold the painting to the Metropolitan Museum of Art in New York, referring to it then as "the best thing I have done." [41]

Of the galleries devoted to individual artists, only two rooms were bestowed on Californians. William Keith was accorded a solo gallery; Arthur Frank Mathews and Francis McComas shared a space. Keith's exhibit was posthumous, an honor for the "old master of the West," who died in 1911. [42] Most of

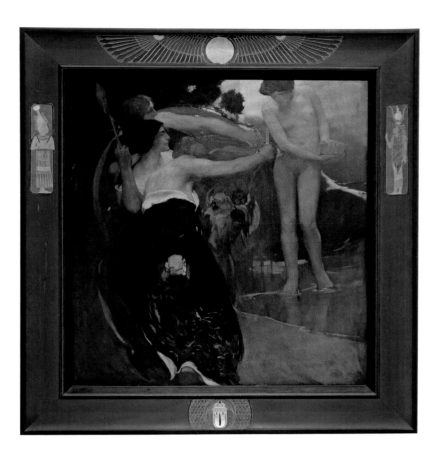

FIG. 84
Arthur Frank Mathews (American, 1860–1945),
Pandora, ca. 1914. Oil on canvas with frame, 67 × 63 in.
(170.2 × 160 cm). Collection of the Oakland Museum
of California, gift of Concours d'Antiques, the Art
Guild, A66.196.11

the twenty-nine works borrowed from private collections were painted later in the artist's career, when Keith worked in a dusky, mystical Barbizon style—a striking contrast to the "vital buoyancy" and brightness of landscapes by Redfield, Twachtman, and others.[43] The deep-red walls on which they were hung contributed to their solemnity. Communicating a personal poetry and emotion, the paintings focused on groves of trees—sometimes with streams or a bit of staffage—and were not meant to transcribe nature, but to communicate its spirit. Many who saw them, and especially those who had known Keith, believed the artist had seen "deeper and more beautifully into the soul of the Californian landscape than any other."[44]

As two of California's top living artists, Mathews and McComas (of San Francisco and Monterey, respectively) both played roles in assembling art for the Exposition. Both also served as jurors and therefore were not eligible for awards. Mathews exhibited sixteen canvases, including many now-signature works, and McComas exhibited ten watercolors, his specialty. Though certainly related in their subtle tonal harmonies and therefore complementary in the shared gallery, the artists' paintings differed in focus. Mathews's contributions were largely figurative, the majority with strong Symbolist overtones (see figs. 84 and 59 and pl. 78). McComas's depicted Monterey and Arizona landscapes in a carefully designed and reductive style (see pl. 77).

However, some critics openly disparaged Mathews, McComas, Keith, and other Northern Californian artists; their muted, Tonalist aesthetic seemed

behind the times. Neuhaus wrote, "It seems peculiar that a country famed for its sunshine should produce men like Keith, Mathews, and McComas, who surely do reflect a rather somber atmosphere, in a type of work which must be called tonal and arbitrary rather than naturalistic."[45] Ironically, Neuhaus, who contributed six paintings to the Exposition, was not immune to such criticism himself, as Jessie Maude Wybro made clear: "Mr. Eugen Neuhaus and Mr. Francis McComas must doubtless be forgiven for their color-vision, since we can only hope for forgiveness in the degree that we forgive. But how sane eyes can see nothing but gray-browns and dull-golds and clay-whites—and other combinations of low tones that the dictionary knoweth not—in the vivid colors in which the ordinary eye sees the Californian landscape, these artists might possibly be able to explain. But assuredly no one else can."[46]

There were, however, other Californians pursuing a bolder and more colorful approach, but their paintings were distributed throughout the American galleries and thus less impactful collectively. Most of the state's major painters were, in fact, represented in the overall display, with approximately 130 pieces by California artists accepted out of about 830 submitted for jurying, alongside additional works gathered by invitation. Many of the former came from younger artists, hinting of things to come. "It is not to the work of the men who have stamped their seals upon the pages of American art in acknowledged authority that you look for the signs of new developments," Williams argued. "It is rather among the newer and less known names that you search after the

tokens of prophecy, the omens and the symbols of the unfolding future."[47] The majority of the twenty medals awarded to Californians in oil painting went to those working in an Impressionist style, including several artists new to the scene. The state's two gold medals in painting honored the mountain subjects and seascapes, respectively, of Henry Joseph Breuer and William Ritschel, which, though not exactly Impressionist, were correspondingly progressive in their emphatically straightforward and bold, painterly approach.[48] However, many silver and bronze medals did go to emerging Impressionists. Williams wrote enthusiastically about the "future-building" number of youthful medal winners from Northern California, who showed oils, watercolors, and prints:

> But when you remember that Armin Hansen, E. Charlton Fortune, Maurice Del Mue, and Bruce Nelson, Frank J. Van Sloun and Anne M. Bremer, Lee F. Randolph and Betty de Yong [sic, Jong], Clark Hobart, Perham Nahl and Percy Gray are all young, some of them practically beginners, and that among them are several who represent some of the most modern technical tendencies, you clearly perceive that the jury (and remember that juries are always conservative) has recognized the new blood of the West most emphatically; and it is this new blood that must build up the body of the future. . . . The West has a great future in art. Indeed, I go so far as to say that the future of art belongs to the West.[49]

Southern Californians received recognition as well. In the category of oil painting, William Wendt's "unusually happy" wooded landscape with a stream, *The Land of Heart's Desire* (1910, private collection), earned a silver medal.[50] Impressionist Guy Rose also won a silver, as did Carl Oscar Borg. Donna N. Schuster won her silver medal in the category of watercolor, miniature paintings, and drawings. Benjamin Chambers Brown, another Impressionist painter, won his bronze for a print.

By nearly all accounts, the art component of the Exposition was an unqualified success, so much so that the public petitioned and convinced the fair's board to extend the exhibition until May 1916, after the Exposition itself had closed. However, many loaned works needed to be returned at fair's end, prompting the need for pieces to replace them. Most of the 120 main galleries were rehung, and these now featured some 6,000 works of art, many by artists not previously on display. Immediately after this post-Exposition exhibition closed, smaller shows continued in the space, including many held by the San Francisco Art Association featuring local artists.

For Californians throughout the state, the Exposition was important not so much for what it introduced but for what it confirmed and the possibilities it opened for the future. "So far as we have gone," artist Bruce Porter argued, "our worth appears to lie, not so much in what we have done, as in what we are and promise to become."[51] The Exposition had been a monumental undertaking to be sure, and never before had so much art been assembled in the western United States. For some Californian artists, seeing the abundance of progressive, vibrant works at the fair fostered a bolder aesthetic approach, prompting a move away from transcendental and tonal concerns to an engagement with color and form. For others, the Exposition confirmed a commitment to paths already pursued. J. Nilsen Laurvik, director of the Palace of Fine Arts, noted of the exhibitions in San Francisco following the close of the fair that a "new spirit was clearly discernible in color and treatment, no less than in subject matter," and that the "Whistlerian tonalities and Barbizon romanticism" in vogue before the Exposition were now conspicuously absent. "On every hand one finds painters, etchers, and sculptors occupying themselves with contemporary themes," he wrote. "At last the noble lines of the California hills are being painted without pseudo-idealistic, romantic preconceptions, and gradually the painter and public are coming to realize how much more beautiful are these realistic versions of our grandiose landscape than the vague, characterless echoes of the Barbizon School, which so long passed for true portraits of California."[52]

As Laurvik suggests, the art of the Exposition not only had an impact on local artists but also shaped public taste broadly, fostering a greater appreciation for art among Californians. According to Exposition chief of fine arts John E. D. Trask, the fair awakened a new aesthetic sense in San Francisco and beyond, providing an impetus for the "growth of the love of beauty."[53] The Exposition also made many aware of the state's deficiencies with regard to art, especially its need for great museums that could encourage young artists and inspire its citizenry. At the same time, it ably proved that Californians had the maturity, wherewithal, and resources to identify, acquire, and display art of utmost significance on a monumental scale.

Collectively, this new sense of awareness and appreciation made an immediate and lasting impact, bolstering public collections and encouraging new arts institutions. In 1916, just a year after the main fair had closed, the Oakland Art Gallery opened under the curatorship of Robert B. Harshe, the former assistant director of the Exposition's Department of Fine Arts. At the same time, the Memorial Museum in Golden Gate Park (now the de Young) actively acquired new works for the collection, including many that had been shown in the Exposition.[54] Seeds for the San Francisco Museum of Art (now the San Francisco Museum of Modern Art) were also sown in 1916, in the galleries of what had been the Palace of Fine Arts, and a year later, Stanford University would complete construction of its new Thomas Welton Stanford Art Gallery. Though delayed by World War I, San Francisco's California Palace of the Legion of Honor opened its doors in 1924. The newest jewel in the city's artistic crown, it too had its genesis in the Exposition, specifically in the French Pavilion, which replicated the Palais de la Légion d'Honneur in Paris on a smaller scale. The pavilion so charmed Alma de Bretteville Spreckels that she had it re-created for her city as an art museum at Land's End (see Chapman, this volume).

Fulfilling widely held hopes, the Exposition had indeed succeeded in providing the world with tangible evidence of San Francisco's economic and cultural emergence. Few could have predicted, however, that it would also foster and secure an integral and lasting place for art within the collective consciousness of the state.

1. Eugen Neuhaus, *The Art of the Exposition: Personal Impressions of the Architecture, Sculpture, Mural Decorations, Color Scheme and Other Aesthetic Aspects of the Panama-Pacific International Exposition* (San Francisco: Paul Elder, 1915), 9.

2. Jules Guérin, quoted in Elmer Grey, "The Panama-Pacific International Exposition of 1915," *Scribner's Magazine*, July 1913, 48.

3. "Color Scheme of the Panama-Pacific International Exposition," *American Architect* 105 (1914): 28.

4. Eugen Neuhaus, "Sculpture and Mural Decoration," *Art and Progress*, August 1915, 364.

5. Michael Williams, "Western Art at the Exposition," *Sunset*, August 1915, 318.

6. Mary Austin, "Art Influence in the West," *Century Magazine*, April 1915, 830.

7. A *New York Times* article stated, "The lovely exterior of the Fine Arts Palace, with its attendant Lagoon which never failed to duplicate its loveliness, was kodaked by the tourist and sketched by the student at all times, night and day." "Exposition Crowds Eager to Learn About Art: Well-Known Artist, Who Was One of Docents at San Francisco, Tells of Criticisms, Amusing and Serious, Heard While She Was at Work," *New York Times*, December 19, 1915.

8. Michael Williams, "A Pageant of American Art," *Art and Progress*, August 1915, 339–340.

9. The first and second panels respectively symbolized the births of European art and Asian art. A third panel represented various ideals in art (Greek, religious, heroic, etc.), and the fourth showcased inspirations of art in the form of five allegorical figures (music, painting, architecture, poetry, and sculpture), with two additional winged figures bringing light and drawing back a veil of darkness.

10. Eugen Neuhaus wrote, "His decorations present very little opportunity for the eye to rest upon them, and they are altogether too involved, in their turbulent compositions." Neuhaus, *Art of the Exposition*, 57.

11. Eugen Neuhaus, *The Galleries of the Exposition: A Critical Review of the Paintings, Statuary and the Graphic Arts in the Palace of Fine Arts at the Panama-Pacific International Exposition* (San Francisco: Paul Elder, 1915), 13–15.

12. "Exposition Crowds Eager to Learn."

13. Rose V. S. Berry, *The Dream City: Its Art in Story and Symbolism* (San Francisco: Walter N. Brunt, 1915), 288.

14. Neuhaus, *Galleries of the Exposition*, 50.

15. Williams, "Pageant of American Art," 343.

16. Ibid., 338.

17. Ibid., 347. Gallery 57 also included the painting *High Noon: California* (date and current status unknown) by the still-living artist Mary Helen Carlisle, who was active in California from 1911 to 1915.

18. Quoted in *Transactions of the Commonwealth Club of California* 10 (November 1915): 488.

19. Neuhaus, *Galleries of the Exposition*, 78.

20. Williams, "Pageant of American Art," 348.

21. Neuhaus, *Galleries of the Exposition*, 85.

22. Michael Williams, *A Brief Guide to the Department of Fine Arts: Panama-Pacific International Exposition, San Francisco, California, 1915* (San Francisco: Wahlgreen, 1915), 42.

23. Fortune and Nelson each won a medal for painting; Hobart's was for printmaking.

24. The original bronze was placed on Elizabeth Boott Duveneck's grave in the Cimitero Evangelico degli Allori, a Protestant cemetery in Florence, Italy.

25. Neuhaus, *Galleries of the Exposition*, 66.

26. Williams, "Pageant of American Art," 344, 351

27. Neuhaus, *Galleries of the Exposition*, 63.

28. In addition to the twenty-six works by Twachtman, nine Paul Manship sculptures shared Gallery 93.

29. Clara T. MacChesney, "Ten American Artists Honored: Each One Has a Special Room for an Individual Exhibition at the Pan-American Exposition," *New York Times*, August 8, 1915. MacChesney (1860–1928) herself contributed three works to the Exposition.

30. Neuhaus, *Galleries of the Exposition*, 76.

31. The Hales also showed ten works in Gallery 40: six by Lilian and four by Philip.

32. Jessie Maude Wybro, "California in Exposition Art," *Overland Monthly*, December 1915, 521; MacChesney, "Ten American Artists Honored."

33. Neuhaus, *Art of the Exposition*, 60.

34. Neuhaus, *Galleries of the Exposition*, 69.

35. Chase, quoted in MacChesney, "Ten American Artists Honored."

36. Neuhaus, *Galleries of the Exposition*, 70.

37. MacChesney, "Ten American Artists Honored."

38. Charles Merrill Mount, "A Phoenix at Richmond," *Arts in Virginia* 18 (Spring 1978): 2–19. *The Sketchers* is believed to portray Wilfrid-Gabriel de Glehn and his wife, Jane Emmet de Glehn, painting as part of Sargent's circle in San Vigilio, Italy, in September 1913.

39. The painting is listed in the official catalogue as *Madam Gautrin*. *Official Catalogue of the Department of Fine Arts, Panama-Pacific International Exposition* (San Francisco: Wahlgreen, 1915), 69.

40. MacChesney, "Ten American Artists Honored."

41. Letter from John Singer Sargent, London, to Edward Robinson, Metropolitan Museum of Art, New York, January 8, 1916, Metropolitan Museum of Art Archives.

42. Williams, "Pageant of American Art," 344. Keith's importance in the development of art in the West was even acknowledged by a portrait of the artist in one of Frank Vincent DuMond's Exposition murals, *The Westward March of Civilization* (see pls. 24–25).

43. Neuhaus, *Galleries of the Exposition*, 71–72.

44. Wybro, "California in Exposition Art," 517.

45. Neuhaus, *Galleries of the Exposition*, 71.

46. Wybro, "California in Exposition Art," 521.

47. Williams, "Pageant of American Art," 351.

48. Californian Arthur Putnam (1873–1930) won a gold medal for sculpture.

49. Williams, "Western Art at the Exposition," 325.

50. Neuhaus, *Galleries of the Exposition*, 77.

51. Bruce Porter, "The Beginning of Art in California," in Bruce Porter et al., *Art in California: A Survey of American Art with Special Reference to Californian Painting, Sculpture, and Architecture, Past and Present, Particularly as Those Arts Were Represented at the Panama-Pacific International Exposition* (Irvine, CA: Westphal Publishing, 1988), 32. First published in 1916 by R. L. Bernier, San Francisco. An artist and designer, Porter was also a member of the Exposition's advisory committee for art in the West.

52. J. Nilsen Laurvik, "Contemporary Art in California: The Forty-Second Annual Exhibition of the San Francisco Art Association," *Art World and Arts & Decoration*, May 1, 1918.

53. John E. D. Trask, "The Department of Fine Arts at the Panama-Pacific International Exposition," in Porter et al., *Art in California*, 87–88.

54. Paintings and etchings representing the work of thirty-two California artists were among the de Young Museum's acquisitions of 1916. These purchases were made possible by a bequest of $10,000 that Alice W. Skae left to the museum in 1903.

HEIDI APPLEGATE

"PROGRESSING ALONG NORMAL, WHOLESOME LINES": MODERN AMERICAN PAINTING

American art was displayed in over one half of the 120 galleries within the Palace of Fine Arts at San Francisco's Panama-Pacific Exposition (PPIE) of 1915. The American section, by far the largest of the exhibition, included works by historical American artists, by foreign artists thought to have influenced American art, and by established and emerging contemporary American artists. These distinct components of the exhibition were designed to achieve recognition for American artists through a chronological presentation of the development of art in the United States within the context of the history of Western art. According to John E. D. Trask, director of the Department of Fine Arts, the selection of contemporary works by American artists was to be "the climax of the whole exhibition."[1]

As at previous world's fairs, the fine art selected for the Palace exhibition tended to be conservative and retrograde, with academic realism and Impressionism dominating.[2] The major innovation in the American section at the PPIE was the designation of fifteen special rooms for retrospective displays of established American artists (all men), as a kind of canonization of America's old guard. Despite this commitment to glorifying conservatism, Trask and the other members of the Fine Arts Department surely recognized that after the 1913 Armory Show in New York, no international exposition could lay claim to including the most current examples of contemporary art without somehow acknowledging the controversial formal developments of European modernism unleashed two years earlier. The inclusion of a gallery in the Palace's Annex devoted to the radical abstraction of the Italian Futurists (see fig. 18), a European avant-garde movement that had not been represented at the Armory Show, allowed the department to do just that, while also generating the same kind of sensational, attendance-boosting attention garnered at the 1913 exhibition. Relegated to the Annex and shown outside the context of the development of modernism, the Futurists were referred to in bewildered and humorous press coverage as being either physically or mentally impaired, and their work became a useful contrast to the American experimentation in the Palace proper, which was sane, in touch with reality, and accessible to the average viewer.[3]

"EVOLUTION, NOT REVOLUTION IN ART"

Although other, smaller exhibitions of European modernism had been held in the United States before 1913, for many Americans the Armory Show was their first introduction to modern art. As such, it was conceived with the intention of helping the general public understand new art movements in connection with their historical antecedents, and in this regard was a model for the PPIE.[4] Historian Milton Brown's assessment of the Armory Show as "a supreme effort to educate American taste" could also be said of the PPIE, but on a much larger scale.[5] Officials from the Department of Fine Arts devoted considerable attention to helping visitors make sense of a vast and stylistically diverse collection through varied installation practices, an outpouring of didactic offerings—public lectures, an unprecedented number of specialized guidebooks, and the publication of an extensive bibliography for further reading—as well as docent-led tours of the exhibition. Based on the "shock" experienced by

FIG. 85
Ben Macomber, "Weird Pictures at PPIE Art Gallery Reveal Artistic Brainstorms," *San Francisco Chronicle Sunday Magazine*, August 8, 1915

FIG. 86
Arthur Milman, "STEVE BUNK AT THE FAIR—Stevie Wise to the Futurists? Sure he is!" *San Francisco Bulletin*, October 23, 1915

American audiences at the Armory Show and the extensive and often derisive commentary that the exhibition provoked, both the Fine Arts Department and contemporary American critics made a concerted effort to explain the more radical of the works on display in San Francisco two years later, and to encourage the public to approach the exhibition with an open mind.[6]

Two critics in particular, J. Nilsen Laurvik and Christian Brinton (both members of the Exposition's International Jury of Awards), were well prepared to help audiences navigate the unknown and often confounding territory of modern art at the PPIE. Both Laurvik and Brinton had written extensively on the Armory Show, and Brown credited them as the only two critics in 1913 who had sufficient knowledge of the latest trends to most fully and accurately explain them: "They were never apologists for modernism, but they not only helped in the defense of some of its aspects, they also played a role in the general education of the public to the significance of what was going on. They helped American criticism take its first steps out of the fog of uninformed opinion."[7] Brown also noted that it was a common strain of "progress" in Laurvik's and Brinton's thinking that "kept them from acceptance of the most recent art" and primitivism in particular, which Laurvik viewed as a major step backward. It was their argument for the "validity of change" and their notion of change as progress in art that was most helpful to the public in understanding the new movements.[8]

Both Laurvik and Brinton revised and updated their commentary on the Armory Show's modern art to appeal to the audience at the PPIE.[9] While Laurvik placed new emphasis on the higher social status gained through an appreciation for the more intellectual realm of modern art, Brinton aimed to allay fears of radical extremism, as he did in his 1913 "Evolution, not Revolution in Art":

> There are, to begin with, no revolutions in art. The development of artistic effort advances normally along definite lines. The various movements overlap one another, and in each will be found that vital potency which proves the formative spirit of the next. The esthetic unity of man is as indisputable as

is his ethnic unity, and, given similar conditions, he will not fail to produce similar if not absolutely identical results.[10]

In a version of the essay written for the PPIE and re-titled "The Modern Spirit in Contemporary Painting," Brinton expanded this review of the Armory Show, repeating his argument nearly verbatim.[11] The essay, which detailed the comprehensive evolution of contemporary painting, may be read as a corrective to the PPIE exhibition, which had large gaps in its chronology of modern European art. Édouard Manet, Paul Cézanne, Paul Gauguin, and Vincent van Gogh, all mentioned in the essay, were each represented by just one or two canvases at the PPIE (see pl. 141 and figs. 149–150), and all but Van Gogh's lone picture hung in the French Pavilion, not in the Palace of Fine Arts. Brinton also gave extensive consideration to Henri Matisse, Pablo Picasso, and Francis Picabia, whose works were not included at all. But even more than offering a corrective, Brinton was concerned with providing reassurance to the Exposition's audience. "The Modern Spirit" opens with an acknowledgment that "the more recent phases of current art" are not only "stimulating but possibly also disconcerting." Matisse, whose "voluntary savagery" caused such consternation in 1913, is presented in 1915 as a "devoted husband and father" and a "mild-mannered iconoclast," whose beliefs contained nothing "to frighten or confuse." Picasso was the "logical" next step in the evolution of form, while the "impetuous" Futurists "go further toward destruction and demolition than do any of their colleagues." Yet even the "virulent, not to say savage assault upon aesthetic convention," the "violence and bombast," and "anarchistic frenzy" of the Futurists is no cause for concern, he attested.

Brinton's word choice throughout the essay is remarkable, particularly given his argument *against* revolution in art. Beginning with the "two imperishable truths" won by Manet, who "*demolished* the sterile prestige of the academic tradition" and "freed art from the *tyranny* of subject," Claude Monet carried on in "the *struggle* for light," and Impressionism "brought about a *veritable revolution* in pictorial representation" (emphasis added).[12] The terms Brinton uses to describe the Futurists become increasingly incendiary but build to underscore

FIG. 87
John Singer Sargent (American, b. Italy, 1856–1925), *Madame X (Madame Pierre Gautreau)*, 1883–1884. Oil on canvas, 82 ⅛ × 43 ¼ in. (208.6 × 109.9 cm). The Metropolitan Museum of Art, New York, Arthur Hoppock Hearn Fund, 1916, 16.53

FIG. 88
A lost canvas by Mary Curtis Richardson (American, 1848–1931), *The Young Mother*, n.d. Photograph ca. 1915, by Gabriel Moulin

FIG. 89
William McGregor Paxton (American, 1869–1941), *The House Maid*, 1910. Oil on canvas, 30 ⅛ × 25 ³⁄₁₆ in. (76.5 × 63.9 cm). National Gallery of Art, Washington, DC, Corcoran Collection (Museum Purchase, Gallery Fund)

his overriding message of reassurance: "There is, in any event, little occasion for alarm, since to no matter what lengths our restless Nietzscheans of brush, palette, and chisel may go, they cannot destroy the accumulated treasury of the past."[13] The PPIE's overwhelming preponderance of works demonstrating the influence of Impressionism, itself considered at one time an artistic revolution, reinforced Brinton's declaration of the security and continuity of all that had come before.

Compared with his 1913 essay, Brinton's sympathy for the "disconcerting" nature of modern art along with a new stress on the "wellnigh impassable" divide between the artist and the public are the key distinctions of his 1915 statement. To help the public better understand modern art, and to warn against the "either immature or indurate" reactions of condemnation and derision, Brinton asked readers to keep in mind "the all-important fact that art is a social expression. . . . The new art preaches before all else the supremacy of the personal factor. Social as well as aesthetic in aspect, it bases itself upon an unfettered, uncompromising individualism."[14] Even the less radical artists "all conceded that it was no longer the exclusive function of art to relate facts, but to communicate sensations; not to record life, but to interpret life."[15] It was up to viewers to "strive, in as far as possible to place ourselves in the position of the artist himself," to give oneself over to the "intensive appeal" of a subjective experience, rather than to "the mere materialization of external appearances."[16]

American modernism at the PPIE was defined by this movement away from objective representation toward a more subjective experience of reality on the part of artists, and for viewers, toward an increased appreciation of the artist's individualized expression. In his guide to the Palace of Fine Arts, local journalist Ben Macomber described the newly recognizable modern style of art in the American section in contrast to European trends:

The prime movement of the times presenting boldness, brilliance and a laxity of detail in portrayal, the art of America, as shown in this exhibition, embodies these characteristics without emphasizing them. . . . American artists are showing marked individualities, even in their acceptance of popular precepts. . . . [T]hey restrain the too bold stroke of the radical Impressionist, but outline with firmness, so that details are more easily imagined by the observer, even when an expected delineation is absent.[17]

That is to say, bold, but not too bold, with some details perhaps left for the viewer to fill in, while at the same time clearly demonstrating an individual style. Works by well-established artists throughout the contemporary American section, such as those by John Singer Sargent (see pls. 39–41), James McNeill Whistler (see pls. 31, 86–89), Childe Hassam (see pl. 61), and Robert Henri (see pl. 38) fit this description, as did those of the younger generation, which included George Bellows (see fig. 94), Hugh Henry Breckenridge (see fig. 92), Anne M. Bremer (see pl. 83), Arthur Beecher Carles (see pl. 84), Marguerite Thompson Zorach, and William Zorach (see pl. 85). Like Brinton and Macomber, guidebook author and gallery docent Rose V. S. Berry reinforced the importance of considering an artist's technique as a form of personal expression. In her discussion of William Merritt Chase (see pl. 35), Berry noted that "he has a style that is distinctively his own." Berry invoked Chase to identify yet another fundamental aspect of modern art: "he has no patience with literary or story-telling art. . . . His work stands for all he wishes it to stand for, without the help of an interpreter."[18] Indeed, the many commentators on the exhibition could not seem to stress enough that attuning to the individual expression of the artist was far more important than focusing on subject matter.

THE ROLE OF THE FUTURISTS

Individualism could be taken too far, according to critics of the Futurists at the PPIE, who judged them as having "painted themselves out of all sympathy with the common experience of common humanity."[19] The intensity of the color and the fragmentation of the human figure to express energy and movement in Umberto Boccioni's *Dynamism of a Soccer Player* (pl. 168) required extensive interpretation for the average viewer to begin to understand the "physical force" of a "ball player tearing down the field," as John D. Barry attempted to provide in one of his popular newspaper columns.[20] The stunningly unusual appearance of these works was made even more so by the Futurists' relegation to the Annex, wholly outside the context of Western art history as presented within the Palace of Fine Arts.

Acting as the Fine Arts Department's special delegate to Europe, Laurvik had secured the participation of the Futurists during his eleventh-hour trip to Europe to invite works from countries that did not send official representations to the fair due to the war (see Introduction, this volume). Italy did, in fact, send an official section to the Palace, but the Futurist exhibition curated by poet Filippo Tommaso Marinetti, who founded the movement, shared no relation to it. Instead, like the other submissions from unofficial countries, the Futurist works were installed in the international section in the Annex, a pavilion built to house overflow artwork from the Palace. In addition to Futurism, other European avant-garde movements such as Austrian Expressionism and Hungarian modernism were also represented in the Annex.

The Futurists' extreme experimentation with color and abstract form provided a convenient foil even for those artists deemed the most "radical" inside the Palace. Without their inclusion in the Annex, the message of tolerance and open-mindedness preached by department officials and guidebook authors in response to the art on view throughout the fairgrounds could not be driven home with such effect. Like Barry's discussion of Boccioni, other local press coverage of the Futurists attempted to explain their work (see fig. 85), while a comic strip poked fun at visitors who feigned understanding (fig. 86). Indeed, it was nearly impossible to appreciate or even comprehend Futurism without also considering adequate examples of the intervening movements of Post-Impressionism, Fauvism, and Cubism.[21] As noted above, limited examples of these movements could be found in the French Pavilion, and the selection of works for the foreign sections within the Palace of Fine Arts was similarly outside the jurisdiction of the Art

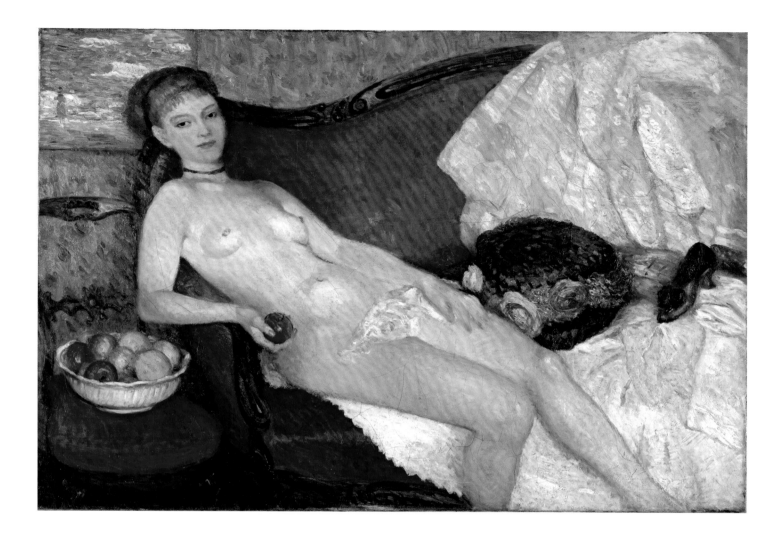

Department; Trask had no intention of influencing the decisions of the official foreign delegations.[22] The isolated presentation of the Futurists in the Annex was in stark contrast to that of the American modernists in the Palace, who were positioned within a carefully curated, albeit still selective, history of American art.

Within galleries devoted primarily to validating a conservative status quo, many of the younger American artists could emerge as "extreme" in comparison with established artists such as Frederick Carl Frieseke (see pl. 54 and figs. 77 and 95), winner of the grand prize, who "the Jury believed represented most clearly and convincingly those qualities of painting which were considered typical of the artistic ideals of [the] time."[23] American artists throughout the galleries were promoted by department officials, professional critics, and commentators as developing a healthy brand of modernism—one that evolved from a long line of forebears and stopped well short of degeneration.

THE SPECIAL ROOMS

The designation of fifteen galleries honoring distinguished individual American artists, as well as three centrally located galleries devoted to specific groups of artists, was a significant and generally well-received aspect of the

Palace exhibition that had never been undertaken at a world's fair before 1915 to such an extent. The galleries devoted to individual artists helped to convey the message that American art had attained the highest level of achievement in an international field—that it was no longer home to a few standouts but had spawned more than a dozen men worthy of honorary status. As Trask stated on his return to San Francisco from his planning trip to Europe in 1913, "We don't have to take our hats off to anyone. [John Singer] Sargent is pre-eminent in England, Childe Hassam is as interesting as any of the French painters, and in landscape Edward Redfield . . . would excite favorable attention and win high honors in any gallery in Europe."[24] Department of Fine Arts officials and commentators emphasized the opportunity these galleries provided to study the individual styles of established artists in depth and to better understand their different tendencies and influences.[25] Works by Hassam, Redfield (see pl. 65), and John Henry Twachtman (see pl. 59) demonstrated various adaptations of French Impressionism; those by Chase and Frank Duveneck (see pl. 33 and fig. 79) represented the influence of the Munich school; Sargent's paintings revealed allegiances to Diego Velázquez; and examples by Whistler showed his debt to Gustave Courbet and Japanese art. Brinton considered these rooms to be the

"best features" of an otherwise enormous and unwieldy exhibition.[26]

Among the artists honored with their own galleries, Sargent sent relatively few paintings—thirteen to Duveneck's thirty and Hassam's thirty-eight.[27] The works divided nearly equally between portraits and what Sargent called his "subject pictures," which had become the focus of his late career as he tired of portraiture. The PPIE was the first time the once-controversial *Madame X (Madame Pierre Gautreau)* (fig. 87) was exhibited in the United States, and many of the guidebooks singled it out for special notice. When Sargent offered it for sale to New York's Metropolitan Museum of Art at the close of the fair, he famously wrote, "I suppose it is the best thing I have done."[28] All but one of the remaining portraits in Sargent's gallery depicted people who were close to the artist personally, signaling that, like *Madame X*, they were not standard commissions. Sargent's portraits had made him famous, and although he was well known for refusing specific demands or expectations on the part of his sitters, it is significant that he included only one commissioned portrait, *John Hay* (1903, Brown University), in his gallery. Even with the recognition that formal commissions were harder to secure for loan, the subjects that Sargent chose to represent his career at the PPIE thwart any misperceptions about his autonomy as an artist.

A contemporary assessment of the Sargent gallery by Stanford professor Arthur Bridgman Clark underscores the artist's contribution to the prevailing conservative styles in the American galleries as represented by the pictures selected for the exhibition. Of *Henry James* (1913, National Portrait Gallery, London), *Madame X*, and *John Hay*, Clark wrote, "It is difficult to realize that Sargent was ever attacked as extreme in turbulence of brush work, these canvases show so little of it; he appears rather as a very skillful but conservative realist."[29] As New York critic Royal Cortissoz wrote in his review, *Madame X* alone justified Sargent having a gallery of his own, but the portrait, with its carefully overworked surface, would not have adequately represented Sargent's style.[30] Eugen Neuhaus, a UC Berkeley professor who served on the International Jury of Awards, on the other hand, turned his attention to the subject pictures:

One thing is evident from [the paintings in the Sargent gallery]—that for surety of touch and technical directness he stands practically alone. . . . In nothing does he disclose his marvelous precision of technique so completely as in some of the outdoor studies, like the "Syrian Goats" and the "Spanish Stable" [*Stable at Cuenca*, pl. 41]. There is nothing like them in the exhibition anywhere, and these two things alone make up for what is really

FIG. 92
Hugh Henry Breckenridge's lost canvas *The White Vase*, n.d. From *Art and Progress*, December 1915. San Francisco History Center, San Francisco Public Library

FIG. 93
Cecilia Beaux (American, 1855–1942), *Ernesta (Child with Nurse)*, 1894. Oil on canvas, 50½ × 38⅛ in. (128.3 × 96.8 cm). The Metropolitan Museum of Art, New York, Maria DeWitt Jesup Fund, 1965, 65.49

not a comprehensive display of one of the greatest modern living painters. However, a man whose standard of excellence is relatively very even does not need a large representation.[31]

By encouraging visitors to focus on what may be the two most unassuming subjects in the Sargent gallery, Neuhaus advocated taking pleasure in form as divorced from subject or meaning. The cropped foreground of *Stable at Cuenca* together with the cursorily rendered face of the foreground figure—Sargent left out the man's eyes—convey a spontaneous and rapidly captured impression of the space and its contents, while also eliminating any similarity to formal portraiture.

In addition to the galleries devoted to individual artists, there were three central galleries given over to specific groups, although these rooms were never highlighted on any of the floor plans. The largest of these, Gallery 65, was devoted to women artists, with works by Cecilia Beaux (see pls. 42–43), Mary Cassatt (see pl. 44), Bessie Potter Vonnoh (see pl. 46), and Mary Curtis Richardson, a San Francisco artist whose *Young Mother* (fig. 88) was one of the most popular pictures of the entire Exposition. Gallery 80, just inside the main entrance, represented the Boston school, with paintings by William McGregor Paxton (see fig. 89), Philip Leslie Hale, Willard LeRoy Metcalf (see pl. 64), and others.

Those commentators who recognized the regional focus of this room tended to contrast it with Gallery 51 just across the hall, a room dedicated to works by teachers and students of the Pennsylvania Academy of the Fine Arts. These three central rooms, and Gallery 51 in particular, served as important spaces where debates over the definition and validity of modern art were continued, but in a highly controlled and contextualized way that assured the celebration of American experimentation.

Robert Henri was among the artists whose work appeared in Gallery 51. Henri, who was recognized along with Chase and Duveneck in a 1915 article in *Arts and Decoration* as one of "but three men in America who combine good painting with good talking"—that is, with explaining their philosophies of art—seems an obvious oversight for an individual room, particularly given his influence as a teacher.[32] Henri's break with the National Academy of Design in 1907, his increasingly hostile relationship with Chase, and the tension among the students of both artists (which frequently erupted into violent brawls) led to his dismissal from his teaching duties at the New York school in 1909. The school's manager called Henri "very radical in his art notions, too radical for us. We want refinement."[33] Even had he been offered a gallery of his own in 1915, Henri most likely would have declined, opposed as he was to the very idea of

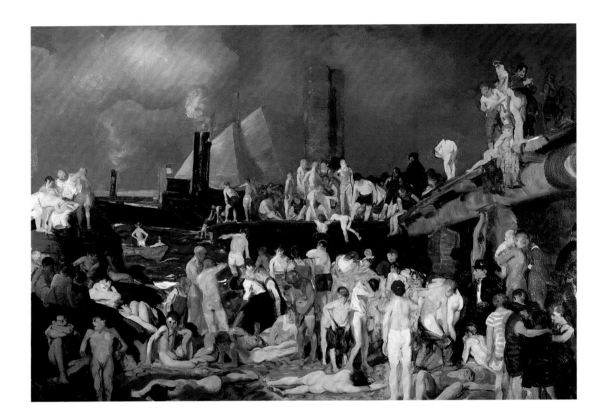

FIG. 94
George Bellows (American, 1882–1925), *Riverfront No. 1*, 1915. Oil on canvas, 45 ⅜ × 63 ⅛ in. (115.3 × 160.3 cm). Columbus Museum of Art, Ohio, Museum Purchase, Howald Fund, 1951.011

juried exhibitions.[34] Nonetheless, he did serve on the Fine Art Department's advisory committee for New York, helping to identify works to invite from that state for the exhibition. As Trask noted in his final report, there was "not one single resignation" from any of the committees.[35]

Henri not only served in an advisory capacity, but also agreed to send seven paintings to the PPIE, which were all exhibited in Gallery 51, along with multiple canvases by Breckenridge, Carles, Thomas Pollock Anshutz (see pl. 37), William James Glackens (see pl. 74), and John Sloan (see pls. 100–102). Given Trask's connection to the Pennsylvania Academy (he resigned as its director in November 1912 to devote himself fully to the PPIE), it is not surprising that the school would be specially featured, however Gallery 51 was generally not identified in this way. Instead, guidebook authors and critics consistently called attention to this room as the place to see the most radical examples of modern trends by the "independents and extremists in American art."[36] In her guidebook and presumably also in her tours of the exhibition, Berry used these "daring" younger men as a point of comparison for the Boston school across the hall whose artists she described as "extremists in the way of finish and refinement."[37] Berry drew on the proximity of these two central galleries to compare the very different techniques of the artists in each room and to point out that even the most conservative styles may be seen as extreme in their own way.

Berry's description of the artists in Gallery 51 is particularly revealing:

They are decrying at all academical things, screaming at tradition; putting things down in pure color with no half tones and doing things along lines

in a manner altogether different. . . . They work like mad. Robert Henri will complete things in a single effort or feel it scarcely worth while. This means big [technique], big scope, and great power, tremendous endurance, but not necessarily ideally constructed pictures. They possess a charm however; they are compelling and they demand attention if the visitor by any chance should pass before them.[38]

Characterizing these artists as mad was a way to link them to the Futurists, who were commonly denigrated as insane. Yet Berry's next series of descriptors evokes a nationalistic sense of (manly) strength, size, and impressiveness, representing a healthy breed of experimentation tied to American individualism—it still manages to "charm" its viewers rather than frighten, amuse, or anger them. Berry ended her guidebook tour of the main Palace building in Gallery 51 before delving into the Annex and the Futurists, thus reinforcing the connection between the controversial Americans and the radical Italians.

In his guide, Macomber noted that "Room 51 has been called 'the Chamber of Horrors,'" a term in use since the 1840s to refer to intentionally shocking exhibits.[39] The same designation was given by the local press to the Futurist gallery in the Annex, as it had to the room at the Armory Show that included Marcel Duchamp's *Nude Descending a Staircase (No. 2)* (fig. 90) along with other Cubist and Orphist works by Picasso, Picabia, Georges Braque, and Robert Delaunay.[40] At the time of the PPIE, Duchamp's infamous painting was owned by Frederic Torrey, a San Francisco art dealer and collector who bought the picture out of the Armory Show, but it was not included in the PPIE.[41] Gallery

51, in striking contrast to both the Duchamp room at the Armory Show and the Futurist gallery in the Annex, contained paintings in academic, Impressionist, and mildly Post-Impressionist modes, nothing that remotely could be considered radically modern, let alone Cubist or Futurist. Calling Gallery 51 "the Chamber of Horrors," and thereby exaggerating claims for the audacity of works in it, was commentators' means of inciting controversy and calling attention to the "radical" Americans who could hold their own for extreme experimentation alongside the French and Italians. Nationalism was, of course, rampant at any world's fair (see Acker, this volume), but in 1915 it was also a direct response to the foreign overshadowing of American artists at the Armory Show, whose work had not provoked the intense reaction inspired by their international counterparts.

In his guide to the Palace exhibition, local journalist and self-taught art critic Michael Williams helpfully identified Gallery 51 as being devoted to the legacy of Anshutz and his teaching career at the Pennsylvania Academy. Williams described Henri as "a piquant and stimulating figure in the radical set," who "has displayed a remarkable originality and independence."[42] He also mentioned other "radical and experimental" members of this "school of individualistic realism" such as Carles, Glackens, and Breckenridge, whom he deemed "ultra-modern," a term Berry reserved solely for the Futurists. Of the wall of Breckenridge paintings, Williams wrote:

> [Breckenridge is] a highly interesting case of a mature artist turning from a settled style to a newer, technically more radical, style and winning success therein. . . . The large group of still life and flower pictures which he displays is an interesting chapter on the development in America of the movement in search of an intense reality in painting which stems from the work of Cézanne and van Gogh, but which has exfoliated into strange branches and fruits which sometimes show no apparent connection with the trunk from which they spring.[43]

True to his overarching goal of establishing a lineage for each artist in the exhibition, Williams linked Breckenridge with Cézanne and Van Gogh while also emphasizing the American artist's original and individual pursuit of his own style. The allusion to a blossoming tree further emphasizes the natural qualities of Breckenridge's experimentation.

Neuhaus, who also lectured extensively on the exhibition, wrote of Gallery 51: "This magnetic collection comes as a shock to the public, who can't be blamed for its disapproval of the recent sensational experiments of Henri and Glackens."[44] He judged Glackens's *Girl with Apple* (fig. 91) "absolutely absurd and vulgar beyond description," and the rest of his works "ridiculous in their riotous superficiality."[45] The subject of the female nude precipitated the occasional scandalized reaction among American viewers at the PPIE, but Neuhaus advocated looking beyond a work's subject matter to its technique. For example, he praised Carles's *Repose* for having "all the qualities of an old master, with modern virility and colour added to it," as if to assure his audience that the painting's subject was not at issue.[46] He allowed that the wall of Breckenridge

still lifes (see fig. 92) may be "startling at first," but went on to compliment them as "a serious and successful contribution to modern art, without being in the least grotesque. I should like to have one of them in my house, without fear of their very vigorous colour."[47] For Neuhaus, Breckenridge's pictures, which won a gold medal, represented safe and tasteful experimentation. His use of color was strong and invigorating rather than corrupting, a crucial distinction Neuhaus made between American and foreign extremists at the PPIE.

If even the most traditional subjects caused a furor in the American Chamber of Horrors across the atrium, the response of commentators and the public to innovations by contemporary women artists in Gallery 65 was consistently positive. Berry enthusiastically praised the women's room for displaying "greater talent as a whole" than any other in the exhibition.[48] As a depiction of a woman and a child, Ellen Emmet Rand's *In the Studio* (pl. 45) was typical of works in the women's gallery, but as a reinterpretation of *Las Meninas* with Rand herself assuming the role of Velázquez, the painting explicitly announced her allegiance to the old masters and her seriousness as an artist. *In the Studio* prompted Neuhaus to write, "The portraits of our women painters are all far more original in composition and colour arrangement than those of the men."[49] Neuhaus's comment applied equally well to Anne M. Bremer's portraits, one of which was included in Gallery 65, with another (*The Fur Collar*, pl. 83) holding its own among portraits by Bellows and George Luks in Gallery 120.

One wall of Gallery 65 was given over almost entirely to seven paintings by Beaux, who was awarded a medal of honor for her body of work, the second-highest award behind Frieseke's grand prize and one given to only eight other painters. Curiously, Beaux should have been out of contention for awards since all of her entries were painted before 1900 and, thus, did not meet the requirement for entry into the juried competition, but her medal of honor seems to have been awarded without regard to this criterion.[50] Beaux's technique was described in commentary as "brilliant," "bold," and "vigorous," and her approach to composition "daring."[51]

Beaux sent some of her best work of the 1890s to the PPIE, including *Man with the Cat (Henry Sturgis Drinker)* (pl. 42), a portrait of her brother-in-law that was a notable picture in a room dominated by representations of women and children. With tributes to Manet in *Sita and Sarita* (1894, Musée d'Orsay) and to Edgar Degas in *Ernesta (Child with Nurse)* (fig. 93), Beaux, like Rand, referenced her sources, albeit perhaps not as overtly. Her portrait of Drinker was noted for being "very unusual and the cat in his lap . . . more so."[52] Beaux explained her portraits as "color compositions and arrangements"; the majority of her pictures at the PPIE demonstrated her particular affinity for explorations with white paint, but none of these displayed her skillful technique so well as *Man with the Cat*.[53] While the details in the room behind Drinker's head are rendered as abstracted planes of paint in order to maintain focus on his face, other such sections as his coat sleeves and right pant leg, the space beneath the chair, and the chair itself disintegrate into passages of masterful, expressive brushwork. Beaux's preference for white also distinguished her works from the many well-known Grand Manner portraits of fashionable women in black in

the American section, including Chase's *Portrait of Mrs. C. (Lady with a White Shawl)* (pl. 35), Henri's *Lady in Black Velvet (Portrait of Eulabee Dix Becker)* (pl. 38), Sargent's *Madame X*, and Whistler's *Arrangement in Black, No. 2: Portrait of Mrs. Louis Huth* (1872–1873, private collection).

Other innovative aspects of Beaux's work made her a compelling example for discussing the key components of American modernism within the context of the exhibition as a whole. Berry recognized the modernity of Beaux's simplicity and lack of storytelling. She wrote of Beaux's "two small children" (identifiable, based on her description, as *Ernesta* and *Dorothea and Francesca* [1898, Art Institute of Chicago]):

> They are painted in a severely simple manner yet they please and charm from first to last. The painter has resorted to no device, no tricks, no flowers, no little thing tossed in for color and a scheme, one baby walking along with its nurse, who is cut off the canvas below the waist, and the other child engrossed in a dancing lesson; nothing in the way of a story to tell, no hidden meaning, everything on the surface, pictures for the sake of pictures.[54]

In *Ernesta (Child with Nurse)*, Beaux's cropped composition is carefully constructed—not simple at all—and could just as easily be judged a device or trick as the absence of one. John D. Barry praised Beaux for being "as clever as Sargent" and similarly used Beaux's "ruthless" treatment of the nurse in *Ernesta* as a convenient lesson in distinguishing compositional strategies from mere gimmickry. He explained the severe cropping of the figure as a "novel scheme," not a "snobbish" jab at the nurse's social or economic position, as the wary viewer might suspect.[55] These contemporary commentaries are excellent examples of how the unconventional framing or choice of a subject was regarded with suspicion, as a "trick" to attract attention. Visitors to the art exhibition were on heightened alert to such contrivances, particularly with regard to the Futurists, and this mind-set was often applied to works throughout the Palace of Fine Arts.[56]

In a rare negative assessment of Beaux's work at the PPIE, Clark deemed her technique to be "an exaggeration of Sargent's clever brushwork . . . beautiful but not very substantial; in the portrait [*Man with the Cat*], we attend more to the folds in the man's clothes than to his character."[57] As his comment implies, the obligation of portraiture to capture the sitter's likeness or personal qualities was somewhat at odds with the modernist celebration of an artist's individual style, since technique could distract the viewer and detract from the dominance of the sitter. Given this challenge, it is not surprising that all of the portraits Beaux sent to the PPIE were uncommissioned; her Grand Manner depictions of high society women in elaborate gowns or men in professional attire were nowhere to be found. Her wall of paintings blurred the distinction between portraiture and genre, more readily allowing her shift in emphasis from subject to style, but when her technique was compared to Sargent's—even when it was praised for equaling his brilliance—the implication tended to be that her style, and by extension, her own individual expression as an artist, was derivative of his.[58]

INDIVIDUALISM IN THE COMPETITION ROOMS

Trask's efforts to create a genealogy for modernism by establishing connections among artists in the historical section, the loan collection, the special rooms, and works hanging in the undifferentiated mass of competition galleries were made more challenging by vagaries of the installation. As noted by Neuhaus, four large rooms at the northern end of the Palace had been designated part of the American section, but were "in grave danger of being overlooked. Undoubtedly to offset this apparent isolation, some of the most alluring paintings can be found at this end."[59] The largest concentration of Frieseke's prizewinning group was here, in Gallery 117 (see fig. 78). William Zorach's *Woods in Autumn* (pl. 85), an extraordinary picture bearing chromatic and compositional similarities to works by Gauguin and Matisse, hung in Gallery 119. As evidence of how dismissive most commentators were of modern trends, Zorach's work was noted in only one gallery guide, and even then only obliquely, as among "a surprising conglomeration of paintings and drawings . . . wherein the extremists have their say."[60]

Described in one guidebook as "the most successful American attempt to grasp sanely the bigness and freedom of the post-Impressionist movements," Bellows's four pictures were next door in Gallery 120.[61] *Polo Crowd* (1910, private collection) had been exhibited at the Armory Show, and at the PPIE was noted as a "bold" canvas, a "summary on a large scale expressing the force and energy of a crucial moment," as well as "very masterful" in its expression of motion.[62] Although no direct comparisons were made between them, the language used to describe *Polo Crowd*, with emphasis on movement and energy, implied a connection to Boccioni's *Dynamism of a Soccer Player* in the Annex. In *Riverfront No. 1* (fig. 94), a semi-comical portrayal of a mass of naked immigrant boys swimming off a pier in New York City, Bellows challenged traditional notions of academic idealism while simultaneously paying tribute to the expressive potential of the human figure.[63] Bellows occupied the most recent step in the venerable tradition of Frans Hals, Velázquez, and Manet, as bridged by Chase, Duveneck, Whistler, and Sargent, the further experimentation of his teacher Henri, and the other radical—but not-too-radical—independents in Gallery 51.

In his review of the American section, Cortissoz wrote that "it is with a sigh of relief that I turn to Mr. Bellows's pell mell of water rats. . . . He paints the better because he paints human life in the raw, not all smothered in the ribbons and roses of the boudoir or the properties of the studio," a thinly veiled slap at Frieseke's *In the Boudoir* (fig. 95), which hung nearby.[64] Bellows and Frieseke represented opposing trends in American art at the PPIE, yet their work was contextualized in a way that made celebrating their differences the primary lesson of the exhibition. The most progressive artists divorced an artwork's subject and style from its meaning in order to highlight individualism as the central component of American modernism. As Williams wrote of Bellows: "Sturdily, almost stubbornly independent, he has always refused to yield to commercial reasons, or to compromise with his own experimental nature."[65] Despite the relatively traditional aspects of his work, Frieseke's being awarded the biggest prize was no surprise to some, like John D. Barry, who explained, "You can see

FIG. 95
Frederick Carl Frieseke (American, 1874–1939),
In the Boudoir, by 1914. Oil on canvas, 35 3/16 × 46 in.
(89.3 × 116.9 cm). Los Angeles County Museum
of Art, Mr. and Mrs. Allan C. Balch Collection,
M.45.3.526

at a glance what individuality he has. After studying one of his canvases it is easy enough to pick out the other."[66] Along the same lines, Rose V. S. Berry wrote, "[His] pictures . . . are like nothing else to be seen [in the exhibition]; that means that this artist is original in an unusual degree."[67] Frieseke's coronation was a testament to the conservative values of world's fair art exhibitions (and their juries), but Bellows was also rewarded—with a gold medal in 1915, and with elevation to individual-gallery status in the post-Exposition exhibition that was installed in the Palace of Fine Arts after the fair's close and open through May 1916.

The main lesson that the Fine Arts Department and guidebook authors sought to convey was the idea that art is a product of individual expression and that an artist's technique is as important—in fact more so—than his or her subject matter. Most commentators encouraged visitors to move beyond a focus on subject matter, and Clark even went so far as to provide the language of formal analysis, enabling his readers to describe brushwork, color, light and shadow, and composition for themselves, and thus empowering them to make their own assessments of works in the exhibition. In the service of emphasizing healthy individuality, there was a pronounced interest in masculine qualities such as size and strength; even works in the women's gallery were noted for how "virile" they were.[68] These terms of praise—"sane" was another common description of the Americans—strongly implied that foregoing the mad abstraction in the Annex out of a preference for one's own style was to be commended.

In his review, Cortissoz suggested that the American artists' insistence on personal style may have accounted for the jumbled presentation of the American section, but he managed to turn even this weakness into a positive statement about American art. For Cortissoz, the exhibition's failure at making the successive influences on American art clear "is possibly not altogether to be ascribed to the hanging. It is due, in a measure, to the individuality of the American artist. He is not invariably to be labelled in an instant, a fact telling more effectively perhaps, than any other, in the character of this exhibition as a whole."[69]

Brinton, on the other hand, lamented that American artists displayed less of a sense of style and individuality than the foreigners in the exhibition. The Art Department had assembled a reassuringly conservative American section that, "as a rule," included "nothing that could possibly perturb the cautious or timorous."[70] He concluded: "While one cannot describe the paintings at the Panama-Pacific Exposition as being in any degree radical or modernistic, still they are sufficiently indicative of the fact that art in America is progressing along normal, wholesome lines."[71]

1. "Trask Replies to Vezin," *American Art News*, July 18, 1914, 2.

2. This was true of the other national sections as well. As Ben Macomber noted, "Though France is the home of the Post-Impressionists, and Italy that of the Futurists, the flagrancy of neither of these schools is on view here. Both countries show their best balanced art since 1905." Ben Macomber, *The Jewel City: Its Planning and Achievement; Its Architecture, Sculpture, Symbolism, and Music; Its Gardens, Palaces, and Exhibits* (San Francisco: John H. Williams, 1915), 123.

3. See Arthur Price, "Laughs and Letters of a World's Fair Stenographer. No. 22—In the Palace of Super-Fine Arts," *San Francisco Call*, September 11, 1915; Michael Williams, "Radical Art at Exposition," *American Art News*, October 2, 1915, 2; "Futurist Art under Attack," *San Francisco Examiner*, April 24, 1916.

4. Milton Brown, *The Story of the Armory Show* (New York: Abbeville Press, 1988), 64, 112.

5. Ibid., 112. Approximately three hundred thousand people saw the Armory Show in New York, Chicago, and Boston versus the ten million visitors estimated to have visited the Palace of Fine Arts. The Armory Show contained 1,300 works in New York compared with more than 11,400 works of art in the Fine Arts Department at the PPIE. The Armory Show ran for roughly three months total in its three venues, while the PPIE was open for fourteen months, including the post-Exposition period. See Darcy Tell, "The Armory Show at 100: Primary Documents," *Archives of American Art Journal* 51, nos. 3–4 (Spring 2013): 15; and Frank Morton Todd, *The Story of the Exposition: Being the Official History of the International Celebration Held at San Francisco in 1915 to Commemorate the Discovery of the Pacific Ocean and the Construction of the Panama Canal* (New York: G. P. Putnam's Sons, 1921), 4:10. Both exhibitions benefited from major publicity campaigns to advertise and explain the art on view. One article claimed that publicity for the PPIE surpassed that of all previous world's fairs combined: "Exposition Ranks as World's Most Advertised Event," *San Francisco Examiner*, February, 21, 1915.

6. Brown, *Story*, 133–142. See also Kimberly Orcutt, "'Public Verdict': Debating Modernism at the Armory Show," and Sarah Burns, "Cubist Comedy and Futurist Follies: The Visual Culture of the Armory Show," in *The Armory Show at 100: Modernism and Revolution*, exh. cat. (New York: New-York Historical Society, 2013), 327–339; 345–359.

7. Brown, *Story*, 183, 186.

8. Ibid., 178–179.

9. See Christian Brinton, "Evolution, Not Revolution in Art," *International Studio* 49, no. 194 (April 1913): 27–35. Laurvik's essay on modernism was published in the PPIE's official catalogue. See J. Nilsen Laurvik, "Post Scriptum: Apropos New Tendencies," in *Catalogue de Luxe of the Department of Fine Arts, Panama-Pacific International Exposition*, ed. John E. D. Trask and J. Nilsen Laurvik, (San Francisco: Paul Elder, 1915), 1:128–132. His booklet *Is It Art?* was published at the time of the Armory Show and reprinted by Paul Elder during the fair. See "Is It Art?," *San Francisco Chronicle*, August 1, 1915.

10. Brinton, "Evolution," 28. As Andrew Walker emphasizes, Brinton "relied on an evolutionary understanding of art history that stressed the consistent progress of innovative styles." Andrew Walker, "Critic, Curator, Collector: Christian Brinton and the Exhibition of National Modernism in America, 1910–1945" (PhD diss., University of Pennsylvania, 1999), 23.

11. Christian Brinton, "The Modern Spirit in Contemporary Painting," in *Impressions of the Art at the Panama-Pacific Exposition* (New York: John Lane, 1916), 13–27.

12. Ibid., 14–17. On symbols and language of war used in discussing the Armory Show, see Charlotte Laubard, "The 1913 Armory Show: Stakes, Strategies and Reception of a Media Event," in

American Art, 1908–1947, from Winslow Homer to Jackson Pollock, ed. Eric de Chassey (New York: Harry N. Abrams, 2002), 63.

13. Brinton, "Modern Spirit," 26.

14. Ibid., 13, 19.

15. Ibid., 20.

16. Ibid., 27.

17. Macomber, *Jewel City*, 108–109.

18. Rose V. S. Berry, *The Dream City: Its Art in Story and Symbolism* (San Francisco: Walter N. Brunt, 1915), 205.

19. "Scrambled Art and Scones. Two Features of the Fair and Their Effect Upon a Neutral Observer," *San Francisco Bulletin*, September 6, 1915. See also Edwin S. Parker, "An Analysis of Futurism," *International Studio* 58, no. 230 (April 1916): 59–60.

20. John D. Barry, "Ways of the World. The Italian Futurists: The Group Now Exciting Astonishment and Ridicule Among Visitors in the Palace of Fine Arts," *San Francisco Bulletin*, August 28, 1915.

21. As one of the docents noted, "If only [the public] could have gently, gradually been led by the vagaries of Matisse or of Picabia down to the atrocities of Balla, Carra and Severini, instead of this sudden plunge!" "Exposition Crowds Eager to Learn About Art," *New York Times*, December 19, 1915.

22. In correspondence with John Beatty, director of the Carnegie Institute, Trask made clear that each foreign commission was given complete control over the determination of its own national section: "You will understand that the contemporaneous foreign pictures to be shown in the Exposition should properly appear in the foreign sections, and I have no desire at all to exert any influence upon the various foreign national commissioners suggesting either the character of their exhibits generally or any individual exhibits to be included." Trask to Beatty, September 13, 1913, Carnegie Institute Museum of Art Records, 1883–1962, bulk 1885–1940, Archives of American Art. Even if Trask could not be held responsible for the conservatism of the French Section, the juries oversaw the selection of a decidedly restrained presentation of American modernism. As Nancy Boas has noted in her comparison of the American artists included in both exhibitions, "the most conservative Armory entries were among the most advanced at the PPIE." Nancy Boas, *The Society of Six: California Colorists* (San Francisco: Bedford Arts, 1988), 62.

23. Eugen Neuhaus, *The History and Ideals of American Art* (Palo Alto: Stanford University Press, 1931), 269.

24. "Trask Praises U.S. Art," *American Art News*, December 27, 1913, 9.

25. John E. D. Trask, "Report of the Department of Fine Arts," (unpublished transcript, September 16, 1916), 16, San Francisco History Center, San Francisco Public Library; "Art Exhibits Drawn from All Nations," *Examiner* (San Francisco), March 14, 1915; "The Spectator at the World's Fair," *Outlook*, April 14, 1915, 896. Two important precedents for the idea of galleries devoted to individual artists were exhibitions held at the Pennsylvania Academy in 1908. The first was the exhibition of The Eight, a group of independent American artists who joined forces with Robert Henri in 1907 to display their work in an exhibition outside the National Academy, originating at Macbeth Gallery in New York, in which each artist was allotted a set amount of space, but with no restrictions on the number or type of objects to include. Trask subsequently oversaw the tenth anniversary exhibition of The Ten, in which each artist was given complete control over the selection of ten of his works to exhibit.

26. Christian Brinton, "American Painting at the Panama-Pacific Exposition," *International Studio* 56, no. 222 (August 1915): 28.

27. The smaller galleries of individual artists were generally praised for having fewer works. As John D. Barry noted of the room of Whistler's paintings, "In some ways it's a good thing that the collection here is so small. It enables people to take it all in

and to get a pretty fair idea of what Whistler was trying to do." John D. Barry, *The Palace of Fine Arts and the French and Italian Pavilions: A Walk with a Painter, with a Discussion of Painting and Sculptures and Some of the Workers Therein, Mainly from the Painter's Point of View* (San Francisco: H. S. Crocker, 1915), 12. Several of the individual-artist rooms were criticized for being repetitious. As one review noted, "One half the number of canvases would have sufficed in at least eight of the exhibits." "An Exhibition Defeating Itself," *Literary Digest* 51, no. 9 (August 28, 1915): 405.

28. John Singer Sargent to Edward Robinson, January 8, 1916, Metropolitan Museum of Art Archives, quoted in Stephanie L. Herdrich and H. Barbara Weinberg, *American Drawings and Watercolors in the Metropolitan Museum of Art: John Singer Sargent* (New Haven: Yale University Press, 2000), 5.

29. Arthur Bridgman Clark, *Significant Paintings at the Panama-Pacific Exposition: How to Find Them and How to Enjoy Them* (Palo Alto: Stanford University Press, 1915), 6–7.

30. "Just as the 'Mrs. Huth' would have spoken alone for Whistler the 'Madame Gautreau' would have been a sufficient warrant for Sargent's having a separate room." Royal Cortissoz, "Pictures in the American Salon. A Tour of the Fine Arts Palace at the San Francisco Fair," *New York Tribune*, June 30, 1915.

31. Eugen Neuhaus, *The Galleries of the Exposition: A Critical Review of the Paintings, Statuary and the Graphic Arts in the Palace of Fine Arts at the Panama-Pacific International Exposition* (San Francisco: Paul Elder, 1915), 71.

32. "Who's Who in American Art," *Arts and Decoration*, November 1915, 33.

33. "R. Henri to Head a School," *New York Sun*, January 6, 1906, quoted in Kimberly Orcutt, *William Merritt Chase and Robert Henri*, exh. cat. (Greenwich, CT: Bruce Museum, 2007), 46.

34. George Bellows biographer Charles Morgan describes the awkwardness of Bellows's involvement with the PPIE selection jury with respect to Henri, who was "violently opposed" to submitting his own work to the exhibition. Charles H. Morgan, *George Bellows: Painter of America* (New York: Reynal, 1965), 185. At the time, Henri was also occupied with organizing an art exhibition for the Panama-California Exposition in San Diego that was held concurrently with the San Francisco fair. See Jean Stern, "Robert Henri and the 1915 San Diego Exposition," *American Art Review* 2, no. 5 (September–October 1975): 108–117.

35. Trask, "Report," 6.

36. Sheldon Cheney, *An Art-Lover's Guide to the Exposition: Explanations of the Architecture, Sculpture, and Mural Paintings, with a Guide for Study in the Art Gallery* (Berkeley: At the Sign of the Berkeley Oak, 1915), 86.

37. Berry, *Dream City*, 275.

38. Ibid., 275–277.

39. Macomber, *Jewel City*, 121. The term "Chamber of Horrors" was first used in 1843 to refer to a room at Madame Tussaud's Wax Museum in London containing wax versions of decapitated heads from executed victims of the French Revolution. See Pamela Pilbeam, *Madame Tussaud and the History of Waxworks* (London: Hambledon and London Press, 2003), 69, 108. Of the 1877 Impressionist exhibition in Paris, American artist Julian Alden Weir wrote: "I never in my life saw more horrible things. . . . They do not observe drawing nor form but give you an impression of what they call nature. It was worse than the Chamber of Horrors." Quoted in Barbara Weinberg, Doreen Bolger, and David Park Curry, *American Impressionism and Realism: The Painting of Modern Life, 1885–1915*, exh. cat. (New York: Metropolitan Museum of Art, 1994), 14. When used to refer to works of fine art, the term was associated with artists who "dismembered" traditional forms, as with Duchamp and Picasso at the Armory Show and the Futurists at the PPIE.

40. "Scrambled Art and Scones"; See also Michael R. Taylor, "Marcel Duchamp's Nude Descending a Staircase [No. 2] and

the 1913 Armory Scandal Revisited," *Archives of American Art Journal* 51, nos. 3–4 (March 2013): 52.

41. Francis Naumann, "Frederic C. Torrey and Duchamp's *Nude Descending a Staircase*," in *West Coast Duchamp*, ed. Bonnie Clearwater (Miami Beach: Grassfield Press, 1991), 18. Naumann provides a thorough discussion of Torrey's ownership and exhibition of the painting at his Sutter Street gallery in 1914; see 11–23. Trask presumably had no intention of asking Torrey to lend the painting, as he would not meddle with the selection of works in the foreign sections (see note 22 above) and he also did not want to include works by the most radical Armory Show artists in the loan section. As he stated in a description of the exhibition that he sent to members of the advisory committees, "In the loan collection there will be no contemporaneous foreign works at all." Trask to Robert Fletcher, July 23, 1913, San Francisco Art Institute Archives.

42. Michael Williams, *A Brief Guide to the Department of Fine Arts: Panama-Pacific International Exposition, San Francisco, California, 1915* (San Francisco: Wahlgreen, 1915), 33.

43. Ibid.

44. Neuhaus, *Galleries of the Exposition*, 78. Neuhaus's popular lectures on the art exhibition were transcribed and published as this book during the fair. See Eugen Neuhaus, *Drawn from Memory, a Self Portrait* (Palo Alto: Pacific Books, 1964), 95–96.

45. Ibid., 78–79.

46. Ibid., 79. Clark also praised Carles's nudes as "very solid painting and sense of form, good composition." Clark, *Significant Paintings*, 10. For Barry's commentary on the responses to nudity in the art exhibition, see John D. Barry, "Ways of the World. Attitude Towards Painting: A Matter of Some Concern to the Crowds of People that Visit the Palace of Fine Arts," *San Francisco Bulletin*, June 26, 1915; and "Ways of the World. Nudity in Art: The Education We Are Now Receiving in Regard to This Complicated and Generally Misunderstood Human Subject," *San Francisco Bulletin*, August 5, 1915. For a send-up of the nudity issue, see Thomas H. Kennedy, *The Devil at the Fair or Reflections on Nude Art* (San Francisco: Thomas H. Kennedy, 1915).

47. Neuhaus, *Galleries of the Exposition*, 79.

48. Berry, *Dream City*, 262.

49. Neuhaus, *Galleries of the Exposition*, 60.

50. The awards policy was stated twice in *Circular of Information, Panama-Pacific International Exposition, San Francisco, 1915, Department of Fine Arts* (San Francisco, 1914). However, there is no mention of this policy in his final report (Trask, "Report").

51. Cheney, *Art-Lover's Guide*, 82; Neuhaus, *Galleries of the Exposition*, 60.

52. Berry, *Dream City*, 269. Berry may have had reservations about the cat's placement: "The cat is wonderfully well painted however, and from a little distance the fur has a lifelike quality scarcely believable." The pose of the girl's left hand in *Sita and Sarita* echoes that of Olympia's right, and the black cat that confronts the viewer is a near replica of the black cat at Olympia's feet. The placement of the cat in Beaux's portrait of Drinker serves a similarly provocative purpose as that of Olympia's hand, both drawing attention to and concealing a specific region of Drinker's lap. See Sylvia Yount, Nina Auerbach, and Mark Bockrath, *Cecilia Beaux: American Figure Painter*, exh. cat. (Atlanta: High Museum of Art, 2007), 33–34.

53. See Beaux's notes for an address to the American Academy of Arts and Letters, 1926, microfilm 428, frame 412, Beaux Papers, Archives of American Art, cited in Yount, Auerbach, and Bockrath, *Cecilia Beaux*, 32.

54. Berry, *Dream City*, 270.

55. Barry, *Palace of Fine Arts*, 35. Barry's guide was a compilation of his "Ways of the World" columns on art that were published in the *San Francisco Bulletin*. His column on the women's gallery

first appeared in the *San Francisco Bulletin* on October 6, 1915.

56. Barry's discussion of the public's response to the Futurists hinges on a sense of anxiety over being tricked into believing their work was meant to be taken seriously. John D. Barry, "Ways of the World."

57. Clark, *Significant Paintings*, 10.

58. Kevin Sharp notes Beaux's debt to Manet and Degas, who intentionally blurred the line between genre and portraiture. He also argues that uncommissioned portraits of family and friends "stimulated [Beaux's] artistic growth . . . and ensured that she always had interesting pictures, appealing in their formal and thematic complexity, on hand for major exhibitions." Kevin Sharp, "Cecilia Beaux and the Rise of American Portraiture in the 1890s," in Yount, Auerbach, and Bockrath, *Cecilia Beaux*, 62, 69.

59. Neuhaus, *Galleries of the Exposition*, 84.

60. Cheney, *Art-Lover's Guide*, 87.

61. Ibid.

62. Neuhaus, *Galleries of the Exposition*, 86; Clark, *Significant Paintings*, 9.

63. Marianne Doezema's comparison of Bellows's work from earlier National Academy and Pennsylvania Academy annuals with that of Philip Leslie Hale, William McGregor Paxton, and William Sergeant Kendall is particularly applicable to the PPIE, where Bellows continued to be pitted against these same practitioners of academic technique and idealized feminine beauty of the genteel tradition—seven years later and in the context of a much larger exhibition. Marianne Doezema, *George Bellows and Urban America* (New Haven: Yale University Press, 1992), 90–91. Doezema also notes here that Laurvik criticized Paxton's *Glow of Gold and Gleam of Pearl* in 1908 as "pretentious" and "superrefined affectation." This painting hung in Gallery 80, the room for the Boston school paintings, in the Palace of Fine Arts at the PPIE.

64. Cortissoz, "Pictures in the American Salon," 9.

65. Williams, *Brief Guide*, 43.

66. Barry, *Palace of Fine Arts*, 18.

67. Berry, *Dream City*, 294.

68. One of Cheney's comments about Gallery 65 suggests that he didn't realize that only women artists were featured here: "It is notable how many of the really virile paintings here are by women." Cheney, *Art-Lover's Guide*, 82. For the period meaning of these terms, see Bruce Robertson, *Reckoning with Winslow Homer: His Late Paintings and Their Influence*, exh. cat. (Cleveland: Cleveland Museum of Art, 1990), 63–67; and Virginia M. Mecklenburg, "Manufacturing Rebellion: The Ashcan Artists and the Press," in Rebecca Zurier, Robert W. Snyder, and Virginia M. Mecklenburg, *Metropolitan Lives: The Ashcan Artists and Their New York*, exh. cat. (Washington, DC: National Museum of American Art, 1995), 191–213.

69. Cortissoz, "Pictures in the American Salon," 9.

70. Brinton, "American Painting," 32.

71. Ibid.

27 Hiram Powers (American, 1805–1873)
California, ca. 1861
Marble
27 ⅛ × 18 ⅛ × 12 in. (69 × 46 × 30.5 cm)
Fine Arts Museums of San Francisco, gift of M. H. de Young, 42194
Palace of Fine Arts, Gallery 66, no. 3110

28 Frederic Remington (American, 1861–1909)
The Bronco Buster, 1895
Bronze
24 × 20 × 12 ½ in. (61 × 50.8 × 31.8 cm)
Fine Arts Museums of San Francisco, museum purchase,
gift of Doris Schmiedell and the M. H. de Young Museum Foundation, 69.21
Palace of Fine Arts, Gallery 64, no. 2977

29 Winslow Homer (American, 1836–1910)
The Artist's Studio in an Afternoon Fog, 1894
Oil on canvas
24 × 30 ¼ in. (61 × 76.8 cm)
Memorial Art Gallery, University of Rochester, New York, R. T. Miller Fund, 41.32
Palace of Fine Arts, Gallery 54, wall A, no. 2519 as *Afternoon Fog*

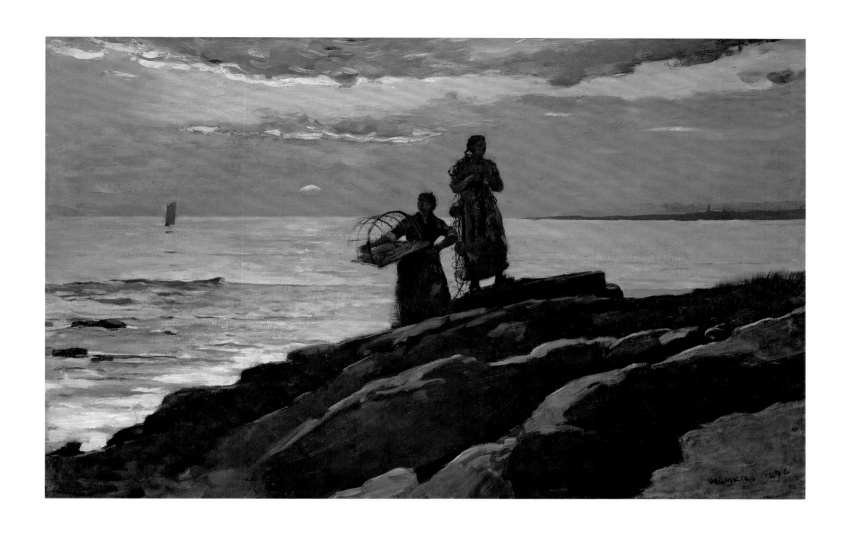

30 Winslow Homer (American, 1836–1910)
Saco Bay, 1896
Oil on canvas
23⅞ × 38 in. (60.5 × 96.4 cm)
Sterling and Francine Clark Art Institute, Williamstown, Massachusetts, 1955.5
Palace of Fine Arts, Gallery 54, wall A, no. 2514 as *The Coming Storm*

31 James McNeill Whistler (American, 1834–1903)
Study in Rose and Brown, ca. 1884
Oil on canvas
20 × 12 ¼ in. (50.8 × 31.1 cm)
Collection of the Muskegon Museum of Art, Michigan, Hackley Picture Fund Purchase, 1914.21
Palace of Fine Arts, Gallery 28, wall D, no. 274

32 Edwin Austin Abbey (American, 1852–1911)
The Penance of Eleanor, Duchess of Gloucester, 1900
Oil on canvas
49 × 85 in. (124.5 × 215.9 cm)
Carnegie Museum of Art, Pittsburgh, purchase, 02.1
Palace of Fine Arts, Gallery 57, wall B, no. 2653

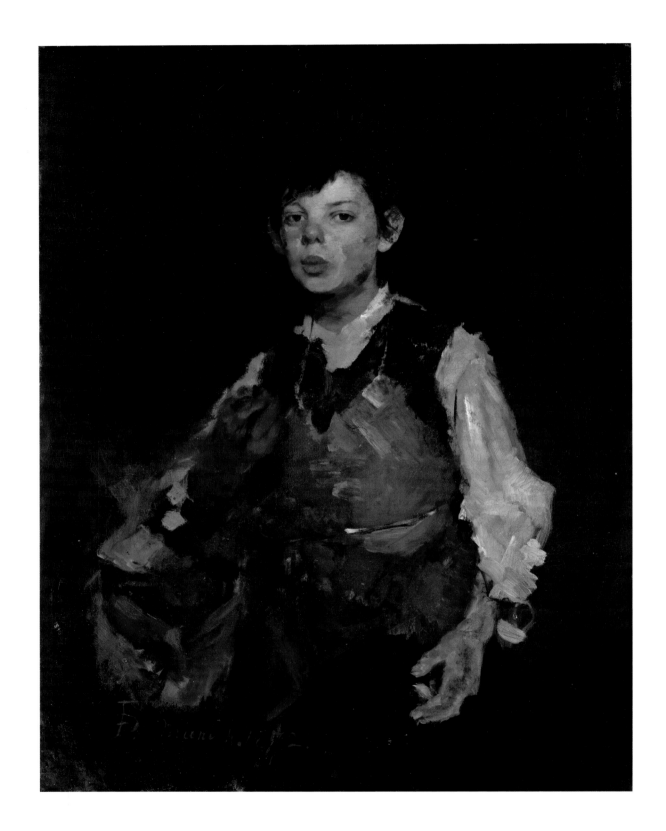

33 Frank Duveneck (American, 1848–1919)
Whistling Boy, 1872
Oil on canvas
27 ⅞ × 21 ⅛ in. (70.8 × 53.7 cm)
Cincinnati Art Museum, gift of the artist, 1904.196
Palace of Fine Arts, Gallery 87, wall A, no. 3868

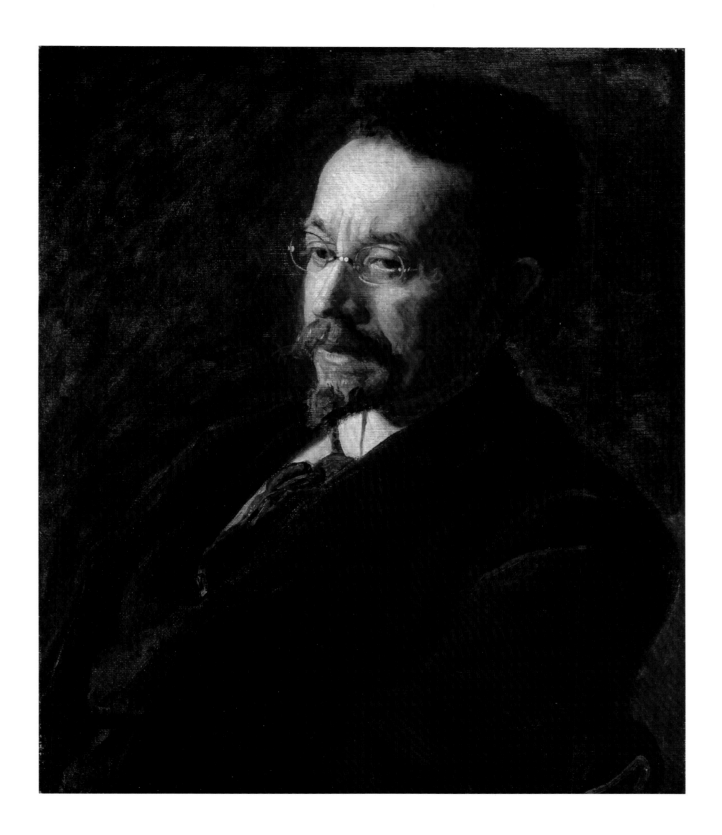

34 Thomas Eakins (American, 1844–1916)
Portrait of Henry O. Tanner, ca. 1897
Oil on canvas
24 ⅝ × 20 ⅛ in. (62.5 × 51.1 cm)
The Hyde Collection, Glens Falls, New York, bequest of Charlotte Pruyn Hyde, 1971.16
Palace of Fine Arts, Gallery 64, wall C, no. 2965

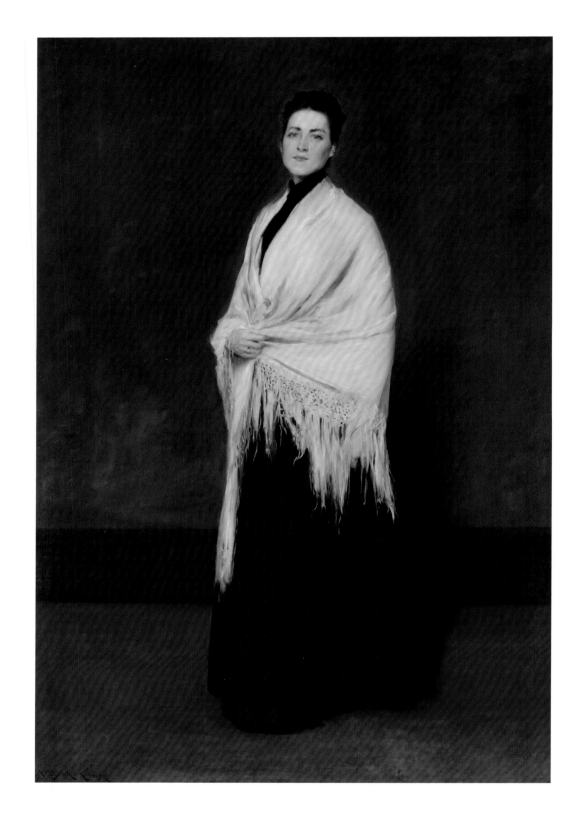

35 William Merritt Chase (American, 1849–1916)
Portrait of Mrs. C. (Lady with a White Shawl), 1893
Oil on canvas
75 × 52 in. (190.5 × 132.1 cm)
Pennsylvania Academy of the Fine Arts, Philadelphia, Joseph E. Temple Fund, 1895.1
Palace of Fine Arts, Gallery 79, wall D, no. 3766, as *Woman with the White Shawl*

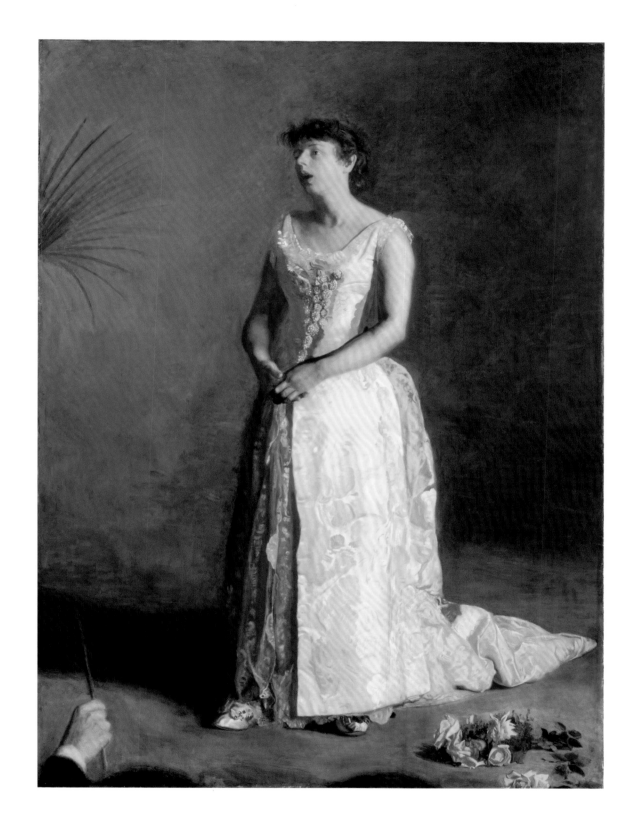

36 Thomas Eakins (American, 1844–1916)
The Concert Singer, 1890–1892
Oil on canvas
75 ⅛ × 54 ¼ in. (190.8 × 137.8 cm)
Philadelphia Museum of Art, gift of Mrs. Thomas Eakins and Miss Mary Adeline Williams, 1929-184-19
Palace of Fine Arts, Gallery 64, wall C, no. 2960

37 Thomas Pollock Anshutz (American, 1851–1912)
Incense Burner, 1905
Oil on canvas
64 × 40 in. (162.6 × 101.6 cm)
Pennsylvania Academy of the Fine Arts, Philadelphia, Henry D. Gilpin Fund, 1940.11
Palace of Fine Arts, Gallery 51, wall B, no. 2474

38 Robert Henri (American, 1865–1929)
Lady in Black Velvet (Portrait of Eulabee Dix Becker), 1911
Oil on canvas
77 ½ × 36 ⅞ in. (196.9 × 93.8 cm)
High Museum, Atlanta, gift in memory of Dr. Thomas P. Hinman through exchange and general funds, 73.55
Palace of Fine Arts, Gallery 51, wall D, no. 2501

39 John Singer Sargent (American, b. Italy, 1856–1925)
 Reconnoitering (Portrait of Ambrogio Raffaele), 1911
 Oil on canvas
 22 × 28 in. (55.9 × 71.1 cm)
 Galleria d'arte moderna di Palazzo Pitti, Florence, Inv.143.613480
 Palace of Fine Arts, Gallery 75, wall C, no. 3631

40 John Singer Sargent (American, b. Italy, 1856–1925)
The Sketchers, 1913
Oil on canvas
22 × 28 in. (56 × 71.1 cm)
Virginia Museum of Fine Arts, the Arthur and Margaret Glasgow Fund, 58.11
Palace of Fine Arts, Gallery 75, wall C, no. 3629

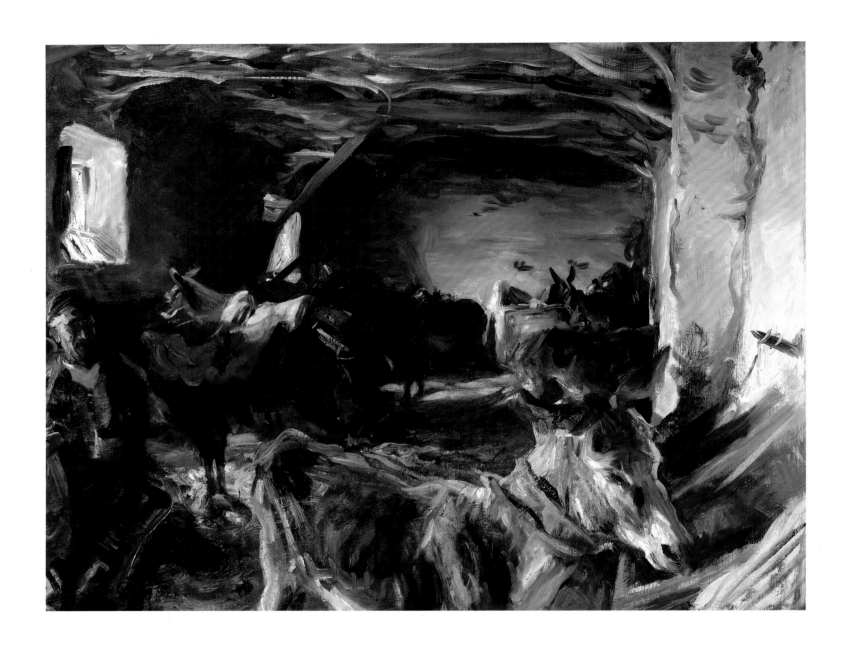

41 John Singer Sargent (American, b. Italy, 1856–1925)
Stable at Cuenca, 1903
Oil on canvas
22 ½ × 28 ⅜ in. (57.2 × 72.1 cm)
Smithsonian American Art Museum, Washington, DC, purchase made possible by the American Art Forum,
and through the Catherine Walden Myer and Luisita L. and Franz H. Denghausen Endowments, 2014.1
Palace of Fine Arts, Gallery 75, wall D, no. 3633, as *Spanish Stable*

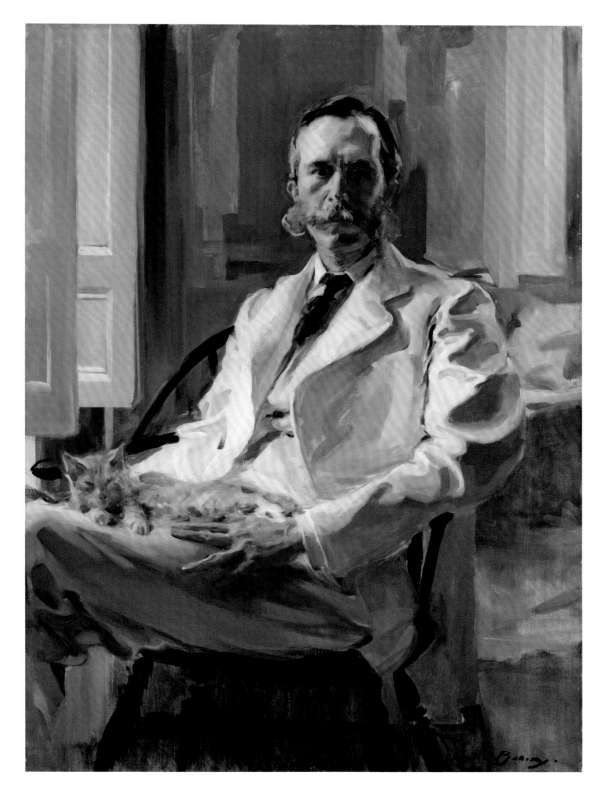

42 Cecilia Beaux (American, 1855–1942)
Man with the Cat (Henry Sturgis Drinker), 1898
Oil on canvas
48 × 34⅜ in. (121.9 × 87.8 cm)
Smithsonian American Art Museum, Washington, DC, bequest of Henry Ward Ranger
through the National Academy of Design, 1952.10.1
Palace of Fine Arts, Gallery 65, wall D, no. 3038, as *Portrait*

43 Cecilia Beaux (American, 1855–1942)
New England Woman, 1895
Oil on canvas
43 × 24 ¼ in. (109.2 × 61.6 cm)
Pennsylvania Academy of the Fine Arts, Philadelphia, Joseph E. Temple Fund, 1896.1
Palace of Fine Arts, Gallery 65, wall D, no. 3036, as *Study in Whites*

44 Mary Cassatt (American, 1844–1926)
Mother and Child with a Rose Scarf, ca. 1908
Oil on canvas
46 × 35 ¾ in. (116.8 × 89.5 cm)
The Metropolitan Museum of Art, New York, bequest of Miss Adelaide Milton de Groot (1876–1967), 1967, 67.187.122
Palace of Fine Arts, Gallery 65, wall B, no. 3008, as *Woman and Child: Rose Scarf*

45 Ellen Emmet Rand (American, 1875–1941)
In the Studio, 1910
Oil on canvas
44 ¼ × 36 ¼ in. (112.4 × 92.1 cm)
William Benton Museum of Art, University of Connecticut, Storrs, gift of John A.,
William B., and Christopher T. E. Rand
Palace of Fine Arts, Gallery 65, wall A, no. 2993

46 Bessie Potter Vonnoh (American, 1872–1955)
 The Scarf, ca. 1908
 Bronze
 13 ½ × 5 ½ × 6 ½ in. (34.3 × 14 × 16.5 cm)
 Museum of Fine Arts, Boston, anonymous gift in memory of John G. Pierce Sr., Res.65.62
 Palace of Fine Arts, Gallery 65, case 2, no. 3069

47 Robert Ingersoll Aitken (American, 1878–1949)
 Xoros (Dancing Bacchante), ca. 1910
 Bronze
 With base: 18 ¾ × 12 ¼ × 7 in. (47.6 × 31.1 × 17.8 cm)
 Private collection
 Palace of Fine Arts, Gallery 68, no. 3284

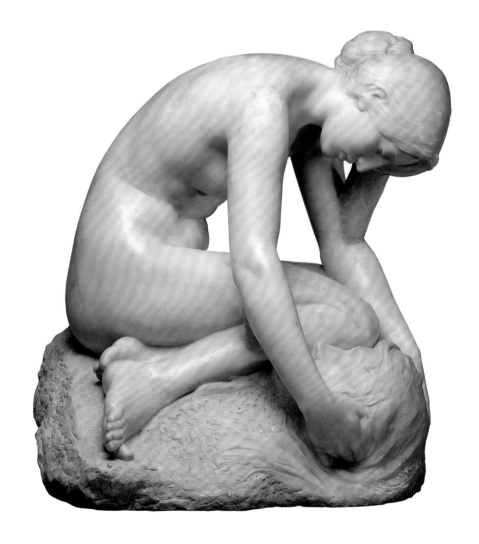

48 Edward Berge (American, 1876–1924)
Muse Finding the Head of Orpheus, 1899
Marble
29 × 27 ¹³⁄₁₆ × 22 ¹⁄₁₆ in. (73.6 × 71 × 56 cm)
Walters Art Museum, Baltimore, bequest of Lily Berge, 1985, 28.29
Palace of Fine Arts, Colonnade, no. 4483

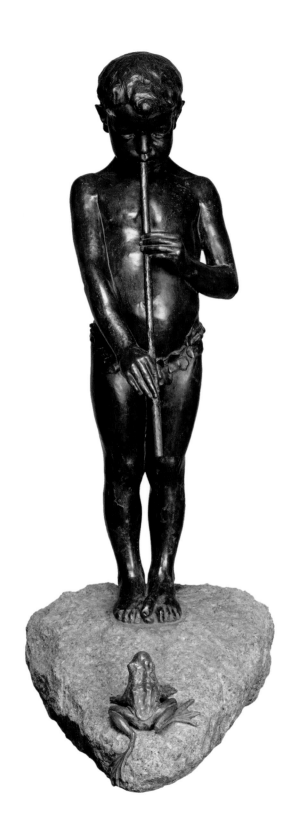

49 Clement John Barnhorn (American, 1857–1935)
Boy Pan with Frog, 1914
Bronze and stone
48½ × 19 × 26 in. (123.2 × 48.3 × 66 cm)
Fine Arts Museums of San Francisco, gift of Walter Scott Newhall Jr., 65.27
Palace of Fine Arts, Colonnade, no. 4518

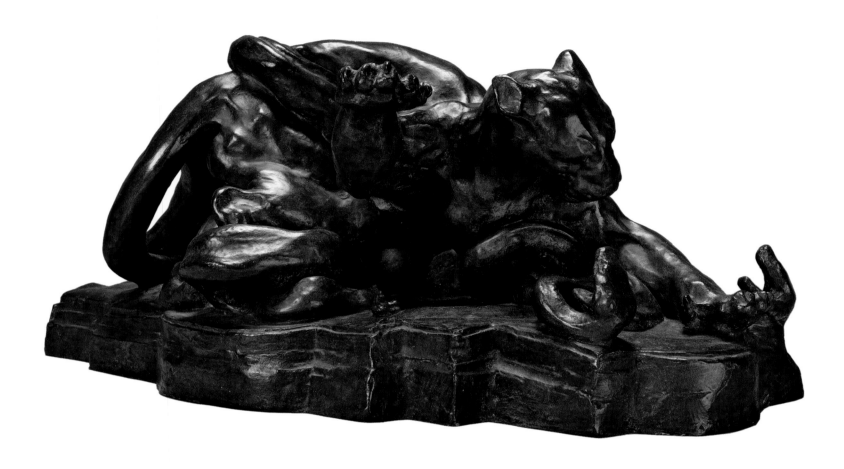

50 Arthur Putnam (American, 1873–1930)
Combat: Puma and Serpents, ca. 1906
Bronze
11 × 26 ½ × 12 ½ in. (27.9 × 66 × 30.5 cm)
Fine Arts Museums of San Francisco, gift of Alma de Bretteville Spreckels, 1924.155.1
Palace of Fine Arts, Gallery 67, case 1, no. 3208, as *Puma and Snake*

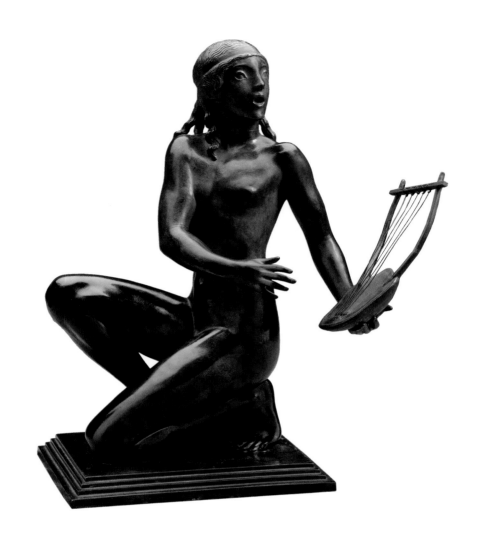

51 Paul Manship (American, 1885–1966)
Lyric Muse, 1912
Bronze, copper wire
12 ¾ × 6 ¾ × 5 ½ in. (32.4 × 17.3 × 14 cm)
Museum of Fine Arts, Boston, gift of Miss Mary C. Wheelwright, 42.373
Palace of Fine Arts, Gallery 93, no. 4078

52 Theodore Robinson (American, 1852–1896)
The Valley of Arconville, ca. 1887
Oil on canvas
18 × 21⅞ in. (45.8 × 55.7 cm)
Art Institute of Chicago, Friends of American Art Collection, 1941.11
Palace of Fine Arts, Gallery 57, wall C, no. 2668, as *Le Val Arconville: Eure*

53 Guy Rose (American, 1867–1925)
The Backwater, ca. 1910
Oil on canvas
20 × 24 in. (50.9 × 61 cm)
Private collection
Palace of Fine Arts, Gallery 72, wall C, no. 3499

54 Frederick Carl Frieseke (American, 1874–1939)
 The Garden Chair, ca. 1912
 Oil on canvas
 28 ¼ × 35 ¾ in. (71.6 × 90.7 cm)
 Collection of Ambassador and Mrs. Ronald Weiser
 Palace of Fine Arts, Gallery 117, wall B, no. 4103

55 Lawton Silas Parker (American, 1868–1954)
La paresse (Idleness), 1913
Oil on canvas
50 × 60 in. (127 × 152.4 cm)
M. Christine Schwartz Collection, Chicago
Palace of Fine Arts, Gallery 69, wall B, no. 3298

56 George Hitchcock (American, 1850–1913)
The Vanquished (Vaincu), ca. 1898
Oil on canvas
39 ⅜ × 35 ⅜ in. (100 × 90.5 cm)
Musée d'Orsay, Paris, RF 1977 194
Palace of Fine Arts, Gallery 56, wall B, no. 2615

57 Joseph M. Raphael (American, 1869–1950)
Spring Winds, ca. 1914
Oil on canvas
29 ¼ × 36 ⅛ in. (74.3 × 91.8 cm)
Fine Arts Museums of San Francisco, museum purchase, Skae Fund Legacy, 41765
Palace of Fine Arts, Gallery 67, wall B, no. 3165

58 Gari Melchers (American, 1860–1932)
The Open Door, ca. 1905–1910
Oil on canvas
62 × 48¼ in. (157.5 × 122.8 cm)
Gari Melchers Home and Studio, University of Mary Washington, Fredericksburg, Virginia
Palace of Fine Arts, Gallery 77, wall A, no. 3668

59 John Henry Twachtman (American, 1853–1902)
Mother and Child, ca. 1893
Oil on canvas
30 ⅛ × 25 ⅛ in. (76.5 × 63.8 cm)
Fine Arts Museums of San Francisco, gift of the family of Jacob Stern from his collection, 2007.45
Palace of Fine Arts, Gallery 93, wall B, no. 4063

60 Edmund Charles Tarbell (American, 1862–1938)
On Bos'n's Hill, 1901
Oil on canvas
41 ¾ × 30 ¾ in. (106 × 78 cm)
Cleveland Museum of Art, gift of Mr. and Mrs. Thomas A. Mann and Robert A. Mann, 1992.398
Palace of Fine Arts, Gallery 89, wall D, no. 3958

61 Childe Hassam (American, 1859–1935)
Aphrodite, Appledore, 1908
Oil on canvas
81⅞ × 55⅞ in. (208 × 142 cm)
American Academy of Arts and Letters, New York
Palace of Fine Arts, Gallery 78, wall D, no. 3731, as *Aphrodite*

62 Edward Francis Rook (American, 1870–1960)
Laurel, ca. 1905–1910
Oil on canvas
40 ¼ × 50 ¼ in. (102.3 × 127.6 cm)
Florence Griswold Museum, Old Lyme, Connecticut, gift of the Hartford Steam Boiler Inspection
and Insurance Company, 2002.1.117
Palace of Fine Arts, Gallery 48, wall C, no. 2374

63 Harry Leslie Hoffman (American, 1874–1966)
A Mood of Spring, ca. 1913
Oil on canvas
30 × 40 in. (76.2 × 101.6 cm)
Florence Griswold Museum, Old Lyme, Connecticut, gift of Mrs. John Hoffman and Family, 2003.8
Palace of Fine Arts, Gallery 118, wall B, no. 4180

64　Willard LeRoy Metcalf (American, 1858–1925)
Winter's Festival, 1913
Oil on canvas
26 × 29 in. (66 × 73.7 cm)
Fine Arts Museums of San Francisco, gift of Mrs. Herbert Fleishhacker, 47.5.3
Palace of Fine Arts, Gallery 80, wall D, no. 3811

65 Edward Willis Redfield (American, 1869–1965)
The Hills and River, 1914
Oil on canvas
50 ¼ × 56 in. (127.6 × 142.1 cm)
Fine Arts Museums of San Francisco, gift of Marian Huntington, 1928.20
Palace of Fine Arts, Gallery 88, wall D, no. 3937

66 Daniel Garber (American, 1880–1958)
Quarry, Evening, 1913
Oil on canvas
50 × 60 in. (127 × 152.4 cm)
Philadelphia Museum of Art, purchased with the W. P. Wilstach Fund, 1921, W1921-1-3
Palace of Fine Arts, Gallery 68, wall C, no. 3265

67 Robert Spencer (American, 1879–1931)
Courtyard at Dusk, 1913
Oil on canvas
30 × 36 ⅛ in. (76.2 × 91.8 cm)
Fine Arts Museums of San Francisco, gift of Mr. and Mrs. Ronald MacDougall, 1960.31
Palace of Fine Arts, Gallery 68, wall C, no. 3263

68 **Gifford Beal** (American, 1879–1956)
Old Town Terrace, 1914
Oil on canvas
36 ¼ × 48 ½ in. (92.1 × 123.2 cm)
Ruth Chandler Williamson Gallery, Scripps College, Claremont, California, SH1
Palace of Fine Arts, Gallery 73, wall B, no. 3542

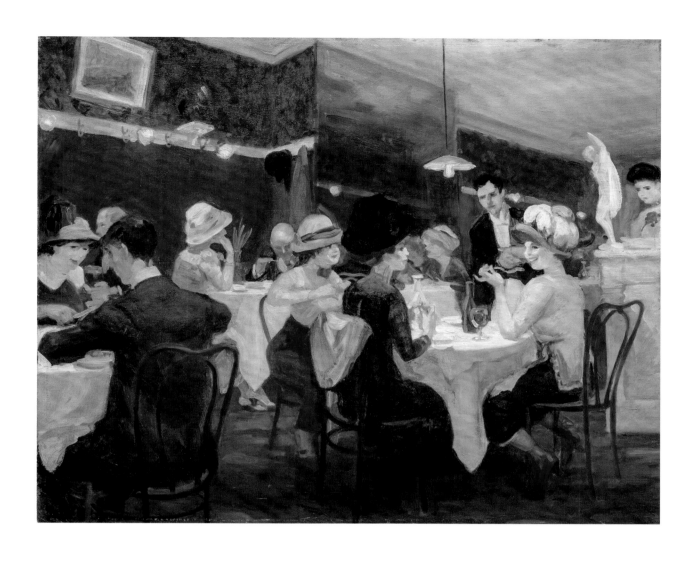

69 John Sloan (American, 1871–1951)
 Renganeschi's Saturday Night, 1912
 Oil on canvas
 26¼ × 32 in. (66.7 × 81.3 cm)
 Art Institute of Chicago, gift of Mary Otis Jenkins, 1926.1580
 Palace of Fine Arts, Gallery 51, wall C, no. 2496, as *Renganeschi's: Sunday Night*

70 Julian Alden Weir (American, 1852–1919)
The Bridge: Nocturne (Nocturne: Queensboro Bridge), 1910
Oil on canvas mounted on wood
29 × 39 ½ in. (73.6 × 100.4 cm)
Hirshhorn Museum and Sculpture Garden, Smithsonian Institution, Washington, DC,
gift of Joseph H. Hirshhorn, 1966, 66.5507
Palace of Fine Arts, Gallery 49, wall D, no. 2426, as *Towards Queensboro Bridge: Nocturne*

71 Julian Alden Weir (American, 1852–1919)
The Plaza: Nocturne, 1911
Oil on canvas
29 × 39 ½ in. (73.6 × 100.4 cm)
Hirshhorn Museum and Sculpture Garden, Smithsonian Institution, Washington, DC,
gift of Joseph H. Hirshhorn, 1966, 66.5508
Palace of Fine Arts, Gallery 49, wall D, no. 2423

72　David Brown Milne (Canadian, 1882–1953)
Black and White I, 1911
Watercolor
18 × 22¼ in. (46 × 58 cm)
Collection of Laura and Byrne Harper
Palace of Fine Arts, Gallery 40, wall B, no. 1729

73 David Brown Milne (Canadian, 1882–1953)
Black and White II, 1911
Watercolor
18 × 23 in. (46 × 58.5 cm)
Collection of Greg Latremoille
Palace of Fine Arts, Gallery 40, wall B, no. 1734

74　William James Glackens (American, 1870–1938)
The Green Car, 1910
Oil on canvas
24 × 32 in. (61 × 81.3 cm)
The Metropolitan Museum of Art, New York, Arthur Hoppock Hearn Fund, 1937, 37.73
Palace of Fine Arts, Gallery 51, wall A, no. 2466

75 Fokko Tadama (American, b. Sumatra, 1871–1937)
 Public Market, Seattle, ca. 1910
 Oil on board
 31 ⅞ × 54 in. (81 × 137.2 cm)
 Fine Arts Museums of San Francisco, The Palace of Fine Arts, San Francisco, CP13219
 Palace of Fine Arts, Gallery 56, wall C, no. 2629

76 Arthur Wesley Dow (American, 1857–1922)
The Enchanted Mesa, 1913
Oil on canvas
32 ¾ × 54 in. (83 × 137 cm)
Avery Architectural & Fine Arts Library, Columbia University, New York, transferred from
the Women's Faculty Club, C00.1371
Palace of Fine Arts, Gallery 69, wall D, no. 3319

77 Francis McComas (American, b. Australia, 1874–1938)
Navajo Gateway, Arizona, 1914
Watercolor
26 ¾ × 21 ¹⁄₁₆ in. (68 × 53.5 cm)
Fine Arts Museums of San Francisco, museum purchase, Skae Fund Legacy, 41781
Palace of Fine Arts, Gallery 76, wall C, no. 3654

78　Arthur Frank Mathews (American, 1860–1945)
California, 1905
Oil on canvas with frame
Framed: 47½ × 38 in. (120.7 × 96.5 cm); unframed: 26 × 23½ in. (66 × 59.7 cm)
Oakland Museum of California, gift of Concours d'Antiques, the Art Guild, A66.196.4
Palace of Fine Arts, Gallery 76, wall B, no. 3644

79　Gottardo Piazzoni (American, b. Switzerland, 1872–1945)
Lux Aeterna, 1914
Oil on canvas
42 ½ × 60 ½ in. (108 × 153.7 cm)
Fine Arts Museums of San Francisco, gift in memory of Ethel A. Voorsanger by her friends
through the Patrons of Art and Music, 1981.90
Palace of Fine Arts, Gallery 68, wall B, no. 3253

80 Clark Hobart (American, 1868–1948)
The Blue Bay: Monterey, ca. 1914
Oil on canvas
20 ¼ × 24 ¼ in. (51.4 × 61.6 cm)
Fine Arts Museums of San Francisco, museum purchase, Skae Fund Legacy, 41772
Palace of Fine Arts, Gallery 117, wall B, no. 4104

81 Bruce Nelson (American, 1888–1952)
The Summer Sea, ca. 1914
Oil on canvas
30 × 40 in. (76.2 × 101.6 cm)
Irvine Museum, California
Palace of Fine Arts, Gallery 118, wall B, no. 4176

82 E. Charlton Fortune (American, 1885–1969)

Summer, 1914

Oil on canvas

22¼ × 26 in. (56.4 × 66 cm)

Private collection

Palace of Fine Arts, Gallery 117, wall B, no. 4109, as *Summer*

83　Anne M. Bremer (American, 1872–1923)
The Fur Collar, ca. 1914
Oil on canvas
21½ × 16½ in. (54.6 × 41.9 cm)
Mills College Art Museum, Oakland, gift from the Albert M. Bender Estate
Palace of Fine Arts, Gallery 120, wall B, no. 4421

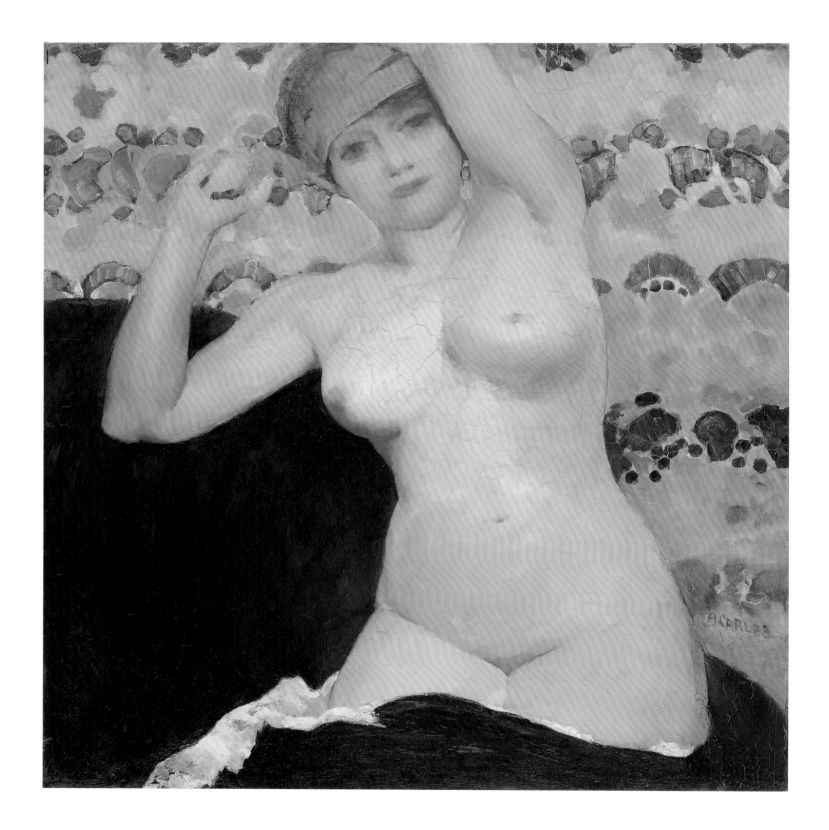

84 Arthur Beecher Carles (American, 1882–1952)
Torso, 1914
Oil on canvas
25 × 24 in. (63.5 × 61 cm)
San Francisco Museum of Modern Art, gift of the San Francisco Art Association, 35.1313
Palace of Fine Arts, Gallery 51, wall A, no. 2471

85 **William Zorach** (American, b. Lithuania, 1887–1966)
Woods in Autumn, 1913
Oil on canvas
28 ¾ × 23 ¾ in. (73 × 60.3 cm)
Whitney Museum of American Art, New York, gift of an anonymous donor, 71.221a–b
Palace of Fine Arts, Gallery 119, wall C, no. 4347

PRINTMAKING AND PHOTOGRAPHY

COLLEEN TERRY

PRINTS AT THE EXPOSITION

Thousands of prints were displayed throughout the galleries of the Palace of Fine Arts and its Annex at the Panama-Pacific International Exposition (PPIE) in 1915. The US section boasted eight galleries featuring prints: five devoted entirely to the medium and an additional three in which prints were shown alongside paintings and drawings. European and Japanese prints also were hung in the Palace in sections dedicated to the art of individual countries, while the Annex featured prints from countries, including Austria, Hungary, Norway, and England, who did not participate officially in the Exposition due to wartime circumstances.

Though "etchings, engravings, and block prints in one or more colors" as well as "auto-lithographs with pencil, crayon, or brush" were welcome in these galleries, "copies" and "works resulting from industrial-mechanical processes" were excluded from the Department of Fine Arts.[1] Consequently, prints could also be found in the Palace of Liberal Arts, where they filled exhibits celebrating advances in commercial printing technology.[2] Exhibits of paper manufacture, too, provided an occasion to display prints (see fig. 96).[3] Additionally, visitors could see prints on the walls of some of the state buildings and national pavilions, particularly the French Pavilion, which displayed work by French and Belgian printmakers; the Italian Pavilion, where architectural vistas by Giovanni Battista Piranesi were on view; and in the Swedish Pavilion's Social Rooms, which were hung with etchings by Anders Zorn.[4] Widespread throughout the PPIE's many exhibits, prints at the fair served then, as now, as both works of fine art and examples of technical progress. An overview of the print sections of the Palace of Fine Arts and the Annex gives an idea of its organization and varied contents.

Showing more than two thousand impressions, the US section was the primary home of prints at the fair, and commentators of the day offered variations on critic Michael Williams's observation that "the prints department of the Fine Arts has assembled by far the most notable exhibition ever held in this country."[5] Unquestionably, the contemporary print section was larger than its predecessors in the two previous major American world's fairs, in Chicago (1893) and Saint Louis (1904), a fact that reflected the increased popularity of prints and printmaking in this country during the early years of the twentieth century.[6] Led by director of the Department of Fine Arts John E. D. Trask, the organizers of the Palace of Fine Arts exhibition made a concerted effort to involve a diverse group of artists. Though they specifically invited artists of particular repute to participate, they also advertised an open call for submissions in such journals as *American Art News*, a significant source of news for the art practitioner and the enthusiast alike.[7] To encourage widespread geographic participation, the organizers also established nine selection juries located around the United States and Europe.[8] For the print section, participants primarily represented the Northeast, the Midwest, and California—all areas where print associations existed or would soon be formed.[9] Additionally, a historical loan section featuring prints from the eighteenth and nineteenth centuries was organized, due largely to the efforts of Robert B. Harshe, who served as temporary director of the Department of Fine Arts for some years before becoming its assistant director.[10]

In their sequential arrangement along the Palace's central western wall, the

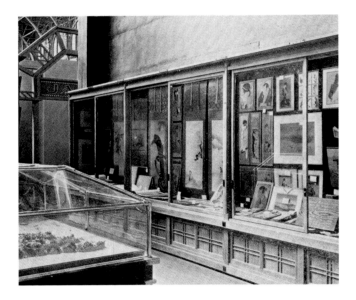

five galleries dedicated to American prints (as well as one in which both prints and drawings by James McNeill Whistler were shown) were part of a scheme "designed to draw the crowds in an orderly manner through the exhibitions that are arranged to give a unified idea of the development of American art."[11] Though one reviewer characterized the print galleries as "somewhat inconspicuous," access was possible from a variety of routes through the Palace.[12] From the main west entrance, visitors needed only to head south through a gallery of sculpture to access immediately the American print galleries. Alternatively, they could enter the print galleries after first visiting galleries devoted primarily to eighteenth- and nineteenth-century American paintings (Galleries 54–60).

The American print galleries were divided into three principal sectors: historical prints and wood engravings occupied most of Gallery 30; contemporary black-and-white intaglio, lithographs, and monotypes could be found in Galleries 32 and 33; and woodcuts, intaglio, lithographs, and monotypes, all printed in color, were displayed in Gallery 34 (see Breuer, this volume).[13] Two adjacent galleries were dedicated to individual artists who, in the jury's estimation, had made significant contributions to American printmaking: Whistler, whose prints (along with a few drawings) were exhibited in Gallery 29, and Joseph Pennell, represented by recent etchings and lithographs hung in Gallery 31. In total, the print galleries presented what one reviewer described as "the most complete and representative collection of prints that has yet been made in this country."[14]

Well before the exhibition opened, Trask had hoped for just such a positive response, and on behalf of his department in the summer of 1914 he sent invitations to eminent artists, requesting their submission of specific prints.[15] In his letters, Trask described his goals for the approaching exhibition's print section as one that would "have the fullest educational value and may result in the stimulation of a lively interest in the study and collecting of prints."[16] To that end, the department made clear its intention to accept far more works than could be shown in the small spaces dedicated to printmaking and so proposed a scheme whereby "a representative group" of prints by select artists would be uniformly framed and hung for the duration of the exhibition.[17] The remainder of the accepted prints would be "installed in such a manner as to make them readily accessible for inspection by the visitors of the Exposition," a manner that might include the exhibition of unframed prints in glass-topped cases whose contents would be "changed from time to time to add to the interest and variety of the print rooms."[18] As the catalogue of the exhibition attests, hundreds of prints lined the walls of the galleries, but the whereabouts of more than fifteen hundred submissions (numbers 6001–7591 in the catalogue) are today ambiguous. However, there can be no doubt that over the course of the exhibition these prints were seen—probably in cases such as those proposed by Trask—since even without specific positions in numbered galleries on lettered walls, artists whose work was assigned catalogue numbers in these upper sequences were still honored with awards, and their prints were still sold and were discussed in reviews of specific galleries along with prints hung on gallery walls.[19]

Awards may have helped focus the visitors' eyes, which could easily become overwhelmed when surrounded by the thousands of visual delights on view at the Palace and Annex. Chaired by graphic artist and author Joseph Pennell, long a promoter of printmaking in America, the group jury for etchings and engravings included Adriano de Sousa-Lopez, a Portuguese artist who also sat on the group jury for paintings and drawings; Louis Christian Mullgardt, then-president of the California Society of Etchers; artist Frank Duveneck, whose international colleagues on the jury voted to award him a special medal of commendation for his contributions to American art; and Thomas Wood Stevens, a charter member of the Chicago Society of Etchers.[20] Upon convening toward the end of May 1915, these men bestowed prizes on a range of artists working in various print processes and artistic styles.[21]

In the American galleries, many of the artists who garnered medals were names that would have been familiar to the print enthusiasts who counted among

the visitors to the Palace, especially those from San Francisco. Fifteen of the twenty-four American etchers named in the 1913 opening announcement for the downtown Print Rooms of Hill Tolerton (the first significant venue in San Francisco to routinely feature exhibitions of prints) later received PPIE medals or some other form of commendation for their printmaking achievements.[22] Visitors also might have seen works by the same artists on view in Chicago, New York, or Philadelphia, where print exhibitions were increasingly regular occurrences.

As in the American print component of the Armory Show two years prior, rarely did the subjects or artistic styles of the entries in the PPIE's American print galleries challenge the prevailing conservative tastes, which reflected preferences from the late nineteenth century lingering well into the first decades of the new one.[23] Setting the tone for much of the content was the gallery filled with Whistler's etchings and lithographs, which, although avant-garde for their time, would have been more widely accepted and influential by 1915. Observed to "open other vistas into the magical region," Whistler's prints were described in reviews as examples of "quintessential good taste and a psychic perceptiveness to the finer forces of beauty."[24] Intaglios depicting scenes of Holland, London, and Venice from all periods of the artist's printmaking career were well represented, while lithographs largely displayed his keen interest in the human figure.

In his description of the print galleries in the Palace of Fine Arts, Harshe outlined the contents of the Whistler gallery as only an insider in the selection process could. He claimed that *La vieille aux loques* (1858)[25] was selected as the most characteristic plate within the artist's early *French Set* of etchings. He also asserted that *Black Lion Wharf* (pl. 86) and two other etchings on view from the

Thames Set—Rotherhithe (1860) and *The Lime-Burner* (1859)—were of such merit as to have never been surpassed "in brilliancy, in reticence of line, in unexpected patterns of dark and light, in originality of composition."[26] Harshe likewise enthusiastically praised Whistler's views of Venice and Holland, particularly *Long Venice* (1879/1880), which he regarded as "nothing more than a distant cobweb of gossamer delicacy spun above a film of ink."[27] Equally keen on Whistler's lithographic work, Harshe paid special attention in his commentary to *The Thames* (pl. 87), *The Little Nude Model, Reading* (1889/1890), and *The Smith, Passage du Dragon* (1894). Though he mourned the fact that the exhibition included only one of the artist's tentative experiments with color lithography, *Draped Figure, Reclining* (pl. 89), the author declared this example "the most noteworthy" of his forays in that direction.[28] The popularity of Whistler's prints in the decade after his death, in 1903, remained high.[29] He continued to receive exhibitions at the major print galleries in New York, his prints commanded higher and higher prices, and Joseph Pennell recently had published a book on the older artist's remarkable achievements.[30] Certainly in singling out Whistler with his own gallery in the print section—the only deceased American artist to be granted one—the organizers of the print component (including both Harshe and Pennell) were keen to celebrate his extraordinary contributions to American printmaking.

Nowhere was Whistler's legacy more greatly felt than in Galleries 32 and 33, where contemporary etchers reimagined his subject matter and atmospheric handling of print media to fit their own artistic visions.[31] Though John Marin had already begun to move away from Whistler's aesthetic by the time of the

Mr, Richard Mather.

Cottonus Matherus
S. Theologiæ Doctor Regiæ Societatis Londinensis Socius,
et Ecclesiæ apud Bostonum Nov-Anglorum nuper Propositus.
Ætatis Suæ LXV, MDCCXXVII. P.Pelham ad vivum pinxit ab Origine Fecit et excid.

PPIE, his five contributions to the fair, including *Bal Bullier, Paris* and *Ca d'Oro, Venice* (pls. 90–91), exhibited a Whistlerian approach to the picturesque views of European tourist attractions that was aligned with the day's prevailing consumer tastes.[32] Another artist who evinced a vestige of Whistler's style was silver medalist Ernest David Roth, whose work in Venice captured the essence of the city even when he applied his etching needle to depicting sites off the tourist-beaten path, as in *The Gate, Venice* (pl. 92). From 1912 to 1914, Roth traveled through Europe with Jules André Smith, who would receive at the PPIE a gold medal for his prints of primarily Italian subjects (see pl. 93). Bertha E. Jaques had seen the comprehensive exhibition of Whistler's etchings at the 1893 World's Columbian Exposition in Chicago, and well into the second decade of the twentieth century her work continued to display an affinity for representing variable atmospheric conditions that Whistler had championed earlier (see pl. 94).[33] For her contributions to the PPIE, Jaques was awarded a bronze medal.

On the northern side of the contemporary galleries was Gallery 34, the sole gallery of color prints, while to the south was Gallery 31, devoted to Pennell, the only living American-born artist honored with a print gallery of his own. Pennell traveled to San Francisco from his London home in late April 1915

to supervise its hanging with a wide assortment of his recent etchings and lithographs before the space opened to the public on May 2.[34] Prominently displayed were selections from the artist's series of lithographs made during his stay in Panama (1912), where he witnessed the construction of the famed canal (see pl. 96).[35] Others of his prints displayed a range of domestic and international architectural subjects, but *In the Zeppelin Shed, Leipzig* (fig. 97) was rare in referencing both the overt hostilities that were increasingly observed all over Europe and his artistic engagement with the modernist style then taking root. Pennell's lithographs were among the most prominent of those exhibited in the American section of the fair, and it was the opinion of one commentator that this exhibition of his prints would "lead to a tremendous quickening of interest in and production of the lithograph," an assessment that would turn out to be accurate.[36]

Within Pennell's gallery, visitors could observe some of the larger trends in subject matter appearing elsewhere in the contemporary print galleries, including a preoccupation with architectural themes and an interest in the increasingly industrialized city. Both Ralph Pearson and Bror Julius Olsson Nordfeldt, who evocatively captured in etchings the development of Chicago (see pls. 97–98), won silver medals for the bodies of work they exhibited. A silver medal also was

awarded to Earl Horter, whose *Smelters, Pittsburgh* (pl. 99) illustrated changes then afoot in that increasingly modern city. Bronze-medal winner John Sloan contributed a group of prints, including *Roofs, Summer Night*; *The Women's Page*; and *Night Windows* (pls. 100–102), that highlighted the sometimes squalid conditions that typified New York's urban living.

Though the modern city was of great interest to many artists, the unique qualities of regional landscapes also appealed to American printmakers. In their work, such artists as George Elbert Burr, silver medalist Perham Wilhelm Nahl (see pl. 103), and bronze medalist Benjamin Chambers Brown featured the distinct weather conditions, foliage, and land formations that could only be found in the American West, whether Colorado or the rocky California coast. Earl Reed depicted the flora and fauna of Lake Michigan's blustery eastern shores, gold medalist Cadwallader Washburn exhibited views of New Jersey, and bronze medalist Ernest Haskell showed the rocky shore of Maine's Ragged Island (see pl. 104).

Roi Partridge and Haskell are examples of another group of contemporary American printmakers at the PPIE whose work may be characterized, as it was in the day's literature, as "decorative."[37] Though Haskell had fallen under the spell of Whistler's idiom when he traveled to Europe in the 1890s, he

had, by 1912, established a style all his own with the development of his flick engraving technique, an embellishing flourish characterized by the amassing of thousands of tiny dots and most discernable in such prints as *Amelia* (fig. 98) but detectable even in his landscape and tree portraits, such as those of Ragged Island. In other prints, including *White Butterfly* (pl. 105), Partridge offered an altogether different display of the "decorative," breaking from the representational academicism found in so many American prints of the day and looking instead to the Symbolism of Europe. His *Early Morning, Notre Dame* (pl. 107) reveals aspects of Impressionism and Pointillism, and his *Dancing Water (Pont Neuf)* (pl. 106) was lauded by Harshe for "its rich pattern and wide grey-lined rendition of the stone work of Pont Neuf."[38]

The greatest number of American print galleries may have been hung with contemporary works, but Gallery 30, a single large gallery housing the loan section of historical prints, gave fairgoers the opportunity to marvel at earlier technical feats in printmaking. Critics agreed that the prints of the Revolutionary War patriot Paul Revere were not to be missed;[39] the same was said of a handful of prints regarded as some of the earliest examples of their respective media to be made in what would be, and later was, the United States. These included John Foster's portrait of Reverend Richard Mather dating from about 1670,

believed to be the first woodcut made in the American colonies (fig. 99); Joseph Wright's print of George Washington (1790), rumored to be the country's first etching; an early mezzotint by Peter Pelham of Cotton Mather, "the witch finder" of Salem, Massachusetts (fig. 100); the second lithograph produced by Bass Otis, America's first lithographer; and John Hill's *New York from Governor's Island* (ca. 1824–1826), the first color aquatint printed on these shores.[40] Also featured in this gallery were such nineteenth-century artists as Mary Nimmo Moran and Thomas Moran, who helped usher in the early twentieth-century wave of interest in etching in America.

Finally, a significant component of Gallery 30 was not historical at all; it was the assembled collection of wood engravings by such contemporary adherents of the process as Henry Wolf and Timothy Cole, who were great practitioners and promoters of this seemingly antiquated craft.[41] While many of their prints reproduced the work of earlier masters, Harshe credited these artists as "translators—not imitators."[42] The technical skills with which they rendered tone and captured effects of light achieved critical acclaim in the press and from the awards jury, with Wolf receiving the exhibition's highest award, the grand prize, in the category of printmaking. Accomplished as his translations of other artists' compositions were, Wolf's most impressive achievements to the modern eye, perhaps, were his independent compositions, such as *Lower New York in a Mist* (fig. 101).

In addition to witnessing the development of printmaking in America, visitors to the Palace of Fine Arts could see contemporary prints from foreign nations in galleries devoted to France, Japan, the Netherlands, Portugal, and Sweden, although the examples exhibited there did not represent the diversity of printmaking in these countries.[43] The prints included in the French section,

in particular, bore little resemblance to the selection sent to New York's Armory Show in 1913;[44] rather than the outpouring of color lithography that featured in that exhibition, the PPIE's French print selections (in both the Palace of Fine Arts and the French Pavilion) were primarily black and white. Harshe characterized the French prints as "a semi-retrospective group, conservative, fully representative of the best traditions of France," citing in particular Félix Bracquemond's *The Seagulls* (ca. 1880) and Marcellin Desboutin's *Man with a Pipe: Self-Portrait* (fig. 102), both exhibited in the French Pavilion.[45]

In contrast to the European prints in the Palace and in nations' individual pavilions, many of the European prints exhibited in the Annex—especially those in the galleries dedicated respectively to Austrian, Hungarian, and Norwegian artists—teemed with energy and colors that were largely unseen elsewhere in the print sections and hinted at such burgeoning artistic styles as Cubism and Expressionism. In the Austrian section, a strong affiliation for the native Jugendstil was visible, as evinced in the stylized color prints of animals created in the 1910s by Ludwig Heinrich Jungnickel, who was awarded a silver medal for them, and in some of the color works of Emil Orlik, which harked back to Vienna's golden age. Though Orlik did not receive an award, Harshe admired his contributions in the realm of portraiture, observing that in *Portrait of Mahler* (fig. 103) the artist composed "bits of literature," capturing the essence of his sitter and embodying him with "a certain sparkling *esprit*."[46]

In the Hungarian section, the work of such artists as József Rippl-Rónai and Róbert Berény echoed a dynamism similar to that found in the Austrian spaces.[47] Color lithographs by Rippl-Rónai, who was awarded a silver medal, exhibited, alternately, affinities for the Parisian Nabis and the Wiener Werkstätte. Béla Erdössy also won a silver medal for his single entry, the color linoleum cut *Path*

in Snow (*Havas út*) (fig. 104). More daring by far were the print entries by the most progressive band of Hungarian artists, known as The Eight. One of the group, Róbert Berény, exhibited three such works, including the 1912 etching *Sewing in the Garden* (fig. 105).[48] Though Berény's prints are not mentioned by name in the exhibition's many reviews, his graphic pieces share qualities of his painted work, which, one critic observed, "brings something new and powerfully disturbing into modern painting."[49]

It was also in the Annex that Norway staged an installation of Edvard Munch prints, at that time America's largest to date.[50] Jens Thiis, the curator responsible for Norway's fine arts entries, encouraged Munch to select prints that would reflect positively on Norway, on Thiis, and, of course, on the artist himself.[51] Munch indulged this request, selecting more than fifty woodcuts, lithographs, and intaglios that demonstrated the dramatic range of his technical prowess in the Expressionist mode. Yet in the artist's woodcuts and color lithographs, "which seem to have been produced with a spirit of improvisation," Harshe perceived a soul "possessed by a demon of unrest."[52] The critic Christian Brinton was moved to defend the artist as one of "vigorous and independent personality," despite the fact that his art was "not perhaps meeting with the success it merits."[53] Though many Americans remained cautious in their assessment of Munch, the International Jury awarded his

prints a gold medal. Carl Nielsen of Christiania (now Oslo) admired them so much that he purchased an impression of every one in the exhibition.[54] Prints such as *Madonna* (pl. 160), *Moonlight I* (pl. 161), *Vampire II* (1895/1902), and the iconic *Self-Portrait* of 1895 (pl. 159), as well as a group of images of sick and dying children, may have contributed to their appraisal by some viewers as melancholic, but such prints were supplemented by relatively less sepulchral portraits and figure studies, and a playful assemblage of animal lithographs made during 1908 and 1909.[55] Though Munch's selection was the largest in the Norwegian section, the prints of other countrymen received attention in the press as well. These included color woodcuts by Pola Gauguin, son of the Post-Impressionist painter Paul Gauguin (and resident of Norway from 1912 to 1949), and complex color intaglios by Olaf Lange.

The mood of the print contributions from England to the Annex was somewhat quieter than that conveyed by many of their neighbors. This more conventional approach to printmaking led the British spaces to be characterized by one conservative art critic as "a refreshing contrast to the dominant tone of most of the [Annex] galleries."[56] The largest English entry was made by Frank Brangwyn, whose more than eighty intaglio prints ranged in subject matter from laborers and construction projects to picturesque views of some of Europe's top tourist destinations, including the Venice site depicted in *Browning's House*,

Windy Day

PANAMA-PACIFIC INTERNATIONAL EXPOSITION
DEPARTMENT OF FINE ARTS

Artists Name *Maud Squire* M № 732

Address *39 Bd St. Jacques, Paris*

Edition restricted in number to *25* Price *$7*

Duplicates can be secured from *A. Goldthwaite, 20 W. 10th St. N.Y.*

Upon request duplicates will be furnished to the number of

To be returned to *M. Squire, Paris*

Attach this lightly at one corner to back of print.
Additional labels may be had on application.

89.20.79

Venice (fig. 106). His work was celebrated in the press, and the awards jury granted him a medal of honor.[57]

Nearly half of the living American printmakers represented in the Palace of Fine Arts who were eligible for awards received prizes for their work. In addition to the accolades bestowed on them by the group jury, it seems that, at least in the case of the Americans, those artists who received prizes also were more likely to benefit from an innovation of the exposition's organizers, which permitted visitors to purchase duplicate prints directly from agents of the Department of Fine Arts stationed within the Palace, a scheme that resulted in the widespread dispersal of many of the exhibited prints.[58] Through its efforts, the sales department helped expand such West Coast collections as that of Portland-based art collector Charles Francis Adams, who purchased at least eighty prints from the fair.[59] The sales department also approached non-collectors for whom a print might be a nice souvenir of the Exposition.[60]

To purchase a print from the fair, the customer inquired of sales manager John G. Dunlap or his assistant, Helen Wright, both of whom were empowered to make a sale if an impression was available.[61] This availability was subject to the artist's inclination; when submitting a print to the selection committee, the exhibitor provided information indicating whether duplicate impressions were available, and if so, from whom they might be secured, and the sales price he or she required. The back of each exhibited print bore a label with this information (see fig. 107). When a purchase request was made, Dunlap, Wright, or one of their associates consulted the label and, if appropriate, contacted the artist or an agent to secure the impression. For this service, the customer paid a fee of fifteen percent, which went to the Exposition Company, in addition to the sales price.[62]

Though the sales program was not without its challenges, particularly when it came to obtaining additional impressions from abroad,[63] it was evidently popular, with 122 American artists selling 772 prints, for a total sales figure of $5,593.33.[64] Of the Americans, Helen Hyde and Joseph Pennell found the

largest purchasing audience, with 91 and 85 impressions sold, respectively; Ernest David Roth (44 sold), Henry Wolf (30 sold), and Bertha Lum (28 sold) were the next most popular. These impressive sales figures were not the rule, however, and the majority of artists who sold prints from the fair sold fewer than ten impressions each.[65] California was the ultimate destination for many of the American works, with 513 of them intended for addresses in the state. Foreign prints accounted for $1,707.50 of total exposition sales, and 170 foreign prints were purchased by California residents.[66]

The fact that so many prints remained in California after the fair's close may have given hopes of a bright future to local printmakers and sellers alike. Certainly PPIE participant and founding member of the California Society of Etchers Pedro J. de Lemos believed that the "wild and wooly West" was finally coming into its artistic own when he observed, "California is buying etchings. … And there is no greater indication of the rise of art, and that California will become the art center of the West than this fact."[67] De Lemos exhorted his fellow printmakers to "keep the fires burning" and to capitalize on the popularity that the Exposition had brought to "the autographic art" of etching.[68] Though de Lemos was focused on the market for etchings in particular, the same could be said for the demand for woodcuts, wood engravings, lithographs, and color prints, which were also popular with fairgoers. Over the next few years all across the country, artists and enthusiasts organized themselves into associations with the goals of educating the public and providing opportunities for exhibition.[69] While the First World War would briefly change the priorities of both artists and collectors, the print's position in American art was on the rise.

1. *Circular of Information, Panama-Pacific International Exposition, San Francisco, 1915, Department of Fine Arts* (San Francisco, 1914), 4.

2. For example, Norman T. A. Munder & Company exhibited a selection of etchings in the Palace of Liberal Arts and received an award for reproductive color printing and black-and-white halftone. See Norman T. A. Munder & Co., *Descriptive catalogue of a printing exhibit at the Panama-Pacific International Exposition, San Francisco, 1915* (Baltimore: N. T. A. Munder, 1915). Japanese woodcuts were also shown in the Palace of Liberal Arts, where the Tokyo publisher Shimbi Shoin exhibited highly acclaimed, handmade reproductions of *ukiyo-e* prints. See Jiro Harada, "Japan at the Panama-Pacific International Exposition," in *California's Magazine, Edition de Luxe* (San Francisco: California's Magazine Company, 1916), 2:322. The Palace of Varied Industries also contained at least one print, a woodcut by Gustave Baumann, which was categorized in the photography section, although it is not clear why. Though Baumann also received a gold medal in the Palace of Fine Arts for his color woodcuts, in this classification he received an honorable mention. Gustave Baumann Block Prints Nashville Ind., carton 90, folder 14 "Awards: Lib. Arts," Panama Pacific International Exposition Records, BANC MSS C-A 190, The Bancroft Library, University of California, Berkeley.

3. *The Blue Book: A Comprehensive Official Souvenir View Book of the Panama-Pacific International Exposition at San Francisco, 1915* (San Francisco: Robert A. Reid, 1915), 200. In the exhibition featuring the history of Japanese paper manufacture on display in the Palace of Liberal Arts hung prints by or after early Japanese masters of the woodcut. No detailed catalogue of this exhibit survives, and it remains uncertain whether the prints on view were eighteenth- and nineteenth-century prints, or reproductions made in the twentieth century.

4. For additional information on the French Pavilion, see essays by Melissa Buron and Martin Chapman in this volume. The contents of the Italian Pavilion are discussed in Frank Morton Todd, *The Story of the Exposition: Being the Official History of the International Celebration Held at San Francisco in 1915 to Commemorate the Discovery of the Pacific Ocean and the Construction of the Panama Canal* (New York: G. P. Putnam's Sons, 1921), 3:267–268. Zorn's etchings are mentioned in the *Official Swedish Catalogue, Panama-Pacific International Exposition, San Francisco, 1915* (Stockholm: Centraltryckeriet, 1915), 25. The art room in the Oregon State Building contained a selection of photographs, prints, and drawings made by Oregonian artists; see Robert Lundberg, "The Art Room in the Oregon Building: Oregon Arts and Crafts," *Oregon Historical Quarterly* 101, no. 2 (Summer 2000): 218.

5. Michael Williams, *A Brief Guide to the Department of Fine Arts: Panama-Pacific International Exposition, San Francisco, California, 1915* (San Francisco: Wahlgreen, 1915), 54.

6. At the Chicago World's Columbian Exposition in 1893, nearly 650 American prints were organized by media into eight galleries; see the Department of Publicity and Promotion, ed., *World's Columbian Exposition 1893: Official Catalogue, Part X, Department K, Fine Arts* (Chicago: W. B. Conkey, 1893), 33–41. The print component of the art department at the Saint Louis Louisiana Purchase Exposition of 1904 included no fewer than 350 works; see *Official Catalogue of Exhibitors: Universal Exposition, Division of Exhibits, Department B, Art*, rev. ed. (Saint Louis: Official Catalogue, 1904), 53–57. American interest in prints waxed and waned in the final decades of the nineteenth century; in the twentieth century interest was renewed largely thanks to the efforts of Bertha E. Jaques (a PPIE medalist) and the Chicago Society of Etchers, which she helped found in 1910. The society provided exhibition opportunities for printmakers starved for the chance, and by 1913 could count members all over the United States as well as abroad; see Joby Patterson, *Bertha E. Jaques and the Chicago Society of Etchers* (Cranbury, NJ: Associated University Presses, 2002).

7. "Panama-Pacific Information," *American Art News*, October 17, 1914, 2.

8. The Fine Arts Collection Centers were located in London, Paris, Boston, New York, Philadelphia, Cincinnati, Saint Louis, Chicago, and San Francisco. *Circular of Information*, 9–12. Though the selection juries were mostly composed of painters, many printmakers whose work would later be seen at the PPIE, including Joseph Pennell (Great Britain), Frank Duveneck and Bertha E. Jaques (Midwest), and Benjamin Chambers Brown and Mahonri Mackintosh Young (West) found their way onto the advisory committees. *Official Catalogue (Illustrated) of the Department of Fine Arts, Panama-Pacific International Exposition (With Awards)* (San Francisco: Wahlgreen, 1915), n.p.

9. In addition to the Chicago Society of Etchers, other significant print societies founded in this period include the California Society of Etchers, the Printmakers of California, the New York Society of Etchers, the Association of American Etchers, the Print Club of Philadelphia, the Brooklyn Society of Etchers, the Painter-Gravers of America, and the Print Club of Cleveland. Patterson, *Bertha E. Jaques*, 60. See also Marilyn Kushner, "Genesis of the Twentieth-Century Print Club and Its Major Importance to the Field of Graphic Art," in *American Identities: Twentieth-Century Prints from the Nancy Gray Sherrill, Class of 1954, Collection* (Wellesley, MA: Wellesley College, 2004), 82–95. These print societies tended to focus their energies on intaglio, the preferred print medium of the day, thanks in part to the so-called etching revival of the 1880s and 1890s, but woodcut and lithography also had a presence and were growing in popularity.

10. Harshe also credited Dr. Frank Weitenkampf (then graphic arts curator of the New York Public Library) with assisting in this aspect of the exhibition. Robert B. Harshe, "Prints and Their Makers," in *Catalogue de Luxe of the Department of Fine Arts Panama-Pacific International Exposition,* ed. John E. D. Trask and J. Nilsen Laurvik (San Francisco: Paul Elder, 1915), 1:61.

11. M. W., "Exp. Art Display Not Ready," *American Art News*, March 6, 1915, 3.

12. Eugen Neuhaus, *The Galleries of the Exposition: A Critical Review of the Paintings, Statuary and the Graphic Arts in the Palace of Fine Arts at the Panama-Pacific International Exposition* (San Francisco: Paul Elder, 1915), 91.

13. Two additional galleries not near this dedicated section also contained a significant number of prints by American artists. Frank Duveneck, a member of the group jury for etchings and engravings, exhibited his prints alongside his paintings in Gallery 87. Medal-of-honor winner Daniel Albert Veresmith exhibited his prints in Gallery 119, where visitors could see them alongside paintings and drawings by a range of artists. *Official Catalogue (Illustrated)*, 77–79.

14. Charles Olmsted, "Prints at the Exposition," *Art and Progress*, August 1915, 381.

15. Two such invitations can be found in MS 002, carton 6, folder 12, Thomas Wood Stevens Papers, University of Arizona Libraries, Special Collections (hereafter cited as Stevens Papers).

16. John E. D. Trask to Helen B. Stevens, June 18, 1914, MS 002, carton 6, folder 11, Stevens Papers. From these invitations, it can be surmised that many of the requested prints had been previously exhibited at major exhibitions of American prints, including those presented by the Chicago Society of Etchers from 1911 onward.

17. Invited artists were advised that those prints selected for hanging would require a frame provided by the Department of Fine Arts at a cost to the artists of one dollar per work. A fee of twenty-five cents would be charged for matting each print selected for display in an exhibition case (ibid.). Meanwhile, artists undergoing the jury selection process were advised that they, too, could have their works framed "at moderate cost . . . to preserve, as far as possible, a uniform style of framing." Alternatively, artists were advised to frame their entries in black or warm gray, with a narrow, flat molding, since an artist's choice of frame was grounds for exclusion from the exhibition. *Circular of Information*, 17. In his summation of this scheme, official PPIE historian Frank Morton Todd declared that it had "worked well, and secured uniformity of setting." Todd, *Story of the Exposition*, 4:14.

18. Trask to Stevens, June 18, 1914. In his final report of the Department of Fine Arts, which exists in an unpublished typescript and a shorter published version, Trask observed that the original plan had called for cases that were "an integral part of the wall and not objectionable to the eye." However, the final design was not one approved by Trask. Instead, the Division of Works changed the design, such that an iron pipe supported the cases. In Trask's words, "they were ugly." John E. D. Trask, "Report of the Department of Fine Arts" (unpublished typescript, September 16, 1916), 30. San Francisco History Center, San Francisco Public Library.

19. One notable example is Arthur Wesley Dow, whose nineteen print entries are all in the 6000s. Nevertheless, Dow received a bronze medal for his prints; reviewers such as Harshe and Olmsted discussed them; and Charles Francis Adams of Portland, Oregon, purchased *The Gap* (pl. 108). Harshe, "Prints and Their Makers," 1:63; Olmsted, "Prints at the Exposition," 382. Olmsted also referenced the cases in his descriptions of the print galleries. Olmsted, "Prints at the Exposition," 381.

20. Rose V. S. Berry describes the circumstances leading up to Duveneck's commemorative award in *The Dream City: Its Art in Story and Symbolism* (San Francisco: Walter N. Brunt, 1915), 230–231.

21. The winners of all such awards are designated in many of the exhibition's catalogues. See *Official Catalogue (Illustrated)*. Invited artists were advised, "Only such works as have been produced since 1904 will be eligible for awards, but while, speaking broadly, the Exposition will be contemporaneous, prints produced earlier than 1904 will not necessarily be excluded." Trask to Stevens, June 18, 1914.

22. The artists from Tolerton's roster who would go on to win PPIE honors were Frank Duveneck (commemorative); Charles Henry White (medal of honor); Donald Shaw MacLaughlin, Jules André Smith, Cadwallader Washburn, and Herman Armour Webster (gold); Bertha Lum, Bror Julius Olsson Nordfeldt, and George Senseney (silver); George Charles Aid, Bertha E. Jaques, Katharine Kimball, and George M. Plowman (bronze); and James McNeill Whistler and Joseph Pennell, who were both ineligible to receive awards but were granted special commendation in the form of their own galleries in the Palace of Fine Arts. See Hill Tolerton, *The Opening of the Print Rooms of Hill Tolerton, November 1, 1913* (San Francisco: Tolerton, 1913), n.p. Previously with the Albert Roullier Art Galleries of Paris and Chicago, Tolerton was quite familiar with the renowned etchers of his day. His commitment to printmakers was considerable; in the years after the PPIE, his print rooms would be used for the California Society of Etchers's annual exhibitions. Maryly Snow, "Digging the Archives: The Documented History of CSP's Origins," in *California Society of Printmakers: One Hundred Years, 1913–2013*, ed. Maryly Snow (San Francisco: California Society of Printmakers, 2013), 49.

23. For a summary of the American prints included in the Armory Show, see Marilyn Satin Kushner, "Revisiting Editions: Prints in the Armory Show," in *The Armory Show at 100: Modernism and Revolution,* ed. Marilyn Satin Kushner and Kimberly Orcutt (New York: New-York Historical Society, 2013), 317–319.

24. Williams, *Brief Guide*, 45.

25. As multiples, the specific impressions of the prints exhibited in the PPIE are difficult to trace to current collections. Thus, only dates have been provided throughout this essay.

26. Harshe, "Prints and Their Makers," 1:67–68. Harshe was surely speaking as someone in tune with the day's taste; even earlier, Joseph Pennell had characterized *Black Lion Wharf* as "one of the greatest engraved plates that has been produced in modern times." Letter to the *London Daily Chronicle*, February 22, 1895, repr. in "J. A. McNeill Whistler," *Print-Collector's Quarterly* 1, no. 1 (February 1911): 34.

27. Harshe, "Prints and Their Makers," 1:68.

28. Ibid., 1:68–69.

29. Katharine A. Lochnan, *Whistler and His Circle: Etchings and Lithographs from the Collection of the Art Gallery of Ontario* (Ontario: Art Gallery of Ontario, 1986), 26.

30. Joseph Pennell and E. R. Pennell, *The Life of James McNeill Whistler*, 2 vols. (London, 1908).

31. Eric Denker, *Reflections and Undercurrents: Ernest Roth and Printmaking in Venice, 1900–1940* (Carlisle, PA: Trout Gallery, Dickinson College, 2012). Denker discusses the lure of Venice to Whistler and many of the artists who would later be featured in the PPIE.

32. By 1915, Marin had already exhibited prints and drawings of New York's Woolworth Building that displayed signs of modernist fracture. He would retain this expressionist bent throughout his career as a printmaker. Carl Zigrosser, *The Complete Etchings of John Marin* (Philadelphia: Philadelphia Museum of Art, 1969), 16–18.

33. Patterson, *Bertha E. Jaques*, 32–33. Patterson also discusses the influence of Whistler on other members of the Chicago Society of Etchers who exhibited at the PPIE.

34. "Pennell's Etchings Now on View at Exposition," *San Francisco Chronicle*, May 2, 1915.

35. Pennell discussed his time in Panama in "Joseph Pennell's Lithographs of the Panama Canal," *Print Collector's Quarterly* 2, no. 3 (October 1912): 291–315.

36. Olmsted, "Prints at the Exposition," 381. To further his encouragement of lithography, Pennell served as president of London's Senefelder Club, which promoted the print process, and authored numerous treatises focused on its history and technical process. See Joseph Pennell and Elizabeth Robins Pennell, *Lithography and Lithographers: Some Chapters in the History of the Art together with Descriptions and Technical Explanations of Modern Artistic Methods* (New York: Macmillan, 1915).

37. Harshe, "Prints and Their Makers," 1:70.

38. Ibid.

39. Harshe, "Prints and Their Makers," 1:61; Olmsted, "Prints at the Exposition," 381.

40. Olmsted, "Prints at the Exposition," 381.

41. Almost the entire issue of the *Print Collector's Quarterly* of July 1911 was given over to the subject of wood engraving. Both Wolf and Cole submitted articles, and together were the subject of a critical essay.

42. Harshe, "Prints and Their Makers," 1:63.

43. One exception may have been the Japanese galleries, in which Olmsted identified a retrospective exhibition of Utagawa Hiroshige, Kitagawa Utamaro, and Katsushika Hokusai, though none of the exhibition catalogues corroborate his information. Olmsted, "Prints at the Exposition," 384. It is possible that the prints were added to the exhibition after the many catalogues were printed. Prints like these were certainly visible in the post-Exposition period, since William Seltzer Rice later recalled, "My first acquaintance with prints of this type was at an exhibition of Japanese Block Prints at the Palace of Fine Arts in San Francisco, shortly after the World's Fair in 1915." William S. Rice, "Wood Block Printing with One Block," *Everyday Art*, October 1929, 5.

44. Kushner describes the European component of the Armory prints in "Revisiting Editions," 319–320.

45. Harshe, "Prints and Their Makers," 1:72–73.

46. Ibid., 1:74.

47. Dr. Simon Meller organized this section, and the majority of its contents came from the collection of the Szépművészeti Múzeum, Budapest, which provided assistance to Laurvik at a time when many Hungarian museums had already closed and stored away their collections in preparation for the First World War. Gergely Barki, "Panama-Pacific International Exposition: Hungarian Art's American Debut or Its Bermuda Triangle?," *Centropa* 10, no. 3 (September 2010): 262.

48. I owe thanks to fellow catalogue contributor Gergely Barki for pointing me toward this etching.

49. Michael Williams, "'Crazy' Is Usual Verdict on Futurists," *Sunday Oregonian*, November 28, 1915. Gergely Barki's essay in this volume presents further information on paintings from Hungary at the PPIE, including those by Berény and others of The Eight.

50. In the Armory show just two years earlier, Munch was represented by only eight prints: four lithographs and four woodcuts. Kushner, "Revisiting Editions," 322.

51. Jens Thiis to Edvard Munch, January 3, 1915, Munch Museum Archive, Oslo, as cited in Bessie Rainsford (Tina) Yarborough, "Exhibition Strategies and Wartime Politics in the Art and Career of Edvard Munch, 1914–1921" (PhD diss., University of Chicago, December 1995), 1:83.

52. Harshe, "Prints and Their Makers," 1:74.

53. Christian Brinton, "Scandinavian Art at the Panama-Pacific Exposition," *American-Scandinavian Review* 3, no. 6 (November–December 1915): 354.

54. Christian Brinton, *Exhibition of Etchings, Lithographs, and Woodcuts by Edvard Munch of Christiania, Norway* (New York: Bourgeois Galleries, 1919), n.p. The entire group of prints remained in San Francisco for the post-PPIE exhibition of 1916 (cat. nos. 1231–1287a), and in 1919 they were presented to New York audiences in a monographic exhibition at the Bourgeois Galleries. A review of that show described the artist as "a type of decadence" whose melancholic subjects could be overlooked if only they "were balanced by aesthetic beauty." "Three Etchers of the Present Day," *New York Tribune*, December 7, 1919.

55. According to a post-Exposition list bearing insurance values, *Madonna* and *Self-Portrait* were also among the most valuable of Munch's prints, each listed at $120. List of Austrian, Hungarian, Finnish, and Norwegian exhibits— consisting of paintings, graphics, bronzes, porcelains, culture, embroideries and rugs—acquired by J. Nilsen Laurvik from abroad and on exhibition at the Palace of Fine Arts by the San Francisco Art Association, 1916, 14, Archives of the San Francisco Art Association, San Francisco Art Institute.

56. Williams, "'Crazy' Is Usual Verdict."

57. Brangwyn also contributed a mural painting for the PPIE's Court of Ages (the Court of Abundance). The eight panels representing the elements are today visible in the Herbst Theatre in the War Memorial and Performing Arts Center in San Francisco.

58. Fifty of the fifty-three American printmakers who received commendation sold prints under this scheme. Another fifty artists who were eligible but did not receive an award sold prints, as did twenty-two who were ineligible due to professional affiliation with the exhibition or because they were no longer living. However, the prize-winning artists sold considerably more than the non-prize-winning artists, with a sales total of 439 prints, or approximately seventy percent of the 620 prize-eligible American prints sold. *Panama-Pacific International Exposition, San Francisco 1915, Report of the Department of Fine Arts* (San Francisco: Panama-Pacific International Exposition, 1915), 23–24.

59. Letter from Trask to Thomas Wood Stevens with official list of awards made in the Department of Fine Arts reported by the Department Jury and confirmed by the Superior Jury, July 22, 1915, MS 002, carton 6, folder 11, Stevens Papers.

60. The Charles Francis Adams Collection now forms part of the graphic arts department at the Portland Art Museum.

61. A notice in the Thomas Wood Stevens Papers suggested that prints and small bronzes might be of particular interest to Exposition visitors looking for a souvenir of their visit. MS 002, carton 6, folder 11, Stevens Papers.

62. Helen Wright, Dunlap's assistant and an employee of the Congressional Library (the Library of Congress) on temporary leave for the run of the Exposition, gave special attention to the sale of prints. Trask, "Report" (unpublished manuscript), 34.

63. Dunlap explains this fee structure in a letter to Laurvik. John G. Dunlap to J. Nilsen Laurvik, June 1, 1916, San Francisco Art Institute Archives.

64. Letters between Trask, Laurvik, and Jane De Maranville, Secretary of the Department of Fine Arts, dating between June and November of 1916, discuss problematic sales of Harald Oskar Sohlberg's 1912 etching and aquatint *Fisherman's Hut*, which had taken place the previous year. It seems that due to irregular mail service between San Francisco and Norway, the artist never received or acknowledged two print orders from American customers, who were eventually refunded the price of the prints. San Francisco Art Institute Archives.

64. *Report of the Department of Fine Arts* (1916), 23–24; Trask, "Report" (unpublished typescript), n.p., table "Tabulation of Sales Department of Fine Arts Panama-Pacific International Exposition."

65. *Report of the Department of Fine Arts* (1916), 23–24.

66. Trask, "Report" (unpublished typescript), n.p., table "Tabulation of Sales Department of Fine Arts Panama-Pacific International Exposition"; an incomplete list of the foreign print artists whose works were sold from the fair is also appended to the report; Todd, *Story of the Exposition*, 4:16.

67. Pedro J. Lemos, "California and Its Etchers—What They Mean to Each Other," in Bruce Porter et al., *Art in California: A Survey of American Art with Special Reference to Californian Painting, Sculpture, and Architecture, Past and Present, Particularly as Those Arts Were Represented at the Panama-Pacific International Exposition* (San Francisco: R. L. Bernier, 1916), 113.

68. Ibid.

69. See note 9 above for a list of the first wave of clubs and associations. In the 1920s, additional groups formed in Birmingham, Alabama; Denver, Colorado; Washington, DC; Honolulu, Hawaii; Indianapolis, Indiana; Wichita, Kansas; Baltimore, Maryland; Boston, Massachusetts; Kansas City, Missouri; Buffalo, Rochester, and Albany, New York; Charleston, South Carolina; Dayton and Toledo, Ohio; Philadelphia, Pennsylvania; Dallas, Texas; Seattle, Washington; and Toronto, Canada. Patterson, *Bertha E. Jaques*, 60.

Karin Breuer

Gallery 34: Contemporary Color Prints

Within the spectacular celebration of American printmaking in the galleries of the Palace of Fine Arts at the Panama-Pacific International Exposition (PPIE) was a 550-square-foot space reserved for the display of contemporary prints in color. Installed on the four walls of Gallery 34 were 106 color woodcuts, intaglios, monotypes, and lithographs that had been created (most since 1904) by thirty-three artists, both men and women, from all across the United States. Given the relatively small size of the space, this large group of prints in uniform frames was probably hung tightly, salon style, in multiple rows on the high walls of the gallery. Based on the order of their wall positions noted in the *Official Catalogue of the Department of Fine Arts*, the prints were arranged aesthetically, by subject matter and compatibility of color palette.[1] Unframed prints were matted and displayed in glass-topped cases. Robert B. Harshe, assistant chief of the Department of Fine Arts, was credited with this carefully considered installation.[2] As an active printmaker and the first president of the California Society of Etchers, he naturally was broad-minded about the presentation of works by advanced color printmakers, some of whom were his colleagues and personal friends. Harshe also revealed his sympathetic leanings toward color prints with frequent remarks about them in his insightful review of the print submissions for the official *Catalogue de Luxe of the Department of Fine Arts*.[3]

Located at the end (or the beginning, depending on one's route) of a row of connected contemporary print galleries, Gallery 34 was well positioned to be a noteworthy space. Although not officially described in guides, maps, or plans as an area exclusively dedicated to color prints, a "color gallery" must have been anticipated by Harshe and the section's organizers given the large numbers of such prints that were accepted for exhibition.[4] Both critics and the public positively received their innovative decision to designate a separate gallery for color prints.

Gallery 34 was lauded in reviews and articles that were roughly contemporaneous with the exhibition. In his gallery-by-gallery review of art exhibits, Eugen Neuhaus, chairman of the advisory committee for the West and member of the International Jury of Awards at the PPIE, noted, "Across the vestibule the graphic arts are continued, beginning with color lithographs and monotypes, and continued with etchings. George Senseney, Arthur Doro [*sic*, Dow], Helen Hyde, Pedro [de] Lemos, Clark Hobart, and others too numerous to mention excite considerable interest."[5] Sheldon Cheney, who wrote an art guide to the Exposition, labeled his entry for Gallery 34 "Color Prints" and noted that the selection "showed the achievement of the younger artists in mediums that were practically unknown in this country ten years ago."[6]

Indeed, by 1915 color printmaking in America was seen as experimental even in the most progressive of printmaking circles. Color print techniques were not widely utilized and were seldom the sole focus of contemporary American printmakers, even those represented in Gallery 34.[7] "One might say that one etcher in eight is apparently working at the problem of the color print . . . and that most of this work is in a state of advanced experiment rather than solid achievement," wrote Thomas Wood Stevens, an instructor at the Art Institute

of Chicago who served on the PPIE's group jury for etchings and engravings, of a 1913 exhibit of contemporary American etchings.[8] Nevertheless, Stevens and his fellow jurors acknowledged color prints as worthy of attention and encouragement by awarding medals and honorable mentions to fifteen of the thirty-three artists whose works were exhibited in Gallery 34, including nine artists who submitted only color prints.[9]

The recognition of color printmaking in a separate gallery at the PPIE is even more significant considering that the prevailing public taste for prints was still somewhat conservative, favoring the traditional black-and-white etching and illustration that had been popular since the mid-nineteenth century. This is a fact borne out at the PPIE by the carefully organized galleries presenting American print history as a black-and-white trajectory culminating in hundreds of contemporary etchings (see Terry, this volume). By its very separation from that section, Gallery 34 must have been perceived as a space designed to showcase new and modern ways of printmaking.

Prior to 1915, American art audiences were exposed gradually to color prints in commercial gallery exhibitions, but only a handful of museum shows featured them. Regional printmaking societies, many of them recently formed, included some color prints in their member exhibitions, but in large part the color prints in these displays were by artist-members who were better known for their black-and-white work. Color printmaking as a trend experienced slow growth in the United States as compared to its development in Europe. The author of a catalogue introduction for an exhibition of Margaret Patterson's color woodcuts in 1914 noted, "Wood block printing is an art still in its infancy in this country, whereas in Europe it has met with success and favor."[10]

The development of the European color print was based in large part on the great popularity of the Japanese *ukiyo-e* woodcut in France in the late nineteenth century. Many painter-engravers saw its distinct compositional devices, motifs, and bright color palette as decidedly modern alternatives to academic conventions. They were stimulated to revive woodcut and lithography in novel and significant ways, partly in response to their new understanding of the effective use of color in Japanese prints. As a result, by 1900 color printmaking was widely practiced in France, in particular, but also in England and Germany.

The introduction of color into American printmaking came later, largely through the efforts of artists who had studied or trained in Europe in the late nineteenth and early twentieth centuries. Art students who traveled to artistic centers there were exposed to color printmaking—especially color lithography, but also color etching and color woodcut—as common practice in print workshops. For many of them, when they returned to the United States, it was with a new zeal for color despite the public's preference for black-and-white etching and illustration.

Color woodcut, or woodblock printing, as it is sometimes called, was the technique of choice for many early color printmakers in America, particularly for those whose introduction to color prints came via the Japanese print. Works by several of these innovators in the medium were selected for display in Gallery 34, and Arthur Wesley Dow was foremost among them. According to Harshe's review, Dow's masterful command of technique, evident in the nineteen color woodcuts shown in Gallery 34, allowed him to be "as free with his blocks as the

painter [is] with his palette." [11] Based in New England, Dow traveled to Paris to study art at the end of the nineteenth century and discovered Japanese woodcuts at that time. By 1892 he was making his own small-format color woodcuts incorporating the flat decorative shapes and bright, transparent colors typical of Japanese prints. Later, as a teacher and writer, he extolled the virtues of the color woodcut and influenced a second generation of printmakers. Among his students and followers were Edna Boies Hopkins, Margaret Jordan Patterson, and Pedro J. de Lemos, all of whom exhibited and received awards for their color prints in Gallery 34.

Chicago-based Bror Julius Olsson Nordfeldt also was studying in Paris in 1900 and was captivated by the Japanese-influenced contemporary color printmaking he saw there. Interested in pursuing the creative possibilities of the color woodcut technique, he sought training in England with Frank Morley Fletcher, and by 1903 he was producing fairly sophisticated color woodcuts. Nordfeldt submitted nine of these, all created in 1906, to the PPIE.[12] Harshe described the artist's handling of color in one of the woodcuts as "masterly," and the color itself as "evanescent and impalpable."[13] New as they might have been to the West Coast audience, Nordfeldt's color prints were familiar in Midwestern art circles; selections such as *Anglers* (fig. 108) had been exhibited previously in the print room of the Art Institute of Chicago, Albert Roullier Art Galleries in Chicago, and the Milwaukee Art Society. An early student of Nordfeldt's,

Elizabeth Colwell, also exhibited color woodcuts at the PPIE. Two of her best-known color works in the medium, *Lake in Winter* (pl. 111) and *The Great Pine* (fig. 109), were among several selected for Gallery 34.

In addition to being influenced by Japanese composition and color, a few of the artists whose color woodcuts were shown in Gallery 34 were influenced by Japanese subjects, and their works showed kimono-clad women engaging in traditional activities, street scenes with temples and traditional architecture, and lush landscapes featuring famous bridges and waterways. In his survey of the print galleries, Harshe observed, "Bertha Lum and Helen Hyde have not only used the wood block in the Japanese manner, but find their subjects in Nippon as well."[14] Both Hyde and Lum traveled widely in Japan, where they engaged Japanese artisans to teach them to carve woodblocks and print from them. Hyde, the first American artist to produce color woodcuts in Japan, was represented at the PPIE with forty-one color prints, nine of which were hung in Gallery 34. *The Bath* (pl. 112) and *Mount Orizaba* (fig. 110) featured subjects that were emblematic of the range she exhibited throughout her illustrious career, which included a long residency in Japan and later stays in China, Mexico, and India. By the time of the PPIE in 1915, Hyde was an immensely popular and well-known artist whose color prints were exhibited and sold nationally. She also was recognized internationally with feature articles and works reproduced in art journals and periodicals.[15]

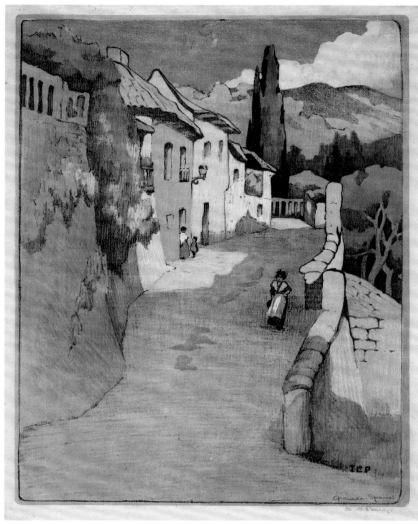

Bertha Lum submitted thirty-one color woodcuts to the PPIE, of which ten were shown on the walls of Gallery 34 (the others were probably on view in the cases). These included sophisticated early woodcuts from 1905 to 1907, most representing Japanese subjects, as well as one, *Tanabata* (pl. 113), that demonstrated a style of fanciful illustration that later would appear more frequently in her work. Like Hyde, Lum worked tirelessly for commercial representation and had modest success with galleries in New York and Chicago prior to 1915. The inclusion of her prints in the PPIE and the silver medal she was awarded for her body of work there were of critical importance to her subsequent career.

Unlike the Japanese-inspired woodcuts of Lum, Hyde, Dow, and Nordfeldt, who hand-printed their works using water-based inks, Gustave Baumann's color prints had their origins in the European tradition of multiple-block woodcuts printed with oil-based inks on a press. Born in Germany and raised in Chicago, Baumann traveled to Munich in 1905 when he was in his early twenties to attend the Königliche Kunstgewerbeschule, a traditional school that emphasized the applied arts. It was there that he learned the fundamentals of the color woodcut technique in the Munich manner, in which bold, flat areas of color were placed adjacent to one another without the interruption of a black outline.[16] Returning to the Midwest a year later, Baumann settled in an artist's colony in rural Indiana, where he achieved success with his woodcuts, including the large, ambitious landscapes *Harden Hollow* (fig. 111) and *Plum and Peach Bloom* (fig. 112), which were among his eight gold-medal-winning entries exhibited at the PPIE.

At least ten of the thirty-three artists who showed prints in Gallery 34 submitted color intaglio prints, many of which combined the techniques of etching, soft-ground etching, and aquatint. Fairly experimental in nature, these prints were mainly isolated efforts by inventive artists who had broken from conventional American etching practice, such as George Senseney and George Elbert Burr. The prints were technically innovative and incorporated new ideas about process, but their subject matter remained somewhat conservative, perhaps to appeal to a broad public taste for landscapes, views, and genre scenes in the European tradition.

George Senseney studied at the Corcoran School of Art in Washington, DC, and then moved to Paris in 1899, where he studied art at the Académie Julian. He taught at the Art Students League in New York from 1906 to 1907, and later spent several years in France where he was elected to the Société de la gravure originale en couleurs. His reputation as an expert in color printing was recognized as early as 1910, when he wrote "Etching in Color." In this highly technical essay, the artist concluded that while the color etching process was the final development of an old and valuable art, "the possibilities have only been touched—the future holds much in store."[17] Many of Senseney's complex intaglio prints, such as *Bridge of Sighs* (fig. 113), utilized multiple techniques— etching, aquatint, drypoint, and soft-ground etching—with each plate inked successively in a different color, requiring complex overprinting.

George Elbert Burr was another artist who was recognized for his unusual handling of the intaglio process. After studying at the Art Institute of Chicago and traveling abroad for four years beginning in 1886, he was a practicing

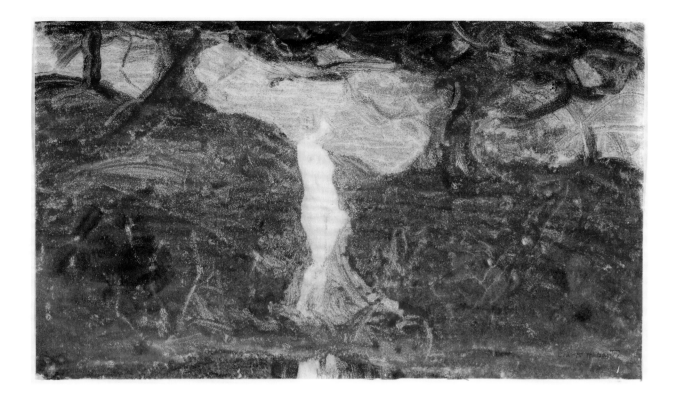

watercolorist and printmaker in New Jersey and later in Denver, Colorado, where he moved in 1906. Although he was prolific and exhibited widely early in his career, Burr did not achieve success with his color intaglios until 1904. That year he developed a method in which he would paint an image on an aquatinted copper plate with ordinary printing ink, then selectively wipe certain areas in such a way that each plate held a "distinct picture, each proof requiring a separate painting on the copper, no two being alike, the pictures varying according to the mood and will of the artist."[18] Due to this working method, Burr printed very few impressions from a plate, and his color prints, including *Arizona Clouds* (fig. 115) essentially were monoprints.

Robert Harshe observed the prevalence of such other forms of intaglio as aquatint in Gallery 34, commenting that "present day American etchers are turning again to aquatint after a lapse of many years."[19] He singled out Maud Hunt Squire, "who used it to give flat color tones to her brokenly etched Brittany groups of market women,"[20] and also Pedro J. de Lemos, who employed regular areas of aquatint in conjunction with soft-ground etching in his California landscapes, including the print *Summer Evening* (pl. 109). Interestingly, both artists later turned to color woodcut as their primary method of printmaking, either out of expediency (aquatint and etching required a well-equipped studio) or because woodcut could better accommodate the broad areas of color they desired in their compositions.

Harshe's contemporary account of prints on view in Gallery 34 cited Isabel Percy West as an artist who exhibited color lithographs, and she may have been the only one to do so.[21] Born in the Bay Area, West studied art at the Mark Hopkins Institute in San Francisco from 1901 to 1905, and then trained under Frank Brangwyn, who helped revive artistic lithography at his recently opened London School of Art. She later studied in New York with Arthur Wesley Dow and earned an advanced degree in art from Columbia University in 1907 before returning to California. West's sophisticated practice of color lithography, as evidenced in *Granada, Spain* (fig. 114), a complex five-color print utilizing tusche ink and crayon, is indicative of the promise seen in the medium. "We are, I feel sure, on the eve of a revival of artistic lithography in this country," wrote Harshe in his summary of contemporary lithographs at the Exposition.[22]

Four artists, three of them active in Oakland, California, exhibited color monotypes in Gallery 34. Clark Hobart, Xavier Martinez, and Perham Wilhelm Nahl had shown examples of this medium in San Francisco galleries such as Paul Elder's in the years prior to 1915, but the process was still new enough that Harshe, in his PPIE catalogue essay on prints, felt it necessary to define it and to note the different individual color effects achieved in the works of Hobart and Nahl. He cited "the jewel like quality of [Adolph Joseph Thomas] Monticelli" and "the oriental virtuosity of [Paul-Albert] Besnard" as hallmarks of Hobart's remarkable control of the process. Harshe contrasted that artist's technique with the "brownish monotones" of Nahl, whose palette was more commonplace among monotype artists.[23] Hobart, the only artist exhibiting at the PPIE whose passion for the monotype would result in a serious lifelong involvement with it, was awarded a silver medal for work exhibited in Gallery 34, including *Nymph at the Pool* (fig. 116). For Hobart's San Francisco dealer, Nils Helgesen, the award translated into commercial appeal: in a catalogue

introduction to an exhibition at his eponymous gallery, Helgesen identified the color monotype as an art form well suited to the "embellishment of modern homes. Moderately small in size . . . glowing in color . . . it forms a decorative spot that must liven up and otherwise greatly enhance the appearance of the space within which it is hung, while at the same time it bears its message to lovers of the beautiful, as an individual object of art."[24]

The belief held by Helgesen and the early twentieth-century print dealers in the artistic and decorative value of contemporary prints was shared by the organizers of the print section at the PPIE. Harshe and his committee successfully strategized that, in addition to engendering among visitors an appreciation for the print as an art form, the sale of duplicate prints, an innovation adopted at the PPIE, would allow attendees who could not afford a painting or sculpture to "secure a genuine bit of art in the form of an etching, a lithograph, a wood engraving, a color print, a monotype."[25] Exposition sales figures reveal that buyers purchased large numbers of prints, many of them in color. Helen Hyde led in total sales, with 91 of her color woodcuts comprising the largest share of the 772 total prints sold.[26]

Perhaps due to the high number of sales and medals they garnered, the color printmakers of the Exposition enjoyed increased and important recognition later in 1915 and in the years that followed. Starting in November 1915, the annual watercolor and miniatures exhibitions held at the Pennsylvania Academy of the Fine Arts began to include woodcuts and etchings "in colors," among other media, something that previous annuals had not done. Likewise, in the catalogue introduction to an otherwise very conservative November 1915 exhibition of American wood engravings sponsored by the American Institute of Graphic Arts in New York, Frank Weitenkampf, a curator at the New York Public Library and a well-known supporter of contemporary trends in printmaking, singled out the color woodcuts by Dow, Hyde, Colwell, Hopkins, and Nordfeldt. PPIE gold-medal winner Gustave Baumann organized an exhibition titled *American Block Prints and Wood Engravings* at the Art Institute of Chicago in February 1916 to which he invited all of his fellow medal winners from Gallery 34 as well as some new practitioners of the color woodcut. Nordfeldt's submissions to that show were examples of the new "white line" technique that he had recently introduced to a group of artists in Provincetown, Massachusetts. So innovative was the technique that within the next few years Provincetown became a center for the production of the color woodcut.

Undoubtedly, their experiences at the PPIE stimulated and encouraged all of the individual color print artists who exhibited there, but it was the California-based artists who may have benefitted most from exposure at the Exposition. Color lithographer Isabel Percy West, who sold six prints at the fair, maintained years later that the Exposition "brought new art and artists into the city," giving such local printmakers as herself "their first really important chance," an opportunity for their color prints to be seen on a national stage alongside works by a distinguished group of American and European printmakers.[27] Young California artists, including William S. Rice and Frances Gearhart,

were exposed to color prints at the fair and became prolific color printmakers in the 1920s and 1930s. Frances's sister Edna, who was also an artist, perhaps summed it up best when she wrote years later of the validation of color that she witnessed in San Francisco, "The Panama Pacific Exposition sponsored the new movement of decorative use of brilliant colors."[28] Although she was referring to both painting and printmaking, no doubt she voiced a common consensus among color printmakers: due in large part to the PPIE, color woodcut, intaglio, and lithography were no longer trends, nor solely experimental, but worthy new entries in the American printmaking canon.

1. The sequential order of the installation in Gallery 34 was indicated in the "United States Section" gallery descriptions, and wall placements for individual works were listed in the "Biographical Index for Etchers, Lithographers, etc." in the *Official Catalogue (Illustrated) of the Department of Fine Arts, Panama-Pacific International Exhibition (With Awards)* (San Francisco: Wahlgreen, 1915), 34–35.

2. Eugen Neuhaus noted that Harshe "put much thought into these many cases and wallspaces" in the graphic arts sections. Eugen Neuhaus, *The Galleries of the Exposition: A Critical Review of the Paintings, Statuary and the Graphic Arts in the Palace of Fine Arts at the Panama-Pacific International Exposition* (San Francisco: Paul Elder, 1915), 91.

3. Robert B. Harshe, "Prints and Their Makers," in *Catalogue de Luxe of the Department of Fine Arts Panama-Pacific International Exposition,* ed. John E. D. Trask and J. Nilsen Laurvik (San Francisco: Paul Elder, 1915), 1:61–75.

4. In her essay in this volume, Colleen Terry describes the selection process and notes that well in advance of the PPIE's Opening Day, organizers requested specific prints, including color prints, from individual artists for submission to the contemporary print galleries, suggesting that the organizers expressly intended to exhibit color prints.

5. Neuhaus, *Galleries of the Exposition*, 90.

6. Sheldon Cheney, *An Art Lover's Guide to the Exposition: Explanations of the Architecture, Sculpture, and Mural Paintings, with a Guide for Study in the Art Gallery* (Berkeley: At the Sign of the Berkeley Oak, 1915), 90.

7. Thirteen of the thirty-three artists with work in Gallery 34 submitted only their color prints to the PPIE: Gustave Baumann, Clark Hobart, Edna Boies Hopkins, Helen Hyde, Beatrice Sophia Levy, Bertha Lum, Xavier Martinez, Isabel Percy West, H. W. Rubins, Phil Sawyer, George Senseney, Maud Hunt Squire, and Anni Von Westrum.

8. Thomas Wood Stevens, "An Exhibition of Contemporary American Etchings," *Art and Progress*, May 1913, 949.

9. The following medal winners exhibited a significant number of prints in Gallery 34: Gustave Baumann (gold); Clark Hobart, Edna Boies Hopkins, Bertha Lum, Bror Julius Olsson Nordfeldt, and George Senseney (silver); Benjamin Brown, Elizabeth Colwell, Arthur Wesley Dow, Helen Hyde, and Isabel Percy West (bronze); and Xavier Martinez, Margaret Jordan Patterson, Pedro J. de Lemos, and Beatrice Sophia Levy (honorable mention).

10. Introduction to *Wood Block Prints in Colors by Margaret Patterson*, exh. cat. (New York: Louis Katz Art Galleries, 1914), unpaginated.

11. Harshe, "Prints and Their Makers," 1:63.

12. Prints were produced in multiple editions, making them difficult to trace to current collections.

13. Harshe, "Prints and Their Makers," 1:63. Harshe was referring specifically to a print titled *House of the Madonna*. However, there is no such color woodcut known by that title in Nordfeldt's oeuvre. Harshe was probably referring to *The Piano*, the only color print by Nordfeldt exhibited on the walls of Gallery 34. *House of the Madonna* may have been an etching later known as *House of the Virgin, Morlaix* that was exhibited in another PPIE gallery.

14. Ibid.

15. See Bertha E. Jaques, "An Artist's Home in Japan," *Craftsman* 15, no. 2 (November 1908): 186–191; L. Van der Veer, "Miss Helen Hyde's Chromoxylographs in the Japanese Manner," *International Studio* 24, no. 95 (January 1905): 239–242; and E. A. Taylor, "The First Exhibition of the Society of Wood-Engraving, Paris," *International Studio* 49, no. 240 (March–June 1913): 128–137.

16. Martin F. Krause and Madeline Carol Yurtseven, "Hand of a Craftsman, Heart of an Artist," in Martin F. Krause, Madeline Carol Yurtseven, and David Acton, *Gustave Baumann: Nearer to Art* (Santa Fe: Museum of New Mexico, 1993), 14.

17. George Senseney, "Etching in Color," *Palette and Bench* 2 (May 1910): 218.

18. George Elbert Burr, quoted in David Acton, *A Spectrum of Innovation: Color in American Printmaking, 1890–1960*, exh. cat. (New York: W. W. Norton; Worcester, MA: Worcester Art Museum, 1990), 66.

19. Harshe, "Prints and Their Makers," 1:66.

20. Ibid.

21. Ibid., 1:65. Harshe offered that "Few American lithographers, with the exception of men who have designed for theatrical posters, have used color lithography. The mechanical difficulties connected with color lithography . . . have prejudiced many artists against them."

22. Ibid.

23. Ibid., 1:64.

24. N. R. Helgesen, *The Color Monotypes of Clark Hobart*, exh. cat. (San Francisco: The Helgesen Galleries, 1915), n.p.

25. Charles Olmsted, "Prints at the Exposition," *Art and Progress*, August 1915, 381.

26. Lum sold twenty-eight color prints, Squire nineteen, and Senseney ten.

27. Isabel P. West, "Recollections of San Francisco," Part II (typed manuscript, n.d.), collection of the Society of California Pioneers, 55.

28. Edna Gearhart, "The Brothers Brown—California Painters and Etchers," *American Magazine of Art* 20, no. 5 (May 1929): 283.

James A. Ganz

Exposing Photography at the Fair

INTRODUCTION

Photography played a significant role in the planning and the promotion of the Panama-Pacific International Exposition (PPIE), and it appeared in one form or another in virtually every pavilion. Lantern slides, movies, and photographic enlargements mounted on poster boards were integral to many of the displays. Fairgoers could marvel at a forty-foot-long photographic panorama of big trees in the Southern Pacific Railroad Building, attend narrated lantern slide shows in the Palace of Education and Social Economy, experience photographic cycloramas of Midwestern farmland in the Palace of Agriculture, and view the latest in photographic, photomechanical, and cinematic technologies in the Palace of Liberal Arts. Although Edmund O'Neill, chairman of the Liberal Arts jury, boasted of the splendid diversity of his department, encompassing "books, maps, heavy and fine chemicals, musical instruments, artificial teeth, astronomical and microscopical apparatus, road making materials and machines, electrical apparatus, typewriters, photographs, dog remedies, artificial limbs and scores of other exhibits of widely different character and value," the decision to classify all forms of photography, including artistic, or "pictorial," photography, among typewriters and dog remedies rather than among paintings and sculptures in the Palace of Fine Arts was fraught with controversy.[1]

One of the first steps in planning a world's fair is the adoption of an overall system of classification that will determine where specific exhibits, products, and disciplines will be juried, displayed, and judged for awards. While allowing that "photographs relating to any exhibit may be shown in connection therewith in any exhibit palace," the PPIE's "Official Classification of Exhibits" lumped together photographic equipment, processes, and products in Group 33 of the Liberal Arts Department, which was further divided into three distinct classes:

> 122. Materials, instruments and apparatus of photography, equipment of photographic studios, stereopticons, mutographs, kinetoscopes, moving pictures, etc.
>
> 123. Negative and positive photography on glass, paper, wood, cloth, films, enamel, etc. Photogravure in intaglio and in relief; photocollography, photolithography, Stereoscopic prints. Enlarged and micrographic photographs. Color photography. Direct, indirect and photo-color printing. Scientific and other applications of photography.
>
> 124. Pictorial photography.[2]

This final class was designated for artistic photographs created and presented for pure aesthetic contemplation rather than technical, scientific, or documentary purposes. Also connoting a painterly style that emphasized soft focus and subtle tonalities, Pictorialism became associated particularly with the followers of Alfred Stieglitz, the New York gallery director, publisher, and photographer who led the Photo-Secession movement, which promoted photography as an art form. By the time of the PPIE, Clarence H. White had taken Stieglitz's place as the high priest of Pictorialism, while Stieglitz and his closest associates began moving toward "straight photography," a more objective approach free of the technical manipulations and self-conscious artistry associated with Pictorialism.

THE PALACE OF LIBERAL ARTS

The influential photographer Edward Weston, who had experienced the PPIE both as an exhibitor and a fairgoer, opened his lecture on "Photography as a Means of Artistic Expression" before the College Women's Club of Los Angeles on October 18, 1916, with an indignant preamble: "We will start today with this premise, that pictorial photography is, or at least can be, one of the Fine Arts, basing our assumption on its acceptance in that classification by such institutions as [the] Carnegie Institute, Chicago Art Institute, Albright Art Gallery, and others. On the contrary, California, usually progressive, relegated pictorial photography to the Liberal Arts Building at the Exposition where it reposed in a delightful 'atmosphere' with telescopes, talking machines, butter churns, and patent nursing bottles!"[3] He observed, "that little room which contained pictorial photographs . . . contained many a gem that would put to shame some of the superficially pretty, tightly executed paintings that were so laboriously, painfully and startlingly real as to outshine even a mechanically perfect photograph of the record school, in naturalism. I felt a wave of indignation come over me as I looked at them, and thought of the exquisite prints by Clarence H. White, Karl Struss, Anne Brigman, and others, hidden away in the Liberal Arts Building."[4]

The simmering conflict over the status of pictorial photography at the PPIE, which rehashed similar battles fought—and generally lost—by photographers in previous world's fairs, played out in the pages of *Camera Craft*, the journal affiliated with the San Francisco–based California Camera Club. The controversy erupted in the March 1913 issue, when photography's assignment to the Palace of Liberal Arts was first announced.[5] Theodore Hardee, chief of the Department of Liberal Arts, downplayed this decision, blaming it primarily on a lack of available "acreage" in the Palace of Fine Arts. "The contention is invalid," retorted prominent club member Dr. Henry D'Arcy Power in the next month's issue.[6] "Had there been but a few square feet set apart in the Department of Fine Arts, and the best we could send hung therein, this protest would not have been penned: but, as it is, the writer believes that he voices the opinion of those who have the best interests of their vocation at heart when he advises all who have produced pictures in the spirit and interest of art to abstain absolutely from exhibiting."[7]

Hardee's "Final Report" to the PPIE's director of exhibits gives insight into the behind-the-scenes struggles in organizing the gallery of pictorial photography. He called it "one of the most difficult pieces of work in the Department and required no end of preliminary detail work," explaining, "it was really a Bureau of its own, although an integral part of the Liberal Arts Department."[8] Finding himself ill equipped to handle this specialized field of impassioned enthusiasts, Hardee appointed a special honorary advisory committee consisting of painter Will Sparks, commercial photographer Howard C. Tibbitts, and Fayette J. Clute, founding editor of *Camera Craft*.[9] In June 1913, Hardee circulated a letter to clubs and individuals soliciting applications to exhibit, stating, "this department is especially desirous of securing as representative an exhibition of Photographic work, particularly that having pictorial merit, as it is possible to obtain."[10]

Plans took shape the following spring for the construction of a two-story photography booth to occupy Block 14 of the liberal arts building, a space of roughly 129 by 20 feet, and the design was unveiled in the April 1914 issue of *Camera Craft*. The proposal was to place all commercial exhibitors, such as the Ansco Company and the Eastman Kodak Company, on the ground floor, with their fees intended to absorb the full cost of the structure, and art photographers given free space on the mezzanine.[11] But by late summer, this scheme was abandoned, as not enough companies were willing to commit to financing the communal booth.[12] On December 1, 1914, Hardee announced a new plan for a smaller booth to display only pictorial photography in the adjacent Block 7. Without the commercial manufacturers to defray the costs, and in the absence of a dedicated budget for this nonprofit art gallery in a pavilion largely conceived as a trade show, the art photographers now would be charged one dollar for each accepted photograph, with an additional one-dollar surcharge per piece for its framing.[13]

Members of the artistic photography community took umbrage over the new fees. Among the most vocal in his displeasure was the Oakland photographer and critic Sigismund Blumann, whose heated correspondence with Hardee lit up the pages of *Camera Craft*.[14] "These charges are beyond all reason and amount to a prohibitive tax," Blumann raged. "If the nature and conditions of such a section (Pictorial) were fully understood by your committee, this fee would never have been imposed. Pictorial Photographers exhibit as they produce, not for gain or any exploitation, but for the love of the doing." He closed, "It seems as though you were proposing something similar to charging the actor for the privilege of performing to an audience who have paid admission in a theatre that has been donated to you."[15] The records show that Blumann withdrew his application to exhibit.[16] According to Weston, he was not alone in his decision to boycott, as "many leading workers in modern photography would not exhibit on account of [the venue], hence the exhibit was not at all representative of the best that can be done in this country."[17]

Hardee next formed a selection committee for the pictorial gallery, consisting of Tibbitts and Clute from the advisory group plus four local photographers: Anne W. Brigman, Francis Bruguière, William Edward Dassonville, and Edward N. Sewell.[18] The chronological register of entry blanks submitted by potential exhibitors reveals a tepid initial response. Mary Ann Booth of Springfield, Massachusetts, was the first to apply, in late June 1913; her photomicrographs would eventually be installed not in the pictorial gallery but in the nearby commercial booth of Sprague-Hathaway Studios, a Massachusetts-based portrait studio and framer, for the lack of a more appropriate location. Over the next six months, group applications also arrived from the Buffalo Camera Club (September 2, later withdrawn) and the Wilkes-Barre Camera Club (October 6). Entry forms trickled in from individuals throughout 1914, including Weston (June 1), Imogen Cunningham (June 29), Jane Reece (July 6), Bianca Conti

FIG. 117
Sprague-Hathaway Studios Booth, Palace of
Liberal Arts. Photograph by Cardinell-Vincent
Co. From Theodore Hardee, "Final Report of
Theodore Hardee, Chief of the Department of
Liberal Arts, to the Director of Exhibits" (unpub-
lished typescript, 1915). San Francisco History
Center, San Francisco Public Library

FIG. 118
Detail of fig. 117 showing a doorway to the picto-
rial photography gallery

(October 8), and Laura Adams Armer (October 9). On January 28, 1915, a series of familiar names forming a virtual roll call of well-known Pictorialists appeared in the register for a group application, including Clarence H. White, Alvin Langdon Coburn, Edward R. Dickson, Karl Struss, and George Henry Seeley. An internal memo identified this submission as a "collective exhibit obtained through Messrs. [William Gordon] Shields, [Edward] Dixon [*sic*, Dickson], and [William B.] Dyer," who had specified that it was to be ineligible for competition. The memo further stated that "this collection of about fifty prints was the backbone of the Pictorial Photograph Gallery in Liberal Arts, as they had (most of them) been displayed in the London, Paris and New York salons."[19]

Despite these significant additions, Brigman and Bruguière reached out to Alfred Stieglitz. On February 3, they sent him a telegram on behalf of Hardee to ask if he would support the exhibition with loans as he had done for the Third San Francisco Photographic Salon of 1903:

SPECIAL COMMITTEE ON SELECTION FOR PICTORIAL PHOTOGRAPHY BOOTH OF EXPOSITION FEEL THAT PHOTO[-]SECESSION SHOULD BE REPRESENTED[.] IF YOU COULD EXPRESS US IMMEDIATELY TO LIBERAL ARTS DEPARTMENT CARE EXPOSITION HERE TWENTY OR THIRTY PRINTS WE WOULD BE MOST HAPPY TO HANG THEM AT OUR EXPENSE[.] FEEL IT WOULD BE A GOOD THING FOR PHOTOGRAPHY IF YOU CAN DO THIS[.] PLEASE WIRE ANSWER QUICK[,] CARE THEODORE HARDEE[,] CHIEF LIBERAL ARTS DEPARTMENT[.][20]

Stieglitz seems not to have replied, but in light of his tough stance against exhibiting Photo-Secession work in the 1904 Louisiana Purchase Exposition in Saint Louis, where the venue also was a liberal arts palace, his snubbing of the San Francisco Exposition could easily have been predicted.[21]

With the final additions in place, the pictorial photography gallery was ready for the Exposition's opening day. Any concerns harbored by the participants that their space might be inferior to that designated for the large commercial exhibitors would have been fully realized when they finally found it. The installation was mounted in a roughly seventy-by-ten-foot back alley tucked into the extreme southwest corner of the liberal arts pavilion behind several other exhibits. A view in Hardee's "Final Report" of the Sprague-Hathaway Studios booth (see fig. 117) includes, at far right, the modestly signed north doorway of the adjacent pictorial gallery with seven photographs visible in the interior (see fig. 118), double-hung from a rail on burlap-covered walls. The final tally of 148 prints by 47 photographers inside was itemized in the Department of Liberal Arts *Official Catalogue of Exhibitors*,[22] as well as in a flimsy *Pictorial Photography Catalogue* published by the Wahlgreen Company and sold for ten cents.[23]

When fairgoers ventured into this gallery, they left behind the technological marvels on display nearby and entered a quiet realm for aesthetic contemplation. The selection committee members—other than Sewell, who opted to exhibit exclusively in his own separate booth—were given generous wall space here. Brigman showed twelve powerful works that featured nudes amid the distinctive trees and cliffs of Northern California. She included such previous prizewinners as *Finis* (1912), which Stieglitz had submitted on her behalf to the Annual Exhibition of Photographs at Wanamaker's department store in Philadelphia in 1913,[24] and *The Soul of the Blasted Pine* (pl. 120), which had appeared in the January 1909 issue of *Camera Work*. Bruguière's sixteen submissions were dominated by nocturnal views of the Exposition (see pl. 126), several of which later appeared as illustrations in George Sterling's *The Evanescent City*.[25] Dassonville exhibited a dozen of his artful platinum prints of landscapes, figure studies (see pl. 122), and portraits in addition to his commercial work, which was shown in a separate booth elsewhere in the pavilion.[26]

Not surprisingly, Californians accounted for more than half of the exhibitors

in the pictorial gallery. Weston, then established as a portrait photographer in the Los Angeles suburb of Tropico, exhibited three recent figural works: *Child Study in Gray* (1914), *Dolores* (ca. 1914?), and *Carlota* (pl. 123), the latter "made with an 8 x 10 studio camera, Verito lens of 18 inches' focal length, in January [1914] at 10:00 A.M., by light of window and door."[27] This striking figure study, in which Weston's lover, photographer Margrethe Mather, portrayed the widowed Empress Carlota of Mexico, was one of the most acclaimed and frequently exhibited photographs from this breakout period of his career,[28] but it was *Child Study in Gray* (alternately titled *A Flower from the Land of Sunshine*, ca. 1914), a mawkish portrait of a beaming blonde girl, that was singled out for a bronze medal. (In the photography section of the Liberal Arts division, individual photographs were awarded medals, unlike the Fine Arts division where medals were given exclusively for bodies of exhibited work.)

West Coast women played a significant role in the pictorial gallery. Besides Brigman, of Oakland, Bay Area artists included Armer, of Berkeley; Maude Jay Wilson, of Palo Alto; and Conti and Florence Burton Livingston, both of San Francisco. Cunningham, still living in the Pacific Northwest and a relative newcomer to the exhibition circuit, showed eight photographs. In nude studies like *Eve Repentant* (pl. 121), a work that scandalized Seattle when it was published in a local magazine in 1915, the emergent artist echoed the mystical stagecraft of Brigman. Similar allegorical imagery characterizes some of the

early prints produced by Cunningham's new husband, Roi Partridge, a fellow Seattle artist who had forty-two etchings accepted in the Palace of Fine Arts exhibition (see Terry, this volume). In a different vein, Cunningham's *Trafalgar Square* (1910) paid homage to Coburn, who had published a strikingly analogous fountain view in his portfolio *London* (1909).[29] Coburn's own contributions to the gallery included *Broadway at Night* (pl. 127), a photogravure from his *New York* portfolio of 1910,[30] which Roy Harrison Danforth described in his review as "a sepia vivid enough in its realism to make many a Gotham visitor homesick."[31]

The circle of Clarence H. White was in full force. White recently had helped found *Platinum Print: A Journal of Personal Expression* with Edward R. Dickson in the fall of 1913, and established his own school of photography in New York the following year, having previously taught at Teachers College at Columbia University at the invitation of Arthur Wesley Dow. Three of White's photographs appeared in San Francisco, including *The Orchard* (pl. 124). The list of White's pupils exhibiting in the PPIE included Dickson (see pl. 130), Francesca Bostwick, Arthur D. Chapman, Dwight A. Davis, Henrietta Kibbe Briggs, Jane Reece (see pl. 125), and Karl Struss, the latter of whom took night classes with White at Columbia and went on to teach there himself in the summer of 1912. Among Struss's photographs displayed in the gallery was his nocturnal view of the steps leading up to Columbia's Earl Hall (pl. 128). Another New York cityscape that stood out for its unconventional perspective was Chapman's

Diagonals (pl. 129), a disorienting study of Christopher Street from the Eighth Street station of the Sixth Avenue El.[32]

Of the local commercial photographers who operated their own booths in the Palace of Liberal Arts, Willard E. Worden orchestrated one of the most lavish installations (see fig. 119), apparently having taken advantage of the Liberal Arts Department's offer to put exhibitors in touch with "expert booth designers and builders now in San Francisco who have had wide experience at previous expositions."[33] Wedged between the Eastman Kodak Company and the Ansco Company exhibits, Worden's booth featured a camera-wielding personification of photography accompanied by a putto with a palette, the tableau signed by itinerant sculptor Edmund Senn, a veteran of the Chicago and Saint Louis world's fairs.[34]

A nearly forgotten figure in the history of Bay Area photography between the periods dominated respectively by Carleton Watkins and Ansel Adams, Worden was a commercial operator who favored such unusual formats as vertical panoramas that he sold in custom frames. In his questionnaire for the awards jury, Worden indicated that he had been in business since 1901, employed five people, and had produced $20,000 worth of goods during the previous year.[35] Under "merits claimed for articles exhibited," he wrote, "Artistic composition in negatives. Selection of viewpoint, light, and atmospheric conditions to produce striking and pleasing pictures. Fitting the printing medium to quality of negative

to bring out its best qualities. Quality and tone of the print as an artistic production." Asked for "the value of articles as measured by their usefulness, their beneficent influence on mankind in its physical, mental, moral and education aspects," he responded, "To stimulate the imagination, train the eye and mind to see and understand nature and to record nature in her noblest aspects." To that end, he lined the walls of his booth with picturesque prospects of the Golden Gate (see pl. 131), sand dunes, tidal pools and eucalyptus along the city's undeveloped western coastline, seagulls soaring in the mist (a specialty dating back to his first studio, in the Cliff House), mountainous Yosemite landscapes, and views of the Exposition, for which he served as an official photographer (see pl. 21).[36] Nowhere to be seen were portrayals of San Francisco in the aftermath of its recent disaster, the 1906 earthquake and fire, the primary meal ticket for Worden and other local photographers (see fig. 1). The apparent scarcity of such imagery here and elsewhere in the Exposition suggests an effort, unwritten yet generally acknowledged, to suppress this infamous chapter of the Bay Area's history and instead focus on its natural beauty and growing economy.

Worden mastered a number of techniques, including the retouching of negatives and combination printing, to manipulate tonal values and to emphasize his compositions' most dramatic and picturesque qualities. His customers could choose between various print sizes and formats—generally rectangular prints from 8-by-10 to 24-by-30 inches, and panoramas from 8-by-16 to 18-by-36

FIG. 122
Eastman Kodak booth, Palace of Liberal Arts,
1915. Photograph by Cardinell-Vincent Co. From
Theodore Hardee, "Final Report of Theodore
Hardee, Chief of the Department of Liberal
Arts, to the Director of Exhibits" (unpublished
typescript, 1915). San Francisco History Center,
San Francisco Public Library

inches—and gray or sepia toning. For a premium price, Worden offered hand tinting, which represented a significant aspect of his commercial operation.[37] Like stamped tin ceilings that stood in for plasterwork, or slate mantelpieces covered with faux-marble finishes, framed hand-colored photographs gave middle-class consumers a less expensive substitute for traditional watercolors or oil paintings to decorate their homes. At their best, hand-colored prints from Worden's studio could be exceptionally delicate and refined (see pls. 132–133), yet this method was looked down upon by such members of the photographic intelligentsia as Stieglitz and Weston as a cheap corruption of the medium.[38]

To the right of Worden's exhibit was the booth of the Ansco Company (see fig. 120), a commercial manufacturer from Binghamton, New York, that staged a popular photo contest, "America's 50 Loveliest Women." A redeeming, if seemingly improbable, aspect of this venture was the participation of Stieglitz, whose well-known abhorrence of Eastman Kodak, Ansco's rival in the film and camera business, may have led him to agree to serve as a juror for the competition. The contest was heavily promoted in photography periodicals and such mainstream magazines as *Ladies' Home Journal*.[39] "If Louis XIV Had Owned Your Camera," reads the copy accompanying a Rococo portrait, "probably the charms of every beauty of the Grand Monarch's days would be as famous as those of fascinating Elizabeth de Bologne. As it is, only a few master portraits remain to immortalize the glories of seventeenth and eighteenth century femininity. But you, with your camera, can help perpetuate the charms of American womanhood."[40] The ad campaign did not fail to mention Stieglitz's role on the jury.[41] That he took this lighthearted contest seriously is revealed in his officious "Judge's Report for the

Ansco Competition," in which he proclaimed that the jury could not in good conscience award prizes to more than forty-two of the entries even though fifty winners were promised: "It would have been unfair to photography, unfair to the judges, and unfair to all competitors who had been successful and unfair to those who had been unsuccessful."[42] Among the more distinguished winners was the London-based Emil Otto Hoppé, three of whose studies of Malvina Longfellow (née Langfelder) Carter, an American actress living abroad, made the final cut (see fig. 121).[43]

For the overall photography section, the jury of awards that convened in early May 1915 consisted of five foreign commissioners to the PPIE and the following representatives of the photography world: Anthony L. Noriega (president of the Motion Picture Operators Local No. 162, San Francisco), Simon L. Stein (photographer, Milwaukee), Dr. Percy Neyman (president of the San Francisco Camera Club and the San Francisco Commercial Club, and an exhibitor in the pictorial gallery), William Hartman (secretary of the Photographic Dealers Association of America, Brooklyn), George Habenicht (photographer, San Francisco), and H. Pierre Smith (photographer, San Francisco).[44] In their report, the panel noted their assignment's complication by "the scattered area covered by the Department of Liberal Arts, the Jurors having to make long trips to other buildings and isolated places on the Ground."[45] Indeed, their task was immense, their purview comprising the photographs concentrated not only in the pictorial gallery and surrounding booths, but also in the US government section and the foreign exhibits in the Palace of Liberal Arts and in individual countries' pavilions.

The editors of *Camera Craft* praised the jury for recognizing the work of those who had little previous exposure in the exhibition circuit along with the contributions of the better-known photographers.[46] The medal of honor, an award inferior to the grand prize but above gold, silver, and bronze, was bestowed on both Worden and Sewell for their exhibits, and on Booth for her photomicrographs. In the pictorial gallery, the top winners were two local women: Conti, whose photograph *Mother and Child* (ca. 1914) was awarded a medal of honor, and Brigman, who received the grand prize for her collective display; gold medals were given to Henry Berger Jr. of Portland, Oregon, and Louis A. Goetz of San Francisco.

The Eastman Kodak Company received the grand prize for its cameras, as well as a gold medal for "the Best, Most Complete and Most Attractive Installation in the Department of Liberal Arts." With a heavily ornamented facade designed by the San Francisco architectural firm of Bliss and Faville (see fig. 122), the Kodak exhibit booth was described in the *Bulletin of Photography* as "a little art gallery de luxe," but it was actually quite substantial, occupying 4,500 square feet on two floors.[47] The ground level was devoted to glass cases filled with camera equipment and the booth's most popular feature, a display of portraiture executed in the newfangled Kodachrome process that garnered a gold medal for the Rochester-based company. "Color photography may no longer be classed with the dreams of the alchemists—nor as an elusive will-o'-the-wisp," read the description in the accompanying *Catalogue of the Kodak Pictorial Exhibit*. "The examples shown are largely the work of those who had had, until recently, no experience in color photography. Remarkable as they are, they should be viewed only as indicating the possibilities of a new process."[48] Unlike the full-color slide and motion picture film successfully mass-marketed under the same name two decades later, the 1915 Kodachrome process employed two negatives exposed through red and green filters to produce positive color transparencies. Because of its limited palette, this early form of Kodachrome was best suited to the flesh tones of portraiture, and the results, which were unveiled at the University of Rochester Memorial Art Gallery in October 1914 and the following year at the PPIE and the Royal Photographic Society in London, rivaled those of the autochrome, which had been developed in France by the Lumière brothers (see figs. 3–5, 29, 34, 55, and 72).[49]

The booth's second floor was devoted to the Kodak Gallery, an exhibition of 161 bromide enlargements from negatives made with Kodak cameras. "In the selection of the pictures," stated the catalogue:

> there has been no endeavor to make a purely art exhibit. That many of the pictures are worthy of salon honors is merely incidental. Human interest rather than art has been the basis of the selection. How, in the hands of the amateur, the Kodak delightfully tells the story of travel and sport and adventure, and how it has become the fascinating historian of the home is the real lesson of this little exhibit.[50]

Among the exhibitors was Zane Grey, author of the Western novel *Riders of the Purple Sage* (1912) that was already a bestseller, and naturalists Hobart V. Roberts and Howard H. Cleaves, whose article "Hunting with the Lens" had appeared in the July 1914 issue of *National Geographic* magazine. The gallery was not limited to vernacular photography, but also presented work by professional portraitists, including Oscar Maurer, Rudolf Eickemeyer Jr., and W. B. Cline, a technician in Kodak's research division. Scenes of Native American life were shown in works by Frederick I. Monsen, author of *With a Kodak in the Land of the Navajo* (1909), and Joseph Kossuth Dixon, whose seven entries, including *The Sunset of a Dying Race* (fig. 125), also were featured in the Rodman Wanamaker exhibit booth in the Palace of Education and Social Economy.

THE PALACE OF EDUCATION AND SOCIAL ECONOMY

In the Palace of Education and Social Economy, photographs served rhetorical roles far from the aesthetic ideals of the pictorial photographers, while co-opting many of their technical and formal strategies. Within this pavilion, the Rodman Wanamaker Indian Exposition (see figs. 123–124) presented a fascinating case study in photographic showmanship. This extravagantly designed booth was added in May 1915 by special invitation of Exposition officials,[51] but its backstory was a series of expeditions to Native American territories between 1908 and 1913 bankrolled by Wanamaker, the Philadelphia department store magnate, and led by Joseph Kossuth Dixon, a loquacious ex-Baptist preacher who seems to have credentialed himself "Doctor." Dixon and his team of photographers sought to record the so-called "vanishing race" in thousands of stills, hand-colored lantern slides, and motion pictures.[52] The stated goal of their final expedition transcended mere documentation: circulating an audio greeting from President Woodrow Wilson, as recorded by Thomas Edison, their aim was to encourage tribal leaders to take a pledge of allegiance to the American flag. Dixon publicized the expeditions in his book *The Vanishing Race: The Last Great Indian Council* (1913), which used this pictorial archive to illustrate aspects of Native American culture and first-person reminiscences by members of their diverse communities.

Classified in Group 14 of the Department of Social Economy, "Agencies for the Study, Investigation and Betterment of Social and Economic Conditions," the Wanamaker booth had, in the words of Dixon, a three-pronged agenda:

> I. To present an accurate, historic and artistic exposition of Indian life, manners, customs and conditions.
>
> II. To crystallize a sentiment in the nation that will open a new door for the Indian and remedy his present deplorable condition by removing the administration of his affairs from politics.
>
> III. To awaken in the hearts of the American people a sense of justice and fair play that will result in the cooperation of the Nation in the building of a suitable memorial to a vanishing race.[53]

FIG. 123
The Rodman Wanamaker Indian Exposition, Palace of Education and Social Economy, 1915. Paul Robertson Collection, San Jose

FIG. 124
Interior of the Rodman Wanamaker Indian Exposition, Palace of Education and Social Economy, 1915. Collection of Donna Ewald Huggins

FIG. 125
Joseph Kossuth Dixon (American, ca. 1856– ca. 1926), *The Sunset of a Dying Race*, 1909. Photogravure, image: 21 × 16½ in. (53 × 42 cm). The Denver Public Library, Western History Collection, Z-3215

In practical terms, Dixon described the multimedia components of the display as follows:

> About 500 enlarged photographs selected from 8,000 negatives of Indian life and lore, giving specimens of the types—men, women and children—of every Indian tribe in the United States, together with a careful pictorial delineation of environment, conditions, manners and customs, homes and home life, sports and ceremonies. Three lectures daily [by Dixon], illustrated with slides and motion pictures. Literature detailing present conditions of Indian life.[54]

Like Edward Curtis's twenty-volume *North American Indian* (1907–1930), the Dixon-Wanamaker archive is composed of formal studio portraits and staged scenes. Their elegiac imagery, as evidenced by such titles as *The Last Outpost*, *The Final Trail*, *Vanishing into the Mists*, and *The Sunset of a Dying Race* (fig. 125) (all 1909), reinforced the concept of Manifest Destiny that also tainted the fair's public art program and Joy Zone attractions (see Acker, this volume). With darkroom wizardry liberally applied to heighten the pathos, Dixon's photographs sometimes echoed the dramatic landscapes of certain pictorialists, such as Worden. Although Wanamaker's drive to raise money for a National American Indian Memorial ultimately failed, his PPIE booth garnered a grand prize, with Dixon receiving a silver medal. Recently, some scholars have sought to look past the theatricality and political incorrectness of the original enterprise to investigate the documentary value of the extensive visual archive.[55]

The gold medal–winning National Child Labor Committee (NCLC) booth (see fig. 126), also located in the Palace of Education and Social Economy, was an extraordinary showcase of social documentary photography. Assigned to Group 19 (labor), Class 63 ("Regulation and inspection of factories, mines and other work. Woman and child labor"), the display featured the child labor photographs of Lewis W. Hine, his most important body of work. As a staff photographer of the New York–based NCLC, Hine produced more than five thousand negatives capturing the cruel and miserable conditions endured by America's working children.[56] "For many years I have followed the procession of child workers winding through a thousand industrial communities, from the canneries of Maine to the fields of Texas," he wrote in 1914. "I have heard their tragic stories, watched their cramped lives and seen their fruitless struggles in the industrial game where the odds are all against them."[57] A photograph of the installation, which Hine designed and for which he received honorable mention from the jury, reveals an array of framed and numbered placards, six by three feet in scale, combining hand-lettered slogans, charts, and mounted enlargements. Helen L. Mabry, another operative of the NCLC and the National Consumers League who directed both of their exhibits, is seen at left, proselytizing to a group that appears to include Hine, standing third from the left.

Hine called his collages of image and text "time exposures," a potent, if cryptic, phrase that simultaneously evokes the technical feature of a camera's shutter speed, the idea of an evolving narrative, and the process of uncovering an inconvenient truth. The NCLC booth incorporated twenty-five of these time exposures, fifteen of which illustrated "The High Cost of Child Labor" and the other ten "What Are We Going to Do about It?"; several were reproduced in the exhibit

FIG. 126
National Child Labor Committee (NCLC) booth, Palace of Education and Social Economy, 1915. Photograph by Cardinell-Vincent Co., from copy negative by Lewis Hine. Library of Congress, Washington, DC, Prints and Photographs Division, LC-H5- 4098

FIG. 127
Exhibit panel "Every Child Should Work," NCLC booth, Palace of Education and Social Economy, 1915. 6 ⅛ × 3 ⁹⁄₁₆ in. (15.4 × 9.1 cm). Library of Congress, Washington, DC, Prints and Photographs Division, LC-DIG-nclc-04959

FIG. 128
Lewis W. Hine (1874–1940), "Carrying-in" boy in Alexandria Glass Factory, Alexandria, Va., 1911. Gelatin silver print, 4 ⁹⁄₁₆ × 6 ½ in. (11.6 × 16.4 cm). Library of Congress, Washington, DC, Prints and Photographs Division, LOT 7478, no. 2260

FIG. 129
Cover of the Survey (November 13, 1915) Hoover Institution Library, Stanford University, California

handbook *The High Cost of Child Labor* that also appeared in the *Child Labor Bulletin*.[58] In one panel, which bears the message "Every Child Should Work but the Work Must Develop not Deaden" (fig. 127), the headline is punctuated by a silhouetted figure of a young child, with six photographs below, including, at lower right, the *"Carrying-in" boy in Alexandria Glass Factory, Alexandria, Va.* (fig. 128). Hine turned his critical lens on the PPIE itself for a pictorial essay that appeared concurrent with the Exposition in *Survey*, a progressive journal devoted to social reform (see fig. 129). Titled "Children of the Joy Zone," it represented the PPIE's youngest performers from Morocco, Japan, Lapland, and several Native American tribes who were deprived of normal childhoods to serve as "mere cogs in the grown-ups' play-machine, mechanical and deadening."[59]

Far from the visual poetry of the Pictorialists, the ostensibly stark realism of Hine's photographs also diverged from the heroic iconography of labor that characterized the fair's public murals.[60] They also bore no relation to the contemporaneous mill imagery of Robert Spencer on view in the Palace of Fine Arts; while the painter's anonymous and mature laborers are represented generally in their off hours (see pl. 67), Hine's young workers, whose names and ages he scrupulously recorded in his field notes, appear painfully trapped in the tedium of their lost childhoods.

THE TEMPLE OF CHILDHOOD

In the years leading up to the Exposition, a very different form of juvenile exploitation vexed the photography world nearly as much as the placement of the pictorial gallery did. The improbable focus of controversy was the Temple of Childhood, a concession dreamt up by Saint Louis businessman Richard Myron Sayers, who apparently did not want to follow his late father's footsteps in the oil and grease brokerage. Inside the Temple, he envisioned a retail space for children's products as well as a large photography gallery of the nation's

progeny. With an advisory board of established photographers (including Simon Stein, who also sat on the PPIE's jury of awards), offices in New York and in the San Francisco Chronicle Building, architectural plans by Louis Christian Mullgardt, and a whopping advertising budget, the enterprise was launched in 1913 with the promise of commissioning 250,000 child portraits from photography studios across the country.[61]

Less overtly exploitive than the Joy Zone's notorious exhibit of Incubator Babies, which featured live babies as well as live storks, the proposed pavilion was less a monument to childhood than to the commodification of childhood, a growing trend in American consumer culture and mass media, with an ad campaign almost irresistibly calculated to appeal to middle-class maternal pride. The ploy involved luring parents to photography studios by means of an official-looking certificate notifying the recipients that their offspring had been selected for representation in the Temple. Complementary sittings for portraits of their children to be sent off to San Francisco were accompanied by a "hard sell" to these parents for their own personal copies. The exhibition of children's portraits in the Temple was a mere pretense to attract fairgoers to a showroom of commercial products. The editors of *Collier's* saw through this scheme and were among its most outspoken critics in the mainstream press:

Factory owners and mine operators who pour little children into a chute and pour profits out at the other end have nothing on the well-meaning directors of the Panama-Pacific Exposition. Not that the latter depend upon child labor. No, the form their exploitation of youth takes is harmless enough, from the standpoint of economics; it is contemptible only in taste. . . . Do you care to place *your* children on public exhibition—to be grinned at and appraised by thousands of sight-seers, drunk and sober, clean and unclean?[62]

The mothers of America answered with a resounding, "Yes!" Indeed, the bad

press only fed the demand. In the words of the Temple's director, "Everywhere all over the country the newspapers are taking up this childhood exhibit and devoting full pages to its publicity. All over the country the women are awakening to the educational side of the work of The Temple of Childhood."[63]

Controversy arose when disgruntled commercial photographers initially shut out of the potentially lucrative scheme began to talk to the press. They questioned the concession's legitimacy, and sought to expose its predatory organizers for taking advantage of clients and camera operators alike while lining their own pockets.[64] Extensive coverage followed in such journals as the *Bulletin of Photography*, which devoted two dozen pages to the topic in late 1913.[65] But by January 1914, *Camera Craft* reported that every photographer "in good standing" would be allowed to participate, concluding that "the advisory board desires to state that they regard the Temple of Childhood plan as a great stimulus to the photographic business, and one that, if conducted upon a high plane, will reflect great credit upon the entire profession."[66]

The Exposition's extensive files on the International Child Life Exhibit Company, the firm behind the Temple, were preserved carefully as a result of its mounting legal entanglements. They chronicle the firm's slow collapse as it squandered its funds, failed to break ground on its pavilion, and forfeited its concession, culminating in involuntary bankruptcy adjudication in the US District Court of Northern California on January 13, 1915; in its final audacious act, the bankrupt concessioner sued the Exposition Company for breach of contract.[67] The *Brooklyn Daily Eagle* broke the story to its readers on Valentine's Day: "Childhood Temple Scheme Fizzles Out, Will Be No Exhibition of Brooklyn Babies' Pictures at 'Frisco Fair."[68]

Caught up in the plot was Col. Theodore C. Marceau of New York, a colorful entrepreneur in commercial portraiture who ran a national chain of studios from his headquarters on Fifth Avenue.[69] Marceau corresponded with the president of the PPIE, expressing his concern: "Many thousands of children have already been photographed, representing practically every state in the Union and including children and grandchildren of United States Senators, Representatives, State Officials, Judges and other people of prominence, and we submit that the representations made to parents by literature sent from San Francisco that these pictures would be exhibited in the Exposition and by widespread publicity in the daily press, were the inducements that led them to have these pictures made."[70] When the Temple scheme collapsed, Marceau spearheaded a competition, sponsored by the *Eagle*, of its readers' entries taken by his firm and its affiliate, the Otto Sarony Company, with winning photographs to be mounted in the Palace of Education.[71] A journalist for the *Eagle* wrote of the awards ceremony, "Some three hundred of the medal and ribbon winners were . . . as much more beautiful than their photographs as a humming bird is more beautiful than any picture of it that was ever painted."[72]

CONCLUSION: TWO VIEWS OF THE FAIR

Despite the unfortunate clash over the pictorial gallery, the PPIE offered an overwhelming variety of educational, technological, scientific, and commercial applications of photography, a microcosm of a medium well on its way to becoming a universal aspect of modern life, while it also stubbornly asserted photography's place in the art world. In rapt attendance was the young San Franciscan Ansel Adams, whose thirteenth birthday coincided with opening day of the fair. His father, recognizing the Exposition's educational potential, gave him a season's pass in lieu of school for the year. In an oral history from the 1970s, the legendary landscape photographer and environmentalist was asked about his experience of the PPIE, and several observations stand out, including his interest in the abstract art shown in the Annex, which he preferred to the "God-awful, bad, romantic and arid sculpture" on the grounds.[73] But at least in

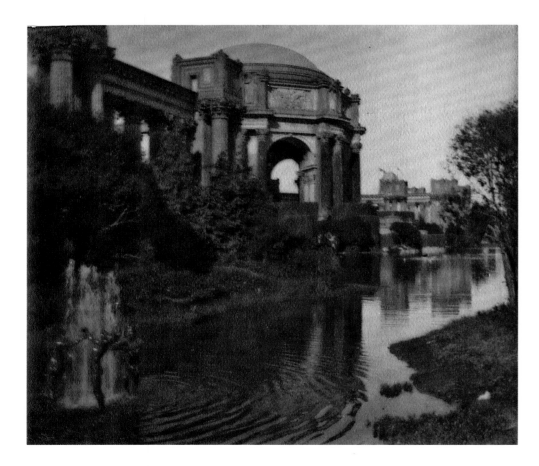

FIG. 130
Ansel Adams (American, 1902–1984), *Palace of
Fine Arts*, 1915. Gelatin silver print, 7½ × 8½ in.
(19.1 × 21.6 cm). David H. Arrington Collection

FIG. 131
Paul Strand (American, 1890–1976), *Panama-
Pacific Exposition, San Francisco*, 1915. Platinum
print processed with mercury, 10 × 12⅞ in.
(25.4 × 32.7 cm). National Gallery of Art,
Washington, DC, Patrons' Permanent Fund,
1995.36.113

FIG. 132
Paul Strand (American, 1890–1976), *Wall Street*,
1915 (printed 1977). Platinum/palladium print,
9⅜ × 12⅝ in. (24.4 × 32.1 cm). Fine Arts Museums
of San Francisco, gift of Michael E. Hoffman,
New York, in honor of Mr. Joseph Folberg for his
generous support and commitment to photogra-
phers and photography, 1992.96.2

hindsight, he claims to have taken issue with the photographic offerings. In reference to the pictorial gallery, which he misremembered as containing works by members of the California Camera Club exclusively, he recalled "the Camera Club show was so dreadful I looked at part of it and just left."[74] It is a curious statement that contradicts the teenager's evident embrace of Pictorialism as revealed in one of his earliest known photographs, a view of Maybeck's Palace of Fine Arts (fig. 130) from the south end of the lagoon, with Anna Coleman Ladd's fountain sculpture *Wind and Spray*.[75]

While Adams's view of the PPIE appears clouded by his later ambivalence to Pictorialism, Paul Strand's unique photographic memento (fig. 131) offers a fresh perspective.[76] A former student of Hine's and a colleague of many of the pictorial gallery's exhibitors, Strand visited the PPIE and its photographic galleries in the spring as part of a cross-country tour. Writing to his mother on May 3, 1915, on Hotel Argonaut stationery, he complained about San Francisco's bad weather ("some of the natives like to tell you that it is very unusual, but it isn't at all") and described a pleasant visit to Brigman's abode in Oakland ("a charming little studio hidden away in a garden behind a fence, a very delightful little place, so different from all the ordinary boxes nearby").[77] About the PPIE he limited his comments to praising a Richard Wagner concert in Festival Hall and the Japanese galleries in the Palace of Fine Arts. "This fair was really a pleasant surprise," he reported. "It is quite wonderful and much more interesting

in every way than [the Panama-California Exposition in] San Diego. Mean to spend some time there if the sun will only shine." On a typical gray day, Strand staked out an unexceptional spot on the fairgrounds and produced a remarkable photograph that disregards the atmosphere of fantasy and romance to focus instead on the formal qualities of an architectural fragment. Far from the hustle and bustle of *Wall Street* (fig. 132), Strand's image of the PPIE set the stage for one of the first great icons of modernist photography.[78]

The author wishes to thank: Laura A. Ackley, Carol Acquaviva, David Arrington, Tom Beischer, Bonnie Bell, David Benjamin, Cheri Bianchini, Victoria Binder, Heather Brown, Timothy Brown, Susan Charlas, Matthew Clarke, Renato Consolini, Verna Curtis, Randy Dodson, Susan Ehrens, Debra Evans, Jon Frembling, Susan Herzig, Susan Hill, Lisa Hodermarsky, Graham Howe, Donna Ewald Huggins, Drew Johnson, Sarah Kennel, Valerie Krall, Gary Kurutz, Marianne Leach, Anna Lucas Mayer, Andrea Nelson, Phillip Prodger, Paul Robertson, Andrew Smith, Robert Tat, Colleen Terry, Paul H. Thomas, Laurie Thompson, and Donald Whitton. I am especially grateful to Achenbach Foundation for Graphic Arts Research Fellow Kirk Nickel for his valuable assistance in the research for this essay.

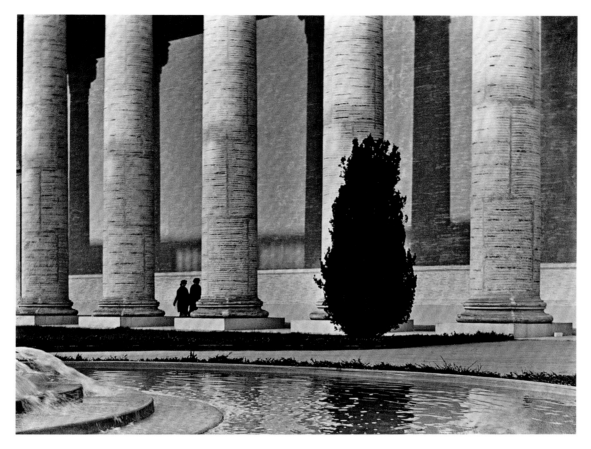

1. Edmund O'Neill, Chairman of the Department Jury, to the Superior Jury of Awards, repr. in Theodore Hardee, "Final Report of Theodore Hardee, Chief of the Department of Liberal Arts, to the Director of Exhibits" (unpublished typescript, 1915), Panama-Pacific International Exposition files, San Francisco History Center, San Francisco Public Library.

2. *Liberal Arts, Official Catalogue of Exhibitors, Panama-Pacific International Exposition* (San Francisco: Wahlgreen, 1915), 11.

3. Original manuscript in the Weston-Hagemeyer Collection, Center for Creative Photography, University of Arizona, Tucson, repr. in Peter C. Bunnell, ed., *Edward Weston on Photography* (Salt Lake City: Peregrine Smith, 1983), 18.

4. Ibid., 18–19.

5. "Photography at the Panama-Pacific," *Camera Craft* 20, no. 3 (March 1913): 133.

6. "Photography at the Panama-Pacific Exposition, A Protest," *Camera Craft* 20, no. 4 (April 1913): 184.

7. Ibid.

8. Hardee, "Final Report," 263–264.

9. The appointment of the committee was announced in "Photography at the Panama-Pacific," *Camera Craft* 20, no. 4 (April 1913): 182.

10. Theodore Hardee, quoted in "Photography at the Panama-Pacific," *Camera Craft* 20, no. 8 (August 1913): 281.

11. "Photography at the Panama-Pacific," *Camera Craft* 21, no. 4 (April 1914): 189.

12. See Theodore Hardee form letter to potential commercial exhibitors, July 8, 1914, in which he writes, "The time is now fast approaching when we must determine which of these plans are to be followed," and sets a deadline of August 1 for their replies. A second letter sent on August 10 from Clute to a number of commercial manufacturers states that the deadline had been extended upon his request. Both letters are archived in carton 90, folder 2 "Records…Exhibitors," Panama Pacific International Exposition Records, BANC MSS C-A 190, The Bancroft Library, University of California, Berkeley (hereafter cited as PPIE Records).

13. "Photography at Our Coming Exposition," *Camera Craft* 22, no. 1 (January 1915): 29–30. Hardee's December 1 letter is printed in full on p. 30.

14. "That Charge for Accepted Photographs," *Camera Craft* 22, no. 2 (February 1915): 73–76.

15. Sigismund Blumann to Theodore Hardee, December 8, 1914, repr. in *Camera Craft* 22, no. 2 (February 1915): 74–75.

16. Application record, August 31, 1914, carton 89, folder 31 "Record by Group of Applications Received," PPIE Records. Blumann's application to exhibit was subsequently struck through on the official register.

17. Edward Weston, "Photography as a Means of Artistic Expression," repr. in Bunnell, ed., *Edward Weston on Photography*, 19.

18. Hardee, "Final Report," 264; California artist Will Sparks was part of the original committee but resigned before the group first convened. The inaccurate characterization of Brigman and Bruguière as co-organizers or cochairs of the pictorial gallery that has been repeated frequently in the literature can be traced to Weston Naef's publication of the telegram signed by the two photographers and sent to Stieglitz (see note 20 below); see Weston Naef, *50 Pioneers of Modern Photography: The Collection of Alfred Stieglitz* (New York: Metropolitan Museum of Art, 1978), 201.

19. Memorandum, carton 91, folder 18 "Awards: Liberal Arts, No Awards," PPIE Records.

20. Anne W. Brigman and Francis Joseph Bruguière to Alfred Stieglitz, telegram, February 3, 1915, carton 8, folder 187 "Bruguière correspondence," Alfred Stieglitz/Georgia O'Keeffe Archive, YCAL MSS 85, Beinecke Rare Book & Manuscript Library, Yale University (hereafter cited as Stieglitz/O'Keeffe Archive).

21. See Alfred Stieglitz, "Pictorial Photography: The St. Louis Exposition," *Camera Work* 1 (January 1903): 37–45; and subsequent editorials in *Camera Work* 2 (April 1903): 51; *Camera Work* 4 (October 1903): 56; *Camera Work* 5 (January 1904): 50; *Camera Work* 8 (October 1904): 38. See also "Julius C. Strauss vs. Alfred Stieglitz," *Wilson's Photographic Magazine* 40, no. 556 (April 1903): 186–188.

22. *Liberal Arts, Official Catalogue of Exhibitors*, 18–19.

23. This ephemeral catalogue exists in very few copies. I am grateful to Jon Frembling for providing me with a scan of a copy in the Stephen White Collection of Karl Struss Papers, carton 2, folder 4 "Exhibition Catalogues, 1915," Amon Carter Museum of American Art, Fort Worth.

24. Susan Ehrens, *A Poetic Vision: The Photographs of Anne Brigman*, exh. cat. (Santa Barbara: Santa Barbara Museum of Art, 1995), 81. As multiples, photographs exhibited at the PPIE are difficult to trace to current collections. Thus, only dates have been provided throughout this essay.

25. George Sterling, *The Evanescent City* (San Francisco: A. M. Robertson, 1916).

26. Several of Dassonville's exhibited prints, including *Figure Study* (pl. 122), remained in his estate and were kept with their original identifying labels from the Exposition, listing the address of his portrait studio in the Sachs Building at 140 Geary Street. Susan Herzig and Paul Hertzmann, eds., *Dassonville: William E. Dassonville, California Photographer, 1879–1957* (Nevada City: Carl Mautz, 1999), 20, fig. 1.2. Three other PPIE labels survived in Dassonville's estate: *Day Dreams* (ca. 1910), *The Monterey Coast* (date unknown), and *Portrait of Miss C.* (date unknown). Susan Herzig, e-mail message to author, February 25, 2014.

27. *American Photography*, November 1916, 634 (illustration on 589).

28. See Beth Gates Warren, *Artful Lives: Edward Weston, Margrethe Mather, and the Bohemians of Los Angeles* (Los Angeles: J. Paul Getty Museum, 2011), 59–61.

29. Alvin Langdon Coburn, *London* (London: Duckworth and Brentano's, 1909).

30. Alvin Langdon Coburn, *New York* (London: Duckworth and Brentano's, 1910).

31. Roy Harrison Danforth, "Photography at the Exposition," *American Annual of Photography* 30 (1915): 286.

32. See Bonnie Yochelson, *Pictorialism into Modernism: The Clarence H. White School of Photography*, exh. cat. (New York: Rizzoli, 1996), 66.

33. "Photography at Our Coming Exposition," *Camera Craft* 21, no. 9 (September 1914): 462.

34. A native of Austria, Edmund Senn (1873–1945) was a regular on the Exposition circuit, having contributed his services to the fairs in Chicago and Saint Louis. He later worked for Universal Pictures in Hollywood, and ended his career in El Paso, Texas. Ironically, the most detailed account of his life and career, which would have otherwise gone unrecorded, was occasioned by an act of vandalism in his El Paso studio that made the local newspapers in 1927; see "From Dust to Dust—the Work of a Lifetime. Edmund Senn, Famous Artist, Comes Back to El Paso After Long Absence to Find his Beautiful Brain Children a Mass of Ruins," *El Paso Herald*, September 27, 1927.

35. Jury questionnaire, carton 91, folder 16 "Awards: Liberal Arts, Western–Zer," PPIE Records.

36. After the fair, Worden moved the contents of his booth to 312 Stockton Street near Union Square, a location that he operated into the 1940s as an all-purpose art gallery selling everything from English mezzotints to California School paintings.

37. Worden advertised his colored photographs as being executed with oil paint, but an examination of several extant prints by Debra Evans and Victoria Binder finds that some were tinted with heavy applications of oil paint that obscure the photographic base while others were more lightly enhanced with transparent watercolors. The quality of the tinting varied widely, suggesting that a number of different colorists were responsible for the work. Worden had studied painting at the Pennsylvania Academy of the Fine Arts and would have had the ability to hand-color his own photographs, but as his business grew he would have delegated the time-consuming task to his studio assistants. He is known to have employed Sargent Johnson in this capacity in 1925; see the African American Registry website listing for Johnson. This site mistakenly states that the San Francisco city directory of 1920 lists him as working for Worden that year; in fact the city directories place him with Worden in 1925.

38. Other exhibitors of hand-colored photographs included David Davidson of Providence, Rhode Island, and Anna Thatcher of Tipton, Indiana, both of whom showed their work in the Palace of Varied Industries.

39. There is no evidence that Stieglitz received any payment for his services other than a No. 3A Ansco Speedex camera, mailed to him on January 23, 1915; see letter from A. Lamouette to Alfred Stieglitz, carton 3, folder 50 "Ansco Company correspondence, 1911–1917," Stieglitz/O'Keeffe Archive.

40. *Popular Photography* 2, no. 9 (June 1914): unnumbered page preceding table of contents.

41. The other jurors were the illustrator Harrison Fisher and actress Minnie Maddern Fiske.

42. Alfred Stieglitz, "Judge's Report for the Ansco Competition," n.d., carton 3, folder 50 "Ansco Company correspondence, 1911–1917," Stieglitz/O'Keeffe Archive. *Photo-Era* published the full contest results along with the explanation that only thirty-nine of the fifty prizes were awarded, and that a supplementary jury would be appointed to determine eleven more winners that "will represent technical and chemical qualities not taken into account by the original jury." "America's Loveliest Women Contest," *Photo-Era* 34, no. 5 (May 1915): 262.

43. According to Graham Howe, Longfellow is known to have sat for Hoppé in 1915, 1917, 1918, 1919, and 1920; e-mail message to author, July 1, 2014. The photographer achieved fame and fortune with his *Book of Fair Women* (London: J. Cape, 1922) in which Longfellow made an appearance.

44. Hardee, "Final Report," 292. The foreign commissioners were Louis Mastropasqua (Italy), H. C. Yang (China), Hans Ledeboer (the Netherlands), Professor Jiro Harada (Japan), Guillermo Koch (Argentina), and Dr. José de Sousa Bettencourt (Portugal). Harada served as the chairman.

45. Hardee, "Final Report," 317.

46. "The Awards in The Pictorial Section, P.-P.I.E.," *Camera Craft* 22 no. 10 (October 1915): 411–412. Conti's *Mother and Child* was reproduced as the frontispiece to this issue.

47. "Grand Prize and Two Gold Medals for Eastman Kodak Company," *Bulletin of Photography* 17, no. 414 (July 14, 1915): 40. The writer mistakenly states that the Kodak booth was located in the Palace of Fine Arts. I am grateful to Laura A. Ackley for informing me of the booth's architects.

48. *Catalogue of the Kodak Pictorial Exhibit, Liberal Arts Building, Panama-Pacific International Exposition* (Rochester: Eastman Kodak, 1915), n.p.

49. See Jane Baum McCarthy, "The Two-Color Kodachrome Collection at the George Eastman House," *Image* 30, no. 1 (September 1987): 1–12.

50. *Catalogue of the Kodak Pictorial Exhibit*, n.p.

51. "Will Show Finest Collection of Indian Art. Representative of Rodman Wanamaker Gallery Here to Make Arrangements," *San Francisco Chronicle*, April 30, 1915.

52. Dating and attribution of the Dixon-Wanamaker photographs

is clarified in James S. Brust et al., *Where Custer Fell: Photographs of the Little Bighorn Battlefield Then and Now* (Norman, OK: University of Oklahoma Press, 2005,) 197–198n48. Dixon's photographic team consisted of W. B. Cline and John D. Scott.

53. Quoted from the International Jury of Award work sheet, carton 110, folder 9 "Social Economy: Awards," PPIE Records.

54. Ibid.

55. The archive is now part of the Mathers Museum of World Cultures at Indiana University. See Susan Applegate Krouse, *North American Indians in the Great War* (Lincoln: University of Nebraska Press, 2007), 169–170.

56. The literature on Hine's NCLC photographs is extensive. The author has particularly benefited from Verna Posever Curtis and Stanley Mallach, *Photography and Reform: Lewis Hine & the National Child Labor Committee*, exh. cat. (Milwaukee: Milwaukee Art Museum, 1984); George Dimock, "Children of the Mills: Re-Reading Lewis Hine's Child-Labour Photographs," *Oxford Art Journal* 16, no. 2 (1993): 37–54; Patricia Pace, "Staging Childhood: Lewis Hine's Photographs of Child Labor," *Lion and the Unicorn* 26, no. 3 (September 2002): 324–352; and Kate Sampsell-Willmann, "Social Testimony: Lewis Hine's Expertise," in *Lewis Hine as Social Critic* (Jackson: University Press of Mississippi, 2009), 56–96.

57. Lewis W. Hine, "The High Cost of Child Labor," *Child Labor Bulletin* 3, no. 1 (May 1914): 63.

58. Lewis W. Hine, "The High Cost of Child Labor," *Child Labor Bulletin* 3, no. 4 (February 1915): 25–45.

59. "Children of the Joy Zone," *Survey* 35, no. 7 (November 13, 1915): cover and 164–165.

60. See Dimock, "Children of the Mills," 37–54.

61. "The Temple of Childhood," *Camera Craft* 21, no. 1 (January 1914): 33–34.

62. "Exploiting Childhood," *Collier's*, November 15, 1913, 13; see also "Wallingford at the Fair," December 6, 1913, 12–13.

63. Richard M. Sayers to Wilfred A. French (editor and publisher of *Photo-Era*), September 4, 1913, repr. in "The Temple of Childhood, Photographers should carefully read this correspondence and give it consideration before signing any contracts," *Bulletin of Photography* 13, no. 324 (October 8, 1913): 465.

64. See, for instance, "Just an Advertising Dodge/Temple of Childhood for Panama Pacific Exposition Yields Photographer Much Money," *Alton (IL) Evening Telegraph*, August 11, 1913.

65. "The Temple of Childhood," 462–468; "The Temple of Childhood—What Is It?" *Bulletin of Photography* 13, no. 327 (November 12, 1913): 611–623; "What 'Collier's Weekly' says about the 'Temple of Childhood,'" *Bulletin of Photography* 13, no. 328 (November 19, 1913): 654; "Three 'Temple of Childhood' Stories," *Bulletin of Photography* 13, no. 331 (December 10, 1913): 739–741.

66. "The Temple of Childhood," *Camera Craft* 21, no. 1 (January 1914): 34.

67. Carton 160, folders 1–22 "Temple of Childhood," PPIE Records. Bankruptcy reported in *Photo-Era* 34, no. 5 (May 1915): 258. See also "The Temple of Childhood Wins," *Photo-Era* 36, no. 3 (March 1916): 148.

68. *Brooklyn Daily Eagle*, February 14, 1915. The article states that some 15,000 photographs that had been shipped to San Francisco were languishing in storage.

69. See the biography of Theodore C. Marceau on Broadway Photographs, accessed September 19, 2014, http://broadway.cas.sc.edu/content/theodore-c-marceau.

70. Letter signed by Theodore C. Marceau and four other photographers from New York, Boston, Philadelphia, and Washington, DC, to Charles C. Moore, January 11, 1915, carton 160, folder 22 "Temple of Childhood 1914–1915," PPIE Records.

71. Announced in "Eagle Gets Babies' Photos for Contest," *Brooklyn Daily Eagle*, February 23, 1915. There is no evidence that the photographs were exhibited in San Francisco.

72. "Beautiful Children," *Brooklyn Daily Eagle*, May 9, 1915.

73. Ansel Adams, "Conversations with Ansel Adams," an oral history conducted 1972, 1974, 1975 by Ruth Teisler and Catherine Harroun, Regional Oral History Office, The Bancroft Library, University of California, Berkeley, 1978, 28–29.

74. Ibid., 31.

75. Phillip Prodger, *Ansel Adams: At the Water's Edge*, exh. cat. (Salem, MA: Peabody Essex Museum, 2012), 12–13 and 31, note 11. Prodger cites variants in the Ansel Adams Archive at the Center for Creative Photography, Tuscon, Arizona, "marked in an unknown hand (possibly Beaumont Newhall's), 'Prints for N. N. [Nancy Newhall] Extremely valuable (?) Most early pix by A. A. Portals of the Past.'" Based on this information he suggests that Adams called the subject *The Portals of the Past*, but at the time of the fair this epithet was indelibly linked with the ruins of the Alban Towne mansion from the 1906 earthquake (see fig. 1) that had been moved to Golden Gate Park and became an icon of the city's perseverance in the aftermath of the disaster. It seems more likely that the annotator of the prints in the Center for Creative Photography had misidentified the site.

76. Customarily identified as a view of the Palace of Fine Arts, Strand's photograph actually depicts the colonnade of either the Palace of Agriculture or the Palace of Food Products, with a small fragment of the Fountain of Ceres in the lower left foreground. Matthew Clarke of the National Gallery of Art made the correct identification of the site in the summer of 2014. I am grateful to Matthew and his colleague Andrea Nelson for sharing this information with me. E-mail message to author, August 24, 2014.

77. The letter is quoted in Maria Morris Hambourg, *Paul Strand, Circa 1916*, exh. cat. (New York: Metropolitan Museum of Art, 1998), 25; the original letter is in carton 39, folder 3, Paul Strand Archives, AG 17, Center for Creative Photography, University of Arizona, Tucson.

78. Maria Morris Hambourg refers to Strand's PPIE photograph as one of a handful of preliminary sketches for *Wall Street*. Hambourg, *Paul Strand, Circa 1916*, 28.

86 James McNeill Whistler (American, 1834–1903)
Black Lion Wharf, 1859, from the *Thames Set*, 1871
Etching
5⅞ × 8¾ in. (14.8 × 22.3 cm)
Fine Arts Museums of San Francisco, museum purchase, Graphic Arts Council Exhibition Fund, 1981.1.188
Palace of Fine Arts, Gallery 29, wall C, no. 316

87 James McNeill Whistler (American, 1834–1903)
The Thames, 1896
Lithotint with scraping
10 ½ × 7 ¾ in. (26.7 × 19.6 cm)
Fine Arts Museums of San Francisco, museum purchase,
Achenbach Foundation for Graphic Arts Endowment Fund, 1992.140
Palace of Fine Arts, Gallery 29, wall A, no. 291

88 James McNeill Whistler (American, 1834–1903)
Weary, 1863
Drypoint
7⅛ × 5¼ in. (19.7 × 13.3 cm)
Fine Arts Museums of San Francisco, museum purchase,
Vera Michels Bequest Fund and Achenbach Foundation for Graphic Arts Endowment Fund, 1995.88
Palace of Fine Arts, Gallery 29, wall C, no. 319

89 James McNeill Whistler (American, 1834–1903)
Draped Figure, Reclining, 1892
Color transfer lithograph on thin transparent transfer paper
7 ⅛ × 10 ⅛ in. (18 × 25.8 cm)
Fine Arts Museums of San Francisco, museum purchase,
Achenbach Foundation for Graphic Arts Endowment Fund, 1965.68.1
Palace of Fine Arts, Gallery 29, wall B, no. 301

90 John Marin (American, 1872–1953)
Bal Bullier, Paris, 1906
Drypoint
5 3⁄8 × 7 3⁄4 in. (13.8 × 19.8 cm)
Cantor Arts Center, Stanford University, California, gift of Dr. Ralph and Marilyn Spiegl, 1980.40
Palace of Fine Arts, print cabinets, no. 6713

91 John Marin (American, 1872–1953)
 Ca d'Oro, Venice, 1907
 Etching
 7 × 9 ⅜ in. (17.8 × 23.8 cm)
 Portland Art Museum, Portland, Oregon, gift of Heirs of Charles Francis Adams Collection:
 Peter F. Adams, Mrs. Sandra Adams Beebe, and Charles Anthony Adams, 89.20.78
 Palace of Fine Arts, print cabinets, no. 6714

92 Ernest David Roth (American, b. Germany, 1879–1964)
The Gate, Venice, 1906
Etching
7 ½ × 6 ⅜ in. (19.1 × 16.3 cm)
Fine Arts Museums of San Francisco, Achenbach Foundation for Graphic Arts, 1963.30.24946
Palace of Fine Arts, print cabinets, no. 7175

93　Jules André Smith (American, 1880–1959)
The Little Foundry, 1913–1914
Etching
7⅞ × 11 in. (20.1 × 27.8 cm)
Fine Arts Museums of San Francisco, gift of Theodore M. Lilienthal, 1957.199.26
Palace of Fine Arts, Gallery 32, wall D, no. 616

Charing Cross Bridge

Bertha E. Jaques

94 Bertha E. Jaques (American, 1863–1941)
Charing Cross Bridge, 1913
Etching
8½ × 11 in. (21.6 × 27.9 cm)
Mills College Art Museum, Oakland
Palace of Fine Arts, print cabinets, no. 6603

95 Donald Shaw MacLaughlin (American, b. Canada, 1876–1938)
Quai des Grands Augustins, Paris, 1906
Etching
9 × 13¾ in. (22.7 × 34.9 cm)
Fine Arts Museums of San Francisco, bequest of William M. Fitzhugh, 1957.188.60
Palace of Fine Arts, print cabinets, no. 6702

96 Joseph Pennell (American, ca. 1860–1926)
The End of the Day, Gatun Lock, 1912
Lithograph
22 ¼ × 16 ¾ in. (56.4 × 42.5 cm)
Fine Arts Museums of San Francisco, Achenbach Foundation for Graphic Arts, 1963.30.24086
Palace of Fine Arts, Gallery 31, wall B, no. 509

The Asphalters, Wabash Ave. Ralph M Pearson

97 Ralph Pearson (American, 1883–1958)
The Asphalters, Wabash Avenue, 1911
Etching with drypoint
10 ⅞ × 8 in. (27.6 × 20.3 cm)
Fine Arts Museums of San Francisco, gift of Dan London, 1954.148.9
Palace of Fine Arts, print cabinets, no. 6930

98　Bror Julius Olsson Nordfeldt (American, b. Sweden, 1878–1955)
Bridge Builders, Chicago, 1912
Etching and drypoint
9⅞ × 11⅞ in. (25.2 × 30.1 cm)
Fine Arts Museums of San Francisco, gift of Mrs. B. J. O. Nordfeldt, 1956.375.31
Palace of Fine Arts, print cabinets, no. 6848

99 Earl Horter (American, 1881–1940)
Smelters, Pittsburgh, ca. 1914
Etching
9 13/16 × 18 5/8 in. (25.3 × 47.4 cm)
Portland Art Museum, Portland, Oregon, gift of Heirs of Charles Francis Adams Collection:
Peter F. Adams, Mrs. Sandra Adams Beebe, and Charles Anthony Adams, 89.20.30
Palace of Fine Arts, print cabinets, no. 6554

John Sloan, 1906 –

100proofs John Sloan

100 John Sloan (American, 1871–1951)
Roofs, Summer Night, 1906, from the series *New York City Life*, 1905–1906
Etching
5¼ × 7 in. (13.3 × 17.8 cm)
Fine Arts Museums of San Francisco, museum purchase,
Achenbach Foundation for Graphic Arts Endowment Fund, 2015.4
Palace of Fine Arts, Gallery 32, wall D, no. 636

101 John Sloan (American, 1871–1951)
The Women's Page, 1905, from the series *New York City Life*, 1905–1906
Etching
5 × 7 in. (12.7 × 17.7 cm)
Herbert F. Johnson Museum of Art, Cornell University, Ithaca, New York, gift of Theodore B. Donson,
Class of 1960, 84.083.001
Palace of Fine Arts, print cabinets, no. 7218

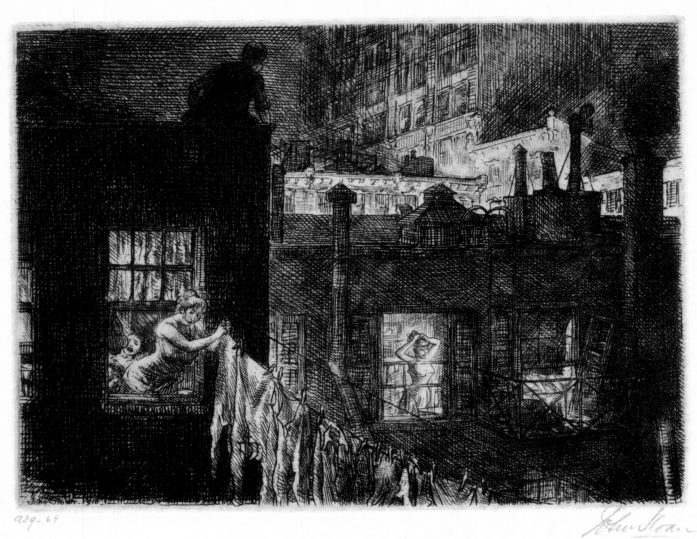

102 John Sloan (American, 1871–1951)
Night Windows, 1910
Etching
5 ⅜ × 7 in. (13.6 × 17.7 cm)
Library of Congress, Washington, DC, Prints and Photographs Division, FP-XIX-S634, no. 152 (A size)
Palace of Fine Arts, Gallery 32, wall D, no. 637

Monotype.

Perham W. Nahl.

103 Perham Wilhelm Nahl (American, 1869–1935)
Monterey Cypress, ca. 1914
Monotype printed in olive green ink
11 ⅛ × 9 in. (28.3 × 23 cm)
Portland Art Museum, Portland, Oregon, gift of Heirs of Charles Francis Adams Collection:
Peter F. Adams, Mrs. Sandra Adams Beebe, and Charles Anthony Adams, 89.20.107
Palace of Fine Arts, Gallery 33, wall D, no. 649

104　**Ernest Haskell** (American, 1876–1925)
Dwarfs of Ragged Island, 1912
Etching and engraving
6 ⅜ × 4 ¾ in. (16.1 × 11.9 cm)
Fine Arts Museums of San Francisco, Achenbach Foundation for Graphic Arts, 1963.30.25426
Palace of Fine Arts, Gallery 32, wall A, no. 539

105 Roi Partridge (American, 1888–1984)
White Butterfly, 1912
Etching
17 ½ × 10 ⅜ in. (44.3 × 26.4 cm)
Portland Art Museum, Portland, Oregon, gift of Heirs of Charles Francis Adams Collection:
Peter F. Adams, Mrs. Sandra Adams Beebe, and Charles Anthony Adams, 89.20.120
Palace of Fine Arts, Gallery 33, wall B, no. 692 (as G. Roy Partridge)

106 Roi Partridge (American, 1888–1984)
Dancing Water (Pont Neuf), 1911
Etching
12 ⅞ × 9 ⅜ in. (32.8 × 23.9 cm)
Fine Arts Museums of San Francisco, gift of Mrs. A. S. MacDonald, 42123
Palace of Fine Arts, Gallery 33, wall B, no. 690 (as G. Roy Partridge)

107 Roi Partridge (American, 1888–1984)
Early Morning, Notre Dame, 1912
Drypoint
12 ⅜ × 8 ¼ in. (32.1 × 20.9 cm)
Fine Arts Museums of San Francisco, gift of Henry D. Meyer, 1961.69.2
Palace of Fine Arts, print cabinets, no. 6908 (as G. Roy Partridge)

108 Arthur Wesley Dow (American, 1857–1922)
The Gap, ca. 1914
Color woodcut
4 ³⁄₁₆ × 7 in. (10.6 × 17.8 cm)
Portland Art Museum, Portland, Oregon, gift of Heirs of Charles Francis Adams Collection:
Peter F. Adams, Mrs. Sandra Adams Beebe, and Charles Anthony Adams, 89.20.64
Palace of Fine Arts, print cabinets, no. 6347

Summer Evening

Pedro J. Lemos

109 Pedro J. de Lemos (American, 1882–1954)
Summer Evening, ca. 1914
Soft-ground etching and color woodcut with hand coloring on Japanese paper
8 13/16 × 8 3/4 in. (22.7 × 22.3 cm)
Fine Arts Museums of San Francisco, California State Library long loan, L323.1966
Palace of Fine Arts, print cabinets, no. 6647 (as Pedro J. Lemos)

110 Bertha Lum (American, 1879–1954)
Rainy Twilight, 1905
Color woodcut on Japanese paper
6⅜ × 9½ in. (16.7 × 24.1 cm)
Fine Arts Museums of San Francisco, gift from the estate of Edward T. Houghton through
Mr. and Mrs. Edouard J. Bourbousson, 1962.77.19
Palace of Fine Arts, Gallery 34, wall A, no. 830

111 Elizabeth Colwell (American, 1881–1954)
Lake in Winter, ca. 1909
Color woodcut on Japanese paper
8⅛ × 10½ in. (20.6 × 26.6 cm)
Fine Arts Museums of San Francisco, California State Library long loan, L391.1966
Palace of Fine Arts, Gallery 34, wall B, no. 846

112 Helen Hyde (American, 1868–1919)
The Bath, 1905
Color woodcut on Japanese paper
16 ¼ × 10 ¼ in. (41.3 × 26 cm)
Fine Arts Museums of San Francisco, gift of Helen Hyde, 26320
Palace of Fine Arts, Gallery 34, wall B, no. 871

113 Bertha Lum (American, 1879–1954)
Tanabata, 1912–1913
Color woodcut on Japanese paper
15 ⅟₁₆ × 7 ⅛ in. (38.2 × 18.1 cm)
Fine Arts Museums of San Francisco, gift from the estate of Edward T. Houghton
through Mr. and Mrs. Edouard J. Bourbousson, 1962.77.39
Palace of Fine Arts, print cabinets, no. 6686

Edna Boies Hopkins

114 Edna Boies Hopkins (American, 1877–1937)
Zinnias, ca. 1908–1909
Color woodcut
10⅞ × 7⅜ in. (27.6 × 18.8 cm)
Library of Congress, Washington, DC, Prints and Photographs Division, FP-XX-H794.no.4 (B size)
Palace of Fine Arts, Gallery 34, wall D, no. 907

115 Margaret Jordan Patterson (American, b. Indonesia, 1867–1950)
The Swan, ca. 1914
Color woodcut
8 ¾ × 6 ¼ in. (22.2 × 15.9 cm)
Herbert F. Johnson Museum of Art, Cornell University, Ithaca, New York,
Bequest of William P. Chapman, Jr., Class of 1895, 62.2929
Palace of Fine Arts, Gallery 34, wall B, no. 862

116 Bror Julius Olsson Nordfeldt (American, b. Sweden, 1878–1955)
The Wave, Moonrise, 1906
Color woodcut on Japanese paper
9 ⅜ × 11 ⅛ in. (23.7 × 28.3 cm)
Fine Arts Museums of San Francisco, California State Library long loan, L118.1966
Palace of Fine Arts, print cabinets, no. 6869

117　Bror Julius Olsson Nordfeldt (American, b. Sweden, 1878–1955)
The Piano, 1906
Color woodcut on Japanese paper
8¼ × 10⅛ in. (20.8 × 25.6 cm)
Fine Arts Museums of San Francisco, gift of Elizabeth S. Tower, 1980.1.90
Palace of Fine Arts, Gallery 34, wall D, no. 902

118 Beatrice Sophia Levy (American, 1892–1974)
Song of Summer, 1914
Color etching and aquatint
14 × 10 in. (35.6 × 25.4 cm)
Portland Art Museum, Portland, Oregon, gift of Heirs of Charles Francis Adams Collection:
Peter F. Adams, Mrs. Sandra Adams Beebe, and Charles Anthony Adams, 89.20.118
Palace of Fine Arts, Gallery 34, wall D, no. 899

119　Maud Hunt Squire (American, 1873–ca. 1954)

Windy Day, 1907

Color aquatint

5⅞ × 5⅜ in. (15.1 × 13.8 cm)

Portland Art Museum, Portland, Oregon, gift of Heirs of Charles Francis Adams Collection:

Peter F. Adams, Mrs. Sandra Adams Beebe, and Charles Anthony Adams, 89.20.79

Palace of Fine Arts, print cabinets, no. 7241

120 **Anne W. Brigman** (American, 1869–1950)
The Soul of the Blasted Pine, 1906
Gelatin silver print
7 ⅜ × 9 ⅝ in. (19.4 × 24.4 cm)
Private collection
Palace of Liberal Arts, Block 7, Pictorial Photography Gallery, no. 54

121 Imogen Cunningham (American, 1883–1976)
Eve Repentant, 1910
Platinum print
10 ½ × 8 ¼ in. (26.7 × 21.1 cm)
Private collection
Palace of Liberal Arts, Block 7, Pictorial Photography Gallery, no. 25

122 William Edward Dassonville (American, 1879–1957)
Figure Study, ca. 1906
Platinum print
9 ¹¹⁄₁₆ × 7 ¹¹⁄₁₆ in. (24.6 × 19.5 cm)
The Wilson Centre for Photography, London, 97:5687
Palace of Liberal Arts, Block 7, Pictorial Photography Gallery, no. 63

123 Edward Weston (American, 1886–1958)
Carlota, 1914
Platinum print
9 ¼ × 6 ¼ in. (23.5 × 15.8 cm)
Collection of John J. Medveckis
Palace of Liberal Arts, Block 7, Pictorial Photography Gallery, no. 16

124　Clarence H. White (American, 1871–1925)
The Orchard, 1902
Platinum print
9½ × 7½ in. (24 × 19.1 cm)
Library of Congress, Washington, DC, Prints and Photographs Division, PH-White (C.), no. 15 (A size)
Palace of Liberal Arts, Block 7, Pictorial Photography Gallery, no. 111

125 Jane Reece (American, 1869–1961)
Maid o' the Sea, 1907
Platinum print
6 ¼ × 4 ⅜ in. (15.9 × 11.8 cm)
Dayton Art Institute, Ohio, gift of Miss Jane Reece, 1952.19.5
Palace of Liberal Arts, Block 7, Pictorial Photography Gallery, no. 142

126　Francis Bruguière (American, 1879–1945)
Machinery Hall, West Entrance, at Night, 1915
Gelatin silver print
13⁷⁄₁₆ × 10 ½ in. (34.2 × 26.7 cm)
Fine Arts Museums of San Francisco, gift of the Whitton Family to the Percy Gray Collection, 2012.75
Palace of Liberal Arts, Block 7, Pictorial Photography Gallery, no. 46

127　Alvin Langdon Coburn (American, 1882–1966)
Broadway at Night, ca. 1910
Photogravure
7 ⅞ × 5 ¾ in. (20.1 × 14.7 cm)
George Eastman House, Rochester, New York, bequest of the photographer, 1967:0144:0070
Palace of Liberal Arts, Block 7, Pictorial Photography Gallery, no. 120

128 Karl Struss (American, 1886–1981)
Columbia University, Night, 1910
Gum dichromate over platinum print, mercury-processed
9 ½ × 7 ⅜ in. (24 × 19.4 cm)
National Gallery of Art, Washington, DC, Horace W. Goldsmith Foundation through
Robert and Joyce Menschel, 2007.59.2
Palace of Liberal Arts, Block 7, Pictorial Photography Gallery, no. 125

129 Arthur D. Chapman (American, 1882–1956)
Diagonals (Christopher Street from the 8th Street Station of the Sixth Avenue El, New York), 1913
Platinum print
8 × 6 in. (20.5 × 15.4 cm)
Library of Congress, Washington, DC, Prints and Photographs Division, LL/15564
Palace of Liberal Arts, Block 7, Pictorial Photography Gallery, no. 132

130 Edward R. Dickson (American, b. Ecuador, 1880–1922)
Design in Nature, ca. 1913
Platinum print
7 × 5 in. (22.8 × 19.1 cm)
Library of Congress, Washington, DC, Prints and Photographs Division, PH-Dickson, no. 4 (A size)
Palace of Liberal Arts, Block 7, Pictorial Photography Gallery, no. 105

131 Willard E. Worden (American, 1868–1946)
Seal Rocks, ca. 1915
Sepia-toned gelatin silver print
13 ½ × 10 ½ in. (34.3 × 26.7 cm)
Collection of Susan Hill

132 Willard E. Worden (American, 1868–1946)
Poppies and Lupine, ca. 1915
Gelatin silver print with applied color
18 ⅜ × 14 ½ in. (46.5 × 37 cm)
Collection of Bonnie Bell

133 Willard E. Worden (American, 1868–1946)
Japanese Tea Garden, ca. 1915
Gelatin silver print with applied color
9 ½ × 7 in. (24.2 × 17.8 cm)
Jerry Bianchini Collection

THE FRENCH PAVILION
AND THE ANNEX

THE FRENCH PAVILION

Considering the fact that France was embroiled in the First World War, it is remarkable that the country managed to send a pavilion to the Panama-Pacific International Exposition (PPIE) in San Francisco in 1915. France was the only principal player in the European conflict to have a pavilion at the world's fair that year. Regarded as the leading display of foreign art at the PPIE, the French Pavilion was intended as a bastion of French culture and a symbol of Franco-American accord.[1] It would leave a tangible legacy to San Francisco in the form of a future museum, the California Palace of the Legion of Honor, built in 1924, which was inspired by the Pavilion and today houses some of the French works of art from the Exposition.

France initially withdrew its participation in the Exposition after the outbreak of war in July 1914. Even though Germany already had invaded French territory and was advancing on Paris, the government was persuaded to rethink its strategy by Captain Asher C. Baker, the fair's director of exhibits, who made a special journey to Paris in November 1914 to encourage France to send a significant selection of art for the PPIE, a plea further advocated by the American ambassador to France, Myron T. Herrick.[2] In an effort to sway the French, the Americans offered to send a naval cargo ship to bring back the French exhibits to the fair.

Support for participation in the Exposition also came from within the professional art world of France. A lengthy supplication by Léonce Bénédite, director of the Musée du Luxembourg (whose collections are now held by the Musée d'Orsay), encouraged the country's artistic participation in the fair. In a letter to a government minister (unnamed, but possibly Gaston Thomson, then minister of commerce, or the minister of fine arts) dated November 30, 1914, Bénédite entreated the government to send a pavilion, envisaging it executed with "*un éclat exceptionnel*" (an extraordinary brilliance) to promote the arts of France. He cited two main reasons that the project be realized: "to create an outlet for the French school of art through the sales of works of art thereby offering relief to artists who have been badly affected by the war"; and "to demonstrate the superiority of French culture, the importance of its school of painting, the solidity of its education, the continuity of its great traditions, the elevation of its principles" in order to counter German propaganda about its own cultural superiority.[3] This extensive plea, comprising eleven pages of densely handwritten text, outlined his plan for the French submission and offered up the collections of contemporary French art, notably Impressionism, from the Musée du Luxembourg for the Exposition.

Realizing the cultural importance and the propaganda value of showing French art and architecture in America, the French government eventually reconsidered, and by December 1914 it relented and approved moving forward with the project.[4] In January 1915, the USS *Jason* was sent to Marseille to pick up the French works of art destined for San Francisco.[5]

Due to these hesitations, the French Pavilion had to be designed and constructed very rapidly. The structure was built in nine weeks to the specifications of French architect Henri Guillaume, but the installation took much longer, and the Pavilion was not ready to be opened until June 1915, some months

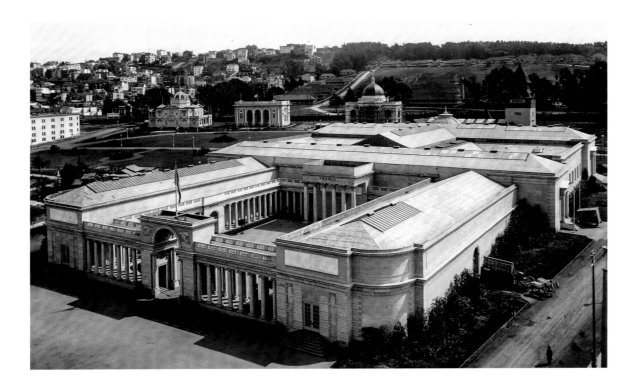

after the official opening of the Exposition on February 20.[6] The neoclassical architecture of the Pavilion, which was derived from the Palais de la Légion d'Honneur in Paris, would house a wide range of works representing the artistic creations of France, both old and new. These objects included paintings such as Édouard Manet's *The Balcony* (*Le balcon*) (fig. 149), the sculpture of Auguste Rodin, seventeenth-century Gobelins tapestries, and contemporary Sèvres porcelain. With the United States still neutral in the European conflict, it was important to the French government that France was well represented in California at a time when it was fighting a propaganda war with Germany for the goodwill of Americans.

The other main combatants of World War I—Germany, Austria-Hungary, Great Britain, and Russia—did not send official representations. According to an unflattering and inaccurate French report, the Italians relinquished their pavilion on the very day war was declared.[7] In reality, Italy was represented by an extensive pavilion situated on the Avenue of the Nations, with several buildings around a courtyard that exhibited Italian painting and sculpture. Although Britain was not represented by a pavilion, English artist Frank Brangwyn painted murals in the Court of Abundance (also called the Court of the Ages) that were well received.[8] A group of German paintings was included, shown both between the pavilions of the neutral countries Holland and Sweden and in the Annex.[9]

The French Pavilion was organized by that nation's Ministry of Commerce, Industry, Post, and Telegraphs. Once the French government decided to move forward with its representation, Albert Tirman (see fig. 164), who had been involved with the project as far back as 1913 as the commissioner-general for the French government's submission to the PPIE, was brought back from his

military post in the war to resume his position.[10] Tirman's office in the Ministry of Commerce was the "command post" for the Pavilion, and special letterhead was printed for its activities related to the PPIE. Jean Guiffrey, a curator at the Musée du Louvre, was appointed commissioner of fine arts. Guiffrey had spent three years (1911–1914) as a visiting curator of paintings at the Museum of Fine Arts in Boston and was, therefore, well suited for his role in the PPIE, which carried the substantial task of selecting works of fine and decorative art from France's national collections. The extensive historical sections of the Pavilion ultimately would include eighty paintings and sculptures from the Musée du Luxembourg, furniture from the Mobilier national, tapestries from the Gobelins national manufactory, and porcelain from the Sèvres national manufactory, all selected by Guiffrey to conform to what he felt were American tastes (for example, the large selection of Impressionist objects, which had proven appeal in the United States). Manufactured goods were exhibited *hors concours* (outside the competition for awards), as the war prevented many makers from participating.[11] For the contemporary section, Guiffrey invited artists to submit to a jury specially convened to choose the works for display at the fair; these works would be offered for sale during the exhibition in the Palace of Fine Arts. Additionally, Guiffrey's considerable responsibilities included selecting architecture from the Monuments Historiques and theater arts.[12] After the fair, he would remain involved in the touring exhibition of art from the French Pavilion to several venues around the United States, including the Panama-California Exposition of 1915–1916 in San Diego, and museums in Chicago, Buffalo, and Brooklyn.

The inspiration for the French Pavilion was the famous Palais de la Légion

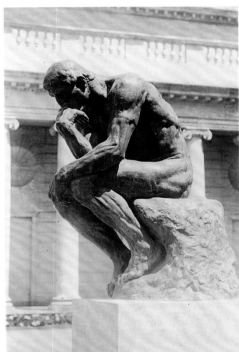

d'Honneur in Paris, which housed France's highest order of chivalry. This choice was perceived as a patriotic gesture, but the style of the building also conveyed the leading role that France took in the arena of classically inspired Beaux-Arts architecture, which was at its zenith in the decades bridging the nineteenth and twentieth centuries. Prominent in the cityscape of Paris, variations on this traditional classicism were being built in the United States (see Dreyfus, this volume) and throughout the world, from Madrid to Buenos Aires. The Légion d'Honneur, originally designed as the Hôtel de Salm by architect Pierre Rousseau between 1782 and 1787, represented the most refined and sober type of French neoclassicism, with colonnades and plain but elegant overall forms lightly decorated with low-relief sculpture. When it was recast as the French Pavilion, its restrained style and delicate proportions would stand in stark contrast to the monumental Roman classicism and Spanish Colonial revival style that characterized the main structures of the fair, in particular the enormous Palace of Fine Arts by Bay Area architect Bernard Maybeck, which was situated nearby (see Kastner, this volume).

Government architect Henri Guillaume was chosen as the designer of the Pavilion. He trained at the École des Beaux-Arts, later winning seven medals from that institution and receiving a government diploma, and his subsequent work mainly was confined to monuments. Guillaume certainly had a less stellar career than Maybeck, but his talent for faithful rendering suited the project. He had casts made of the architectural details of the Légion d'Honneur in Paris, which arrived in San Francisco on December 24, 1914. Undertaken by the Division of Works of the Exposition, the ensuing construction was completed in only nine weeks, a feat of which the French were particularly proud.[13] As

with the other buildings of the fair, the Pavilion was built of plaster staff around a wooden core.[14]

At the opening ceremonies for the Pavilion in March 1914, as Guiffrey related in his report, the French representatives were careful not to celebrate too openly, due to the dire wartime circumstances at home, and they left when the dancing started.[15] For the official dedication of the French Pavilion on April 9 (see fig. 134), PPIE president Charles C. Moore gave a speech in front of a large crowd in which he mentioned the deep and sympathetic feelings between the French and the American peoples. Although the building was complete, the installation of the exhibition was delayed due to the late arrival of the *Jason* in San Francisco on April 11. Additional weeks were consumed in the unpacking of the ship. Once unloaded, the packing cases were draped with French and American flags and transported across the fairgrounds to the Pavilion with great fanfare. The rules of the Exposition and extremely lengthy customs procedures meant that more than a month would elapse until the Pavilion finally opened to the public on June 6.[16]

Measuring more than sixty thousand square feet, the Pavilion was positioned on gently sloping ground, running back from the Avenue of the Nations behind the Palace of Fine Arts (see fig. 133). The rise in elevation had not been anticipated during the design stage in Paris, necessitating the addition of steps inside the main galleries. However, the celebrated entrance facade of a triumphal arch with colonnades, flanked by the wings of the building so difficult to see in Paris because of its location on a narrow street, appeared much more impressive at the fair, commanding a broad perspective in front of two large lawns.

Rodin's *The Thinker* was the centerpiece of the Court of Honor, set within a

FIG. 136
Entrance hall (Gallery 1) of the French Pavilion
showing the Joan of Arc tapestries and Alfred
Boucher's *La Gallia*, 1915. Photograph by Keystone
View Co. California History Room, California
State Library, Sacramento

FIG. 137
Gobelins tapestries and other works of art installed
in the Main Central Hall (Gallery 2) of the
French Pavilion with the rotunda in the distance,
1915. The Rotunda, viewed in the distance, is
depicted with red curtains rather than the blue
identified in contemporary descriptions. Hand-
colored photograph. Ackley Collection

FIG. 138
Auguste Rodin's *Saint John the Baptist Preaching*
and *The Age of Bronze* (pl. 135), which were later
added to the display in the Main Central Hall,
1915. San Francisco History Center, San Francisco
Public Library

peristyle of Ionic columns (see fig. 135). This over-life-size version of the model originally was cast in 1902 and received public acclaim when it was positioned outside the Panthéon in Paris in 1906. The interplay between Rodin's sculpture and the architecture of the Pavilion was much admired at the fair, and would be reiterated at the California Palace of the Legion of Honor.

Inside the Pavilion, long skylights illuminated the galleries, and the walls were hung with fabric. For the French fine arts section, traditional and modern paintings—with a core display of Impressionism—were displayed on green velvet walls that were framed with mahogany paneling (see fig. 141). In Guiffrey's eyes, due to the luxury of the decorations and the value and number of objects on display, the French installation outshone all other foreign pavilions at the fair.[17]

Throughout the Pavilion, works of art reflected a strong streak of patriotism that was appropriate for wartime without being too overwhelming. Prominently displayed in front of the main stairs was a patriotic allegory of modern France, the statue *La Gallia* (date and current location unknown) by Alfred Boucher, which depicted an armed figure wearing a helmet with the Gallic cockerel. There were four Joan of Arc tapestries, recent creations of the Gobelins factory, shown nearby. Woven after designs by the artist Jean-Paul Laurens, they illustrated the story of the Maid of Orleans, the French heroine of the Hundred Years' War (see pl. 134 and fig. 136). To complete the picture of the finest contemporary French products, modern Sèvres porcelain also was displayed in the main entrance.

The contemporary decorative arts from national manufactories shown in the entrance were balanced by historical art in the large central gallery that ran back from the entrance hall down the spine of the building.[18] In the central gallery

the installation was devoted to grand artistic achievements of the past. Four magnificent seventeenth-century Gobelins tapestries from a series on Alexander the Great, after designs by Charles Lebrun, hung on the walls, accompanied by impressive furniture and Savonnerie of the same period from French royal palaces lent by the Mobilier national in Paris (see fig. 137). From the collections at Versailles came modern reproductions of marble busts of such famous Frenchmen as Molière, Cardinal Richelieu, Jean-Baptiste Colbert, and Jean de La Fontaine that were displayed in concert with the tapestries. Contemporary art was introduced by way of four additional Rodin sculptures lent by San Francisco's Alma de Bretteville Spreckels, which included *The Age of Bronze* (pl. 135), *Saint John the Baptist Preaching* (see fig. 138), and *The Prodigal Son* (pl. 136), as well as in other sculptures from French collections.

The rotunda at the end of the main gallery reproduced the circular salon of the Légion d'Honneur in Paris to sumptuous effect. Echoing the French building's original furnishings that were supplied during the Napoleonic Empire, it was decorated with blue and gold hangings and furniture, as well as a round carpet bearing the sixteen divisions and emblems of the Légion d'Honneur. Playing into the French notion that Americans were fascinated by Napoléon, the installation featured autographed papers and letters from the emperor shown in vitrines.

Contemporary decorative arts were shown in a small room to the left of the rotunda (see fig. 139). Glass by Lalique, including a mirror belonging to the queen of England, dominated the displays, along with other glass by makers Marinot and Delaherche. Precious objets d'art in enamel, silver, gold, and gemstones represented the luxury trades of Paris. To these objects were added

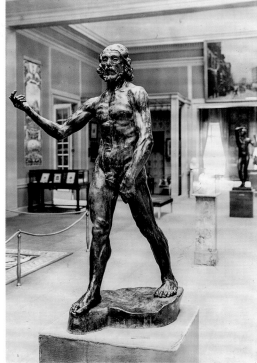

bookbindings, illuminated parchments, and silk embroideries. Although there were electric lamps in bronze by the metalworker Edgar Brandt, none of the views of the interiors of the French Pavilion show evidence of electric lighting, and it is known that difficulties in installing lighting caused delays in the theatrical exhibits (see below). The gallery also included sculpture by Albert Bartholomé, drawings by Maurice Denis (who also painted a frieze in the Palace of Fine Arts), and drawings for stained-glass windows by Suzanne Lalique. A retrospective exhibition of French art from 1870 to 1910 occupied the two following rooms, Galleries 5 and 6 (see Buron, this volume). The Pavilion's principal exhibition, it contained significant nineteenth-century French paintings from the Musée du Luxembourg. These works included Manet's *The Balcony*, one of many depictions of Rouen Cathedral by Claude Monet (pl. 144), *The Gulf of Marseille from L'Estaque* (*Le golfe de Marseille vu de l'Estaque*), by Paul Cézanne (pl. 141), *Jason*, by Gustave Moreau (1865; Musée d'Orsay), and particularly relevant due to its overt reference to war, *Hope* (*L'espérance*), by Pierre Puvis de Chavannes (fig. 151).

The remaining galleries of the French Pavilion were more diverse. An exhibit in one room concerned the urban planning and infrastructure of Paris. Two large rooms offered antique and modern furniture and decorative arts, probably to promote the manufacturers or to be sold, described as Artistic Furniture and Furnishings. There were medals and portraits of the great men of France, a group of lithographs, and an architectural exhibit with drawings and plans from the Monuments Historiques shown alongside another painting by Monet of Rouen Cathedral and Paul César Helleu's painting of the interior of the Cathedral at Reims. As remarked by Neuhaus, some of the displays were arranged more for

beauty than for chronology.[19] An entire room was set aside for memorabilia associated with the writers of the Romantic school, including reproductions of the hands of Victor Hugo and Alexandre Dumas, and a sketch of a statue dedicated to Honoré Balzac. To promote tourism, there were dioramas of picturesque France: views of Marseille, Mont Saint-Michel, Chartres Cathedral, and Paris. A very popular display devoted to dressmakers and milliners occupied the two large rooms flanking the entrance hall. The theater arts section, the opening of which was delayed because of a problem installing the electric lighting,[20] included sketches of costumes, theatrical figures, and a series of illuminated dioramas of famous French plays.

The final section of the Pavilion was given to displays of art from Belgium, which was generally perceived in the United States as a heroic underdog overrun by a belligerent Germany early in the war. Generously hosted by France, the Belgian section of the Pavilion measured more than six thousand square feet, and consisted of two galleries and a dedicated entrance. Of the two galleries, one was devoted to Belgian paintings, sculpture, and antique lace, with busts of the Belgian king and queen, while the other contained models of Belgian towns, including a sixty-foot-long rendition of the port of Antwerp.

The aims of the French Pavilion, as voiced by Léonce Bénédite, were undeniably achieved: the art exhibited, especially painting, was much admired, and the Pavilion generally was viewed as the finest of the national buildings.[21] Franco-American relations were reinforced, as Guiffrey concluded in his report on the Pavilion: "The exposition at San Francisco has contributed to expanding the idea of France in the minds of Americans, of its vitality, its strength, of

FIG. 139
Contemporary decorative arts in Gallery 4 of the
French Pavilion, 1915. Photograph by Cardinell-
Vincent Co. San Francisco History Center, San
Francisco Public Library

its genius, in order to fortify the love and sympathy that has always existed between these two great nations."[22]

The ultimate legacy of the French Pavilion lies in the California Palace of the Legion of Honor museum, which opened as a memorial to the Californian war dead on Armistice Day, November 11, 1924 (see fig. 172). Alma de Bretteville Spreckels, with her husband, Adolph, had already been thinking about building a museum for the city of San Francisco before the Exposition, and she was so impressed by the simple classicism of the Pavilion that she chose it as the model for her new museum. Its almost austere elevations were suitable for the purposes of a war memorial as well as a museum. Its simplicity also suited the rising tenets of modernism. The setting of the new museum was, however, far removed from the cramped urban streetscape of the original Palais de la Légion d'Honneur in Paris. Like the French Pavilion, the Legion of Honor was positioned within a parklike landscape that gave the structure a new emphasis and greater importance within its surroundings (see fig. 133).

The Legion was intended largely as a showcase for French art, and some of the objects in its founding collection derived from the PPIE. The French government contributed the Joan of Arc tapestries designed by J. P. Laurens and manufactured by the Gobelins workshops, as a well as a large group of Sèvres porcelain. The tapestries had been shown alongside Sèvres products at the entrance to the French Pavilion; however, the selection of porcelain given to the Legion was entirely different from that shown in 1915. It was a larger and more modern group chosen by the French government specifically to represent that nation's decorative arts and the national manufactory in San Francisco.

The group of Rodin sculptures lent by Mrs. Spreckels to the PPIE—as well as additional pieces she selected purposefully for the museum in the succeeding years—were part of her legacy to the Legion and to San Francisco. She had first met Rodin on a 1914 trip to France, where she was introduced to him by the American dancer Loïe Fuller. With Fuller acting as a broker, Mrs. Spreckels became one of the principal American patrons of Rodin in the last years of the sculptor's life. Although she was not part of the Woman's Board of the PPIE, Mrs. Spreckels was determined to play a part in the Exposition—and ultimately to be recognized as a leading figure in the city. She effected this ambition through the loan of her Rodins to the French Pavilion. The display of the artist's works at the PPIE was a revelation to some viewers, and Rodin was recognized as the father of modern sculpture.[23]

The Rodin sculptures, fittingly, remain a core of the collections of the Legion of Honor. *The Age of Bronze*, *Saint John the Baptist Preaching*, and *The Prodigal Son* are still shown along the central axis of the Legion, as they were in the French Pavilion. Rodin's *The Thinker* was placed at the Legion in nearly the same spot where it had been situated at the Pavilion—at the center of the Court of Honor. The 1924 opening ceremonies for the new museum, which were attended by Albert Tirman and Jean Guiffrey, were held around the sculpture. *The Thinker* thus became a centerpiece of the museum, reiterating the connection between the art and the architecture that had been established at the fair. It has remained an icon of the Legion of Honor ever since.

1. See Eugen Neuhaus, "France," in *The Galleries of the Exposition: A Critical Review of the Paintings, Statuary and the Graphic Arts in the Palace of Fine Arts at the Panama-Pacific International Exposition* (San Francisco: Paul Elder, 1915).

2. John D. Barry, "An Emissary to France and Italy," in *The City of Domes: A Walk with an Architect about the Courts and Palaces of the Panama-Pacific International Exposition with a Discussion of Its Architecture, Its Sculpture, Its Mural Decorations, Its Coloring, and Its Lighting, Preceded by a History of Its Growth* (San Francisco: John J. Newbegin, 1915). The prominent presence of such business interests in San Francisco as Lazard Frères bank and the City of Paris department store also may have influenced the decision.

3. Léonce Bénédite to an unnamed French government official, November 30, 1914, LIIX, Archives des musées nationaux, Paris.

4. Bernice Scharlach, *Big Alma: San Francisco's Alma Spreckels* (San Francisco: Scottwall, 1990), 67. According to Scharlach, PPIE president Charles C. Moore made "a surprise visit to M. Albert Tirman [commissioner-general of France]" in 1914.

5. Also known as "the Christmas ship," on its outbound journey, the *Jason* brought Christmas toys and clothing to European children affected by the war.

6. This history is outlined in "Exposition de San Francisco," F/21/4074, Archives nationales, Paris.

7. Report on the fair, n.d., Secretariat d'État des beaux-arts, Office de la propagande, correspondance générale, F/21/4074, Archives nationales, Paris.

8. See Stella G. S. Perry, *The Sculpture and Mural Decorations of the Exposition* (San Francisco: Paul Elder, 1915), n.p.; Eugen Neuhaus, "Mural Decorations," in *The Art of the Exposition: Personal Impressions of the Architecture, Sculpture, Mural Decorations, Color Scheme and Other Aesthetic Aspects of the Panama-Pacific International Exposition* (San Francisco: Paul Elder, 1915); and Barry, "The Brangwyns," in *City of Domes*.

9. See Neuhaus, "Germany," in *Galleries of the Exposition*. Neuhaus's Germanic heritage may have encouraged him to include this citation, whereas he omits mention of the British or Russian art shown at the fair.

10. Barry, "An Emissary to France and Italy," in *City of Domes*.

11. Frank Morton Todd, *The Story of the Exposition: Being the Official History of the International Celebration Held at San Francisco in 1915 to Commemorate the Discovery of the Pacific Ocean and the Construction of the Panama Canal* (New York: G. P. Putnam's Sons, 1921) 219. The French government requested that French manufacturers be considered out of contention for awards because many of them, even those not located in invaded territory, were too embarrassed by their wartime circumstances to make exhibits, and it was deemed unfair to allow their competitors the advantages that would be achieved by advertising any awards that resulted from such an unfair contest. For this reason, no prizes or medals were awarded to French exhibitors at the PPIE.

12. Report on the fair, F/21/4074, Archives nationales, Paris.

13. Barry, "An Emissary to France and Italy."

14. Ibid. According to Todd, the building cost around $100,000. Todd, *Story of the Exhibition*, 220.

15. Jean Guiffrey, report on the fair addressed to a French minister [Gaston Thomson, minister of commerce?], [June 1914?], correspondance générale, F/21/4075, Archives nationales, Paris.

16. Ibid.

17. Ibid.

18. Much of the following description of the works of arts shown in the French Pavilion is derived from Marie Soulas, *The French Pavilion and Its Contents* (San Francisco: Pernau, 1915).

19. Neuhaus, "France," in *Galleries of the Exposition*.

20. Guiffrey, report on the fair.

21. Neuhaus was less impressed: "France, unfortunately, does not rise above the commonplace, in an extensive building hastily constructed." Neuhaus, *Art of the Exposition*, 25.

22. Guiffrey, report on the fair.

23. "Fine as is the exhibit in the French section of the Palace of Fine Arts, the best pictures and sculptures are shown here. In the Court of Honor stands the masterpiece of the master sculptor of modern times, 'The Thinker,' by Auguste Rodin. In the galleries are his 'John the Baptist' and other important bronzes." Ben Macomber, "The French Pavilion," in *The Jewel City: Its Planning; Its Architecture, Sculpture, Symbolism; Its Gardens, Palaces, and Exhibits* (San Francisco: John H. Williams, 1915).

MELISSA E. BURON

FRENCH PAINTINGS AT THE EXPOSITION: A TRIUMPH OF DIPLOMACY

The Panama-Pacific International Exposition may be considered a world university for 1915 . . . [and] the world at large the student body.[1]

INTRODUCTION

The French participation in San Francisco's Panama-Pacific International Exposition (PPIE) of 1915 represented a cultural and diplomatic triumph. As World War I spread throughout Europe that year, French government officials organized a representative collection in a matter of months that demonstrated the country's overall distinction in the fine arts and, in particular, the pervasive influence of Impressionism. Although their reception of individual works was varied, critics unfailingly commended the French Commission and the American PPIE officials for their determination and resilience in bringing the presentation of French art to fruition.

The account of how these loans arrived in San Francisco from war-torn Europe provides a glimpse into the tenacity and ingenuity of the PPIE representatives on both sides of the Atlantic. As plans for the Exposition accelerated during the summer of 1914, declarations of war by several European countries initially presented a devastating setback to the American organizers, especially John E. D. Trask, director of the PPIE's Department of Fine Arts, who aimed for a substantial international display.[2] The American artist Elizabeth Nourse, who lived in Paris at the time, captured that city's atmosphere in her diary entry from August 18, 1914, "No one talks of anything but the war, even one dreams of war."[3] Ultimately, with much of the continent in turmoil, convincing the

French government to participate in the fair proved challenging.

One major obstacle to the French government's involvement in the PPIE was its preoccupation with safeguarding the priceless collections in Parisian art museums. As *American Art News* reported in September 1914, "Few of the thousands of artists and art lovers who have been wont to visit the Louvre daily . . . would recognize their haunt now. . . . The 'Winged Victory' is sheltered behind heavy iron plates [and] . . . the upper stories of the Louvre . . . have been turned into hospitals."[4] Many paintings and statues from the Musée du Luxembourg along with treasures from other public and private galleries were removed from display and hidden underground, or secured behind protective screens for safety. The prospect of French participation in the fair was unlikely with the locations and security of so many works of art in flux.

Undeterred, however, the PPIE art directors optimistically believed that this unstable atmosphere might actually improve their chances of borrowing French art. In his Exposition guide, *The City of Domes*, the critic John D. Barry explained: "It was thought that many of the Europeans would be glad to send their collections to this country for safe keeping during the war time."[5] Unfortunately, this was not the case. As Barry clarified, "a good deal of concern was felt about sending the treasures on so long a journey, subject to the hazards of attack by sea. Furthermore, from the European point of view, San Francisco seemed far away."[6] Given the country's focus on the war and concerns about the safety of its national treasures, it seemed impossible that France would contribute to the PPIE. To prevent this significant absence, the fair's Department of Fine

Arts sent special envoys to negotiate with European officials on their behalf.

Captain Asher C. Baker, director of the Division of Exhibits, arrived in France in early November 1914, just months before the PPIE was set to open in February 1915.[7] He was met with a very discouraging state of affairs: not only were French art loans to the international section of the Palace of Fine Arts in jeopardy, but the possibility of a French government–sponsored pavilion also appeared improbable. In response to Baker's plea for a French presence, the initial reply from an unnamed official was that "under the circumstances, any participation of France whatsoever was out of the question: France was in mourning, and did not wish to celebrate anything."[8] Undaunted, Baker sought the support of the US ambassador to France, Myron T. Herrick. With Herrick's backing, Baker engaged Albert Tirman, the commissioner-general of the French Commission to the PPIE, the government-appointed organizational body responsible for the country's representation at the fair. Tirman had been part of the original delegation that visited San Francisco in 1913 to select the site for the French Pavilion (see fig. 164). Together with Tirman, Baker appealed to Gaston Thomson, the French minister of commerce, maintaining that "without France, an Exposition could not be international, and that the participation of France at this time, with her flag flying in San Francisco, would be like winning a battle before the world."[9] Although the United States was still officially neutral regarding the European conflict, Baker maintained that French presence at the PPIE "would show the people of the United States France's gratitude for the money sent [to] the wounded and the suffering, and would warm the hearts of the American people."[10]

Léonce Bénédite, curator and director of the Musée du Luxembourg, who was hailed in the PPIE's official catalogue as "one of the most eminent of living French critics and connoisseurs of art," also played an important part in convincing the government that France should take part in the Exposition.[11] On November 30, 1914, he wrote a long letter an unnamed minister of France (possibly Albert Dalimier, undersecretary of state for fine arts, or the minister of commerce) that justified the diplomatic significance of the country's contributions to the fair and the economic opportunity it would give contemporary French artists who could offer their works for sale there.[12] These petitions on political, cultural, and economic grounds, from both American and French advocates such as Baker and Bénédite, hit the intended target and ultimately secured French involvement in the Exposition.

With France confirmed as a participating country, Jean Guiffrey carried out his duties as commissioner of fine arts for the PPIE. His responsibilities included soliciting artists' submissions for the section of French contemporary loans in the Palace of Fine Arts, chairing the selection jury for those objects, and curating the retrospective section of the French Pavilion and the historical loan section of the Palace.[13] Guiffrey's pedigree in the hierarchy of the French art world is noteworthy in light of his immense responsibility and prominent position at the PPIE: he was the son of the eminent art historian Jules Guiffrey, who founded the Société de l'histoire de l'art français. Jean was granted a leave of absence from his post as an assistant curator at the Louvre after he was appointed to a three-year term as curator of paintings at the Museum of Fine Arts (MFA), Boston, in 1911.[14] When his tenure ended on April 1, 1914, the MFA's trustees warmly recognized that "M. Guiffrey brought to this position wide knowledge and keen appreciation of art as well

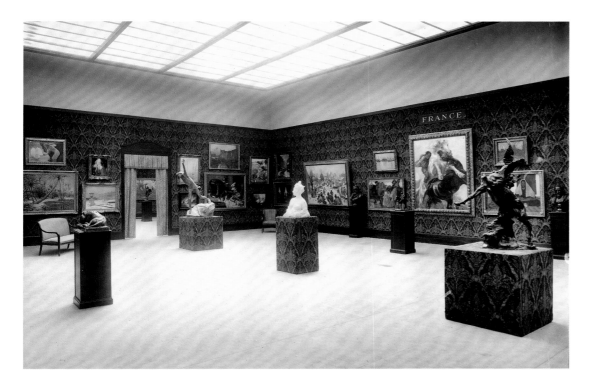

FIG. 140
Exposition officials visit the USS *Jason* on
April 15, 1915, four days after its arrival in San
Francisco. Photograph by Cardinell-Vincent Co.
San Francisco History Center, San Francisco
Public Library

FIG. 141
Gallery 17 in the French section in the Palace of
Fine Arts, 1915. Photograph by Gabriel Moulin.
San Francisco History Center, San Francisco
Public Library

as the practical wisdom essential to make that knowledge and appreciation effective."[15] These attributes and experiences ably prepared him to shepherd French loans for the PPIE. He hoped that these works of art would help to nurture in the minds of Americans the idea of France—its vitality, its strength, its genius—and to further strengthen the friendship and sympathy that long existed between these two great peoples.[16]

Since the French commissioners had delayed confirming their participation in the Exposition until late 1914, they were behind schedule for its official opening on February 20, 1915. With just a few months to prepare as the countdown to the PPIE's inaugural day drew closer, they hastily arranged loans from museums, dealers, collectors, and artists. Soliciting works from the latter was complicated by the absence of many artists who had enlisted for military service or had left the country. *American Art News* reported that "the change in art life due to the war is incalculable. . . . The Louvre, the [Musée de] Luxembourg and other museums are closed. . . . Ninety percent of the French artists are at the front, and thousands of artists of other nationalities have disappeared."[17] However, submissions from contemporary artists such as Bernard Boutet de Monvel, who enlisted in 1914, were ultimately secured even with this substantial hurdle. With the scarcity of artists and an abbreviated time frame for their selection process, the Commission cast a wide net by mailing invitations to artists via organizations to which they belonged, such as the Société des artistes français, the Société du Salon d'Automne, and the Société nationale des beaux-arts.[18] On November 28, 1914, Albert Dalimier, France's undersecretary of state for Fine Arts, invited artists "to present one or two of your works that you consider particularly representative of your talent."[19] According to the Commission, these

would be offered for sale at the Exposition, enabling artists to reap the material satisfactions they deserved despite the contemporary European political and economic instability.

France's neighbor Belgium, which was occupied by Germany and unable to present its own pavilion, encountered similar problems in gathering works of art. According to the essay "Belgian Painters at San Francisco" in the PPIE's *Belgium Catalogue*, "Great difficulties were experienced in collecting these [loans]. Our country was suddenly invaded and most of our artists had deserted their studios. It became necessary to seek works of Belgian art in foreign lands in order to fill the space which the French Government . . . has generously put at their disposal in the galleries of the French Pavilion."[20] One such example was Théo van Rysselberghe's painting *Garden of the Generalife in Granada* (pl. 146), which was lent by the artist's Parisian dealer.

Once loans were secured, plans to secretly transport the artworks to San Francisco from France, Belgium, Britain, and other European participants were devised by an advisory committee that included American artists Joseph Pennell and John Singer Sargent.[21] Pennell, "buccaneerish with pleasure," later regaled a *New York Times* journalist with his role in the clandestine endeavor, which was undertaken with as little publicity as possible.[22] The US Navy collier *Jason*, which had departed from New York on November 14, 1914, to deliver Christmas presents for children in the European war zones, was repurposed for its return to the United States as a floating storehouse of priceless paintings, sculptures, and tapestries.[23] Treasures from French museums, collectors, and the government were loaded at the port of Marseille along with Belgian art and loans from American artists living in France. Pennell stated, "the greatest secrecy

had to be preserved as to the itinerary of the *Jason*, and the dates of her sailing from any of the ports which she touched, for, with her cargo of art works she would have been a rich prize for the Germans, whose torpedoes and submarines she has luckily escaped." [24] Despite a few close calls, the "Christmas Ship" *Jason* avoided detainment or attack in the open waters. The *Jason* inspired legions of admirers, including Mabel Collyer of San Francisco, who commemorated the expedition in poetry:

> This is the good ship *Jason*! Hail!
> Laden with Golden store!
> Under the Stars and Stripes we sail
> On quest of peace—not war! [25]

Although the *Jason*'s return voyage, which brought art to the PPIE, was a more covert affair than its initial crossing to deliver presents, the sentiments expressed in Collyer's celebratory words apply perfectly to either assignment.

The *Jason* arrived in San Francisco on April 11, 1915, via the Panama Canal—an appropriate route given its destination to an exposition celebrating the canal itself. [26] Despite the country's perilous wartime circumstances, according to Pennell, "The French Government . . . insist[ed] on paying the cost of transportation for its own collection and that of Belgian treasures to the port of Marseille. . . . France may be fighting for her life but she believes in helping along the cause of art." [27] When the shipments were unloaded in San Francisco on April 16, 1915, Exposition dignitaries gathered to receive the cargo at the ferry slip (see fig. 140). [28] Fittingly, among those present to mark the occasion "in solemn ceremony and with due regard to the significance of the occasion"

were Commissioner-General Tirman and his staff, and Captain Baker, whose combined diplomatic efforts secured these loans for the public's enjoyment and education in San Francisco. [29]

The appeals for European art loans were so successful that rather than lacking enough art, as was once feared, there were more objects than the Palace of Fine Arts could accommodate, necessitating the addition of a Fine Arts Annex for the overflow (see Ganz, Introduction, this volume). [30] Barry credited the uncertainty over conflict in Europe for this unexpected advantageous outcome, stating, "The Fine Arts Department is now making a better showing than it could have made if there had been no war. American collectors, with rare canvases, were persuaded to help in the meeting of the emergency by lending work that, otherwise, they would have kept at home." [31] French works from American private collections, dealers, and museums supplemented those lent to the Exposition by the government, dealers, collectors, and artists of France.

The approximately nineteen million visitors to the PPIE saw the abundance of French art in two locations that offered distinct aesthetic experiences: the galleries of the Palace of Fine Arts, at the western edge of the Exposition grounds, and the French Pavilion, near the Palace, off of the Avenue of the Nations (see fig. 158). The Palace's international galleries were labyrinthine and seemingly endless. Trask and his colleagues had approved loans that demonstrated contemporary trends in France as well as the influence of Gallic aesthetic achievements on American artists. The Pavilion's galleries, meanwhile, were under the control of the French Commission. They were more intimate and presented a retrospective display of exhibits, including French furniture, sculptures, tapestries, and paintings from 1870 through 1910.

FIG. 142
Pascal Adolphe Jean Dagnan-Bouveret (French, 1852–1929), *Consolatrix Afflictorum*, 1899. Oil on canvas, 88 × 77 in. (223.5 × 195.6 cm). Frick Art and Historical Center, Pittsburgh

FIG. 143
Pierre-Auguste Renoir (French, 1841–1919), *Garden in the Rue Cortot, Montmartre*, 1876. Oil on canvas, 60 ¾ × 35 in. (154.3 × 88.9 cm). Carnegie Museum of Art, Pittsburgh, Acquired through the generosity of Mrs. Alan M. Scaife, 65.35

FIG. 144
Claude Monet (French, 1840–1926), *Garden at Sainte-Adresse*, 1867. Oil on canvas, 38 ⅜ × 51 ⅛ in. (98.1 × 129.9 cm). The Metropolitan Museum of Art, New York, Purchase, special contributions and funds given or bequeathed by friends of the Museum, 1967, 67.241

THE PALACE OF FINE ARTS

Go slowly, study thoroughly what you study, and keep an open mind—
for that way leads to the widest enjoyment.[32]

At the Palace of Fine Arts, French paintings were featured in galleries devoted to contemporary French art (Galleries 11–18) and also were interspersed with works from other nations in the historical loan galleries (Galleries 61–63 and 91–92), which highlighted noteworthy artists from abroad who inspired American artists (see photo, fig. 141, and floor plan, fig. 159). According to Trask, the Palace offered "a loan collection of works of the artists of all times and all schools which have influenced our own [American] development . . . [for visitors to] appreciate and understand the American artists of our own day . . . [and allowing] the artist of today opportunity for the study of his own work in comparison with the work of all the world."[33] Among the thousands of attractions in the Palace, approximately three hundred French paintings were on view in Galleries 11–18 alone. Critics recognized that this vast expanse of art could overwhelm visitors, as Sheldon Cheney warned in his *Art-Lover's Guide to the Exposition*: "Do not visit the Fine Arts exhibits blindly, without knowing what they are aimed to show; and do not try to see the whole exhibition in one day. First understand the scope and arrangement of the displays, and then follow some definite system by which you are sure to get the best out of each individual section. It is better to see one part thoroughly than to carry away a confused impression of the whole."[34]

The French paintings displayed at the Palace of Fine Arts highlighted the breadth of nineteenth-century painting styles from that country as well as their influence on American artists. The galleries also featured a section devoted to French paintings from American collections. The Carnegie Institute, Pittsburgh, lent *A Vision of Antiquity—Symbol of Form* (pl. 142), by Pierre Puvis de Chavannes, a classically inspired painting exhibited at the Paris Exposition Universelle of 1889. Puvis's work had a profound effect on American muralists, including Arthur Frank Mathews and Frank Vincent DuMond, who were both represented on the Exposition grounds (see Lee, this volume). Among the extensive loans from the Buffalo Fine Arts Academy was James Tissot's *L'ambitieuse* (*The Political Woman*) (pl. 138), from his *La femme à Paris* series depicting fashionable Parisian women. *L'ambitieuse* was an important addition to the historical rooms since the artist William Merritt Chase, who was honored with his own gallery in the American section, had owned the painting previously. Oregonian C. E. S. Wood, an artist, collector, and member of the Fine Arts Department's advisory committee for the West, lent *The Violoncellist* (pl. 137), a Realist work by Gustave Courbet. A nearby gallery featured Jean-François Millet's *Study for "Mercury Leading the Cows of Argus to Water"* (1846–1848, Los Angeles County Museum of Art), a landscape typical of the Barbizon school style, from the collection of Mr. and Mrs. Allan C. Balch.[35] *Consolatrix Afflictorum* (fig. 142), Pascal Adolphe Jean Dagnan-Bouveret's composition based on a theme of religious mysticism, was similarly lent by a wealthy industrialist, the distinguished art patron Henry Clay Frick.[36]

French dealers were another important source of noteworthy loans to the Palace of Fine Arts, and their Impressionist and Post-Impressionist paintings represented a special attraction for visitors. The Parisian Galerie Bernheim-Jeune's contributions included *The Dining Room in the Country* by Pierre Bonnard (1913, Minneapolis Institute of Arts).[37] Galerie Durand-Ruel, an early and leading

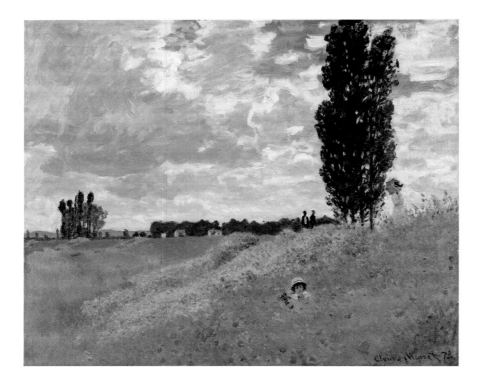

promoter of the Impressionists, also lent a number of canvases, including one of Pierre-Auguste Renoir's key landscape paintings of the 1870s, the ambitiously scaled and brilliantly colored *Garden in the Rue Cortot, Montmartre* (fig. 143), as well as Camille Pissarro's *Houses at Bougival (Autumn)* (pl. 139). Cheney described the particular significance of the Impressionist paintings in the Palace:

> But the most important distinction, for the student of contemporary tendencies, is that which concerns the term "Impressionism." . . . Impressionism has had more effect on the current of art than has any other movement in history. Not only in the handling of light and in freshness of coloring has the whole of painting been profoundly changed, but there is a general tendency to paint the impression rather than the actuality, the harmonious effect rather than the literal fact.[38]

Cheney's point was illustrated by the wall of seven paintings by Claude Monet in Gallery 61, which included *Garden at Sainte-Adresse* (fig. 144), *Walk in the Meadows at Argenteuil* (fig. 145), and *Grainstack at Sunset, Winter* (fig. 146), all lent anonymously by Galerie Durand-Ruel.[39] According to Eugen Neuhaus, a painter and UC Berkeley professor who served as chairman of the Fine Arts Department's advisory committee for the West and as a member of its International Jury of Awards, this room was a "delightfully refreshing gallery," characterized by the aesthetic philosophy, "More light and plenty of it!"[40] Cheney, on the other hand, commented that the works by Monet, the "greatest apostle of Impressionism," were "uneven," but, nonetheless, "should be studied thoroughly" for their demonstration of the Impressionist technique, since "no other group will be referenced to so often in connection

with the American galleries."[41] Despite his ambivalence about the Monet selection, Cheney's assessment of Impressionism's significance in relation to contemporary American painting cannot be understated: his commentary on the successive American galleries consistently highlights works by such artists as Ernest Lawson and Julian Alden Weir that confirm the influence of Impressionism, especially that of Monet.[42] Demonstrating this point most specifically were the many paintings on view by Americans—including, for example, Theodore Robinson (see pl. 52)—who lived among the expatriate community concentrated near Monet's home at Giverny, France.[43] These comments by Neuhaus and Cheney reiterate the special regard critics held for Impressionism and the affinities they identified between French paintings and their American counterparts.

The Palace's selection of Impressionist works also was highlighted in Barry's highly descriptive *The Palace of Fine Arts and the French and Italian Pavilions*, which details the author's tour of the PPIE with an unidentified artist. Like Cheney, Barry emphasized the influence of the Impressionists—and not just on American artists:

> As we go through the Exposition we shall find that nearly all the work done during the past twenty-five years, whether it is impressionistic or not, has been influenced by Monet and Manet and their school. . . . The impressionists opened up an entirely new field of art, and, in so doing, they opened up a new field of beauty in the world. They made us see beauty where we had been unaware of it before, or only partly aware. They showed us that, just as music was the poetry of sound, painting was the poetry of sight.[44]

Evincing their own enthusiasm for the movement, Barry credits his own zeal for Impressionism and that of his companion as a motivating factor in visiting the French section of the Palace.[45]

Despite the unprecedented scale of Impressionist works displayed in the Palace of Fine Arts, and in the French Pavilion when it finally opened, the PPIE arguably was not the first exposure to this style of painting for many Californians. In the 1890s, the San Francisco gallery Vickery, Atkins and Torrey organized exhibitions that were supported with loans from such local philanthropists as Mrs. William H. (Ethel) Crocker, the pioneering California collector of French Impressionist art.[46] Paintings by Monet, Pissarro, Renoir, and Alfred Sisley also were on view in the Fine Arts Building at the California Midwinter International Exposition of 1894.[47] Some affluent Californians and enterprising artists from the state even visited Paris and the expatriate community around Giverny, where they would have encountered both French and American Impressionists and their work.[48] However, the PPIE was undeniably the first opportunity on the West Coast to see a dense gathering of paintings that suggested affinities between French artists and their American and international counterparts, thus supporting the Exposition's aim to create a "world university."

Although critics generally approved of the Impressionists, the contemporary French painting galleries (Galleries 11–18) received more mixed reviews. These rooms displayed a mélange of pictures and sculptures, including works by Jacques-Émile Blanche, Lucien Simon, and Odilon Redon among a vast array of other artists whose names are more obscure today.[49] Of special interest were paintings lent directly by the artists, such as André Édouard Devambez's *The Charge* (*Le charge*) (pl. 145).[50] This dramatic aerial view of a violent nighttime riot in Paris provides a fascinating contrast with the more bucolic imagery typical of the Impressionists. Moreover, this painting echoed the anarchic subject matter in works by the Italian Futurists that were on display in the nearby Annex.

Overall, Neuhaus praised the Palace's French section for the "very desirable spaciousness in the hanging of the pictures," but explained that "there is no chronological succession in evidence in the hanging . . . of this section, and old and new, conservative and radical, are hung together with no other consideration than harmonious ensemble."[51] Although he applauded the organization of these rooms, the critic remarked that they culminated in a small gallery, which especially offended his aesthetic taste:

> The last and smallest of the French galleries [Gallery 13] is given over to some recent phases of French art. After looking at the serious work of the French in the other galleries, a first-hand acquaintance with this medley of newest pictures is hardly satisfactory. There is a feeling of affected primitiveness about most of them, particularly in a small canvas of a bouquet of flowers in a green vase, which is the acme of absurdity. If Odilon Redon wanted to be trivial, he has achieved something quite wonderful. Certain ultra-modern manifestations of art are never more intolerable than when seen together in large numbers, as in this gallery. Still, the French section can well afford some of these experimenting talents, since the general character of their other work is so high.[52]

Cheney's assessment of these galleries as a whole echoed Neuhaus's words: "The French section is one of the most interesting, but is hardly representative of the best that country has achieved in art. . . . [I]t upholds France's traditional

standing as the home of 'good painting,' but this is by no means a collection of masterpieces. The most noticeable tendency is that toward the decorative."[53] Notwithstanding the differences in critical opinion, the abundance of circulated commentary on the variety of French paintings in the Palace published by authors including Barry, Cheney, and Neuhaus demonstrates the significant role that these works played as cultural ambassadors among the variety of other sources for entertainment available at the PPIE.

THE FRENCH PAVILION

Isn't it marvelous how well the French do things? Their standard is perfection. . . .
Just to look about here is to realize how much thought and feeling they
have put into the arrangement of their treasures. There are only two things that
they have left out, their wine and their pâté de foie gras.[54]

The French Pavilion was one of the largest foreign buildings at the PPIE, as well as one of the last buildings completed. As a result of the late negotiations ensuring France's participation in the fair, construction did not begin until January 7, 1915, only six weeks before the Exposition's Opening Day, on February 20, 1915.[55] Remarkably, the building was erected in just nine weeks, but it did not open to the public until June 6, 1915, following the arrival of the *Jason*, which delivered the fine arts contents. Even if it was behind the PPIE's overall schedule, bringing the Pavilion to fruition in the bellicose European political climate of late 1914 and early 1915 was an extraordinary accomplishment. Barry recognized the magnitude of this feat in his opening remarks on the Pavilion in *The Palace of Fine Arts and the French and Italian Pavilions*:

It is astonishing that [the French Pavilion] should have been undertaken at all. France was in throes of war. . . . In the midst of all this turmoil to ask the French people to turn their attention to an Exposition thousands of miles away seemed like an absurdity. But they saw a chance of showing their appreciation of the help given the wounded and impoverished by sympathetic Americans, and they made a great effort. . . . In a short time they were able to do what, for most nations, would have required many months or years of preparation.[56]

This acknowledgment of the hasty preparations also emphasizes that compared with the development stages for other national buildings, the French Pavilion's planning phase was condensed and the selection process for artworks was abbreviated.

Cheney's *Art-Lover's Guide to the Exposition* went to press before the French Pavilion was finished, and reading between the lines reveals the lingering ambiguity over what the building would actually display. In the relatively brief description of the state and foreign buildings at the end of the publication, Cheney notes only that this Pavilion would "contain an extensive art display . . . [with] a number of statues by Rodin . . . which alone would make a visit imperative for every art lover."[57] In fact, the French Pavilion ultimately presented, in addition to the aforementioned Rodin works, loans of paintings, tapestries, and sculptures from the government, dealers, artists, and private collections in France. This impressive assortment of materials was housed in a three-quarter-scale replica of the Palais de la Légion d'Honneur in Paris (see Chapman, this volume). Barry remarked that the galleries were so evocative

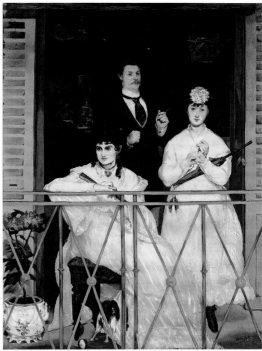

that after entering the Pavilion, he and his companion "felt as if we had been transported into France."[58] In *Impressions of the Art at the Panama-Pacific Exposition*, Christian Brinton, a critic and member of the International Jury, similarly observed, "the atmosphere of the [Musée du] Luxembourg was . . . transported to San Francisco with the coming of these canvases."[59]

The Luxembourg's extensive loans to the Pavilion included such images of French industry as Fernand Cormon's painting *A Forge* (1893, Musée d'Orsay, Paris) and portraits of entrepreneurs, including Jules Bastien-Lepage's *Simon Hayem* (1875, National Gallery of Art, Washington, DC). The building also featured works with overtones that related to the turbulent political environment in France. The American writer Laura Ingalls Wilder, who later achieved fame for her Little House series, which included *Little House on the Prairie* (1935), visited the Pavilion during a stay with her daughter and son-in-law. She remarked on the melancholy atmosphere of Jean Baptiste Édouard Detaille's *The Dream* (*Le rêve*) (fig. 147; see also fig. 148):

> There is one little long room [Gallery 6]. As we came to the archway opening into it and looked down we saw on each side large paintings of battle scenes. . . . At the end of the room, covering the whole end wall . . . was a painting of the armies of France. . . . Dawn was just breaking along the skyline and on the clouds rolling away rode the "Phantom Armies of France," the ghosts, I think, of all men and horses who have ever been killed in all the wars of France. The whole picture was the most wonderful lifelike thing I have ever seen, and the whole room was a shrine of sorrow.[60]

Detaille had observed combat firsthand in the Franco-Prussian War (1870–1871),

and this composition, which was exhibited in Paris at the Exposition Universelle of 1889, conjured the grim realities faced by French soldiers.

As at the Palace of Fine Arts, the Impressionist works, and Monet's paintings in particular, were attractions in the French Pavilion. His *Rouen Cathedral Facade* (*La cathédrale de Rouen. Le portail vu de face*) (pl. 144), lent by the Musée du Luxembourg, was shown in Gallery 14, a room that highlighted French architecture and also included building models and photographs. The Post-Impressionists Paul Cézanne and Paul Gauguin were represented in Gallery 6 by *The Gulf of Marseille from L'Estaque* (*Le golfe de Marseille vu de l'Estaque*) (pl. 141) and *Faa Iheihe* (fig. 150), respectively. Nearby, in Gallery 5, Édouard Manet's *The Balcony* (*Le balcon*) (fig. 149; see also fig. 148), another loan from the Musée du Luxembourg, was the artist's only work at the Exposition. This painting featured his future sister-in-law, the Impressionist artist Berthe Morisot. Its flatness, bold color scheme, and ambiguous narrative originally shocked audiences and critics, who vigorously attacked it when it was first exhibited at the Paris Salon in 1869. The caricaturist Cham (Amédée-Charles-Henry de Noé) made a sketch of the piece with the caption, "Do close that window," while the critic Wolff derided it as "this uncouth art, where . . . [Manet] lowers himself to engage in competition with house painters."[61] By 1915, however, San Francisco's critics were more favorable. At the PPIE, Barry credited it with "introducing a new technique, a more natural treatment of light, bringing out truer effects of perspective."[62] It seems that Barry greatly admired the aesthetic ideals expressed by the once provocative Manet.

Barry also singled out the paintings of Puvis de Chavannes. *Hope* (*L'espérance*) (fig. 151) was noted as being "so greatly admired by artists the world over. . . . Its

beauty and charm can be perceived even by those who do not appreciate the work of this master in general. It is, indeed, one of his greatest triumphs."[63] Painted in response to the Franco-Prussian War, its symbolism—an olive branch, blossoming flowers, and breaking dawn—suggests the anticipation of peace and optimism for tranquility and rebirth. Barry also praised the artist's designs for the Panthéon murals depicting Geneviève, the patron saint of Paris, who interceded on behalf of the city in 451 when Attila's Huns threatened invasion. Arthur Bridgman Clark, associate professor at Stanford University, recommended, "To study this canvas is one of the choicest opportunities of the Exposition."[64] Like *Hope* and Detaille's *The Dream, Sainte Geneviève Distributing Supplies to Paris* (1893–1898, Musée d'Orsay, Paris) summoned associations between World War I and previous French conflicts. Not all works on view in the Pavilion recalled the tense political situation in France, but collectively they demonstrated a variety of nineteenth-century French painting styles, from the precise observation of Detaille and the iconic Impressionism of Monet, to the modern aesthetic of Manet and the classicism of Puvis.

POST-EXHIBITION PERIOD AND LEGACY

The ramifications of the French art exhibitions at the PPIE were artistic, cultural, and political, although some of these effects materialized long after the Exposition ended. One of the earliest and most conspicuous efforts to prolong San Francisco's access to French art from the fair was a failed campaign to keep Gauguin's large frieze *Faa Iheihe* in the city.[65] The painting was for sale via the dealer Ambrose Vollard, who had previously lent it to New York's Armory Show in 1913. A group of local artists, including Gottardo Piazzoni, Lucia K. Mathews, and Ralph Stackpole, wanted to purchase it for a planned museum that would be housed at the Palace of Fine Arts (see Introduction, this volume). They argued that it would be "an irreparable loss—and a shame—if San Francisco [did] not secure this admirable example of a remarkable school for its prospective museum."[66] Sadly, since the necessary funds were not raised in time, the effort was unsuccessful, and *Faa Iheihe* ultimately went to the Tate Gallery, London, in 1919.

In another disappointment for the city, French art was absent from the four-month post-Exposition display that opened to the public at the Palace of Fine Arts on January 1, 1916. Before the plans for this extension were confirmed, arrangements had been made to circulate a traveling exhibition of French and Belgian works after the PPIE closed.[67] Jean Guiffrey hoped that delaying their return to France for at least a year would decrease the risks associated with sending art home during wartime. Additionally, many works were for sale, and according to Guiffrey, purchases during the tour also would decrease the volume of art returned, thereby lowering the related shipping costs. At any rate, he argued, "these works of art might remain in the US until the end of hostilities without disadvantage, since currently the Museums are closed, and thus they could not be presented to the public if they were in Paris."[68]

Various announcements of the post-Exposition tour imply that negotiations to host the exhibition transpired directly between the venues and the French government, but Cornelia Bentley Sage Quinton, director of the Albright Art Gallery (today the Albright-Knox Art Gallery), Buffalo, who also served in an advisory role to the PPIE's Fine Arts Department, is credited with managing the tour.[69] Sage Quinton's lengthy correspondence with Guiffrey and Trask reveals that in the fall of 1915, she approached the former with her idea for a traveling exhibition and insisted that she should have full responsibility for organizing it.[70] By December 10, 1915, Guiffrey had a list of artists willing to send their works on tour.[71] Approximately eighty French and Belgian paintings from the French Pavilion went on display in Chicago in January 1916.[72] After Chicago, the selection traveled to multiple cities, including Saint Louis, Missouri; Buffalo, New York; Pittsburgh, Pennsylvania; Youngstown, Ohio; Toronto, Canada; Detroit, Michigan; Toledo, Ohio; Minneapolis, Minnesota; Des Moines, Iowa; and Omaha, Nebraska. Although Sage Quinton had hoped to include as many important French loans as possible, the paintings from the Musée du Luxembourg collection were sent on a separate tour from San Francisco to San Diego, Pittsburgh, and Buffalo, where Sage Quinton supervised the installation. There, approximately twenty-five thousand visitors attended the opening, and

FIG. 150
Paul Gauguin (French, 1848–1903), *Faa Iheihe*,
1898. Oil on canvas, 21 ¼ × 66 ¾ in. (54 × 169.5 cm).
Tate, London, presented by Lord Duveen 1919,
N03470

FIG. 151
Pierre Puvis de Chavannes (French, 1824–1898),
Hope (*L'espérance*), 1871–1872. Oil on canvas,
27 ¾ × 32 ¼ in. (70.5 × 82 cm). Musée d'Orsay,
Paris, INV 20117

the celebrated actress Sarah Bernhardt gave an address on the French pictures.[73] The exhibition continued on to several cities through April 1919.

Many of the French and Belgian works on the circuit were available for purchase, and some artists agreed to give twenty-five percent of their profits to the Fraternité des artistes, an organization supporting the families of artists serving in the war. By the time the tour reached Buffalo, its third stop, it was a commercial success. As *Academy Notes* reported, "Twenty-one sales have been made from the exhibition of French and Belgian Art selected from the Panama-Pacific Exposition since the collection came under the management of the Buffalo Fine Arts Academy and its Director. In St. Louis two works were purchased, one by the City Art Museum; in Chicago two important collectors invested in as many canvases, and in Buffalo seventeen examples found permanent homes."[74] Sage Quinton especially wanted to support artists with whom she had a personal connection, such as Bernard Boutet de Monvel, whose mother she corresponded with: "I had a letter from dear Madame Boutet de Monvel. . . . Bernard is still safe, although she fears every moment for his life on account of his flying in an areoplane [*sic*] over German territory. I wish we could sell that picture, as I fear the mother and grandmother need the money."[75] In a letter dated January 29, 1916, Sage Quinton explained her preoccupation with sales to Guiffrey: "It is a real joy to me to work for France, her art and artists, and I am sure I have done, am doing and will do everything in my power for the cause."[76] Indeed, the tour was quite successful at every venue, stoking enthusiasm for French art and culture across the country and encouraging local collectors and museums to make acquisitions.[77]

The tour also laid the groundwork for future Franco-American collaborations in the fine and decorative arts. For example, in 1920, Paul Léon, France's minister of fine arts, and Léonce Bénédite, who was still director of the Musée du Luxembourg, organized an exhibition of French art at the Albright in Buffalo. The connection between the PPIE, France, and the Albright came full circle in 1924 when Sage Quinton became director of the California Palace of the Legion of Honor in San Francisco, a permanent museum inspired by the French Pavilion in both its architecture and its devotion to French culture.[78] Given Sage Quinton's background, connections, and expertise, it is not surprising that the Legion's inaugural exhibition in 1924 prominently featured a review of French art, which was described as "a continuation of that of 1915."[79] Contributors to the catalogue included Guiffrey and Bénédite, who returned to San Francisco as representatives of France at the Legion's opening ceremony (see fig. 172).

The fortitude and resourcefulness of the government, artists, and collectors of France who supported the country's participation at the PPIE during the tumultuous early days of World War I helped cement the cultural and political ties between France and the United States, and with San Francisco, in particular. The Exposition's display of French paintings, especially those by the Impressionists, established irrefutably the importance of that movement to American artists. Although critics did not universally praise the French paintings shown at the PPIE, these loans fostered a continued enthusiasm for French art in America. The courageous organizers, both American and French, who advocated for this significant triumph in the midst of war, embodied one of the fair's most important objectives: "In the art of the Exposition the great underlying theme is that of achievement. The Exposition is being held to celebrate the building of the Panama Canal, and to exhibit to the world evidences of the progress of civilization in the decade since the last great exposition—a period among the richest in the history of civilization. So the ideas of victory, achievement, progress and aspiration are expressed again and again."[80]

1. *An Announcement: Congresses, Conferences, Conventions* (San Francisco: Panama-Pacific International Exposition, 1915), 6.

2. There were even concerns that the PPIE might be postponed or cancelled altogether, which Exposition officials vehemently countered in the press: "Exhibition Will Not Be Delayed," *San Francisco Chronicle*, September 10, 1915. For more, see Laura A. Ackley, "The Exposition Will Not Be Postponed," in *San Francisco's Jewel City: The Panama-Pacific International Exposition of 1915* (Berkeley: Heyday, 2015), 85–95.

3. Elizabeth Nourse, "Extracts from the Diary of an American Artist in Paris: August and September, 1914," *Art and Progress*, December 1914, 43.

4. "Protecting the Louvre," American Art News, September 19, 1914, 1.

5. John D. Barry, *The City of Domes: A Walk with an Architect about the Courts and Palaces of the Panama-Pacific International Exposition with a Discussion of Its Architecture, Its Sculpture, Its Mural Decorations, Its Coloring, and Its Lighting, Preceded by a History of Its Growth* (San Francisco: John J. Newbegin, 1915), 26.

6. Ibid.

7. Art critic J. Nilsen Laurvik, a special representative of the PPIE's Department of Fine Arts and commissioner of fine arts for Norway, was also tasked with securing loans from foreign nations. Just before the fair's official opening, the *San Francisco Chronicle* reported that Laurvik secured loans from countries including Hungary, Austria, Italy, and Norway. "Art Treasures for Exposition. Laurvik Secures Comprehensive Collection That Is Coming on the Jason," *San Francisco Chronicle*, February 19, 1915. Also see Barki, this volume.

8. Barry, *City of Domes*, 23.

9. Ibid., 24.

10. Ibid.

11. John E. D. Trask and J. Nilsen Laurvik, eds., *Catalogue de Luxe of the Department of Fine Arts, Panama-Pacific International Exposition* (San Francisco: Paul Elder, 1915), 1:ix.

12. Léonce Bénédite to unnamed French government official, November 30, 1914, LIIX, Archives nationales, Paris. I wish to acknowledge, with deep appreciation, Monique Nonne, who assembled documents from the Archives that helped me to piece together the complicated puzzle of events leading to French participation in the PPIE.

13. Correspondance générale, Sécretaire d'État des Beaux Arts, Office de la Propagande, F/21/4074, Archives nationales, Paris. Translation mine.

14. "New Curator for Boston, Jean Guiffrey of the Louvre, Paris, Coming to Art Museum," *New York Times*, April 11, 1911.

15. "M. Jean Guiffrey," *Museum of Fine Arts Bulletin* 12, no. 70 (June 1914): 34.

16. Correspondance générale, Jean Guiffrey to unnamed minister, undated, F/21/4075, Archives nationales, Paris. Translation mine.

17. "The Arts in War," American Art News, December 26, 1914, 1.

18. Dossier 8a, listes des invitations, F/21/4073, Archives nationales, Paris.

19. Albert Dalimier to unnamed addressee, November 28, 1914, dossier 8a, listes des invitations, F/21/4073, Archives nationales, Paris.

20. *Belgium Catalogue: Panama-Pacific International Exposition* (San Francisco, 1915), 4.

21. Sargent was the chairman of the Department of Fine Arts's advisory committee for Great Britain, and Pennell was its honorary secretary.

22. "Secret Trip of Jason Ended: Joseph Pennell Tells How Ship with Art Treasures from Belligerents for California Exposition Kept Under Cover," *New York Times*, April 18, 1915.

23. For more, see Lilian Bell, *The Story of the Christmas Ship* (Chicago: Rand McNally, 1915).

24. "Foreign Art for Fair," *American Art News*, April 17, 1915, 1.

25. Bell, *Story of the Christmas Ship*, 376.

26. The *Jason* also brought works from Spain, Italy, Greece, Austria, Germany, and Great Britain. See "Big Collier Jason Brings Priceless Cargo," *San Francisco Chronicle*, April 12, 1915.

27. "Secret Trip of Jason Ended."

28. "Exposition Art Arrives," *American Art News*, May 1, 1915, 1.

29. "First of Jason Cargo Unloaded: Consignment of Exhibits to French Pavilion Met by Officials," *San Francisco Chronicle*, April 16, 1915.

30. The Fine Arts Annex was completed in July 1915.

31. Barry, *City of Domes*, 26.

32. Sheldon Cheney, *An Art-Lover's Guide to the Exposition: Explanations of the Architecture, Sculpture and Mural Paintings, with a Guide for Study in the Art Gallery* (Berkeley: At the Sign of the Berkeley Oak, 1915), 79.

33. John E. D. Trask, "The Influence of World's Fairs on the Developments of Art," *Art and Progress*, February 1915, 117.

34. Cheney, *Art-Lover's Guide*, 77.

35. Allan Christopher Balch was a pioneer in the electric industry who, along with his wife, donated a sizable art collection to the Los Angeles County Museum of Art.

36. Today Frick's acquisitions form the core of the Frick Collection in New York and the Frick Art and Historical Center in Pittsburgh.

37. Other notable loans from the Galerie Bernheim-Jeune included *Bois de Boulogne* (*The Lawn; Preliminary Sketch for a Decorative Panel*) by Édouard Vuillard (ca. 1908, Norton Museum of Art, West Palm Beach, Florida) and *The Abduction of the Daughters of Leucippus* by Ker-Xavier Roussel (1911, Musée d'Orsay, Paris), both of which were on view in the French Pavilion.

38. Cheney, *Art-Lover's Guide*, 78.

39. According to e-mail correspondence from Flavie Durand-Ruel to James A. Ganz, dated November 10, 2014, "Durand-Ruel sent on 21st December 1914 the following 18 pictures to San Francisco, for the Panama Pacific International exhibition, insured by Mr. J. D. Trask: Mary Cassatt, *Femme et enfant avec écharpe rose* [*Mother and Child with a Rose Scarf*, pl. 44], 1910 [ca. 1908] (Breeskin, 509); Cassatt, *Femme lisant dans un jardin*, 1880 (Breeskin, 94); Cassatt, *Femme à l'éventail*, 1880 (Breeskin, 80); Claude Monet, *Meule, coucher de soleil* [*Grainstack at Sunset, Winter*, fig. 146], 1891 (Wildenstein, 1282); Monet, *Vétheuil*, 1901 (Wildenstein, 1639); Monet, *Nymphéas, paysage d'eau*, 1906 (Wildenstein, n°1657); Monet, *La Seine à Port Villers*, 1894 (Wildenstein, 1372); Monet, *Le Havre, terrasse au bord de la mer* [*Garden at Sainte-Adresse*, fig. 144], 1866 [1867] (Wildenstein, 95); Monet, *Bateaux échoués, Fécamp*, 1881 (Wildenstein, 645); Monet, *La Promenade dans les prairies à Argenteuil* [*Walk in the Meadows at Argenteuil*, fig. 145], 1873 (Wildenstein, 276); Camille Pissarro, *Village aux environs de Mantes* [*Houses at Bougival (Autumn)*, pl. 139], 1870 (Pissarro & Durand-Ruel Snollaerts, 157); Pissarro, *Le Jardin du presbytère à Knokke*, 1894 (Pissarro & Durand-Ruel Snollaerts, 1040); Pierre-Auguste Renoir, *Deux femmes assises* (Dauberville, 1012); Renoir, *Dans le jardin*, 1884 (Daulte, 464); Renoir, *Fleurs et fruits*, 1884 (Dauberville, 706); Renoir, *Promenade au bord de la mer*, 1892 (Dauberville, 861); Alfred Sisley, *Saint Mammès*, 1883 (Daulte 506); Sisley, *Une Avenue de peupliers, Moret*, 1888 (Daulte, 674)."

40. Eugen Neuhaus, *The Galleries of the Exposition: A Critical Review of the Paintings, Statuary and the Graphic Arts in the Palace of Fine Arts at the Panama-Pacific International Exposition* (San Francisco: Paul Elder, 1915), 13.

41. Cheney, *Art-Lover's Guide*, 80.

42. Ibid., 85, 86.

43. For more on the artists' colony in Giverny, see Sona Johnston, *In Monet's Light: Theodore Robinson at Giverny* (London: Philip Wilson, 2004); and *Impressionist Giverny: A Colony of Artists,* *1885–1915* (Giverny: Terra Foundation for American Art, 2007).

44. John D. Barry, *The Palace of Fine Arts and the French and Italian Pavilions: A Walk with a Painter, with a Discussion of Painting and Sculptures and Some of the Workers Therein, Mainly from the Painter's Point of View* (San Francisco: H. S. Crocker, 1915), 16.

45. Ibid., 29.

46. "Art and Charity," *San Francisco Chronicle*, November 4, 1891. See also William H. Gerdts, "The Land of Sunshine," in *Masters of Light: Plein-Air Painting in California 1890–1930* (Irvine, CA: Irvine Museum, 2002), 29–30. Vickery, Atkins and Torrey closed in 1933.

47. *The Official History of the California Midwinter International Exposition. A Descriptive Record of the Origin, Development and Success of the Great Industrial Expositional Enterprise, Held in San Francisco from January to July, 1984* (San Francisco: H. S. Crocker and Company, 1894), 123. San Francisco's de Young Museum originated as the Fine Arts Building at the California Midwinter International Exposition of 1894 in Golden Gate Park.

48. For more on California Impressionism, see William H. Gerdts and Will South, *California Impressionism* (New York: Abbeville Press, 1998); and Susan Landauer, *California Impressionists* (Irvine, CA: Irvine Museum, 1996).

49. The contemporary styles and movements that were not represented, such as Fauvism and Cubism, give a good idea of the conservatism of the exhibition, especially in comparison to the 1913 New York Armory Show and the more avant-garde European works shown in the Annex.

50. André Devambez's father, Édouard, founded the family's publishing house, which produced a French guide to the PPIE: *Exposition universelle et internationale de San-Francisco. 1915: Catalogue officiel de la section française* (Paris: Devambez, 1915).

51. Neuhaus, *Galleries of the Exposition*, 17.

52. Ibid., 22–23.

53. Cheney, *Art-Lover's Guide*, 92.

54. Barry, *Palace of Fine Arts*, 47.

55. "Hundreds of Extra Men Work on French Building," *San Francisco Chronicle*, February 19, 1915.

56. Barry, *Palace of Fine Arts*, 45.

57. Cheney, *Art-Lover's Guide*, 98.

58. Barry, *Palace of Fine Arts*, 47.

59. Christian Brinton, *Impressions of the Art at the Panama-Pacific Exposition* (New York: John Lane, 1916), 174.

60. Roger Lea MacBride, ed., *West from Home: Letters of Laura Ingalls Wilder to Almanzo Wilder, San Francisco, 1915* (New York: HarperCollins, 1974), 103–104.

61. Quoted in Françoise Cachin, Charles S. Moffett, and Juliet W. Bareau, *Manet, 1832–1883* (New York: Metropolitan Museum of Art, 1983), 307.

62. Barry, *Palace of Fine Arts*, 51.

63. Ibid., 50.

64. Arthur Bridgman Clark, *Significant Paintings at the Panama-Pacific Exposition: How to Find Them and How to Enjoy Them* (Palo Alto: Stanford University Press, 1915), 14.

65. Anna Cora Winchell, "Artists and Their Work," *San Francisco Chronicle*, January 2, 1916.

66. Helen Dare, "Who Says That You Can't Get Artists to Agree?," *San Francisco Chronicle*, January 4, 1916.

67. "Palace of Fine Arts to Be Open to Public Jan. 1," *San Francisco Chronicle*, December 7, 1915.

68. Jean Guiffrey, "Rapport sur les oeuvres d'art demeurées aux États-Unis après la fermeture d'Exposition de San Francisco," December 14, 1916, dossier I, correspondence générale, F/21/4075, Archives nationales, Paris. Translation mine.

69. "Exhibition of French and Belgian Art, Selected from the Panama-Pacific International Exposition, at the Albright Gallery," *Academy Notes* 11, no. 2 (April 1916): 35, 48. The

first female director of a major art museum in the United States, Sage Quinton was director of the Albright Art Gallery from 1910 through 1924. The Buffalo Fine Arts Academy is the parent organization of the Albright, now known as the Albright-Knox Art Gallery.

70. Cornelia Sage Quinton to Jean Guiffrey, telegraph, October 27, 1915, box/folder number RG 2.3:3.30, AK2.3, Cornelia Bentley Sage Quinton Records, 1908–1930, G. Robert Strauss, Jr. Memorial Library, Albright-Knox Art Gallery (hereafter cited as Sage Quinton Records). I am grateful for the assistance of Gabriela Zoller, acting head of research resources and art collection cataloguer in the department of Research Resources at the Albright-Knox Gallery, Buffalo, for sharing correspondence from the Sage Quinton Records. These letters and telegrams provided a fascinating glimpse into the intricate negotiations and preparations that led to the post-Exposition tour.

71. Guiffrey to Sage Quinton, telegraph, December 10, 1915, box/folder number AK2.3, RG2.3:3.30, Sage Quinton Records.

72. "Coming Exhibitions," *Bulletin of the Art Institute of Chicago* 10, no. 1 (January 1916): 250.

73. Sage Quinton to Lewis F. Pilcher, November 1, 1916, box/folder number AK2.3, RG3.1:13.11, Sage Quinton Records.

74. "Editorial," *Academy Notes* 11, no. 2 (April 1916): 60.

75. Sage Quinton to Guiffrey, May 2, 1916, box/folder number AK2.3, RG 2.3:5.15, Sage Quinton Records.

76. Sage Quinton to Guiffrey, January 29, 1916, box/folder number AK2.3, RG 2.3:5.15, Sage Quinton Records.

77. On December 28, 1916, the net sales total was recorded at $26,320.75. Unnamed assistant to Sage Quinton to Maurice Heilmann, French ambassador to the United States, December 28, 1916, box/folder number AK2.3, RG 3.1:13.11, Sage Quinton Records.

78. Today, the Legion of Honor and the de Young together compose the Fine Arts Museums of San Francisco. Alma de Bretteville Spreckels, who founded the museum with her husband, Adolph B. Spreckels, saw the French Pavilion during the PPIE and later modeled her museum after it. See Chapman, this volume.

79. *Catalogue: Inaugural Exposition of French Art in the California Palace of the Legion of Honor, Lincoln Park, San Francisco, California, 1924–1925* (San Francisco: J. H. Barry, 1924–1925), 8.

80. Cheney, *Art-Lover's Guide*, 7.

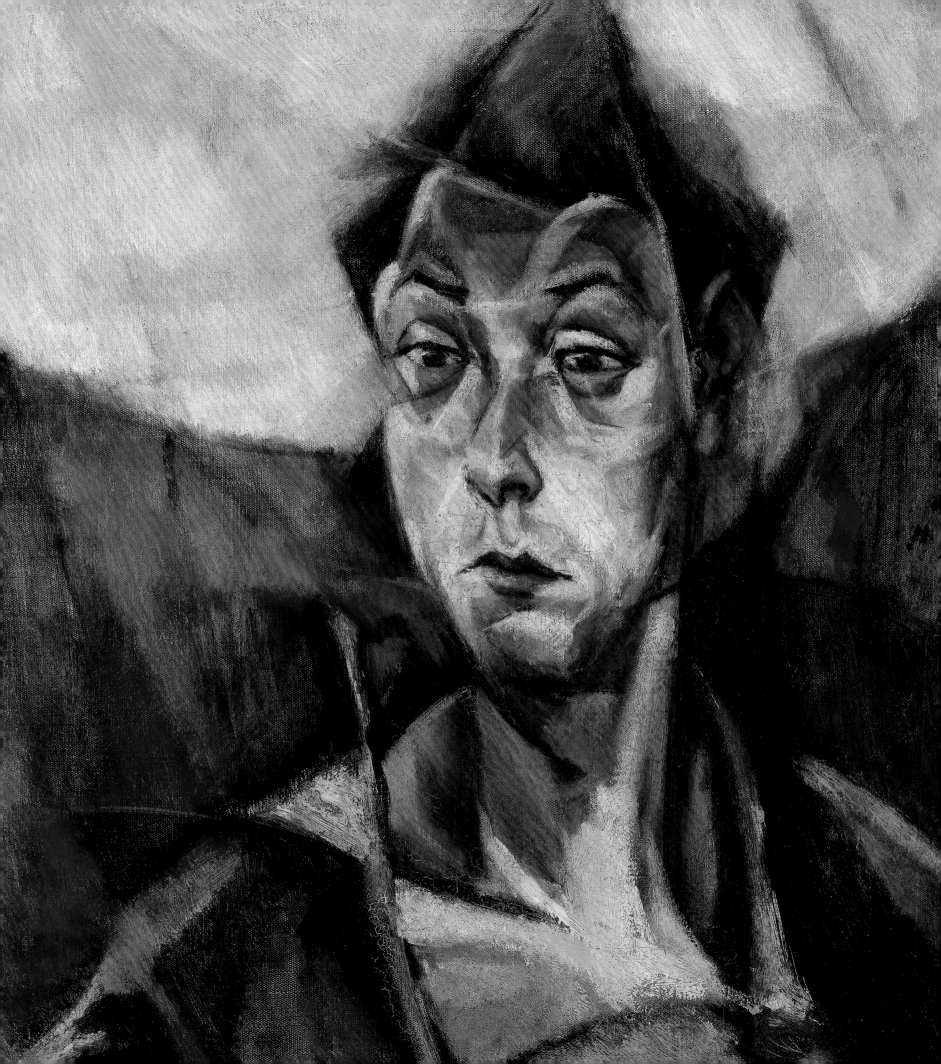

A DEBUT OF HUNGARIAN
ART IN AMERICA

A portrait of composer Béla Bartók by Róbert Berény (fig. 152), one of a group of progressive Hungarian artists known as "The Eight," was exhibited in the Hungarian section of the fine arts display at the Panama-Pacific International Exposition (PPIE) of 1915 and vanished without a trace within a year of the fair. It was believed to be missing until art historian Júlia Szabó saw it in the home of Bartók's son in Florida in 1991.[1] It seems that many of the almost five hundred Hungarian works shown at the San Francisco Exposition shared similar fates: Some did not make it back to Hungary until many years later; some never made it home at all. Thus, while the PPIE exhibition is hailed as the first representative display of modern Hungarian art in the United States, it also might be characterized as a "Bermuda Triangle," a site where many mysterious and unsolved disappearances have their origins.

Though Hungary did not have its own pavilion at the PPIE or its own section in the Palace of Fine Arts, it was among the unofficial exhibitors at the fair. In his introduction to the *Catalogue de Luxe of the Department of Fine Arts*, director of fine arts John E. D. Trask related how countries that were not official participants—mostly, as in Hungary's case, due to World War I—were nonetheless represented by works lent by institutions, artists, art societies, and private collections.[2] Trask added that in order to secure the European loans, diplomacy and assistance from consuls was required. Most of the European works of art in the international section arrived in San Francisco in April 1915 aboard the US Navy collier *Jason*,[3] which was specially commissioned by the American government for that purpose after it had delivered Christmas gifts from America to war-stricken parts of Europe (see Chapman and Buron, this volume).[4] According to the original plan, only material destined for the PPIE from nations at war was to arrive onboard the *Jason*. It turns out, though, that other nations packed their cargo aboard as well.

The task of rounding up art objects for the international section fell to J. Nilsen Laurvik, who represented his native Norway on the PPIE's International Jury of Awards for the Fine Arts Department.[5] Laurvik's résumé made him the perfect man for the job. He was an influential art critic who wrote for American and Scandinavian art publications. Inspired by a trip to Budapest in 1913, he organized a traveling exhibition called *Hungarian Peasant Art* the following spring.[6] In late spring of 1914 the PPIE's Department of Fine Arts sent Laurvik as its delegate to some of the European countries not officially participating in the Exposition; based on the promise of this visit, he made a second trip to Europe in November.[7] The critic's artistic and literary pedigree as well as his Norwegian ancestry must have given him credibility among the European institutions, collectors, and artists from whom he sought loans of works. The argument used by PPIE organizers to persuade lenders was that during wartime the art would enjoy greater security in far-off America than in their homelands—an ironic claim given the eventual fate of many of the Hungarian works.

Laurvik's European itinerary included visits to Scandinavia, Italy, Vienna, and Budapest, where his efforts to secure works for exhibition at the fair were beset with difficulties due to the war.[8] First, collectors were unsure about the future and were wary of sending their art treasures into the unknown. Second,

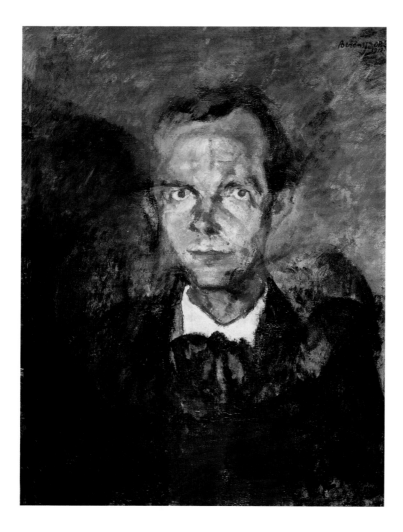

FIG. 152
Róbert Berény (Hungarian, 1887–1953), *Portrait of Béla Bartók*, 1913. Oil on canvas, 26 ⅜ × 17 ¾ in. (67.5 × 45 cm). Property of Péter Bartók, deposit at the Paul Sacher Stiftung, Basel, Switzerland

many museums were closed and their art possessions hidden away for safekeeping. In light of this fact, one wonders, how was the American critic able to borrow nearly five hundred works from a country with whom the United States would be at war just three years later?

It seems that Laurvik's connection to Hungary was of a more personal nature. His trip there in late August 1914 actually was his second visit to the country. Laurvik had first come to Budapest in June 1913 as a correspondent for the American press to cover the bustling International Women's Suffrage Congress. Participating at the congress as a translator was Elma Pálos, who later became the stepdaughter of world-renowned psychoanalyst Sándor Ferenczi, a member of Sigmund Freud's inner circle. Ferenczi had initially courted Elma, but later married her mother, Gizella, while Elma—perhaps to "escape" from Ferenczi—wedded Laurvik on September 18, 1914, a year after their brief meeting at the congress.[9] A December 1914 letter from Laurvik to the French painter and art collector Frank Burty Haviland reveals that in addition to her taking part in President Hoover's humanitarian relief efforts in Europe, his new wife helped him with diplomatic matters and the collection of Hungarian paintings for the PPIE.[10]

Laurvik's marriage to Pálos opened up an impressive circle of art-world acquaintances in Budapest. Her stepfather, Ferenczi, was himself a collector and lent several pieces to the Exposition. One of Ferenczi's best friends was Róbert Berény of The Eight, who hosted a gathering for the Laurviks on one occasion and pledged twenty-six works to the show. Laurvik also called on the studio of Bertalan Pór, another artist of The Eight.[11] Other members of the group also lent paintings—twenty-four in all—which raises the question of which artists Laurvik may have met in Budapest. What is clear is that Laurvik was known and trusted by members of The Eight. The works owned by the artists themselves would be put up for sale at the PPIE (as was the case for many exhibitors), and the members of the group also likely believed they would achieve some financial profit by selling their work in the promising US market.

Through Berény, Laurvik also met György Bölöni, the famous Hungarian critic and early proponent of modern art, who, as a handwritten invitation from the artist suggests, may already have known (or known of) Laurvik.[12] Bölöni was to play an important role in the PPIE on account of this acquaintance. Laurvik tapped him to write the Hungarian chapter for the Exposition's official catalogue (Laurvik was a co-editor and Pálos translated it into English). An

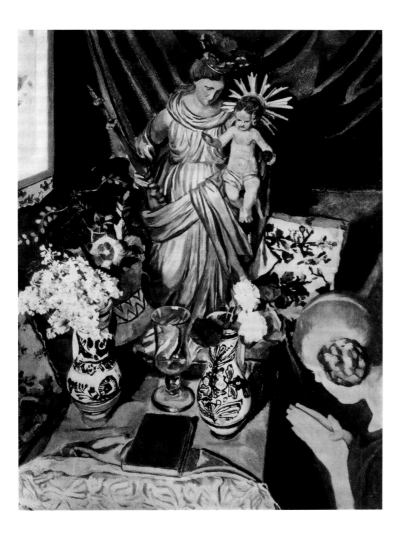

FIG. 153
A lost canvas by Pál Jávor (Hungarian, 1880–
1923), *Hungarian Home Altar*, n.d. From Christian
Brinton, *Impressions of the Art at the Panama-Pacific
Exposition* (New York: John Lane, 1916)

archive of Bölöni's personal papers suggests he also collaborated on the collection of Hungarian works.[13] On December 30, an editorial in the daily *Magyarország* attacked Laurvik for entrusting the selection of Hungarian entries to a critic not known for his impartiality instead of turning to official bodies such as the National Hungarian Artists' Association or the Artistic League.[14] Another champion of modern art, Béla Lázár also was accused in the editorial of sending requests for submissions only to artists who made up his clique at the Café Japan, a popular hangout for artists and writers. Thus, the article argued, the country would be represented by one-sided and perhaps even objectionable work. Lázár's reply was printed the next day. He denied the slurs, stating that, just as in his earlier writings, he would remain impartial throughout the selection process.[15]

While in Hungary, Laurvik also made the acquaintance of Count Gyula Andrássy the Younger, an important politician who in 1912 tried to prevent the Balkan Wars and later became foreign minister of Austria-Hungary. The count not only offered part of his own art collection for the purposes of the exhibit, but he also exhorted others to follow his example.[16] He encouraged the idea even in his newspaper, and this strong support turned the tide. Other collectors followed suit until Laurvik finally was able to call up more than one hundred people within five weeks and secure their loans.[17] The well-known collector Marcell Nemes allowed Laurvik access to his private gallery and lent important material for the show.[18] Although most Hungarian museums were closed due to the war, the Museum of Fine Arts in Budapest assisted Laurvik in some capacity with the country's graphic art section of the exhibition: in the official catalogue, the graphic art appears with the note "arranged by the Fine Arts Museum of Budapest." The catalogue also makes it clear that some of the artists included in the exhibition, in addition to lending their own work, offered creations by other artists as well.

Once Laurvik had completed his collection, the Hungarian works were transported from chaotic Budapest to Genoa on a caravan of overloaded furniture wagons.[19] The Hungarian convoy arrived three days after the *Jason* was due to embark, but, fortunately, the ship's departure was delayed and the material made it in time.[20] From Genoa, after stops in Marseille and England, it was a direct overseas route, including passage through the Panama Canal, to San Francisco, where the paintings, graphic works, sculptures, embroideries, and other articles were not unpacked until they reached the entrance to the Palace of Fine Arts.[21]

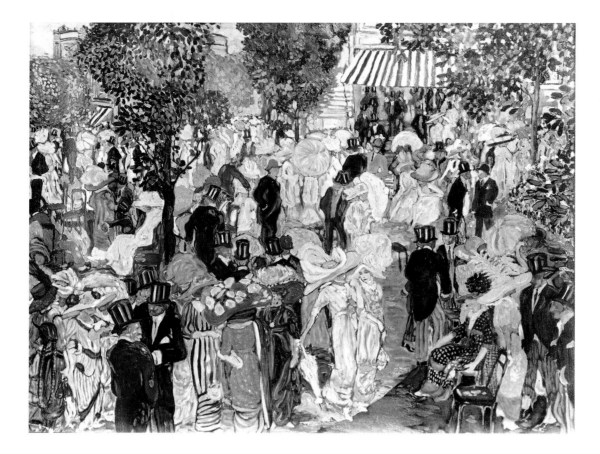

FIG. 154
A lost canvas by Gyula Batthyáni (Hungarian, 1823–1890), *Longchamps*, ca. 1910. From Christian Brinton, *Impressions of the Art at the Panama-Pacific Exposition* (New York: John Lane, 1916)

FIG. 155
A lost embroidery by Róbert Berény, 1912. From *The Catalogue of the Third Exhibition of the Group of The Eight* (Budapest: Nemzeti Szalon, 1912)

Because of the great success of Laurvik and the other PPIE officials who were sent to Europe to solicit loans of art, there were more European works than could be accommodated in the Palace of Fine Arts, and a new building was quickly erected. Intended to house material from countries not formally participating in the fair and by artists who were not officially chosen to represent their countries in the pavilions of participating nations, the Annex opened in July 1915, five months after the fair began. It appears now that, isolated from the Palace of the Fine Arts—that is, the main building that conjured a more conservative spirit—works that reflected a more modern European spirit were concentrated in the Annex. For example, segregated from the conservative Italian exhibit, which occupied a wing in the Palace of the Arts, works by the Italian Futurists received an independent space in the new building.

The Hungarian paintings clearly made up the second most progressive section after the Futurists, in terms of their modernity and their relative impact given the high proportion of works exhibited. The nearly five hundred Hungarian pieces were spread out over eight galleries as well as among entrance halls and staircases in the Annex.[22] The official PPIE catalogue lists seventy-six Hungarian painters, forty-four graphic artists, and twelve sculptors who exhibited.[23] Beyond the numbers, however, the most distinctive feature of the Hungarian material was that, unlike that of most other countries exhibiting in the Annex, it was retrospective, beginning with major nineteenth-century artistic trends and continuing to the present, with an emphasis on contemporary developments.

In Laurvik's view, this scope made the Hungarian section the most interesting and most instructive of all the European displays.[24]

Unraveling the complicated provenance of the works shown requires first reconstructing the exhibit as much as possible, an important but enormous and difficult undertaking. Unlike the French, Belgian, and Swedish sections, where a few archival photographs were taken (including one of the Swedish section by Laurvik), there are, unfortunately, no pictures documenting the Hungarian section.[25]

Exhibition catalogues, brochures, visitor guides, and contemporary reviews of the show give us some idea of what was exhibited. However, the existence of conflicting information among several catalogues makes it difficult to reconstruct exactly which works were displayed. The use of generalized titles, lack of dates, and difficulties in translation confuse matters further. In addition to the official *Catalogue de Luxe*, a two-volume illustrated catalogue[26] and two smaller temporary catalogues were published.[27] Both of the latter went to press before the arrival of the Hungarian collection, and one of the two doesn't include the international section at all. The revised edition of the temporary catalogue offers provisional lists that appear less comprehensive than those in the *Catalogue de Luxe*, but that nonetheless include some titles not found in the official catalogue.

An unpublished list of the Austrian, Hungarian, Finnish, and Norwegian material borrowed by Laurvik clears up some discrepancies between the various catalogues. The list, which resides in the archives of the San Francisco

Art Association (SFAA) at the San Francisco Art Institute, is annotated with handwritten notes prepared at the conclusion of the exhibit.[28] The notes explain that the works that turned up in the revised temporary catalogue but were absent from the official catalogue did arrive in San Francisco, but that the organizers had decided not to display them. Hence, for example, Berény's painting *View of Capri* (1913, Hungarian National Gallery) did not appear at the fair, nor did an unidentified female portrait by the artist. It seems these works remained in storage for the duration of the exhibit. The list also clarifies the media of several pieces in the Berény collection, which included paintings, graphic works, and embroideries.[29] Berény's embroideries are rare today—just one entirely intact example is available for study—although he designed and sold a great number of them between 1911 and 1917 and exhibited them in Berlin, Vienna, Budapest, and even in São Paolo, Brazil (see fig. 155). Some titles in the official catalogue clearly refer to embroidered works (for example, *Yellow Embroidery*), but for most part the catalogue does not distinguish between paintings and embroideries.

Two smaller publications that were sold at the entrance to the exhibition give valuable insight into the organization of the Hungarian section. *A Brief Guide to the Department of Fine Arts* covers the layout of the Hungarian wing room by room, even categorizing the works by theme.[30] It also contains a list of Hungarian artists who won prizes from the Fine Arts Department's International Jury of Awards.[31] The list gives an idea of the scope of the exhibition and suggests

the preference of the jury for more conservative works: for example, those by István Csók, Lajos Márk, and János Vaszary, all of which were reproduced in the *Catalogue de Luxe*. *The Reader's Guide to Modern Art* booklet, on the other hand, gives biographical information about the artists on display.[32] This useful contemporary source also includes an extensive bibliography of English, French, and German publications concerning Hungarian art. While the guide does not help us reconstruct the exhibition today, it did give visitors to the PPIE an introduction to Hungarian art.

Besides the exhibition catalogues and guides, Laurvik's own reports on the exhibition contain useful information.[33] One of these contains the only reference to *Two Girls in a Garden* by Impressionist István Csók.[34] *Impressions of the Art at the Panama-Pacific Exposition*, by Laurvik's close colleague Christian Brinton, boasts twenty-seven reproductions of works displayed in the international section.[35] Four are Hungarian paintings, three of which are not reproduced in the PPIE catalogue: an unknown but award-winning painting by Pál Jávor (fig. 153); Gyula Batthyáni's *Longchamps*, a still-lost painting known only through reproductions (fig. 154); and *Parisian Interior* (*Párizsi enteriór*), one of the best-known works of József Rippl-Rónai, generally considered to be the father of Hungarian modernism (pl. 158).[36]

A slim volume by Arthur Bridgman Clark offers the most precise account to date of the pictures' arrangement.[37] It includes a diagram of the Annex, in which The Eight's wing is mislabeled "Hungarian Cubists." The Eight were not

Cubists, and they employed heterogeneous styles, but without any satisfactory stylistic category in which to lump them, Clark likely wished to indicate somehow that it was a progressive group. The PPIE exhibition was the first time that this band of Hungarian modernists was presented to American audiences, and The Eight's dedicated wing in the Annex unmistakably broadcast its significance. The Eight held only three group exhibits in Budapest, yet their impact proved to be as essential to the development of modern Hungarian painting as József Rippl-Rónai's.[38] Károly Kernstok, the oldest member of the group, and Pór drew attention with their gigantic classicizing panels. Lajos Tihanyi, The Eight's talented deaf-mute painter (see pl. 153), and Berény arguably were the most avant-garde artists, rather akin to the Expressionists of the day, although with isolated endeavors that bore stylistic similarities to Cubism and Futurism. Even at the beginning of his career, Berény was among the most radical innovators. In 1907, he displayed work at the Salon des Indépendants in the same room with examples by Matisse and the French Fauves. So had another member of The Eight, Béla Czóbel, who was not included in the PPIE exhibition.

An article in the Hungarian newspaper *Világ* by Laurvik's wife, Elma Pálos, described the Hungarian portion of the exhibit in great detail, relating that the works of The Eight (except for Czóbel and Dezső Orbán, who also did not exhibit), with an emphasis on the Berény collection, came to be in one wing, where they "caused a sensation." "The small adjoining room is pure fresh color and warm, endearing atmosphere. Here we find the silk embroideries by Róbert Berény and his wife [Ilona (Léni) Somló], compositions rich in fine, fantastic, surprising ideas."[39] She also made reference to a staircase hung with Bertalan Pór's large compositions.[40]

Pálos's enthusiasm for the work of The Eight is not surprising, perhaps, but how did the American critics receive it? Clark, for one, hailed the group as the only artists on view, beside the Italian Futurists, who had a "progressive" distinction.[41] He singled out the Bartók portrait, but added that a large part of a wall of Berény paintings reflected "chaotic ideas."[42] In addition to naming Ödön Márffy's painting *Forest Path*, which is still unidentified among any of the artist's known extant works, Clark highlights Pór's *My Family* (*Család*) (pl. 154), in which he regarded the painter as the embodiment of a new art.[43]

Brinton's book contains a surprisingly informed critique of the Hungarian section. In two chapters on the foreign paintings, he devoted a considerable amount of space to the Hungarian work, demonstrating both an understanding of the country's art history and astonishingly good local knowledge. Brinton sketched a convincing history of modern Hungarian painting, from the epoch-making *Picnic in May* by Impressionist Pál Szinyei Merse, through the formation of MIÉNK (the Hungarian Circle of Impressionists and Naturalists), to the

inception of The Eight and beyond.[44] He also criticized the fair's introduction to Hungarian art as rather incomplete, citing its failure to include Cubists Alfred Reth, Joseph Csaky, Árpád Késmárky, and Elemér Kóródy as well as a number of radical young painters already well known in Budapest, Berlin, and Paris.[45] The American critic may have been a bit harsh on PPIE organizers; while painter Alfred Reth and sculptor Joseph Csaky were internationally renowned, the latter two painters, Kóródy and Késmárky, were almost unheard of.

Hungarian press coverage of the exhibition was understandably negligible due to the war. Aside from Pálos's review, one of the most informative reports appeared in the columns of the newspaper *Újság* six months after the close of the Exposition. The article lists the ten Hungarian works that were reproduced in the official catalogue and the Hungarian artists who received prizes. Of perhaps more interest are the journalist's remarks about the circumstances surrounding the Hungarian objects after the show: "As far as we know, J. Nilsen Laurvik, the official organizer of the Hungarian wing, has sent an official report to the Ministry of Public Education regarding the fate of the Hungarian exhibit. According to his account, while we are at war, it is impossible to send home the works that were not purchased. Thus, the collection—just like those of other European nations—will be displayed on an American tour to audiences in bigger cities."[46]

The Fine Arts Department did send selections of the French, Belgian, and Swedish works on tour after the PPIE for the express purpose of selling them, but there is no evidence to support the existence of a traveling Hungarian exhibition. Instead it seems that the Hungarian collection stayed on view in San Francisco after the fair closed in December 1915. Due to the popularity of the art portion of the Exposition, the public requested that the exhibition remain open another six months. Thus, at the close of the PPIE, after most works from American donors were returned and pieces that were sold went home with their new owners, the core material that remained was displayed again.[47] An illustrated catalogue of this post-Exposition exhibition indicates that all of the Hungarian material in the previous display (except for Viktor Olgyay's print *Allee*) was removed from the Annex and reinstalled in the Palace of Fine Arts where it remained on display until May 1916.[48]

The Hungarian artworks did not return home after the 1916 exhibition either. Hundreds of letters and other documents in the SFAA Archives provide a detailed picture of the afterlife of the Hungarian material, the delay in shipping it back to Hungary, the related complaints, and Laurvik's involvement in the whole affair. Most of the letters are requests from the lenders—if not outright demands—that the PPIE return the property to its rightful owners. It is clear from these documents that after the close of the post-Exposition exhibition and

the United States's entry into the war in April 1917, the American government seized the Hungarian works as goods of an enemy state and entrusted their handling to the Alien Property Custodian. What happened next is a question that has no clear answer.

Hungarian art historian Éva Bajkay offered one suggestion, which is regrettably laconic and without a source: "After the San Francisco World Expo, the Hungarian works embarked on a long and difficult-to-follow American circuit. In the course of the tour and in the chaos of World War I, the works disappeared. Since 1920, the Szinyei Merse Society in Budapest has shouldered the task of trying to track down artwork that went abroad."[49] The fact of such an American tour after the exhibition is not proven, however it is certain that the Szinyei Merse Society considered it its responsibility to bring the works home. As the organization's 1925 report explained, "[The Szinyei Merse Society] has taken initial steps in the interest of extraditing and bringing home Hungarian material from the wartime exhibit that remained in Vienna on account of the revolution [the Hungarian Revolution of 1919], as well as the material stranded in America for the past ten years after the San Francisco World Expo."[50]

The archive of the Museum of Fine Arts in Budapest has preserved a dossier of documents related to the extradition of Hungarian works from the United States after the PPIE.[51] A 1922 letter from Elek Petrovics, then director of the Museum of Fine Arts, reveals that a company called Artes was entrusted with the receipt of an undetermined amount of Hungarian material.[52] It seems that Artes received the commission for the works' receipt and possible disposal from the artists and owners, but it is not clear with whom and with regard to which works the company made an agreement. The letter also indicates that Artes was in liquidation at the time and that it had not yet collected a single item in San Francisco. Further correspondence testifies that, one year later, the company still had not returned any of the works.

The artists and owners themselves also endeavored to initiate proper extradition. Some turned directly to the Alien Property Custodian, while others sought aid from the Hungarian consulate in New York, and still others addressed their complaints to Laurvik, who naturally forwarded them on to PPIE officials. Some appealed to every intermediary they could get a word in with—every friend, lawyer, and other influential person—for help.[53] For example, Márk Vedres, a sculptor associated with The Eight, engaged a New York–based Hungarian lawyer named Ernő Kiss to lobby on his behalf. In 1922 Vedres's bronzes and a portrait of him by Rippl-Rónai (pl. 157) were sent back to him in Italy, where he was residing at the time. Lajos Tihanyi asked both Elma Pálos and György Bölöni to intercede for him. In 1920, he wrote to Bölöni, "If you get ahold of the leaders of 'Artes,' please see that my interests are served with regard to the American pictures. Elma once wrote that Artes took over the American pictures with a notary public, etc., but they did not write a line to us interested 'foreigners.' Please ask after Rob's [Róbert Berény's] and Kstok's [Károly Kernstok's] affairs, too, lest there be an artesian stench to the whole business."[54]

A *New York Times* article from March 8, 1923, also confirms that after being stranded for years, some of the Hungarian works would be restored to their owners in swift fashion, with proceedings initiated on the government level.[55] The article also posits another fate for some of the art: The author noted that perhaps not all of the Hungarian artists would ask for their works back, but would rather offer them for sale in the United States, quickly adding that this alternative would be more advantageous for them. After all, instead of the devalued Hungarian crown, they would reap hard dollars for their art on the American market.

An exchange of letters between Laurvik and the Alien Property Custodian's manager in the summer of 1923 gives credence to this idea.[56] The two parties agreed to deliver the articles that had been stuck in San Francisco to New York for a momentous exhibition that fall. The works authorized for sale by their owners would be offered there. Laurvik also mentioned potential buyers in San Francisco, including the San Francisco Museum of Art (later the San Francisco Museum of Modern Art [SFMOMA]), where he served as director. On behalf of the museum, which was an outgrowth of the PPIE and the San Francisco Art Association (see Introduction, this volume), he offered to acquire a few bronze sculptures and medals as well as the greater share of the graphic works. As of today, there is no record of these items in the SFMOMA collection or of how the New York exhibition fared—if it materialized at all.

We do know that in the spring of 1924—after almost nine years in limbo in the United States—a significant number of Hungarian pieces finally arrived home. A memorandum in the archive of the Museum of Fine Arts in Budapest states that on May 31, 1924, a load of shipping cargo arrived from Regensburg, Germany, bearing Hungarian artwork from San Francisco.[57] Captain H. E. Osann, representing the Alien Property Custodian, transferred the articles to Géza Paur, head secretary of the National Hungarian Artists' Association.[58] The Ministry of Religion and Public Education then commissioned Paur to forward the items to their respective owners. Another memo indicates that all of the material, including a list of the art objects, was sent to the Ministry of Religion and Public Education. At some point this vital document was transferred to the national archive; it was destroyed when a bomb hit the building during World War II.

Although the trail of documents on this core material ends here, a number of paintings displayed at both the PPIE and the post-Exposition exhibition are currently housed in Hungarian public and private collections. These works, therefore, found their way back to Hungary by one means or another, but in most cases we do not know how or when. Perhaps only in connection with Bertalan Pór's paintings do credible data stand at our disposal. In addition to *My Family*, the artist exhibited the now-well-known large canvases *Sermon on the Mount* (1911, Hungarian National Gallery) and *Longing for True Love* (1911, Janus Pannonius Múzeum), as well as a series of more than seventy graphic works.[59] Thanks to the intervention of Czechoslovakia, where the artist was a citizen, Pór was able to get these pieces back, albeit not until 1924.[60]

In recent years, thanks to a boost in art sales, many works have surfaced with an official PPIE label affixed to the back, with which we can definitively identify those that were featured in the exhibition.[61] For example, in 2007, a scandal arose surrounding a Mihály Munkácsy picture seized in customs. One of the most celebrated artists in Hungary, Munkácsy earned an international reputation for his genre pictures and large-scale biblical paintings. Though some experts questioned its authenticity as a Munkácsy, the painting unquestionably appeared at the San Francisco fair, where it was listed in the official catalogue as *Sunset*.[62] At a Hungarian auction in 2004, an Ödön Márffy still life from the artist's period in The Eight turned up, with the telltale PPIE label on the back (pl. 155).[63]

Research also occasionally has uncovered such lost works as Berény's portrait of Bartók and his *Golgotha (Scene V)* (pl. 156), which have a fascinating history. In a letter to his first wife, Léni Somló, written in 1926 after their divorce, Berény explained that all of his other works had been returned to him except these two. "I am happy you are going to Máli's [Anna Lesznai's]. Give my regards, tell her I love her, and say that I have not gotten the Christ picture or the Bartók portrait back from America. I have not been able to track down their whereabouts. It appears they have been stolen—no money, no word."[64] At one point Laurvik informed the artist that the pictures had burned during a fire onboard a ship, and, according to his daughter Anna, Berény died believing this was the case.[65] Despite Laurvik's claim, not long after Berény's death in 1953, the hidden pictures implausibly came out of a San Francisco storage facility belonging to Laurvik.[66] They were summarily auctioned, and then changed hands many times. The Bartók portrait now hangs in the director's office at the Paul Sacher Stiftung in Basel, Switzerland. *Golgotha* disappeared for a time, only to resurface a few years ago at auction. Members of Berény's family brought the sale to a halt, and just recently the painting was returned to their possession.

Elma Pálos shed some light on the mysterious circumstances surrounding these pictures when she confessed in her old age that Laurvik had wanted to buy them from Berény. According to Pálos, her husband did not actually *intend* to appropriate them, but Laurvik was "a true Peer Gynt, full of schemes and fancies, but unable to realize his good intentions."[67] As in Berény's letter, Pálos only made mention of the two misappropriated pictures. This raises the question: What could have happened the twenty-one works by Berény whose titles figure on the pages of the PPIE catalogue but do not appear in any professional literature on the artist?

The whereabouts of works of art by other members of The Eight that were shown at the PPIE are also unknown, but a small number of identifiable ones by Kernstok and Pór now reside in such public collections as the Hungarian National Gallery in Budapest and the Janus Pannonius Múzeum in Pécs. Additionally, a few others by Tihanyi, Márffy, and Dezső Czigány have turned up in the course of monograph research by Hungarian art historians.[68]

Many works remain unaccounted for. Where are the works by Béla Uitz mentioned by Éva Bajkay in the catalogue for the 1991 Uitz exhibition at the Albertina in Vienna that also disappeared after the PPIE?[69] Or where could Károly Ferenczy's *Landscape* (fig. 156) and Béla Iványi-Grünwald's *Nascence* (fig. 157)—which we know only from their black-and-white reproductions in the official catalogue—be hiding? The list goes on and on, and more questions keep arising: Were these works actually lost or, as in the case of Berény's, simply "appropriated"? Or perhaps they were purchased? Will the mystery of the missing Hungarian art be solved?

An answer to this last, provocative question may not be possible until a complete reconstruction of the Hungarian material on display at the PPIE is attempted. *The Art of Hungary: 1915, Revisited*, a chamber exhibit at the Federal Reserve Building in Washington, DC, in 2005, succeeded in gathering a few paintings that were in the PPIE exhibition as well as several other works that had nothing to do with it.[70] Nonetheless, the exhibition demonstrated the need for more serious research—along the same lines, but with more resources and a more professional grounding—with the aim of making preparations for a reconstructed exhibit.

1. Júlia Szabó brought my attention to the unusual fate of this portrait during the course of my research for a monograph on Berény. Júlia Szabó, "Berény Róbert Bartók Béla portréja," *Új Művészet* 7 (1993): 14–18, 81.

2. John E. D. Trask and J. Nilsen Laurvik, ed., *Catalogue de Luxe of the Department of Fine Arts, Panama-Pacific International Exposition* (San Francisco: Paul Elder, 1915) 1: xvi.

3. "Secret Trip of Jason Ended: Joseph Pennell Tells How Ship with Art Treasures from Belligerents for California Exposition Kept Under Cover," *New York Times*, April 18, 1915.

4. John D. Barry, *The City of Domes: A Walk with an Architect about the Courts and Palaces of the Panama-Pacific International Exposition with a Discussion of Its Architecture, Its Sculpture, Its Mural Decorations, Its Coloring, and Its Lighting, Preceded by a History of Its Growth* (San Francisco: John J. Newbegin, 1915), accessed online at http://www.books-about-california.com/Pages/The_City_of_Domes/The_City_of_Domes_main.html.

5. John Nilsen Laurvik's name appears in a variety of ways in scholarly literature, from abbreviations of his Christian name to misspellings of his surname. Anna Oelmacher records it as "Lawrick," and Éva Bajkay as "Lawrieck." Even Elma Pálos misspelled her husband's name in her critique of the Exposition, writing "Lawrik J. Nielsen." The strangest error, "Hervé Laurik," and the version that appears the most complete, "John August Nilsen Laurvik," both appear in the edition devoted to the correspondence between Sándor Ferenczi and Sigmund Freud. Éva Brabant et al., ed., *Sigmund Freud Ferenczi Sándor Levelezése*, vol. I/2, 1912–1914, and vol. I/3, 1915–1916 (Budapest: Thalassa Alapítvány–Pólya Kiadó, 2002). References to the critic's origins are also often flawed. Ferenczi mistakenly called him Swedish despite the fact that Laurvik was his stepson-in-law.

6. The exhibition was presented by the Natural Arts Club in New York from March 11 to May 25, 1914, and the Newark Museum Association from April 10 to May 10, 1914. I wish to thank Zoltán Fejős for drawing my attention to these catalogues: *Touring Exhibition of Hungarian Peasant Art organized under the auspices of the National Arts Club of New York by the Home Industry Association of Budapest, Hungary, 1914–1915* and *The Applied Arts of Hungarian Peasants in the Public Library*.

7. "Collecting Art Exhibits in War-Ridden Europe: Some Experiences of the Special Representative of the Panama-Pacific Exhibit," *American Review of Reviews* 51 (January–June 1915): 462–463. A copy of Laurvik's passport that I received from a relative places him in Vienna on December 21, 1914.

8. Barry, *City of Domes*.

9. Emanuel Berman, "Sándor, Gizella, Elma: A Biographical Journey," pt. 2, *International Journal of Psychoanalysis* 85 (April 2004): 489–520.

10. J. Nilsen Laurvik to Frank Burty Haviland, December 1914, Musée d'Orsay Archive. I wish to thank Krisztina Passuth for drawing my attention to this letter.

11. Anna Oelmacher, *Pór Bertalan* (Budapest: Képzőművészeti Alap Kiadóvállalat, 1955), 28.

12. Róbert Berény to György Bölöni, n.d., V.4132/281, Bölöni Papers, Petőfi Museum of Literature Manuscript Collection, Budapest. Berény wrote on the back of his card: "Dear Gyurka, The Laurviks are coming to see us tomorrow around 4 pm to listen to Hungarian music. They and I would be very pleased if you could come, too. As far as I know, he has something to discuss with you. I'm sure you'll drop by. Affectionately, Rob." This and all translations from Hungarian are mine.

13. The Bölöni Papers at the Petőfi Museum of Literature include several notebooks. One of these states, "J. N. Laurvik director of the Fine Arts Palace S. Francisco California U.S.A. 18 pictures. 15 50×60 cm, 3 9 cm, 1 landscape (illegible) ¼ and 1-3 across 700600. Transfer assignment, or by shipping agent, transportation is charged on him and . . . (illegible) 4 h. . . (illegible)."

14. "A magyar művészek és a san franciscó világkiállítás," *Magyarország*, December 30, 1914.

15. Béla Lázár, "A magyar művészek és a san franciscó világkiállítás," *Magyarország*, December 31, 1914.

16. Barry, *City of Domes*.

17. "Collecting Art Exhibits in War-Ridden Europe," 463. Andrássy's newspaper was *Magyar Hírlap*.

18. "Laurvik on Exposition Art," *American Art News*, April 10, 1915.

19. Trask and Laurvik, eds., *Catalogue de Luxe*, 1:xvi.

20. Barry, *City of Domes*.

21. Trask and Laurvik, ed., *Catalogue de Luxe*, 1:xvi.

22. Elma Pálos, "Magyar művészet San Franciscóban," *Világ*, September 12, 1915.

23. Trask and Laurvik, eds., *Catalogue de Luxe*.

24. J. Nilsen Laurvik, "Notes on the Foreign Paintings," *Art and Progress*, August 1915, 360.

25. The archival photographs taken in the French, Belgian, and Swedish sections are a great aid in reconstructing these exhibits. The photos reside in the San Francisco History Center of the San Francisco Public Library. See illustrations in Buron and Chapman, this volume, for example.

26. *Official Catalogue (Illustrated) of the Department of Fine Arts, Panama-Pacific International Exposition (with Awards)* (San Francisco: Wahlgreen, 1915). There are two versions of this catalogue: one with ninety-three illustrations, including a reproduction of a Hungarian work, Lajos Márk's *In Front of a Mirror*, and one that is not illustrated.

27. *Temporary Catalogue of the Department of Fine Arts, Panama-Pacific International Exposition* (San Francisco: Wahlgreen, 1915); and *Temporary Catalogue (Revised) of the Department of Fine Arts, Panama-Pacific International Exposition* (San Francisco: Wahlgreen, 1915).

28. List of Austrian, Hungarian, Finnish, and Norwegian exhibits—consisting of paintings, graphics, bronzes, porcelains, sculpture, embroideries, and rugs—acquired by J. Nilsen Laurvik from abroad and on exhibition at the Palace of Fine Arts by the San Francisco Art Association, 1916, Archives of the San Francisco Art Association, San Francisco Art Institute (hereafter cited as SFAA Archives).

29. Berény exhibited three graphic pieces, which were displayed separately and featured on a different page of the official catalogue. One of the works, *Sewing in the Garden* (fig. 105), may be the known engraving that dates to 1912. Another was a portrait in charcoal owned by Dr. Ferenczi of Ignotus, the founder and editor of the literary magazine *Nyugat*, which could be the work identified as a 1914 Ignotus portrait in the Petőfi Museum of Literature. The third graphic is unidentified.

30. Michael Williams, *A Brief Guide to the Department of Fine Arts: Panama-Pacific International Exposition, San Francisco, California, 1915* (San Francisco: Wahlgreen, 1915).

31. The following Hungarian artists won medals at the PPIE: For paintings, gold medals went to István Csók, Lajos Márk, and János Vaszary; silver medals went to Earl Gyula Batthyány, Miksa Bruck, Gyula Glatter, Oszkár Glatz, Baron Ferenc Hatvany, Pál Jávor, Bertalan Karlovszky, Ferenc Lipóth, Baron László Mednyánszky, Róbert Nádler, and Géza Vastagh; and a bronze medal went to Gusztáv Magyar-Mannheimer. For watercolors, drawings, and prints, Willy Pogány and Béla Uitz earned gold medals; Gyula Conrád earned an honorable mention; silver medals went to Béla Erdőssi, Róbert Lénárt, József Rippl-Rónai, Oszkár Glatz, Baron Ferenc Hatvany, Sándor Nagy, and Wallesz-Gitta Gyenes; and bronze medals went to Lajos Papp, Andor Dobai Székely, István Príhoda, and Miklós Vadász. In sculpture, Imre Simay won a silver medal; Erzsi Fehérvári earned an honorable mention; and Lajos Pick, Ede Telcs, and Márk

Vedres won bronze medals. For plaquettes and medals, a gold medal went to Ede Telcs; silver medals went to Fülöp Ö. Beck and Gyula Murányi; and a bronze medal went to A. R. Zutt.

32. Robert B. Harshe, *A Reader's Guide to Modern Art* (San Francisco: Wahlgreen, 1915).

33. Laurvik, "Notes on the Foreign Paintings"; and J. Nilsen Laurvik, "Hungarian and Norwegian Art," *Century* 91 (March 1916): 691–692.

34. Laurvik, "Notes on the Foreign Paintings," 359.

35. Christian Brinton, *Impressions of the Art at the Panama-Pacific Exposition* (New York: John Lane, 1916).

36. This has forced us to revise the exhibition history of *Parisian Interior* somewhat, since the fact of its having been exhibited at the PPIE has been uncovered only recently by scholars of Hungarian art.

37. Arthur Bridgman Clark, *Significant Paintings at the Panama-Pacific Exposition: How to Find Them and How to Enjoy Them* (Palo Alto: Stanford University Press, 1915).

38. In the early 1890s, Rippl-Rónai was an active member of the French group known as the Nabis, and a friend to French modernists Aristide Maillol, Pierre Bonnard, Édouard Vuillard, and Maurice Denis. After its success in Paris, Rippl-Rónai's work did not feature in Hungarian exhibitions until 1900. From that point on, it had a decisive influence on Hungarian painting's orientation toward Parisian developments.

39. Elma Pálos, "Magyar művészet San Franciscóban." Berény's embroidery originally appeared in Hungary at the final exhibit of the Eight in late 1912; however, before then the couple had shown their applied art objects at the Keller und Reiner Salon in Berlin. They soon expanded into manufacturing, producing cushions, bags, tapestries, and other embroidered articles that brought them considerable critical and financial success.

40. The artist confirmed in an interview that his paintings were displayed in separate hall. Bertalan Pór, interview by Béla Horváth, n.d., Institute of Art History, Research Centre for the Humanities, Hungarian Academy of Sciences Archives, Budapest (hereafter cited as MTA-MKI Archives). Pór recalled, "This [*My Family*] and other canvases were then taken to the San Francisco World Fair, where I had a separate hall. I wanted to attend, but the outbreak of the war prevented it."

41. Clark, *Significant Paintings*, 14.

42. Ibid.

43. Ibid. "Pór's 'My Family,' C425, has not flattered these dejected people. His art is a new kind; we can at least admire his sincerity, intensity, and courage."

44. MIÉNK (Magyar Impresszionisták és Naturalisták Köre) was formed in 1908. At the end of 1909, a group of young artists led by Károly Kernstok left the radical wing of MIÉNK and formed The Eight.

45. It is indeed remarkable that Brinton knew of such obscure artists. He may have seen *Exhibition of Contemporary Graphic Art in Hungary, Bohemia, and Austria*, an exhibition of avant-garde graphic art that traveled to five American cities in 1913 and 1914. The accompanying catalogue included an extraordinarily detailed preface with a history of modern Hungarian graphic art up to 1914 written by Martin Birnbaum, the Hungarian-born art critic, historian, collector, and dealer. For more on Kóródy, see János Kiss, *Vásárhelyi Művészélet* (Budapest: Képzőművészeti Alap Kiadóvállalata, 1957), 166; and minutes of teachers' conferences from the National Royal Hungarian Drawing Teacher's Academy, MDK-C-I-1/13 and 39, MTA-MKI Archives. For more on Késmárky, see Késmárky's short autobiography, n.d., MDK-C-I/3490, 1, MTA-MKI Archives; and Tivadar Raith, "Magyarok a Salon des Artistes Indépendents-ban," *Nyugat* (1914): 7.

46. "A Magyar művészet a san franciscó kiállításon. Díjat nyert művészeink," *Újság*, October 27, 1916.

47. Five Hungarian pieces sold during the PPIE exhibition. A register of purchases lists two Hungarian prints: Viktor Olgyay's *Allee* sold for $12 to Herbert Fleishhacker, registered at the Saint Francis Hotel, and István Prihoda's *Study of Female Nude* sold for $15 to C. M. Cole of Mill Valley. In Laurvik's annotated list, the word "sold" appears next to three of Berény's embroidery works. I thank Heidi Applegate, doctoral candidate and contributor to this catalogue, for making this information available to me.

48. *Illustrated Catalogue of the Post-Exposition Exhibition in the Department of the Fine Arts, Panama-Pacific International Exposition* (San Francisco: San Francisco Art Association, 1916).

49. Éva Bajkay, "A magyar grafika az Egyesült Államokban a két világháború között," in *"Külön világban és külön időben": 20. századi Magyar képzőművészek Magyarország határain kívül 1918-tól napjainkig* (Budapest: Magyar Képzőművészek és Iparművészek Társasága, 2001), 21. The Szinyei Merse Society was created after the death of the famous painter Pál Szinyei Merse by a group of his friends to continue his work of discovering and promoting new, young artists. It existed from 1920 to 1949 as one of the major art organizations in Hungary between the two World Wars.

50. Report of the Szinyei Merse Pál Society, ed. Sándor Jeszenszky, February 12, 1925, Szinyei Merse Pál Society, Budapest.

51. I thank Péter Molnos for drawing my attention to this dossier.

52. Elek Petrovich to the Minister of Religion and Education, April 21, 1922, inv. no. 652/1925, 324/1922, Museum of Fine Arts Archive, Budapest.

53. The SFAA Archives contain most of the dozens of letters regarding works loaned by Valér Ferenczy, Henrik Major, Bertalan Pór, Márk Vedres, and Count Gyula Andrássy.

54. Lajos Tihanyi to György Bölöni and his wife, Itóka, November 15, 1920, fond 198/22/15, National Széchényi Library Letter Archive, Budapest. "Artesian stench" is simultaneously a play on "Artes" (the art-handling company) and a reference to a sewer.

55. "'Enemy' Artworks Held Here Six Years To Be Given Back; May Be Sold in America," *New York Times*, March 8, 1923.

56. SFAA Archives.

57. The restoration of works from Regensburg was entrusted to the Shipment and Trade Holding Company (bill of lading no. 11870).

58. Robert J. Baptista, "Spies and Dyes," last modified March 4, 2010, accessed October 21, 2014, http://www.colorantshistory.org/SpiesDyes2.html. At the time, H. E. Osann was chief of the U.S. Military Secret Police in Coblenz.

59. Anna Oelmacher, *Pór Bertalan*, 29. Besides these canvases, Oelmacher only mentions the "Folk Opera Decoration-board" and three related drawings. Nevertheless, it is quite clear from the catalogue that the Pór collection was much larger. The graphic works are included in Trask and Laurvik, eds., *Catalogue de Luxe*.

60. Correspondence related to the return of these works resides in the SFAA Archives.

61. The official PPIE exhibition label is an important, but rarely intact, identifying mark. In most cases, it also bears the name of the owner of the artwork.

62. In addition to bearing the PPIE label, the painting appears in an archival photograph taken in the home of Count Andrassy, who was listed as its lender in the catalogue.

63. Lot 204, Spring Auction (25th Auction), 2004, Kieselbach Gallery, Budapest.

64. Róbert Berény to Léni Somló, August 23, 1926, 23306/1992/II, Hungarian National Gallery Archives. Berény mentions these two works in particular, perhaps because Anna Lesznai was fond of them.

65. This was told to the author on several occasions by Anna Berény.

66. Béla Szíj, "La vie de Róbert Berény, de son enfance à son émigration à Berlin," *Bulletin de la Galerie Nationale Hongroise*, no. 4 (Budapest: A Galéria, 1963): 114–115.

67. Berman, "Sándor, Gizella, Elma," 511.

68. See Valéria Vanília Majoros, *Tihanyi Lajos: A művész és művészete* (Budapest: Monumentum-Art, 2005); Zoltán Rockenbauer, *Márffy: Monográfia és életműkatalógus* (Budapest: Makláry Artworks, 2006),70, 76; and Attila Rum, *Dezső Czigány* (Budapest, 2004), 295–296.

69. Éva Bajkay, *Béla Uitz: Arbeiten auf Papier aus den Jahren 1913–1915* (Vienna: Grafische Sammlung Albertina, 1991), 7.

70. The exhibit ran from September 26 to December 2, 2005.

Oui toutes ces ao
s tout ce que j ai
fait par l aide de

Within the tapestry, text appears on banners:

Eest·par·toi·Evesque·que·ie·meur
Rouen! Rouen! Malheur·à·toi

étaient
t·ie·fai
zu.

134　Jean-Paul Laurens (French, 1838–1921)
The Execution of Joan of Arc, from the series *The Story of Joan of Arc*, 1905–1907
Wool and silk; tapestry weave
92 × 169 in. (233.7 × 429.3 cm)
Fine Arts Museums of San Francisco, gift of the French Government, 1924.32.3
French Pavilion, Gallery 1

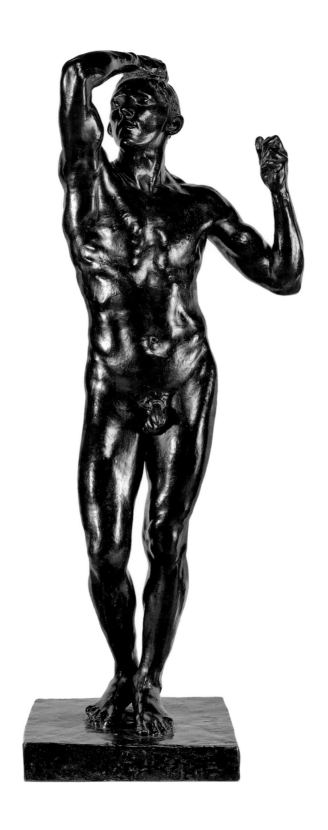

135 Auguste Rodin (French, 1840–1917)
The Age of Bronze, ca. 1875–1877
Bronze
71 ½ × 21 ¼ × 25 ½ in. (181.6 × 54 × 64.8 cm)
Fine Arts Museums of San Francisco, gift of Alma de Bretteville Spreckels, 1940.141
French Pavilion, Gallery 2 (Main Central Hall)

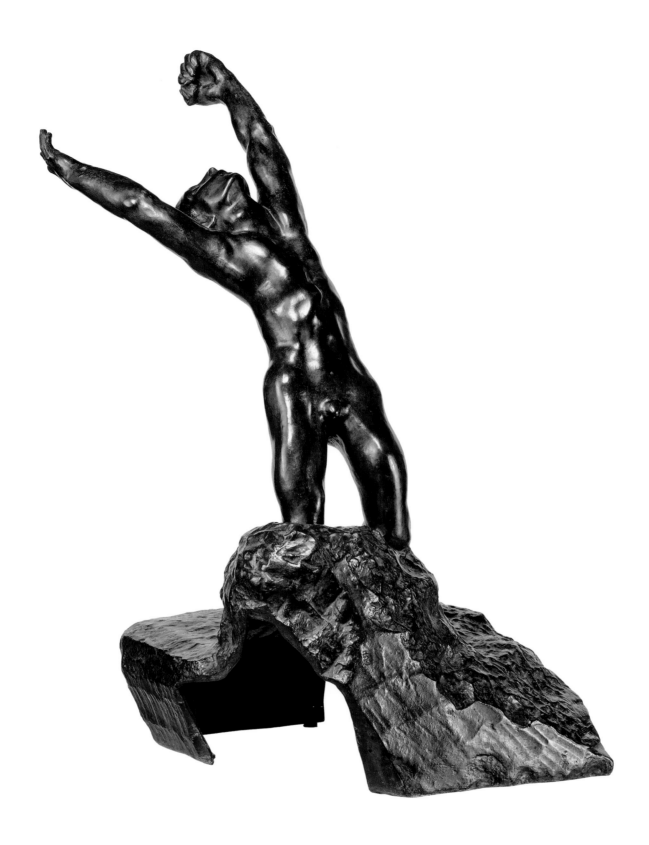

136 Auguste Rodin (French, 1840–1917)
The Prodigal Son, 1887
Bronze
64 × 28 × 34 ½ in. (162.6 × 71.1 × 87.6 cm)
Fine Arts Museums of San Francisco, gift of Alma de Bretteville Spreckels, 1940.137
French Pavilion, Gallery 2 (Main Central Hall)

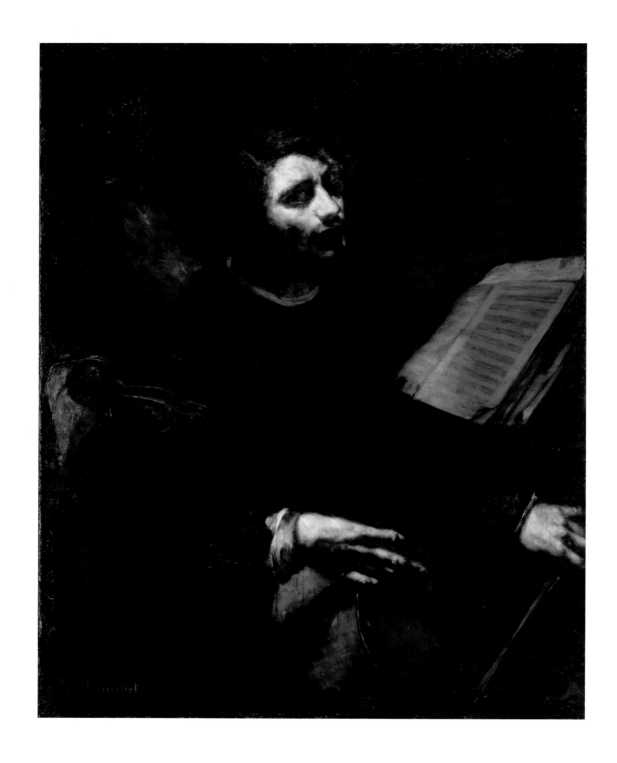

137 Gustave Courbet (French, 1819–1877)
The Violoncellist, 1847
Oil on canvas
44 ¼ × 34 ⅛ in. (112.4 × 86.7 cm)
Portland Art Museum, Portland, Oregon,
gift of Col. C. E. S. Wood in memory of his wife, Nanny Moale Wood, 43.2.1
Palace of Fine Arts, Gallery 92, wall A, no. 4019, as *Young Man with Violincello*

138 James Tissot (French, 1836–1902)
L'ambitieuse (*The Political Woman*), 1883–1885
Oil on canvas
73½ × 56 in. (186.7 × 142.2 cm)
Albright-Knox Art Gallery, Buffalo, New York, gift of William M. Chase, 1909, 1909:10
Palace of Fine Arts, Gallery 92, wall D, no. 4040, as *The Reception*

139 Camille Pissarro (French, 1831–1903)
Houses at Bougival (Autumn), 1870
Oil on canvas
35 × 45⅜ in. (88.9 × 116.2 cm)
J. Paul Getty Museum, Los Angeles, 82.PA.73
Palace of Fine Arts, Gallery 61, wall C, no. 2819, as *Village aux environs de Mantes*

140 Camille Pissarro (French, 1831–1903)
Red Roofs, Village Corner, Winter Effect (*Les toits rouges, coin de village, effet d'hiver*), 1877
Oil on canvas
21½ × 25⅞ in. (54.5 × 65.6 cm)
Musée d'Orsay, Paris, RF 2735
French Pavilion, Gallery 6, no. 62

141 Paul Cézanne (French, 1839–1906)
The Gulf of Marseille from L'Estaque (Le golfe de Marseille vu de L'Estaque), 1878–1879
Oil on canvas
22 ⅞ × 28 ⅜ in. (58 × 72 cm)
Musée d'Orsay, Paris, RF 2761
French Pavilion, Gallery 6, no. 18

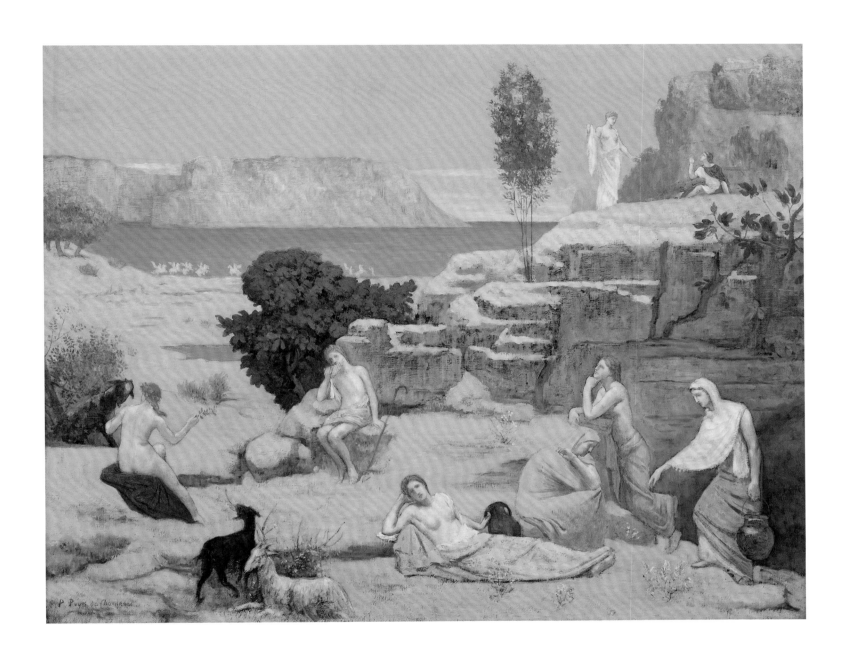

142 Pierre Puvis de Chavannes (French, 1824–1898)
A Vision of Antiquity—Symbol of Form, ca. 1885
Oil on canvas
41 ¼ × 52 in. (104.8 × 132.1 cm)
Carnegie Museum of Art, Pittsburgh, purchase, 97.3
Palace of Fine Arts, Gallery 61, wall D, no. 2831

143 Edgar Degas (French, 1834–1917)
At the Café-Concert, ca. 1879–1884
Oil on canvas
25⅞ × 18⅜ in. (65.8 × 46.7 cm)
National Gallery of Canada, Ottawa, gift of the Saidye Bronfman Foundation, 1995, 38088
Palace of Fine Arts, Gallery 13, no. 310

144 **Claude Monet** (French, 1840–1926)
Rouen Cathedral Facade (*La cathédrale de Rouen. Le portail vu de face*), 1892
Oil on canvas
42 ¼ × 29 ¼ in. (107 × 74 cm)
Musée d'Orsay, Paris, RF 2779
French Pavilion, Gallery 14, no. 54, as *The Cathedral*

145 André Édouard Devambez (French, 1867–1944)
The Charge (Le charge), 1902–1903
Oil on canvas
50 × 63 ¾ in. (127 × 162 cm)
Musée d'Orsay, Paris, RF 1979 61
Palace of Fine Arts, French Section, no. 319

146 Théo van Rysselberghe (Belgian, 1862–1926)
Garden of the Generalife in Granada, 1913
Oil on canvas
31 ¾ × 33 in. (80.6 × 83.8 cm)
Fine Arts Museums of San Francisco, gift of B. Gerald Cantor, 1969.1
French Pavilion, Gallery 17 (Belgian Section), no. 109

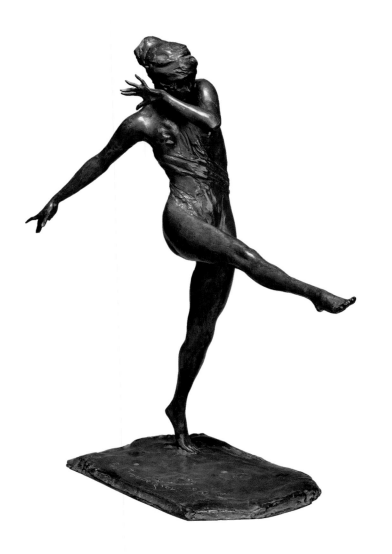

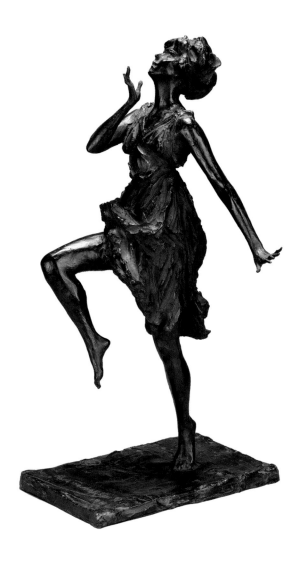

147 Prince Paolo Troubetzkoy (Italian, 1866–1938)
Lady Constance Stewart Richardson, 1914
Bronze
13 ½ × 3 ½ × 12 ¼ in. (34.3 × 9 × 31.1 cm)
Fine Arts Museums of San Francisco, Theater and Dance Collection,
gift of Alma de Bretteville Spreckels, 1962.133
Palace of Fine Arts, Gallery 108, no. 1089

148 Prince Paolo Troubetzkoy (Italian, 1866–1938)
La Danseuse (Mademoiselle Svirsky), 1911
Bronze
21 × 9 ¼ × 6 ¼ in. (53.3 × 23.5 × 15.9 cm)
Fine Arts Museums of San Francisco, gift of Rosamond Hagney, 1985.60.2
Palace of Fine Arts, Gallery 108, no. 1088, as *Mme. Svirsky*

149 Nikolay Fechin (Russian, 1881–1955)
Lady in Pink (Portrait of Natalia Podbelskaya), 1912
Oil on canvas
45 ½ × 35 in. (115.6 × 89 cm)
Frye Art Museum, Seattle, 1990.005
Palace of Fine Arts, Gallery 61, wall B, no. 2816

150 Leo Putz (German, 1869–1940)
On the Shore (Am Ufer), 1909
Oil on canvas
59½ × 55½ in. (151 × 141 cm)
Collection Siegfried Unterberger
Palace of Fine Arts, Gallery 108, wall C, no. 428

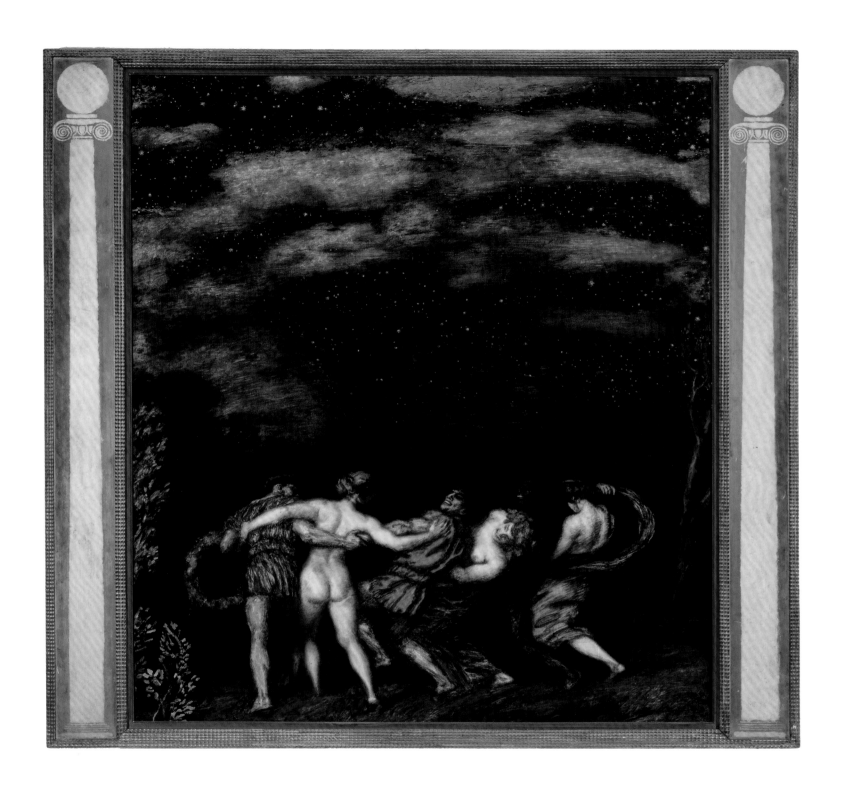

151 Franz von Stuck (German, 1863–1928)
Summer Night, ca. 1910
Oil on canvas in frame
Framed: 46¾ × 49 in. (118.8 × 124.5 cm); unframed: 43½ × 37¾ in. (110.5 × 95.9 cm)
Collection of John and Berthe Ford, Baltimore
Palace of Fine Arts, Gallery 108, wall A, no. 472

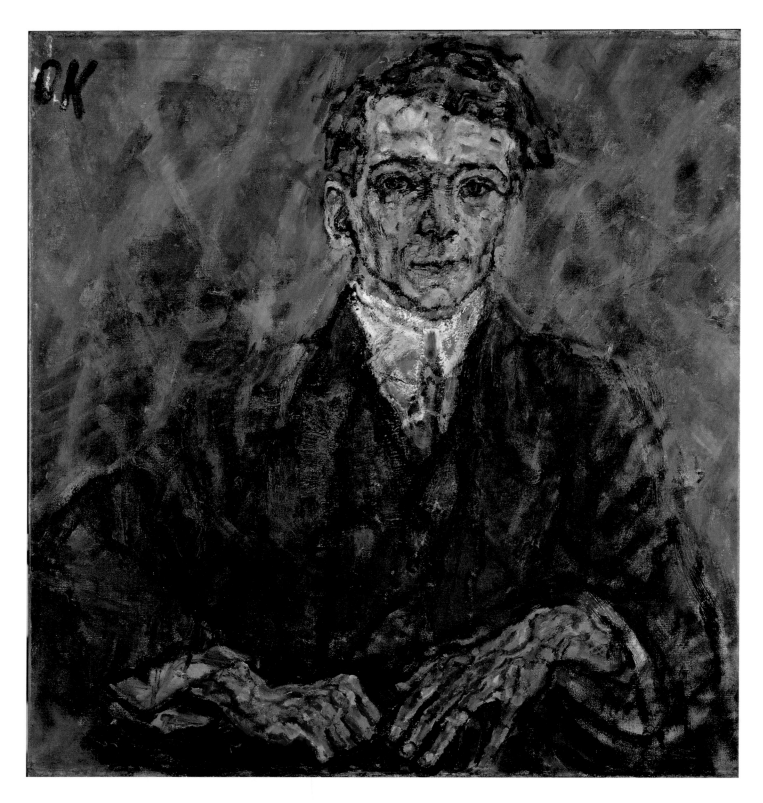

152 Oskar Kokoschka (Austrian, 1886–1980)
Portrait of Egon Wellesz, 1911
Oil on canvas
29 ¾ × 27 ⅛ in. (75.5 × 68.9 cm)
Hirshhorn Museum and Sculpture Garden, Smithsonian Institution, Washington, DC,
gift of the Joseph H. Hirshhorn Foundation, 1966, 66.2776
Palace of Fine Arts Annex, Gallery 142, no. 308

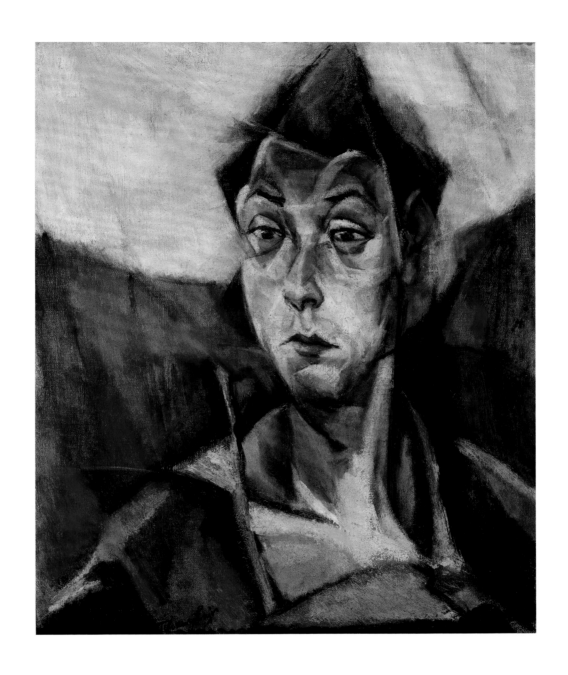

153　Lajos Tihanyi (Hungarian, 1885–1938)
Self-Portrait (*Önarckép*), 1914
Oil on canvas
22 × 17¾ in. (56 × 45 cm)
Magyar Nemzeti Galéria, Budapest, 62.31 T
Palace of Fine Arts Annex, no. 484

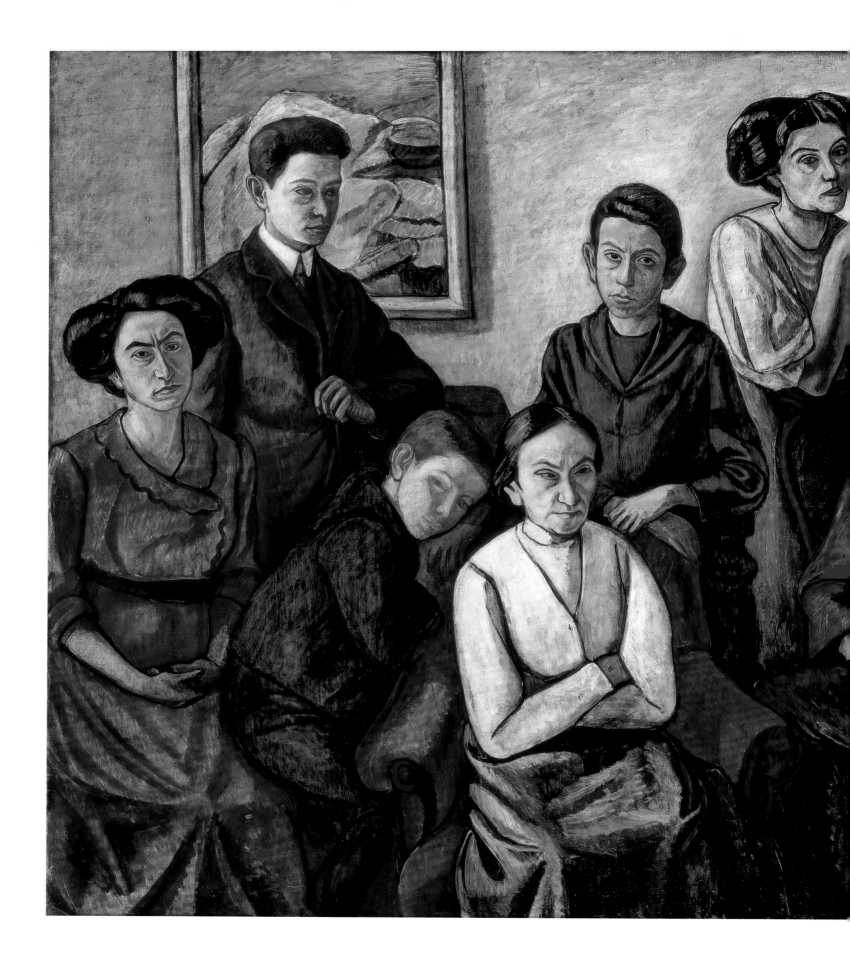

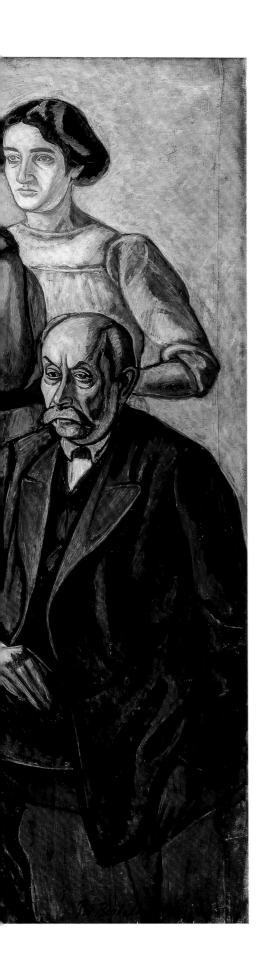

154 Bertalan Pór (Hungarian, 1880–1964)
My Family (*Család*), 1909–1910
Oil on canvas
69 ¼ × 81 ⅛ in. (176 × 206 cm)
Magyar Nemzeti Galéria, Budapest, 60.136T
Palace of Fine Arts Annex, no. 425

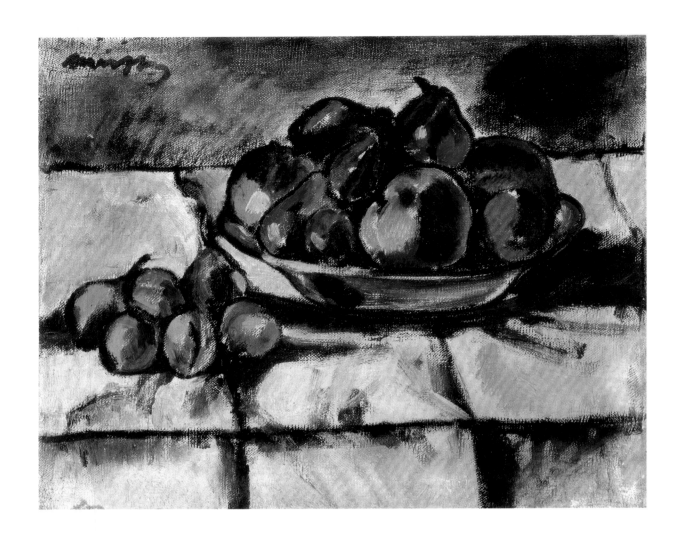

155 Әdön Márffy (Hungarian, 1878–1959)
Still Life, ca. 1910
Oil on canvas
17 ⅜ × 21 ⅜ in. (44 × 55 cm)
Collection of Jill A. Wiltse and H. Kirk Brown III, Denver
Palace of Fine Arts Annex, Gallery 127, no. 375

156 Róbert Berény (Hungarian, 1887–1953)
Golgotha (Scene V), 1912
Oil on canvas
24 ¼ × 19 ⅞ in. (61.5 × 50.5 cm)
Drs. Thomas Sos and Shelley Wertheim, and Lidia Szejko and Nanci Clarence
Palace of Fine Arts Annex, Gallery 127, no. 33

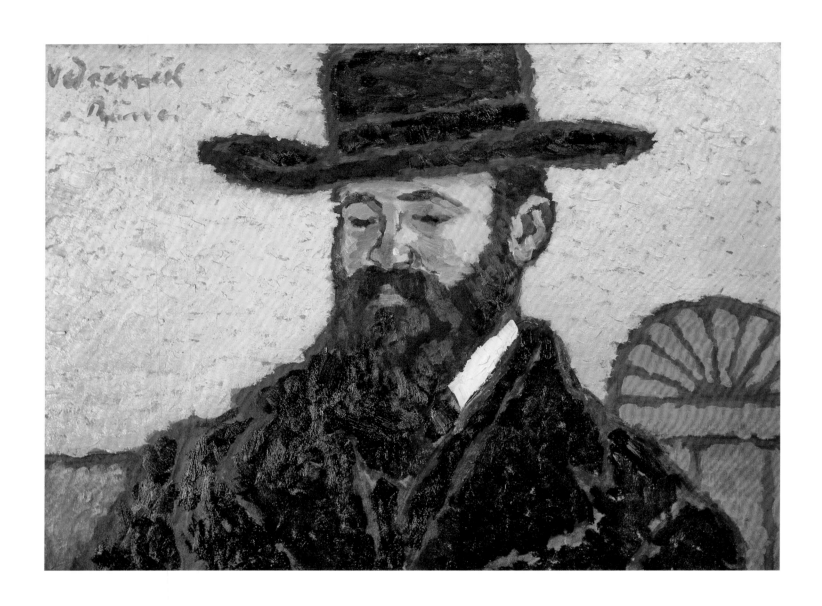

157　József Rippl-Rónai (Hungarian, 1861–1927)
Portrait of Márk Vedres (*Vedres Márk portréja*), 1910
Oil on cardboard
19⅜ × 26¾ in. (50 × 68 cm)
Collection of Elisabetta Vedres
Palace of Fine Arts Annex, Gallery 129, no. 447

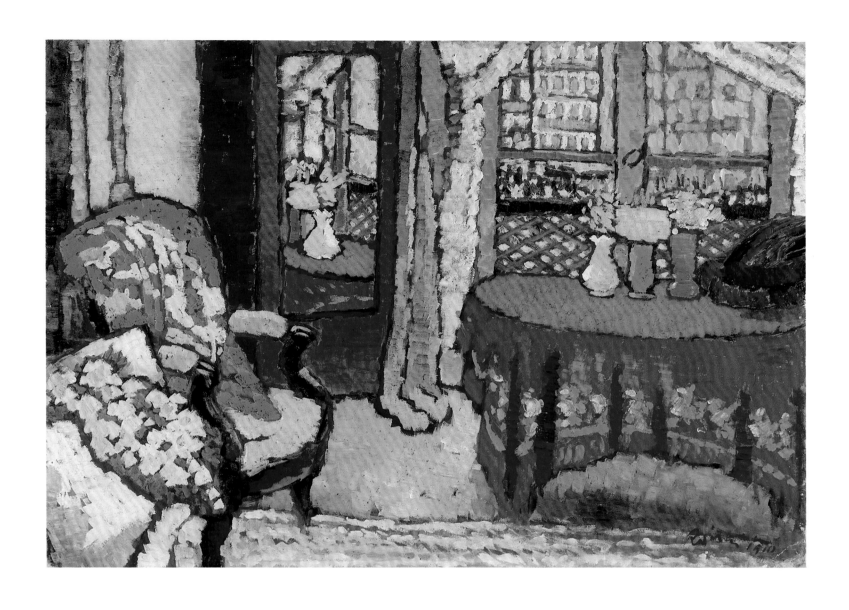

158 József Rippl-Rónai (Hungarian, 1861–1927)
Parisian Interior (Párizsi enteriőr), 1910
Oil on cardboard
29 ¾ × 41 ⅛ in. (75.5 × 104.5 cm)
Kieselbach Collection, Budapest
Palace of Fine Arts Annex, Gallery 129, no. 448

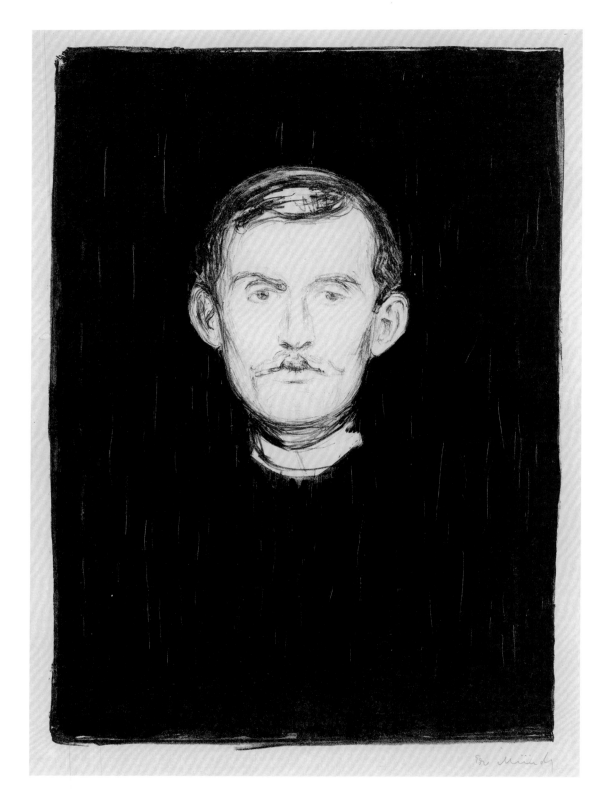

159 Edvard Munch (Norwegian, 1863–1944)
Self-Portrait, 1895
Lithograph
17⅞ × 12½ in. (45.5 × 31.7 cm)
Berkeley Art Museum, California, partial gift of Michal and R. E. Lewis and purchase made possible
by a bequest from Thérèse Bonney, Class of 1916, by exchange, 1995.23
Palace of Fine Arts Annex, Gallery 149, no. 223

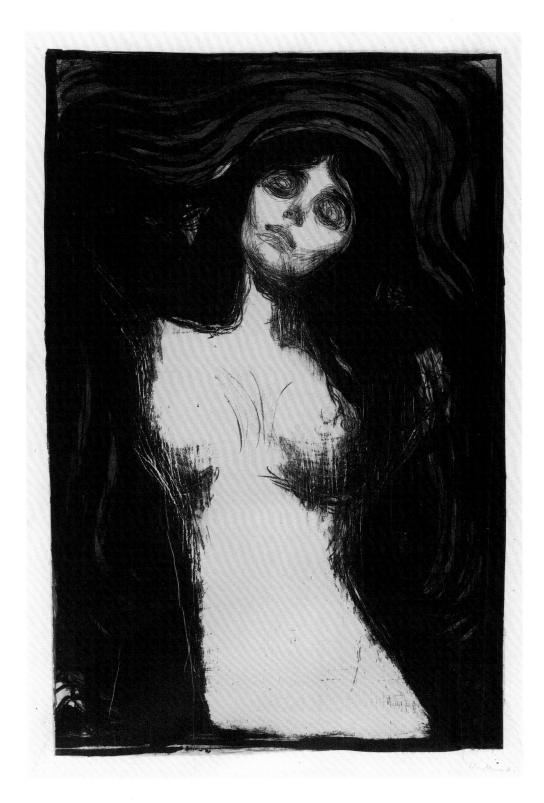

160 Edvard Munch (Norwegian, 1863–1944)
Madonna, 1895–1913/1914
Color lithograph in black, red, and olive, and sawn woodblock or stencil in blue,
hand touched, on thick white Japanese paper
21 ⅞ × 13 ¾ in. (55.6 × 34.9 cm)
Epstein Family Collection
Palace of Fine Arts Annex, Gallery 149, no. 216, as *Loving Woman* (lithograph in 4 colors)

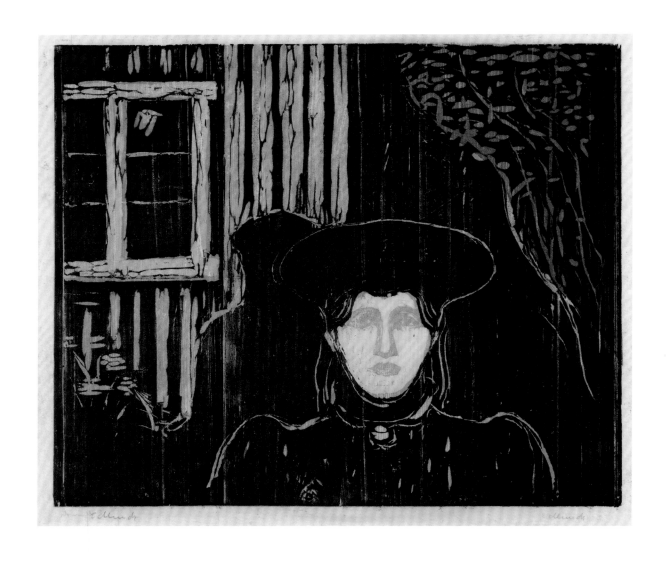

161 Edvard Munch (Norwegian, 1863–1944)
 Moonlight I, 1896
 Color woodcut on thin Japanese paper
 15 ¾ × 18 ½ in. (40 × 47 cm)
 Fine Arts Museums of San Francisco, museum purchase,
 the Herman Michels Collection, Vera Michels Bequest Fund, 1993.121
 Palace of Fine Arts Annex, Gallery 149, no. 222

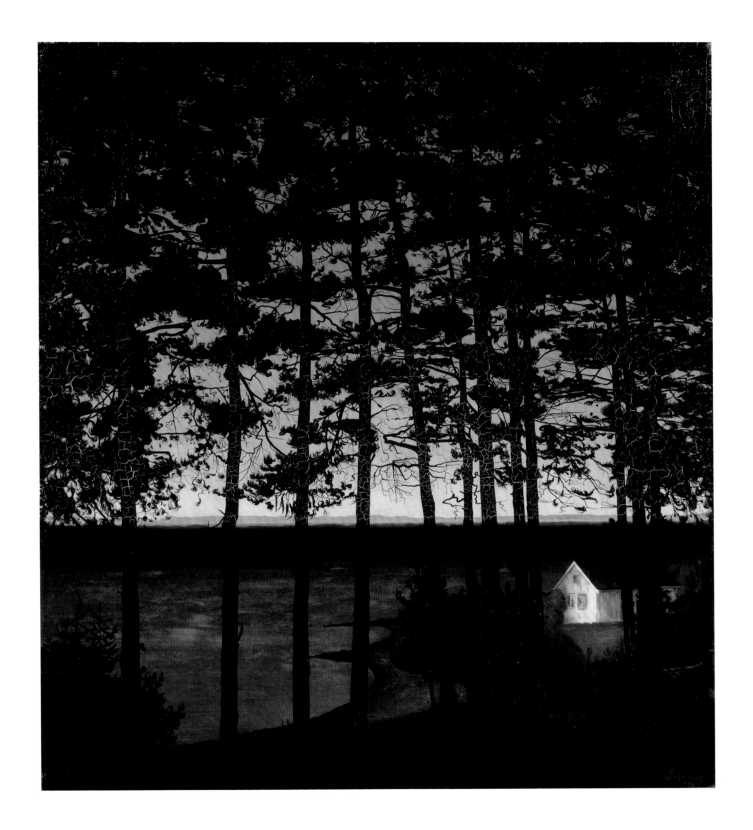

162 Harald Oskar Sohlberg (Norwegian, 1869–1935)
Fisherman's Cottage, 1906
Oil on canvas
43 × 37 in. (109 × 94 cm)
Art Institute of Chicago, gift of Edward Byron Smith, 2000.1
Palace of Fine Arts Annex, no. 117

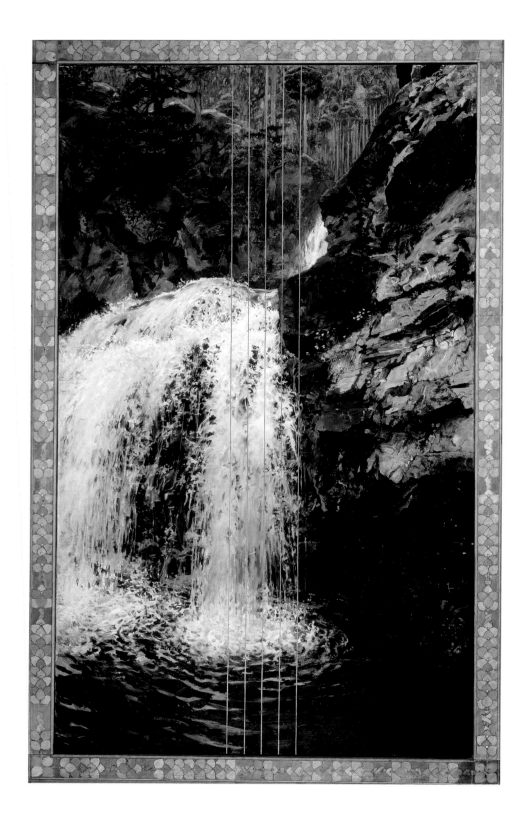

163 Akseli Gallen-Kallela (Finnish, 1865–1931)
Mäntykoski Waterfall (*Mäntykoski*), 1892–1894
Oil on canvas in frame
Framed: 119½ × 75¼ in. (303.5 × 191.2 cm); unframed: 106¼ × 61⅜ in. (270 × 156 cm)
Private collection
Palace of Fine Arts Annex, Gallery 138, no. 216, as *The Waterfall*

164 Akseli Gallen-Kallela (Finnish, 1865–1931)
Symposion (The Problem) (Symposion [Probleema]), 1894
Oil on canvas in frame
Framed: 46 × 56 ¼ in. (117 × 143 cm); unframed: 29 ⅛ × 39 ⅜ in. (74 × 100 cm)
Private collection
Palace of Fine Arts Annex, Gallery 138, no. 169

165 Akseli Gallen-Kallela (Finnish, 1865–1931)
In the Brush, 1910
Oil on canvas
15 ½ × 11 ½ in. (39.4 × 29.2 cm)
Private collection
Palace of Fine Arts Annex, Gallery 138, no. 230

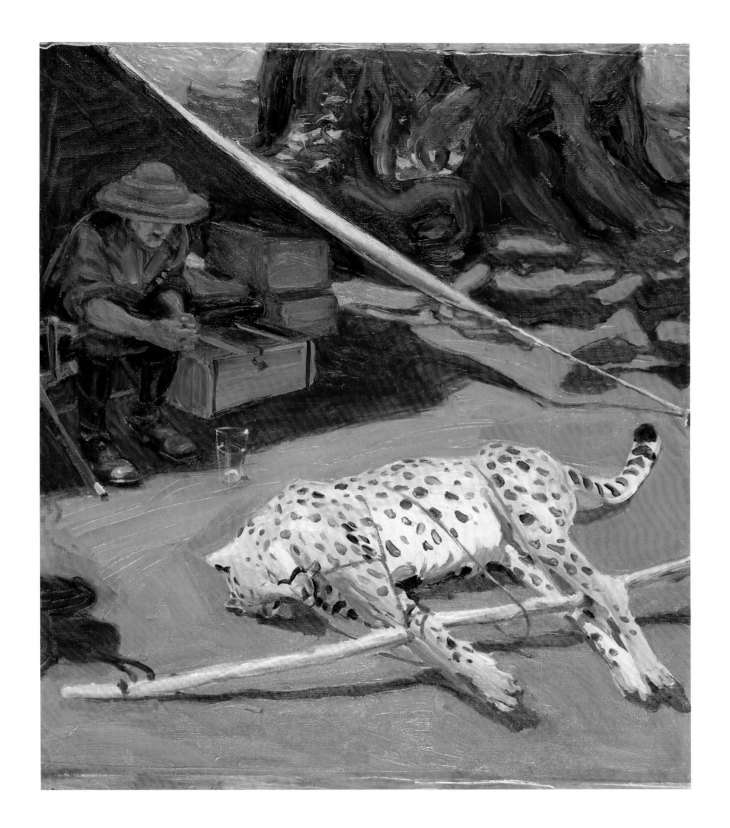

166 Akseli Gallen-Kallela (Finnish, 1865–1931)
Self-Portrait with Cheetah (*Omakuva Cheetahin kanssa*), 1910
Oil on canvas
56¼ × 49¼ in. (143 × 125 cm)
Private collection
Palace of Fine Arts Annex, Gallery 138, no. 211, as *After the Hunt*

167 Umberto Boccioni (Italian, 1882–1916)
Matter (*Materia*), 1912
Oil on canvas
89 × 59 in. (226 × 150 cm)
Gianni Mattioli Collection, on loan to the Peggy Guggenheim Museum, Venice
Palace of Fine Arts Annex, Gallery 141, no. 1142

168 Umberto Boccioni (Italian, 1882–1916)
Dynamism of a Soccer Player, 1913
Oil on canvas
76 × 79⅛ in. (193.2 × 201 cm)
Museum of Modern Art, New York, The Sidney and Harriet Janis Collection, 580.1967
Palace of Fine Arts Annex, Gallery 141, no. 1143, as *Dynamism of a Footballer*

169 Umberto Boccioni (Italian, 1882–1916)
Dynamism of a Cyclist (*Dinamismo di un ciclista*), 1913
Oil on canvas
27 ½ × 37 ⅜ in. (70 × 95 cm)
Gianni Mattioli Collection, on long-term loan to the Peggy Guggenheim Collection, Venice, GM5
Palace of Fine Arts Annex, Gallery 141, no. 1140

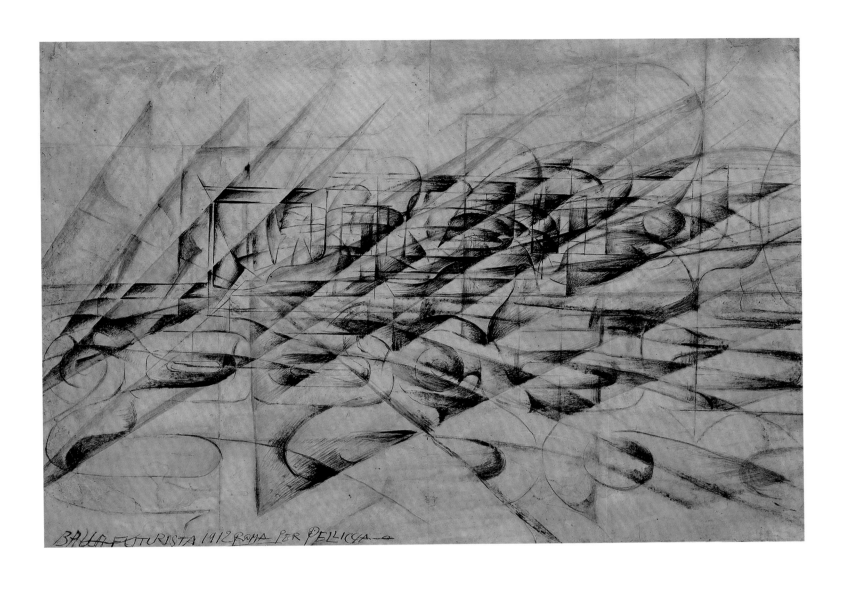

170 Giacomo Balla (Italian, 1871–1958)
Disintegration × Speed, Dynamic Dispersions of an Automobile
(*Disgregazione × velocità, penetrazioni dinamiche d'automobile*), 1913
Gouache, wash and brush and ink on paper laid down on card
26 ⅜ × 37 ⅜ in. (67.7 × 95.7 cm)
Massimo and Sonia Cirulli Archive, New York
Palace of Fine Arts Annex, Gallery 141, no. 1131, as *Dynamism of Dispersion*

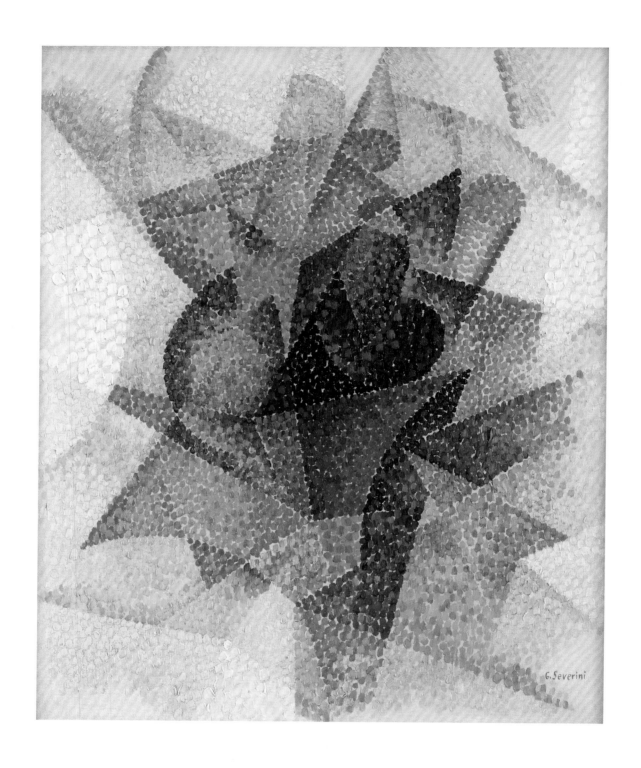

171 Gino Severini (Italian, 1883–1966)
Spherical Expansion of Light, Centripetal, 1913–1914
Oil on canvas
24 × 19 ½ in. (60.9 × 49.5 cm)
Private collection
Palace of Fine Arts Annex, Gallery 141, no. 1167

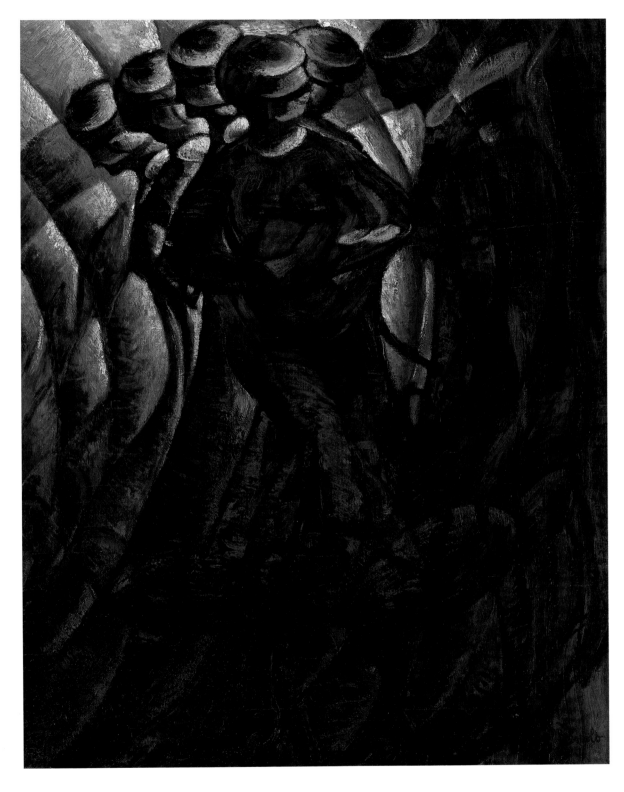

172 Luigi Russolo (Italian, 1885–1947)
Plastic Synthesis of a Woman's Movements
(*Synthèse plastique des mouvements d'une femme*), 1912
Oil on canvas
33 ½ × 25 ⅜ in. (85 × 65 cm)
Musée des Beaux-Arts, Grenoble, France
Palace of Fine Arts Annex, Gallery 141, no. 1161, as *Plastic Summary of a Woman's Movements*

GROUND PLAN OF THE EXPOSITION

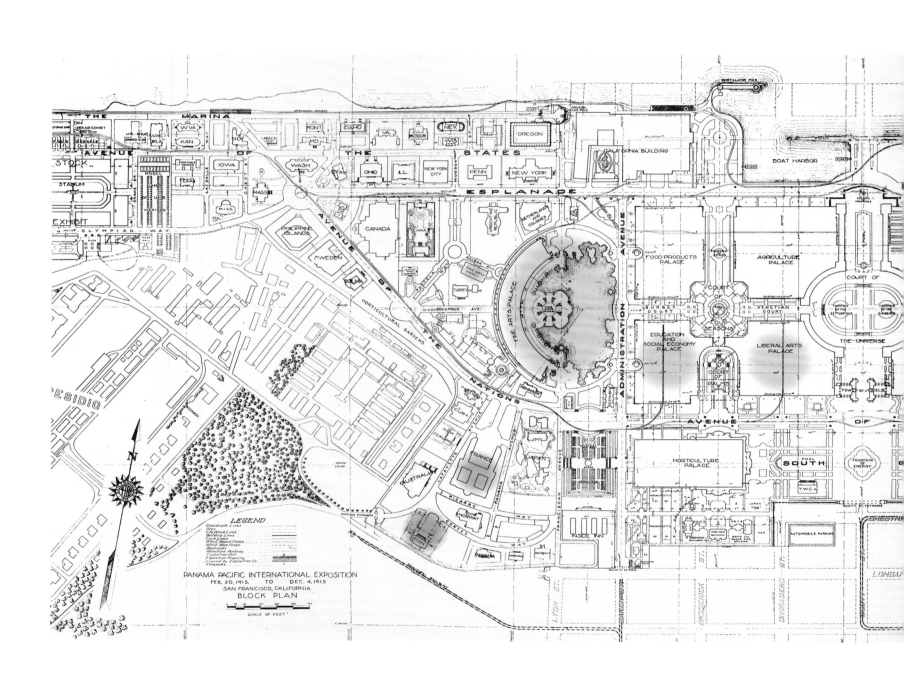

PANAMA PACIFIC INTERNATIONAL EXPOSITION
FEB. 20, 1915, TO DEC. 4, 1915
SAN FRANCISCO, CALIFORNIA
BLOCK PLAN

SCALE OF FEET

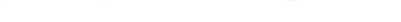

Palace of Fine Arts Annex French Pavilion Greek Pavilion Palace of Education and Social Economy Palace of Liberal Arts

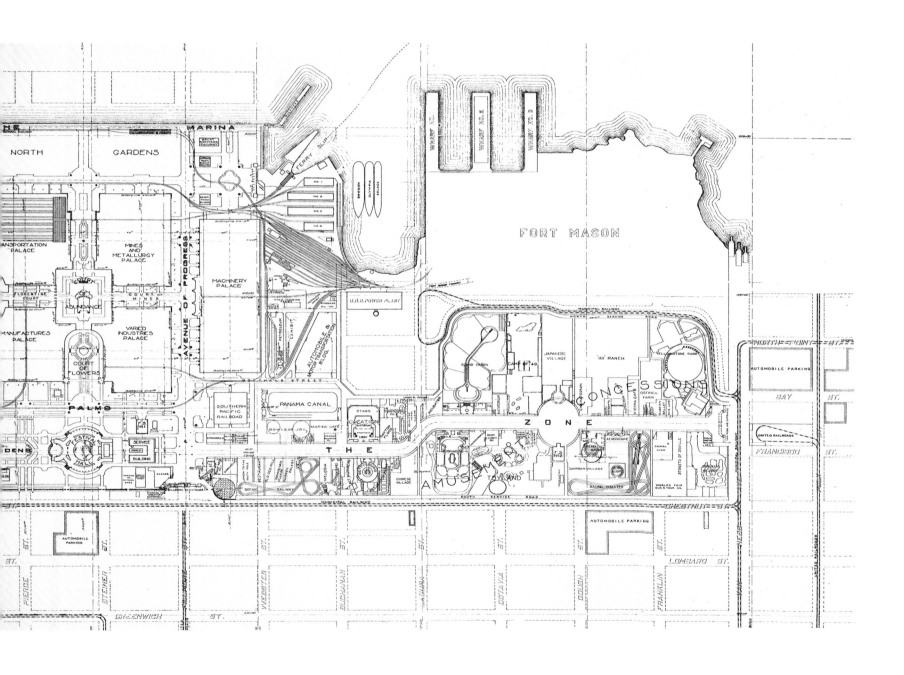

FIG. 158
"Block plan Panama-Pacific International
Exposition, Feb. 20, 1915 to Dec. 4,
1915." Courtesy San Francisco Ephemera
Collection, California Historical Society,
San Francisco, CHS2014.1874

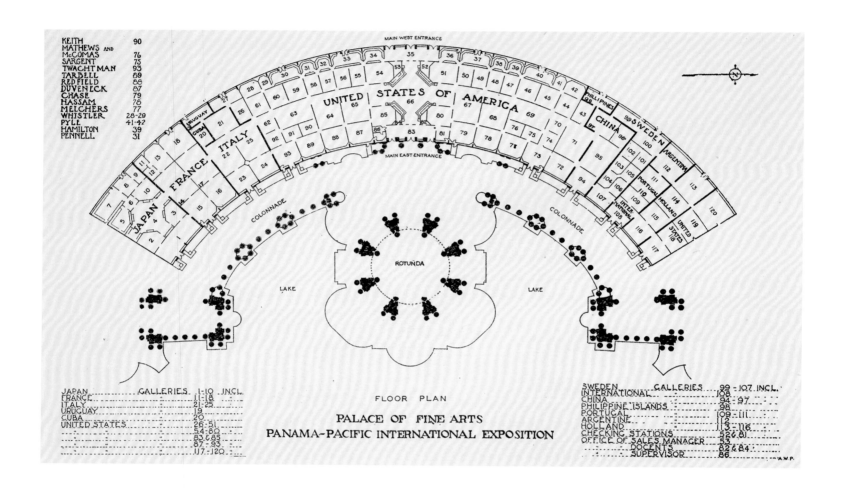

FLOOR PLAN

PALACE OF FINE ARTS
PANAMA-PACIFIC INTERNATIONAL EXPOSITION

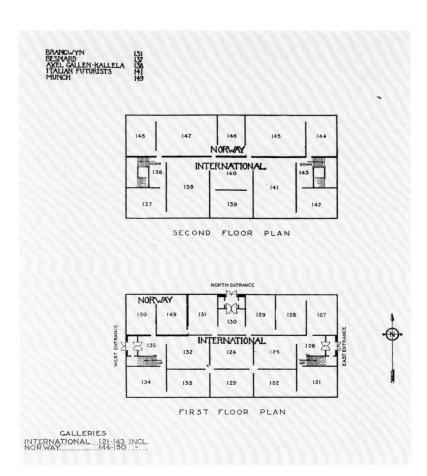

BRANGWYN 131
BESNARD 137
AXEL GALLEN-KALLELA 138
ITALIAN FUTURISTS ... 141
MUNCH 149

| | | | | |
|148|147|146|145|144|

NORWAY

INTERNATIONAL
140

136 | 138 | | 141 | 143
137 | | 139 | | 142

SECOND FLOOR PLAN

NORTH ENTRANCE

NORWAY

150 | 149 | 131 | | 129 | 128 | 127
| | | 130 | | |

INTERNATIONAL

135 | 132 | 124 | 125 | 126
134 | 133 | 123 | 122 | 121

WEST ENTRANCE EAST ENTRANCE

FIRST FLOOR PLAN

GALLERIES
INTERNATIONAL .. 121-143 INCL.
NORWAY 144-150 "

FIG. 159
Floor plan of the Palace of Fine Arts galleries. From Eugen Neuhaus, *The Galleries of the Exposition* (San Francisco: Paul Elder, 1915)

FIG. 160
Floor plan of the Annex galleries. From John E. D. Trask and J. Nilsen Laurvik, eds., *Catalogue de Luxe of the Department of Fine Arts, Panama-Pacific International Exposition* (San Francisco: Paul Elder, 1915)

FIG. 161
Floor plan of the French Pavilion galleries. From Marie Soulas, *The French Pavilion and Its Contents* (San Francisco: Pernau, 1915). San Francisco History Center, San Francisco Public Library

KEY TO GROUND PLAN OF THE FRENCH PAVILION

Room 1. Hall of Modern Sèvres and Gobelins.
 2. Main Central Hall.
 L. Souvenirs of La Fayette.
 R. Souvenirs of Rochambeau.
 3. Rotunda.
 4. Contemporary Decorative Arts.
5 and 6. Retrospective Paintings.
7 and 8. Exhibits of the City of Paris.
 9. East Atrium. Artistic Furniture and Furnishings.
 10. Antiques, China and Ivory.
 11. Theatre.
 12. Doll Land.
 13. Dioramas of Picturesque France.
 14. Historical Monuments.
 15. Architectural Exhibit.
P. L. Library.
 S. Souvenirs of the Romanticists: Balzac, Hugo, Dumas, etc.
16 and 17. West Atrium: Belgian Exhibit:
18 and 19. Dressmakers' and Milliners' Exhibit. Exhibits of French Manufacturers.

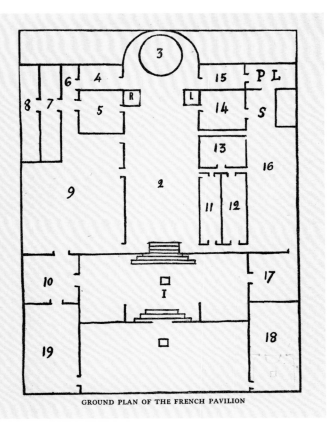

GROUND PLAN OF THE FRENCH PAVILION

Chronology

FIG. 162
Arthur Frank Mathews, ca. 1900. Photograph by
Isabel Porter Collins. Oakland History Room,
Oakland Public Library

FIG. 163
Portrait of Bernard Maybeck, 1932. Photograph
by Gabriel Moulin. Bernard Maybeck Collection,
Environmental Design Archives, University of
California, Berkeley

FIG. 164
Commissioner-General Albert Tirman speaking on
the occasion of the site dedication for the French
Pavilion, September 5, 1913. San Francisco History
Center, San Francisco Public Library

1904

JANUARY 12: Businessman Reuben B. Hale (later a vice
president of the PPIE) writes letter to his fellow directors of
the San Francisco Merchants' Association suggesting that the
city host an international exposition to commemorate the com-
pletion of the Panama Canal, as well as the quadricentennial
of the 1513 discovery of the Pacific Ocean across the Isthmus
of Panama by Spanish explorer Vasco Núñez de Balboa.

1906

JANUARY 6: US Representative Julius Kahn of San Francisco
introduces bill in Congress requesting funding and providing
formal notice of San Francisco's intention to host the exposi-
tion, still anticipated to take place in 1913.

APRIL 18: Earthquake and resulting fires devastate San
Francisco.

DECEMBER 10: Articles of incorporation are filed in San
Francisco for the Pacific Ocean Exposition Company.

1909

OCTOBER 19–24: Success of the citywide Portola Festival held
in San Francisco celebrating the 140th anniversary of the
discovery of San Francisco Bay reaffirms enthusiasm among
civic leaders for hosting a world's fair.

DECEMBER 7: Mass public meeting is called to order at the
Merchants' Exchange to vote on whether San Francisco
should hold the exposition. The question is unanimously
affirmed.

1910

MARCH 22: Exposition company name legally established as
the Panama-Pacific International Exposition Company (PPIE
Co.). Two days later, the company elects a new board of direc-
tors: Homer S. King, president of the corporation; Rudolph
J. Taussig, secretary; A. W. Foster, treasurer; and Charles C.
Moore, chairman of the finance committee.

APRIL 28: Initial stock offering for the PPIE Co. takes place
at the Merchants' Exchange, presided over by Moore: within
two hours, more than $4 million is subscribed.

MAY 1: Governor James Gillett and a delegation travel to
Washington, DC, to present San Francisco's bid for the
Panama-Pacific International Exposition in 1915.

1911

JANUARY 31: US House of Representatives votes in favor of
San Francisco as host city for the 1915 exposition.

FEBRUARY 11: US Senate votes unanimously to adopt the San
Francisco World's Fair Resolution.

FEBRUARY 15: President William Howard Taft signs Kahn
Resolution officially declaring San Francisco the host city for
the 1915 exposition.

MARCH 3: Exposition directors begin hearing suggestions for
the exposition site.

APRIL 4: New officers elected by the Directors of the PPIE
Co.: Charles C. Moore, president; William H. Crocker,
Michael H. de Young, Reuben B. Hale, I. W. Hellman Jr.,
James Rolph Jr., and Leon Sloss, vice presidents; A. W. Foster,
treasurer; Rudolph J. Taussig, secretary; and an executive
committee.

MID-MAY: Stanford art professor Robert B. Harshe appointed
special commissioner of fine and applied arts to the PPIE.

MAY 12: Three hundred women of San Francisco form the
Panama-Pacific International Exposition Association of
Women.

1912

APRIL 14–15: Artist Francis D. Millet, leading candidate for
chief of fine arts of the PPIE, drowns with the sinking of the
Titanic.

MAY 1: At a dinner for Exposition officials hosted by
American ambassador Whitelaw Reid in London, John Singer
Sargent accepts chairmanship of the American selection
committee for Great Britain.

AUGUST 1: Jules Guérin is contracted as director of color and
decoration. Three days later, Alexander Stirling Calder is
contracted as acting director of sculpture, and on September
21, Karl Bitter is contracted as chief of sculpture.

NOVEMBER 9: John E. D. Trask appointed chief of the
Department of Fine Arts; he is approved by the board on
November 27.

1913

JANUARY 15: Theodore Hardee appointed chief of Liberal Arts.

JANUARY–FEBRUARY: Guérin contracts nine painters to execute
mural decorations for the PPIE: Milton Herbert Bancroft,
Frank Brangwyn, William de Leftwich Dodge, Frank Vincent
DuMond, Childe Hassam, Charles Holloway, Arthur Frank
Mathews, Robert Reid, and Edward Simmons.

FEBRUARY 17: *International Exhibition of Modern Art* (the
Armory Show) opens in New York; it later travels to Chicago
and Boston.

APRIL 16: Representatives from France select a site near the
future Palace of Fine Arts for its national pavilion.

MAY 27: On Trask's recommendation, Robert Harshe
appointed assistant chief of the Department of Fine Arts.

JUNE 10: Construction begins on Palace of Fine Arts.

AUGUST 18: Sculptor Charles Grafly awarded the commission
for the *Pioneer Mother Monument* to be erected in front of the
Palace of Fine Arts.

SEPTEMBER 5: Site for the French Pavilion is dedicated.

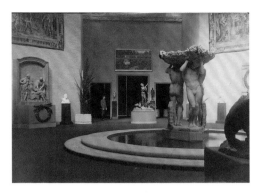

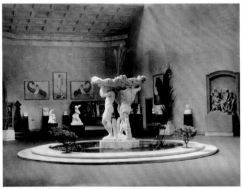

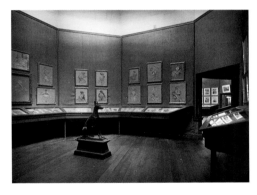

FIG. 165
Palace of Fine Arts, Gallery 66, mid-April 1915, with marble fountain by Gertrude Vanderbilt Whitney (now at McGill University, Montreal). At left, a funerary wreath has been placed on Karl Bitter's *Signing of the Louisiana Purchase*. Entrances into adjacent Gallery 35 are not yet open. Two of Phoebe Hearst's *Coriolanus* tapestries, at upper left and right, were removed when installation was completed later in the spring. Archives of American Art, Smithsonian Institution, Gertrude Vanderbilt Whitney papers

FIG. 166
Palace of Fine Arts, Gallery 66, later in 1915, with view into the adjacent Gallery 65 (the women's gallery). Photograph by Gabriel Moulin

FIG. 167
Palace of Fine Arts, Gallery 39, showing installation of framed drawings by John McLure Hamilton and wall-mounted cases with medals by various American artists. Lantern slide by Gabriel Moulin

SEPTEMBER 10: Trask sails for Europe, where he will remain until December 13. He works on forming advisory committees in London and Paris, and he meets with American artists active abroad, as well as foreign commissioners and officials in countries still uncommitted to participate (England, France, Belgium, Netherlands, Denmark, Sweden, Italy, Austria, Germany).

MID-SEPTEMBER: Trask announces the appointment of advisory committees and describes the Palace of Fine Arts to be constructed on the Exposition grounds (*American Art News*, September 20).

1914

JANUARY: Muralists report to San Francisco for completion and installation of their murals; Mathews, the lone Californian, refuses for several weeks to join them.

FEBRUARY: Perham Wilhelm Nahl's design *The Thirteenth Labor of Hercules* selected as the official poster of the PPIE.

MARCH 1: Charles Francis Browne appointed superintendent of the US section of Fine Arts; he serves in this capacity until April 1915.

MARCH 5–27: Exhibition sponsored by the PPIE Company of paintings by Jules Guérin and the fair's muralists on view in the ballroom of the Palace Hotel in San Francisco. Participants are Frank Brangwyn, William de Leftwich Dodge, Frank Vincent DuMond, Frederick Melville Du Mond, Childe Hassam, Charles Holloway, Robert Reid, and Edward Simmons (Mathews does not take part). In April the exhibition travels to Portland, Oregon, where it is presented under the auspices of the Portland Art Association.

SPRING (DATE UNKNOWN): J. Nilsen Laurvik appointed special representative of the Department of Fine Arts and departs on his first European expedition to solicit foreign participation; he returns to the United States in October.

JULY 28: World War I begins with Austria-Hungary's declaration of war against Serbia.

AUGUST 15: Panama Canal officially opens to ship traffic.

SEPTEMBER: Department of Fine Arts distributes official *Circular of Information* for prospective exhibitors.

SEPTEMBER 20: German Committee cancels plans to participate in the Exposition.

NOVEMBER: J. Nilsen Laurvik departs on his second European expedition to solicit foreign art for the fair; he returns to the United States on February 22, 1915.

LATE NOVEMBER–EARLY DECEMBER: Juries of Selection meet in Paris, London, New York, Boston, Philadelphia, Cincinnati, Saint Louis, and San Francisco.

1915

JANUARY 1: Panama-California Exposition opens in San Diego's Balboa Park; it closes two years later on January 1, 1917.

JANUARY 9–10: On this weekend the Cincinnati public is invited to visit the Frank Duveneck room of the Cincinnati Art Museum, which has been rearranged to reflect the planned display of the artist's work in the Palace of Fine Arts of the PPIE.

JANUARY 25: Concerned by delays in the finishing of the galleries, Trask writes to Captain Asher C. Baker, director of exhibits, "There will be just about enough of the United States Section of the Fine Arts Department hung on February 20th to enable the Exposition to say that the Building was opened on time; but there will be no let-up in the effort of this Department to accomplish as much of the impossible as it is possible to accomplish."

JANUARY 27: *American Art News* reports, "The French exhibit for the Panama-Pacific exposition has just been shown at the Petit Palais."

JANUARY 29: USS *Jason* leaves Genoa for Marseille to collect French art for the PPIE; it then goes on to Plymouth to collect works from England. It departs Bristol on February 26 for return voyage to the United States via the Panama Canal.

FEBRUARY 7: Thirtieth Annual Exhibition of the Architectural League of New York opens in the Fine Arts Building on West 57th Street, with architectural drawings, models, and mural studies for the PPIE; it closes on February 27.

FEBRUARY 20: Opening Day of the Panama-Pacific International Exposition.

MARCH 6: Michael Williams reports in *American Art News* that thirty of the sixty-one galleries devoted to the American section in the Palace of Fine Arts are open, and that many of those are only partially installed.

MARCH 20: Williams reports in *American Art News* that six more galleries of American paintings containing mainly historical works have opened, and that the Swedish section is now completely installed. The Cuban, Uruguayan, Argentine, and Philippine sections are expected to open soon.

APRIL 8: Trask writes to Baker to express concerns about insufficient security staffing in the Palace of Fine Arts and hazards in the galleries: "In the galleries occupied by the Chinese Section I observed four wheel chairs, two of them occupied by men who, to all appearances, were in better health than I and less fatigued, being pushed in and about valuable cloisonnés."

APRIL 9: Formal dedication ceremony for the French Pavilion is held in the building's court of honor with addresses by the mayor of San Francisco, the governor of California, and the commissioner general of France, Albert Tirman.

APRIL 10: Karl Bitter dies in New York; Alexander Stirling Calder replaces him as chief of sculpture. *American Art News* reports that the Dutch section is open in the Palace of Fine Arts.

APRIL 11: USS *Jason* arrives in San Francisco carrying art from Austria, Belgium, France, Great Britain, Greece, Hungary, Italy, Norway, and Spain, as well as works by American expatriates.

APRIL 15: Gallery 120 opens in the Palace of Fine Arts with works by contemporary American painters (among them, George Bellows, Alfred Henry Maurer, George Luks, Rockwell Kent, and Anne M. Bremer [*The Fur Collar*, pl. 83]).

APRIL 17: *First Annual Exhibition of Painting and Sculpture by California Artists*, which features works by a number of artists not exhibiting in the PPIE, opens in the Memorial Museum in Golden Gate Park.

MAY 3: International Jury of Awards is scheduled to meet in San Francisco, but their deliberations are pushed back by three weeks because of the unfinished state of the installations.

FIG. 168
Jury of Awards for the PPIE, 1915. Photograph by Gabriel Moulin. Archives of American Art, Smithsonian Institution, Frank and Elizabeth Boott Duveneck papers

FIG. 169
John F. Flanagan (American, 1865–1952), Panama-Pacific International Exposition Medal of Award given to Harry Leslie Hoffman, 1915. Bronze with gold patination. Florence Griswold Museum, Old Lyme, Connecticut

FIG. 170
Certificate of Award for Gold Medal, awarded to Harry Leslie Hoffman, 1915. Florence Griswold Museum, Old Lyme, Connecticut

MAY 15: Williams reports in *American Art News*, "With the Exposition, now open nearly three months, the process of completing the Fine Arts exhibition is still far from finished. It now seems clear that the space primarily allowed for the exhibits was quite inadequate, or else that they accumulated upon the hands of the fine arts department rather unmanageably, for there are still a large number of the most important sections still to be arranged."

MAY 19: French section (Galleries 11–18) in the Palace of Fine Arts opens to the public.

MAY 20: Opening day of the Italian Pavilion. *San Francisco Chronicle* reports the groundbreaking for Fine Arts Annex building to the west of the Palace of Fine Arts.

MAY 24–JUNE 2: International Jury of Awards chaired by Julian Alden Weir evaluates the Fine Arts exhibits.

MAY 29: Alma de Bretteville Spreckels hosts a reception to open her house museum at 2042 Vallejo Street. The June 12 issue of *American Art News* reports, "Prominent are the Rodin bronzes and examples of the sculptors [Maurice] Maignan and [Constantin] Meunier. There are 36 works by California artists."

JUNE 6: Opening day of the French Pavilion.

JULY 5–9: American Association of Museums holds its annual meeting in San Francisco to coincide with the PPIE.

JULY 14: Opening day of the Greek Pavilion.

JULY 15: Fine Arts awards announced. Grand prizes are awarded to Frederick Carl Frieseke (oil painting), Henry Wolf (etching and engraving), and Ettore Tito (oil painting, Italian section). American medal of honor winners include painters John White Alexander, Cecilia Beaux, Emil Carlsen, Walter Griffin, Willard Metcalf, Richard E. Miller, Violet Oakley, Lawton Parker, and W. Elmer Schofield; and sculptors Herbert Adams, Karl Bitter, and Daniel Chester French. Among the European recipients of medals of honor are Akseli Gallen-Kallela of Finland and Franz von Stuck of Germany for oil painting, and Frank Brangwyn for etching and engraving.

JULY 20: *American Art News* reports attendance at the Palace of Fine Arts through this date totals four million.

AUGUST 2: Opening day of the Fine Arts Annex, containing the Norwegian and international section galleries.

OCTOBER 16: Fine Arts Preservation Day at the PPIE; a portion of the day's ticket sales are dedicated to the preservation of certain Exposition structures, foremost the Palace of Fine Arts.

NOVEMBER 23: At PPIE Company's executive committee meeting, it is decided to keep the Palace of Fine Arts open from January 1 to May 1, 1916.

DECEMBER 4: Closing Day of the PPIE.

DECEMBER 25: *American Art News* reports that Trask is traveling around the East Coast working to replenish the galleries of the Palace of Fine Arts for the post-Exposition period: "He is also to further the plans for a permanent museum to be established in that building, of which, it is rumored, he is to be the director."

1916

JANUARY 1: Partially reinstalled Palace of Fine Arts reopens with a ribbon-cutting by California governor Hiram Johnson. Demolition of the Exposition site begins.

JANUARY 7: *French and Belgian Art from the Panama-Pacific International Exposition*, an exhibition drawn from the French and Belgian section galleries in the Palace of Fine Arts and French Pavilion, opens at the Art Institute of Chicago. It travels to Saint Louis, Buffalo, Pittsburgh, Youngstown, Toronto, Detroit, Toledo, Minneapolis, Des Moines, and Omaha through May 15, 1917. After this tour, many of the works are shown again in Brooklyn (February–March 1918), Boston (January 1919), and Rochester (March–April 1919) in combination with a second traveling exhibition from the Musée du Luxembourg (see February 12, 1916).

JANUARY 30: Art from the PPIE's Swedish section opens as *The Swedish Art Exhibition* at the Brooklyn Museum; during the exhibition's year-long run it travels to the Copley Society, Boston; Pennsylvania Academy of the Fine Arts, Philadelphia; Carnegie Institute, Pittsburgh; Detroit Museum of Art; Art Institute of Chicago; Minneapolis Institute of Arts; City Art Museum, Saint Louis; John Herron Art Institute, Indianapolis; and Toledo Museum of Art.

FEBRUARY 1: Oakland Public Museum, with Robert B. Harshe as its new director, opens the institution's first art galleries in the Oakland Civic Auditorium. In less than a year, Harshe leaves the Bay Area to become assistant director of the Carnegie Institute in Pittsburgh. In 1920 he moves on to the Art Institute of Chicago, where he holds the post of director from 1921 until his death in 1938. Harshe organizes the art exhibition of the Century of Progress International Exposition held in Chicago from 1933 to 1934.

FEBRUARY 5: *American Art News* reports poor attendance at the reopened Palace of Fine Arts: "Official figures show that the daily expense of keeping the Fine Arts Palace open even exceeds the total cash receipts from admissions to the grounds."

FEBRUARY 12: *Retrospective Collection of French Art, 1870–1910 from the Luxembourg Museum, Paris*, an exhibition drawn from the contents of the French Pavilion, opens at the Panama-California Exposition in San Diego; it travels to Pittsburgh, Buffalo, Chicago, Detroit, Cleveland, Saint Louis, Toronto, Indianapolis, Brooklyn, Boston, and Rochester through April 7, 1919.

FEBRUARY 22: *Oakland Tribune* announces a number of additions to the collection of the Oakland Public Museum from the PPIE, including cloisonné and porcelain from the Republic of China, carved shells from the Japanese Pavilion, and a set of wood engravings and an original carved block by PPIE grand-prize winner Henry Wolf.

FEBRUARY 23: Prompted by the appearance of avant-garde European paintings in the PPIE and post-Exposition exhibition, "A Symposium of Modern Art" is held in the ballroom of the Palace Hotel in San Francisco. Chaired by John I. Walter, president of the San Francisco Art Association (SFAA), the participants include journalist Michael Williams; artists Francis McComas and Bruce Porter; aesthetics professor Arthur Pope of the University of California, Berkeley; graphic arts professor Arthur Bridgman Clarke of Stanford University; architect Louis Christian Mullgardt; John E. D. Trask; and J. Nilsen Laurvik, who was unable to speak because of laryngitis.

MARCH 21: Auguste Rodin's *The Thinker*, owned by Adolph and Alma Spreckels, is installed in Golden Gate Park.

MARCH 25: Major expansion of the Memorial Museum is announced by M. H. de Young.

APRIL 20: J. Nilsen Laurvik is appointed the SFAA's director, as well as director of the museum it soon operates in the Palace of Fine Arts starting on May 2.

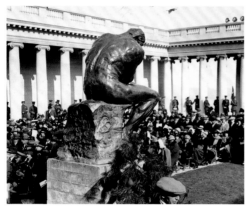

FIG. 171
Postcard of Auguste Rodin's *The Thinker* in Golden Gate Park, ca. 1921. Lake County Discovery Museum

FIG. 172
Opening Day of the California Palace of the Legion of Honor, November 11, 1924. Photograph by Gabriel Moulin. San Francisco History Center, San Francisco Public Library

APRIL 28: Executive Committee of the PPIE passes a resolution to turn the Palace of Fine Arts over to the SFAA, which has raised $30,000 to operate the facility for the first year.

MAY 1: Post-Exposition exhibition closes in the Palace of Fine Arts.

MAY 15: *The Netherlands Art Exhibition*, consisting of paintings and prints shown in the Netherlands Section of the PPIE, opens at the Panama-California Exposition in San Diego; during the exhibition's yearlong run it travels to the City Art Museum, Saint Louis (opens December 10, 1916); Toledo Museum of Art (April 1917); and the Pennsylvania Academy of the Fine Arts (June–August 1917).

JUNE 19: Laurvik opens his first exhibition in the Palace of Fine Arts, featuring six hundred works by California artists in eighteen galleries.

SEPTEMBER 1: Laurvik announces that since the SFAA took over the Palace of Fine Arts on May 1, total attendance has been forty-seven thousand.

OCTOBER 5: Trask's appointment as chief of Fine Arts officially ends. After the PPIE, Trask returns to the East Coast to pursue a career as an independent art consultant. He later serves as director of the Milwaukee Art Institute (1942–1926) and art director for the Philadelphia Sesquicentennial International Exposition of 1926, working under Asher C. Baker, director-in-chief. Trask dies in Philadelphia on April 16, 1926, just over a month before that exposition's opening ceremonies.

DECEMBER 3: After death of William Merritt Chase in New York on October 25, a memorial service is held at the Palace of Fine Arts, where much of his work from the PPIE is still on view. The gallery remains essentially intact until May 1918, when the remaining works are finally shipped to Chase's widow in New York.

DECEMBER 15: Opening of loan exhibition of Mrs. Phoebe A. Hearst Collection in the Palace of Fine Arts.

1917

APRIL 6: United States enters World War I.

1918

NOVEMBER 11: The Allied forces and Germany sign armistice ending World War I.

1919

JANUARY: US government Alien Property Custodian seizes the works by Akseli Gallen-Kallela and the Austrian and Hungarian exhibitors at the PPIE as enemy property but allows them to stay on view in the Palace of Fine Arts; they remain in San Francisco until September 1923.

FEBRUARY 22: Opening day of the major Louis Christian Mullgardt–designed addition to the Memorial Museum in Golden Gate Park.

1920

JANUARY: Plans are announced to build the California Palace of the Legion of Honor in Lincoln Park, a permanent museum and a gift to the city of San Francisco by Adolph and Alma Spreckels.

1921

APRIL 28: Plans are initiated to move the San Francisco Museum of Art to the proposed War Memorial building.

NOVEMBER 16: Trustees of the PPIE Company officially transfer ownership of the Palace of Fine Arts to the trustees of the San Francisco Museum of Art.

1922

MAY 16: Board of the SFAA votes to remove Laurvik as its director. He continues in his role as director of the San Francisco Museum of Art.

1924

JUNE 1: After eight years of operating at a deficit, the San Francisco Museum of Art in the Palace of Fine Arts is closed.

NOVEMBER 11: California Palace of the Legion of Honor opens to the public.

1925

FEBRUARY 27: Trustees of the San Francisco Museum of Art accept Laurvik's resignation as director. Laurvik resumes his activities as an independent curator and arts writer in New York, where he dies on May 2, 1953. Upon his death, his storage locker in San Francisco is found to contain several paintings taken by him from the Exposition's Hungarian section, including Róbert Berény's *Golgotha (Scene V)* (pl. 156).

MARCH 3: US Congress passes an act authorizing the secretary of war to cede to the City and County of San Francisco that portion of the Presidio's land on which the Palace of Fine Arts stands.

APRIL 23: Forty-Eighth Annual Exhibition of the San Francisco Art Association is held at the Legion of Honor.

1927

JUNE 10: Palace of Fine Arts and ten acres of land are signed over by the US Government to the City and County of San Francisco.

1929

MARCH 14: *San Francisco Chronicle* reports that the trustees of the San Francisco Museum of Art have threatened to raze the decaying Palace of Fine Arts (closed to the public since 1924), sell the remains for salvage, and erect a new structure on the site unless the city reimburses the organization $70,000 for maintaining the Palace since 1916. In response, the city and county's supervisors assert their rightful ownership and proceed with major renovations of the rotunda and exhibition building, which continue for the next four years and include the removal of the original interior gallery configuration. The San Francisco Museum of Art's claims of ownership are later resolved by the payment of $20,000 authorized by the Board of Park Commissioners in November 1932.

1931

JULY 16: With renovations of the Palace of Fine Arts continuing, the last of the fair's art, including Arthur Frank Mathews's mural *The Victory of Culture over Force (Victorious Spirit)* (pl. 23) and Fokko Tadama's painting *Public Market, Seattle* (pl. 75), are removed and put into storage at the Legion of Honor. The Palace of Fine Arts reopens on April 2, 1932, with a General Motors car show and indoor tennis courts.

1935

JANUARY 18: The San Francisco Museum of Art opens in the War Memorial Veterans Building. In 1975, it is renamed the San Francisco Museum of Modern Art.

Note: This list documents the exhibition as presented at the de Young, San Francisco, and reflects the most complete information available at the time of publication. Unless otherwise indicated, dimensions reflect height by width or, for sculptures, height by width by depth. Measurements for prints are taken at the plate mark.

Wherever possible, the original gallery location for each object at the Panama-Pacific International Exposition has been indicated. In some cases, the work's exhibition title in 1915 differs from its current title and is also provided.

AMERICAN ART
PAINTINGS, DRAWINGS, AND SCULPTURE

Edwin Austin Abbey (American, 1852–1911)
The Penance of Eleanor, Duchess of Gloucester, 1900 [plate 32]
Oil on canvas, 49 × 85 in. (124.5 × 215.9 cm)
Carnegie Museum of Art, Pittsburgh, purchase, 02.1
Palace of Fine Arts, Gallery 57, wall B, no. 2653

Robert Ingersoll Aitken (American, 1878–1949)
Xoros (Dancing Bacchante), ca. 1910 [plate 47]
Bronze, with base: 18 ¾ × 12 ¼ × 7 in. (47.6 × 31.1 × 17.8 cm)
Private collection
Palace of Fine Arts, Gallery 68, no. 3284

Thomas Pollock Anshutz (American, 1851–1912)
Incense Burner, 1905 [plate 37]
Oil on canvas, 64 × 40 in. (162.6 × 101.6 cm)
Pennsylvania Academy of the Fine Arts, Philadelphia,
Henry D. Gilpin Fund, 1940.11
Palace of Fine Arts, Gallery 51, wall B, no. 2474

Clement John Barnhorn (American, 1857–1935)
Boy Pan with Frog, 1914 [plate 49]
Bronze and stone, 48 ½ × 19 × 26 in. (123.2 × 48.3 × 66 cm)
Fine Arts Museums of San Francisco,
gift of Walter Scott Newhall Jr., 65.27
Palace of Fine Arts, Colonnade, no. 4518

Gifford Beal (American, 1879–1956)
Old Town Terrace, 1914 [plate 68]
Oil on canvas, 36 ¼ × 48 ½ in. (92.1 × 123.2 cm)
Ruth Chandler Williamson Gallery, Scripps College,
Claremont, California, SH1
Palace of Fine Arts, Gallery 73, wall B, no. 3542

Cecilia Beaux (American, 1855–1942)
Man with the Cat (Henry Sturgis Drinker), 1898 [plate 42]
Oil on canvas, 48 × 34 ⅜ in. (121.9 × 87.8 cm)
Smithsonian American Art Museum, Washington, DC,
bequest of Henry Ward Ranger through the National Academy
of Design, 1952.10.1
Palace of Fine Arts, Gallery 65, wall D, no. 3038, as *Portrait*

Cecilia Beaux (American, 1855–1942)
New England Woman, 1895 [plate 43]
Oil on canvas, 43 × 24 ¼ in. (109.2 × 61.6 cm)
Pennsylvania Academy of the Fine Arts, Philadelphia,
Joseph E. Temple Fund, 1896.1
Palace of Fine Arts, Gallery 65, wall D, no. 3036,
as *Study in Whites*

Edward Berge (American, 1876–1924)
Muse Finding the Head of Orpheus, 1899 [plate 48]
Marble, 29 × 27 ¹³/₁₆ × 22 ¹/₁₆ in. (73.6 × 71 × 56 cm)
Walters Art Museum, Baltimore, bequest of Lily Berge, 1985, 28.29
Palace of Fine Arts, Colonnade, no. 4483

Anne M. Bremer (American, 1872–1923)
The Fur Collar, ca. 1914 [plate 83]
Oil on canvas, 21 ½ × 16 ½ in. (54.6 × 41.9 cm)
Mills College Art Museum, Oakland,
gift from the Albert M. Bender Estate
Palace of Fine Arts, Gallery 120, wall B, no. 4421

Anne M. Bremer (American, 1872–1923)
An Old-Fashioned Garden, 1915 [plate 14]
Oil on canvas, 19 ½ × 23 in. (49.5 × 58.4 cm)
Mills College Art Museum, Oakland,
gift from the Albert M. Bender Estate

Alexander Stirling Calder (American, 1870–1945)
Star Maiden, 1914 (cast 1985) [plate 15]
Bronze, 51 × 15 × 9 ¼ in. (129.5 × 38.3 × 23.5 cm)
Collection of Jacque Giuffre and Bill Kreysler

Arthur Beecher Carles (American, 1882–1952)
Torso, 1914 [plate 84]
Oil on canvas, 25 × 24 in. (63.5 × 61 cm)
San Francisco Museum of Modern Art, gift of the San Francisco
Art Association, 35.1313
Palace of Fine Arts, Gallery 51, wall A, no. 2471

Mary Cassatt (American, 1844–1926)
Mother and Child with a Rose Scarf, ca. 1908 [plate 44]
Oil on canvas, 46 × 35 ¾ in. (116.8 × 89.5 cm)
The Metropolitan Museum of Art, New York, bequest of
Miss Adelaide Milton de Groot (1876–1967), 1967, 67.187.122
Palace of Fine Arts, Gallery 65, wall B, no. 3008,
as *Woman and Child: Rose Scarf*

William Merritt Chase (American, 1849–1916)
Portrait of Mrs. C. (Lady with a White Shawl), 1893 [plate 35]
Oil on canvas, 75 × 52 in. (190.5 × 132.1 cm)
Pennsylvania Academy of the Fine Arts, Philadelphia,
Joseph E. Temple Fund, 1895.1
Palace of Fine Arts, Gallery 79, wall D, no. 3766,
as *Woman with the White Shawl*

Alson Skinner Clark (American, 1876–1949)
In the Lock, Miraflores, 1913 [plate 2]
Oil on canvas, 38 ½ × 51 ¼ in. (97.9 × 127.6 cm)
Private collection
Palace of Fine Arts, Gallery 73, wall A, no. 3534

Alson Skinner Clark (American, 1876–1949)
Panama Canal, the Gaillard Cut, 1913 [plate 3]
Oil on canvas, 21 × 22 ½ in. (53.3 × 57.2 cm)
The Delman Collection, San Francisco

Edwin Deakin (American, b. England, 1838–1923)
Palace of Fine Arts and the Lagoon, ca. 1915 [plate 10]
Oil on canvas, 32 ⅜ × 48 ⅜ in. (82.1 × 122.8 cm)
Crocker Art Museum, Sacramento, long-term loan from the
California Department of Finance, conserved with funds provided
by Gerald D. Gordon, LOAN.2006.Deakin

William de Leftwich Dodge (American, 1867–1935)
Atlantic and Pacific, 1914 [plate 26]
Oil on canvas, without ornamental borders: 146 × 559 ½ in.
(370.8 × 1421.1 cm)
San Francisco War Memorial

Arthur Wesley Dow (American, 1857–1922)
The Enchanted Mesa, 1913 [plate 76]
Oil on canvas, 32 ¾ × 54 in. (83 × 137 cm)
Avery Architectural & Fine Arts Library, Columbia University,
New York, transferred from the Women's Faculty Club, C00.1371
Palace of Fine Arts, Gallery 69, wall D, no. 3319

Frank Vincent DuMond (American, 1865–1951)
Study for *The Westward March of Civilization:
Arrival in the West*, 1913 [plate 25]
Oil on canvas, squared in pencil, 32 × 100 in. (81.3 × 254 cm)
Florence Griswold Museum, Old Lyme, Connecticut,
gift of Harold and Barbara Goodwin, 1984.21.6

Frank Vincent DuMond (American, 1865–1951)
Study for *The Westward March of Civilization:
Departure from the East*, 1913 [plate 24]
Oil on canvas, squared in pencil, 32 × 100 in. (81.3 × 254 cm)
Florence Griswold Museum, Old Lyme, Connecticut,
gift of Harold and Barbara Goodwin, 1984.21.5

Frank Duveneck (American, 1848–1919)
Whistling Boy, 1872 [plate 33]
Oil on canvas, 27 ⅞ × 21 ⅛ in. (70.8 × 53.7 cm)
Cincinnati Art Museum, gift of the artist, 1904.196
Palace of Fine Arts, Gallery 87, wall A, no. 3868

Thomas Eakins (American, 1844–1916)
The Concert Singer, 1890–1892 [plate 36]
Oil on canvas, 75 ⅛ × 54 ¼ in. (190.8 × 137.8 cm)
Philadelphia Museum of Art, gift of Mrs. Thomas Eakins and
Miss Mary Adeline Williams, 1929-184-19
Palace of Fine Arts, Gallery 64, wall C, no. 2960

Thomas Eakins (American, 1844–1916)
Portrait of Henry O. Tanner, ca. 1897 [plate 34]
Oil on canvas, 24⅜ × 20⅛ in. (62.5 × 51.1 cm)
The Hyde Collection, Glens Falls, New York, bequest of
Charlotte Pruyn Hyde, 1971.16
Palace of Fine Arts, Gallery 64, wall C, no. 2965

E. Charlton Fortune (American, 1885–1969)
Court of Flowers, 1915 [plate 13]
Oil on canvas, 12 × 16 in. (30.5 × 40.6 cm)
Collection of Melza and Ted Barr, Houston

E. Charlton Fortune (American, 1885–1969)
The Pool (The Court of the Four Seasons), ca. 1915 [fig. 7]
Oil on canvas, 16¼ × 20 in. (41.3 × 50.8 cm)
Private collection

E. Charlton Fortune (American, 1885–1969)
Summer, 1914 [plate 82]
Oil on canvas, 22¼ × 26 in. (56.4 × 66 cm)
Private collection
Palace of Fine Arts, Gallery 117, wall B, no. 4109, as *Summer*

James Earle Fraser (American, 1876–1953)
The End of the Trail, modeled ca. 1894, cast ca. 1925 [plate 22]
Bronze, 44½ × 34 × 11 in. (113 × 86.4 × 27.9 cm)
The Rockwell Museum, Corning, New York, 78.88

Frederick Carl Frieseke (American, 1874–1939)
The Garden Chair, ca. 1912 [plate 54]
Oil on canvas, 28¼ × 35¾ in. (71.6 × 90.7 cm)
Collection of Ambassador and Mrs. Ronald Weiser
Palace of Fine Arts, Gallery 117, wall B, no. 4103

Daniel Garber (American, 1880–1958)
Quarry, Evening, 1913 [plate 66]
Oil on canvas, 50 × 60 in. (127 × 152.4 cm)
Philadelphia Museum of Art, purchased with the
W. P. Wilstach Fund, 1921, W1921-1-3
Palace of Fine Arts, Gallery 68, wall C, no. 3265

William James Glackens (American, 1870–1938)
The Green Car, 1910 [plate 74]
Oil on canvas, 24 × 32 in. (61 × 81.3 cm)
The Metropolitan Museum of Art, New York,
Arthur Hoppock Hearn Fund, 1937, 37.73
Palace of Fine Arts, Gallery 51, wall A, no. 2466

Charles Grafly (American, 1862–1929)
Sketch for *Pioneer Mother Monument*, 1913–1914 [plate 19]
Bronze, 15 × 8½ × 4 in. (38.1 × 21.6 × 10.2 cm)
Ulrich Museum of Art, Wichita State University, Kansas,
gift of Mr. Charles H. Drummond, 1982.27.47

Charles Grafly (American, 1862–1929)
Sketch for *Pioneer Mother Monument*, 1913–1914 [plate 20]
Plaster, figures without base: 21 × 6½ × 4½ in.
(53.3 × 16.5 × 11.5 cm)
Ulrich Museum of Art, Wichita State University, Kansas,
gift of Dorothy Grafly Drummond and Charles H. Drummond,
71.16.123 (base) and 71.16.11 (figures)

Jules Guérin (American, 1866–1946)
*Panoramic View of the Panama-Pacific International
Exposition*, 1913 [plate 6]
Watercolor and opaque watercolor over graphite on paper,
49 × 97 in. (124.5 × 246.4 cm)
Collection of the Exploratorium, San Francisco

Childe Hassam (American, 1859–1935)
Aphrodite, Appledore, 1908 [plate 61]
Oil on canvas, 81⅞ × 55⅞ in. (208 × 142 cm)
American Academy of Arts and Letters, New York
Palace of Fine Arts, Gallery 78, wall D, no. 3731, as *Aphrodite*

Robert Henri (American, 1865–1929)
Lady in Black Velvet (Portrait of Eulabee Dix Becker), 1911 [plate 38]
Oil on canvas, 77½ × 36⅞ in. (196.9 × 93.8 cm)
High Museum, Atlanta, gift in memory of Dr. Thomas P.
Hinman through exchange and general funds, 73.55
Palace of Fine Arts, Gallery 51, wall D, no. 2501

George Hitchcock (American, 1850–1913)
The Vanquished (Vaincu), ca. 1898 [plate 56]
Oil on canvas, 39⅜ × 35⅞ in. (100 × 90.5 cm)
Musée d'Orsay, Paris, RF 1977 194
Palace of Fine Arts, Gallery 56, wall B, no. 2615

Clark Hobart (American, 1868–1948)
The Blue Bay: Monterey, ca. 1914 [plate 80]
Oil on canvas, 20¼ × 24¼ in. (51.4 × 61.6 cm)
Fine Arts Museums of San Francisco, museum purchase,
Skae Fund Legacy, 41772
Palace of Fine Arts, Gallery 117, wall B, no. 4104

Harry Leslie Hoffman (American, 1874–1966)
A Mood of Spring, ca. 1913 [plate 63]
Oil on canvas, 30 × 40 in. (76.2 × 101.6 cm)
Florence Griswold Museum, Old Lyme, Connecticut,
gift of Mrs. John Hoffman and Family, 2003.8
Palace of Fine Arts, Gallery 118, wall B, no. 4180

Charles Holloway (American, 1859–1941)
Study for *The Pursuit of Pleasure*, 1913 [fig. 53]
Oil on canvas, squared for transfer in graphite, 20⅛ × 40 in.
(51.1 × 101.6 cm)
Collection of Margaret E. Haas

Winslow Homer (American, 1836–1910)
The Artist's Studio in an Afternoon Fog, 1894 [plate 29]
Oil on canvas, 24 × 30¼ in. (61 × 76.8 cm)
Memorial Art Gallery, University of Rochester, New York,
R. T. Miller Fund, 41.32
Palace of Fine Arts, Gallery 54, wall A, no. 2519 as *Afternoon Fog*

Winslow Homer (American, 1836–1910)
Saco Bay, 1896 [plate 30]
Oil on canvas, 23⅞ × 38 in. (60.5 × 96.4 cm)
Sterling and Francine Clark Art Institute, Williamstown,
Massachusetts, 1955.5
Palace of Fine Arts, Gallery 54, wall A, no. 2514
as *The Coming Storm*

Paul Manship (American, 1885–1966)
Lyric Muse, 1912 [plate 51]
Bronze, copper wire, 12¾ × 6¾ × 5½ in. (32.4 × 17.3 × 14 cm)
Museum of Fine Arts, Boston,
gift of Miss Mary C. Wheelwright, 42.373
Palace of Fine Arts, Gallery 93, no. 4078

Arthur Frank Mathews (American, 1860–1945)
California, 1905 [plate 78]
Oil on canvas with frame, framed: 47½ × 38 in. (120.7 × 96.5 cm);
unframed: 26 × 23½ in. (66 × 59.7 cm)
Oakland Museum of California, gift of Concours d'Antiques,
the Art Guild, A66.196.4
Palace of Fine Arts, Gallery 76, wall B, no. 3644

Arthur Frank Mathews (American, 1860–1945)
The Victory of Culture over Force (Victorious Spirit), 1914 [plate 23]
Oil on canvas , 119 × 238 in. (302.3 × 604.5 cm)
San Francisco War Memorial

Francis McComas (American, b. Australia, 1874–1938)
Navajo Gateway, Arizona, 1914 [plate 77]
Watercolor, 26¾ × 21 1/16 in. (68 × 53.5 cm)
Fine Arts Museums of San Francisco, museum purchase,
Skae Fund Legacy, 41781
Palace of Fine Arts, Gallery 76, wall C, no. 3654

Gari Melchers (American, 1860–1932)
The Open Door, ca. 1905–1910 [plate 58]
Oil on canvas, 62 × 48¼ in. (157.5 × 122.8 cm)
Gari Melchers Home and Studio, University of Mary
Washington, Fredericksburg, Virginia
Palace of Fine Arts, Gallery 77, wall A, no. 3668

Willard LeRoy Metcalf (American, 1858–1925)
Winter's Festival, 1913 [plate 64]
Oil on canvas, 26 × 29 in. (66 × 73.7 cm)
Fine Arts Museums of San Francisco, gift of
Mrs. Herbert Fleishhacker, 47.5.3
Palace of Fine Arts, Gallery 80, wall D, no. 3811

David Brown Milne (Canadian, 1882–1953)
Black and White I, 1911 [plate 72]
Watercolor, 18 × 22¼ in. (46 × 58 cm)
Collection of Laura and Byrne Harper
Palace of Fine Arts, Gallery 40, wall B, no. 1729

David Brown Milne (Canadian, 1882–1953)
Black and White II, 1911 [plate 73]
Watercolor, 18 × 23 in. (46 × 58.5 cm)
Collection of Greg Latremoille
Palace of Fine Arts, Gallery 40, wall B, no. 1734

Bruce Nelson (American, 1888–1952)
The Summer Sea, ca. 1914 [plate 81]
Oil on canvas, 30 × 40 in. (76.2 × 101.6 cm)
Irvine Museum, California
Palace of Fine Arts, Gallery 118, wall B, no. 4176

Lawton Silas Parker (American, 1868–1954)
La paresse (Idleness), 1913 [plate 55]
Oil on canvas, 50 × 60 in. (127 × 152.4 cm)
M. Christine Schwartz Collection, Chicago
Palace of Fine Arts, Gallery 69, wall B, no. 3298

Gottardo Piazzoni (American, b. Switzerland, 1872–1945)
Lux Aeterna, 1914 [plate 79]
Oil on canvas, 42½ × 60½ in. (108 × 153.7 cm)
Fine Arts Museums of San Francisco, gift in memory of
Ethel A. Voorsanger by her friends through the Patrons
of Art and Music, 1981.90
Palace of Fine Arts, Gallery 68, wall B, no. 3253

Hiram Powers (American, 1805–1873)
California, ca. 1861 [plate 27]
Marble, 27⅛ × 18⅛ × 12 in. (69 × 46 × 30.5 cm)
Fine Arts Museums of San Francisco,
gift of M. H. de Young, 42194
Palace of Fine Arts, Gallery 66, no. 3110

Arthur Putnam (American, 1873–1930)
Combat: Puma and Serpents, ca. 1906 [plate 50]
Bronze, 11 × 26½ × 12½ in. (27.9 × 66 × 30.5 cm)
Fine Arts Museums of San Francisco, gift of
Alma de Bretteville Spreckels, 1924.155.1
Palace of Fine Arts, Gallery 67, case 1, no. 3208,
as *Puma and Snake*

Arthur Putnam (American, 1873–1930)
The Mermaid, 1909 [plate 16]
Bronze, 32 × 13½ × 26¾ in. (81.3 × 34.3 × 67.9 cm)
Fine Arts Museums of San Francisco, gift of
Alma de Bretteville Spreckels, 1924.181.1

Ellen Emmet Rand (American, 1875–1941)
In the Studio, 1910 [plate 45]
Oil on canvas, 44¼ × 36¼ in. (112.4 × 92.1 cm)
William Benton Museum of Art, University of Connecticut,
Storrs, gift of John A., William B., and Christopher T. E. Rand
Palace of Fine Arts, Gallery 65, wall A, no. 2993

Joseph M. Raphael (American, 1869–1950)
Spring Winds, ca. 1914 [plate 57]
Oil on canvas, 29¼ × 36⅛ in. (74.3 × 91.8 cm)
Fine Arts Museums of San Francisco, museum purchase,
Skae Fund Legacy, 41765
Palace of Fine Arts, Gallery 67, wall B, no. 3165

Edward Willis Redfield (American, 1869–1965)
The Hills and River, 1914 [plate 65]
Oil on canvas, 50¼ × 56 in. (127.6 × 142.1 cm)
Fine Arts Museums of San Francisco,
gift of Marian Huntington, 1928.20
Palace of Fine Arts, Gallery 88, wall D, no. 3937

Frederic Remington (American, 1861–1909)
The Bronco Buster, 1895 [plate 28]
Bronze, 24 × 20 × 12½ in. (61 × 50.8 × 31.8 cm)
Fine Arts Museums of San Francisco, museum purchase,
gift of Doris Schmiedell and the M. H. de Young Museum
Foundation, 69.21
Palace of Fine Arts, Gallery 64, no. 2977

Theodore Robinson (American, 1852–1896)
The Valley of Arconville, ca. 1887 [plate 52]
Oil on canvas, 18 × 21⅞ in. (45.8 × 55.7 cm)
Art Institute of Chicago, Friends of American
Art Collection, 1941.11
Palace of Fine Arts, Gallery 57, wall C, no. 2668,
as *Le Val Arconville: Eure*

Edward Francis Rook (American, 1870–1960)
Laurel, ca. 1905–1910 [plate 62]
Oil on canvas, 40¼ × 50¼ in. (102.3 × 127.6 cm)
Florence Griswold Museum, Old Lyme, Connecticut,
gift of the Hartford Steam Boiler Inspection and Insurance
Company, 2002.1.117
Palace of Fine Arts, Gallery 48, wall C, no. 2374

Guy Rose (American, 1867–1925)
The Backwater, ca. 1910 [plate 53]
Oil on canvas, 20 × 24 in. (50.9 × 61 cm)
Private collection
Palace of Fine Arts, Gallery 72, wall C, no. 3499

John Singer Sargent (American, b. Italy, 1856–1925)
Reconnoitering (Portrait of Ambrogio Raffaele), 1911 [plate 39]
Oil on canvas, 22 × 28 in. (55.9 × 71.1 cm)
Galleria d'arte moderna di Palazzo Pitti, Florence, Inv.143.613480
Palace of Fine Arts, Gallery 75, wall C, no. 3631

John Singer Sargent (American, b. Italy, 1856–1925)
The Sketchers, 1913 [plate 40]
Oil on canvas, 28 × 22 in. (71.1 × 56 cm)
Virginia Museum of Fine Arts, Richmond, the Arthur and
Margaret Glasgow Fund, 58.11
Palace of Fine Arts, Gallery 75, wall C, no. 3629

John Singer Sargent (American, b. Italy, 1856–1925)
Stable at Cuenca, 1903 [plate 41]
Oil on canvas, 22½ × 28⅜ in. (57.2 × 72.1 cm)
Smithsonian American Art Museum, Washington, DC,
purchase made possible by the American Art Forum,
and through the Catherine Walden Myer and Luisita L. and
Franz H. Denghausen Endowments, 2014.1
Palace of Fine Arts, Gallery 75, wall D, no. 3633, as *Spanish Stable*

John Sloan (American, 1871–1951)
Renganeschi's Saturday Night, 1912 [plate 69]
Oil on canvas, 26¼ × 32 in. (66.7 × 81.3 cm)
Art Institute of Chicago, gift of Mary Otis Jenkins, 1926.1580
Palace of Fine Arts, Gallery 51, wall C, no. 2496,
as *Renganeschi's: Sunday Night*

Robert Spencer (American, 1879–1931)
Courtyard at Dusk, 1913 [plate 67]
Oil on canvas, 30 × 36⅛ in. (76.2 × 91.8 cm)
Fine Arts Museums of San Francisco, gift of Mr. and Mrs.
Ronald MacDougall, 1960.31
Palace of Fine Arts, Gallery 68, wall C, no. 3263

Fokko Tadama (American, b. Sumatra, 1871–1937)
Public Market, Seattle, ca. 1910 [plate 75]
Oil on board, 31⅞ × 54 in. (81 × 137.2 cm)
Fine Arts Museums of San Francisco, The Palace of Fine Arts,
San Francisco, CP13219
Palace of Fine Arts, Gallery 56, wall C, no. 2629

Edmund Charles Tarbell (American, 1862–1938)
On Bos'n's Hill, 1901 [plate 60]
Oil on canvas, 41¾ × 30¾ in. (106 × 78 cm)
Cleveland Museum of Art, gift of Mr. and Mrs. Thomas A.
Mann and Robert A. Mann, 1992.398
Palace of Fine Arts, Gallery 89, wall D, no. 3958

John Henry Twachtman (American, 1853–1902)
Mother and Child, ca. 1893 [plate 59]
Oil on canvas, 30⅛ × 25⅛ in. (76.5 × 63.8 cm)
Fine Arts Museums of San Francisco, gift of the family
of Jacob Stern from his collection, 2007.45
Palace of Fine Arts, Gallery 93, wall B, no. 4063

Bessie Potter Vonnoh (American, 1872–1955)
The Scarf, ca. 1908 [plate 46]
Bronze, 13½ × 5½ × 6½ in. (34.3 × 14 × 16.5 cm)
Museum of Fine Arts, Boston, anonymous gift in memory
of John G. Pierce Sr., Res.65.62
Palace of Fine Arts, Gallery 65, case 2, no. 3069

Adolph Alexander Weinman (American, b. Germany, 1870–1952)
Descending Night, ca. 1914, cast later [plate 18]
Bronze, 54 × 54 × 19 in. (137.2 × 137.2 × 48.3 cm)
Museum of Fine Arts, Houston, 26.3
Palace of Fine Arts, Gallery 63, no. 2930

Adolph Alexander Weinman (American, b. Germany, 1870–1952)
Rising Day (Rising Sun), ca. 1914, cast later [plate 17]
Bronze, 56 × 54 × 19 in. (142.2 × 137.2 × 48.3 cm)
Museum of Fine Arts, Houston, 26.2

Julian Alden Weir (American, 1852–1919)
The Bridge: Nocturne (Nocturne: Queensboro Bridge), 1910 [plate 70]
Oil on canvas mounted on wood, 29 × 39½ in. (73.6 × 100.4 cm)
Hirshhorn Museum and Sculpture Garden,
Smithsonian Institution, Washington, DC,
gift of Joseph H. Hirshhorn, 1966, 66.5507
Palace of Fine Arts, Gallery 49, wall D, no. 2426, as *Towards
Queensboro Bridge: Nocturne*

Julian Alden Weir (American, 1852–1919)
The Plaza: Nocturne, 1911 [plate 71]
Oil on canvas, 29 × 39½ in. (73.6 × 100.4 cm)
Hirshhorn Museum and Sculpture Garden,
Smithsonian Institution, Washington, DC,
gift of Joseph H. Hirshhorn, 1966, 66.5508
Palace of Fine Arts, Gallery 49, wall D, no. 2423

James McNeill Whistler (American, 1834–1903)
Study in Rose and Brown, ca. 1884 [plate 31]
Oil on canvas, 20 × 12¼ in. (50.8 × 31.1 cm)
Collection of the Muskegon Museum of Art, Michigan,
Hackley Picture Fund Purchase, 1914.21
Palace of Fine Arts, Gallery 28, wall D, no. 274

William Zorach (American, b. Lithuania 1887–1966)
Woods in Autumn, 1913 [plate 85]
Oil on canvas, 28¾ × 23¾ in. (73 × 60.3 cm)
Whitney Museum of American Art, New York,
gift of an anonymous donor, 71.221a–b
Palace of Fine Arts, Gallery 119, wall C, no. 4347

PRINTS AND PHOTOGRAPHS

*Panoramic View of the Panama-Pacific International Exposition—
San Francisco, California, 1915*, 1915 [plate 7]
Published by Pacific Novelty Company
Color letterpress halftone, 5½ × 26¼ in. (14 × 66.8 cm)
Fine Arts Museums of San Francisco, gift of Barbara Jungi in
memory of Elsie F. Miller, 1990.1.8

*Night Illumination—Panama-Pacific International Exposition—
San Francisco, California, 1915*, 1915 [plate 8]
Published by Pacific Novelty Company
Color letterpress halftone, 5½ × 26¼ in. (14 × 66.8 cm)
Fine Arts Museums of San Francisco, gift of Barbara Jungi in
memory of Elsie F. Miller, 1990.1.9

*Panorama of the Panama-Pacific International
Exposition*, 1915 [plate 9]
Published by Cardinell-Vincent Company
Gelatin silver print with applied color, 7⅛ × 41¾ in. (18 × 106 cm)
Fine Arts Museums of San Francisco, Achenbach Foundation for
Graphic Arts, 1963.30.38418

Ansel Adams (American, 1902–1984)
Palace of Fine Arts, 1915 [fig. 130]
Gelatin silver print, 7½ × 8½ in. (19.1 × 21.6 cm)
David H. Arrington Collection

William M. Auerbach-Levy (American, b. Russia, 1889–1964)
Troubadour, 1912
Etching, 9 × 6 in. (22.8 × 15.2 cm)
Fine Arts Museums of San Francisco, gift of Theodore M.
Lilienthal, 1957.199.1
Palace of Fine Arts, Gallery 33, wall D, no. 794

Gustave Baumann (American, b. Germany, 1881–1971)
Harden Hollow, 1912 [fig. 111]
Color woodcut on Japanese paper, 19 13/16 × 26 5/8 in.
(50.3 × 67.7 cm)
Fine Arts Museums of San Francisco, gift of the artist, 1962.72.2
Palace of Fine Arts, Gallery 34, wall D, no. 911

Gustave Baumann (American, b. Germany, 1881–1971)
Plum and Peach Bloom, 1912 [fig. 112]
Color woodcut on Japanese paper, 19 13/16 × 26 3/4 in. (50.3 × 68 cm)
Fine Arts Museums of San Francisco, gift of the artist, 1962.72.3
Palace of Fine Arts, Gallery 34, wall D, no. 904,
as *Peach and Plum Bloom*

Anne W. Brigman (American, 1869–1950)
The Soul of the Blasted Pine, 1906 [plate 120]
Gelatin silver print, 7 5/8 × 9 5/8 in. (19.4 × 24.4 cm)
Private collection
Palace of Liberal Arts, Block 7, Pictorial Photography
Gallery, no. 54

Benjamin Chambers Brown (American, 1865–1942)
Art Palace, Reflections (Panama-Pacific International Exposition),
ca. 1915 [plate 11]
Soft-ground etching in color, 6 7/8 × 4 7/8 in. (17.5 × 12.8 cm)
Fine Arts Museums of San Francisco, California State Library
long loan, A028550

Benjamin Chambers Brown (American, 1865–1942)
Art Palace, S.F. Moonlight (Panama-Pacific International Exposition),
ca. 1915 [plate 12]
Soft-ground etching in color, 6 7/8 × 4 3/4 in. (17.5 × 12.2 cm)
Fine Arts Museums of San Francisco, California State Library
long loan, A028551

Francis Bruguière (American, 1879–1945)
Machinery Hall, West Entrance, at Night, 1915 [plate 126]
Gelatin silver print, 13 7/16 × 10 1/2 in. (34.2 × 26.7 cm)
Fine Arts Museums of San Francisco, gift of the Whitton Family
to the Percy Gray Collection, 2012.75
Palace of Liberal Arts, Block 7, Pictorial Photography
Gallery, no. 46

George Elbert Burr (American, 1859–1939)
Arizona Clouds, before 1915 [fig. 115]
Color mezzotint (sandpaper ground) with color drypoint,
7 1/16 × 9 15/16 in. (18 × 25.3 cm)
Fine Arts Museums of San Francisco, California State Library
long loan, A018247
Palace of Fine Arts, print cabinets, no. 6164

Arthur D. Chapman (American, 1882–1956)
*Diagonals (Christopher Street from the 8th Street Station of the Sixth
Avenue El, New York)*, 1913 [plate 129]
Platinum print, 8 × 6 in. (20.5 × 15.4 cm)
Library of Congress, Washington, DC, Prints and Photographs
Division, LL/15564
Palace of Liberal Arts, Block 7, Pictorial Photography
Gallery, no. 132

Alvin Langdon Coburn (American, 1882–1966)
Broadway at Night, ca. 1910 [plate 127]
Photogravure, 7 7/8 × 5 3/4 in. (20.1 × 14.7 cm)
George Eastman House, Rochester, New York, bequest of the
photographer, 1967:0144:0070
Palace of Liberal Arts, Block 7, Pictorial Photography
Gallery, no. 120

Elizabeth Colwell (American, 1881–1954)
The Great Pine, 1908 [fig. 109]
Color woodcut, 12 5/16 × 9 1/4 in. (31.2 × 23.5 cm)
Fine Arts Museums of San Francisco, museum purchase, gifts in
honor of Sylvia Walters's 75th birthday, gift of William C. Clark,
and Estate of Moses Laskey, 2015.5
Palace of Fine Arts, print cabinets, no. 6235

Elizabeth Colwell (American, 1881–1954)
Lake in Winter, ca. 1909 [plate 111]
Color woodcut on Japanese paper, 8 1/8 × 10 1/2 in. (20.6 × 26.6 cm)
Fine Arts Museums of San Francisco, California State Library
long loan, L391.1966
Palace of Fine Arts, Gallery 34, wall B, no. 846

Imogen Cunningham (American, 1883–1976)
Eve Repentant, 1910 [plate 121]
Platinum print, 10 1/2 × 8 1/4 in. (26.7 × 21.1 cm)
Private collection
Palace of Liberal Arts, Block 7, Pictorial Photography
Gallery, no. 25

William Edward Dassonville (American, 1879–1957)
Figure Study, ca. 1906 [plate 122]
Platinum print, 9 11/16 × 7 11/16 in. (24.6 × 19.5 cm)
The Wilson Centre for Photography, London, 97:5687
Palace of Liberal Arts, Block 7, Pictorial Photography
Gallery, no. 63

Pedro J. de Lemos (American, 1882–1954)
Summer Evening, ca. 1914 [plate 109]
Soft-ground etching and color woodcut with hand coloring on
Japanese paper, 8 15/16 × 8 3/4 in. (22.7 × 22.3 cm)
Fine Arts Museums of San Francisco, California State Library
long loan, L323.1966
Palace of Fine Arts, print cabinets, no. 6647 (as Pedro J. Lemos)

Edward R. Dickson (American, b. Ecuador, 1880–1922)
Design in Nature, ca. 1913 [plate 130]
Platinum print, 7 × 5 in. (22.8 × 19.1 cm)
Library of Congress, Washington, DC, Prints and Photographs
Division, PH-Dickson, no. 4 (A size)
Palace of Liberal Arts, Block 7, Pictorial Photography
Gallery, no. 105

Arthur Wesley Dow (American, 1857–1922)
The Gap, ca. 1914 [plate 108]
Color woodcut, 4 3/16 × 7 in. (10.6 × 17.8 cm)
Portland Art Museum, Portland, Oregon, gift of Heirs of Charles
Francis Adams Collection: Peter F. Adams, Mrs. Sandra Adams
Beebe, and Charles Anthony Adams, 89.20.64
Palace of Fine Arts, print cabinets, no. 6347

Frank Duveneck (American, 1848–1919)
Grand Canal, Venice, 1883
Etching, 11 13/16 × 19 1/2 in. (30 × 49.6 cm)
Fine Arts Museums of San Francisco, gift of Osgood
Hooker, 1959.124.12
Palace of Fine Arts, Gallery 87, wall C, no. 3891

Anne Goldthwaite (American, 1869–1944)
The Letter–Miss Walker, ca. 1908
Etching, 4 × 3 1/8 in. (10.2 × 8 cm)
Fine Arts Museums of San Francisco, gift of
Theodore M. Lilienthal, 1957.199.12
Palace of Fine Arts, print cabinets, no. 6438, as *The Letter*

Robert B. Harshe (American, 1879–1938)
Three Pines, ca. 1915
Etching, 9 3/8 × 7 13/16 in. (23.8 × 19.8 cm)
Fine Arts Museums of San Francisco, California State Library
long loan, A027365
Palace of Fine Arts, print cabinets, no. 6476

Ernest Haskell (American, 1876–1925)
Blind Gypsy, 1910
Etching printed in brown-black ink on Japanese paper,
5 5/8 × 3 15/16 in. (14.3 × 10 cm)
Fine Arts Museums of San Francisco, California State Library
long loan, L584.1966
Palace of Fine Arts, print cabinets, no. 6492

Ernest Haskell (American, 1876–1925)
Dwarfs of Ragged Island, 1912 [plate 104]
Etching and engraving, 6 3/8 × 4 3/4 in. (16.1 × 11.9 cm)
Fine Arts Museums of San Francisco, Achenbach Foundation for
Graphic Arts, 1963.30.25426
Palace of Fine Arts, Gallery 32, wall A, no. 539

Ernest Haskell (American, 1876–1925)
Retrospection, before 1913
Drypoint on chine collé, 5 13/16 × 3 9/16 in. (14.7 × 9.1 cm)
Fine Arts Museums of San Francisco, gift of Theodore M.
Lilienthal, 1956.367.2
Palace of Fine Arts, print cabinets, no. 6493

Clark Hobart (American, 1868–1948)
Nymph at the Pool, ca. 1914 [fig. 116]
Color monotype on cream Japanese paper, 7 3/8 × 12 in.
(18.7 × 30.5 cm)
Portland Art Museum, Portland, Oregon, gift of Heirs of Charles
Francis Adams Collection: Peter F. Adams, Mrs. Sandra Adams
Beebe, and Charles Anthony Adams, 89.20.51
Palace of Fine Arts, Gallery 34, wall A, no. 813

Edna Boies Hopkins (American, 1877–1937)
Zinnias, ca. 1908–1909 [plate 114]
Color woodcut, 10 7/8 × 7 3/8 in. (27.6 × 18.8 cm)
Library of Congress, Washington, DC, Prints and Photographs
Division, FP-XX-H794.no.4 (B size)
Palace of Fine Arts, Gallery 34, wall D, no. 907

Earl Horter (American, 1881–1940)
Smelters, Pittsburgh, ca. 1914 [plate 99]
Etching, 9 13/16 × 18 3/8 in. (25.3 × 47.4 cm)
Portland Art Museum, Portland, Oregon, gift of Heirs of Charles
Francis Adams Collection: Peter F. Adams, Mrs. Sandra Adams
Beebe, and Charles Anthony Adams, 89.20.30
Palace of Fine Arts, print cabinets, no. 6554

Helen Hyde (American, 1868–1919)
The Bath, 1905 [plate 112]
Color woodcut on Japanese paper, 16 1/4 × 10 1/4 in. (41.3 × 26 cm)
Fine Arts Museums of San Francisco, gift of Helen Hyde, 26320
Palace of Fine Arts, Gallery 34, wall B, no. 871

Helen Hyde (American, 1868–1919)
Mount Orizaba, 1912 [fig. 110]
Color woodcut on Japanese paper, 9 11/16 × 9 in. (24.6 × 22.9 cm)
Fine Arts Museums of San Francisco, California State Library
long loan, L231.1966
Palace of Fine Arts, print cabinets, no. 6572

Bertha E. Jaques (American, 1863–1941)
Charing Cross Bridge, 1913 [plate 94]
Etching, 8 ½ × 11 in. (21.6 × 27.9 cm)
Mills College Art Museum, Oakland
Palace of Fine Arts, print cabinets, no. 6603

Bertha E. Jaques (American, 1863–1941)
Rain on the Thames, 1913
Etching, 5 ⅞ × 9 ⁷⁄₁₆ in. (15 × 24 cm)
Fine Arts Museums of San Francisco, California State Library
long loan, L552.1966
Palace of Fine Arts, print cabinets, no. 6602

Beatrice Sophia Levy (American, 1892–1974)
Song of Summer, 1914 [plate 118]
Color etching and aquatint, 14 × 10 in. (35.6 × 25.4 cm)
Portland Art Museum, Portland, Oregon, gift of Heirs of Charles
Francis Adams Collection: Peter F. Adams, Mrs. Sandra Adams
Beebe, and Charles Anthony Adams, 89.20.118
Palace of Fine Arts, Gallery 34, wall D, no. 899

Allen Lewis (American, 1873–1957)
Gowanus Canal, before 1915
Drypoint, 9 ⁷⁄₁₆ × 7 ⅛ in. (24 × 18.1 cm)
Portland Art Museum, Portland, Oregon, gift of Heirs of Charles
Francis Adams Collection: Peter F. Adams, Mrs. Sandra Adams
Beebe, and Charles Anthony Adams, 89.20.54
Palace of Fine Arts, Gallery 33, wall B, no. 695

Bertha Lum (American, 1879–1954)
Rainy Twilight, 1905 [plate 110]
Color woodcut on Japanese paper, 6 ⅜ × 9 ½ in. (16.7 × 24.1 cm)
Fine Arts Museums of San Francisco, gift from the estate
of Edward T. Houghton through Mr. and Mrs. Edouard J.
Bourbousson, 1962.77.19
Palace of Fine Arts, Gallery 34, wall A, no. 830

Bertha Lum (American, 1879–1954)
Tanabata, 1912–1913 [plate 113]
Color woodcut on Japanese paper, 15 ⁵⁄₁₆ × 7 ⅛ in. (38.2 × 18.1 cm)
Fine Arts Museums of San Francisco, gift from the estate
of Edward T. Houghton through Mr. and Mrs. Edouard J.
Bourbousson, 1962.77.39
Palace of Fine Arts, print cabinets, no. 6686

Donald Shaw MacLaughlin (American, b. Canada, 1876–1938)
Quai des Grands Augustins, Paris, 1906 [plate 95]
Etching, 9 × 13 ¾ in. (22.7 × 34.9 cm)
Fine Arts Museums of San Francisco, bequest of William M.
Fitzhugh, 1957.188.60
Palace of Fine Arts, print cabinets, no. 6702

John Marin (American, 1872–1953)
Bal Bullier, Paris, 1906 [plate 90]
Drypoint, 5 ⅜ × 7 ¾ in. (13.8 × 19.8 cm)
Cantor Arts Center, Stanford University, California,
gift of Dr. Ralph and Marilyn Spiegl, 1980.40
Palace of Fine Arts, print cabinets, no. 6713

John Marin (American, 1872–1953)
Ca d'Oro, Venice, 1907 [plate 91]
Etching, 7 × 9 ⅜ in. (17.8 × 23.8 cm)
Portland Art Museum, Portland, Oregon, gift of Heirs of Charles
Francis Adams Collection: Peter F. Adams, Mrs. Sandra Adams
Beebe, and Charles Anthony Adams, 89.20.78
Palace of Fine Arts, print cabinets, no. 6714

Perham Wilhelm Nahl (American, 1869–1935)
Monterey Cypress, ca. 1914 [plate 103]
Monotype printed in olive green ink, 11 ⅛ × 9 in. (28.3 × 23 cm)
Portland Art Museum, Portland, Oregon, gift of Heirs of Charles
Francis Adams Collection: Peter F. Adams, Mrs. Sandra Adams
Beebe, and Charles Anthony Adams, 89.20.107
Palace of Fine Arts, Gallery 33, wall D, no. 649

Perham Wilhelm Nahl (American, 1869–1935)
*The Thirteenth Labor of Hercules: Official Poster for the Panama-Pacific
International Exposition*, 1913–1914 [plate 1]
Color offset lithograph poster, sheet: 22 × 14 in. (55.9 × 35.6 cm)
Collection of Donna Ewald Huggins

Bror Julius Olsson Nordfeldt (American, b. Sweden, 1878–1955)
Anglers, 1906 [fig. 108]
Color woodcut on Japanese paper, 8 ¾ in × 12 ¾ in. (22.2 × 32.4 cm)
Portland Art Museum, Portland, Oregon, gift of Heirs of Charles
Francis Adams Collection: Peter F. Adams, Mrs. Sandra Adams
Beebe, and Charles Anthony Adams, 89.20.98
Palace of Fine Arts, print cabinets, no. 6864, as *Anglers—The Mist*

Bror Julius Olsson Nordfeldt (American, b. Sweden, 1878–1955)
Bridge Builders, Chicago, 1912 [plate 98]
Etching and drypoint, 9 ⅞ × 11 ⅞ in. (25.2 × 30.1 cm)
Fine Arts Museums of San Francisco, gift of Mrs. B. J. O.
Nordfeldt, 1956.375.31
Palace of Fine Arts, print cabinets, no. 6848

Bror Julius Olsson Nordfeldt (American, b. Sweden, 1878–1955)
The Coal Crusher, Chicago, 1912
Etching and drypoint, 8 ⅞ × 12 ⅛ in. (22.5 × 30.8 cm)
Fine Arts Museums of San Francisco, gift of Mrs. B. J. O.
Nordfeldt, 1956.375.33
Palace of Fine Arts, print cabinets, no. 6850

Bror Julius Olsson Nordfeldt (American, b. Sweden, 1878–1955)
The Piano, 1906 [plate 117]
Color woodcut on Japanese paper, 8 ¼ × 10 ⅛ in. (20.8 × 25.6 cm)
Fine Arts Museums of San Francisco, gift of
Elizabeth S. Tower, 1980.1.90
Palace of Fine Arts, Gallery 34, wall D, no. 902

Bror Julius Olsson Nordfeldt (American, b. Sweden, 1878–1955)
The Wave, Moonrise, 1906 [plate 116]
Color woodcut on Japanese paper, 9 ⅜ × 11 ⅛ in. (23.7 × 28.3 cm)
Fine Arts Museums of San Francisco, California State Library
long loan, L118.1966
Palace of Fine Arts, print cabinets, no. 6869

Roi Partridge (American, 1888–1984)
Dancing Water (Pont Neuf), 1911 [plate 106]
Etching, 12 ⅞ × 9 ⅜ in. (32.8 × 23.9 cm)
Fine Arts Museums of San Francisco, gift of Mrs. A. S.
MacDonald, 42123
Palace of Fine Arts, Gallery 33, wall B, no. 690 (as G. Roy
Partridge)

Roi Partridge (American, 1888–1984)
Early Morning, Notre Dame, 1912 [plate 107]
Drypoint, 12 ⅜ × 8 ¼ in. (32.1 × 20.9 cm)
Fine Arts Museums of San Francisco, gift of
Henry D. Meyer, 1961.69.2
Palace of Fine Arts, print cabinets, no. 6908 (as G. Roy Partridge)

Roi Partridge (American, 1888–1984)
White Butterfly, 1912 [plate 105]
Etching, 17 ½ × 10 ⅜ in. (44.3 × 26.4 cm)
Portland Art Museum, Portland, Oregon, gift of Heirs of Charles
Francis Adams Collection: Peter F. Adams, Mrs. Sandra Adams
Beebe, and Charles Anthony Adams, 89.20.120
Palace of Fine Arts, Gallery 33, wall B, no. 692 (as G. Roy
Partridge)

Margaret Jordan Patterson (American, b. Indonesia, 1867–1950)
The Swan, ca. 1914 [plate 115]
Color woodcut, 8 ¾ × 6 ¼ in. (22.2 × 15.9 cm)
Herbert F. Johnson Museum of Art, Cornell University,
Ithaca, New York, Bequest of William P. Chapman, Jr.,
Class of 1895, 62.2929
Palace of Fine Arts, Gallery 34, wall B, no. 862

Ralph Pearson (American, 1883–1958)
The Asphalters, Wabash Avenue, 1911 [plate 97]
Etching with drypoint, 10 ⅞ × 8 in. (27.6 × 20.3 cm)
Fine Arts Museums of San Francisco, gift of
Dan London, 1954.148.9
Palace of Fine Arts, print cabinets, no. 6930

Joseph Pennell (American, 1857–1926)
The Cathedral Door, 1912
Lithograph, 22 ½ × 17 in. (57.2 × 43.2 cm)
Fine Arts Museums of San Francisco, California State Library
long loan, A026283
Palace of Fine Arts, Gallery 31, wall A, no. 483

Joseph Pennell (American, 1857–1926)
The Cut from Culebra, 1912
Lithograph, 22 ⅜ × 17 in. (56.8 × 43.2 cm)
Fine Arts Museums of San Francisco, Achenbach Foundation for
Graphic Arts, 1963.30.24087
Palace of Fine Arts, Gallery 31, wall B, no. 499

Joseph Pennell (American, 1857–1926)
The End of the Day, Gatun Lock, 1912 [plate 96]
Lithograph, 22 ¼ × 16 ¾ in. (56.4 × 42.5 cm)
Fine Arts Museums of San Francisco, Achenbach Foundation for
Graphic Arts, 1963.30.24086
Palace of Fine Arts, Gallery 31, wall B, no. 509

Joseph Pennell (American, 1857–1926)
The Foundations—Building a Skyscraper, 1910
Lithograph, 22 ½ × 17 ⅞ in. (57.2 × 44.3 cm)
Fine Arts Museums of San Francisco, Achenbach Foundation for
Graphic Arts, 1963.30.24085
Palace of Fine Arts, print cabinets, no. 6956, as *Building a
Skyscraper at Night*

Joseph Pennell (American, 1857–1926)
Stock Yards, Chicago, 1910
Etching printed in brown-black ink, 9 ⁷⁄₁₆ × 12 ⁷⁄₁₆ in.
(23.9 × 31.6 cm)
Fine Arts Museums of San Francisco, Achenbach Foundation for
Graphic Arts, 1963.30.24074
Palace of Fine Arts, Gallery 31, wall D, no. 529

Lee F. Randolph (American, 1880–1956)
A Wind-Swept Pine, Monterey, before 1915
Etching with roulette, printed in brown-black ink, 7 ⅛ × 9 ⁷⁄₁₆ in.
(18.1 × 24 cm)
Fine Arts Museums of San Francisco, museum purchase,
Skae Fund Legacy, 41799
Palace of Fine Arts, Gallery 32, wall B, no. 577

Jane Reece (American, 1869–1961)
Maid o' the Sea, 1907 [plate 125]
Platinum print, 6 ¼ × 4 ⅜ in. (15.9 × 11.8 cm)
Dayton Art Institute, Ohio, gift of Miss Jane Reece, 1952.19.5
Palace of Liberal Arts, Block 7, Pictorial Photography
Gallery, no. 142

Ernest David Roth (American, b. Germany, 1879–1964)
The Gate, Venice, 1906 [plate 92]
Etching, 7 ½ × 6 ⅜ in. (19.1 × 16.3 cm)
Fine Arts Museums of San Francisco, Achenbach Foundation for
Graphic Arts, 1963.30.24946
Palace of Fine Arts, print cabinets, no. 7175

George Senseney (American, 1874–1943)
Bridge of Sighs, before 1915 [fig. 113]
Color aquatint with roulette, 18 ³⁄₁₆ × 11 in. (46.5 × 28 cm)
Fine Arts Museums of San Francisco, California State Library
long loan, A062394
Palace of Fine Arts, print cabinets, no. 7204

John Sloan (American, 1871–1951)
Night Windows, 1910 [plate 102]
Etching, 5 ⅜ × 7 in. (13.6 × 17.7 cm)
Library of Congress, Washington, DC, Prints and Photographs
Division, FP-XIX-S634, no. 152 (A size)
Palace of Fine Arts, Gallery 32, wall D, no. 637

John Sloan (American, 1871–1951)
Roofs, Summer Night, 1906, from the series
New York City Life, 1905–1906 [plate 100]
Etching, 5 ¼ × 7 in. (13.3 × 17.8 cm)
Fine Arts Museums of San Francisco, museum purchase,
Achenbach Foundation for Graphic Arts Endowment
Fund, 2015.4
Palace of Fine Arts, Gallery 32, wall D, no. 636

John Sloan (American, 1871–1951)
Turning Out the Light, 1905, from the series
New York City Life, 1905–1906
Etching, 4 ¹³⁄₁₆ × 6 ⅞ in. (12.5 × 17.5 cm)
Fine Arts Museums of San Francisco, Achenbach Foundation for
Graphic Arts, 1963.30.1870
Palace of Fine Arts, Gallery 32, wall D, no. 642

John Sloan (American, 1871–1951)
The Women's Page, 1905, from the series
New York City Life, 1905–1906 [plate 101]
Etching, 5 × 7 in. (12.7 × 17.7 cm)
Herbert F. Johnson Museum of Art, Cornell University, Ithaca,
New York, gift of Theodore B. Donson, Class of 1960, 84.083.001
Palace of Fine Arts, print cabinets, no. 7218

Jules André Smith (American, 1880–1959)
The Little Foundry, 1913–1914 [plate 93]
Etching, 7 ⅞ × 11 in. (20.1 × 27.8 cm)
Fine Arts Museums of San Francisco, gift of Theodore M.
Lilienthal, 1957.199.26
Palace of Fine Arts, Gallery 32, wall D, no. 616

Maud Hunt Squire (American, 1873–ca. 1954)
Windy Day, 1907 [plate 119]
Color aquatint, 5 ⅞ × 5 ⅜ in. (15.1 × 13.8 cm)
Portland Art Museum, Portland, Oregon, gift of Heirs of Charles
Francis Adams Collection: Peter F. Adams, Mrs. Sandra Adams
Beebe, and Charles Anthony Adams, 89.20.79
Palace of Fine Arts, print cabinets, no. 7241

Thomas Wood Stevens (American, 1880–1942)
The Bow and Arrow, ca. 1914
Etching, 13 ¾ × 9 ¾ in. (34.9 × 24.8 cm)
Portland Art Museum, Portland, Oregon, gift of Heirs of Charles
Francis Adams Collection: Peter F. Adams, Mrs. Sandra Adams
Beebe, and Charles Anthony Adams, 89.20.105
Palace of Fine Arts, Gallery 33, wall B, no. 724

Karl Struss (American, 1886–1981)
Columbia University, Night, 1910 [plate 128]
Gum dichromate over platinum print, mercury-processed,
9 ½ × 7 ⅜ in. (24 × 19.4 cm)
National Gallery of Art, Washington, DC, Horace W. Goldsmith
Foundation through Robert and Joyce Menschel, 2007.59.2
Palace of Liberal Arts, Block 7, Pictorial Photography
Gallery, no. 125

Everett L. Warner (American, 1877–1963)
Brooklyn Bridge, before 1915
Etching printed in green ink, 11 ¹³⁄₁₆ × 6 ¹³⁄₁₆ in. (30.3 × 17.7 cm)
Fine Arts Museums of San Francisco, California State Library
long loan, A021118
Palace of Fine Arts, Gallery 33, wall B, no. 708

Cadwallader Washburn (American, 1866–1965)
Bridge at Brielle, from the *New Jersey* series, ca. 1913
Drypoint on Japanese paper, 6 × 8 in. (15.2 × 20.3 cm)
Fine Arts Museums of San Francisco, gift of
Dr. Ludwig A. Emge, 1971.17.1447
Palace of Fine Arts, print cabinets, no. 7348

Cadwallader Washburn (American, 1866–1965)
Exposition Palace Interior, from the portfolio *Building of the Panama-
Pacific International Exposition*, ca. 1914 [plate 4]
Lithograph, 14 ½ × 10 ⅛ in. (36.8 × 25.7 cm)
Fine Arts Museums of San Francisco, Achenbach Foundation for
Graphic Arts, 1963.30.26362
Palace of Fine Arts, print cabinets, no. 7364(?), as *The Half Dome*

Cadwallader Washburn (American, 1866–1965)
Liberal Arts Building—The Entrance, from the portfolio *Building of
the Panama-Pacific International Exposition*, ca. 1914 [plate 5]
Lithograph, 15 ¼ × 11 ¾ in. (38.6 × 29.7 cm)
Fine Arts Museums of San Francisco, Achenbach Foundation for
Graphic Arts, 1963.30.26372
Palace of Fine Arts, print cabinets, no. 7322

Cadwallader Washburn (American, 1866–1965)
A Riverside Path, Manasquan River, from the *New Jersey*
series, ca. 1913
Drypoint on Japanese paper, 8 ¹⁄₁₆ × 11 ¹³⁄₁₆ in. (20.4 × 30.3 cm)
Fine Arts Museums of San Francisco, gift of Dr. Ludwig A.
Emge, 1971.17.1309
Palace of Fine Arts, print cabinets, no. 7338

Herman Armour Webster (American, 1878–1970)
Head of an Old Man, before 1915
Drypoint, 5 ⅞ × 3 ¹⁵⁄₁₆ in. (14.9 × 10 cm)
Fine Arts Museums of San Francisco, Achenbach Foundation for
Graphic Arts, 1963.30.24489
Palace of Fine Arts, print cabinets, no. 7387

Julian Alden Weir (American, 1852–1919)
Arcturus, 1892
Engraving, 9 × 6 ¹³⁄₁₆ in. (22.8 × 17.7 cm) (trimmed within
plate mark)
Fine Arts Museums of San Francisco, gift of
Mrs. Katherine Caldwell, 1976.1.123
Palace of Fine Arts, Gallery 30, wall B, no. 407

Julian Alden Weir (American, 1852–1919)
The Picture Book, ca. 1890
Etching and drypoint, 6 ¹³⁄₁₆ × 4 ¹³⁄₁₆ in. (17.7 × 12.6 cm)
Fine Arts Museums of San Francisco, gift of
Mrs. Katherine Caldwell, 1976.1.118
Palace of Fine Arts, print cabinets, no. 7401

Isabel Percy West (American, 1882–1976)
Granada, Spain, before 1915 [fig. 114]
Color lithograph, 16 ⁷⁄₁₆ × 12 ⅜ in. (41.8 × 32.1 cm)
Fine Arts Museums of San Francisco, California State Library
long loan, L388.1966
Palace of Fine Arts, print cabinets, no. 7020, as *Street in
Granada, Spain* (as Isabelle C. Percy)

Edward Weston (American, 1886–1958)
Carlota, 1914 [plate 123]
Platinum print, 9 ¼ × 6 ¼ in. (23.5 × 15.8 cm)
Collection of John J. Medveckis
Palace of Liberal Arts, Block 7, Pictorial Photography
Gallery, no. 16

James McNeill Whistler (American, 1834–1903)
Black Lion Wharf, 1859, from the *Thames Set*, 1871 [plate 86]
Etching, 5 ⅞ × 8 ¾ in. (14.8 × 22.3 cm)
Fine Arts Museums of San Francisco, museum purchase,
Graphic Arts Council Exhibition Fund, 1981.1.188
Palace of Fine Arts, Gallery 29, wall C, no. 316

James McNeill Whistler (American, 1834–1903)
Draped Figure, Reclining, 1892 [plate 89]
Color transfer lithograph on thin transparent transfer paper,
7 ⅛ × 10 ⅛ in. (18 × 25.8 cm)
Fine Arts Museums of San Francisco, museum purchase,
Achenbach Foundation for Graphic Arts Endowment Fund,
1965.68.1
Palace of Fine Arts, Gallery 29, wall B, no. 301

James McNeill Whistler (American, 1834–1903)
The Little Mast, 1879/1880, from the *First Venice Set*, 1880
Etching and drypoint, 10 ½ × 7 ³⁄₁₆ in. (26.7 × 18.5 cm)
Fine Arts Museums of San Francisco, Frances B. Lilienthal
Memorial Collection, Gift of Theodore M. Lilienthal, 1965.71.4
Palace of Fine Arts, Gallery 29, wall A, no. 287

James McNeill Whistler (American, 1834–1903)
The Riva, 1879/1880, from the *First Venice Set*, 1880
Etching and drypoint, 7 ¹⁵⁄₁₆ × 11 ¾ in. (20.2 × 29.8 cm)
Fine Arts Museums of San Francisco, gift of
Osgood Hooker, 1959.124.5
Palace of Fine Arts, Gallery 29, wall A, no. 299, as *The Riva, No. 1*

James McNeill Whistler (American, 1834–1903)
Rotherhithe, 1860, from the *Thames Set*, 1871
Etching and drypoint, 10 ¹³⁄₁₆ × 7 ¹³⁄₁₆ in. (27.5 × 19.9 cm)
Fine Arts Museums of San Francisco, Achenbach Foundation for
Graphic Arts, 1963.30.460
Palace of Fine Arts, Gallery 29, wall C, no. 318

James McNeill Whistler (American, 1834–1903)
San Biagio, 1880, from the *Second Venice Set*, 1886
Etching and drypoint printed in brown-black ink, 8 ³⁄₁₆ × 11 ¹³⁄₁₆ in.
(20.8 × 30 cm)
Fine Arts Museums of San Francisco, gift of Mr. and Mrs. Robert
F. Gill through the Patrons of Art and Music, 1975.1.132
Palace of Fine Arts, Gallery 29, wall A, no. 288

James McNeill Whistler (American, 1834–1903)
The Thames, 1896 [plate 87]
Lithotint with scraping, 10 ½ × 7 ¾ in. (26.7 × 19.6 cm)
Fine Arts Museums of San Francisco, museum purchase,
Achenbach Foundation for Graphic Arts Endowment
Fund, 1992.140
Palace of Fine Arts, Gallery 29, wall A, no. 291

James McNeill Whistler (American, 1834–1903)
Weary, 1863 [plate 88]
Drypoint, 7 ⅛ × 5 ¼ in. (19.7 × 13.3 cm)
Fine Arts Museums of San Francisco, museum purchase,
Vera Michels Bequest Fund and Achenbach Foundation for
Graphic Arts Endowment Fund, 1995.88
Palace of Fine Arts, Gallery 29, wall C, no. 319

Charles Henry White (American, b. Canada, 1878–1918)
The Old Courtyard, from the *New Orleans Set*, 1906
Etching, 12 ¼ × 7 ⁹⁄₁₆ in. (31.1 × 19.2 cm)
Portland Art Museum, Portland, Oregon, gift of Heirs of Charles
Francis Adams Collection: Peter F. Adams, Mrs. Sandra Adams
Beebe, and Charles Anthony Adams, 89.20.102
Palace of Fine Arts, print cabinets, no. 7419

Clarence H. White (American, 1871–1925)
The Orchard, 1902 [plate 124]
Platinum print, 9 ½ × 7 ½ in. (24 × 19.1 cm)
Library of Congress, Washington, DC, Prints and Photographs
Division, PH-White (C.), no. 15 (A size)
Palace of Liberal Arts, Block 7, Pictorial Photography
Gallery, no. 111

Henry Wolf (American, b. France, 1852–1916)
The Evening Star, 1896
Wood engraving, 4 ¹³⁄₁₆ × 7 ⅜ in. (12.3 × 18.8 cm)
Fine Arts Museums of San Francisco, Achenbach Foundation for
Graphic Arts, 1963.30.26350
Palace of Fine Arts, Gallery 30, wall A, no. 329

Henry Wolf (American, b. France, 1852–1916)
The Morning Star (Motif Found in Central Park, New York), 1903
Wood engraving, 5 ⅞ × 8 in. (15 × 20.3 cm)
Fine Arts Museums of San Francisco, Achenbach Foundation for
Graphic Arts, 1963.30.26143
Palace of Fine Arts, Gallery 30, wall A, no. 337

FRENCH AND BELGIAN ART

Paul Cézanne (French, 1839–1906)
*The Gulf of Marseilles from L'Estaque (Le golfe de Marseilles vu de
L'Estaque)*, 1878–1879 [plate 141]
Oil on canvas, 22 ⅞ × 28 ⅜ in. (58 × 72 cm)
Musée d'Orsay, Paris, RF 2761
French Pavilion, Gallery 6, no. 18

Gustave Courbet (French, 1819–1877)
The Violoncellist, 1847 [plate 137]
Oil on canvas, 44 ¼ × 34 ⅛ in. (112.4 × 86.7 cm)
Portland Art Museum, Portland, Oregon, gift of Col. C. E. S.
Wood in memory of his wife, Nanny Moale Wood, 43.2.1
Palace of Fine Arts, Gallery 92, wall A, no. 4019, as *Young Man
with Violincello*

Edgar Degas (French, 1834–1917)
At the Café-Concert, ca. 1879–1884 [plate 143]
Oil on canvas, 25 ⅞ × 18 ⅜ in. (65.8 × 46.7 cm)
National Gallery of Canada, Ottawa,
gift of the Saidye Bronfman Foundation, 1995, 38088
Palace of Fine Arts, Gallery 13, no. 310

André Édouard Devambez (French, 1867–1944)
The Charge (Le charge), 1902–1903 [plate 145]
Oil on canvas, 50 × 63 ¾ in. (127 × 162 cm)
Musée d'Orsay, Paris, RF 1979 61
Palace of Fine Arts, French Section, no. 319

Jean-Paul Laurens (French, 1838–1921)
The Execution of Joan of Arc, from the series *The Story of Joan of Arc*,
1905–1907 [plate 134]
Wool and silk; tapestry weave, 92 × 169 in. (233.7 × 429.3 cm)
Fine Arts Museums of San Francisco, gift of the French
Government, 1924.32.3
French Pavilion, Gallery 1

Claude Monet (French, 1840–1926)
*Rouen Cathedral Facade (La cathédrale de Rouen. Le portail vu
de face)*, 1892 [plate 144]
Oil on canvas, 42 ¼ × 29 ¼ in. (107 × 74 cm)
Musée d'Orsay, Paris, RF 2779
French Pavilion, Gallery 14, no. 54, as *The Cathedral*

Camille Pissarro (French, 1831–1903)
Houses at Bougival (Autumn), 1870 [plate 139]
Oil on canvas, 35 × 45 ⅜ in. (88.9 × 116.2 cm)
J. Paul Getty Museum, Los Angeles, 82.PA.73
Palace of Fine Arts, Gallery 61, wall C, no. 2819, as *Village aux
environs de Mantes*

Camille Pissarro (French, 1831–1903)
*Red Roofs, Village Corner, Winter Effect (Les toits rouges, coin de
village, effet d'hiver)*, 1877 [plate 140]
Oil on canvas, 21 ½ × 25 ⅞ in. (54.5 × 65.6 cm)
Musée d'Orsay, Paris, RF 2735
French Pavilion, Gallery 6, no. 62

Pierre Puvis de Chavannes (French, 1824–1898)
A Vision of Antiquity—Symbol of Form, ca. 1885 [plate 142]
Oil on canvas, 41 ¼ × 52 in. (104.8 × 132.1 cm)
Carnegie Museum of Art, Pittsburgh, purchase, 97.3
Palace of Fine Arts, Gallery 61, wall D, no. 2831

Auguste Rodin (French, 1840–1917)
The Age of Bronze, ca. 1875–1877 [plate 135]
Bronze, 71 ½ × 21 ¼ × 25 ½ in. (181.6 × 54 × 64.8 cm)
Fine Arts Museums of San Francisco, gift of
Alma de Bretteville Spreckels, 1940.141
French Pavilion, Gallery 2 (Central Tapestry Hall)

Auguste Rodin (French, 1840–1917)
The Prodigal Son, 1887 [plate 136]
Bronze, 64 × 28 × 34 ½ in. (162.6 × 71.1 × 87.6 cm)
Fine Arts Museums of San Francisco, gift of
Alma de Bretteville Spreckels, 1940.137
French Pavilion, Gallery 2 (Central Tapestry Hall)

James Tissot (French, 1836–1902)
L'ambitieuse (The Political Woman), 1883–1885 [plate 138]
Oil on canvas, 73 ½ × 56 in. (186.7 × 142.2 cm)
Albright-Knox Art Gallery, Buffalo, New York, gift of
William M. Chase, 1909, 1909:10
Palace of Fine Arts, Gallery 92, wall D, no. 4040, as *The Reception*

Théo van Rysselberghe (Belgian, 1862–1926)
Garden of the Generalife in Granada, 1913 [plate 146]
Oil on canvas, 31 ¾ × 33 in. (80.6 × 83.8 cm)
Fine Arts Museums of San Francisco, gift of
B. Gerald Cantor, 1969.1
French Pavilion, Gallery 17 (Belgian Section), no. 109

INTERNATIONAL ART / THE ANNEX

Cast of a scene from the north frieze of the Parthenon,
the Acropolis, Athens: four youths carrying water pitchers,
followed by a piper, before 1915 [fig. 42]
Plaster, 40 ⅛ × 48 ¼ × 5 in. (101.9 × 122.5 × 12.7 cm)
Fine Arts Museums of San Francisco, gift of the Greek
Government, PPIE, 44925
Greek Pavilion

Cast of a scene from the north frieze of the Parthenon,
the Acropolis, Athens: procession of three horses and riders
followed by a boy adjusting the belt on the last horseman's
tunic, before 1915 [fig. 43]
Plaster, 40 × 64 × 5 in. (101.6 × 162.5 × 12.7 cm)
Fine Arts Museums of San Francisco, gift of the Greek
Government, PPIE, 44921
Greek Pavilion

Giacomo Balla (Italian, 1871–1958)
*Disintegration x Speed, Dynamic Dispersions of an Automobile
(Disgregazione x velocità, penetrazioni dinamiche d'automobile)*, 1913
[plate 170]
Gouache, wash and brush and ink on paper laid down on card,
26 ⅜ × 37 ⅝ in. (67.7 × 95.7 cm)
Massimo and Sonia Cirulli Archive, New York
Palace of Fine Arts Annex, Gallery 141, no. 1131, as *Dynamism of
Dispersion*

Róbert Berény (Hungarian, 1887–1953)
Golgotha (Scene V), 1912 [plate 156]
Oil on canvas, 24 ¼ × 19 ⅞ in. (61.5 × 50.5 cm)
Drs. Thomas Sos and Shelley Wertheim, and Lidia Szajko and
Nanci Clarence
Palace of Fine Arts Annex, Gallery 127, no. 33

Umberto Boccioni (Italian, 1882–1916)
Dynamism of a Cyclist (Dinamismo di un ciclista), 1913 [plate 169]
Oil on canvas, 27 ½ × 37 ⅜ in. (70 × 95 cm)
Gianni Mattioli Collection, on long-term loan to the
Peggy Guggenheim Collection, Venice, GM5
Palace of Fine Arts Annex, Gallery 141, no. 1140

Umberto Boccioni (Italian, 1882–1916)
Dynamism of a Soccer Player, 1913 [plate 168]
Oil on canvas, 76 × 79 ⅛ in. (193.2 × 201 cm)
Museum of Modern Art, New York, The Sidney and
Harriet Janis Collection, 580.1967
Palace of Fine Arts Annex, Gallery 141, no. 1143, as *Dynamism of
a Footballer*

Umberto Boccioni (Italian, 1882–1916)
Matter (Materia), 1912 [plate 167]
Oil on canvas, 89 × 59 in. (226 × 150 cm)
Gianni Mattioli Collection, on loan to the
Peggy Guggenheim Museum, Venice
Palace of Fine Arts Annex, Gallery 141, no. 1142

Nikolay Fechin (Russian, 1881–1955)
Lady in Pink (Portrait of Natalia Podbelskaya), 1912 [plate 149]
Oil on canvas, 45 ½ × 35 in. (115.6 × 89 cm)
Frye Art Museum, Seattle, 1990.005
Palace of Fine Arts, Gallery 61, wall B, no. 2816

Akseli Gallen-Kallela (Finnish, 1865–1931)
In the Brush, 1910 [plate 165]
Oil on canvas, 15 ½ × 11 ½ in. (39.4 × 29.2 cm)
Private collection
Palace of Fine Arts Annex, Gallery 138, no. 230

Akseli Gallen-Kallela (Finnish, 1865–1931)
The Little Valley, 1910 [fig. 16]
Oil on canvas, 12 ½ × 13 ¼ in. (31.8 × 33.7 cm)
Private collection

Akseli Gallen-Kallela (Finnish, 1865–1931)
Self-Portrait with Cheetah (Omakuva Cheetahin kanssa), 1910
[plate 166]
Oil on canvas, 49 ¼ × 56 ¼ in. (125 × 143 cm)
Private collection
Palace of Fine Arts Annex, Gallery 138, no. 211, as *After the Hunt*

Akseli Gallen-Kallela (Finnish, 1865–1931)
Symposion (The Problem) (Symposion [Probleema]), 1894 [plate 164]
Oil on canvas in frame, framed: 46 × 56 ¼ in. (117 × 143 cm);
unframed: 29 ⅛ × 39 ⅜ in. (74 × 100 cm) Private collection
Palace of Fine Arts Annex, Gallery 138, no. 169

Akseli Gallen-Kallela (Finnish, 1865–1931)
Mäntykoski Waterfall (Mäntykoski), 1892–1894 [plate 163]
Oil on canvas in frame, framed: 119 ½ × 75 ¼ in. (303.5 × 191.2 cm);
unframed: 106 ¼ × 61 ⅜ in. (270 × 156 cm) Private collection
Palace of Fine Arts Annex, Gallery 138, no. 216, as *The Waterfall*

Oskar Kokoschka (Austrian, 1886–1980)
Portrait of Egon Wellesz, 1911 [plate 152]
Oil on canvas, 29 ¾ × 27 ⅛ in. (75.5 × 68.9 cm)
Hirshhorn Museum and Sculpture Garden, Smithsonian
Institution, Washington, DC, gift of the Joseph H. Hirshhorn
Foundation, 1966, 66.2776
Palace of Fine Arts Annex, Gallery 142, no. 308

Ödön Márffy (Hungarian, 1878–1959)
Still Life, ca. 1910 [plate 155]
Oil on canvas, 17 ⅜ × 21 ⅜ in. (44 × 55 cm)
Collection of Jill A. Wiltse and H. Kirk Brown III, Denver
Palace of Fine Arts Annex, Gallery 127, no. 375

Edvard Munch (Norwegian, 1863–1944)
Madonna, 1895–1913/1914 [plate 160]
Color lithograph in black, red, and olive, and sawn woodblock
or stencil in blue, hand touched, on thick white Japanese paper,
21 ⅞ × 13 ¾ in. (55.6 × 34.9 cm)
Epstein Family Collection
Palace of Fine Arts Annex, Gallery 149, no. 216, as *Loving Woman*
(lithograph in 4 colors)

Edvard Munch (Norwegian, 1863–1944)
Moonlight I, 1896 [plate 161]
Color woodcut on thin Japanese paper, 15 ¾ × 18 ½ in. (40 × 47 cm)
Fine Arts Museums of San Francisco, museum purchase,
the Herman Michels Collection, Vera Michels Bequest
Fund, 1993.121
Palace of Fine Arts Annex, Gallery 149, no. 222

Edvard Munch (Norwegian, 1863–1944)
Self-Portrait, 1895 [plate 159]
Lithograph, 17 ⅞ × 12 ½ in. (45.5 × 31.7 cm)
Berkeley Art Museum, California, partial gift of Michal and
R. E. Lewis and purchase made possible by a bequest from
Thérèse Bonney, Class of 1916, by exchange, 1995.23
Palace of Fine Arts Annex, Gallery 149, no. 223

Bertalan Pór (Hungarian, 1880–1964)
My Family (Család), 1909–1910 [plate 154]
Oil on canvas, 69 ¼ × 81 ⅛ in. (176 × 206 cm)
Magyar Nemzeti Galéria, Budapest, 60.136T
Palace of Fine Arts Annex, no. 425

Leo Putz (German, 1869–1940)
On the Shore (Am Ufer), 1909 [plate 150]
Oil on canvas, 59 ½ × 55 ½ in. (151 × 141 cm)
Collection Siegfried Unterberger
Palace of Fine Arts, Gallery 108, wall C, no. 428

József Rippl-Rónai (Hungarian, 1861–1927)
Parisian Interior (Párizsi enterió) 1910 [plate 158]
Oil on cardboard, 29 ¾ × 41 ⅛ in. (75.5 × 104.5 cm)
Kieselbach Collection, Budapest
Palace of Fine Arts Annex, Gallery 129, no. 448

József Rippl-Rónai (Hungarian, 1861–1927)
Portrait of Márk Vedres, 1910 [plate 157]
Oil on cardboard, 19 ⅜ × 26 ¾ in. (50 × 68 cm)
Collection of Elisabetta Vedres
Palace of Fine Arts Annex, Gallery 129, no. 447

Luigi Russolo (Italian, 1885–1947)
*Plastic Synthesis of a Woman's Movements (Synthèse plastique des
mouvements d'une femme)*, 1912 [plate 172]
Oil on canvas, 33 ½ × 25 ⅜ in. (85 × 65 cm)
Musée des Beaux-Arts, Grenoble, France
Palace of Fine Arts Annex, Gallery 141, no. 1161,
as *Plastic Summary of a Woman's Movements*

Gino Severini (Italian, 1883–1966)
Spherical Expansion of Light, Centripetal, 1913–1914 [plate 171]
Oil on canvas, 24 × 19 ½ in. (60.9 × 49.5 cm)
Private collection
Palace of Fine Arts Annex, Gallery 141, no. 1167

Harald Oskar Sohlberg (Norwegian, 1869–1935)
Fisherman's Cottage, 1906 [plate 162]
Oil on canvas, 43 × 37 in. (109 × 94 cm)
Art Institute of Chicago, gift of Edward Byron Smith, 2000.1
Palace of Fine Arts Annex, no. 117

Lajos Tihanyi (Hungarian, 1885–1938)
Self-Portrait (Önarckép), 1914 [plate 153]
Oil on canvas, 22 × 17 ¾ in. (56 × 45 cm)
Magyar Nemzeti Galéria, Budapest, 62.31T
Palace of Fine Arts Annex, no. 484

Prince Paolo Troubetzkoy (Italian, 1866–1938)
La Danseuse (Mademoiselle Svirsky), 1911 [plate 148]
Bronze, 21 × 9 ¼ × 6 ¼ in. (53.3 × 23.5 × 15.9 cm)
Fine Arts Museums of San Francisco, gift of
Rosamond Hagney, 1985.60.2
Palace of Fine Arts, Gallery 108, no. 1088, as *Mme. Svirky*

Prince Paolo Troubetzkoy (Italian, 1866–1938)
Lady Constance Stewart Richardson, 1914 [plate 147]
Bronze, 13 ½ × 3 ½ × 12 ¼ in. (34.3 × 9 × 31.1 cm)
Fine Arts Museums of San Francisco, Theater and Dance
Collection, gift of Alma de Bretteville Spreckels, 1962.133
Palace of Fine Arts, Gallery 108, no. 1089

Franz von Stuck (German, 1863–1928)
Summer Night, ca. 1910 [plate 151]
Oil on canvas in frame, framed: 46 ¾ × 49 in. (118.8 × 124.5 cm);
unframed: 43 ½ × 37 ¾ in. (110.5 × 95.9 cm)
Collection of John and Berthe Ford, Baltimore
Palace of Fine Arts, Gallery 108, wall A, no. 472

The following works reproduced in this catalogue are on view in
a simultaneous exhibition, *Portals of the Past: The Photographs of
Willard Worden*, July 25, 2015–February 14, 2016, at the de Young,
San Francisco.

Willard E. Worden (American, 1868–1946)
The End of the Trail, 1915 [plate 21]
Sepia-toned gelatin silver print, 9 ⅝ × 7 ¼ in. (24.5 × 18.5 cm)
Jerry Bianchini Collection

Willard E. Worden (American, 1868–1946)
Japanese Tea Garden, ca. 1915 [plate 133]
Gelatin silver print with applied color, 9 ½ × 7 in. (24.2 × 17.8 cm)
Jerry Bianchini Collection

Willard E. Worden (American, 1868–1946)
The Memorial Museum, Golden Gate Park, ca. 1910s [fig. 20]
Sepia color photograph, 10 ½ × 13 ½ in. (26.7 × 34.3 cm)
Oakland Museum of California, gift of Robert Shimshak

Willard E. Worden (American, 1868–1946)
Poppies and Lupine, ca. 1915 [plate 132]
Gelatin silver print with applied color, 18 ⅜ × 14 ½ in.
(46.5 × 37 cm)
Collection of Bonnie Bell

Willard E. Worden (American, 1868–1946)
Portals of the Past, 1906 [fig. 1]
Gelatin silver print, 10 ¼ × 13 ³⁄₁₆ in. (26 × 33.5 cm)
Jerry Bianchini Collection

Willard E. Worden (American, 1868–1946)
Seal Rocks, ca. 1915 [plate 131]
Sepia-toned gelatin silver print, 13 ½ × 10 ½ in. (34.3 × 26.7 cm)
Collection of Susan Hill

Selected Bibliography

This list contains a selection of the most relevant sources that are available for further reading and
reference in relation to the art program of the Panama-Pacific International Exposition. It is not a complete record.
Additional sources, especially as they relate to the individual subjects examined
by each author, are indicated in the endnotes for each essay.

PUBLICATIONS FROM THE EXPOSITION PERIOD

An Announcement: Congresses, Conferences, Conventions. San Francisco: Panama-Pacific International Exposition, 1915.

Barr, James A. *The Legacy of the Exposition: Interpretation of the Intellectual and Moral Heritage Left to Mankind by the World Celebration at San Francisco in 1915.* San Francisco: John H. Nash, 1916.

Barry, John D. *The City of Domes: A Walk with an Architect about the Courts and Palaces of the Panama-Pacific International Exposition with a Discussion of Its Architecture, Its Sculpture, Its Mural Decorations, Its Coloring, and Its Lighting, Preceded by a History of Its Growth.* San Francisco: John J. Newbegin, 1915.

———. *The Palace of Fine Arts and the French and Italian Pavilions: A Walk with a Painter, with a Discussion of Painting and Sculptures and Some of the Workers Therein, Mainly from the Painter's Point of View.* San Francisco: H. S. Crocker, 1915.

Berry, Rose V. S. *The Dream City: Its Art in Story and Symbolism.* San Francisco: Walter N. Brunt, 1915.

The Blue Book: A Comprehensive Official Souvenir View Book of the Panama-Pacific International Exposition at San Francisco, 1915. San Francisco: Robert A. Reid, 1915.

Brinton, Christian. "Foreign Painting at the Panama-Pacific Exposition." *International Studio* 56, no. 223 (September 1915): 47–54.

———. *Impressions of the Art at the Panama-Pacific Exposition.* New York: John Lane, 1916.

Burke, Katherine Delmar. *Storied Walls of the Exposition.* San Francisco, 1915.

Burness, Jessie Niles. *Sculpture and Mural Paintings in the Beautiful Courts, Colonnades, and Avenues of the Panama-Pacific International Exposition at San Francisco 1915.* San Francisco: Robert A. Reid, 1915.

Cahill, B. J. S. "The Panama-Pacific Exposition from an Architect's Viewpoint." *Architect and Engineer of California* 39, no. 2 (December 1914): 47–60.

California's Magazine, Edition de Luxe. 2 vols. San Francisco: California's Magazine Company, 1916.

Casts of Ancient Greek Statues, exhibited by the Greek Committee and offered by the Greek Government to the City and County of San Francisco. Athens: Printing Office "Hestia," [1915?].

Catalogue Canessa's Collection, Panama-Pacific International Exposition, 1915. San Francisco: Canessa Printing, 1915.

Catalogue: Inaugural Exposition of French Art in the California Palace of the Legion of Honor, Lincoln Park, San Francisco, California, 1924–1925. San Francisco: J. H. Barry, 1924–1925.

Catalogue of an Exhibition of French and Belgian Art from the Panama-Pacific International Exposition, 1915. Various publishers, 1916.

Catalogue of the Kodak Pictorial Exhibit, Liberal Arts Building, Panama-Pacific International Exposition. Rochester, NY: Eastman Kodak, 1915.

Cheney, Sheldon. *An Art-Lover's Guide to the Exposition: Explanations of the Architecture, Sculpture, and Mural Paintings, with a Guide for Study in the Art Gallery.* Berkeley: At the Sign of the Berkeley Oak, 1915.

Circular of Information, Panama-Pacific International Exposition, San Francisco, 1915, Department of Fine Arts. San Francisco, 1914.

Clark, Arthur Bridgman. *Significant Paintings at the Panama-Pacific Exposition: How to Find Them and How to Enjoy Them.* Palo Alto: Stanford University Press, 1915.

"Color Decoration: The Panama Exposition." *Art and Progress* 5, no. 4 (February 1914): 148.

"Coloring of the Panama-Pacific International Exposition." *Fine Arts Journal* 30, no. 2 (February 1914): n.p.

Cortissoz, Royal. "Pictures in the American Salon. A Tour of the Fine Arts Palace at the San Francisco Fair." *New York Tribune*, June 30, 1915.

Descriptive catalogue of a printing exhibit at the Panama-Pacific International Exposition, San Francisco, 1915. Baltimore: N. T. A. Munder, 1915.

Guide to San Francisco and the Panama-Pacific Exposition 1915. San Francisco: Baldwin Piano, 1915.

Hardee, Theodore. "Final Report of Theodore Hardee, Chief of the Department of Liberal Arts, to the Director of Exhibits." Unpublished typescript, 1915, Panama-Pacific International Exposition files, San Francisco History Center, San Francisco Public Library.

James, Juliet. *Palaces and Courts of the Exposition.* San Francisco: California Book Company, 1915.

———. *Sculpture of the Exposition Palace and Courts.* San Francisco: H. S. Crocker, 1915.

Levy, Louis. *Chronological History of the Panama-Pacific International Exposition by Louis Levy, Chief, Bureau of Local Publicity.* 3 vols. San Francisco: G. B. Tuley, [1913?].

Liberal Arts, Official Catalogue of Exhibitors, Panama-Pacific International Exposition. San Francisco: Wahlgreen, 1915.

Macomber, Ben. *The Jewel City: Its Planning and Achievement; Its Architecture, Sculpture, Symbolism, and Music; Its Gardens, Palaces, and Exhibits.* San Francisco: John H. Williams, 1915.

Markwart, A. H. *Building an Exposition: Report of the Activities of the Division of Works of the Panama-Pacific International Exposition.* San Francisco: Panama-Pacific International Exposition, 1915.

Mathews, Arthur. "The Panama-Pacific International Exposition as a Work of Art." *Philopolis*, June 25, 1915.

———. "The Panama-Pacific International Exposition as a Work of Art, continued." *Philopolis*, July 25, 1915.

Maybeck, Bernard R. *Palace of Fine Arts and Lagoon. Panama-Pacific International Exposition, 1915.* San Francisco: Paul Elder, 1915.

Neuhaus, Eugen. *The Art of the Exposition: Personal Impressions of the Architecture, Sculpture, Mural Decorations, Color Scheme and Other Aesthetic Aspects of the Panama-Pacific International Exposition.* San Francisco: Paul Elder, 1915.

———. *The Galleries of the Exposition: A Critical Review of the Paintings, Statuary and the Graphic Arts in the Palace of Fine Arts at the Panama-Pacific International Exposition.* San Francisco: Paul Elder, 1915.

———. "Sculpture and Mural Decoration." *Art and Progress* 6, no. 10 (August 1915): 364–374.

Official Catalogue (Illustrated) of the Department of Fine Arts, Panama-Pacific International Exposition (With Awards). San Francisco: Wahlgreen, 1915.

Official Guide of the Panama-Pacific International Exposition 1915. September ed. San Francisco: Wahlgreen, 1915.

Olmsted, Charles. "Prints at the Exposition." *Art and Progress* 6, no. 10 (August 1915): 379–384.

Panama-Pacific International Exposition: Rules and Regulations Governing the System of Awards. San Francisco: Panama-Pacific International Exposition, April 1915.

Panama Pacific International Exposition, San Francisco, 1915. Fine Arts, French Section. Catalogue of works in painting, drawing, sculpture, medals-engravings and lithographs. Paris: Librairie Centrale des Beaux-Arts, 1915.

Panama-Pacific International Exposition, San Francisco 1915, Report of the Department of Fine Arts. San Francisco: Panama-Pacific International Exposition, 1915.

Perry, Stella G. S. *The Sculpture and Mural Decorations of the Exposition.* San Francisco: Paul Elder, 1915.

Pictorial Photography Catalogue. San Francisco: Wahlgreen, 1915.

Porter, Bruce, et al. *Art in California: A Survey of American Art with Special Reference to Californian Painting, Sculpture, and Architecture, Past and Present, Particularly as Those Arts Were Represented at the Panama-Pacific International Exposition.* Irvine, CA: Westphal, 1988. First published in 1916 by R. L. Bernier, San Francisco.

Simpson, Anna Pratt. *Problems Women Solved: Being the Story of the Woman's Board of the Panama-Pacific International Exposition.* San Francisco: Woman's Board, 1915.

Soulas, Marie. *The French Pavilion and Its Contents.* San Francisco: Pernau, 1915.

Strother, French. *The Panama-Pacific International Exposition: Where the Twentieth Century Has Paused to Take Stock of Itself and to Record Mankind's Progress in the Past Ten Years.* New York: Doubleday, Page, 1915.

Todd, Frank Morton. *The Story of the Exposition: Being the Official History of the International Celebration Held at San Francisco in 1915 to Commemorate the Discovery of the Pacific Ocean and the Construction of the Panama Canal.* 5 vols. New York: G. P. Putnam's Sons, 1921.

Trask, John E. D. "Report of the Department of Fine Arts." Unpublished typescript, September 16, 1916. Panama-Pacific International Exposition files, San Francisco History Center, San Francisco Public Library.

———, and J. Nilsen Laurvik, eds. *Catalogue de Luxe of the Department of Fine Arts, Panama-Pacific International Exposition.* San Francisco: Paul Elder, 1915.

Williams, Michael. *A Brief Guide to the Department of Fine Arts: Panama-Pacific International Exposition, San Francisco, California, 1915.* San Francisco: Wahlgreen, 1915.

———. *A Brief Guide to the Palace of Fine Arts: Panama-Pacific International Exposition. Post Exposition Period.* [San Francisco?]: San Francisco Art Association, [1916?].

———. "A Pageant of American Art." *Art and Progress* 6, no. 10 (August 1915): 337–353.

LATER PUBLICATIONS

Ackley, Laura A.. *San Francisco's Jewel City: The Panama-Pacific International Exposition of 1915.* Berkeley: Heyday Books, 2014.

Applegate, Heidi. "Staging Modernism at the 1915 San Francisco World's Fair." PhD diss., Columbia University, 2014.

Barki, Gergely. "Panama-Pacific International Exposition: Hungarian Art's American Debut or Its Bermuda Triangle?" *Centropa* 10, no. 3 (September 2010): 259–271.

Benedict, Burton. *The Anthropology of World's Fairs: San Francisco's Panama Pacific International Exposition of 1915.* Berkeley: Lowie Museum of Anthropology, 1983.

Benedict, Burton, M. Miriam Dorkin, and Elizabeth Armstrong. *A Catalogue of Posters, Photographs, Paintings, Drawings, Furniture, Documents, Souvenirs, Statues, Books, Medals, Dolls, Music Sheets, Postcards, Curiosities, Banners, Awards, Remains, Etcetera from San Francisco's Panama Pacific International Exposition 1915.* Exh. cat. Berkeley: Lowie Museum of Anthropology, 1982.

Blackford, Mansel G. *The Lost Dream: Businessmen and City Planning on the Pacific Coast, 1890–1920.* Columbus: Ohio State University Press, 1993.

Boas, Nancy. *The Society of Six: California Colorists.* San Francisco: Bedford Arts, 1988.

Brechin, Gray. "Sailing to Byzantium: The Architecture of the Fair." In *The Anthropology of World's Fairs: San Francisco's Panama Pacific International Exposition of 1915,* edited by Burton Benedict, 94–113. Berkeley: Lowie Museum of Anthropology, 1983.

Burnett, Katharine P. "Inventing a New 'Old Tradition': Chinese Painting at the Panama-Pacific International Exposition." In *Meishu shi yu guannian shi (History of Art and History of Ideas)* 9, 17–57. Nanjing: Nanjing Normal University, 2010.

Gerdts, William H., and Will South. *California Impressionism.* New York: Abbeville Press, 1998.

Hack, Brian Edward. "Spartan Desires: Eugenics and the Sculptural Program of the 1915 Panama-Pacific International Exposition." *PART: Journal of the CUNY PhD Program in Art History* 6 (2000). http://part-archive.finitude.org/part6/articles/bhack.html.

Hewitt, Mark A. *Jules Guérin: Master Delineator.* Exh. cat. Houston: Rice University, 1983.

Lee, Anthony W. *Painting on the Left: Diego Rivera, Radical Politics, and San Francisco's Public Murals.* Berkeley: University of California Press, 1998.

Lee, Portia. "Victorious Spirit: Regional Influences in the Architecture, Landscaping and Murals of the Panama Pacific International Exposition." PhD diss., George Washington University, 1984.

Leja, Michael. "Progress and Evolution at the U.S. World's Fairs, 1893–1915." *Nineteenth-Century Art Worldwide* 2, no. 2 (2003). http://www.19thc-artworldwide.org/spring03/221-progress-and-evolution-at-the-us-worlds-fairs-18931915.

Markwyn, Abigail. *Empress San Francisco: The Pacific Rim, the Great West, and California at the Panama-Pacific International Exposition.* Lincoln: University of Nebraska Press, 2014.

Maybeck, Jacomena. *The Family View.* Berkeley: Berkeley Architectural Heritage Association, 1980.

McCoy, Esther. *Five California Architects.* Los Angeles: Hennessey and Ingalls, 1960.

Missal, Alexander. *Seaway to the Future: American Social Visions and the Construction of the Panama Canal.* Madison: University of Wisconsin Press, 2008.

Moore, Sarah J. *Empire on Display: San Francisco's Panama-Pacific International Exposition of 1915.* Norman: University of Oklahoma Press, 2013.

———. "Manliness and the New American Empire at the 1915 Panama-Pacific Exposition." In *Gendering the Fair: Histories of Women and Gender at World's Fairs,* edited by T. J. Boisseau and Abigail M. Markwyn, 75–94. Urbana: University of Illinois Press, 2010.

Neuhaus, Eugen. *Drawn from Memory, a Self Portrait.* Palo Alto: Pacific Books, 1964.

Newhall, Ruth. *San Francisco's Enchanted Palace.* Berkeley: Howell-North Books, 1967.

Robinson, Carlotta Falzone. "Designing a Unified City: The 1915 Panama-Pacific International Exposition and Its Aesthetic Ideals." *Journal of San Diego History* 59, nos. 1–2 (Winter–Spring 2013): 65–86.

Rufino, Stephanie J. "The Art and Color of Jules Guérin." PhD diss., University of Virginia, 2009.

Rydell, Robert. *All the World's a Fair: Visions of Empire at American International Expositions, 1876–1916.* Chicago: University of Chicago Press, 1984.

Schaeffer, Richard Harry. "The Outdoor Sculpture of the Panama-Pacific International Exposition: A Study in Iconography." Master's thesis, Michigan State University, 1980.

Scharlach, Bernice. *Big Alma: San Francisco's Alma Spreckels.* San Francisco: Scottwall, 1990.

University of California, Davis, Art Department. *Fifteen and Fifty: California Painting at the 1915 Panama-Pacific International Exposition, San Francisco, on Its Fiftieth Anniversary.* Exh. cat. N.p., 1975.

Villiers, Jean-Pierre Andréoli de. "Les futuristes à la Panama Pacific International Exposition de San Francisco en 1915." *Ligeia* 57–60 (January–June 2005): 5–17.

Illustrations without a figure or plate number are indicated by an italicized page number(s).

Abbey, Edwin Austin, 123n57, 128
 The Penance of Eleanor, Duchess of Gloucester, 18, 20–21, pl. 32
academic art, 73, 117, 118, 128, 129, 139, 141, 149, 150, 153n63, 219, 228
Académie Colarossi, 17
Académie Julian, 73, 77, 79, 232
Academy Notes, 321
Adams, Ansel, 114, 241, 247–248, 251n75
 Palace of Fine Arts, fig. 130
Adams, Charles Francis (1862–1943), 223, 224n19, 225n59
Adams, Herbert, 123n55, 382
Africa, 26, 114, 120
African Americans, 46, *fig. 62*
Aid, George Charles, 224n22
Aitken, Robert Ingersoll, *Xoros (Dancing Bacchante), pl. 47*
Albert, Prince Consort, 43
Albertina, 333
Albert Roullier Art Galleries, 224n22, 229
Albright Art Gallery, 238, 320, 321, 323n69
Alexander, John White (1856–1915), 20, 21, 37n61, 123n55, 129, 382
Alexander the Great, 306
allegories, 15, 75, 76–77, 78, 79, 119, 120, 128, 137n9, 240, 306
America. See United States
American Academy in Rome, 18
American Art News, 14, 19, 20, 21, 26–27, 31, 37n61, 123n51, 215, 311, 313, 381, 382
American Indians. See Native Americans; Rodman Wanamaker Indian Exposition
American Institute of Architects, 57
American Institute of Graphic Arts, 234
American Renaissance, 61, 66–68
Andrássy, Jr., Count Gyula (1860–1929), 327, 334n17, 335n53, 335n62
André, Louis-Jules, 52
Anglo-American Exhibition, 21, 377n66
Anglo-Americans, 112, 114
Ansco Company booth, 238, 241, 242, 250n39, 250n42, *fig. 120*
Anshutz, Thomas Pollock, 148, 149
 Incense Burner, pl. 37
Antwerp, 307
applied arts, 18, 19, 232, 334n16, 334n39, 380
Arbuckle, Roscoe "Fatty," 130
Archives of American Art, 36n7
Argentina section, 22, 250n44, 381
Armer, Laura Adams, 239, 240
Armory Show, New York, 1913, 27, 37n53, 122n41, 139, 148, 380
 PPIE and, 26, 116–117, 118, 139–141, 148–149, 152n5, 152n9, 152n22, 152n39, 153n41, 217, 220, 225n50, 322n49
 works previously exhibited at, 17, 20, 150, 320
art colonies, 77, 78, 129
Art Deco, 17
Art Institute of Chicago, 229, 232, 234, 238, 382
 Harshe and, 17, 30, 34, 38–39n139, 382
 loans from, 18, 21, 150
The Art of Hungary: 1915, Revisited, 333
Arts and Crafts, 52
Arts and Decoration, 147
Art Students League, 17, 77, 232
Ashcan School, 26, 118, 128, 129
Asia, 18, 36n20, 114, 116
 depictions of, 76, 114, 115, 120, 122n34, 126, 137n9
 influences of, 111, 119
Athens. See San Francisco, as the new Athens
Atlas, Charles, 76
Austin, Mary, 125
Austria, 15, 250n34, 381

section, 24, 215, 220, 322n7, 322n26, 328, 381, 383
 stranding of works during World War I, 33, 383
Austria-Hungary, 304, 327, 381
Austrian Expressionism, 11, 144
aviation, 46, 122n10

Bajkay, Éva, 332, 333, 334n5, 335n49
Baker, Asher C. (1849–1926), 25, 36–37n50, 303, 312, 314, 381, 383
Bakewell, John, 58n16
Balch, Allan C. (1864–1943), 315, 322n35
Balch, Mrs. A. C., 32, 315
Balkan Wars, 61, 327
Balla, Giacomo, 28, 38n104, 152n21
 Disintegration × Speed, Dynamic Dispersions of an Automobile, 27, *fig. 18, pl. 170*
Balzac, Honoré, 307
Bancroft, Milton, 73, 80n10, 380
Barbizon, 77, 118, 128, 135, 136, 315
Barnhorn, Clement, *Boy Pan with Frog*, 17, pl. 49
Baroque, 45
Barry, John D. (1866–1942), 144, 153n56
 The City of Domes, 58n24, 81n34, 311, 314
 The Palace of Fine Arts and the French and Italian Pavilions, 150–151, 152n27, 153n55, 316–317, 318–320
Bartholomé, Albert, 307
Bartlett, Frederic C., 37n71
Bartlett, Paul Wayland, *Lafayette*, 58n3, 117
Bartók, Béla, 325, 330, 333, 334n1, *fig. 152*
Bastien-Lepage, Jules, *Simon Hayem*, 319
Baths of Caracalla, 67, 122n10
Batthyán, Gyula, 334n31
 Longchamps, 329, *fig. 154*
Baumann, Gustave, 224n2, 232, 234, 235n7, 235n9
 Harden Hollow, 212, 232, *fig. 111*
 Plum and Peach Bloom, 232, *fig. 112*
Bautista de Anza, Juan, 78
Beachey, Lincoln, 46, 122n10
Beal, Gifford, 128
 Old Town Terrace, pl. 68
Beal, Reynolds, 128
Beatty, John, 152n22
Beaux, Cecilia, 123n55, 128, 129, 147, 149–150, 153n58, 382
 Dorothea and Francesca, 150
 Ernesta (Child with Nurse), 149, 150, *fig. 93*
 Man with the Cat (Henry Sturgis Drinker), 138, 149, 153n52, *pl. 42*
 New England Woman, 20, 37n69, *pl. 43*
 Sita and Sarita, 149
Beaux-Arts, 45, 49, 66, 67, 74, 76, 79, 111, 122n40, 305
Belgium, 46, 320, 321, 331, 382
 secret transport of works from, 313, 314, 381
 section, 31, 128, 215, 307, 328, 334n25, 381, 382
Bellows, George, 22, 118, 123n64, 129, 143, 149, 150, 151, 152n34, 153n63, 381
 Polo Crowd, 150
 Riverfront No. 1, 150, *fig. 94*
Bénédite, Léonce (1856–1925), 303, 307–308, 312, 321
Bennett, Edward H., 13
Berény, Róbert, 220, 222, 225n49, 326, 330, 332, 333, 334n12, 334n29, 335n64
 embroideries, 329, 330, 334n39, 335n47, *fig. 155*
 Works
 Golgotha (Scene V), 333, 383, *pl. 156*
 Portrait of Béla Bartók, 325, 333, 334n1, 335n64, *fig. 152*
 Sewing in the Garden, 222, 334n29, *fig. 105*
 View of Capri, 329
 Yellow Embroidery, 329
Berg, George L., 20
Berge, Edward, *Muse Finding the Head of Orpheus*, 56, 64, *fig. 44, pl. 48*

Berger Jr., Henry, 243
Berkeley, 14, 19, 73, 240
 See also University of California, Berkeley
Berlin, 23, 329, 331, 334n39
Bernhardt, Sarah, 321
Berry, Rose V. S. (b. ca. 1879), *The Dream City*, 19, 126, 143, 148, 149, 150, 151, 224n20
Besnard, Paul-Albert, 233
Bettencourt, José de Sousa, 250n44
Birnbaum, Martin, 334n45
Birnie Philip, Rosalind (1873–1958), 20
Bitter, Karl (1867–1915), 15, 123n55, 381, 382
 as chief of sculpture, 15, 16, 380
 Works
 Signing of the Louisiana Purchase, 381
 Thomas Jefferson, 17
Blanche, Jacques-Émile, 317
Bliss and Faville, 243
Blumann, Sigismund (1872–1956), 14, 238, 250n16
Blumenschein, Ernest Leonard, 128
Boas, Nancy, 29, 123n64, 152n22
Bobrovsky, Grigory, 37n98
Boccioni, Umberto, 38n104
 Dynamism of a Cyclist, pl. 169
 Dynamism of a Soccer Player, 27, 144, 150, pl. 168
 Matter, 27, pl. 167
 Muscles in Movement, 17, 28
Böcklin, Arnold, *Island of the Dead*, 56, 126, *fig. 39*
Bohemian Club, 15
Bohm, Max, 129
Bois, Guy Pène du, 129
Bölöni, György (1882–1959), 326–327, 332, 334nn12–13
Bonnard, Pierre, 118, 334n38
 The Dining Room in the Country, 315
Boone, Daniel, 118
Booth, Mary Ann (1843–1922), 238
Borg, Carl Oscar, 123n53, 136
Borglum, Solon, *The American Pioneer*, 119–120, 123n70, *fig. 68*
Boston, 14, 18, 21, 37n71, 129, 152n5, 224n8, 225n69, 251n70, 380, 381, 382
 school, 147, 148, 153n63
Boston Symphony Orchestra, 45
Boston Transcript, 23
Bostwick, Francesca, 240
Boucher, Alfred, *La Gallia*, 306, *fig. 136*
Bourgeois Galleries, 225n54
Boutet de Monvel, Bernard, 313, 321
Bracquemond, Félix, *The Seagulls*, 220
Brandenstein, Edward, 32
Brandt, Edgar, 307
Brangwyn, Frank, 233, 382
 intaglios, 222–223
 murals, 31, 34, 38n125, 81n53, 225n57, 304, 308, 381, *fig. 21*
 Works
 Browning's House, Venice, 222–223, *fig. 106*
Braque, Georges, 148
Brayer, Herbert O., 36n4
Brechin, Gray, 58n26, 66
Breckenridge, Hugh Henry, 143, 148, 149
 The White Vase, 32, *fig. 92*
Bremer, Anne M., 14, 123n53, 129, 136, 143, 149, 381
 An Old-Fashioned Garden, pl. 14
 The Fur Collar, 149, *fig. 83*
Breuer, Henry Joseph, 123n53, 136
Briggs, Henriette Kibbe, 240
Brigman, Anne W., 238, 239, 240, 244, 248, 250n18
 Finis, 239
 The Soul of the Blasted Pine, pl. 120
Brinton, Christian (1870–1942), 118, 141, 145–146, 222

"Evolution, not Revolution in Art," 141, 143, 152n10
 Impressions of the Art at the Panama-Pacific Exposition, 122n37, 319, 329, 330–331, 334n45, *figs. 153, 154*
"The Modern Spirit in Contemporary Painting," 141–143
British Museum, 63, 69n14
Brooklyn, 18, 131, 242, 304, 382
Brooklyn Daily Eagle, 247, 251n68
Brooklyn Museum, 21, 382
Brown, A. Page, 58n17
Brown, Benjamin Chambers, 136, 219, 224n8
 Art Palace, Reflections (Panama-Pacific International Exposition), pl. 11
 Art Palace, S.F. Moonlight (Panama-Pacific International Exposition), pl. 12
Brown, Milton, 139
Browne, Charles Francis (1859–1920), 19, 37n53, 381
Brown Jr., Arthur (1874–1957), 53, 58n16, 66
Bruce, Thomas (Lord Elgin), 69n14
Bruguière, Francis, 238, 250n18
 Machinery Hall, West Entrance, 239, pl. 126
Brussels, 43
Bryan, William Jennings, 45
Budapest, 23, 325, 326, 327, 329, 330, 331
Buenos Aires, 305
Buffalo, 18, 20, 225n69, 304, 320, 321, 382
Buffalo Fine Arts Academy, 21, 315, 321, 323n69
Bull, Edith, 38n132
Bulletin of Photography, 243, 247
Burbank, Luther, 49
Burnham, Daniel, 13, 111, 122n4
Burr, George Elbert, 219, 232–233
 Arizona Clouds, fig. 115
Butler, Theodore Earl, 129

Cahill, B. J. S., 69n4
Calder, Alexander Stirling, 120
 as chief of sculpture, 15, 16, 119, 380, 381
 Fountain of Energy, 120, *fig. 72*
 Star Maiden, 15–16, 36n33, *figs. 8, 9, pl. 15*
California, 16, 17, 27, 44, 57, 58n17, 66, 68, 112, 119, 129, 304, 308, 381, 382
 anti-immigration, eugenics, and xenophobia in, 114, 115, 119, 121, 122n15, 122n20, 122n32
 art and artists, 11, 14, 21, 30, 32, 52, 118–119, 123n53, 123n67, 128, 129, 131, 134–136, 137n17, 137n54, 215, 224n9, 224n22, 227, 233, 234, 239–240, 250n18, 250n36, 317, 381, 382, 383
 influences on art of, 111, 119
 Northern, 77, 111, 112, 135, 136, 239, 247
 as subject matter and inspiration, 76, 77–78, 79, 112, 125, 126, 131, 136, 137n17, 219, 233
 works remaining in, 22, 223
California Academy of Sciences, 29
California Alien Land Law, 115, 122n33
California Building, 30, 35, 112
California Camera Club, 238, 248
California Midwinter International Exposition, San Francisco, 1894, 29, 63, 68, 317, 322n47
California Palace of the Legion of Honor, 7, 32, 34, 39n43, 39n148, 383, *fig. 172*
 French Pavilion and, 58n2, 136, 303, 306, 308, 321, 323n78
 Spreckels and, 11, 34, 39n43, 39n147, 323n78, 383
California School of Design, 71, 79
California School of Fine Arts, 68
Camera Craft, 238, 243, 247
Camera Work, 37n88, 239
Canessa, Ercole (1868–1929), 64
Cardwell, Kenneth H., 58n5
Carles, Arthur Beecher, 26, 143, 148, 149, 153n46
 Repose, 149
 Torso, 32, pl. 84

Carlisle, Mary Helen, *High Noon: California*, 137n17
Carlsen, Emil, 123n55, 129, 382
Carnegie Institute, 152n22, 238, 382
 Harshe and, 30, 382
 works from, 18, 20–21, 24, 25, 33, 315
Carolan, Harriet Pullman (1869–1956), 19
Carter, Malvina Longfellow (née Langfelder) (1889–1962), 242, 250n43, *fig. 121*
Cassatt, Mary, 128, 147, 322n39
 Mother and Child with a Rose Scarf, 322n39, *pl. 44*
 On a Balcony, 21
 Woman with a Fan, 21
Centennial Exposition, Philadelphia, 1876, 43, 122n42
Central School of Arts and Crafts, 17
Century of Progress Exposition, Chicago, 1933, 49, 382
Cézanne, Paul, 149
 The Gulf of Marseille from L'Estaque, 141, 307, 310, 319, *pl. 141*
Cham (Amédée-Charles-Henry de Noé), 319
Chaplin, Charlie, 45
Chapman, Arthur D., 240
 Diagonals (Christopher Street from the 8th Street Station of the Sixth Avenue El, New York), 240–241, *pl. 129*
Chase, William Merritt, 21, 22, 118, 123n61, 143, 383
 one-man gallery, 129, 133, 315
 Works
 Just Onions, 21
 Portrait of Mrs. C (Lady with a White Shawl), 20, *pl. 35*
Cheney, Sheldon (1886–1980), *An Art-Lover's Guide to the Exposition*, 153n68, 227, 315, 316, 317–318
Chicago, 19, 26, 38n100, 152n5, 217, 218, 224n22, 229, 232, 304, 320, 321, 380, 382, *fig. 98*
 jury, 21, 37n71, 224n8
 world's fair (1893), 122n6, 215, 241, 250n34
 children, 16–17, 76, 78, 128, 134, 149, 150, 222, 240, 243, 245, 250n46, 309n5, 313, 322n39
 See also National Child Labor Committee (NCLC) booth; Temple of Childhood
Chile, 18
China, 29, 46, 114, 115, 122nn32–33, 229, 382
 section, 22, 37n83, 122n34, 123n55, 128, 250n44, 381
Chinese Americans, 46, 114–115
Chinese Exclusion Act, 115
Choiseul-Gouffier, Comte de, 69n14
Christiania (Oslo), 23, 222
Church, Frederic Edwin, *Niagara*, 128, 177, *fig. 76*
Cincinnati, 21, 37n71, 224n8, 381
Cincinnati Art Museum, 381
 loans from, 18, 20, 129
Clark, Alson Skinner, 128
 In the Lock, Miraflores, 110, *pl. 2*
 Panama Canal, the Gaillard Cut, *pl. 3*
Clark, Arthur B. (1866–1948), 146, 320, 329–330, 392
classical and classicizing art and architecture, 51, 52, 55, 56, 58n25, 61–68, 73, 111, 119, 131, 304, 305, 308, 315, 320
Cleaves, Howard H., 243
Cline, W. B., 243, 251n52
Clute, Fayette J. (1865–1921), 238, 250n12
Coburn, Alvin Langdon, 239, 240
 Broadway at Night, 240, *pl. 127*
Cody, Buffalo Bill, 45
Coffin, William A., 20
Colbert, Jean-Baptiste, 306
Cole, Timothy, 220
Collier's, 246
Collyer, Mabel, 314
Colorado, 219, 225n69, 233
Columbia University, 17, 233, 240, *pl. 128*
Columbus, Christopher, 43, 117
Colwell, Elizabeth, 229, 234, 235n9
 The Great Pine, 229, *fig 109*
 Lake in Winter, 229, *pl. 111*
Connick, Harris D. H. (1873–1965), 14, 36n32
Conti, Bianca, 238–239, 240
 Mother and Child, 243, 250n46
Cooper, Colin Campbell, 126, 128
 Palace of Fine Arts, San Francisco, *fig. 74*
Copley, John Singleton, 117, 382
Corcoran Gallery, 18, 21, 128
Corcoran School of Art, 232
Cormon, Fernand, *A Forge*, 319
Cortissoz, Royal (1869–1948), 146, 150, 151, 152n30
Courbet, Gustave, 145
 The Violoncellist, 20, 315, *pl. 137*
Couse, Eanger Irving, 128

Crocker, Mrs. William H. (Ethel), 317
Crocker, William H. (1861–1937), 32, 380
Crystal Palace Exhibition, London, 1851, 43
Csaky, Joseph, 331
Csók, István, 329, 334n31
 Two Girls in a Garden, 329
Cuba section, 22, 381
Cubism, 27, 122n41, 144, 148, 149, 220, 322n49, 329, 330, 331
Cumming, Joseph M. (1868–1940), 35, 39n155
Cummings, M. Earl, 21
Cunningham, Imogen, 238, 240
 Eve Repentant, 240, *pl. 121*
 Trafalgar Square, 240
Currier, Joseph Frank, 133
Curtis, Edward, *North American Indian*, 245
Czechoslovakia, 332
Czigány, Dezső, 333
Czóbel, Béla, 330

Dada, 27
Dagnan-Bouveret, Pascal Adolphe Jean, *Consolatrix Afflictorum*, 20, 315, *fig. 142*
Dalimier, Albert, 312, 313
Danforth, Roy Harrison, 240
Darwin, Charles, 112
 See also Social Darwinism
Dassonville, William Edward, 238, 239, 250n26
 Day Dreams, 250n26, *fig. 122*
 Figure Study, 236, 250n26
 The Monterey Coast, 250n26
 Portrait of Miss C., 250n26
Daughters of the Revolution, 114
Davidson, David, 250n38
Davies, Arthur B., 31
Davis, Dwight A., 240
Deakin, Edwin, 14–15
 City Hall from the Top of the Sacramento Street Hill, July 1906, *fig. 2*
 Palace of Fine Arts and the Lagoon, 15, *pl. 10*
decorative arts, 32, 128, 304, 306–307, 308, 321, *fig. 139*
 cloisonnés, 29, 381, 382
 porcelain, 21, 34, 304, 306, 308, 382
 tapestries, 34, 46, 57, 304, 306, 308, 313, 314, 318, 334n39, 381
Degas, Edgar, 149, 153n58
 At the Café-Concert, *pl. 143*
Delaherche, Auguste, 306
Delaunay, Robert, 148
Denio, Elizabeth (1844–1922), 19
Denis, Maurice, 307, 334n38
Denivelle, Paul E., 58n23
Denver, 225n69, 233
Desboutin, Marcellin, *Man with a Pipe: Self-Portrait*, 220, *fig. 102*
Des Moines, 320, 382
de Sousa-Lopez, Adriano, 216
d'Espouy, Henri, 56, 69n22
Detaille, Jean Baptiste Édouard
 The Dream, 319, 320, *figs. 147, 148*
 Sainte Geneviève Distributing Supplies to Paris, 320
Detroit, 18, 320, 382
Detroit Museum of Art, 18, 23, 134, 382
Devambez, André Édouard, 322n50
 The Charge, 317, *pl. 145*
Devambez, Édouard, 322n50
de Young, Michael H. (1849–1925), 29, 30, 32, 33, 36n39, 64, 68, 380, 382
de Young Museum. *See* Memorial Museum (de Young Museum)
Dickman, Charles, 21
Dickson, Edward R., 239, 240
 Design in Nature, *pl. 130*
Dixon, Joseph Kossuth, 243
 Dixon-Wanamaker archive, 243–245, 250–251n52
 The Sunset of a Dying Race, 243, *fig. 125*
Dixon, Maynard, 123n53
Dodge, William de Leftwich, 73
 murals, 73, 74–76, 77, 78, 79, 80n6, 80n10, 81n22, 81n28, 120, 121, 125, 380, 381, *fig. 54*
 Works
 Atlantic and Pacific, 70, 75, 76–77, 121, *figs. 54, 55, pl. 26*
 The Death of Minnehaha, 74
 Discovery, *fig. 54*
 The Purchase, *fig. 54*
Doezema, Marianne, 153n63
Doré Gallery, 24

Dow, Arthur Wesley, 128, 224n19, 228, 233, 235n9, 240
 The Enchanted Mesa, *pl. 76*
 The Gap, *pl. 108*
Duchamp, Marcel, 122n41, 149, 152n39
 Nude Descending a Staircase (No. 2), 148, *fig. 90*
Dumas, Alexandre, 307
DuMond, Elizabeth, *fig. 57*
DuMond, Frank Vincent, 20, 72, 73, 77, 79, 80n10, 315, 380, 381
 The Westward March of Civilization: Arrival in the West, 2, 77–78, 137n42, *pl. 25*
 The Westward March of Civilization: Departure from the East, 78, 137n42, *fig. 58, pl. 24*
DuMond, Helen, *figs. 56, 57*
Dunlap, John G., 38n130, 223, 225nn61–62
Düsseldorf school, 128
Duveneck, Elizabeth Boott, 129, 137n24
Duveneck, Frank, 20, 118, 129, 145, 146, 147, 150, 224n13, 381
 accolades, 22, 123n55, 129, 216, 224n20
 as juror, 20, 22, 37n61, 37n71, 129, 216, 224n8, 224n13, 224n22
 Works
 The Turkish Page, 129, *fig. 79*
 Whistling Boy, 20, 129, *pl. 33*
 Women with Forget-Me-Nots, 129

Eakins, Thomas, 15, 128
 The Concert Singer, 21, 128, *pl. 36*
 The Crucifixion, 128
 Portrait of Henry O. Tanner, 128, *pl. 34*
Eastman Kodak Company, 73, 137n, 7242
 booth, 238, 241, 243, 250n47, *fig. 122*
Eaton, Allen H., 240
École des Beaux-Arts, 52, 56, 66, 67, 73, 305
Edison, Thomas, 45, 243
Eickemeyer Jr., Rudolf, 243
Eiffel Tower, 51, 58n3
The Eight (American), 128, 152n25
The Eight (Hungarian), 222, 225n44, 322n49, 325, 326, 329–330, 331, 332, 333, 334n39, 339n44
Elder, Paul, 152n9, 233
Ellerhusen, Ulric, 55, 115
Emerson, Ralph Waldo, 51
England, 14, 20, 23, 69n14, 117, 123n46, 145, 228, 229, 250n36, 304, 306, 381
 artists from, 26, 215, 222–223, 304, 381
Erdössy, Béla, *Path in Snow*, 220–222, *fig. 104*
eugenics, 112–114, 120, 122n16
Europe, 20, 23, 43, 53, 63, 69n4, 145, 218, 219, 222–223, 325, 381
 art, 23, 61, 126, 128, 131, 137n9, 215, 219, 225n44, 228, 232, 234
 American art and, 111, 115, 117, 129, 143, 145, 219, 228
 influence of, 115, 117, 118, 119, 129, 228, 232
 modern art and modernism, 11, 37n53, 122n41, 139, 141, 144, 322n49, 328
 juries in, 20, 22
 return of works to, 29, 43
 sections, 22, 24, 25–26, 64, 116, 117, 126, 141, 215, 220, 311–312, 313, 314, 325, 328, 331, 381, 382
World War I, 45, 49, 61, 111, 118, 303, 304, 309n5, 311, 312, 313, 314, 318, 325, 326
Exhibition of Contemporary Graphic Art in Hungary, Bohemia, and Austria, 334n45
expansionism, 112, 120
Exposición Internacional del Centenario, Buenos Aires, 1910, 18, 19
Exposition Preservation League, 30, 58n35
Exposition Universelle, Paris, 1889, 58n3, 315, 319
Exposition Universelle, Paris, 1900, 11
Expressionism, 122n41, 220, 330
 Austrian, 11, 24, 144

Falguière, Alexandre, 15
Fauvel, Louis-François-Sébastien, 69n14
Fauvism, 122n41, 144, 322n49, 330
Faville, William (1866–1947), 13, 36n14, 243
Fechin, Nikolay, *Lady in Pink (Portrait of Natalia Podbelskaya)*, 25, *pl. 149*
Federated Women's Clubs of San Francisco, 68
Ferenczi, Sándor (1873–1933), 326, 334n5, 334n29
Ferenczy, Károly, *Landscape*, 333, *fig. 156*
Ferenczy, Valér, 335n53
Ferris, Woodbridge, 121
Fifth Exhibition of Oil Paintings by Contemporary American Artists, 21

Fine Arts Museums of San Francisco, 38n135, 323n78
 See also California Palace of the Legion of Honor; Memorial Museum (de Young Museum)
Finland
 section, 21, 24, 328, 382
 stranding of works during World War I, 33–34, 38–39n139
First Bay Tradition, 53
Fisher, Harrison, 250n41
Fiske, Minnie Maddern, 250n41
Fleishhacker, Herbert (1872–1957), 335n47
Fleishhacker, Mrs. Herbert, 32
Fletcher, Frank Morley, 229
Flood, James Leary, 32
Ford, Henry, 45, 73
Fortune, E. Charlton, 10, 14, 123n53, 128, 129, 136, 137n23
 Court of Flowers, *pl. 13*
 The Pool (The Court of the Four Seasons), *fig. 7*
 Summer, 32, *fig. 78, pl. 82*
Foster, A. W., 380
Foster, John, *Mr. Richard Mather*, 219–220, *fig. 99*
fountains, 15, 16, 17, 45, 55, 56, 120, 248, 251n76, *figs. 72, 165*
France, 58n3, 217, 232, 243, 305, 306, 307, 308, 312, 321, 381
 art and art movements, 118, 126, 145, 228, 305, 316, 326, 330, 334
 and American art, 145, 149
 influence of, 74, 118, 129, 145
 in the post-Exposition tour, 304, 331, 382
 Panama Canal and, 12, 44
 secret of transport of works from, 313–314, 381
 section, 11, 16, 20, 22, 25, 28, 29, 31, 32, 33, 37n83, 46, 58n2, 126, 129, 136, 141, 144, 152n2, 152n22, 215, 220, 303–323, 328, 334n25, 376, 380, 381, 382, *figs. 133, 134, 135, 136, 137, 139, 141, 148, 161, 164*
 in World War I, 303, 311, 312, 321
Franco-Prussian War, 319, 320
Fraser, James Earle, *The End of the Trail*, 16, 34, 39n150, 119–120, 123n70, *fig. 69, pls. 21, 22*
Fraternité des artistes, 321
Freer, Charles Lang (1854–1919), 18, 20, 23, 37n65
 collection of, 131, 134
French, Daniel Chester, 123n55, 382
 Lincoln, 117
Freud, Sigmund, 326, 334n5
Frick, Henry Clay (1849–1919), 18, 20, 315, 322n36
Frieseke, Frederick Carl
 accolades, 22, 118, 123n55, 129, 145, 149, 150–151, 382
 The Garden Chair, 21, *fig. 78, pl. 54*
 In the Boudoir, 150, *fig. 95*
 Summer, *figs. 77, 78*
Fuller, Loïe (1862–1928), 45, 69n11, 308
furniture, 51, 52, 53, 58n6, 304, 306, 307, 314

Gainsborough, Thomas, 117
Galerie Bernheim-Jeune, 315, 322n37
Galerie Durand-Ruel, 315–316, 322n39
Gallen-Kallela, Akseli, 24, 26, 33–34, 39n139, 382, 383
 In the Brush, *pl. 165*
 The Little Valley, *fig. 16*
 Mäntykoski Waterfall, 26, *pl. 163*
 Self-Portrait with Cheetah, *pl. 166*
 Symposion (The Problem), 26, *pl. 164*
Galton, Francis, 114
Garber, Daniel, 37n71, 129
 Quarry, Evening, 21, *pl. 66*
Gauguin, Paul, 141, 150, 222
 Faa Iheihe, 319, 320, *fig. 150*
Gauguin, Pola, 222
Gearhart, Edna, 234
Gearhart, Frances, 234
General Electric, 46
General Federation of Women's Clubs, 19
Genoa, 327, 381
genre scenes, 117, 128, 150, 153n58, 232, 333
Germany, 19, 23, 37n65, 37n87, 51, 61, 115, 129, 228, 232, 309n9, 329, 332, 381, 382
 paintings from, 21, 24, 304, 322n26
 stranding of works during World War I, 33
 in World War I, 33, 61, 303, 304, 307, 313, 314, 321, 383
Gérôme, Jean-Léon
 influence of, 73, 74, 76, 126

Works
 Chariot Race, 56, *fig. 73*
Gerson, Hans G., 57
Gesellschaft für deutsche Kunst im Ausland, 23
Gilded Age, 17
Gillett, James, 380
Giverny, 316, 317
Glackens, William James, 129, 148, 149
 Girl with Apple, 149, *fig. 91*
 The Green Car, *pl. 74*
Glehn, Jane Emmet de, 137n38
Glehn, Wilfrid-Gabriel de, 137n38
Gobelins, 304, 306, 308, *fig. 137*
Goetz, Louis A., 243
Goldberger, Paul, 56–57
Golden Gate International Exposition, 1939, San Francisco, 34
Grafly, Charles, 17
 Pioneer Mother Monument, 16–17, 34, 36n35, 380, *fig. 10*, *pls. 19, 20*
Graham, David Elms (1876–1944), 26, 37n99
Grand Manner, 123n46, 149–150
Grauman, Sid (1879–1950), 114
Great Britain, 23, 24, 43, 117, 123n46
 jury, 20, 37n61, 224n8, 313, 322n21, 380
 section, 222, 309n9, 322n26, 381
 in World War I, 304
Great Depression, 49
Great Railroad Strike, 112
Greece, 45, 61, 66, 67, 79, 119, 137n9
 ancient (classical), 56, 58n30, 61, 63, 64, 68, 69n22
 plaster casts from, 63–64, 68, 69n34, *fig. 50*
 section, 31, 61–63, 67, 68, 69n7, 322n26, 376, 381, 382, *figs. 40, 41*
Grey, Zane (1872–1939), 243
Griffin, Walter, 123n55, 129, 382
Guérin, Jules, 381
 as chief of color, 13, 45, 67, 72–74, 75–76, 77, 79, 80nn5–6, 80n10, 81n52, 112, 122n6, 125, 380
 Works
 Arch of the Rising Sun from the Court of the Universe, *fig. 49*
 Panorama of the Panama-Pacific International Exposition, 42, *fig. 6*
Guiffrey, Jean (1870–1952), 304, 305, 306, 307–308, 312–313, 320, 321
Guiffrey, Jules, 312
Guillaume, Albert, *The Pitch*, 28, 38n106, *fig. 19*
Guillaume, Henri (1868–1930), 303, 305
Gustin, Paul, 21, 118

Habenicht, George, 242
Hackley Gallery of Fine Arts, 20
Hale, Lilian Westcott, 133, 137n31
Hale, Philip Leslie, 133, 147, 153n63
Hale, Reuben Brooks (1869–1950), 44, 380
Hals, Frans, 150
Hambourg, Maria Morris, 251n78
Hamilton, John McClure, 123n57, 129, *fig. 167*
Hansen, Armin, 123n53, 136
Harada, Jiro, 250n44
Hardee, Theodore (1868–1957), 238, 239, 250nn12–13, 380, *figs. 117, 122*
Harriman, Mary Williamson Averell (1851–1932), 32, 38n136
Harshe, Robert Bartholomew (1879–1938), 17, 34, 36n40, 382
 Art Institute of Chicago and, 30, 38–39n139, 382
 Oakland Public Museum and, 29–30, 136, 382
 PPIE and, 17, 18, 19, 36–37n50, 37n51, 38n119, 136, 215, 227, 235, 235n2, 380, *fig. 12*
 "Prints and Their Makers," 217, 219, 220, 222, 224n10, 224n19, 225n26, 227, 228–229, 233, 235n13, 235n21
Harte, Brett, 77, 78
Hartman, William, 242
Haskell, Ernest, 219
 Amelia, *fig. 98*
 Dwarfs of Ragged Island, 219, *pl. 104*
Hassam, Childe, 38n125, 73, 80n10, 118, 129, 133, 143, 145, 146, 380, 381
 Aphrodite, Appledore, *pl. 61*
 California Hills in Spring, 133, *fig. 82*
 Fruit and Flowers, 133
 The South Ledges, Appledore, 21
 Yachts, Gloucester Harbor, 32, 38n137
Hastings, Thomas, 52
Haussmann, Georges Eugène, 122n4
Haviland, Frank Burty, 326

Hayes, Margaret Calder, 36n66
Hearst, George, 53
Hearst, Phoebe Apperson (1842–1919), 16, 30, 32, 57, 381, 383
 and UC Berkeley, 53, 58n13, 59n39, 68
Helgesen, Nils, 233–234
Heller, E. J., 32
Heller, Hugo (1870–1923), 24
Helleu, Paul César, 307
Hellman Jr., I. W., 380
Henri, Robert, 118, 129, 143, 147–148, 149, 150, 152n25, 152n34
 Lady in Black Velvet (Portrait of Eulabee Dix Becker), 21, 150, *pl. 38*
Herculaneum, 64
Herrick, Myron T. (1854–1929), 303, 312
Hill, John, *New York from Governor's Island*, 220
Hine, Lewis W., 248
 "Carrying-in" boy in Alexandria Glass Factory, Alexandria, Va., *fig. 128*
 NCLC booth photographs, 245–246, 251n56, *figs. 126, 128*
Hiroshige, Utagawa, 225n43
history painting, 74, 117
Hitchcock, George, *The Vanquished*, 4, *fig. 56*
Hobart, Clark, 123n53, 129, 136, 137n23, 227, 233, 235n7, 235n9
 The Blue Bay: Monterey, 32, *fig. 78*, *pl. 80*
 Nymph at the Pool, 233, *fig. 116*
Hoffman, Harry Leslie, 129, 382
 A Mood of Spring, 21, *pl. 63*
Hokusai, Katsushika, 225n43
Holloway, Charles, 38n125, 73, 80n10, 380, 381
 The Pursuit of Pleasure, *fig. 53*
Homer, Winslow, 18, 21, 123n57, 128
 The Artist's Studio in an Afternoon Fog, 128, *pl. 29*
 Saco Bay, 21, *pl. 30*
Hoover, Herbert, 326
Hopkins, Edna Boies, 229, 234, 235n7, 235n9
 Zinnias, *pl. 114*
Hoppé, Emil Otto, 242
 Malvina Longfellow, Dressed as Nun, 242, 250n43, *fig. 121*
Horter, Earl, *Smelters, Pittsburgh*, 219, *pl. 99*
Hovenden, Thomas, *Breaking Home Ties*, 117, *fig. 67*
Howe, Graham, 250n43
Hrdlička, Aleš, 58n8, 75
Hudson, Grace (1865–1937), 21, 37n73
Hudson River School, 117, 118, 128
Hugo, Victor, 307
Hundred Years' War, 306
Hungary, 23
 modernism in, 11, 144, 326, 327, 329, 330
 section, 21, 24, 144, 215, 220–222, 225n47, 322n7, 325–335, 381, 383
 stranding of works during World War I, 33, 332, 383
Hunt, Richard Morris, 58n8, 75
Huntington, Archer, 20
Huntington, Henry E., 32
Huntington, Marian, 32, 38n130
Hussey, Edward, 58n1
Huth, Helen Rose, 20, 37n67, 150, 152n30
Huth, Louis, 37n67
Hyde, Helen, 223, 227, 229, 232, 234, 235n7, 235n9
 The Bath, 229, *pl. 112*
 Mount Orizaba, 229, *fig. 110*

Ignotus, 334n29
immigrants and immigration, 114, 122n18, 150
imperialism, 15, 46, 111, 112, 114, 118, 119, 120
Impressionism, 25, 122n41, 141, 149, 316, 329, 330
 American, 118, 126, 128, 129, 131–133, 134, 136, 143, 317
 as dominant style at PPIE, 11, 117, 143, 317
 exhibitions of, 74, 152n39
 French, 118, 126, 145, 219, 303, 304, 306, 311, 315–316, 317, 320
 influence and popularity of, 77, 143, 145, 219, 304, 311, 315, 316–317, 319, 321
India, 46, 229
Indiana, 19, 122, 225n69, 232, 250n38, 382
Inness, George, 18, 118
International Child Life Exhibit Company, 247
Italian Futurism, 330
 gallery, 11, 24, 26–28, 29, 38n112, 122n40, 126, 139, 144, 145, 148, 149, 328, *fig. 18*

responses to, 28–29, 129, 139, 141–143, 144, 148, 149, 150, 150n2, 152n39, 153n56, 317, 330, *fig. 86*
Italy, 28, 29, 45, 61, 119, 133, 137n24, 137n38, 152n2, 218, 332
 section, 22, 26, 37n83, 64, 67, 144, 215, 224n4, 250n44, 304, 316, 318, 322n7, 322n26, 325, 328, 381, 382
 stranding of works in, 24
Iványi-Grünwald, Béla, *Nascence*, 333, *fig. 157*

J. Chiurazzi & Sons, 64, *fig. 45*
Janus Pannonius Múzeum, 333
Japan, 29, 53, 116, 122n33, 224nn2–3, 246, 250n44
 art of, as influence, 131, 145, 228, 229, 232
 section, 22, 123n55, 128, 215, 220, 225n43, 248, 382, *fig. 96*
Japanese Americans, 114
Jaques, Bertha E., 218, 224n6, 224n8, 224n22
 Charing Cross Bridge, *pl. 94*
Jávor, Pál, *Hungarian Home Altar*, 329, 334n31, *fig. 153*
Johnson, Eastman, *The Wounded Drummer Boy*, 117
Johnson, Hiram, 382
Johnson, John G. (1841–1917), 18
Johnson, Sargent, 250n37
Johnson, Walter S., 57
Johnston, Ella (1860–1951), 19
Joy Zone, 46, 55, 73, 111, 114, 245, 246, *figs. 32, 61, 62, 63, 64, 65*
Jugendstil, 220
Jungnickel, Ludwig Heinrich, 220

Kahn, Julius (1861–1924), 380
Kahn Resolution, 380
Kandinsky, Wassily, 122n41
Keeler, Charles, 53
Keith, William, 11, 18, 52, 78, 118, 129, 134–135, 137n42
Kelham, George (1871–1936), 13, 36n14, 122n5
Keller, Helen, 45
Keller und Reiner Salon, 334n39
Kellogg, John Harvey, 114
Kendall, William Sergeant, 153n63
Kent, Rockwell, 129, 381
Kern, Elizabeth, 51
Kernstok, Károly, 330, 332, 333, 334n44
Késmárky, Árpád, 331
Kimball, Katharine, 224n22
Kimbrough, Sara Dodge, 81n20, 81n28
King, Homer S. (1841–1919), 112, 380
King, Thomas Starr, 78
Kiss, Ernő, 322
Knight, Laura, *Self-Portrait*, 26, *fig. 17*
Koch, Guillermo, 250n44
Kokoschka, Oskar, 24, 33, 126
 Portrait of Egon Wellesz, *pl. 152*
Königliche Kunstgewerbeschule, 232
Kóródy, Elemér, 331

Ladd, Anna Coleman, *Wind and Spray*, 248
Ladies' Home Journal, 242
La Farge, John, 123n57, 128
La Fontaine, Jean de, 306
Lalique, 32, 306
Lalique, Suzanne, 307
landscape
 painting, 11, 21, 26, 38n132, 77, 117, 118, 128, 131–133, 135, 136, 145, 315, 316, 333
 photography, 239, 241, 245, 247
 prints, 219, 229, 232, 233
Lange, Olaf, 222
Lapland, 246
Laurens, Jean-Paul
 The Execution of Joan of Arc, 302, *pl. 134*
 Joan of Arc series, 302, 306, 308, *pl. 134*
Laurvik, Elma Pálos (1887–1971), 23, 24, 326, 330, 331, 332, 333, 334n5
Laurvik, John Nilsen (1877–1953), 334n5, 383, *figs. 13, 22*
 autochromes, 37n88
 as juror, 22, 141, 325
 PPIE and, 12, 17, 23–24, 26–27, 31, 33, 34, 38n102, 38n112, 38–39n139, 68, 69n28, 118, 123n57, 123n61, 136, 141, 144, 152n9, 153n63, 225n47, 322n7, 325–327, 328, 329, 331, 332, 333, 334n7, 334nn12–13, 335n47, 381, 382, 383
 SFAA and, 31, 33, 38n126, 38n137, 39nn142–144, 68, 382, 383
 Spreckels and, 39n147

Lawson, Ernest, 128, 316
Lázár, Belá (1869–1950), 327
Lebrun, Charles, 306
Ledeboer, Hans, 250n44
Lemos, Pedro J. de, 123n53, 223, 227, 229, 235n9
 Summer Evening, 233, *pl. 109*
L'Enfant, Pierre, 122n4
Lentelli, Leo, 120
Léon, Paul, 321
Lesznai, Anna, 333, 335n64
Leutze, Emanuel Gottlieb, *Columbus Discovering America*, 117
Levinson, J. B., 32, 38n130
Levy, Beatrice Sophia, 235n7, 235n9
 Song of Summer, *pl. 118*
Lewis, John Frederick, 20
Lewis and Clark Centennial Exposition, Portland, 1905, 73
Library of Congress, 75, 255n61
Livingston, Conti, 240
Livingston, Florence Burton, 240
Lockheed Aircraft Manufacturing Company, 46
London, 14, 17, 20, 21, 24, 37n61, 37n66, 43, 131, 152n39, 217, 218, 224n8, 225n26, 239, 240, 242, 243, 380, 381
London School of Art, 233
Longfellow, Henry Wadsorth, 74
Longfellow, Malvina, 242, 250n43, *fig. 121*
Los Angeles, 21, 32, 44, 238, 240
Los Angeles County Museum of Art, 21, 315, 322n35
Lotos Club, 21
Loughead, Allan, 46
Loughead, Malcolm, 46
Louisiana Purchase Exposition, Saint Louis, 1904, 11, 15, 19, 43, 46, 215, 224n6, 239
Luks, George, 129, 149, 381
Lum, Bertha, 223, 224n22, 229, 232, 235n7, 235n9
 Rainy Twilight, *pl. 110*
 Tanabata, *pl. 113*
Lumière brothers, 243

Mabry, Helen R., 245
Macbeth Gallery, 152n25
MacChesney, Clara, 131, 133, 134, 137n29
Macdonald-Wright, Stanton, 34
MacEwen, Walter, 20, 37n61
Mackintosh, Mahonri, 224n8
MacLaughlin, Donald Shaw, 224n22
 Quai des Grands Augustins, Paris, *pl. 95*
MacNeil, Hermon Atkins (1866–1947), *The Adventurous Bowman*, 15, 35, 120, *figs. 70, 71*
Macomber, Abraham Kingsley, 32
Macomber, Ben (1876–after 1942)
 The Jewel City, 38n106, 58n28, 71, 72, 74, 76, 80n1, 143, 148, 152n2, 309n23
 "Weird Pictures at PPIE Art Gallery Reveal Artistic Brainstorms," 28–29, *fig. 85*
Madame Tussaud's Wax Museum, 152n39
Madrid, 305
Magyar Nemzeti Galéria, 329, 332, 333
Magyarország, 327
Maikop Treasure, 64
Maillol, Aristide, 334n38
Maine, 128, 219, 245
Manet, Édouard, 141, 149, 150, 153n58, 316, 320
 The Balcony, 304, 307, 319, *figs. 148, 149*
Manifest Destiny, 15, 112, 118, 119, 245
Manship, Paul, 17, 137n28
 Lyric Muse, *pl. 51*
Marceau, Theodore C. (1859–1922), 247
Márffy, Ödön, 333
 Forest Path, 330
 Still Life, 333, *pl. 155*
Marin, John, 217–218
 Bal Bullier, Paris, 218, *pl. 90*
 Ca d'Oro, Venice, 218, *pl. 91*
 Paris, 218
Marinetti, Filippo Tommaso (1876–1944), 24, 26–27, 29, 38n102, 38n112, 144
Marinot, 306
Márk, Lajos, 329, 334n31
 In Front of a Mirror, 334n26
Mark Hopkins Institute of Art, 79, 233
Markwart, Arthur H., 37n99, 44
Martin, Walter S., 39n143
Martinez, Xavier, 123n53, 233, 235n7, 235n9
Mastropasqua, Louis, 250n44
Mather, Cotton, 220, *fig. 100*

Mather, Margrethe (1886–1952), 240
Mather, Richard, 219–220, fig. 99
Mathews, Arthur Frank, 38n125, 38n137, 71–72, 79, 129, 135, fig. 162
 as juror, 21, 22, 118, 135
 murals, 31, 38n125, 71–72, 78, 79, 81nn52–53, 133, 135, 380, 381, 383, fig. 21
 one-man gallery, 118, 129, 134
 Works
 California, pl. 78
 Pandora, fig. 84
 Untitled (Mural), fig. 59
 The Victory of Culture over Force (Victorious Spirit), cover, 31, 34, 71, 79–80, 133, 383, pl. 23
 Vision of Saint Francis, 79
Mathews, Lucia K., 320
Matisse, Henri, 31, 122n41, 141, 150, 152n21, 330
Matthieson, J. B., 58n17
Maurer, Alfred Henry, 129, 381
Maurer, Oscar, 243
Maybeck, Bernard (1862–1957), 51–52, 53–55, 57, 58n1, 58n5, 58n7, 58n17, 58nn9–10, 58nn14–15, 59n40, 68, fig. 163
 Berkeley and, 53
 Canberra designs, 55, 58n16, 58n31
 House of Hoo Hoo, 58n28
 Palace of Fine Arts, 11, 14–15, 17, 30, 51, 55–57, 58nn2–4, 58nn20–27, 58nn30–31, 58n35, 59nn37–39, 67, 69n22, 115–116, 125–126, 248, 305, figs. 33, 34, 36, 37, 38
 Wyntoon, 53, fig. 35
Maybeck, Bernhardt, 51, 58n6
Maybeck, Jacomena, 55, 57, 58n4
Maybeck, Wallen, 57
Mazarin, Cardinal, 58n8
McComas, Francis, 118, 129, 134, 135, 382
 as juror, 21, 37n73, 118, 135
 Works
 Navajo Gateway, Arizona, 32, 108, 135, pl. 77
McCoy, Esther, 52, 53–55, 58n7, 58n14
McKim, Mead and White, 13, 15, 67–68
McKinley, William, 44
McLaren, John (1846–1943), 39n152, 56, 112, 116, 125
Meakin, L. H., 37n71
Mediterranean, 45, 56, 66, 79, 112
Melchers, Gari, 20, 123n57, 129, 133–134
 The Fencing Master, 134
 The Open Door, pl. 58
 A Sailor and His Sweetheart, 37n65, 134, pl. 83
 Skaters, 37n65, 134
 The Smithy, 37n66
Meller, Simon, 225n47
Memorial Art Gallery, 243
Memorial Museum (de Young Museum), 11, 29, 322n47, 323n78, fig. 20
 alternative exhibition at, 21, 118, 381
 expansion of, 7, 29, 32, 36n39, 38n114, 38n132, 136, 137n54, 382, 383
 plaster casts and ancient art given to, 31, 64, 68, 69n34, fig. 50
Merchant, William G., 55, 57
Merse, Pál Szinyei, 332, 335n49
 Picnic in May, 330
Metcalf, Willard LeRoy, 123n55, 129, 133, 147, 382
 Winter's Festival, pl. 64
Metropolitan Museum of Art, 18, 31, 32, 38n136, 63, 64, 134, 146
Mexico, 117, 119, 122n15, 229, 240
Michelangelo, 56
Middle East, 120
MIÉNK (Hungarian Circle of Impressionists and Naturalists), 330, 334n44
Mighels, Ella Sterling (1853–1934), 16
Milan, 24, 38n112
Miller, Richard E., 123n55, 129, 382
Millet, Francis D. (1848–1912), 18, 36n45, 380
Millet, Jean-François, Study for "Mercury Leading the Cows of Argus to Water," 315
Milman, Arthur, "STEVE BUNK AT THE FAIR—Stevie Wise to the Futurists? Sure he is!", fig. 86
Milne, David Brown, 129
 Black and White I, pl. 72
 Black and White II, pl. 73
Milwaukee Art Society, 229
Minneapolis, 320, 382
Minneapolis Institute of Arts, 315, 382
Mobilier national, 304, 306
modern art and modernism, 218, 225n32, 248, 334n38

at the Armory Show, 26, 37n53, 122n41, 139
 Hungarian, 11, 144, 326, 327, 329, 330
 at PPIE, 19, 26, 129, 139, 141, 143, 144, 145, 147, 149, 150, 151, 152nn9–10, 152n22, 308, 329, 382
Molière, 306
Monet, Claude, 126, 141, 316, 317, 319, 320
 Bateaux échoués, Fécamp, 322n39
 Garden at Sainte-Adresse, 316, fig. 144
 Grainstack at Sunset, Winter, 316, 322n39, fig. 146
 La Seine à Port Villers, 322n39
 Le Havre, terrasse au bord de la mer, 322n39
 Meule, coucher de soleil, 322n39
 Nymphéas, paysage d'eau, 322n39
 Rouen Cathedral Facade, 307, 319, pl. 144
 Vétheuil, 322n39
 Walk in the Meadows at Argenteuil, 316, 322n39, fig. 145
Monsen, Frederick I., 243
Monterey, 129, 135
 depictions of, 32, 135, 250n26, pls. 80, 103
Montessori, Maria, 45
Monuments Historiques, 304, 307
Moore, Charles C. (1868–1932), 12, 18, 19, 36n45, 69n17, 305, 309n4, 380
 albums of PPIE views, figs. 6, 9, 65, 135
Moore, Sarah J., 111, 112
Moran, Mary Nimmo, 220
Moran, Thomas, 220
Moreau, Gustave, Jason, 307
Morgan, Charles, 152n34
Morgan, J. Pierpont (1837–1919), 18–19
Morgan, Julia, 53, fig. 35
Morisot, Berthe, 319
Morocco, 246
mothers, 16–17, 20, 27, 34, 37n68, 76, 78, 128, 131, 147, 243, 250n46, 322n39, 380
Mullgardt, Louis Christian (1866–1942), 216, 246, 382, 383
Munch, Edvard, 26, 126, 222, 225n50, 225nn54–55
 Madonna, 222, 225n55, pl. 160
 Moonlight I, 222, pl. 161
 Self-Portrait, 222, 225n55, pl. 159
 Vampire II, 222
Munich, 232
 school, 128, 129, 133, 145, 232
Munkácsy, Mihály, 333
Munson, Audrey (1891–1996), 15, 16, 36n27, 36n29
murals, 11, 12, 13, 15, 19, 21, 31, 34, 38n125, 45, 71–81, 115, 119, 120–121, 125, 126, 133, 137n42, 225n57, 246, 304, 315, 320, 380, 381, 383
Murdoch, Helen Messinger (1862–1956), autochromes, 14, figs. 3, 4, 29
Musée d'Orsay, 20, 149, 303, 307, 319, 320, 322n37
Musée du Louvre, 304, 311, 312, 313
Musée du Luxembourg, 20, 37n68, 303, 304, 307, 311, 312, 313, 319, 320, 321, 382
Museum of Fine Arts (MFA), Boston, 304, 312–313
Myers, John Andrew, 36n35

Nabis, 126, 129, 220, 334n38
Nahl, Perham, 123n53, 136, 219, 233
 Monterey Cypress, pl. 103
 The Thirteenth Labor of Hercules, 13–14, 61, 381, pl. 1
Naples, 64
Napoléon, 306
Napoleonic Empire, 306
National Academy of Design, 21, 147, 152n25, 153n63
National Arts Club, 23, 334n6
National Child Labor Committee (NCLC) booth, 245–246, 251n56, figs. 126, 127
National Cowboy and Western Heritage Museum, 39n150, 123n70
National Gallery, Christiania, 24
National Gallery of Art, Washington, DC, 21, 319
National Hungarian Artists' Association, 327, 332
nationalism, 61, 111, 112, 117, 118, 119, 122n32, 148, 149
National Museum, Athens, 63
National Portrait Gallery, London, 146
National Sculpture Society, 15
Native Americans, 125, 246
 depictions of, 16, 79, 119, 120, 243
nativism, 114, 121
Naumann, Francis, 153n41
Nazis, 122n16
Nelson, Bruce, 129, 136, 137n23
 The Summer Sea, pl. 81
Nemes, Marcell (1866–1930), 327

neoclassicism, 17, 45, 61, 64, 66, 304, 305
Netherlands (Holland), 37n65, 381
 scenes of, 217
 section, 22, 220, 250n44, 304, 381, 383
Neuhaus, Eugen (1879–1963)
 as chronicler/reviewer, 58n4, 73, 129, 131–133, 135, 137n10, 146–147, 149, 150, 153n44, 227, 235n2, 307, 309n9, 309n21, 316, 317, 318
 as juror, 20, 21, 118, 129, 146, 227, 316
New Jersey, 23, 219, 233
New Orleans, 44, 49
New York, 13, 16, 19, 21, 26, 39n139, 57, 77, 123n51, 146, 224n10, 313, 320, 332, 381, 383
 artists, architects, and art schools, 13, 15, 17, 51, 52, 73, 74, 75, 77, 125, 126, 128, 129, 141, 224n9, 225n69, 232, 233, 237, 240, 245, 246, 247, 251n70
 depictions of, 128, 131, 150, 219, 220, 225n32, 240–241
 exhibitions, galleries, and museums, 17, 20, 63, 64, 116, 122n41, 134, 139, 146, 152n5, 152n25, 217, 220, 225n54, 232, 234, 237, 239, 320, 322n36, 322n49, 332, 380, 381
 jury, 20, 21, 146, 224n8, 381
New York Evening Post, 23
New York Public Library, 224n10, 234
New York Times, 13, 23, 37n88, 137n7, 313, 332
Neyman, Percy, 242
Nielsen, Carl, 222
nocturnes, 20, 21, 40, 131, 239, 240, fig. 81, pls. 7, 70, 71
Nordfeldt, Bror Julius Olsson, 218, 224n22, 229, 232, 234, 235n9
 Anglers, 229, fig. 108
 Bridge Builders, Chicago, pl. 98
 House of the Virgin, 225n13
 The Piano, 235n13, pl. 117
 The Wave, Moonrise, 226, pl. 116
Noriega, Anthony J., 242
Normand, Mabel, 45
Norman T. A. Munder & Company, 224n2
Norway, 23, 222, 225n63, 325
 section, 21, 22, 24, 26, 215, 220, 222, 322n7, 325, 328, 381, 382
Nourse, Elizabeth, 311
nudes, 16, 26, 118, 120, 122n25, 128, 131, 133, 148, 149, 153n46, 217, 239, 240, 335n47
Núñez de Balboa, Vasco, 44, 380
Nyugat, 334n29

Oakland, 52, 59n39, 233, 238, 240, 248
Oakland Art Gallery, 136
Oakland Public Museum, 11, 16, 29–30, 382
Oakland Tribune, 13–14, 21, 34, 382
Oakley, Violet, 123n55, 129, 382
Oelmacher, Anna, 334n5, 335n59
Old Lyme, 77, 78
old masters, 18, 117, 134, 149
Olgyay, Viktor, Allee, 311, 334–335n47
Olmsted, Charles, 224n19, 225n43
Olmsted Sr., Frederick Law, 58n13
Omaha, 44, 49
O'Neill, Edmund, 237
Open Door policy, 115
Orbán, Dezső, 330
Oregon State Building, 20, 67, 224n4, fig. 48
Orlik, Emil, 220
 Portrait of Mahler, 220, fig. 103
Orphism, 122n41, 148
Osann, H. E., 332, 335n58
Otis, Bass, 220
Ottoman Empire, 69n14
Otto Sarony Company, 247
Overland Monthly, 133

Pacific Ocean, 44, 111, 120, 380
Pacific Ocean Exposition Company, 380
Palais de la Légion d'Honneur, 136, 304, 305, 306, 308, 318
Panama-California Exposition, San Diego, 1915, 152n34, 248, 304, 381, 382, 383
Panama Canal, 23, 76, 381
 PPIE and, 13, 44, 46, 61, 75, 78, 79, 111, 112, 120, 121, 125, 128, 314, 321, 327, 380, 381, fig. 65, pl. 3
 United States and, 12, 43, 44, 61, 111, 112
Panama-Pacific International Exposition Company (PPIE Co.), 11–12, 23, 30, 33, 34, 35, 112, 223, 247, 380
Panama-Pacific International Exposition (PPIE), San Francisco, 1915

Arch of the Nations of the East, 14, fig. 4
Arch of the Nations of the West, fig. 5
Arch of the Setting Sun, 72, figs. 51, 52
Association of Women, 380
Catalogue de Luxe, 27, 118, 123n57, 123n61, 152n9, 227, 325, 328, 329
Column of Progress, 15, 30, 35, 67, 120, figs. 24, 70
Committee on Exploitation and Publicity, 13
Court of Abundance (Court of the Ages), 31, 122n7, 225n57, 304
Court of Flowers, 122n7, pl. 13
Court of the Four Seasons, 122n7, figs. 6, 7
Court of Palms, 79
Court of the Universe, 16, 68, 72, 120, 122n7, figs. 9, 49
Department of Fine Arts, 11, 12, 16, 17–19, 20, 21, 23, 24, 25, 29, 36n1, 36–37n50, 37n51, 38n133, 58n21, 136, 139, 141, 144, 145, 151, 215, 223, 224nn17–18, 227, 238, 311, 314, 315, 316, 320, 322n17, 322n21, 325, 329, 331, 380, 381, 382
Division of Exhibits, 312
Division of Works, 24–25, 61, 224n18, 305
floor plans, 378
ground plan, 376
guidebooks, 11, 19, 63, 76, 79–80, 80n1, 118, 139, 143, 144, 146, 148, 150, 152n5
International Jury of Awards, 19, 21–22, 79, 123n55, 129, 141, 146, 227, 242, 246, 316, 325, 329, 381, 382, fig. 168, endpapers
 as the "Jewel City," 13, 16, 35, 45, 46, 49, 71, 74
 juries (advisory, selection committees), 17, 20, 21, 37n61, 55, 129, 137n51, 148, 153n41, 223, 224n8, 227, 238, 239, 246, 247, 313, 315, 316, 320, 322n21, 380, 381
Music Department, 45
 number of visitors to, 36n1, 43, 49, 116, 152n5, 314
 official catalogue, 11, 19, 37n53, 37n67, 137n39, 152n9, 227, 312, 326, 327, 328, 329, 331, 333, 334n26, 334n29
 one-man galleries, 18, 20, 37n53, 118, 123n57, 129–131, 146, 152n25, 152n27, 224n22
Opening Day, 24, 25, 45, 69n11, 235n4, 239, 247, 318, 381
Palace of Agriculture, 122n3, 237, 251n76
Palace of Education and Social Economy, 11, 19, 114, 122n3, 237, 243–246, 247, 376, figs. 123, 124, 126, 127
Palace of Fine Arts, 11, 12, 14–15, 16, 17, 19, 21, 22, 24, 25–26, 27–28, 29, 30, 31, 32, 33, 34, 35, 36n1, 45, 50, 51–59, 67, 68, 69n22, 69nn28–29, 79, 111, 112, 114, 115, 116–117, 118, 119, 121, 122n3, 122n37, 122nn40–41, 123n60, 125–137, 139, 141, 143, 144–145, 150, 151, 152n5, 153n63, 215, 217, 220, 223, 224, 224n22, 225n43, 225n55, 227, 237, 238, 240, 246, 248, 250n47, 251n76, 304, 305, 307, 309n23, 312, 314, 315–318, 319, 320, 325, 327, 328, 331, 334n13, 334n28, 376, 380, 381, 382, 383, figs. 3, 10, 14, 15, 21, 33, 34, 36, 37, 38, 44, 74, 75, 78, 130, 141, 159, 165, 166, 167, endpapers
Palace of Food Products, 122n3, 251n76
Palace of Horticulture, 45, 46, 58n28, 122n3, fig. 29
Palace of Liberal Arts, 11, 73, 122n3, 215, 224nn2–3, 237, 238–243, 376, figs. 117, 119, 122
Palace of Machinery, 45, 55, 67, 74, 76, 79, 112, 122n3, 122n10, figs. 54, 71
Palace of Manufactures, 73, 122n3
Palace of Mines and Metallurgy, 122n3
Palace of Transportation, 45, 73, 122n3
Palace of Varied Industries, 28, 122n3, 224n2, 250n38
 panoramic views of, 13, pl. 7, pls. 6, 9
 poster for, 13–14, pl. 1
 post-Exposition exhibition and tour, 12, 31, 68, 136, 151, 152n5, 225n43, 320–321, 323n70, 331, 332, 382, 383, fig. 31
 scholarly challenges of, 11–12
 South Gardens, 17, fig. 72
 technology displays, 43, 45, 49, 73, 111, 112, 114
 Tower Gate, 121
 Tower of Ages, 122n7
 Tower of Jewels, 16, 46, 73, 81n34, 119, 120, 125, fig. 28
 Woman's Board of, 16, 19, 308
Pan-American Exposition, Buffalo, 1901, 15, 43, 44, 137n29
Panthéon, 306, 320

Paris, 11, 13, 15, 17, 20, 21, 38n137, 51, 52, 66, 73, 74, 77, 79, 122n4, 129, 136, 152n39, 218, 220, 224n8, 224n22, 229, 232, 303, 304, 305, 306, 307, 308, 309n21, 311, 313, 315, 317, 318, 319, 320, 329, 331, 334n36, 334n38, 381, *pls. 90, 95*
 Salon, 74, 134, 239, 319
 world's fairs, 43
Parker, Lawton Silas, 37n71, 123n55, 129, 382
 La paresse (Idleness), pl. 55
Parrish, Maxfield, 126
Parthenon, 60, 63, 66, 67, 68, 69n11, 69n14, 69n20, *figs. 42, 43*
Partington, Gertrude, 123n53
Partridge, Roi, 219, 240
 Dancing Water (Pont Neuf), pl. 106
 Early Morning, Notre Dame, pl. 107
 White Butterfly, 219, pl. 105
Patigian, Haig (1876–1950), 34
Patterson, Margaret Jordan, 228, 229, 235n9
 The Swan, pl. 115
Paul Sacher Stiftung, 333
Paur, Géza, 332
Paxton, William McGregor, 37n71, 133, 147, 153n63
 Glow of Gold and Gleam of Pearl, 153n63
 The House Maid, fig. 89
Peale, Charles Willson, 117
Pearson, Ralph, 218
 The Asphalters, Wabash Avenue, pl. 97
Pelham, Peter, *Cottonus Matheris (Cotton Mather), 220, fig. 100*
Penez, Charles E. (1883–1960), 68
Pennell, Joseph, 18, 20, 217, 218, 223, 225n26, 225nn35–36, 313–314
 as juror, 22, 216, 224n8, 313, 322n21
 one-man gallery, 123n57, 129, 216, 218, 224n22
 Works
 The End of the Day, Gatun Lock, 218, pl. 96
 In the Zeppelin Shed, Leipzig, 218, fig. 97
Pennsylvania Academy of the Fine Arts, 18, 147, 148, 149, 152n25, 250n37, 382, 383
 annuals at, 153n63, 234
 loans from, 18, 20, 37n65, 134
Pericles, 66–67, 69nn3–4
Peters, Charles Rollo, 21, 118
Petrovics, Elek (1873–1945), 332
Phelan, James D., 39n143, 69n3
Phidias, 63
Philadelphia, 15, 16, 18, 21 24, 36n49, 37n71, 129, 217, 224n8, 225n69, 243, 251n70, 329, 381, 383
Philadelphia Museum of Art, 74
Philippines section, 22, 122n9, 381
Philopolis, 71, 79
Photo-Era, 250n42
Photographic Journal of America, 14
photography, 237–251
 autochromes, 14, 23, 37n88, 75
 hand-colored, 242, 243, 250nn37–38
 Kodak, 73, 137n7, 243
 pictorial gallery at PPIE, 237, 238–240, 242, 243, 245, 246, 247, 248, 250n18, *fig. 118*
 See also Eastman Kodak Company; National Child Labor Committee (NCLC) booth; Pictorialism; Rodman Wanamaker Indian Exposition
Photo-Secession, 237, 239
Piazzoni, Gottardo, 28, 39n142, 320
 Lux Aeterna, 28, pl. 79
Picabia, Francis, 31, 141, 148, 152n21
Picasso, Pablo, 31, 122n41, 141, 148, 152n39
Pictorialism, 237, 239, 246, 248
Piranesi, Giovanni Battista, 56, 115, 215
Pissarro, Camille, 21, 126, 317
 Houses at Bougival (Autumn), 316, 322n39, pl. 139
 Le jardin du presbytère à Knokke, 322n39
 Red Roofs, Village Corner, Winter Effect, pl. 140
Pittsburgh, 20, 24, 25, 33, 219, 320, 382, *pl. 99*
Platinum Print: A Journal of Personal Expression, 240
Plowman, George M., 224n22
Poe, Edgar Allan, "To Helen," 58n30
Pointillism, 126, 219
Polk, Willis (1867–1924), 39n142, 55, 66, 110
Pompeii, 45, 64, 74
Poor, Henry Varnum, 34, 123n53
Pór, Bertalan, 326, 330, 332, 333, 334n40, 335n53, 335n59
 Longing for True Love, 332
 My Family, 332, 334n40, 334n43, pl. 154
 Sermon on the Mount, 332

Porter, Bruce, 21, 52, 136, 137n51, 382
Portland, 223, 224n19, 243, 381
 world's fair, 20, 73
Portland Art Association, 381
Portland Art Museum, 225n59
portraiture, 20, 21, 25, 26, 37n88, 37n98, 38n132, 63, 78, 117, 123n46, 128, 131, 134, 137n42, 149, 219–220, 222, 225n55, 307, 319, 325, 329, 330, 332, 333, 334n1, 334n29
 Beaux's, 149–150, 153n62, 153n58
 Chase's, 20, 133, 150
 Kokoschka's, 24, 126
 photography, 238, 239, 240, 242, 243, 245, 246, 247, 250n26
 Sargent's, 134, 146–147, 150
Portugal section, 22, 220, 250n44
Post-Impressionism, 118, 128, 144, 149, 150, 152n2, 222, 315, 319
Pottier, Christian, 52
Pottier & Stymus, 51–52, 58n6
Power, Henry D'Arcy (1857–1939), 238
Powers, Hiram, 17
 California, 36n49, pl. 27
Pratt, Matthew, 117
Praxiteles, 63, 68
Prihoda, István, 334n31
 Study of Female Nude, 335n47
Print Collector's Quarterly, 225n41
printmaking, 18, 24, 118, 137n23, 215–235
 aquatint, 220, 225n63, 232, 233
 color prints, 218, 220, 223, 224n22, 227–235
 drypoint, 220, 225n63
 engraving, 21, 22, 34, 56, 115, 215, 216, 219, 220, 223, 224n13, 225n26, 225n41, 228, 234, 334n29, 382
 etching, 21, 22, 72, 129, 137n54, 215, 216, 217, 218, 220, 222, 223, 224n2, 224n4, 224n9, 224n13, 225n62, 227, 228, 232, 233, 234, 235n13, 240, 382
 intaglio, 21, 216, 217, 222–223, 224n9, 227, 232–233, 234, 237
 lithography, 61, 216, 217, 218, 220, 222, 223, 224n9, 225n36, 225n50, 227, 228, 233, 234, 235n21, 307
 mezzotint, 220, 250n36
 monotype, 216, 227, 233–234
 societies, 216, 224n6, 224n9, 224n16, 225n33, 225n36, 225n69, 232
 woodcut, 216, 220, 222, 223, 224n9, 224nn2–3, 225n50, 227, 228–229, 232, 233, 234, 235n13
Progressive Era, 114
Prohibition, 49
Provincetown, 234
public art, 16, 34, 38n136, 111, 119, 121, 245
public sculpture, 12, 15, 19
Putnam, Arthur, 17, 33, 137n48
 Combat: Puma and Serpents, pl. 50
 The Mermaid, pl. 16
Putz, Leo, 24
 On the Shore, pl. 50
Puvis de Chavannes, Pierre, 315, 320
 Hope, 307, 319–320, fig. 151
 A Vision of Antiquity—Symbol of Form, 21, 126, 315, pl. 142
Pyle, Howard, 123n57, 129

Race Betterment Foundation booth, 114, *fig. 60*
racism, 15, 112–115, 120, 121, 122n19
Raeburn, Henry, 117
Rand, Ellen Emmet, 128, 149
 In the Studio, 128, 149, pl. 45
Randolph, Lee F., 136
Raphael, Joseph M., 128
 Spring Winds, 6, 32, pl. 57
Redfield, Edward Willis, 21, 118, 129, 131, 135, 145
 as juror, 20, 21, 22, 37n61
 Works
 The Hills and River, 32, 38n130, pl. 65
 Overlooking the Valley, 38n136
Redon, Odilon, 317
Reece, Jane, 238, 240
 Maid o' the Sea, pl. 125
Reed, Earl, 219
Reid, Robert, 58n3, 73, 74, 80n10, 126, 380, 381, *fig. 75*
Reid, Whitelaw, 380
Remington, Frederic, 17, 128
 The Bronco Buster, 128, pl. 28
Renaissance
 American, 61, 66–68
 Italian, 28, 53, 61, 66, 67, 115
Renoir, Pierre-Auguste, 118, 126, 317

Dans le jardin, 322n39
Des femmes assises, 322n39
Fleurs et fruits, 322n39
Garden in the Rue Cortot, Montmartre, 316, fig. 143
Promenade au bord de la mer, 322n39
Reth, Alfred, 331
Revere, Paul, 219
Reynolds, Joshua, 20, 117
Rice, William Seltzer, 225n43, 234
Richardson, Constance, 17, *pl. 147*
Richardson, Mary Curtis, 123n53, 128
 The Young Mother, 128, 147, fig. 88
Richardson, William Symmes, 15
Richelieu, Cardinal, 306
Rippl-Rónai, József, 220, 329, 330, 334n31, 334n38
 Parisian Interior, 329, pl. 158
 Portrait of Márk Vedres, 332, pl. 157
Ritman, Louis, 129
Ritschel, William, 136
Roberts, Hobart V., 243
Robinson, Theodore, 118, 123n57, 128, 316
 The Valley of Arconville, 124, pl. 52
Rococo, 67, 242
Rodin, Auguste, 33, 304, 306, 308, 318, 382
 The Age of Bronze, 306, 308, fig. 138, pl. 135
 The Prodigal Son, 306, 308, pl. 136
 Saint John the Baptist Preaching, 306, 308, fig. 138
 The Thinker, 16, 34, 39n152, 305–306, 308, 309n23, 382, figs. 135, 171
Rodman Wanamaker Indian Exposition, 243–245, 250–251n52, *figs. 123, 124*
Rolph Jr., James, 68, 380
Roman Bronze Works, 16
Romanticism, 115, 307
Rome, ancient, 33, 61, 63, 64, 66, 67, 68, 69n4, 119, 122n10, 305
 as Maybeck's inspiration, 56, 58n30, 67, 69n22, 115, 126
Romney, George, 117
Ronchi, Otto D., *fig. 22*
Rook, Edward Francis, 129
 Laurel, 21, pl. 62
Roosevelt, Teddy, 45
Rose, Guy, 129
 The Backwater, pl. 53
Rose, Norman, 36n27
Rosen, Charles, 131–133
Roth, Ernest David, 218, 223
 The Gate, Venice, 218, pl. 92
Roth, Frederick George Richard, 120
Rousseau, Henri (Le Douanier Rousseau), 74
Rousseau, Pierre, 52
Roussel, Ker-Xavier, *The Abduction of the Daughters of Leucippus, 322n37*
Royal Photographic Society, 14, 243
Rubins, H. W., 235n7
Ruskin, John, 131
Russia, 25, 33, 64, 304, 309n9
Russolo, Luigi, 38n104
 Plastic Synthesis of a Woman's Movements, 27, pl. 172
Ryan, Walter D'Arcy (1870–1934), 46, *fig. 31*
Rydell, Robert, 112, 114, 122n32
Ryerson, Martin (1856–1932), 20
Rysselberghe, Théo van, *Garden of the Generalife in Granada, 313, pl. 146*

Sage Quinton, Cornelia Bentley (1876/1880–1936), 320, 321, 323n69
Saint-Gaudens, Augustus, 18
 Seated Lincoln, 117
Saint Louis, 13, 21, 30, 37n71, 224n8, 241, 246, 320, 381, 382
 world's fair, 15, 215, 241
Saint Louis Art Museum (City Art Museum), 18, 383
Saint Peter's Basilica, 56, 68
Salmagundi Art Club, 123n51
Salon des Indépendants, 330
San Diego, 44, 320
Sandow, Eugene, 76
San Francisco
 Bay Area, 14, 21, 44, 53, 79, 111, 121, 233, 240, 241, 305, 382
 Chinatown, 46, 114–115, 122n31
 City Beautiful, 66, 111
 City Hall, 58n16, 66, 79, *figs. 2, 47*
 earthquake and fire, 7, 11, 12, 20, 43, 44, 66, 79, 80, 122n4, 125, 241, 251n75, 380, *fig. 45*
 Marina, 7, 34, 35, 46, 111, *figs. 23, 24*

as the new Athens, 61, 66–68, 69n26, 69nn3–4, 119
Presidio, 44, 61, 383, *fig. 25*
 War Memorial, 12, 34, 36n4, 39n143, 225n57, 383
San Francisco Art Association (SFAA), 7, 12, 30, 31, 32, 33–34, 38n126, 38nn136–137, 39nn142–143, 39nn148, 68; 136, 328–329, 331, 332, 335n53, 382, 383
San Francisco Art Institute, 12, 68, 71, 329
San Francisco Bulletin, figs. 22, 86
San Francisco Call, 18, fig. 12
San Francisco Chronicle, 27–28, 29, 32, 33, 34, 37n99, 38n132, 46, 71, 73, 80n1, 322n7, 382, 383, figs. 50, 85
San Francisco Examiner, 114
San Francisco History Center, 12, 334n25
San Francisco Museum of Art, 34, 39n143–144, 136, 332, 383
San Francisco Museum of Modern Art (SFMOMA), 7, 34, 136, 332, 383
San Francisco Society of Artists, 30, 32, 38n137
Sargent, John Singer, 18, 20, 118, 123n57, 123n61, 129, 134, 143, 145, 146–147, 150, 152n30, 313
 as juror, 20, 37n61, 322n21, 380
 Works
 Henry James, 146
 John Hay, 146
 Madame X (Madame Pierre Gautreau), 134, 146, 150, fig. 87
 Reconnoitering (Portrait of Ambrogio Raffaele), 134, fig. 39
 The Sketchers, 19, 134, 137n38, pl. 40
 Stable at Cuenca, 146–147, pl. 41
Savonnerie, 306
Sawyer, Phil, 235n7
Sayers, Richard Myron (1888–1940), 246
Scandinavia, 325
Schofield, W. Elmer, 123n55, 129, 131, 382
Schumann-Heink, Ernestine, 45
Schuster, Donna N., 136
Schweinfurth, A. C., 52
Scott, John D., 251n52
Scott, Robert, 46
Scribner's Magazine, 13
Scythians, 64, *fig. 46*
Seattle, 223, 224n19, 246, 383, *fig. 75*
 world's fair, 20
Seeley, George Henry, 88n37, 239
Semper, Gottfried, 56
Senn, Edmund (1873–1945), 241, 250n34
Senseney, George, 224n22, 227, 232, 235n7, 235n9, 235n26
 Bridge of Sighs, fig. 113
Serra, Junipero, 78
Sesquicentennial International Exposition, 1926, Philadelphia, 383
Seurat, Georges, *La Grande Jatte, 74*
Severini, Gino, 27, 38n104, 152n21
 Spherical Expansion of Light, Centripetal, pl. 171, back cover
Sèvres, 304, 306, 308
Sewell, Edward N., 238, 239, 243
Sharp, Kevin, 153n58
Shoin, Shimbi, 224n2
Sickert, Walter, 20
Simmons, Edward, 73, 80n10, 81n34, 380, 381
Simon, Lucien, 317
Sisley, Alfred, 20, 126, 317
 Saint Mammès, 322n39
 Une Avenue des peupliers, 322n39
Skae, Alice W. (1846–1903), bequest of, 32, 38n133, 38n135, 137n54
Sketch Club, 30
Skiff, Frederick J. V. (1851–1921), 18, 19, 35, 37n61, 118, 123n57
Sloan, John, 129, 148
 Night Windows, 219, pl. 102
 Renganeschi's Saturday Night, 21, pl. 69
 Roofs, Summer Night, 219, pl. 100
 The Women's Page, 219, pl. 101
Sloss, Leon, 380
Smith, Byron L. (1853–1914), 26, 37–38n100
Smith, H. Pierre, 242
Smith, Jules André, 218, 224n22
 The Little Foundry, pl. 93
Smithsonian Institution, loans from, 20, 21, 131, 134
Social Darwinism, 78, 120, 122n16
Société de l'histoire de l'art français, 312
Société des artistes français, 313
Société du Salon d'Automne, 313
Société nationale des beaux-arts, 313

Society of American Painters, 20
Solhberg, Harald Oskar, 26
 Fisherman's Cottage, 26, 37–38n100, *pl. 162*
 Fisherman's Hut, 225n63
 Winter Night in the Mountains, 26, 37–38n100
Somló, Léni, 330, 333
Sousa, John Philip, 45
South America, 116
Southern Pacific Railroad Building, 237
Spain, 18, 78, 380, *fig. 114*
 influences and motifs, 66, 111, 119, 122n15, 134, 146, 233, 305
 section, 322n26, 381
Spanish-American War, 111
Sparks, Will, 21, 131, 238, 250n18
 Owl's Roost, *fig. 80*
Spencer, Herbert, 122n16
Spencer, Robert, 246
 Courtyard at Dusk, 21, *pl. 67*
Spreckels, Adolph (1857–1924), 308, 323n78
Spreckels, Alma de Bretteville (1881–1968), 30, 382, *fig. 33*
 California Palace of the Legion of Honor and, 11, 34, 39n143, 39n147, 136, 308, 323n78, 383
 Rodin bronzes, 33, 34, 39n152, 306, 308, 382
Squire, Maud Hunt, 233, 235n7, 235n26
 Windy Day, *fig. 107*, *pl. 119*
Stackpole, Ralph, 58n3, 115, 320
 Shrine of the Inspiration, 58n3
Stanford University, 17, 19, 36n50, 136, 146, 320, 380, 382
 statuary, 16, 17, 28–29, 34, 39n150, 39n152, 43, 55, 58n3, 58n23, 63, 64, 68, 71, 72, 115, 117, 119, 121, 306, 307, 311, 318
Steichen, Edward, 133
Stein, Simon L., 242, 246
Sterling, George, *The Evanescent City*, 239
Stern, Alexandra, 114
Stern, Sigmund, 32
Stevens, John Calvin, 128
Stevens, Thomas Wood, 216, 227–228
Stieglitz, Alfred, 23, 237, 239, 242, 250n18
 as Ansco booth juror, 242, 250n39
 J. Nilsen Laurvik, 37n88, *fig. 13*
still life, 133, 149, 333
Stimmel, William S. (1864–1935), 25
Strand, Paul, 248
 Panama-Pacific Exposition, San Francisco, 248, 251n76, *fig. 131*
 Wall Street, 248, 251n78, *fig. 132*
Streamline Moderne, 49
Struss, Karl, 238, 239, 240
 Columbia University, Night, 240, *pl. 128*
Stuart, Gilbert, 117
Stuck, Franz von, 24, 382
 Summer Night, *pl. 151*
suffrage, 122n25, 326
Survey, 246
Svirsky, Mademoiselle, 17, *fig. 148*
Swann Galleries, 37n88
Sweden, 331, 381
 section, 22, 215, 220, 304, 328, 331, 334n25, 381, 382
Swedenborgian Church, 52, 58n11
Symbolism, 26, 122n41, 135, 219
Synchromism, 122n41
Szabó, Júlia, 325, 334n1
Szépművészeti Múzeum, 24, 225n47, 327, 332

Tadama, Fokko, 34
 Public Market, Seattle, 383, *pl. 75*
Taft, William Howard, 44, 380
Tanner, Henry Ossawa, 21, 128, 129, *pl. 34*
Taos, 129
Tarbell, Edmund Charles, 133–134
 as juror, 20, 21, 22, 37n61
 one-man gallery, 118, 129, 134
 Works
 On Bo's'n's Hill, *pl. 60*
Tate Gallery, 320
Taussig, Rudolph J., 380
Temko, Allan (1924–2006), 56
Temple of Childhood, 246–247
The Ten, 118, 152n25
Terry, Colleen, 235n4
Thatcher, Anna, 250n38
Thiis, Jens (1870–1942), 222
Third San Francisco Photographic Salon, 239
Thomson, Gaston, 303, 312
Tibbitts, Howard C. (1863–1937), 238

Tiffany, Louis Comfort, 128
Tihanyi, Lajos, 330, 332, 333
 Self-Portrait, 324, *pl. 153*
Tirman, Albert (1868–1939), 304, 308, 309n4, 312, 314, 381, *fig. 164*
Tissot, James
 L'ambiteuse (The Political Woman), 21, 300, 315, *pl. 138*
Titanic, 18, 380
Todd, Frank Morton, 56, 67, 69n7, 69n26, 81n28, 120, 122n9, 224n17, 309n14
Toledo, 225n69, 320, 382
Toledo Museum of Art, 383
Tolerton, Hill, 217, 224n22
Tonalism, 28, 118, 128, 135
Toronto, 225n69, 320, 382
Torrey, Frederic, 148, 153n41, 317
Trajan's Column, 67
Transcontinental Telephone Call Theater, 46, *fig. 30*
Trask, John E. D. (1871–1926), 11, 13, 16, 17, 18, 19–20, 21, 22, 23, 24–25, 30–31, 32, 33, 36n35, 36n49–50, 37n59, 37n61, 37n68, 37n71, 37n73, 37n87, 38nn136–137, 58n21, 115, 116, 117, 119, 122n42, 123n43, 123n51, 123n57, 123n67, 136, 139, 145, 150, 152n22, 152n25, 153n41, 215, 216, 224n21, 225n63, 311, 314, 315, 320, 325, 380, 381, 382, 383, *fig. 11*
 Report of the Department of Fine Arts (final report), 12, 148, 153n50, 224n18
Troubetzkoy, Prince Paolo, 17, 37n98
 La Danseuse (Mademoiselle Svirsky), 17, *pl. 148*
 Lady Constance Stewart Richardson, 17, *pl. 147*
Trumbull, John, 117
Tryon, Dwight William, 128
Twachtman, John Henry, 20, 21, 123n61, 135
 Mother and Child, *pl. 59*
 one-man gallery, 18, 118, 129, 131, 137n28, 145
Twain, Mark, 77
27th Annual Exhibition of American Paintings, 21
291 Gallery, 23

Uitz, Béla, 333, 334n31
Újság, 331
ukiyo-e, 224n2, 268
Underground Chinatown, 46, 114–115
United States, 18, 21, 23, 33, 43, 49, 64, 67, 111, 114, 117, 122n18, 245, 247, 307, 313, 321, 323n69, 381
 American art and architecture, 11, 13, 18, 19, 20, 21, 22, 52, 58n8, 67, 75, 77, 111–153, 129, 227, 228, 313, *fig. 167*
 influences on, 115, 116, 117–118, 119, 123n46, 139, 143, 145, 151, 229, 314, 315, 316, 321
 painting, 11, 21, 38n136, 71–72, 116, 123n43, 125–137, 139–153, 381
 printmaking, 216–220, 223, 224n6, 224n9, 224n13, 224n16, 225n58, 227–235
 American West, 111, 115, 125, 128, 136, 219
 East Coast, 23, 33, 118, 382, 383, *fig. 30*
 France and, 303, 307–308, 321
 glorification of, 49, 115, 117, 118, 119, 122n9
 Hungarian art in, 325, 326, 332
 introduction of modern art in, 122n41, 139
 juries, 215
 Midwest, 20, 215, 224n8, 229, 232, 237
 New England, 20, 37n69, 78, 229, *pl. 43*
 Northeast, 215
 Panama Canal and, 12, 43, 44, 61, 111, 112
 section, 11, 17, 18, 19, 20–21, 22, 25, 31, 111–153, 116, 146, 215, 219–220, 227–235, 235n1, 316, 380, 381, *fig. 167*
 West Coast, 11, 20, 114, 118, 223, 229, 240, 317
 World War I and, 49, 111, 304, 312, 332, 383
 See also specific states
University of California, Berkeley, 58n9, 58n13, 73, 146, 316, 382
 Greek casts transferred to, 68
 Maybeck and, 53, 59n39
University of Rochester, 19, 243
Untermyer, Samuel (1858–1940), 20
Uruguay section, 22, 37n83, 381
US government, 33, 44, 46, 242, 332, 383
 House of Representatives, 44, 380
 Senate, 44, 380
 State Department, 23, 33
US Marines, 46
USS *Jason*, 20, 46, 303, 305, 309n5, 313, 314, 318, 322n26, 325, 327, 381, *fig. 140*
Utamaro, Kitagawa, 225n43

van Gogh, Vincent, 141, 149
van Sloun, Frank, 21, 136
Vassardakis, Cleanthe, 68, 69n26
Vaszary, János, 329, 334n31
Vedres, Márk, 332, 334n31, 335n53, *pl. 157*
Velázquez, Diego, 145, 150
 Las Meninas, 149
Venice
 Biennale, 21, 24, 33
 depictions of, 217, 218, 222–223, 225n31, *figs. 91, 92, 106*
Venizelos, Eleutherios, 61, 68
Veresmith, Daniel Albert, 224n13
Versailles, 56, 306
Vezin, Charles (1858–1942), 31, 37n59, 123n51
Vickery, Atkins and Torrey, 317, 322n46
Vienna, 23, 24, 220, 325, 329, 332, 334n7
Világ, 330
Vollard, Ambroise (1866–1939), 320
Vonnoh, Bessie Potter, 17, 147
 The Scarf, *pl. 46*
Vuillard, Edouard, 334n38
 Bois de Boulogne (The Lawn), 322n37

Walker, Andrew, 152n10
Walter, John I. (1879–1930), 33, 39n142, 68, 382
Walters, Henry, 20
Wanamaker, Lewis Rodman (1863–1928), 239
 booth, 243–245, 250–251n52, *figs. 123, 124*
Ward, John Quincy Adams, 118
Warner, Murray (1869–1920), 36n20
 autochromes, 14, *figs. 5, 34, 55, 72*
Washburn, Cadwallader, 219, 224n22
 Arch of the Setting Sun, with Shadows (PPIE), 72, *fig. 51*
 Exposition Palace Interior, *pl. 4*
 Liberal Arts Building—The Entrance, *pl. 5*
Washington, DC, 13, 21, 33, 122n4, 225n69, 251n70, 333, 380
Washington, George, 220
Watkins, Carleton, 241
Weber, Max, 31
Webster, Herman Armour, 224n22
Weimar, 134
Weinberger, Caspar, 57
Weinman, Adolph Alexander
 Descending Night, 16, 36n29, 72, *fig. 5*, *pl. 18*
 Rising Day (Rising Sun), 16, *pl. 17*
Weir, Julian Alden, 21, 128, 152n39, 316, 382
 The Bridge: Nocturne (Nocturne: Queensboro Bridge), *pl. 70*
 The Plaza: Nocturne, 21, *pl. 71*
Weitenkampf, Frank, 224n10, 234
Wendt, William, 21, 118
 The Land of Heart's Desire, 136
West, Benjamin, 117
West, Isabel Percy
 Granada, Spain, 233, 234, 235n7, 235n9, *fig. 114*
Weston, Edward, 238, 242
 Carlota, 240, *pl. 123*
 Child Study in Gray, 240
 Dolores, 240
 "Photography as a Means of Artistic Expression," 238
Westrum, Anni Von, 235n7
Whistler, James McNeill, 118, 133, 143, 145, 150, 224n22, 225n31
 influence of, 131, 136, 217–218, 219, 225n33
 one-man gallery, 18, 20, 118, 129, 131, 152n27, 216, 217
 prints, 129, 216, 217
 Works
 Arrangement in Black, No. 2: Portrait of Mrs. Louis Huth, 20, 150, 152n30
 Arrangement in Grey and Black No. 1 (Portrait of the Artist's Mother), 20
 Black Lion Wharf, 217, 225n26, *pl. 86*
 Draped Figure, Reclining, 217, *pl. 89*
 Green and Violet: Portrait of Mrs. Walter Sickert, 20
 La vielle aux loques, 217
 The Little Nude Model, Reading, 217
 Long Venice, 217
 Nocturne in Black and Gold: The Falling Rocket, 20, 131, *fig. 81*
 The Smith, Passage du Dragon, 217
 Study in Rose and Brown, 20, *pl. 31*
 Symphony in Blue and Pink, 131
 Symphony in White and Red, 131

The Thames, 217, *pl. 87*
 Variations in Blue and Green, 131
 Weary, *pl. 88*
White, Annie, 52
White, Charles Henry, 224n22
White, Clarence H., 237, 238, 239, 240
 The Orchard, *pl. 124*
Whyte, Robert A., 38n109
Widener, Joseph, 18, 20
Wiener Werkstätte, 220
Wilder, Laura Ingalls, 319
Wilkes-Barre Camera Club, 238
Williams, Michael (1877–1950), 14, 19, 118, 123n60, 128, 129, 149, 215, 381, 382
Wilson, Maude Jay, 240
Wilson, Woodrow, 243
Wolf, Henry, 220, 223, 225n41, 382
 Lower New York in a Mist, 220, *fig. 101*
women
 artists (Gallery 65), 17, 123n57, 128, 147, 149–150, 151, 153n55, 153n68, 227, 240, 243, *figs. 14, 166, endpapers*
 depictions of, 51, 55, 58n24, 77, 114, 115, 122n25, 128, 133, 134, 149–150, 229, 233, 242, 315
Women's Auxiliary of the Palace of Fine Arts, 68, 69n28
Wood, Charles Erskine Scott (1852–1944), 20, 315
Woodville, Richard Caton, *War News from Mexico*, 117, *fig. 66*
Worcester, Joseph, 52
Worden, Willard E., 245, 250n37
 booth, 241–242, 243, 250nn36–37, *fig. 119*
 Works
 The End of the Trail, *pl. 21*
 Japanese Tea Garden, *pl. 133*
 The Memorial Museum, Golden Gate Park, *fig. 20*
 Poppies and Lupine, *pl. 132*
 Portals of the Past, *fig. 1*
 Seal Rocks, *pl. 131*
Wores, Theodore, 21
World's Columbian Exposition, Chicago, 1893, 11, 43, 58n17, 75, 111, 122n4, 218, 224n6
 PPIE and, 63, 67, 73, 122n42, 125, 215
world's fairs, 7, 11, 12, 15, 18, 20, 22, 37n53, 43–49, 51, 61, 63, 67, 71, 72, 73, 111, 112, 117, 121, 122n2, 122n6, 122n34, 122n42, 139, 145, 149, 151, 152n6, 215, 225n43, 237, 238, 241, 303, 380
World War I (First World War, Great War), 33, 45, 46, 61, 122n40, 144, 303, 304, 307, 309n5, 311, 313, 320, 321, 325, 327, 331, 335n49, 383
 outbreak of, 11, 22, 23, 45, 121, 136, 223, 225n47, 334n40, 381
 United States and, 49, 111, 304, 312, 332, 383
 works stranded and lost during, 12, 24, 33, 332
World War II, 332, 335n49
Wright, Helen, 223, 225n61
Wright, Joseph, 220
Wright, Willard Huntington (1888–1939), 34
Wright brothers, 46
Wuerpel, Edmund H., 37n71
Wybro, Jessie Maude, 133, 135

xenophobia, 31, 112–114, 115, 121

Yang, H. C., 250n44
Youngstown, 320, 382

Zinn, Bruno F., 55
Zorach, Marguerite Thompson, 143
Zorach, William, *Woods in Autumn*, 26, 143, 150, *pl. 85*
Zorn, Anders, 215, 224n4

Published by the Fine Arts Museums of San Francisco and University of California Press on the occasion of the exhibition *Jewel City: Art from San Francisco's Panama-Pacific International Exposition* at the de Young Museum, San Francisco, from October 17, 2015, through January 10, 2016.

This exhibition is organized by the Fine Arts Museums of San Francisco.

Thank you to our early supporters of this exhibition.

PRESIDENT'S CIRCLE

LISA & DOUGLAS GOLDMAN FUND

BENEFACTOR'S CIRCLE

ART WORKS.
arts.gov

The catalogue is published with the assistance of the Andrew W. Mellon Foundation Endowment for Publications.

Library of Congress Cataloging-in-Publication Data
Jewel city : art from San Francisco's Panama-Pacific International Exhibition /
James A. Ganz with Emma Acker, Laura Ackley, Heidi Applegate, Gergely Barki,
Karin Breuer, Melissa E. Buron, Martin Chapman, Renée Dreyfus, Victoria Kastner,
Anthony W. Lee, Scott A. Shields, Colleen Terry.
 pages cm
 Includes bibliographical references and index.
 ISBN 978-0-520-28718-1 (hc) — ISBN 978-0-520-28719-8 (pb)
1. Art, Modern — 20th century — Exhibitions. 2. Art — Exhibitions — History —
20th century. 3. Panama-Pacific International Exposition (1915 : San Francisco, Calif.)
I. Ganz, James A. II. Fine Arts Museums of San Francisco.
 N64931915 .J49 2015
 709.04 — dc23
 2015010939

24 23 22 21 20 19 18 17 16 15
10 9 8 7 6 5 4 3 2 1

Fine Arts Museums of San Francisco
Golden Gate Park
50 Hagiwara Tea Garden Drive
San Francisco, CA 94118-4502
www.famsf.org

Leslie Dutcher, Director of Publications
Danica Michels Hodge, Editor
Jane Hyun, Editor
Diana Murphy, Editorial Assistant

University of California Press
155 Grand Avenue, Suite 400
Oakland, CA 94612-3758
www.ucpress.edu

Project management by Danica Michels Hodge
Design and typesetting by Bob Aufuldish, Aufuldish & Warinner
Production management by Amanda Freymann, Glue + Paper Workshop
Copyediting by Kathryn Shedrick
Proofreading by Susan Richmond
Indexing by Jane Friedman
Separations by Professional Graphics Inc.
Printed and bound in China by Asia One

DETAILS
Cover: Arthur Frank Mathews, *The Victory of Culture over Force (Victorious Spirit)* (detail, pl. 23). Back cover: Gino Severini, *Spherical Expansion of Light, Centripetal* (detail, pl. 171). Page 2: Frank Vincent DuMond, study for *The Westward March of Civilization: Arrival in the West* (detail, pl. 25). Page 4: George Hitchcock, *The Vanquished (Vaincu)* (detail, pl. 56). Page 6: Joseph M. Raphael, *Spring Winds* (detail, pl. 57). Page 10: E. Charlton Fortune, *The Pool (The Court of the Four Seasons)* (detail, fig. 7). Page 40: *Night Illumination— Panama-Pacific International Exposition—San Francisco, California, 1915* (detail, pl. 7). Page 42: Jules Guérin, *Panoramic View of the Panama-Pacific International Exposition* (detail, pl. 6). Page 50: Dome and colonnades of Palace of Fine Arts at night (detail, fig. 38). Page 60: Cast of a scene from the north frieze of the Parthenon (detail, fig. 43). Page 70: William de Leftwich Dodge, *Atlantic and Pacific* (detail, pl. 26). Page 108: Francis McComas, *Navajo Gateway, Arizona* (detail, pl. 77). Page 110: Alson Skinner Clark, *In the Lock, Miraflores* (detail, pl. 2). Page 124: Theodore Robinson, *The Valley of Arconville* (detail, pl. 52). Page 138: Cecilia Beaux, *Man with the Cat (Henry Sturgis Drinker)* (detail, pl. 42). Page 212: Gustave Baumann, *Harden Hollow* (detail, fig. 111). Page 226: Bror Julius Olsson Nordfeldt, *The Wave, Moonrise* (detail, pl. 116). Page 236: William Edward Dassonville, *Figure Study* (detail, pl. 122). Page 300: James Tissot, *L'ambitieuse (The Political Woman)* (detail, pl. 138). Page 302: Jean-Paul Laurens, *The Execution of Joan of Arc* (detail, pl. 134). Page 310: Paul Cézanne, *The Gulf of Marseille from L'Estaque (Le golfe de Marseille vu de L'Estaque)* (detail, pl. 141). Page 324: Lajos Tihanyi, *Self-Portrait (Önarckép)* (detail, pl. 153). Endpapers, hardcover edition (in order of appearance): Gallery 65 in the Palace of Fine Arts (detail, fig. 14); Gallery 66 in the Palace of Fine Arts (detail, fig. 166); Jury of Awards for the PPIE (detail, fig. 168); Gallery 68 in the Palace of Fine Arts (detail, fig. 15)

PHOTOGRAPHY CREDITS
Unless otherwise indicated below, photographs are courtesy of the institution indicated in the figure or plate caption. Every effort has been made to identify the rightful copyright holders of material not specifically commissioned for use in this publication and to secure permission, where applicable, for reuse of such material. Errors or omissions in credit citations or failure to obtain permission if required by copyright law have been either unavoidable or unintentional. The authors and the publisher welcome any information that would allow them to correct future reprints.

Figures
1, 2, 16, 19, 33, 42, 43, 45, 49, 51, 52, 53, 96, 98, 102, 103, 109, 110, 113, 114, 115, 117, 118, 122, 124, 153, 154, 156, 157, 159, 160 Randy Dodson, Fine Arts Museums of San Francisco. 3, 4, 29 Royal Photographic Society / Science & Society Picture Library. 7 Courtesy Bonhams. 9, 10, 14, 15, 18, 21, 44, 69, 70, 71, 75, 78, 88, 135, 141, 163, 165, 167, 168, 172 © Moulin Studios. 13 © 2015 Georgia O'Keeffe Museum / Artists Rights Society (ARS), New York. 17 Reproduced with permission of The Estate of Dame Laura Knight DBE RA 2015. All rights reserved. 22 Courtesy San Francisco Art Institute. 39, 77, 87, 93, 144 The Metropolitan Museum of Art, New York, www.metmuseum.com. 46 Courtesy of Penn Museum, image #173611. 50, 85 San Francisco Chronicle / Polaris. 54 archival print courtesy of Leftwich Kimbrough; Randy Dodson, Fine Arts Museums of San Francisco. 66 © Moulin Studios. 66 The Walters Art Museum, Susan Tobin. 73 © The Art Institute of Chicago. 76 Scala / White Images / Art Resource, NY. 81 Erich Lessing / Art Resource, NY. 90 Bridgeman Images; © Succession Marcel Duchamp / ADAGP, Paris / Artists Rights Society (ARS), New York. 91, 146, 149 Bridgeman Images. 95 Los Angeles County Museum of Art, www.lacma. org; © Frances Frieske Kilmer Family Trust. 100 © The Metropolitan Museum of Art, New York. 106 Randy Dodson, Fine Arts Museums of San Francisco, © David Brangwyn. 111, 112 Randy Dodson, Fine Arts Museums of San Francisco, © Ann Baumann Trust. 121 © 2015 Curatorial Assistance, Inc. / E.O. Hoppé

Estate Collection. 130 Used with permission of The Ansel Adams Publishing Rights Trust. All rights reserved. 131 Courtesy of the National Gallery of Art, Washington, © Aperture Foundation Inc., Paul Strand Archive. 132 Randy Dodson, Fine Arts Museums of San Francisco, © Aperture Foundation Inc., Paul Strand Archive. 143 © 2015 Carnegie Museum of Art, Pittsburgh. 145 Erik Gould. 147, 151 Peter Willi / Bridgeman Images. 150 Tate, London / Art Resource, NY. 152 © Peter Bartók. 162 Courtesy Oakland Public Library, Oakland History Room. 171 UIG / Bridgeman Images

Plates
1, 4, 5, 6, 7, 8, 9, 11, 12, 16, 21, 23, 26, 27, 28, 47, 49, 50, 53, 57, 59, 64, 65, 67, 75, 77, 79, 80, 86, 87, 88, 89, 92, 93, 95, 96, 97. 98, 100, 104, 106, 107, 109, 110, 111, 112, 113, 116, 117, 120, 126, 131, 132, 133, 134, 135, 136, 146, 147, 148 Randy Dodson, Fine Arts Museums of San Francisco. 2 Image © Mint Museum of Art, Inc. 13, 54, 82 Courtesy Bonhams. 15 © 2015 Calder Foundation, New York / Artists Rights Society (ARS), New York. 17, 18, 29, 30, 33, 60, 138, 167 Bridgeman Images. 32, 142 © 2015 Carnegie Museum of Art, Pittsburgh. 34 Joseph Levy. 38 Michael McKelvey. 40 Katherine Wetzel, © Virginia Museum of Fine Arts. 44, 74 The Metropolitan Museum of Art, New York, www.metmuseum.org. 46 © 2015 Museum of Fine Arts, Boston. 51 © Estate of Paul Manship. 52 © The Art Institute of Chicago. 56, 144 © RMN–Grand Palais / Art Resource, NY. 63 © Estate of Harry Hoffman. 66 The Philadelphia Museum of Art / Art Resource, NY. 68 Susan Einstein. 69 © 2015 Delaware Art Museum / Artists Rights Society (ARS), New York. 70, 71 Cathy Carver. 72, 73 Terry James, Halifax, © Estate of David Milne and Mira Godard Gallery. 84 Aurora Crispin, courtesy San Francisco Museum of Modern Art. 85 Digital image © Whitney Museum of American Art. 90, 91 © 2015 Estate of John Marin / Artists Rights Society (ARS), New York. 101, 102, 159, 160, 162 © Artists Rights Society (ARS), New York. 121 Randy Dodson, Fine Arts Museums of San Francisco, © 2015 The Imogen Cunningham Trust. 122 © Estate of William E. Dassonville. 123 © 2015 Center for Creative Photography, Arizona Board of Regents / Artists Rights Society (ARS), New York. 127 Courtesy of George Eastman House, International Museum of Photography and Film. 139 Digital image courtesy of the Getty's Open Content Program. 140 © RMN–Grand Palais (Musée d'Orsay) / Jean-Gilles Berizzi. 141 © RMN–Grand Palais (Musée d'Orsay) / Hervé Lewandowski. 143 © Musée des beaux-arts du Canada. 145 © ADAGP, Paris–RMN–Grand Palais (Musée d'Orsay) / Hervé Lewandowski. 150 Bridgeman Images, © Artists Rights Society (ARS), New York. 151 John Dean. 152 Lee Stalsworth, © Artists Rights Society (ARS), New York. 153, 154, 155, 158 György Darabos and Árpád Fákó, Budapest. 156 Helga Sigvaldadottir. 161 Randy Dodson, Fine Arts Museums of San Francisco, © 2015 Artists Rights Society (ARS), New York. 163, 164, 166 © Jorma Gallen-Kallela Family Collection. 165 Randy Dodson, Fine Arts Museums of San Francisco, © Jorma Gallen-Kallela Family Collection. 168 © The Museum of Modern Art / Licensed by SCALA / Art Resource, NY. 169 © AISA / Bridgeman Images. 170 courtesy Christie's. 170 © 2015 Artists Rights Society (ARS), New York / SIAE, Rome. 171 Christopher Burke Studio / ShootArt, © 2015 Artists Rights Society (ARS), New York / ADAGP, Paris. 172 © Musée de Grenoble / The Estate of Luigi Russolo

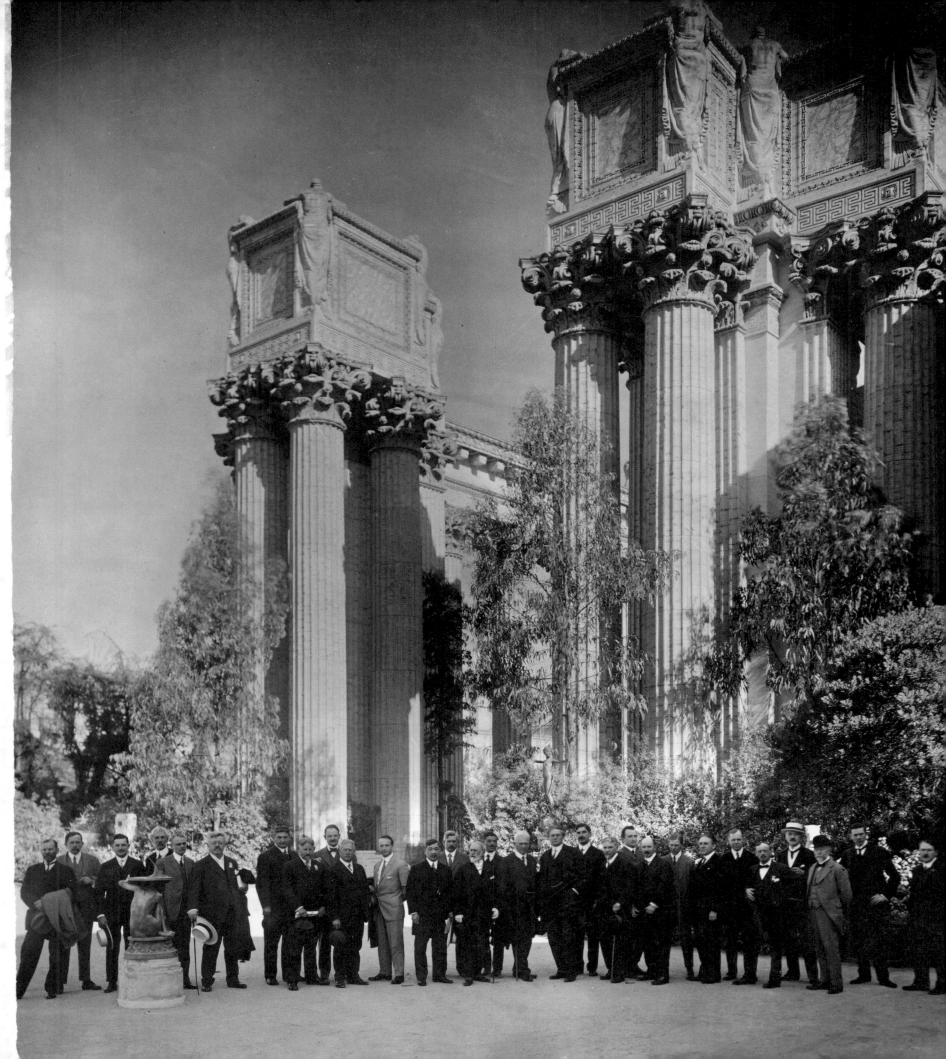

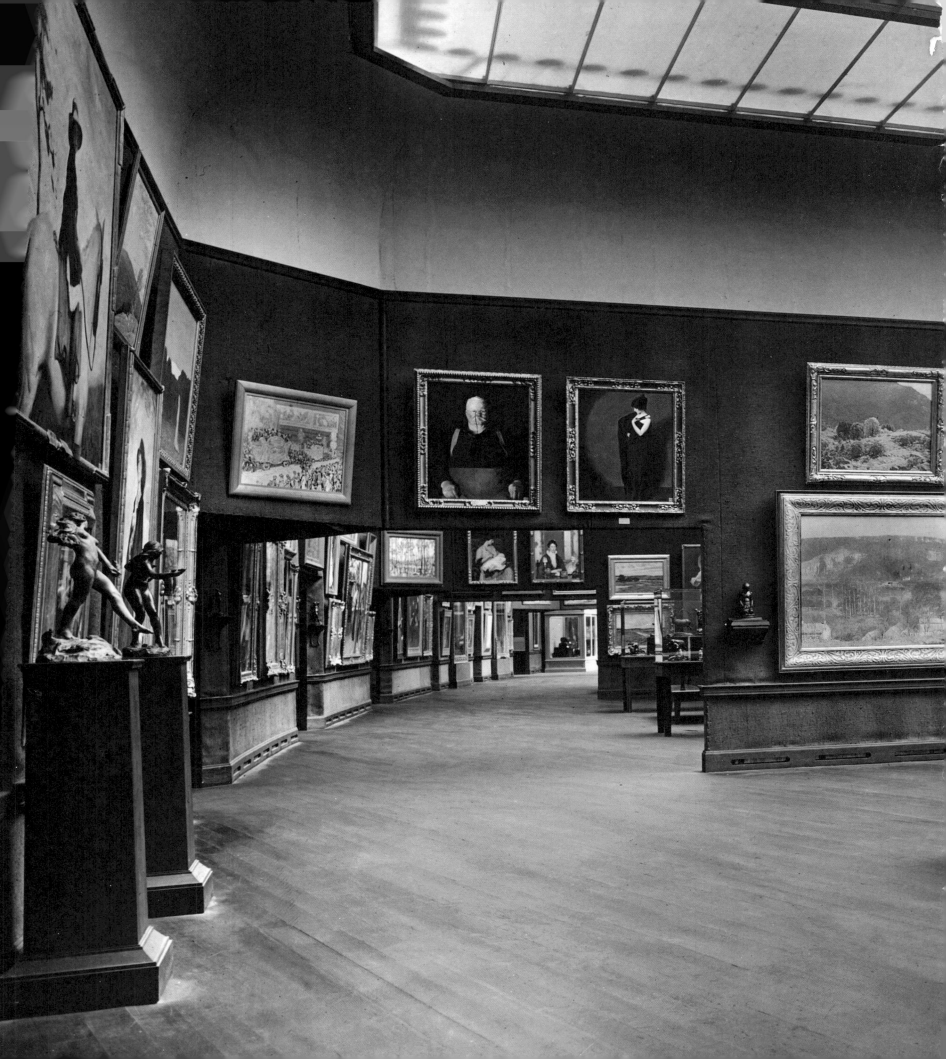